# Starting Your Career as an
# Illustrator

# Starting Your Career as an Illustrator

# Michael Fleishman

**ALLWORTH PRESS**
**NEW YORK**

Allworth Press books may be purchased in bulk at special discounts for sales
promotion, corporate gifts, fund-raising, or educational purposes. Special editions can
also be created to specifications. For details, contact the Special Sales Department,
Allworth Press, 307 West 36th Street, 11th Floor, New York, NY 10018 or
info@skyhorsepublishing.com.

19 18 17 16          5 4 3 2 1

Published by Allworth Press, an imprint of Skyhorse Publishing, Inc.
307 West 36th Street, 11th Floor, New York, NY 10018.

Allworth Press® is a registered trademark of Skyhorse Publishing, Inc.®, a Delaware
corporation.

www.allworth.com

Cover and interior design by Michael Fleishman; cover assembly by Mary Belibasakis
Cover and chapter title illustrations Copyright © 2016 Michael Fleishman

Library of Congress Cataloging-in-Publication Data is available on file.

Print ISBN: 978-1-62153-509-6
Ebook ISBN: 978-1-62153-515-7

Printed in the United States of America

# TABLE OF CONTENTS

**ACKNOWLEDGMENTS** xi

**INTRODUCTION** xii

## SECTION I | STARTING OUT 1

### CHAPTER 1 | SO YOU WANT TO BE AN ILLUSTRATOR? 3
Definitions ◘ Meanings
◘ Doing It All ◘ Art Therapy ◘ Be Yourself
◘ Pressures ◘ Commitment ◘ It's Pretty Simple? ◘ Freelance
or Independent? (Benun) ◘ Self-Employed ◘ Focus (Sommer)
◘ Taking Stock ◘ Working from Home ◘ Sales ◘ Hustle and
Bustle ◘ Stand Out a Mile ◘ Game Plan

### CHAPTER 2 | EDUCATION 25
The Long Haul ◘ An Education ◘ The Puzzle ◘ Going Up…
◘ Learning the Ropes ◘ School Rules ◘ Onto the Eclectic
◘ Art School ◘ DIY ◘ Carry On ◘ A Real Education
◘ Success 101 ◘ Learning Curve ◘ Learning in Practice
◘ On-the-Job Training ◘ A Business Education

### CHAPTER 3 | OPPORTUNITIES 50
What Is an Illustrator? ◘ Here's a Tip ◘ What Does It Take to Be
an Illustrator? ◘ Should You Do It All… ◘ …And Should You Do
It Right Now? ◘ Finding the Right Markets ◘ Starting Your Career
◘ Getting Work and Winning New Clients ◘ Location, Location,
Location ◘ New Kid in Town ◘ Talk Is Kinda Cheap ◘ Working
with New Businesses ◘ Networking ◘ Pro Bono ◘ Referrals
◘ More to Life (Terry) ◘ Game Plan

### CHAPTER 4 | OFF ON THE RIGHT FOOT 73
Dress for Success ◘ The War Between the States (of Mind)
◘ The Stuff ◘ They're Coming for You, Barbara ◘ The Dude Abides
◘ Do I Have What It Takes? ◘ Is the Opportunity to Succeed There?
◘ Research, Research, and More Research ◘ Brand Me
◘ The Chase Is On

## CHAPTER 5 | FINANCES 92

The Business Section ◘ Get It Down ◘ The Business Plan ◘ The Practical Plan ◘ Fits the Bill ◘ Count On Me ◘ Everything at a Price ◘ Make the Ends Meet ◘ A Recipe for Success ◘ Get the Money You Need ◘ A Loan against the World ◘ The Five Cs of Credit ◘ Take Some Credit ◘ Beyond the Bank ◘ Meaningful Relationships

## SECTION II | EVERYTHING RIGHT IN ITS PLACE 117

### CHAPTER 6 | SETTING UP SHOP 119

The Space ◘ Practicalities ◘ Working at Home ◘ Working Away from Home ◘ The Dotted Line ◘ One Sec—I'm on the Phone ◘ Kibitz and Bits ◘ Choose Your Supplies and Equipment ◘ Play Ball: Opening Day ◘ Computers, "Buy" and Large ◘ Why Did You Buy That? ◘ Chips Off the Ol' Block ◘ Practically Functional? ◘ Software and Tear ◘ Bizware ◘ Just Tell Me What You Want ◘ Buy the Buy

### CHAPTER 7 | MANAGING YOUR BUSINESS 145

Get Over It ◘ Juggler ◘ Dictator ◘ Managing Your Work ◘ People Who Need People ◘ Managing Your Money ◘ Lay Out Your Plan ◘ Monitoring Expenses and Income ◘ Staying on Track ◘ Your IRS Obligations ◘ Right around the Corner ◘ Twister ◘ Putting Money Back into Your Studio ◘ Big Better Best ◘ Chunks ◘ Brass Tacks ◘ Package Goods ◘ Devil's Advocate ◘ The Kick ◘ Rethink ◘ I'll Manage

## SECTION III | TAKING CHARGE 173

### CHAPTER 8 | CLIENTS 175

Match Game ◘ Business in Mind ◘ Why Freelance? ◘ Better Than the Next Guy ◘ Get a Job ◘ Balancing Act ◘ Business Chops ◘ All Atwitter about Social Media ◘ All Join In ◘ Leading Interests ◘ Promote Yourself ◘ Walk This Way ◘ Old School ◘ Keepers ◘ The Message ◘ Satisfaction Guaranteed

### CHAPTER 9 | PRICING 199

Everything Has Its Price ◘ The Elements of Pricing ◘ The Price Is Right? ◘ A Virtue ◘ Rate Hikes ◘ Pricing—Based on What? ◘ Standards and . . . ◘ . . . Practices ◘ A Bonny Rate ◘ Summing Up: Every Price Has Its Thing

### CHAPTER 10 | THE PORTFOLIO 223

About the Portfolio ◘ Survey Says ◘ Justified ◘ Compare and
Contrast ◘ The Real Deal ◘ Assembling the Portfolio ◘ A Unified
Front—and Back ◘ Call Write Now ◘ Presenting Yourself ◘ Take a
Meeting ◘ A Bit of a Drop-off ◘ Speedy Delivery

### CHAPTER 11 | MARKETING, NETWORKING, AND PROMOTION 244

Together ◘ Take Off (Garrett) ◘ Absolutely
◘ Cold Play ◘ Keep It Short ◘ Heads ◘ Tails ◘ Same Ol'
◘ Props ◘ If a Tree Falls ◘ Pop Up ◘ Empire Building ◘ By
the Numbers ◘ On Notice ◘ Dust to Dust ◘ It Sells

### CHAPTER 12 | ENTREPRENEURS 261

One Hell of an Eye ◘ The Signpost Up Ahead ◘ Pizzoli ◘ It's
Alive! ◘ Next Stop ◘ The More the Merrier? ◘ Facing the
Crowd ◘ The Source ◘ No Competition ◘ Go Copyright Yourself
◘ Pain and Power ◘ It's Absolutely Criminal ◘ Worth Fighting For
◘ Pulling Strings

### CHAPTER 13 | DIGITAL 287

What's the Difference? ◘ Fast Times

### CHAPTER 14 | ON THE WEB 303

Thrive ◘ Social ◘ Crazy and Cool ◘ Back in the Day ◘ Visibility
◘ Deal Direct ◘ Call and Response ◘ The Portfolio Online ◘ The
Online Portfolio, Step by Step ◘ The Critical List ◘ Like Rolling Off
a Blog ◘ It's about the Content ◘ A Host of Decisions ◘ Building
Your Blog: The Right Stuff ◘ Sell It, Baby! ◘ The Now

### SECTION IV | TO MARKET 329

### CHAPTER 15 | SEQUENTIAL ART 331

Art in Sequence ◘ Funny Business ◘ The Biz ◘ McCranie
◘ Jager ◘ Maihack ◘ Sommer ◘ Todd ◘ Cho ◘ Break In
◘ Millidge ◘ State of the Art ◘ Graphic Novels ◘ Busy Busy Busy
◘ Animation ◘ You Bet ◘ Role Playing ◘ Future Opportunities
◘ Burnout

### CHAPTER 16 | MAGAZINES, NEWSPAPERS, BOOKS 354

Is Print Dead? ◘ Magazines ◘ Transition ◘ Typecast ◘ Type Cast ◘ Zines of the Times ◘ The Look ◘ What Magazines Need ◘ Researching the Market ◘ The Approach ◘ Starting Block ◘ Newspapers ◘ Front Page News ◘ Saving Trees ◘ Start Small ◘ Skills for Newspapers ◘ Send It to Me ◘ Books ◘ By the Book ◘ Eeeeee, Books! ◘ Please Allow Me to Introduce Myself ◘ Whom to Contact ◘ Booked Solid ◘ Introduction

### CHAPTER 17 | PAPER PRODUCTS 373

Power On ◘ Over the Moon ◘ Passion Play ◘ Beyond the Obvious ◘ Bless Hue ◘ Baer with Me ◘ Mum's the Word ◘ Running the Shop ◘ Make a Living ◘ Dalziel ◘ Triggers ◘ Greeting Cards ◘ A Rose by Any Other Name ◘ The Company You Keep ◘ What Type of Cards Are There? ◘ Card Alternatives ◘ Suitable Art ◘ Many Happy Returns—Researching Cards ◘ Pay Me Now or Pay Me Later ◘ Rights (and Wrongs) ◘ Easy as Pie ◘ Submit ◘ Commissioned Designs ◘ The Back Door ◘ Using Freelance Help ◘ Card Formats ◘ Other Paper Products ◘ The World from Your Own Backyard ◘ Independence Day

### CHAPTER 18 | DESIGN STUDIOS AND ADVERTISING AGENCIES 401

Much to Do ◘ Local ◘ Wants . . . ◘ Do the Do ◘ Please Allow Me to Introduce Myself

### CHAPTER 19 | SMALL BUSINESS 414

Right at Home ◘ The Long Run ◘ What Types of Freelance Help Do Small Businesses Need? ◘ Straight Up the Block ◘ Introductions ◘ No Thanks ◘ Samples ◘ Awww, Go Direct Yourself ◘ Locals Preferred? ◘ Printers? Yes, Printers ◘ Careful Does It

### SECTION V | ON YOUR WAY 427

### CHAPTER 20 | TEACHING 429

Nobility ◘ Adorable ◘ Joy and Effect ◘ Marks, Brother ◘ Stay the Course ◘ Wax On ◘ Flexibility ◘ Life in the Class Lane ◘ What Are You Teaching? ◘ The Test Lab ◘ Works for Me ◘ The Front Lines ◘ It All Fits ◘ Good/Bad (Betza)

**CHAPTER 21 | IT HAPPENS** 446

I Got My Reasons ◘ It's Personal (Quon) ◘ Freda ◘ Rust
◘ Bethany ◘ Erin ◘ Sister Act ◘ Burnt ◘ Damage Control
◘ Embrace Failure. Learn from It ◘ Fail to Fail ◘ Flight or Fight
◘ Unstuck ◘ Big Time ◘ A Distraction Every Minute ◘ Buck Up!
◘ Layers ◘ Shifting ◘ Bounce ◘ A Good Fit
◘ Stay with the Program

**CHAPTER 22 | THE NEXT CHAPTER** 471

It Don't Come Easy ◘ Know Yourself ◘ Recognize the Fact That . . .
◘ . . . And Understand This ◘ Alternative Realities ◘ Square Peg/
Round Hole ◘ Keep Your Avant-Garde Up ◘ Victory ◘ Are You
Busy? ◘ Piece of Cake ◘ Snider ◘ I See You ◘ Great Talent/Big
Heart ◘ The Neighborhood ◘ Get Back ◘ Secure ◘ And There
It Is ◘ Let's Connect ◘ Stay the Course, of Course

# Acknowledgments

**Without question,** to my wife, Joanne Caputo (the Pittsburgh Piewright). Next, to my sons Cooper and Max. Because family is what counts when you absolutely, positively have to get your book written overnight.

A big thank-you to all the generous correspondents who added their unique insights, wisdom, and seasoned commentary—your invaluable input was far more than merely appreciated.

Some folks were enthusiastically there from *go, team, go*—you guys were the *rock.* Then there were contributors who jumped in somewhere along the way, as well as those who ran with me closer to the finish line—y'all were da *roll.*

To my esteemed colleagues, valued counselors, and dear friends, I am deeply indebted to you for your comic timing, gracious help, solid guidance, and unstinting support.

And, of course, thanks to Zoe Wright, Tad Crawford, and Kelsie Besaw (along with all the crew at Skyhorse and Allworth) as well as all the folks who contributed to the first renditions of this book.

# ➡ INTRODUCTION

**If this introduction sounds** much like the intro to its sister, *Starting Your Career as a Graphic Designer*, it should: *Illustrator* is directly built off its sibling volume and both combine (or rather branch off) to update their parent title, *Starting Your Career as a Freelance Illustrator or Graphic Designer*.

You probably have run into *the line*, or similar, in just about every "current" illustration book, haven't you? It's most likely in the intro (as it is in this book *and* its sib). It's a relevant, absolute *constant*, an inescapable truism, so let's get it out on the table and out of the way. *The line*, as filtered through this project, would go something like this: "There have been incredible changes in the profession since this book first appeared as yet another two separate volumes for a different publisher," says (fill in the blank here). Of course, in this case it would be "says *me*, Michael Fleishman." You'd have to really fire up the Wayback Machine, Mr. Peabody, to see just when (and how) those titles were combined to create the original update offered by Allworth Press (but trust me, that deed was done).

Changes? Yeah. Sure. But compared to what? At what point? The advent of photography was quite the game changer in the nineteenth century, just as four-color reproduction seriously impacted the field back in the early twentieth century. Telecopying (a.k.a., the fax machine) was rather high tech in the seventies. I'm hardly downplaying the incredible impact of the computer, the Internet, and social media; I'm simply saying to keep a bit of proper perspective—your job description is changing as you read these words. The quotes encapsulating the word "current" are purely intentional. Hey, it's all relative.

So, yes, since the second go-round of this book, there has indeed been an epic interaction of art and technology: the above-mentioned radical morphing of communications and marketing through the rise of social media; the modern (and extraordinary) delivery systems that squarely slam the global marketplace into your backyard. The thud of that shock wave has forever rocked both illustration and design and, not coincidentally, rolled our book's third incarnation back to the future of two volumes again.

*Illustrator* and *Designer* address common challenges facing those who want to move up, out, or on. You might be a beginner—long on talent but short on experience—or perhaps you're a burgeoning professional just getting out of school. You could be on staff—doing staff stuff anywhere—and interested in a jet pack to rocket you to _____ (well, the sky *is* the limit).

Wherever you are on the continuum, I wanted to keep this updated volume as realistic and honest as the original, but now even more pertinent and absolutely current. Toward that goal, I adapted (and folded in) some particularly relevant

content from my books, *How to Grow as an Illustrator* (Allworth Press), *Exploring Illustration* (Cengage), and *Drawing Inspiration: Visual Artists at Work* (Cengage).

While there has been that windstorm of changes previously mentioned, let's paraphrase illustrator Ward Schumaker from an earlier interview: those who gracefully lean into those winds will do quite well. Schumaker remarked that there is no such thing as thinking locally, and I agree, now more than ever. The technology that has made this possible was only hinted at in the very first editions of this work. It is simply business as usual now, and continues to evolve.

Over the years some lessons remain constant. Of course, what you know is key. Great chops construct the shark tank of talent you must demonstrate every day, on every job. It still matters who you know—in any business climate, military-grade networking is important. As Schumaker says, "We must use each other to compare techniques, talk business and finances, to join in solidarity; we must be there for our colleagues."

Master marketer Roger Brucker tells you to diversify, diversify, diversify. Paraphrasing illustrator Elwood Smith: changes in the industry have opened the gates to other venues and fresh disciplines that mark whole new opportunities for creative growth. As Smith says, "The Muse is guiding me into areas I never dreamed of. I am inspired to move into other areas of creative activity that I've been meaning to investigate (but previously [was] too busy to do)."

This edition of *Illustrator* is still liberally salted and generously stacked with studio-smart tips plus nuts-and-bolts information from illustrators up and down the ladder. It answers some basic questions including:

- How to find jobs and analyze what market is right for you.
- Ways to stay ahead of the competition and pick up new business.
- How to get noticed.
- How to network and get referrals . . .

. . . and much more.

The new *Illustrator* presents a positive yet practical look at biz, process, and product. And this update, like the earlier editions of the book, offers the same well-rounded, personal perspective from men and women who've been there (and seen that, and done that, too). Hopefully it's obvious; but if not, all contributors quoted in this book without an introduction are either illustrators (or designers), unless otherwise noted in the text.

So enough schmoozing already—let's get started.

# Section I
# Starting Out

# Chapter 1

# So You Want to Be an Illustrator?

---

*If you're doing this right, there is no downside. Are you kidding? I draw robots and spaceships and cars and trucks all day long and I pay the mortgage in the process. What's not to love?*

—Brian Biggs

# DEFINITIONS

We can probably all agree that an *illustrator orchestrates visuals to tell a story*, elicit a response, communicate a message, sell (or sell to), inform, or educate an audience. You could define it this way: *illustrators are militant visual problem-solvers*, schooled in advanced information technology, seeking to communicate organization (both pictorial and intellectual) or, conversely, advance chaos (both pictorial and intellectual).

We often interface the aesthetics between type and image and are frequently at the core of graphic design that transcends the flat promise of a traditional "good read." Illustrators today bob and weave with interactive and animated content for eager viewers (and readers) now always hungry for something more, or—at the very least—different than a static page or image may offer.

Wow. The preceding definitions may be too esoteric or shimmery for some and too mechanical for others—all talk and no action. But as Allan Wood says with a smile, "We are the music makers . . . we are the dreamers of dreams." Wood is quoting Willy Wonka (who, in the movie *Willy Wonka & the Chocolate Factory*, is actually quoting from Arthur O'Shaughnessy's famous poem "Ode").

"Illustrators facilitate the creative process and collaborate with our clients to help manifest their ideals," says Wood. "We engage and communicate with our client's audience through visual language. In essence, we create cultural artifacts—no different from ancient Greek or Egyptian artifacts (the only difference is that our focus is not religion, but consumerism).

"At its most basic level," Wood says, "this reflects the cultural views of the times. At its height, it reflects and creates—and at times, challenges—the cultural ideals of the times."

So whether it's simply by mechanical definition or through heavy perspiration, a calculated pragmatic approach or an inspired midnight revelation, as Mr. Wonka also says, "There is no life I know to compare with pure imagination."

# MEANINGS

Those illustrators at the top of the game inherently have a focus and a sense of the task (backed by a natural grasp of the rudiments). It just feels "good" or "right." At the core of it all, it's pure *fun*. I'd definitely make the wager that most of these illustrators live with an obsession for the practice of illustration. A particular intensity—that peculiar burn—*to make art* forever burns bright.

You might never have thought you'd grow up to be an "illustrator." Or an "artist." Or a "designer." Or a "craftsman." Perhaps your teachers and high school guidance counselors—maybe even your parents—told you that "you can't make a living doing that. How about law or med school, kiddo?"

From his studio in Pittsburgh, Pennsylvania, Phil Wilson tells you that this—the idea that an art career is a vocational dead end—simply is not true. "This business is a business like any other business," he says emphatically, "with good people making a good living at it. But you must be prepared and know your craft inside and out. You have to take it seriously as a career and not 'play' at it half-heartedly.

"You have to want it more than anything else. It has to be as important and as necessary to you as the air you breathe," Wilson says. "You have to be dedicated and disciplined. As to your work ethic, you must put in whatever hours it takes to do a job and do it professionally; to do every job on time and with the utmost attention to the requirements, quality and detail . . . there will be no room for slop."

As a kid raised in the Philippines, all Rigie Fernandez wanted to do was draw from (and dream up characters for) Filipino comic books. Illustrators like Joey Celerio (huge at that time in his homeland) inspired him to pursue his passion for drawing.

His father motivated and helped Fernandez to follow his muse. This eventually led to Fernandez getting a degree in fine arts. "It fueled the same passions I had when I was younger," he considers, "to create all the things that I imagine and share it with the world.

"Labels—'freelancer,' 'independent'—are not important to me," Fernandez pauses to consider. "But it's important to clients. This is why freelancers must work on their personal branding, establish their credibility, and improve their client-handling and communication skills. Play it smart—network. And be up to date with the latest trends."

"The term art is so general," says Dadu Shin, "I could call a scientist an artist. I believe illustration is art. However, I'm not naive enough to think that it doesn't have a large commercial component to it.

"To me, the label isn't important," Shin says. "It used to be; when I was just starting out; because it was a reflection of what others thought of me and my profession. However, I don't care about that anymore, I just want to create good and meaningful work."

## LA CASA

Cristina Martin Recasens tells us she is devoted to illustration. "I've seen many jobs and all kinds of commissions," she says, "so for me, it's obvious that an illustrator can be a designer, artist, cartoonist—even an experienced waiter. The creative person who needs to work to survive welcomes anything—all of it helps you grow."

Born in Barcelona, Spain, and now based in the Pyrenees, Recasens equates her creative life to a large house with many doors. Outside, the doors may look the same; inside they open up to rooms of completely different realities. You decide in which room you want to live.

"The money you earn often depends on the environment of the room you choose," Recasens says. "Your relationships, the efficiency of your workplace, even your mindset about life in general and business specifically, that's all established by your response to your environment," says Recasens.

"Don't regard a challenge as a barrier," says Recasens. "In my opinion, that's, shall we say, archaic—old-fashioned. It's all about being honest with yourself and choosing the environment in which you'll feel (and work) better.

"But above all, you must seek out the discipline you enjoy—work *that* truth; put in the time (especially in the beginning, when you may not be making much money).

"And," she says, "it's vital not to be lured by the false gods of fame, recognition and ego." For Recasens, the only possible way to grow and thrive creatively is through humility and the conviction that what you are doing expresses your true passion. "That's the room you want to stay in when you deal with the inevitable difficulties you'll encounter during your career," she says.

## DOING IT ALL

This book is the sister volume to *Starting Your Career as a Graphic Designer* (which initially addresses a relevant question: is your perspective that of a designer or an illustrator?). And as Brian Fencl tells us in that book, maybe the great thing about being "simply a designer" is that you don't have to choose what you want to be—illustrator, photographer, designer, what have you. "You can set up a business where you do all of it," Fencl says.

But if you define yourself as an "illustrator," you do set up a business that establishes a day-to-day act of making images. Illustrators like Fencl, Chris Spollen, and Ray-Mel Cornelius speak of the problem-solving, divergent thinking and a *lifestyle* of learning—foundations ingrained at a deep level. "This is what I call *creative intelligence*," says Fencl. "You work, contribute, adapt and innovate."

Jason Petefish specifies that both design and illustration fall under the general topic of "visual communication," but says, "The illustrator is not necessarily a 'designer,' and on a design gig, it may be the designer who hires the illustrator." He's not saying that illustrators are subordinate to designers. Hardly—they're more like copilots on the same bombing run.

"Many illustrators hold their own very well without being hired by a designer or creative director," Petefish says. They are skilled in both design and

illustration. And, according to Petefish, "good" visual design subjectively means tasteful skills and the marketplace will be the ultimate purifying arbiter of quality (or lack of). "Especially the higher up you go," says Petefish.

## ART THERAPY

"Creating has always been a form of therapy for me, a way to express my thoughts and issues visually," says Dadu Shin. "If I need to get something off my chest, I always know a pencil and a blank sheet of paper are there to listen. I love what I do, and I'm grateful to live the life I lead."

Shin takes immense pleasure in creating for a living. That sheer joy is apparent in his work, and the artist finds that same sense of fun spilling out into his personal and professional relationships as well. "To find people you connect with always enhances life in so many aspects," he says.

Shin is a firm believer in experimentation. He loves to play with different materials and new processes. And with that exploration comes failure and mistakes. "Failures and mistakes are important," Shin says. "Failures and mistakes are necessary. Certainly in the development of your work, but for the development of your character—to open your eyes and allow you to see more objectively.

"Looking at yourself from another point of view teaches you a lot about yourself and how you need to improve, what needs worked on. Follow the same formula every time, every piece, and the chances you'll create something new and surprising are pretty low."

All that being said, Shin feels it is essential to firmly practice what he preaches above. Thus, failure must foster the persistence to believe that making mistakes is beneficial, and you simply work through them. "Rejection is hard. Multiple rejections can be devastating," he says from experience. "It's okay to feel bad for yourself, but then allow yourself to be your best self through focus and hard work. Stand up for your ideas and values, live with integrity."

So Shin feels that "happiness" is nebulous—that's just not how he views success in life anymore. "Finding peace of mind is what I see as ideal now," he says. "Peace of mind relieves the anxieties and insecurities about how to relate and express yourself to the world.

"Moving on is an integral factor here as well. To dwell is to dig yourself into a deeper and darker hole," says Shin. "Moving on from past misgivings, allowing things to come and go, is a big part of finding that peace.

"Once you are comfortable with yourself, you can contribute your ideas and beliefs to the public because internally your core values are coming from a clear and genuine place. It'll also allow you to weed out the people who don't appreciate you for who you really are."

# BE YOURSELF

Shin finds that speaking in your own voice means confronting your excuses and rationalizations from the start. When he was younger he had difficulty looking at what he was doing objectively. "My work was just a mishmash of my hero artists," says Shin. "I was lying to myself, convincing myself that I wasn't being a hack. If I had been objective about it from the beginning, I would have spent more time trying new stuff, discovering my true voice rather than piggybacking on things other people had discovered for themselves.

"It's easy to tell if the artist is invested in what they were doing, or if they aren't at all," Shin says. "People can tell when you're faking and lying in your drawing.

"To be self-aware allows you to have confidence in whatever you are doing. Jumping on different bandwagons and not truly knowing what you stand for can be confusing. I know because I've been there. Knowing yourself is pivotal to creating work that has a real genuine voice.

"When you start to look at things through your own eyes and mind, and not through the eyes and minds of others, you begin to form your identity. Knowing yourself gives you insight into why you do things, and knowing why you do things is extremely helpful in understanding your place in this world."

## COOL KIDS

"Fitting in and being liked was important to me when I was younger," Shin admits. "However it's way less important now. Trying to please everyone is the worst thing you can do for yourself. You lose sight of who you are when you are agreeing with everyone else's ideas.

"As we grow older," says Shin, "thinking for yourself becomes far more critical. Do things you like, believe what you believe is right, love who you want to love—all things that allow us to be more genuine. All I ask of others is that they be genuine and honest with me.

"When it comes to work, we are all different," Shin says. "But two artists can be similar because they have similar personalities, aesthetics, or backgrounds. And yes, trends exist in the world at large—the world of illustration is not exempt here.

"But if you're always trying to be part of the "cool kids club," your illustration will never be yours and people will see that. I appreciate work that much more when I can see the artist's voice in it. When it comes to originality in illustration, it works just as it does in life."

# PRESSURES

"I work well under pressure," says Shin, "my brain works quicker when I'm on a tight deadline. But regardless of this, everyone is coping with something. We're

all in our heads all the time and fighting battles, small and big. Realizing this has resulted in an increase in my empathy. I don't judge people as much anymore, because I know I have no idea what battles they're fighting at any given moment. I also put less weight on first impressions for the same reasons."

Reflecting on his profession, Shin says, "It's a tough industry; certainly not a stable gig. To make a living at this job you must have faith in yourself. You have to believe that you are good enough to be hired, that your work is worthy to share with the world. You have to have an inherent confidence that good projects will come, or you'll shrivel up and die out pretty quickly."

And, of course, he understands that anxiety, insecurity, and "taking it personally" are in mortal conflict with faith and hope. "Anxiety and insecurities about your own work can be defeating," Shin says. "There's a constant battle going on in my head: 'this piece is awful . . . wait no, it's actually pretty good! Oh no, it's terrible again.'

"I've also learned not to take constructive criticism personally—it's about being objective about your own work and not going on the defensive with excuses of why you did or didn't do whatever."

## COMMITMENT

While the relationship to her art and career has changed through the years, Katherine Streeter says that her love and commitment to this job has always been the most constant sure thing in her life. "There have been many turns along the way," she admits, "change is always a given in life. Of course that goes for career and lifestyle as well. Freelancing is risky. It fits for some personalities, but it's certainly not for everyone.

"I've been at this a long time," Streeter says, "and sometimes I can't believe that I'm still surviving as a freelancer; that work has been steady enough to pay rent all of these years."

### DEAL

Over the years, Streeter has dealt with some standard anxieties of the freelance life: failure and rejection, living on the edge of security, and taking risks. "It's easier to take risks at twenty than at forty, but this job is always about risks," she points out. "So I realize that I must be who I am and that perhaps a completely secure situation would actually bore me. Maybe that will change down the line. I'll be open to it if it does; but for now, I still get great satisfaction out of this gig and remain optimistic."

Streeter maintains that this is pivotal: you must be optimistic and believe that there is a place for your work—somewhere. "If you are pessimistic then it will be a dark road moving forward because there will always be rejection," she says. "The percentage of jobs that come from one promotional blast is usually

low. There are killed assignments and criticized concepts. But this is all as it should be; it is the way the industry works."

## FAIL SAFE

Streeter believes that failure allows a person to grow—in life and in art. "This is where the optimism comes in," she says. "In the face of failure, it is hard to see that as a positive thing, but if you allow it to teach you something, then you get stronger.

"My studio is full of piles and piles of years' worth of art," says Streeter. "I sometimes think that I should stack it all into a bonfire and let it go, but sometimes I like to look back and sift through the piles. They are reminders of my journey with style and craft. And I'm able to objectively see my own creative growth in a way that is impossible to witness in the moment.

"In a pile of 100 pieces, there *might* be two or three that seem worthy. The pile is full of failed attempts, but each failed piece brought me that much closer to the ones that won awards.

"It's been healthy for me to keep my own work going all the time," Streeter says. "My personal side projects allow me to feel balanced so that all of my heart and soul does not go into the commercial work (if that was the case, I would probably take rejection a lot harder).

For Streeter, failure is more in her gut than her head. She may understand logically that something works for the context it is in—i.e., there are pieces that get chosen or accepted or are printed—but in her mind's eye, it's "this could have been better," or "I wish another concept I proposed had been chosen."

Still, she lives with it and moves on. "The work I do that feels the most like me is on that gut level," Streeter says. "When I experiment outside of my illustration jobs, I let myself get back to my true voice. Sometimes I lose [that true voice] if I'm too worried about creating a piece to fit the assignment, if the focus is only about solving the problem or creating something to please the art director. These things are important, of course, but if I forfeit my own vision, then to me that is a failed piece. When this happens, it is a reminder to me to maintain the balance of my personal work with my commercial work I mentioned previously.

"Everyone must find their balance. For some, illustration is everything, their total focus and survival; and for others, it is a part-time job and they are able to choose the assignments that best fit their schedule or interest."

## ROLLING

"Changes? I tend to roll with them," Streeter says. "I get restless when things stay the same too long anyway. The goal is hopefully to keep changing for the better, but freelancing is a roller-coaster ride, and there are changes that happen for the worse sometimes. The economy goes up and down; budgets vary; design

and trends change, and public interests shift. There's the fear of print dying. Art directors switch jobs.

"And a person changes. Most people who create will grow as they make work over the span of many years. Fitting into a place as one's work changes is ideal but sometimes there are awkward growth spurts where there is nowhere to fit in. It's okay—that will change too."

## DIVERSIONS BIG OR SMALL

"Distraction is always there," says Streeter, "beautiful sunny days; kids and family schedules; life obligations and personal problems; dark (and light) times; the constant stream of social media. It's a challenge to stay focused, but an exercise to keep that in check.

"Career setbacks are tough. We work so hard to make our goals or gain something personal or professional. It can feel more unfair than life setbacks I think. A setback is failure that allows us to survey things and reevaluate. It's better for the long run than it is in the moment. It can be like hitting a pause button, which can feel like stagnation. Yet in the big picture, it can be quite necessary and positive."

## SENSE OF PURPOSE

"Assignments give me a sense of purpose more than personal projects do," says Streeter. "Assignments also give me a deadline, which is something I work well with.

"The process of illumination is powerful and important, especially when starting out," Streeter says, "but it is not for everyone. It's important to keep trying until you find what you are best at doing.

"I am most content when I'm producing *something*, even if it's a scrapbook gift for my sister. I am happy when I'm being creative. If I can spend at least part of every day doing or planning something creative, then I'm balanced.

"But it is more of a challenge for me to stick to my own project deadlines, which are never really set up because I want my personal work to breathe and change as it needs to. This happens more when the projects are free of constraints and boundaries."

# IT'S PRETTY SIMPLE?

Take down that two-column ledger labeled "Life of an Illustrator." You'll see a "plus" column on the left and a tag reading "minus" on the right. In the "plus" column: Freedom, at last! Or is it freedom, at least? There's no time clock to punch; you draw up your schedule. No toiling "nine-to-five," (unless you want it that way)—just be sure you meet your deadlines and make your appointments (or any meetings). You decide when to work, where, and for how long.

Found in the "minus" column: the vocation of illustration is demanding. You will hustle. You'll work extended hours, and the buzzword here is "more." More hours, yes, but this is a theoretical gray area: the operative word is *more*. More. More. More. You can do a wider variety of better gigs (read that, "more creative" assignments, or at least, more of the type of work you want to do). There is the potential to earn more money in the process.

Dip into your great reserves of self-discipline; look in the mirror and meet a tough new employer—you! And that salesperson's gig your dad was always recommending? Congratulations, you landed the job. Marketing and self-promotion will become very important to you. Just hit that particular nail square on the head—this is a business. You. Are. In. Business. However, the worlds of art and commerce can be compatible. And while the root word "success" is wonderfully subjective, there are wonderfully successful illustrators out there; I'm rooting for you to join that club (hey, let's get jackets).

Another spin off all the above is that a steady paycheck may be history. Your money could come in dribbles or drabs, spurts, bursts, (or hopefully, and better yet) torrents, or droves. The true meaning of the terms "accounts receivable," "accounts payable," and "cash flow" will be obvious (hopefully, not painfully so).

The professional security of a full-time position is not applicable here. The business of freelance illustration can be a fiscal roller-coaster ride—jobs may not be steady; you certainly won't land every exciting assignment you pursue, and odds are, you'll have to take some grunt assignments to pay the bills (hey, hey, join the club).

But Allan Wood feels that it's important to look at the more "mundane jobs" as a solid means to sustain cash flow as well as peace of mind. Says Wood, "This in turn establishes a strong foundation to pursue what you want to do in a calm and calculated manner."

## MAKE YOUR MARK (FOLKS JUST LIKE YOU)

### KING: IT COMES IN BUNCHES AND BUMPS

In a mud brick house on an island off the coast of Australia, Stephen Michael King has designed, illustrated, and written—in his words—a whole bunch of books. As I write this, his last count was about 95. His agent told him recently that he's sold well over 1,000,000 books in Brazil *alone*.

King will tell you that this prolific career has been based on trusting his intuition and following his heart. "Not too many business principles have purposely entered my life," he confesses, "but I'm reliable, always meet a deadline, and aim for a personal creative truth in all my characters and illustrations."

This self-professed "go with the flow" kinda guy has a happy track record of pleasing big publishers and repeat customers who seek him out for his hand skills and old world view of putting something beautiful out into the world for people to find. "This joyfully naive concept means that I've lived a life where I can accept fallow periods, similar to a farmer at the mercy of good and bad seasons," King says.

But King also celebrates that he's had a bumper crop for some fifteen years now. He told me that he considers promoting himself more, but fears there wouldn't be enough work hours in his day to handle the resulting volume. A real concern is that a full-scale program may very well distract him from his true passion: illustrating, writing, and design. "The seasons have been kind to me," he says. "Currently, I'm booked out roughly two years in advance on all jobs."

## FREELANCE OR INDEPENDENT?

Do you call yourself a freelancer or an independent? Writing in *How* Magazine, Ilise Benun (who also runs the great Marketing-Mentor.com site) asks if that term "freelancer" is a bit of a dirty word. From here, the perceived gulf between the "independent" and "freelance" protocols is more attitude than reality.

Okay, the undertones of the root words "free" or "independent" may conjure up various definitions for certain clients. Joe Customer infers "cheap" or "unskilled," "hobbyist," "desperate," or "transitory." Jane Client assumes "fancy and expensive," "out of our league," or "contrary and dogmatic."

The terms may very well be too nonspecific and vague, and negative connotations may hold some sway with somebody somewhere, but I wouldn't lose much sleep over these tags. Don't permit outside observations to color *your* own mindfulness. While labels often carry the heavy lifting of self-perception, you should describe whatever you say you do as what feels right to you. The bigger concern is how you conduct yourself professionally; how you run your practice and interact with clients (all the way from clear paperwork to straight pricing structures to critical customer service).

Maybe, as Benun suggests, it's a simple matter of rephrasing (mix and match at will): "I am a self-employed/independent contractor/entrepreneur/communications expert/visual problem-solver/graphics guru/creative consultant. I run a shop/work solo/own a studio/maintain a practice that offers visual solutions and much more." Semantics to the rescue again!

### SYNONYMOUS WITH WHAT?

"I never liked calling myself a freelancer, even though I do use the word," says Charlene Chua. "I don't have anything against the term itself. But I think there is

an association with it . . . like, it's somehow akin to being unaccredited or something. I don't know why people keep asking me if I am freelance—is that a polite way of saying 'have you gotten a real job yet'? Are people confused by the notion of self-employment? Or is 'freelance' simply synonymous with 'cheap'?"

Says Chua, "My definition of an illustrator: an illustrator is someone who solves design problems with pictures. An illustrator is a visual communicator. We make pictures to communicate concepts that aren't easily explained through words alone. Also, I think we excel at creating the imagined and impossible. Illustrators bring dreams and fantasy to life, or at the very least, allow other people to see a small portion of a fantasy. I would like to think that an illustrator is a blend of a designer and an artist."

## SELF-EMPLOYED

Defined very simply, whether you employ the tag of a freelancer or call yourself an independent, you are a self-employed subcontractor marketing your illustration by the job to several buyers. That's very short and sounds just as sweet.

But beyond the dictionary, you will be the office manager, secretarial pool, sales staff, marketing department, maintenance, and mailroom rolled into one. The ever-growing stack labeled *Important Things That Must Be Done Right Now* lies immediately under the bowling ball, cleaver, and cream pie you'll swear you're juggling as a one-person shop.

A common denominator (in fact, a primary motivation) will be your dedicated passion for this vocation. It's more than a mere job, it's a calling. Are you applauding yourself as an entrepreneur with an independent spirit, a sense of adventure, and your own bold vision of success? Hear, hear!

Come April 15, you can benefit from the same tax breaks any small business enjoys. And, like small-business owners everywhere, there is a certain pride one only gets from calling your own shots. Your business is the vehicle to exercise your particular talents on demand.

Like a classic Western movie, it's not so complicated. On this job, somebody's telling you to "draw, pardner." Slap the genuine leather of your portfolio, and you'll then face off as a hired gun shooting to get to the Okay Corral (get it?). You also ride off into the sunset loaded up with a silver bullet: the power to say "no thank you, ma'am" at any time. Sure; *any* time. You always have the choice to say no; always. The code of the West, of course, only dictates that you clarify, agree on, and document the specifics of an assignment before consenting to the task.

### WHO'S THE BOSS?

So ultimately, are you really your own boss? Understand that somebody is contracting your service, not buying your soul. And being in charge of your career

is not always simultaneous with always being in charge. Even those illustrators boasting consummate experience and expertise may at times assume the role of the facilitator or collaborator.

When Brian Biggs was an art director hiring illustrators, he realized that "I wanted to do what they did. Some people are more comfortable getting a steady paycheck and having that predictability," he says. "I wasn't one of them.

"I can't stand to be on someone else's clock. I like that every single day is different from the one before. You still have to do the work, but for the most part, it's up to you to decide when to do it. It also means that you must be pretty versatile and able to say yes to anything."

"My skills and knowledge are used by my clients for their benefit," Allan Wood says. "I enable the creative process for my clients and collaborate with them to manifest their ideas, ideals and vision."

Wood realizes that in the cosmic scheme of things, it is the client who will use the finished illustration, not him. He came to understand that he will work with an incredible variety of clients, and as he puts it, "It's naive to think I come with all the answers."

## FOCUS

As people found Mikkel Sommer's work, he began receiving mounting emails from nervous art students asking a litany of anxious questions, routinely about starting out and making a name for yourself.

But he knows there is no set formula or pat response. When it comes to process and style, Sommer thinks changes in illustration hinge on certain trends peculiar to time and place. "*Your* geography," he says, "your schooling; where you work; how long you've been illustrating. It's too easy to generalize, too hard to specify."

And when it comes to product, there could be many factors. Sommer works mostly in comics; and he notices more publishers doing online comics to save expenses. "Some old publishers have died," he says. "Some publishers that used to be small and humble are big and evil now. And new passionate and personal publishers keep popping up from time to time. It's an interesting time to work in comics. It's all shifting about and changing constantly. And things are so global that you never have to be a part of a collective or a group to accomplish anything—which, unfortunately, is also a little sad.

"It's a battlefield out there, or a jungle, or both," says Sommer. "Something the students always ask me online is 'how do I get noticed?' I tell them that you shouldn't focus on the *act* of getting noticed itself, but purely on *creating* work that you're passionate about, then get that online. Put it on some sort of blog, and perhaps the right kind of people will see the work, and the passion within. Or perhaps not. Then you keep drawing."

# TAKING STOCK

Of course, taking stock of the industry invariably comes with some self-assessment. "I wish I didn't have to think about career or business, but it's impossible to avoid if you do a lot of work," Sommer says. "I've had to choose between projects, and certain directions I want to move towards. I've done interviews and I've written bios that represent myself in some specific ways that are expected of me.

"But I don't think one category applies to me—I work in editorial illustration, animation, children's books, and comics—even though I'm perceived in different ways when actually compared to what I'm doing at the moment.

"People judge hard within the creative world," Sommer says. "They wanna put you in a box and mark you as fast as they can. As an editorial illustrator I get positive feedback (most of the time); the audience knows what I'm talking about when I mention newspapers, books, and whatnot. But when it comes to comic books, viewers are more confused. They think *Spider-man*, or *Peanuts*, or *Persepolis*, and so on. If it's not any of those it's too complicated for them to care about. I'm not talking about the creative community, it's more the general readership.

"So I avoid telling people what I do most of the time," says Sommer. "I definitely don't call myself an artist yet. Maybe one day."

## SELF-ASSESSMENT

Let's do some self-reflection (we will dive into this much deeper in the next chapter, but for now, just mull things over a bit). Consider this a wee pop quiz. Be honest and objective about who you are, what you can do, and how well you do it. This won't necessarily prevent headaches, heartbreak, or disasters, but it will give you a strong foundation to weather the storm.

Begin by examining your communication skills, marketing acuity, as well as knack for self-promotion and salesmanship, plus entrepreneurial savvy.

Look at your experience. How—and if—you stand out from the pack will play a role here. Business acumen, background, and motivation all must strike the right chord here too. Along with this, examine your organizational skills, drive, and determination. Your technical prowess is obviously critical, and rounds out this rudimentary exercise for now.

# WORKING FROM HOME

Many people actually believe that, because you work from home, you're not actually working. Illustrators typically work alone, usually without the feedback and camaraderie of others, often weathering the peaks and valleys minus a support system. Outside your door, the competition is awesome—in numbers and ability. But you're up to the challenge, right? Your new boss—that's you, remember—buys into that, correct?

As I mentioned earlier, good organization skills will be crucial. While it is the art that will be your bread and butter, realize early that an artist's beret is only one hat you'll be wearing. No smiling faces of coworkers; no water cooler chat with that lovely guy from down the hall to break up the morning. *You* are all those people, doing all those things. Working all day. Getting it all done. Those are all your responsibilities now.

Illustration must be your love—something enjoyed with all your heart; something you need to do, something you would do purely for yourself without pay. When you come right down to it, how many folks can say they truly love their work? Well, *you* can—and that's the biggest plus of all.

Let's introduce you to some of the concerns you'll deal with here. This is just to kick off the conversation. We'll examine these issues (and more) in depth in later chapters.

## MAKE YOUR MARK (FOLKS JUST LIKE YOU)

### ALLEN: THE GREAT ESCAPE

Brian Allen recommends that you determine specific goals when starting out. "Work and build a strong portfolio," he says. "Accrue critical experience, create your website. At the same point, prepare financially. I suggest stashing an additional five months' pay into personal savings as a cushion if things don't take off right away.

"I spent a lot of time calculating my expenses, as well as projected business expenses, and then compared that with possible earnings. Investigate if the prices you'll be charging will add up to what it takes to support you." Reader, this is exceptionally wise advice, and for more on sound financial planning, see Chapters 5 and 6.

Next, Allen says to make a list of the stuff—supplies and materials; equipment, hardware, and software—you will need to freelance full time and determine how you will purchase all this (intermittently or immediately). Tie up loose ends; have the essential mechanisms in place.

For continued strategies here, head over to Chapter 6, "Setting Up Shop."

# SALES

Perhaps you dread the thought of selling your work, let alone "being in business." Maybe you question if you're suited temperamentally to freelancing or working independently? Some illustrators do feel that marketing their work is akin to putting their children up on eBay. But realize that you're only selling your skills, not your soul. And then recognize that someone is paying you to produce images for a purpose.

Remember that you are an actual person, selling just your services as a problem-solver, to real people *who need your help*. And keep in mind that you should be selling *usage* of the art rather than the product itself. If you can do that, this anxiety can be easily suppressed.

No, I'm not endorsing you to advocate for a dishonest vendor, buy into a politically repulsive political group, or shill for an unhealthy or repugnant (morally, ethically, physically, spiritually) product.

## MAKE YOUR MARK (FOLKS JUST LIKE YOU)

### REDNISS: ACCESSIBILITY

"I used to believe any kind of commercial art was selling out," states illustrator Lauren Redniss. "I was sure I'd be a *painter*."

But Redniss yearned to learn (more, more, more); to be more engaged in the world, to work with a more stimulating crowd. Exploring other options, she eventually went back to school for her MFA. "I didn't know what illustration was beyond children's books," she says. "But it seemed to represent the chance to both write and draw, to collaborate with other folks, *to be surprised* by those collaborations." It was also a sly subterfuge to create art without worrying if it was important or new, or anything else that, in her words, used to paralyze her when she picked up a paintbrush.

Redniss enjoyed how accessible illustration was; she liked how it was intended to be understood. "This was more appealing to me than the gallery world," she says, "where work often seems deliberately obscure, or meant only for a rarefied audience."

The difference between an artist and an illustrator? "It doesn't make much difference to me," Redniss says. "I think an illustrator—someone who is commissioned to produce a visual representation for a specific purpose—can approach her work as art, and a so-called artist can produce paintings with no more soul than a bank logo. It is up to the individual to put herself into her work, to invest it with ideas and passion. This will come across in the final presentation, wherever it appears. Maybe that medium will be labeled 'illustration.' Maybe it will be labeled 'art,' or 'graffiti,' or 'skywriting.'"

Redniss sums up by saying that it's all about *the idea*. "If you have concepts and you communicate them visually, you are an artist. If you can get those ideas into your commercial work, great. If they don't fit, find another medium."

## HUSTLE AND BUSTLE

Your time schedule will hardly be regular, and you'll riff off other people's deadlines. There will be moments so quiet you can hear a pen drip, and hectic periods when 24-hour days are not enough; hustling is all relative for the freelancer.

Happiness and security? It's my experience that happiness and security in freelancing are achieved by hustling, but the word itself gets a bit of the stink eye. Hustling is nothing more than honest, hard effort. It is aggressively and energetically plying your trade; an assertive attitude combined with a robust work ethic that makes for good product.

But regardless of your sweat equity, Phil Wilson cautions that there are never any guarantees. He does know one thing, however: "If you're freelance," he says with a laugh, "you're not going to fire yourself!"

## WRITTEN IN STONE

Call it your Declaration of Independence or look at it as the Ten Commandments of Freelancing; read through this inventory and regard these guiding principles as if written in stone.

1. Thou shalt learn when to say no. If you don't like the suggestion, work it out amicably. Learn the art of compromise. Be flexible, versatile, and cooperative. Compromise need not be capitulation; it leaves both parties feeling that they work well as a team. However, accept the fact that there are actually some art directors who just won't meet you halfway. Truly difficult folks are not worth the headaches or heartaches. At this point you just need to safely get out of Dodge with some style and grace.

2. Thou shalt be polite, persistent, productive, and positive. Always communicate in a professional manner. Follow directions. Listen to your client and respect their vision. Educate your client. Don't be a prima donna.

3. Thou shalt strive to constantly increase your skill level and expertise. Grow and learn; up your game. Get it better than the day before.

4. Thou shalt relax and have confidence in yourself. Nobody's shooting at you, and you're not doing brain surgery on your mom. Believe in yourself and others will too.

5. Thou shalt make it a point to have fun. Love your profession. Remember this when you are putting in the long hours. Do what you want, work where and when you want, and work with nice people only.

6. Thou shalt have a personal life. Never feel guilty about making (and taking) time for yourself and loved ones—it's important.

7. **Thou shalt always be honest and ethical.** Never promise something you can't deliver; and remember: You are selling a product, not your soul.

8. **Thou shalt be a good businessperson.** With stars in our eyes, we key on those first four letters in the word *freelancer*. The financial (and physical) costs of running and maintaining your business will quickly reveal the realities behind the lofty conceptions. Be an informed freelancer: protect your rights by keeping abreast of the ethical standards, laws, and tax reforms. Stay current with pricing guidelines. Learn effective negotiation skills. Maintain excellent records. Don't start a project without paperwork.

9. **Thou shalt not take rejection personally.**

10. **Thou shalt never miss a deadline.** Be late with a job and chances are that particular art director will never call you again.

## STAND OUT A MILE

At some point, the question about style will insidiously creep into the conversation. In a real sense, knowledge and aptitude, business chops, energy and perseverance, and—yeah, sure—style, are joined at the hip of your decision to be a illustrator.

Victor Melamed is an illustrator and cartoonist, as well as a teacher at Moscow's Higher School of Art and Design (that's Moscow, Russia, by the way). And as Melamed will tell you, "Finding a personal style has nothing to do with finding your audience. And the client relationship is actually only a minor part of creative success."

Think about it: clients—looking for a particular style—expect a certain predictability, but frequently the stylist of a "preferred look" and the guy who gets the commission are two different people. More importantly, "predictable" as an adjective in front of the title "artist" can severely limit you, ultimately blocking your creative and professional growth. So, says Melamed, "Moving through new styles, or even working in several, does not stifle (or ruin) your career. You're in control here . . . what work—style, technique, approach, whatever—and how much of it do you want a client to see?"

Your individuality may not surface on your first attempts. Nor can you wait for it to descend upon you from the heavens. "The only thing to do is work," Melamed says, "and consciously search for possibilities outside of one's safety zone. And style? As that venerable philosopher, Ol' Blue Eyes, sang about it: you've either got it or you haven't got it . . . [and] if you got it, it stands out a mile."

Melamed points out that the acute questions to ask are: who are you . . . what makes you who you are? What experience brought you to this creative place? What

pushes you forward? What interests you? What do you want to talk about . . . what do you have to say to your audience (literally and figuratively)? And who is your audience? Men, women; adults, children; students, intellectuals; truck drivers, football fans?

And finally, there's this big one: what is, as Melamed labels it, your USP (unique selling point)? What do you offer that your colleagues don't, and is this what the audience wants to see? "If your USP is attached to a very narrow focus," says Melamed, "for instance, portraits of tigers—or at an even smaller access point, collage portraits of tigers—your USP may be a hard sell, indeed."

## GAME PLAN

Kristine Putt will tell you that your career should be about growth, your development: as a person and as an illustrator (and not necessarily in that order). To grow, you must seek criticism, not praise. "Praise will only tell you that you've arrived," Putt says. "Criticism points to where you can improve. Understand that you should strive to solve your client's communication problem. So we must endeavor to improve our ability to resolve any difficulties with every new project and each new client. The only way we can get better is by seeking criticism."

To do so, you must stretch and step out of your comfort zone. Be willing to take on projects that provoke a very bowel-clenching fear that screams, "I've never done anything like this before . . . I have absolutely no clue how to even begin!"

Putt insists you jump all over this and take the gig anyway. She points out that you will figure it out. "And if you have trouble," she smiles, "there is no better support system than your community of colleagues . . . help is usually only a tweet away."

Such cheek also means you should always be more than willing to say "no." For example, refuse to do any design that is religiously, politically, ethically, or morally offensive to you. "And of course, you scrupulously refuse assignments that can damage your credibility or professional image," Putt says.

Being a focused illustrator means expanding your horizons. Putt asserts that you can't be on duty 24/7. "Have other hobbies and interests, or you'll fade fast," she says. "Plus you'll run out of conversation starters in mixed company. Not everyone knows what *one-point perspective* is. You don't want to be the boring geek at family reunions. Have something other than 'art talk' to contribute."

The play here, according to Putt, is to keep yourself continually stimulated. Sure, you'll land those fascinating and ultrasonically artistic gigs that give you a reason to live (in the studio, at least). But you may not be able to avoid dry, boring, and repetitive assignments that could lead to burnout and possibly creative

despair. You don't want to wind up hating your clients, despising your work, even dreading stepping into your studio in the morning—even if it's just immediately down the hall from the john.

This is a very dangerous place for any illustrator to be (in the creative funk, not off the john and up the hall). You do know that not every project is nomination-worthy, and you probably appreciate that no amount of remuneration will truly fill such hollows. To prevent this from happening, Putt suggests you make it a point to create personal art projects. "Even if no one sees them," she asserts, "even if you're not going to sell them. Keep your creative juices flowing, or you'll quickly find that you've lost interest in what you once loved to do."

Throughout this book, you'll find numerous testimonials rhapsodizing over the benefits of personal side projects. These creative ventures prime the pump of continued learning and improvement—of growth—but only if you stay on top of what keeps it real and fresh. "The world changes constantly," Putt says. "We need to keep up or we'll fall behind very quickly. Pay attention to what's current and continue to evolve or your style of illustration will be dumped long before your shelf date.

"Don't be *that* guy—doing this your whole life, but technically stalled back in the day; stylistically inappropriate by today's standards, glaringly wrong for today's markets."

## CHUTZPAH

Mikkel Sommer calls your attention to the fine line between audacity and being deferential and insecure. It's one thing to be humble, but he feels that when it comes to dealing with clients, writers, and publishers, it's important to establish early boundaries.

"Tell or show your client that you are a hard worker," he says. "Demonstrate that you are passionate as well as on time; that you can't be walked over; you're definitely a team player, but can't—or won't—be dominated.

"This is something I still fight with a lot," says Sommer. "It's the same when discussing payment and contracts; you can quickly seem like a diva if you complain about a certain clause or make demands.

"Sorry to say, it still seems that many illustrators are not respected or treated well in the industry today. I think that many art directors, editors, and publishers simply take it for granted that a number of illustrators are insecure and poor, so it's: 'hey—they're easy to use and take advantage of.' The only thing you can do is stay strong—for yourself and as an example for others."

# ON THE BOARD

## (PROFESSIONAL VIEWPOINTS IN 50 WORDS OR LESS)

What's the usage for the artwork? Illustrators create art for the specific purpose of getting the work published. The fine artist generally does not. As Murray Tinkelman once commented to me, "The difference between illustration and fine arts is that, in illustration, the original is the reproduction."

—Scott Bakal

We get caught up in these dialogues about art/craft/illustration. "Illustration" AND "art" are both usable commodities. A painting on my wall reminds me that there is more to life than just working. That painting reminds me to dream. At the end of the day, what is more useful?

—Sarajo Frieden

Why did I want to be an illustrator? This question makes it sound like I had a choice—the key for me was realizing I needed to make art to be happy.

—Avram Dumitrescu

Work out what you're passionate about. If you enjoy what you're doing, then not only will you perform better day to day, but your work will improve as well.

—Anthony Hortin

© Michael Fleishman 2016

© Greg Betza 2016

Is your illustration unique, eye catching and fits the context in which it's used? Does it support the message? Better yet, does the illustration evoke an emotional response, make the audience pause and react to it—positively or negatively? Either/or, it doesn't matter, just as long as it's memorable.

—Ken Bullock

Michelangelo, Da Vinci, Rembrandt, Sargent, Homer, and Eakins are all illustrators in the modern definition.

—John Schmelzer

My new mantra goes:"Process, Not Product." An "artist" is a by-product of one who is constantly creating art.

—George Coghill

Did I say how much fun this is?

—Michael Fleishman

© Charlene Chua 2016

# Chapter 2

# Education

---

*You do, you learn. Life itself is one big lesson—a series of events that prompt us to question ourselves and our abilities. We learn from mistakes made, and we will learn from mistakes we have yet to make. A good student of life always learns from life's events.*

—Charlene Chua

# THE LONG HAUL

Both younger and older illustrators benefit from education (research and net-working, too, but more on that later). Your particular education should be—no, make that *must* be—a lifelong, career-defining journey of personal discovery and professional exploration, regardless of setting. And don't think for a minute that you'll ever corner the market on "lots you don't know." Wow, what a great first world problem to have. As Tom Garrett says enthusiastically, "Being curious and open to change will keep you moving and fuel your illustration."

There are myriad fine, even fun, solutions to address this situation; welcome and embrace the challenge. The modern "global university" can actually be where you make it and how you find it. We live in a wonderful time of fresh and readily available academic opportunities—across town, just up the block, or right down the hall and online. Learning situations—and great mentors, teachers, and advisors—are anywhere and everywhere you are (and they can be anyone).

What hasn't changed, and never will, are solid traditional basics: smart time management, determined motivation, serious hard work, obvious illustration skills, and savvy business chops. Throw in some applied energy and the willingness to explore, learn, and grow. Be aware of the now; stay current with tools, toys, and trends. All the aforementioned requirements know no age bias.

"That education as an artist is so important," says Scott Bakal, picking up this thread. "Some people disagree, but I feel being in an academic environment with your peers and learning new, contemporary (as well as classic) techniques and styles will only help you grow.

"Even if this doesn't improve your style, you'll gain *knowledge*, which is just as important," he says. "Knowing what is happening around you in the field and what has happened in the past will help you make better decisions as your career progresses forward."

This is not just idle chatter for Bakal, who after eleven years in the field, decided to enroll in a master's program. "I felt I needed a psychic and creative kick in the ass," he confesses. "I put myself around other creatives and working professionals to feel that competition and get that sense of group self-exploration again. I wanted to explore new ideas and see how others in the industry were operating."

But he stipulates that you need not be going back for another degree. "I would, however, always recommend a continuing education class," Bakal qualifies. "At the least, a basics class where you are surrounded by other artists."

# AN EDUCATION

Phillip Wilson is a Pittsburgh-based illustrator with experience in animation as well as the illustration field. Wilson says that art is a continuous learning process

that never stops. He's been working professionally for over forty-five years now and feels that he's still learning every day.

Fred Lynch is a professor of illustration at Montserrat College of Art and Rhode Island School of Design, his alma mater. "Being a great artist is a lifetime pursuit," Lynch says. "Picasso, when asked how long a particular artwork had taken him to create, would answer by stating his age. And, being an artist is not something you retire from."

Business magazine articles about the "top qualities of best employees, or bosses in today's marketplace" make Lynch smile. Lynch understands that illustrators exhibit identical traits every day. The same flexibility and patience, courage and tenacity, plus communication skills that drive a successful business steer a meaningful academic experience (or pertinent illustration career).

"At art school," Lynch says, "you make the difficult transition from making 'art' as 'play' to making art as 'work'—your life's work: *Art Work*. I'm an artist who is a professor. I'm also an artist who is an illustrator. Maybe you'll be an artist who is an illustrator, or an artist who is a graphic designer, game designer, or art director. Or, maybe you'll be an artist who is an entrepreneur: a buyer or a seller. Maybe you'll 'just' be an artist who's an artist."

## MAKE YOUR MARK (FOLKS JUST LIKE YOU)

### AGLIARDI: CULTURE SHOCK

"Art school presents the possibilities," says Allegra Agliardi, "to experiment, to test your capacities in a protected situation. I think it's important to go to a real art school. The Internet can never replace this—that whole 'cybernetic communication' thing simply lacks the energy!

"At school you breathe the passion, the motivation, the enthusiasm of teachers and friends," Agliardi says. "That exchange of experiences, strong and dense, motivates and sustains you; it provokes you to move forward. Actual verbal communication is wonderful and stimulating. Why miss the opportunity?"

Agliardi discusses her art school experience from the perspective of a true explorer. "My first year as a new college student was a major culture shock in itself," she says. "Many students coming from Italian art high schools looked so sharp and skilled, while people like me—those who attended traditional high schools—seemed rather fragile and immature, certainly not as talented. At the start I was uncomfortable. I always considered myself to be a rather competent student, but initially I felt like a fish out of water."

Italian art students often do what is called a "visitor year" abroad, and Agliardi did her junior year at the Glasgow School of Art. That's Glasgow, Scotland. Navigating a

different curriculum at a strange school in another country and you have to do it speaking a foreign language. Are we having fun yet?

But backspace just a bit. Agliardi's school in Milan, IED Milano, is a design school, and the focus was on illustration as a function of design—the correlation of technique and style was a major emphasis.

"At IED Milano," Agliardi says, "we were obsessed with finding 'the style.' At GSA, they vigorously endorsed the concept behind the illustration and not the form of the illustration—that composition, technique, and language should follow the concept and serve it (not the other way around). Style would come with the time. I still remember them telling me: 'We are not interested in nice images, but in good ideas!'

"And you know, teaching methods at GSA were completely different," says Agliardi. "In Milan, it was a bit of a step-by-step process; comfortable, but maybe too limited. Glasgow was the opposite: more self-directed . . . 'here's the general schedule, your brief is on Monday, the check on Wednesday, the final critique is on Friday.' It was more stressful as you had to be seriously self-motivated and function independently: solve the brief, and then explain and defend your choices in the 'public discussion.'

"My year at GSA was a radical departure from my first year at IED Milano," Agliardi remembers. "It was honestly revolutionary for me: the way we worked at my school in Milan was completely inoperative. But I must say that in both academic environments the underlying principle was the same—behind it all is good drawing that must be rooted in a solid concept, because without that the illustration doesn't work, even if it's a beautiful rendering."

## THE PUZZLE

I always regard every illustration as solving a puzzle. A commissioned illustration is certainly about communication. Make that *immediate* communication. Fundamentals are inextricably linked to this, of course. Yes, style and technique, along with brainstorming and conceptualizing rub together in that place where vision wells up, materializes, and then blossoms (hopefully). Your education should be at the center of that place, fostering a euphoric exploration of a visually kinetic idea. Here technique and imagination, actively paired with interpretation and the quest for insight and meaning, are the means to make a statement—your statement. Not coincidentally, making that point effectively can also be big fun.

There is a real excitement in articulate problem-solving, distilling ideas with minimal, effective (visual) language; enticing the audience and maintaining viewer interest. Not giving away too much, but saying just enough. Handing off inspiration to concept. The segue of composition into technique. Juggling

representation with exposition . . . even the most straightforward answers can involve exhaustive process and perception.

### STREET LEGAL

Let's not put the (c)art before the horse, but your education turns the ignition key. Art education revs the creative engine and guns the professional motor as you wind out your illustration career.

But this only examines a big picture in a wide frame. Any day in the professional life can teach us *something*. Every assignment—whatever the size and scope—offers some kind of a learning opportunity . . . if we're open to it. Does every day represent a major test or pop quiz? More often than not it does, so accept that challenge. Every day—and any day—at the drawing board is a stellar opportunity to push forward or pull through.

"Technique is important," says Brian Biggs, "but can't be a crutch. At the same time, having chops is helpful in saying what you want to say. But even more critical: I get up, be nice to people, draw pictures; repeat. If I quit learning things, my career would evaporate. "Do awesome work, don't be a jerk, understand what it means to work for someone who is paying you," Biggs says, "and did I say, do awesome work?"

## MAKE YOUR MARK (FOLKS JUST LIKE YOU)

### HANNON: OPTIONS

We cover different educational options in this chapter but while we're hangin' at the water cooler, Mark Hannon has some comments about art school. "It is not a given that artists are misfits within the microcosm of their high schools," Hannon says, "but that was the case with me. In art school I found myself in the company of many other misfits from their own high schools. It was the first time I felt a sense of community within a school setting.

"Many first-year art students come to art school having been the best artist in their high school and were used to all the fawning and admiration that came with it," says Hannon. Once at art school they are now in the company of the other best artists from their high schools. It can be a shock to some students when they meet other young people whose skills and ability far outpace their own. Things can change in four years' time though."

## GOING UP . . .

The simple fact is that a college education will not be cheap (about $35K per year, on average). The cost of postsecondary schooling can be a huge factor in determining where you attend—or if you even *go* to—art school, of course. While

there are cost-effective alternatives (community college, for instance), we're not going to ignore or gloss over a real fiscal fact of life.

However, I'm also going to take the high road in our discussion about academics. While, financially, it may be easier said than done, and even easier written in this case, I'm going to work from another bona fide reality: that your art education is the ground-floor professional investment you *must* make, laying the pivotal infrastructure of commitment to your career.

### . . . ONLY UP

Okay, let's bravely chuck costs aside. From there, what you do with this education, and where you go with that is entirely up to you. Ken Meyer, Jr., says that some see illustrators as, "Privileged individuals who screw around and get paid for it. Many non-artists have no appreciation for the years of learning that go into even the most basic of art making."

Meyer points out that, granted, there are those who seem to spring fully formed from the womb, creating incredibly inventive work—but these illustrators are few and far between.

So, like most illustrators I know (myself included), you will build from the foundation you establish and spurn any ostensible restrictions. You will, hopefully, navigate around your limitations, figure out your blind spots, and move in a different direction than the crowd. You decide to pace yourself. Or not.

You can push the limits, expand boundaries, play by (or toy with) the rules, but, ultimately, one relevant question remains: "What did we learn here?" Remember, on his way to turning on the lightbulb, Thomas Edison regarded each failed experiment as simply what not to do again. Career-wise, if you learn only that one lesson, I think your education has been worthwhile.

And that's the essence of an education, is it not? You *hopefully* learn to: honestly evaluate your choices; objectively consider what doors to open or close; examine the possibilities fairly; soberly consider your actions, then actually live with the results. Again, hopefully, and let me add, *happily*.

## LEARNING THE ROPES

Many elements factor into a "successful" career. Sure, there's *luck* involved. I wouldn't curse good fortune, especially as it translates into job opportunities, but let's examine some tangible factors (more or less).

- ➡ *Location* may enter into the equation. Where you do business might be a plus or minus, not to mention being in the right place at the right time (more luck). But thanks to today's hot rod technology, the modern illustrator can work with anyone, any time, anywhere: small town, big city; down the block, across the world.

- *Attitude*, either positive or negative, may be part of the mix. Who you know can make a difference.
- *Perseverance* comes into play.
- *Energy and stamina* are crucial in both the long and short terms.
- *Business acumen.* You are *selling* your illustration. If this presents a problem, get over yourself; this only makes simple sense.
- *Aptitude* certainly comes into play.
- *Talent*, the natural ability to do something well, must be a prerequisite. Are there individuals who make it with minimal gifts? Without a doubt. You'll find them in every endeavor. But if quality is critical, I'll go with chops and panache every time.
- *Age and experience* also factor in. Consider the fabled joys and benefits here, arguably: expertise and efficiency for starters. But this may be outweighed by the ostensible advantages of *youth* (here, you fill in the blanks; to me, this is fairly open-ended and somewhat relative).
- *Education.* As mentioned above, luck may be a small factor where job opportunities are concerned, but not when we're discussing ability. To learn how to thrive in this field—at any age, to get to any level of competence—an art education is essential.

## SCHOOL RULES

June Edwards wants to level with you. "Even the most skilled and enthusiastic high school senior is unlikely to find long-term employment as an illustrator," she says. She admits there are exceptions, but if you're interested in a long-term career in the field she advises you to enroll in an art program where the necessary skills can be nurtured and developed. "This is a wise move," she says. "The networking and knowledge you gain from working with professors experienced in illustration is enriching."

Edwards talks enthusiastically about an undergraduate art program where you will be surrounded by people with similar interests, a curriculum that offers the opportunities to learn from both faculty and peers. Here you'll absorb essential information and critical feedback; you'll devote your best efforts to producing a quality portfolio that lands plum illustration assignments and/or finds you an agent. "Your goal as a student studying illustration is to generate work that will enable you to find illustration jobs after graduation," says Edwards.

## ONTO THE ECLECTIC

In our conversation, Edwards pointed out that many art students enter college with a preference for one media, one style, and one subject. "But it is important that you approach your course of study with an open mind," she says. "The

classes you take will help you build a strong career, but only if you embrace a diverse range of sources. A truly high level of skill is exquisitely forged from many different ideas, styles, and tastes." Here is Edwards's Honey Do list:

1. Learn about the history of illustration to provide a solid background for your illustration work.

2. Explore the traditional mediums; acquire a high level of competency in as many media as possible. "In the past," she says, "you were probably most comfortable and successful using one specific media, but after much practice you may find that your creativity is enhanced using other drawing materials and methods."

3. Learn how to draw from life: figures, objects, interiors, buildings, landscapes. Sometimes reference photographs are necessary, but copying a photograph usually results in "flat"-looking, uninspired drawings. As Edwards says, "Skill in rendering from life should inform all that you do."

4. Draw every day—there is no substitute for practice. Examine your work and determine ways to improve your results. "Time you spend in school is optimized when you get feedback from your peers and professors," Edwards says. "In fact, your experience in school is absolutely unique: graduates often mention how much they miss the structure of assignments and the enriching experience of being surrounded by like-minded individuals."

5. Embrace challenging assignments. "If your solution to an illustration assignment is obvious or uninspired, the results will probably be boring as well," says Edwards. "Explore many ideas before committing to one; you want to develop the kind of critical thinking skills that are the hallmark of the career illustrator."

6. Be inventive. "Mixed media or illustrations created with unusual materials may lead to some sexy opportunities," Edwards says. "Art directors are often looking for unusual hooks that grab attention."

## MAXED OUT

But don't slow down or stop when you check off the above list; there are many other things you can do to maximize your time at school:

➡ Develop a wide range of related skills: freelancing will help with your general cash flow and will provide useful connections.

➡ Learn about design. What? You think illustration is *not* about design? Snapouttavit! Study the specifics of designing for publications, presentations, and for the web. Become familiar with printing processes (print is not terminal yet). Look for opportunities to produce publications and presentations while you are in school—for clients, if you can get the gigs—and keep in mind that everyone had to begin somewhere.

"A strong portfolio can reflect a history of enriching visual events," Edwards says, "and may compensate for less actual job experience."

▶ Adding a minor to broaden your skills is smart: your advisor will help you select one that enhances your course of study.
▶ Attend as many exhibits, workshops, seminars, lectures, and forums as you can.
▶ Enter your work into competitions and exhibitions.
▶ Become active in a club or organization related to your interests.
▶ Many illustration departments organize trips to museums, exhibits, and conferences each semester. During spring break there may be trips abroad associated with specific classes.
▶ Universities often have affiliations with art schools in other countries: you may be able to spend an exciting semester studying abroad.
▶ School-sponsored activities are enriching, fun and cost-effective: the activity fee you pay each semester subsidizes many of them. After graduation you will probably pay a lot more for similar activities and travel.
▶ Your active participation in extracurricular activities will demonstrate that you are eager to learn and will help you get into the habit of developing contacts (sometimes illustration assignments come from referrals). Keep information about each event/activity you attend, and add these items to your résumé and LinkedIn profile. "It is much easier to update each semester than to try to remember four years of exhibitions, conferences, and workshops as you prepare for graduation and your career," Edwards advises.
▶ Visit the Career Services Department at your school early and become familiar with all the services it offers, even if you only intend to simply freelance after graduation. Career services departments hold job fairs and will help you explore careers and employers. You can get help composing your résumé and LinkedIn profile, and they will help you sharpen your interview skills.

## MAKE YOUR MARK (FOLKS JUST LIKE YOU)

### HURST: THE ROCK ON THE PATH

"Self-promotion is a tricky path for me," says Margaret Hurst. "It's not always easy to take a step back from your work and make an assessment of yourself as an illustrator. That requires a lot of objectivity and honesty."

To facilitate this candor, Hurst tells us that it is helpful to get a valued opinion from another professional whom you trust. Fortunately, she's part of a studio of six other

professional illustrators/designers. "You also have to make yourself visible—a lot—in the digital age," she says. "People expect you to be 'popping up' with something new every minute!"

Hurst has always believed that illustration is a means of communication on every level: commercially, personally, and everything in between. And she firmly believes that storytelling adds dimension to every form of illustration and visual communication.

While her focus has always been drawing, Hurst's art has been vastly informed by her lifelong love of reading. "Art was a huge personal life decision," says Hurst, "and I found that after my years of reading and writing at Boston University I was prepared and ready to dedicate myself to my art. I truly believe those years of reading and writing were a great contribution to my art career. It gave me an opinion and a point of view on life and art."

Once Hurst started art school at Parsons School of Design, drawing became her true love and commitment. "Like June Edwards mentions previously, you have to draw every day," Hurst says. "Drawing is a lot of work, but it gives me enormous pleasure. Drawing is my rock. Drawing every day means I will continue to learn every day. Being a teacher reminds me of that. My students are great teachers!"

# ART SCHOOL

Formalities! Do you *need* art school? And by extension, do you actually need a degree? For my money, to compete in this field, some sort of art education is essential. You must learn the basics, understand the tools, and master the necessary skills to play the game well. Unless your name is Wyeth or Tintoretto, the best place I have found to do all this—if not the shortest, then perhaps the most efficient, time possible—is art school. Yes, those aforementioned dead white guys are painters, but this certainly, well, illustrates my point.

"It's true that some illustrators, somewhere, do not have formal training," says Tom Garrett, "but I think that the majority of students gain tremendous knowledge through a college program."

"I wouldn't be where I am today if it wasn't for my education at Parsons," PJ Loughran adds. "Art school gives you a chance to focus and develop your craft in a way that usually can't be done once you're out in the real world and financially independent."

## BRICK VS. CLICK

Now, let's do a slight spin on that original question . . . is the *physical* art school necessary? In our current day and age with the Internet, the MOOC (Massive

Open Online Course) is a relatively recent hot innovation in distance education. Is it possible to be a "home schooled" illustrator? What kind of illustration education is earned going this route? How "good" are the illustrators earning their stripes here?

In Kelly White's opinion, choosing the right school provides a critical foundation you won't find elsewhere. According to White, the degree is not the key. Whether you attend community college and/or simply shoot for a certificate, she feels art school is important and will give you a huge advantage over simply learning on your own (via YouTube or similar).

"At art school you learn to give and get," White says, "to respond to creative criticism. That's incredibly helpful in so many ways. This provides huge lessons that extend way beyond simply adding up 'likes' to your DeviantArt posts. You'll figure out how to accept alternative ideas, but also learn to know when to stick to your guns; how to explain why you did what you did—what works and what actually doesn't.

"You also get a chance to step out on a limb and experiment (so later you won't be jeopardizing a client's time or money). And maybe most important— you get the opportunity to ask questions . . . lots and lots of questions."

## ART SMARTS

I agree with White; and if you're not too cool for school, you might then ask if a two-year commercial art school is better than a four-year art program at a university?

The answer depends on your needs, sensibilities, and attitudes; your goals, personal schedule, and timetable.

A two-year commercial program may be career-focused and technical (if not accelerated). The four-year university curriculum will be rounded and diverse (if not more intensive). It depends on *your* needs . . . the choice of an eclectic university process vs. a concentrated commercial approach must be an individual one.

## SMART ARTS

As both a seasoned professional and master teacher, Garrett offers pertinent comments when asked to discuss this angle of art education. He believes that the difference between a four-year program versus two-year vocational training is that the emphasis is placed on learning new ways of problem-solving. "In a rigorous four-year program the student gains a whole range of skills," he comments. "Students have the time to grow and develop multiple professional solutions to one assignment. Students learn how to verbally communicate their ideas and gain an understanding of the professional world with exposure to the best business practices and ethics."

Garrett also feels that a longer program enables the student to be aware of history and its context with other disciplines (for instance, fine arts, fashion, and architecture as well as illustration and design). The outcome often means that the student is not just mimicking the latest styles and trends. Instead, the student is learning ways of being more innovative. "This approach," Garrett states, "also prepares them for changes in the field down the road in regards to technology, the economy, and artistic growth."

### "Q" VERSUS "Q"

At the same time, consider a recurrent hot button (at least, in regards to general education and certainly when discussing academics on the Internet): the old debate about *quantity vs. quality*. The ultimately long-winded discourse on education and scholarship you'd be participating in—especially when you consider learning online—has always been a pretty chunky time suck (rather like the Internet itself).

The question, as I have heard it, comes down to this: Is it better to function "a mile deep and an inch wide" or just the opposite: "a mile wide and an inch deep"?

What's better for *you*? Do you prefer a survey-type strategy—the "mile wide/inch deep" hypothesis—that adopts a broad action plan addressing the subject at large (a.k.a. an introduction)? Or does a narrower in-depth focus that examines a topic (perhaps as a specialization)—the "mile deep/inch wide" thingie—fit your bill? And indeed, your first illustrative decision may be whether to *go* to a physical art school at all.

## MAKE YOUR MARK (FOLKS JUST LIKE YOU)

### SHIN: IOU

"I owe so much to my teachers, mentors, friends, and colleagues," says Dadu Shin. "Even if they weren't aware of it, they were helping me by inspiring me to do better. I'm grateful for all their help and am fully aware I would not be where I am today without their assistance. I try to always remember that and to keep myself humble.

"I still remember what it was like to graduate and be thrown into the real world and how scary that was," Shin says. "Without guidance, I would definitely have had a more difficult time making it as an illustrator.

"So when I see new graduates who are in the same position and dealing with the same issues I was, I can't help but try to help them. If you're going to take, you owe it to give back."

# DIY

Is it possible to be self-taught? "Definitely," says Gerald D. Vinci. But as D. Vinci cautions, you may only focus on acquiring skills and not about what it means to be an *effective* illustrator, designer, or whatever.

D. Vinci can point you to the myriad resources out there allowing the casual student to expend minimal energy and still achieve a professionally polished competent piece (for instance, free Illustrator brushes or Photoshop effects). "There are thousands of forums out there that will tell you how to do just about anything," D. Vinci says. "But the issue with this is that instead of learning how to do it yourself, you are just adopting someone else's knowledge, technique, what have you. Anyone looking at the bigger picture can see the major problem with this scenario. There is going to be a point where you will need to troubleshoot issues. Without necessary background knowledge you are missing that key component to being a true professional."

D. Vinci is not saying that all self-taught illustrators will be lazy, cheap, and ducking the real work. Cutting corners is not necessarily a bad thing, but here D. Vinci cites the age-old adage, "Work smarter, not harder." He *is* saying that there are times where finding more efficient ways to do things only makes sense, and that the "total package" of background and service is the mark of genuine professionalism a more educated illustrator may deliver.

D. Vinci and other seasoned professionals know that time and experience typically shake out such inconsistencies. They understand that lopping off the necessary corners is only impractical—your business *will* suffer for it. And here, he offers another old saw to ponder: "With age comes wisdom," and concludes, "We can hope, anyways."

## MAKE YOUR MARK (FOLKS JUST LIKE YOU)

### CHUA: I KNOW WHAT I LIKE TO DRAW

"It's been a long time, so I'm not sure if I even remember when I wanted to be an illustrator," says Charlene Chua. "I always liked drawing. And at some point in my teens, I liked comics, and wanted to be a comic book artist. Through that, I think, I decided I wanted to be an illustrator.

"In actuality, I think what I wanted to do was draw sexy girls," says Chua, "and that remained the case for some time. Comics and sexy girls."

At the time, there were few choices for anyone wanting to study illustration in Singapore. Chua discussed two fine arts schools that had the dubious reputation as clearing houses for dropouts and dreamers. There were the polytechnics (closer to trade

schools) offering design courses with minimal illustration components, and ultimately Chua chose this direction due to pure economics. "My family could not afford to send me to art school in another country," she says. "And I had no intention of taking a hefty loan that would require me to stay and work in Singapore to pay it off over an extended period of time."

Long story short, it didn't work out. Chua left, cobbled together a portfolio, and with luck and raw talent, landed a job as a designer, drawing cartoons for a training CD-rom (remember those?). Eventually she moved on to other design jobs and stopped creating art.

But a regular job and steady paycheck isn't necessarily the formula for success or happiness. After a few years of this slog, Chua decided to quit and pursue illustration instead. "I tried getting into comics, and that did not work out," she says, "but I started to get some illustration work with magazines. The ball eventually got rolling, and I felt confident about calling myself an illustrator."

## EDUCATION OPTIONS: THE OVERVIEW

You have choices! According to Fred Carlson and Scott Bakal, there are many academic alternatives. They share this expert and succinct overview of the options for this chapter:

- ➡ Students may earn a certificate, an associate's degree, bachelor's, master's, even a doctorate degree.
- ➡ The BA (Bachelor of Arts), and BFA (Bachelor of Fine Arts), and BS (Bachelor of Science) degrees are granted at four-year colleges and universities. Training available at two- and three-year professional schools results in a certificate or associate's degree.
- ➡ Large public colleges and universities offer a broad curriculum. Smaller colleges, institutes, and online schools present more specialized experiences (and may concentrate on a particular industry).

  "If you want an education that encourages interaction with a variety of people and subjects in addition to illustration, plus a range of degrees from the bachelor's level to the doctorate level, the university experience is probably best," says Carlson. "If you prefer more intensive, studio-centered instruction and theory, as well as advanced courses targeted to particular markets, a four-year school offering a variety of specializations is better for you."

- ➡ Community colleges typically offer shorter programs—two-year degrees in the form of associate's degree or certification—that tack toward a vocational focus. These

credits and degrees offer entry-level opportunities or serve as transfer credits to a four-year school.

◘ Here Bakal points out that there are no "tech schools" for illustration specifically. You will find tech schools that offer tech-oriented career programs with an emphasis on computer competence, computer-aided design, and software skills. Such a vocational/technical education is planned to teach you exactly what you need to know to get a job in a small segment of the graphic design field (including programs in the applied graphic arts, printing industries, and computer graphics).

◘ Illustration workshops, trade conventions, and specialized illustration training (local or online; individual or group formats) offer brief, intensive training in a desired subject or skill set. These special programs bring adults together to educate and congregate, renew and update horizons.

"The value of any degree varies slightly between design and illustration," says Bakal, "but the concept is the same." So just as a point of reference: A bachelor's degree (typically accomplished in four years) is required for most entry-level *design* positions; graduates of a two-year program normally qualify as assistants to designers. Candidates with a master's degree (usually, another two-year program) often hold an advantage on the job hunt.

"But," as Bakal points out, "the value of a master's in illustration is variable and programs range from full-time programs like SVA's Master's compared to Hartford's Low-Residency curriculum."

Of course, those entering the job market—regardless of their pedigree—should develop a portfolio, and novice illustrators can usually expect (at least) a two- to three-year period of professional growth and personal development—call it learning the ropes out in the actual field.

# CARRY ON

So I'll repeat myself a bit; it's not that much of a conundrum. For me, push doesn't even come to shove, regardless of where you weigh in. I will tell you to go to *school*—get an art education, somewhere, somehow. That chat may begin with the very idea of a formal curriculum, but it will then heat up even further when you consider the idea of a continued education: going on to earn a graduate degree—an MA or MFA.

This is another topic of much debate and valuable consideration. Some argue that a master's degree is a mere piece of paper and simply just the path to a teaching gig. They will point out that the caliber of your work experience, backed by the quality of your portfolio, are the only true industry standards.

Without squabbling over the value of that little piece of hard won paper (earned either as an undergrad or graduate), you may want to look into

alternatives: online programs and/or the so-called specialty—or portfolio—schools (for example, The Art Department; Miami Ad School; Tutormill; Creative Circus; VCU Brandcenter; Brainco; and the Chicago Portfolio School). As Bakal says, "There are a host of nonuniversity programs like The Master Class, SmArt School and others, as mentioned above, that focus on illustration outside the degree earning world."

## A REAL EDUCATION

Ken Bullock has his take on the advantages of your education. Sure, a good program will teach you the basics. A solid curriculum *should* provide the creative and technical tools you fall back on during production: the brainstorming and concepting, color theory, a foundation in the usual hand skills, including layout, typography, and presentation. Yes, illustrators need this, too.

You may have attended a notable school or program known for producing industry heavyweights. Cited on your résumé, the name of such an institution may wedge a foot in the door you need, but, as Bullock reminds us, "Your portfolio will generally do a better job here.

"At the risk of sounding either cynical or silly, the degree only lets you honestly say that *you have a degree*, providing you an edge compared to your competition with no degree (or without a similar pedigree)."

And here is where Bullock drives his point home: "Generally when you graduate, your portfolio is filled with school samples and projects. After all, you just graduated right? And then, the next thing you will repeatedly hear will be, 'Have you done any real work?'"

Most clients want to see that you have actually done some bona fide illustration gigs—the "real work" Bullock flags—for authentic clients. They want to be able to judge you/your work based on field conditions. They know that most school projects aren't as demanding or deadline driven so Bullock advises you to "Get some freelance under your belt before you graduate."

This, as Bullock points out, will complement your portfolio and make you a better candidate when you hit the market looking for a job. "Critically consider what to put into your portfolio, for both school and freelance work," Bullock says. "If you have any doubts, leave it out. Even a bona fide assignment that is not seriously strong enough to go into your portfolio should not make the cut.

"Regarding the type of degree, an associate's, bachelor's, or master's . . . I would hazard a guess that most illustrators working in the industry have a bachelor's degree, or, at least, an associate degree," Bullock says. "I know there are illustrators out there with a master's. I would even say that there are those with no degree whatsoever. But I would argue that illustrators on both ends of that spectrum are in the minority.

"Most job postings list a bachelor's degree. If your portfolio is good and you've worked a few jobs, they will sometimes 'overlook' the associate's degree. Generally, smaller shops and privately owned companies are more willing to accept someone with an associate degree than the larger firms and corporations (who often use the degree to screen people out). All of that considered, I have been in the field for over seventeen years and have done well with my associate degree."

## HIRE ED

June Edwards recommends that students seek out illustration (and graphic design) opportunities on campus. "Many colleges and universities have part-time and work/study programs that offer experience in specialized fields," she says.

According to Edwards, the best opportunities here would be with the university's Public Relations Department, but other departments on campus might also be looking for illustrations and design work to advertise their services or to promote upcoming events. Some departments or service areas you might check into are the library, technology, recreation/fitness, health/medical, bookstore, dining services, and the counseling center.

"Most universities have a Print Services Department," Edwards says. "Those folks are usually swamped with work and often have one or two employment positions for students. The campus newspaper is usually a student-run production; involvement with that (or any of the many newsletters produced by various departments) would look good on your résumé. Illustrations are an important part of these publications: you may be able to have your work published on an ongoing basis."

## SUCCESS 101

I believe, as does Edwards (who sparked this dialogue), that education is a two-way street. You must show up—you *participate*. Your willing contribution is essential. Edwards's manifesto declares that the student has a responsibility to consciously *engage* in the process. The professor will recognize the quality of that engagement and can make the presentation more meaningful and relevant.

When appropriate, students must *inquire*: ask questions and add your thoughts or ideas. Students must be prepared for each class session and participate in discussions. "All creative exercises—including lectures, discussions, assignments—demand individual creative problem-solving," says Edwards. "Not all aspects will be nailed down or completely defined by your professor. It is up to you to come up with unique, appropriate solutions—your personal interpretations and responses to discussions and assignments are vital."

Long term, the techniques students use to make the most out of each class can be applied to a work situation in the future: cultivating positive student/professor relationships in school can help you understand how to develop positive relationships with art directors. Fully participating in discussions and critiques in school will help you collaborate effectively with colleagues.

### CHAIN CHAIN CHAIN

Another life skill you cultivate in school is problem-solving. "Sometimes you will encounter a persistent problem in a class even though you work hard and try your best," Edwards says from experience.

"Begin by defining specifically what the difficulty is and whether others are having the same problem. Could the problem be a result of a misunderstanding on your part? Make an appointment with your professor as soon as possible: explain the situation clearly and work together to find a resolution. If the problem persists you should consult with your advisor to find out whom you should speak with next."

Understand that real problems do not just go away; you must solve them or make a sacrifice. In school the little burnt offering will be your grade and apparent knowledge of the subject.

"This is an unacceptable outcome given the cost of an education these days," says Edwards. "Be a team player though, and always go up the chain of command. You will find that solving the problems you encounter in school will be similar to solving problems at work."

## LEARNING CURVE

"Art school for me was just great," Lori Osiecki will tell you. "It gave me the opportunity to experiment and connect with other creative people. At art school I learned how to pull it all together so that I could actually support myself doing something I enjoy. It doesn't get any better than that."

But during her last months at school, Osiecki used her student status to earn some practical, real-world credits. She scheduled interviews with design firms, advertising agencies, and magazines—any art director who would be willing to spend fifteen minutes with her every Friday she had free.

"I told them that I was not asking for work," Osiecki tells us, "just some *advice*; that I valued what they had to offer—direction, criticism; anything. I wanted to shape my portfolio. I wanted to be able to find a job. I did not want to do something else to support my art habit."

Osiecki found that these art directors were incredibly generous with their time. And she listened to what they had to say. "I reworked my book so that I felt good about it. I knew it inside and out," she says. "I became comfortable with the interview process. I clearly identified my target markets. And I landed my first job within two months of graduating.

"It was a fine job and a wonderful experience," Osiecki says. "I had the good fortune of meeting and working with some of the best artists in the country. True mentors. I still keep in touch with many of the people I met. Creative bonding—there's nothing like it."

## LEARNING IN PRACTICE

Yes, you can get the (art) job done even if you are knee deep into another job. Even if that job is not particularly "arty," and even if that job may be a non- or low-paying gig. Here we're talking *ostensibly*. In the short term, perhaps on the surface. And, yes, there *is* such a thing as a practical education (directly or indirectly espoused by the pros above).

Certainly, some artists are not cut out for a "traditional" art education. However, life always offers distinct possibilities (one way or another). As Jenny Kostecki-Shaw comments, "Life experience is in itself a good art education.

"Ben Shahn advised us to not disregard *anything*," Kostecki-Shaw says. "If you can't go to school or can 'only' get a job in an auto factory then *do that*. If your head and heart are open to all possibilities, it's not 'just work.' Observe, feel, touch, believe and think—all this can come out in your art."

You can mix and match your options to maximize opportunities, and all of these choices work together as valid means to an end. "There are unique alternatives," Ulana Zahajkewycz says, "enabling you to gain knowledge and skills through your own research."

Let's take a look at a few.

### INTERNSHIPS

Are internships available for illustrators? I'll have to give this one a qualified "yeah, but . . . ." As Bakal says, "There are differences between working as an intern in a design office compared to a single illustrator's studio."

Internships for illustrators are out there—in my research I found postings at places like online magazines, software companies, T-shirt (and general apparel) shops, animation studios, and museums—but metaphorically, it will be akin to hitting distant, tiny targets spaced at great intervals; you have a shot, but you better be Annie Oakley (look her up).

Internships for graphic designers are a better bet, and illustration duties are often advertised as part of the job description. But while these opportunities are somewhat plentiful, your pool of competition is vast and deep—positively transatlantic. What kind of a swimmer are ya?

Can internships help? Yes, they can. Of course, internships aren't for everyone. And I guess we have to tack on the small print: *if you can get one*. And most likely, this will be your first real taste of that particular work experience; and it

may not be a paying situation. Also an internship doesn't guarantee you will be hired by the employer at the end of the gig.

We could write an entire chapter or compelling thesis paper (at least) on the ethics and legalities of unpaid internships, but let's just advise that a full workday at no pay is not universally appealing, and the concept of the nonpaying internship smacks of slave labor to many. For an internship to be a smart beginning move for you, it has to be available and practical to your situation (not to mention, affordable).

Saying all that, if you're willing to invest your time and energy in potentially marvelous professional training, an internship can be priceless—just the catalyst to change the course of your life and career.

## APPRENTICESHIPS

On Brian Biggs's wish list for students would be less classroom-based education and more experience-based alternatives—like an apprenticeship. And indeed, if your chops and work ethic are impeccably good, and should the interview gods favor you that day, you may be able to land an apprenticeship with an established professional, without the structure of classes or an institution. Here, you learn the foundations of business, as well as mechanical chops; history and fundamentals, all on a one-to-one basis.

Ulana Zahajkewycz worked with just such an important mentor for roughly five years and found the experience absolutely invaluable. "Seeing the day-to-day operations of an illustration business was an immeasurable help to me," she says. "Observing how an illustration veteran ran his shop is the type of experience I wish all illustration students everywhere could get. Luckily, where I teach, there is an emphasis on internships, so this is actually a reality for our students."

## TEST OUT

The United States Department of Labor guidelines—labeled as "The Test For Unpaid Interns"—determine an internship with the criteria below. Note that employers calling people "interns" who don't meet these guidelines are liable for significant penalties (including withholding taxes that should have been collected). We quote:

1. The internship, even though it includes actual operation of the facilities of the employer, is similar to training that would be given in an educational environment;
2. The internship experience is for the benefit of the intern;
3. The intern does not displace regular employees, but works under close supervision of existing staff;

4. The employer that provides the training derives no immediate advantage from the activities of the intern; and on occasion its operations may actually be impeded;

5. The intern is not necessarily entitled to a job at the conclusion of the internship; and

6. The employer and the intern understand that the intern is not entitled to wages for the time spent in the internship.

## ON-THE-JOB TRAINING

Are there mainstream jobs or alternative opportunities out there that will require your illustration skills? Perhaps. I found listings calling for artists to produce illustration and design for signage, with window and shop decoration as part of the job responsibilities (for instance, I saw a fun job at the local branch of a major food market seeking an in-house illustrator to do their trademark chalkboard signage).

For illustrators, arguably the best "on the job training" is *freelancing*. But for the sake of this discussion point, let's address the general paradigm here: there's a lot to be said for on-the-job training. For many, this combination of drive, hard work, and basic chops is *the* best art school (even *after* two to four years of actual art school).

"I look back at myself and think I was a pretty strong art student," says Doug Klauba. "But by the time I got out of school, I realized I had *so much more* to learn and I needed a little further direction. But I also saw that I needed to take this direction from *myself*."

"Your work ethic—your focus—is vital," Benton Mahan continues. "You improve, get better. *Motivation is more important than talent.* If you are motivated, you will figure out what you can do with the talent you have."

## WHEREFORE ART THOU, ART SMARTS?

When I asked Brian Biggs to weigh in on the relative merits of art school versus street smarts he said, "In my mind, the two go together."

Biggs loved his art school experience, with all the dorm room philosophy and the young, brash confidence that came with it. Not to mention learning how to handle criticism and give the same.

"Yet no one in art school taught me how to look at a press sheet and make sense of CMYK," he says. "This was design school, but the experience is similar. In the illustration

department where I taught, the entire sophomore year was dedicated to teaching to paint anatomy and realistically. Total waste of time. Storytelling and voice would have been better. Once one graduates, no one is hiring an illustrator because they can draw an arm or torso correctly. They hire artists who have something to contribute and, yes, yes, who aren't jerks.

"It is possible to be a 'home schooled' illustrator—the Internet now makes this a given and not everyone has access to expensive art degrees. Anyone can post their work and have it seen, from anywhere. The world—as it turns out after all—is, indeed, flat," Biggs says, uh, flat out.

## A BUSINESS EDUCATION

It's simple: if you're in business, you need a business education. Kinda *duh* or *meh*, huh? Maybe we're talking formal schooling. Perhaps it's dedicated reading at the library backed by extensive online research. You could take a few classes at the local community college and then you network like nobody's business (except it's your *business*).

Wherever you learn it, sound business acumen, good marketing strategies, and a solid financial plan form a critical trifecta. That is, if you want to stay in business, of course. Not "just making it," mind you, but thriving—seriously churning up some water. We should hope for nothing less, right?

In upcoming chapters we'll assess how much money you'll need, how to realistically plan to earn that, plus where and how to get the needed capital. We'll also look at how to create a working budget to maintain a cash flow to keep your enterprise in the black (for instance: 1. estimating how much you think you'll earn to ascertain if you can make ends meet and 2. comparing costs and income to see if your business plan is viable). That's all ahead in upcoming chapters 5 through 7, so hang in there and read on.

## MAKE YOUR MARK (FOLKS JUST LIKE YOU)

### RODRIGUES: GROUND FLOOR OPPORTUNITY

Born in Brazil and earning a degree in fine arts, Antonio Rodrigues will proudly discuss his body of work boasting traditional techniques. His art (and the related professional work he did) was personal. But in his words, he hadn't reached an appropriate audience.

Rodrigues earned a decent living at his (Brazilian) government job. But with long, demanding days forcing short, catch-up nights, his creative work was ultimately cubbyholed into hobby status. "I eventually got fed up," Rodrigues states. "Every day was the same routine. I had a stable job. I lived in a nice flat. But something was missing."

Then he did a gutsy thing: he let all that go and started anew in London, England. Rodrigues didn't own a work permit (meaning he couldn't hold a formal job or even sell his stuff). At some point, friends pointed out how much they enjoyed the business cards, CD and DVD covers, posters, as well as character illustration they saw in his portfolio. "I took their advice," he remembers, "and kicked off my new business direction."

He says with candor that he was incredibly new to the game. "London was a great place to learn the craft, as the whole city inspires you visually," he says. "Incredible professional events and seemingly uncountable museums and galleries. And, of course, just as I was starting to put it all in gear it was already time to move from London to Havana, Cuba."

But Rodrigues was determined to stay on track with his master plan; he made the time to keep learning. His fine arts background made it somewhat of an easier start. He was already familiar with the general hardware but knew that the software—Photoshop, Illustrator, or InDesign—was the critical key. "And I was well enough aware," he says. "I had to learn how to integrate my vision with my customer's and how to get inside the client's head, translating a visual into the message they want to pass on."

From Havana, it was back and forth to London; then to Washington, DC, and New York City and back to Brazil. He researched up a storm, became well read, and networked like a demon. But it should be said that this grassroots approach, while certainly a romantic notion, isn't universally appreciated. His portfolio was met with rejection. "I remember vividly my first interview with an art director in London who, after seeing a few pages of my printed portfolio, told me to look elsewhere—there was no place in the market for 'people like me.' Harsh, mean, somewhat unfair . . . but also true," Rodrigues says honestly.

For Rodrigues, quitting was out of the question. He decided to scrutinize his book and work hard to make that portfolio more professional and marketable. Early 2012, clients started to pop up, exposure in print and online was coming slowly but surely. At this writing, Rodrigues's goal is to maintain a small studio with a fair list of good clients. He shoots for varied style and techniques, and a consistent, fresh approach to every project.

# ON THE BOARD
(PROFESSIONAL VIEWPOINTS IN 50 WORDS OR LESS)

Questions floating around in students' heads seem endless. Can I improve? What's my style? Do I just plain suck? Sometimes these questions are obstacles to learning. Teachers can enable real learning by helping students manage and prioritize those questions. You don't need all the answers, just which questions to target.

—Charlene Chua

Going on Google at the beginning of the sketch process is searching, not thinking.

—Ellen Weinstein

I read somewhere that when you attend art school you do not just learn, you become. And while there is only so much you can truly learn in school, don't be a fool and pass up the opportunity for a formal education.

—Gerald D. Vinci

Art and art schools make you humble pretty quickly, and the best students work exceptionally hard. There is no such thing as hiding in your classroom.

—Fred Lynch

© Mikkel Sommer 2016

© Rick Antolic 2016

As a student, I didn't envision where I'd be now. You can come out of this with a real career.

—Charlene Smith

Anyone can open YouTube or subscribe to a website offering tutorial videos, and you can read books. These are all great options. But such resources are simply better when complementing an actual classroom setting.

—Kelly White

Know that experience is the best education one can pay for. One doesn't necessarily have to go sit in a classroom to learn. I learned a lot at school, but the first night spent at a press-check in Oklahoma City, I learned much, much more.

—Brian Biggs

Before I went to art school, I was convinced I knew everything I needed to know. But from my first day, I knew I had found my niche. [Art school] didn't affect my imagination, it just gave me the tools to bring my ideas to fruition.

—Erin Brady Worsham

© Julia Minamata

# Chapter 3

# Opportunities

*When you enjoy what you are doing (yes, even the business side), it's not work.*
*It's just what you do. I work seven days a week, but they are all Saturdays.*

—George Coghill

## WHAT IS AN ILLUSTRATOR?

In our first chapter, Charlene Chua said she defined an illustrator as someone who solved design problems with pictures, and in that chapter we attempted to adequately answer the question, but it's an appropriate lead-in for this chapter, as well.

Back in Chapter 1, we asserted that type and image are much the top and/or bottom of any definition of graphic design. Chua, a former designer, compares and comments here. "I like illustration more than pure graphic design because I like drawing," Chua says. "There is greater freedom in this act of creation than with my design projects.

"When I did design, it was always a consideration of space and text, images and logos. Most of the effort went into accommodating the text and presenting that in the strongest manner. It didn't matter if there was a lot of text or a little, the designs I worked on hinged on the viewer reading the copy. The creative direction was usually decided well before I was called in.

"As an illustrator—at least for the majority of projects I work on, editorial or otherwise—I'm brought in at the end of the design process, and I have to work within pretty tight boundaries.

"This can be frustrating for some illustrators, particularly those with a good eye for design or concepts. I think a lot of projects these days are simply 'blank squares' and the illustrator is called to 'fill it in.' And that's a shame because a good illustration should be part of a good design, not just something you slide in to fill a gap at the end.

"With illustration, I am free to assume that the viewer will draw their conclusions based on the art alone," says Chua. "Most of the time the intended response is an emotional one too; I'm not responsible for communicating '50% OFF THIS CHRISTMAS!'. As the illustrator, my job for such a promotion would only be to get people into the Christmas mood," Chua says.

## HERE'S A TIP

Malcom Gladwell's great book, *The Tipping Point*, is, as Gladwell himself puts it, "A book about change. In particular, it's a book that presents a new way of understanding . . . change." For me, the past, present, and future of illustration are all about the thresholds of visual change—in concept and manner—as well as a fresh understanding beyond a historically fixed image or static page.

Illustration is a field that positively pops with diversity (not to mention characters of wild and wide temperament). I'm not sure there's a prototypical "modern illustrator," but if there is, he or she is now somewhat of a professional shape shifter. This de facto chameleon manages a career that takes frequent and unpredictable turns as new markets spring up to keep pace with technology, and

skill sets must morph in surprising directions, mirroring a culture and society evolving with these mechanics. There, I almost said it in one sentence.

Maybe the constant is that "big personalities" are ageless—historians have long cited similar variations of this conventional wisdom that remain immune to the vagaries of time. If you're an "illustrator," you enjoy the challenge and revel in the visual task. You're a force—your India ink burns dense black and white hot (but not out). You're flexible and versatile, personal and professional (as in reliable/dependable/on time/available).

You team up graciously—collaborating as you must—but roll independently, when you must. You're on point when you get the shot (even when somebody's taking potshots at your illustration). You stay easy when it gets hard. Train tough. Reach a little higher and wider. You practice. You practice patience. You can zig and zag—adapt to learn (and vice versa) as well as stay with your program. You focus. You discuss. Think. Consider. You *communicate*. You work hard to be open and mindful while you strive to be open-minded, understanding, and empathetic.

## WHAT DOES IT TAKE TO BE AN ILLUSTRATOR?

Kelly White will tell you it takes thick skin. "Get used to people telling you (in no uncertain terms) that the drawing you just spent hours (or possibly days) on just isn't good enough. Or isn't what they wanted—even though you gave them *exactly* what they asked for."

But White will also tell you that you can't take it personally. "A true professional lets her client know she cares about this project and conveys a confidence in the job she's doing," she says. Also important: the presence to explain what's needed (and why), or why *this* works when *that* does not.

It's about dedication to and joy in what you do, through slow times as well as chaos and crunch time (with no weekends off, no free time; no overtime pay either. Free time? What the hell is that?) "The thing is," White says, "if you love your work, your job, and illustration … it's *all* worth it."

Phil Wilson tells us that a good illustrator must be well-rounded and have at least a passing interest in just about everything. "One thing I've learned in this business," Wilson says, "is that you never know what you'll be asked to do. Widen your scope. I believe the more you know, the more opportunities you'll have to get work."

## SHOULD YOU DO IT ALL . . .

But we may throw up a wee red flag here. "I have a concern," says Matt McElligott, "that we imply that graphic design is something easily added to an illustrator's skill set (or vice versa). We also might not put enough emphasis on the idea that each endeavor—successful graphic design and triumphant illustration—requires a separate and equally robust amount of training."

Let's say that you're a well-rounded designer, and illustration is part of your tremendous skill set. Being a jack-of-all-trades, if you can cut it, would be to your distinct advantage in the beginning, when you may have to do everything to make a living. But as your business takes off, you'll probably, and eventually, concentrate on what you do best.

If you are an illustrator and a designer, you can promote yourself as such, or market your illustration to some companies, and design work to others. It will be easier—and smarter—to do this on a local level. Granted, it is good for an illustrator to have as much understanding of design as possible, but if you're serious about doing both, you may find it more convenient to market and advertise yourself as a designer separately.

As part of the team, an illustrator will do only one end of a job—the illustrations, obviously—but a designer may wear many hats on a project, including snagging the juiciest illustrations. The designer controls the creative flow, while an illustrator may not enjoy the same perks.

Of course, along with any perks come added responsibilities. Jobs can become so design-intensive you may not do any drawing for days or weeks at a time. If you want to be an illustrator, this will present real problems, so seriously consider how you're going to sell yourself.

## . . . AND SHOULD YOU DO IT RIGHT NOW?

First, there is the obvious question: should you freelance (or go independent) immediately out of school? Right out of the gate, a novice illustrator's career path will arc differently than the neophyte designer. For White, the answer to this query depends on the person and his or her ability. "Whether you are an illustrator or designer, it can take a while before you make any real money," White says, "so in financial terms, if you have a solid support system that enables your freelance enterprise to get up and running, you're off to a good start."

It's a two-pronged attack. "Learn all you can about the business side and creative end of freelancing," White says. Of course, she recommends that you master industry standard (and client friendly) technology. And she advises you stay up to date on current trends—including hardware and software—following blogs and listening to podcasts, plus joining and participating in groups (Twitter, Facebook, Pinterest, Instagram, Google+, LinkedIn, and so on).

"The social media marketing mentioned above poses a big question when starting out," White states, "how to do it, which sites to use, how much time to spend on all this. But, she says, "I believe it is *extremely* important for freelancers to build a following and a *community* that supports their endeavors and creates more trade for them in the long run."

Yes, White flags social media marketing, but in a related thread, she wisely points out that deducing your target audience (in other words, who you want

to illustrate for) is critical. "Doping out your audience should be high on your creative bucket list," she says. "It's as important as learning to manage your time, tying into (then staying on top of) new trends, and monitoring the pulse of what is going on in the industry."

And beyond these obvious (and the obviously technical) basics, you must project an absolute commitment to succeed, a positive attitude that showcases what White calls "the sheer initiative to make almost anything possible."

## FOCUS

Thereza Rowe has some excellent advice for you. "Illustration is a vast field," she says. "It's important to discover what interests you most and zero in on those areas. Whether it be advertising, editorial, children's books, or whatever—each of these is big enough to build a career upon.

"It doesn't mean that one shouldn't branch out and have some variety on the portfolio," Rowe says, "but I do think it's best to eventually specialize in one or two particular areas. This gives more clarity to your objectives. After all it's much easier to find your way once you've decided where you wish to be."

## FINDING THE RIGHT MARKETS

How do you analyze what market is right for you? Initially, the job is easy enough: you must keep your eyes wide open. First, consider and understand what you like to do best. Then go online. As we're about to be sitting even more, get off your butt and now *take a walk* to the local library. Yes, we're going to actually move and check out real references you can physically hold in your hands and study . . . what a concept!

Follow this up with a trip to the bookstore. Find a newsstand, too, if you still have them in your town. Go to the movies (and pay attention to the posters, displays, and ads); watch TV, including the commercials. Your immediate task is to look around you . . . at anything and everything; righteously *study it all*.

This is serious browsing, but should also be a big hoot. See who's doing what, and how they're doing it. Research who's putting it out there (and what *it*, in all its glory, *is*). Reiterating Kelly White's earlier good advice, Rhonda Libbey tells us, "Figuring out what kind of illustration you want to do, and creating a portfolio that suits that market best, means a little detective work."

And it's elementary, my dear Watson—we're researching who's illustrating and what's being illustrated. The idea is to evaluate *your* work in light of what *you*

see as the marketplace's current needs and trends—what resonates for you? Do keep your eyes open (and do take some notes, Holmes).

"Find out who commissions illustration—as well as design work and photography—for those areas," Libbey says. "Sometimes it is an art director, editor or publisher, film director, or author. Find out what they like, who is currently illustrating (plus shooting and designing for them. Think *contacts*.) Most importantly, find out how they solicit new talent."

According to Libbey, chances are the above potential clients are approached by many creatives every day, and these folks will follow a specific protocol to review new material. "Perhaps they seldom scout for new talent at all," she says.

For example, a well-known comic book company may require you to attend a particular comic book convention and sign up to meet one of their reps in person. Some of these companies will adhere to a strict "no unsolicited submissions" policy.

"The good news," says Libbey, "is that most companies in the business of commissioning art and design know that they will always need to have a dialogue with new talent, and all of them try to make it easy to find their submission guidelines. Usually it can be found somewhere on their website."

## UP FOR DISCUSSION

I asked Chris Sickels to comment on four hot topics currently pressing buttons for illustrators at this writing.

1. *Is print dead or dying?*

   "Print is weeding itself out," Sickels says, "but books that are printed nicely and crafted well are still appreciated; maybe purchased more as an object than a literary form."

   Sickels thinks that even without physical print, people are still hungry for visual content, perhaps even more so today than when print was dominant. "There are so many outlets now," he says. "People need visuals to cut through that clutter and keep content relevant and prominent."

2. *Should illustrators actively explore animation?*

   There has been a gradual shift in the zeitgeist that the moving image does indeed have a place in the illustration world.

   "I just did a small, fully animated PSA," Sickels says. "It's just another way to say, 'my work can go that route.' It's great that stop motion is doing pretty well. My work isn't that refined or clarified, but I think it might be able to find its little niche, figure out where it can fit in all of that sequential illustration noise.

"But I do feel that the power of a single illustration is still pretty unbeatable," says Sickels. "Just because it's been animated, I don't know that a GIF version, let's say, is always better. A GIF must add another layer, support the timing of the concept and not just be eye candy.

3. *It seems like everybody wants to score a children's book these days. What about breaking into this popular genre?*

"Perhaps the ideal situation if you want to break into children's illustration is to be an author/illustrator," Sickels says. "But children's books don't offer an immediate return nor any guarantee that the book will be a success.

"You have to do it for the love of the project—you have to put it out there and see what happens. You have to ask yourself, can you commit to the time and energy it takes, the uncertain return on investment?"

4. *Should I get a rep?*

A big, big question just about all illustrators ask at some point (if not right off the bat). "Some illustrators are better at handling things on their own," Sickels says. "I'm better as part of a team. It was just waiting till I found the rep that I *personally connected* with.

"Some reps you feel could just as easily be selling dishwashers; it's only about *sales.* Where's the respect for your imagery, where's the connection on the creative aspects of who you are? Could you enjoy a cup of coffee with this person outside of work?

"Before I signed on with my present rep, there was a dialogue going on prior to either one of us worrying about the illustrator/representative arrangement," Sickels says. "We established a friendship before we even committed to a business relationship. I felt that I had to do my homework and build my chops up. I needed to work with art directors and deadlines and have a consistent portfolio before I felt that someone could invest in me.

"New illustrators who work with reps too early on in their careers often get upset about commission prices; they may have no clear idea about what is involved and can't appreciate the value of a rep's commission."

## STARTING YOUR CAREER

"I worry that, at this writing, the novel topic of kick-starting your career is askew," Ken Bullock says. What Bullock wants to emphasize is that your career path is paved partially on what you want to do and where you are—both geographically and economically. Larger cities, like Bullock's Houston, Texas, may offer both freelance and full-time circumstances. A more economically depressed location presents different challenges.

"You might have to work for someone doing something you don't want to do while you build your portfolio with freelance work," he advises. "You might have to take a mainstream, lesser paying job and make what you can of it until things get better. Take advantage of any and every opportunity. Fight for a cause and support it with pro bono work—you never know where it might lead. This helps them and yourself."

Let's specifically address some career specifics and look at the choices you may consider. Each can make significant differences in your career outcome. Each, of course, comes with unique advantages/disadvantages and each makes individual demands on you. Let's list several options and compare them, shall we?

## GETTING WORK AND WINNING NEW CLIENTS

Bullock thinks there's something funny going on here. "It's a bit of a muddle," he says with a laugh. "In my experience, when you are starting out, getting work is rather like asking the bank to give you credit. If you don't already have credit they won't give you any."

Clients want to see work you have done before they will give you a gig, and they want to see work you've done relative to their market (or for their competition). You may likely hear: "Yo—if you haven't done any work in our industry, how do we know you can do this for us?" Credibility and viability—at least in the eyes of a potential client—is usually established via actual (or perceived) experience.

"At a point in your career, people's ears will start to perk up because of who you worked *for* and not so much because of your skills (the actual reason you landed those assignments in the first place)," says Bullock. "Oh, your portfolio will continue to shine, and your talent will still be obvious. But I'll bet that your stellar reputation (earned through certain big-name assignments) will cause your freelance stock to soar. Congratulations, you now have moved into the hallowed ranks of the 'very credible' illustrator."

Bullock calls this the "she actually worked *there*" effect. In a portfolio review you could replace that "there" with any prestigious client (*Rolling Stone*) and/or big gig (a *Rolling Stone* cover). Cue drumroll. Here, the other party will invariably respond with "Wow . . . *you* worked *there*! This was *you*?" Cymbal crash. They then follow up with: "If you're good enough to be hired by these guys, you can definitely help us!" Rim shot.

At that juncture, your business network opens up exponentially as well. People move on and up to other positions; you stay in touch and—voilà—inside contacts all over the place. "This network creates invaluable entree into other clients for freelance or even full-time employment," Bullock comments. "And let's face it, folks hire people they know, like, respect, and admire."

# LOCATION, LOCATION, LOCATION

Do freelancers who live in a big city have a better chance at success than those who live in small towns? Theoretically it should be easier to market your services on the spot, as opposed to marketing from a remote location. On the surface of it, small-town freelancers wanting to market in the big city reasonably would meet challenges of time and distance their metropolitan brothers and sisters don't face.

Regardless of location, your shot at success will not be the proverbial "piece of cake," and not too many years ago, the answer to the question above would have been a resounding "yes." But it can be done. It's being done. How? We live in a brave, and not-so-new world—the global village of instant communication and light speed response.

Any "yes" answer to our big question above must be qualified by many factors: the Internet, state-of-the-art computer production tools, digital delivery and cloud storage; today's telephone technology, phone answering systems and services; and, sure, express mail couriers (local, national, and international), too.

This modern mixtape gives an out-of-town freelancer all the tools to effectively set up shop in any city, just about anywhere in the world. But success can be elusive *wherever* you operate. Living in New York City, considered the hub of the industry, doesn't guarantee a cushy career. It's a bit like peeling the layers of an onion, and defining what qualifies you as "a success" is relative and rather subjective.

A freelancer—call him Max—earning, say, $50,000 last year, was tickled to earn this money, until he talks to an illustrator—call her Nancy—making $75,000 a year via fewer assignments (all numbers stated for convenience only). Nancy meets a hot ticket illustrator at a conference who netted even more than *that* (and with a month's vacation in Cancun, to boot). This wows our heroine. Nancy vows that she, too, will be "just as successful."

Your stats may vary, but you get the picture. Your chances for success may be better by living in the big city. Without a doubt, there is more work in the right Big Apple block than in all of my small town of Milford, Delaware. But the relaxed quality of life in this friendly, tranquil haven may not be found anywhere in (any) Metropolis or Gotham City. It's a trade-off artists living and working in places like this have made without a second thought.

## LOCAL VS. NATIONAL

What are the best markets for a beginner to try? You shouldn't limit yourself to local clients. I always advise starting locally and small, but with an eye on the regional, then national (yes, even international) markets and the "big time." Learn to conduct business at home, and then use this initial training to branch out beyond your own turf.

The timetable to climb the ladder is up to you—again, success may be subjective as well as elusive. Modern communications coupled with current technology and digital delivery makes it just as easy to get a job around the world as it is across town. However, there are excellent markets waiting for you, and literally right down the street.

Let's brainstorm a bit:

- ◘ The public television station is looking to energize the mail campaign for its upcoming fund drive.
- ◘ That local city magazine is putting together a special event issue and needs your compelling art to entice their audience.
- ◘ Your neighborhood library wants to pump life into its website as well as its newsletter.
- ◘ The university could use smart illustrations to perk up articles for the alumni magazine.
- ◘ How about that busy advertising agency across town? Could it use some illustration help? Call it.
- ◘ No matter how you slice it, the corner deli is looking for a new graphic identity (and ongoing signage).
- ◘ Your dentist, interested in stationery and letterheads, also needs a catchy checkup reminder.
- ◘ An insurance company wants to soften payment notices and complement other mailed material (and its in-house magazine could stand a serious visual overhaul).

It's easy to see that good assignments are where you find them. Keeping that in mind, I'd look to your own backyard for those first jobs. With this invaluable experience, moving to larger markets will be that much easier.

## NEW KID IN TOWN

If you're new in town, getting started again locally or expanding your horizons regionally means that marketing and promotion is the name of the game right now. In a word: advertise!

- ◘ Of course, update your website (as well as business card and forms).
- ◘ Place an ad in the local newspaper.
- ◘ Consider an announcement on your cable channel's community calendar or a late, late night television spot (when ad rates are dirt cheap).
- ◘ Spread the word around: Organize that mailing program. Tell your new neighbors. Join the local art organizations and schmooze. Send emails, or stick flyers on windshields.
- ◘ Check in at the chamber of commerce; maybe members can refer you to potential clients who need your work.

> ▶ Get on the phone. Yes, even make cold calls if you have the stamina. Get a listing in the yellow pages. The idea is to tell one and all (not just the business community) who you are, what you do, and where to find you.

At some juncture point, it's a relatively short hop to go regional; but initially, establish a home base—professionally and personally. The markets aren't going away; they'll be there (wherever "there" may be) when you're comfortably settled and situated in position to solicit their business.

## DIVE RIGHT IN

Julia Minamata says that the best way to get into the field is to dive right in! "I had class-mates who were already working, so that felt normal to me," she says. "I started sending out postcards as soon as I graduated. And from my second year of college onward I was entering illustration contests—our teachers encouraged us to enter the contests—I think that was the earliest promoting I did."

## TALK IS KINDA CHEAP

Mega, an illustrator/designer actually (and currently) living in Bali, spent six years as an editorial art director in Europe (specifically for magazines), so the French native can speak with some authority about working from that side of the drawing table. Based on that experience, he wants to offer what I call five wee pearls of wisdom he says he wishes someone had given him when he was a student.

"The first one," he says with a chuckle, "may seem weird, coming from a guy offering advice, but here it is: 'Just shut up and work. Talkers are not doers.'" One thing that frustrated Mega in art school was the process his teachers used to encourage students to verbalize about projects. "But you don't necessarily need to do this," he insists. "I disagree ... Actions speak louder than words."

As a student, Mega was typically laboring with low or no funds. For a while, he worked in a burger joint to buy a ticket to New York City and pound the pavement. "I went to all the offices of people I wanted to meet—certain record labels, skateboard companies, headquarters of select brands. I would just knock on doors, pretending to be a journalist looking to interview the different players of the New York (so-called) underground scene. And it worked."

His enthusiasm opened doors for him and even established lasting friend-ships. Back home, "I worked, and worked a lot," Mega says. "I produced a book called *NYC Rules*, a fairly ambitious graphic design project about the Big Apple's alternative scenes. Then I would just go to all the magazine offices—with no

appointment, mind you—and present what I did and give them a copy. (Everybody likes free stuff.) Result: All the important media talked up my project and soon I was hired as the art director of a French publication. This was the beginning of my career in the industry." By the way, folks at his old school are still talking about this bit of guerrilla marketing. As the man said, talkers are not doers. Actions speak louder than words.

But true to his ideals, Mega says this to cap off the discussion: "First and foremost, last but not least—stop listening to me. Form your own opinions, go back to your work and be awesome."

## THE HERE. THE NOW.

Mega will tell you that it's all about the here and now. Yes, you might be too busy, a bit scared, somewhat unsure about what you are actually doing. Or perhaps you're too exhausted because of your day job. You could be just plain sick of it all, even depressed. "But whatever," he emphasizes, "you do what you do because you love art, and you make art because this is your passion . . . so you have no excuse. Don't wait. Do. Now. Life is too short to watch any TV. Stop smoking weed, stop procrastinating, stop complaining. Practice. Art is about commitment. It all depends on you. Better to put any available time and your energy into your work, instead of losing a job for the wrong reasons."

When he was working as an art director for magazines, Mega was in charge of every visual aspect of the publication. It was his charge to find illustrators or photographers to complement the articles supplied by his editor. "The problem was," he remembers, "most people don't respect a deadline, and I had to wait on these slow pokes to finish my layout. I quickly realized that if you want something done, you'd better do it yourself." So Mega began replacing late visuals with his own illustrations. Eventually, he started to get noticed purely as an illustrator and other magazines began ordering his artwork for their use.

## TIME WILL TELL

Is it a no brainer to advise you to unpretentiously be confident? Mega started from nothing (as he puts it). "Nobody in my family is sensitive to art," he tells us, "I come from a poor background. I had no help (and, in life, nobody will help you anyway)." He was a garbage collector, cleaned airport toilets, and carried luggage. He worked the door at a nightclub. He even worked as Santa Claus in a clothing shop.

Let me point out that these were full-time gigs. Any money earned bought food and paid the rent. All this, of course, so he could have a place to work on his illustration and design, late at night, when he came back from, well, work. Art is nothing if not about perseverance. "Persevere, and relish the day you can afford to quit your day job," he says, "when you can just use this invaluable extra time to

work more and more on your passion. People who spend an hour here and there working on their art cannot compete with you anymore. The labels 'good' or 'bad' don't matter, there is no good and bad. There is only dedication. So fail away . . . get better, stay true to yourself, that's the best way to succeed."

## OPPORTUNITY KNOCKS?

Mega's professional journey kicked off with minor gigs in, as he says, "Small and boring cities in the South of France. Nothing happening; a general lack of interest for the arts; no great exhibitions, no cool artists." But he ultimately realized that it was better to pull off what he wanted to do, head to where he needed to go, check out what he hoped to see, instead of complaining about not having those opportunities.

He can begin new projects (and do what he likes). And what he likes is "everything that is around me," he says, "in my head and in my heart." His latest project (at this writing), *Longing to Be Knotted Together*, took him about five months to complete, working eight to ten hours a day, seven days a week. "No time for party, no more girlfriend," he sighs. "Just pure dedication—and a generous slice of craziness I guess." Of course, he then had to figure out the perfect production values—the paper, inks, and screen printing process, etc.—to suit his vision. At that point, he started looking for galleries to show this sweet stuff. "The process was long and painful," he says. "But you don't wait for things to happen, you are the one who can create your opportunities."

By the time you read this, he will have embarked on an exhibition tour that took him to Australia (Melbourne, Sydney, Adelaide); Jakarta; Singapore, Kuala Lumpur; Berlin, and back to his native France (Marseille and Paris) and more. "So there's nothing happening in your town?" he asks with a sly and ostensibly sympathetic grin. "Ahh; too bad . . . by drawing or designing what you wish to see; by creating the events you hope to experience; by writing/illustrating and designing the books you care to read—you can meet all your goals (but of course, you gotta stick to it)."

Teaser: this is a perfect time and *opportunity* to point out our sidebar on entrepreneurs, coming up at the end of this chapter.

## FOOL OF YOURSELF

Your ego is a great marketing tool; ego is what marketing is all about. "But as Mega reminds you, "It has no place in real life. Injecting your giant ego into the work never produces anything of quality," he says. "I can't emphasize this enough: be nice in your real life. Be kind to the people around you (but humbly discount any help you offer). Stay equally humble in your business relationships. The day you need something . . . those folks who benefitted by your kindness will line up to return the favor. And, hey, maybe even buy some illustration."

## WORKING WITH NEW BUSINESSES

Freelancers just starting out may look at new businesses as kindred spirits, but some words of caution here: be careful when taking an assignment with a new business, as new businesses frequently fail and don't pay. Do your homework prior to working for any company, regardless of track record. Chances are good that that pioneering enterprise or established organization will treat you right, but reputation—or bright promise, for that matter—is no guarantee that they will be a dream client.

The best offense is always a strong defense. Thoroughly research their website. Write explicit and detailed emails when a job is being proposed and/or then discussed. Get on the phone or hold a Skype meeting and take good notes. If you're a terrible note taker, record the conversation (best to do this with notification and permission, of course. By the way, Skype currently works seamlessly with a handy app called Call Recorder). Ask incisive questions at every meeting, beginning with the first, and do this at any opportunity. Be prepared to discuss your rates, terms, and needs, and evaluate how the client's needs compare with yours. It's best to clarify and communicate right at (and from) the start.

## NETWORKING

The one thing everybody has, and almost always loves to give away, is advice. Yes, it's okay to seek advice; never shy away or sniff your nose at formal or informal information gathering.

Networking is a low-key, direct means of communication that pays handsome dividends because there is much to learn from other freelancers. Your fellows are veritable storehouses of information; reference and referrals; help, solace, and counsel.

Hobnob. Compare notes. Commiserate. After all, you share the same basic experience, rather identical trials and tribulations. Almost invariably, most contacts enjoy talking shop and are easy to find. Start with the Internet, of course. Tap into the ever proliferating number of social media networks, websites, chat boards, plus news, interest, and discussion groups.

Obviously, check out your local illustration, art, and design community resources, as well. Any traditionalists out there? You could start with the local yellow pages under "Artists" (commercial and fine arts) or even "Graphic Designers."

Anyone not know how to network? Regardless of method or scope, the formula is simple: introduce yourself; make friendly conversation while asking pertinent questions; acquire other names and numbers, rinse and repeat. Then just keep in touch.

The first commandment of networking? "Thou shalt never stop." As Brian Fencl says, "Action creates more action and that leads to opportunity."

## WHAT GOES 'ROUND . . .

Invaluable help; stimulating ideas; compelling information; new colleagues, and fresh contacts await. Mary Grace Eubank says, "I'm a firm believer in what goes around, comes around. Keep track of whom you contact and be aware of how they can help you." *And how you can help them.* Eubank made it clear that you should not feel guilty about using connections. Keep in mind that most of your contacts will be receptive and helpful—you must act the same.

Why network only with other illustrators? If a knowledgeable source is willing and available, network with designers, editors, art/design directors, copywriters, or the production coordinator (even when you're not involved on a job). Approach the sales manager, too. If you want some real insider information, talk to any secretary, assistant, or clerk. It's medieval to believe that you're the center of the universe when so much is accomplished through the collective process. Most folks are complimented to be considered experts. If you have specific questions, why not go right to a particular source?

It should also be said that you could run into the dark side of networking. Some folks just lack, shall we say, mature interpersonal skills (read any juicy tweets, lately?). Some are just plain busy; perhaps too busy to talk at length, short in fuse, reason, or self-control.

I've also found that, while just about everybody is willing to contribute a certain amount of information regarding business chops, many others are unwilling to share the mechanics behind an innovative technique or unique approach. This is justified and perfectly legit; it's not to their advantage to give the farm away.

And while most of your contacts will be happy to chat or will politely decline, you'll inevitably run into those who virtually accuse you of trying to steal state secrets. Remember that stress and competition and drive can create surprising attitudes. Credit that person for her unique perspective, thank him for his fascinating advice, and say good-bye. Move on.

# PRO BONO

Volunteering or donating your time and service can be an effective means of generating publicity (or doing a good turn). The trade-off you make with the group commissioning the art is your skill in exchange for a credit on a final product.

Thus, you are doing the job based on a higher calling or as business/marketing strategy (nothing wrong with that). You usually have the chance—or you should make that a caveat—to do your own thing, so you gain a potential showcase.

While the concept of *pro bono* is not universally loved, you shouldn't dismiss pro bono as a simple giveaway or write it off as merely paying your dues. Nope. If you establish ground rules, define limits and clarify expectations, pro bono could be a healthy investment of your available time, energy, and spirit.

Local arts and theater groups will frequently offer opportunities for high exposure through posters and other promotional vehicles. There's nothing like seeing your work all over town. Other possibilities for pro bono work include charity fund-raisers (walkathons, road races, charity balls). The people who run these events and volunteer their services are often the movers and shakers in your community. They're frequently high-profile types in a good position to circulate your name. And they may be possible sources of future business.

Another advantage to pro bono work is the caliber of the support services—and again, usually—at your disposal. Frequently, top-quality printers and color service bureaus will donate their services for a charitable event, allowing you to familiarize them with your capabilities. You'll also have a chance to use services and goods that budget-conscious clients may not have afforded you.

And don't forget you may donate your time to the firms offering support services in exchange for collaboration on a promotional piece (always ask for a credit for your contribution and get an agreement that they won't change your illustration without your permission).

In the best of all worlds, volunteering your time and/or your art services (pro bono work) to good causes would certainly be only a win-win situation. But, as this is reality, and as we discussed, the concept of *pro bono* is not universally loved. Let's discuss this a bit, shall we?

## PURPOSE

Some may see pro bono as merely freebies, but we'll try to look at a bigger picture of positive angles. As a volunteer, you'll gain confidence at the drawing board doing actual assignments. You'll have creative freedom without any pressures to cut the best deal, and you can illustrate according to your vision. You will learn about deadlines and working with a client.

You acquire a piece for your portfolio, work experience for your résumé, and achieve name recognition. You get profitable leads, make new contacts, and establish a reputation as someone willing to go the extra mile. In addition, volunteers have the happy and satisfying experience of completing a job well done for a worthwhile purpose.

## PRINCIPLE

You'll find established artists donating their services; so pro bono is not simply a newbie's right of passage thing.

However, pro bono is not everyone's idea of, well, a good idea. "I'm not against pro bono work, *in principle*," Rick Antolic states right up front. "But I always advise my people to be cautious about who gets work from you for free. You will never stop being asked to do work gratis, so don't ever be known as the

go-to guy for a free lunch. You'll never be able to command higher prices with that kind of reputation (or should I say, 'exposure')."

So when is it okay to work for free? Antolic has a "Rule of Threes" when it comes to accepting pro bono:

1. The assignment is something you'd *love* to do in the first place.
2. You can do the job exactly to your liking, and that end product can strengthen your portfolio.
3. Do pro bono only if you know that the client truly cannot pay.

"Often times, a client can pay, but they will first try to get it for free," Antolic cautions. "Don't fall for that."

## FEEL GOOD

"Pro bono is something big companies do to make themselves feel good," says Peter Arkle. "They choose charities they want to help and then they approach people like me and tell me they cannot pay me much. They go on about the good cause but, usually the cause is their cause, not mine.

"Sometimes I am happy to help but usually if I want to do work for not much money I prefer to choose the cause myself. If a big company wants me to help make them look good they should pay properly for that."

## REFERRALS

If you do your best work, meet your deadlines, and are dependable, the referrals will take care of themselves.

Referrals come in two varieties: as leads and as references. To get a reference, you'll need a few jobs under your belt first. These referrals usually are the result of a rewarding and positive performance. The client likes your work and passes the word on: "This is the person to see to get the assignment done right; call her."

Leads often accompany references. The satisfied client above not only refers you to one compatriot, she also supplies you the name and address of yet another businessperson needing your services. A graphic designer gives you a hot tip that the design studio across town is looking for an illustrator of your caliber right away. (You send an email or make the phone call, mention your contact, and gently nudge toward a next step.) You call the art director on your last job and network a little: "Do you know anybody who knows anybody who needs anybody?" (This art director, more than happy to help, gives you a list of five new contacts; it's now up to you.)

## MAKE YOUR MARK (FOLKS JUST LIKE YOU)

### ARKLE: A CUT ABOVE

Peter Arkle thinks of an illustrator as someone who makes things *illustrious*. As in makes things better: "Boring business articles in drab magazines suddenly look more interesting," he says. "A book that no one would pay any attention to is suddenly screaming for attention.

"You have to be able to read and understand (people and articles or whatever you're illustrating) and then you have to be able to react to what you learn. You have to be imaginative and crazy, but you must also know how far you can take the craziness . . . or, at least, if you want to be crazy you have to be prepared to make changes to tone things down, if needed.

But most importantly, Arkle says your drawing skills need to be sharp enough so readers can actively share what is in your imagination. "I try to be like a hairdresser," says Arkle. "I treat my clients well and do a good job, maybe even surprise them and make them happy. That way they come back for more, tell their friends and remember me when they move jobs. And if they say the haircut I've drawn for them looks silly I don't argue."

Arkle happily reports that nowadays the markets are finding him, and currently keeping him busy. "I am sure I'm missing out on some super-exciting work that I could be doing, but at the moment, I'm pretty content. I am not good at networking. I rarely go to events that would do my illustration career any good at all. I have never tweeted or Facebooked or anything social at all! So if my situation changes I'll just keep trying to be nice, keep scribbling like mad and keep trying to be as good as possible—all while my fingers are crossed."

## MORE TO LIFE

Will Terry has some misgivings. "I'm not sure I fully believe in helping people towards freelance illustration," he says candidly. "I'm more into helping my students and online followers develop their own projects/dreams/ideas."

Terry won't try to dissuade you from a freelance career if that is your goal; he's done well as a freelancer, thank you. He just wants to impress upon us that modern illustrators have to think up, down, left, and right, off center. Especially these days, as the old opportunities just aren't there. You must create your own breaks.

Terry has been on the illustration roller coaster for many years. He's enjoyed boom years and hard times. He's transmogrified his job description and jump-started the fabled "next phase" of his career. Over the long haul, he has shifted his focus, changed his direction, and busted all kind of moves as he's explored and dabbled in both advertising and editorial genres.

Eventually came successful forays into video, podcasts, and online publishing (driving both sales and establishing his academic brand). This led Terry to the conclusion that, as he says, "There is more to life than just freelancing."

## ROW TO HOE

"With freelance you're relying on too many outside factors," Terry says. "Someone else is calling the shots. And you have to be better than so many more people. Back in the day when it was just the *Showcase* and *Workbook* annuals you could get away with the notion that 'I can fit in and maybe be a little cut above the average here.' Now with a global marketplace, you have to better than *the whole world* of illustrators.

"Competing on that scale is something else entirely. That's a game you can play. You can grind and grind away. You can definitely work on your craft (that's admirable) and try to be "the best" (that's a debatable worthy ambition). But that's not the lifestyle I want to pursue.

"My online endeavors mean I can make money while I sleep," says Terry, who's currently so busy he's actually turning down jobs!

Terry still gets what he labels "a fair amount of freelance," but in an ironic twist of fate, he finds these opportunities usually come at inopportune moments. Case in point, he recently had to refuse a picture book plus two other plum assignments as these gigs interfered with personal work.

But he does so gingerly and diplomatically, because, as he states from experience, "I don't know what my future is going to look like.

"As said earlier, I know the illustrators today, in this world, need to think of themselves differently. The once healthy editorial market is almost gone. My students—who, by the way, draw way better than I did when I left school—have a tougher gig ahead of them."

## SIDEWAYS

I don't despair over Terry's honest assessment of illustration's state of the union, because he provides an equally honest assessment of shifting circumstances. He's not painting a rosy picture of delusion; he rightly points out new technologies that have created opportunities and opened markets for those willing to be entrepreneurs, pioneers even.

"It's about pure necessity," says Terry. " I heard somewhere the notion that everybody has *something* they're already doing that they can turn into a side income, maybe even a better income than their present job."

This is priceless advice. So you're wrong if you think you're "limited" by being "just" an illustrator.

## GAME PLAN

"There are questions to ask," Terry considers. "What do *you* want in life? Do you like working in that style . . . would you rather be working in *this* style? Is there a response to it? What is *good* art, after all? How do you objectively determine value?

"You can play the game two ways: You can try to be the best at your art style ... that means that you have to be world class. Or you can combine your art with a world class idea.

"I try to impress upon my students that the idea is more important than the craft," Terry says. "If you can fuse your art—regardless of your skill level—with that killer idea, you might just have a shot at a career with this art thing."

## DONALD, DUCK!

"I don't think you can just turn on or off the entrepreneurial spirit; you have to fail a lot—over and over again, be committed and determined," Terry says. "I suspect that with financial success comes a lack of motivation for some, not for all.

"A by-product of success is that it can sometimes suck out your ambition, doing exactly the opposite of what you want it to do, or think it 'should' do. So you have to go through a process of having projects that don't work—you must fail so you can be successful one day. That's hard for anybody to hear, maybe students more so. They want to work—need that job—to pay off loans, start a family, whatever."

And along those lines, Terry says he's not terribly fond of the animation industry. In Terry's observation it's a big business that chews up young talent. How so?

He cites frequent layoffs and a big turnover, which means a distinct lack of job security. On top of that, Terry says the job doesn't seem to pay much; or the wages don't go far in the designated meccas of the animation industry (Los Angeles, he's talking about you).

But animation gigs are currently oh-so-sexy and alluring to students, so there's always a fresh crop willing to accept these facts of life. Of course, one man's cautionary tale is another woman's success story.

"My advice to students is that you need to *get better*, work every day," Terry says. "School gave you the tools to practice and critique, but your education after those college days must continue for many years. You must stick with it; you probably won't be good enough right after school to generate a million-dollar gig so the long-term plan is to get better somehow."

Finding a graphic design job after school keeps you in the field, but may spread you thin psychically and artistically. Terry actually recommends students take non-art-related jobs so they have the creative energy to work on outside personal projects that offer a potential to become lucrative opportunities. Of course, the potential is also there for such projects to tank, but as is said, all great treasures are guarded by dragons.

# ON THE BOARD
### (PROFESSIONAL VIEWPOINTS IN 50 WORDS OR LESS)

My best work has come by the tightrope I walk while creating—the feeling that when what you're about to do could destroy hours of labor or make something bold and fantastic.

—Julia Breckenreid

Should a novice freelance? That's a provocative question that is highly subjective. Generally, if one is studying in school to be an illustrator, I would say, no, don't freelance. Why? Partly because, as a student, shouldn't your days be busy enough with schoolwork?

—Charlene Chua

Every day has the potential to be exciting and rewarding. The opportunity of a lifetime could be waiting for you in the next email or phone call.

—Randy Glasbergen

I do the best work I can with what I have, and if that's seen by someone, then that's nice. If not, I'm not gonna force it on anyone.

—Mikkel Sommer

The talent will either be there or not already. You must be incredibly dedicated and focused; it all comes down to 'work hard' and then 'work harder.' You evaluate the rewards honestly and decide whether to stick with it or not.

—Fred Carlson

We're no longer just visual artists. Today you must become a strategist who can envision illustration that is technically feasible, financially viable, and visually engaging.

—C. J. Yeh

© Michael Fleishman 2016

Technology enables vendors to offer on-demand services for just about anything! It's a great opportunity for artists to make money from their images.

—Julia Minamata

Find work, do the work. There are no rules. If you're ready to jump in, jump.

—Brian Biggs

Don't believe anyone who says "it's not what you know, it's who you know"—it's what you know AND who you know. The "what" being much more important than the "who." What about "doing your best"? That's about trying to do BETTER than your best—reaching to exceed your grasp.

—Shaun Tan

© Red Nose Studios 2016

© Avram C. Dumitrescu 2016

MELISSA DORAN

# Chapter 4

# Off on the Right Foot

*There is no right way to do the wrong thing.*

—Toby Keith uses it in a country song;
it gets attributed to Harold Kushner or Ken Blanchard;
but its origin apparently trails back to at least mid-nineteenth century
(however, I heard it from my man, Roger Brucker)

## DRESS FOR SUCCESS

Congratulations, you've graduated! Or maybe you've been doing something else—perhaps practicing graphic design, for instance (or selling insurance for that matter). Perhaps you realize you're simply tired of working for others, or you may be a former student—of anything—who doesn't care to work for someone else.

At any rate, you're a hotshot illustrator, itching to make an individual creative statement and get it out there. What *do* you need to succeed in the illustration biz? It's a good question, and one we will explore in depth in this chapter.

Well, you *won't* have to bother with dress clothes, traffic and weather conditions, and office politics (family politics are another story, and we'll deal with that later). You want to name your own business hours and you enjoy the idea of a personal workspace. You'd like to pick and choose your assignments; you want to challenge yourself with bigger and better projects. Let's face it, the notion of being the boss—being your own boss—is appealing (if not absolutely alluring). Maybe just being around your spouse or partner more or seeing your kids grow up is at the tip-top of your wish list.

For whatever reasons, you have the "itch" to go out on your own. Do you have the ardent urge to be an "illustrator"? Is there this gut feeling that art — illustration, design, painting, drawing, sculpture, ceramics, whatever—is what you *have* to do, that this direction is *your* career path?

"I had no idea what illustration was," says Scott Bakal, "no concept of what it meant to be an 'illustrator' when I started. It actually had to be explained to me. I just considered myself an artist that liked the paintings that I saw in magazines and books."

But Bakal saw that this worked for him. He had opinions and ideas. He realized that illustration was a chance to get many of his ideas out there visually. "Having the opportunity to visually expound on religion, politics, and social issues is stimulating and fresh," he says.

"Keeping your vision of the world and how you present it in your illustration is the core of an illustrator's existence," says Bakal. "If you can't hold on to that, then I feel you lose out on your own self-expression."

## THE WAR BETWEEN THE STATES (OF MIND)

At your local bookstore or library you might see this book, *Starting Your Career as an Illustrator*, snuggled on the shelf next to her sister, *Starting Your Career as a Graphic Designer*. And you may see the two tags hyphenated as illustrator/designer (or vice versa), because there are folks who are adept illustrator/designers (and versa vice).

But an illustration studio and a design studio are not peas in an iPod. Certain skills and methodology definitely overlap. But for clarity's (and comparison's) sake, first let's define the basic term *design studio*. A design studio is an entity with a definite name and identity. Something as straightforward as "B. Lebowski, Freelancer" would qualify, as well as the more esoteric "Area Rug Graphics." These concerns will be owned by graphic designers who work primarily out of their own place of business (at home or in the studio) and are not working primarily in someone else's studio, agency, or graphic design department. The primary business would be total design, from concept to completion, rather than single aspects of production.

And for continued clarity and comparison, let's revisit the discussion (from Chapter 1) about the ostensible difference between an "artist" and an "illustrator."

"If you know exactly what you'll be paid before you start a project, then you probably are an illustrator," John Schmelzer says. "I consider the likes of Michelangelo, Da Vinci, Rembrandt, Sargent, Homer, and Eakins, all to be illustrators in the modern definition."

This great debate has been raging since artists first called themselves illustrators. "Certainly, ever since the Abstract Expressionists came into being around World War II, and the clash between the Abstractionists and the Representationalists of the time," Bakal points out. "In my opinion, it doesn't matter. There is good art and bad art. Beyond that, it is just a never-ending fight over *isms* and movements that will never be won.

"This leads to the intent of use for the artwork created," Bakal says. "The illustrator creates art for the specific purpose of getting the work published where the fine artist generally does not. Humorously, I like Maxfield Parrish's comment on the gap between fine art and illustration: 'The difference is about $30,000 a year.'"

So you didn't miss the memo. For many of us, the contrast between a "fine" artist and an "illustrator" is pure mindset. It certainly is the difference of definitions. And maybe it's this confusion over the definition of "illustration" and "art" (or "fine art") that has often led to contentious debate, and to more than a little misunderstanding. For, as illustrator and educator Bob Selby points out, "The difference between these terms is not a question of aesthetic opinion. Illustration (and its meaning) is a matter of English, not art."

"There is no hierarchy," he scoffs. "There is no great stone somewhere in the misty woods with 'fine art' carved at the top of a list and 'illustration' ranked somewhere around number five. The definition of illustration has nothing to do with quality."

## MAKE YOUR MARK (FOLKS JUST LIKE YOU)

### FRIEDEN: CHANGE OF (HE)ART

"If you want to make illustrations, make them," Sarajo Frieden says. "If you want to make art, make art. Do both if it suits you. Make toys, films, animations, puppets, and perform—if that's what *you* want to do. My suggestion is to *just get over it.* Get rid of rules, names, and anything that makes you smaller. Don't let anyone else define you."

Frieden's bilateral solution (a.k.a. good advice) is based on the wisdom of professional experience, and her thinking has actually undergone a 180-degree spin here. "Illustration is kind of my latest career," she says. "I went to art school, waitressed, and then made my way up the food chain in the design world. Freelancing as a designer for the record industry somehow led me to more illustration and, voilà! Here I am doing that artist/illustrator thing and everything else in between."

Frieden can't think of a time where this question has mattered less. The same inspirations that feed her personal/fine art work feed her commissioned work. She simply tries to stretch and grow with *everything* she does. "Hopefully that makes me more interesting," she says, "and makes my work, whether for galleries or books or products, more interesting as well."

## THE STUFF

If you bought this book, you have more than a vague curiosity about going out on your own—freelancing. That's a good sign right there. How do you find out if you have the right stuff?

Well, you won't be required to break the sound barrier every workday, but answer these initial queries and then consider the evaluation questions posed under this chapter's later section, *Do You Have What It Takes?* For your best results, respond truthfully and appropriately.

### WHAT ARE YOU GETTING OUT OF THIS?

What *are* you getting out of this? Why are you doing it? Question your motives and answer candidly. You can make a nice hunk of change freelancing, but you could also win the lottery before you create the next *Family Guy*. If you want to freelance just for some easy "big bucks," you're in for a rude surprise. And do you have the special skills that translate into that moneymaking opportunity? Your business exists only to profitably practice your craft. Without talent, even a superbly structured framework won't take you far.

## ARE YOU SELF-DISCIPLINED?

Do you have the drive and ambition to turn that skill into a success? Talent without drive and motivation does not generate income. A dream without desire cannot be fulfilled. Freelance illustration should be what you *have* to do—for your soul and your checkbook.

It's easy to be excited about landing the cover of the *New Yorker*. The great assignments spark an energy that feeds itself. But behind the glitter of those "important" jobs lies your everyday world. So throw this into that mix: there will be mundane tasks and tiresome chores, and your commitment lies here as well. You should attend to all the daily tasks with a healthy, positive spirit.

There may come a day when you pick and choose only select commissions, even assigning grunt work to an assistant. But until then, as a freelancer, you must diligently face the small daily drudgeries with the same aplomb shown those "bigger" responsibilities. You may be bored by those modest or simple jobs that cover the rent, but you must have the determination to see them through, to make sure they're done right. A poor attitude will cripple your workday. Lackadaisical habits will get you into trouble quickly. Can you think in the long term?

## HOW'S YOUR BUSINESS ACUMEN?

Regardless of your favored moniker—"freelancer" or "independent"—you are presumably engaged in running an illustration *business*—an endeavor fraught with many complexities. To make a go of it, you'll need to be a qualified professional and *businessperson*.

Good illustration is good business. No, flip that: good business is good illustration. Either way, I adapted a time-worn, overworked maxim here. Many have claimed authorship to the original ("good design is good business") and almost everyone has quoted it, but it's absolutely relevant here and excruciatingly true, maybe now more than ever.

If you have little or no sense of how to run a business, it is time to learn. On-the-job training will teach you the hard way; better to read, research, and study before you become the one-minute manager.

How's your bankbook? In times of low pay, slow pay, or (heaven forbid) no pay, can you—should you—support yourself and your business with personal savings? Realistically, how long should you do this if your business is new, not up to speed, or in a lull?

My accountant tells me to have a reserve of at least six months in the bank just in case, but everyone's situation is slightly different; your safety net might be three months to a year (go ahead—definitely err on the side of caution. If you need—and have—the extra cushion, you'll breathe so much easier). The numbers will vary but a hard fact of economics remains constant: can you launch and sustain your business if you're not generating income?

## ARE YOU DECISIVE?

As the Lord High Everything you'll be making all of many decisions and taking responsibility for the consequences. Remember, you are the boss. And, hey, boss—does taking a risk scare you? If you can't even chance a response, you've answered the question already. Without being cute, freelancing is risky business. After all, it is your talent, your time and energy, and your money being poured into this venture. Professionally, no one else goes down the tubes with you if you fail; personally, you and your family have much to lose.

## CAN YOU TOLERATE A FAIR AMOUNT OF REJECTION?

Unfortunately, this is a fact of life for every freelancer up and down the ladder. You will get rejected for many reasons, those misjudgments regarding your abilities probably being the least of your worries. In simplistic terms, the creative director looks at your work and says, "Will I make my point by using this illustration? Or it might be, can I sell my product with this art?" If the answer is no, your work will be rejected.

When all is said and done, it is the portfolio that counts. Remember that rejection is the downside of an isolated opinion, a particular preference. It's not the gospel. I won't kid you, rejection hurts. But if you have faith in yourself and your ability, it will never kill. Create an inner strength from your substantial talent, and draw from it. Rejection is simply part and parcel to freelancing. Can you take it?

The decision that lands you any assignment usually comes down to this question: who's the best and brightest (read the more utilitarian, *appropriate*) illustrator meeting this job's particular needs?

# THEY'RE COMING FOR YOU, BARBARA

They are out there. They're waiting for you. While this may sound like the promo to a bad zombie flick, it's neither hype nor horror. The small horde of your skilled peers is tremendously talented, hard working, and organized. In general, I've found the competition to be a rather loose and friendly fraternity. We do play the same game, in the same ballpark. But your comrades-at-arms won't all act like your bosom buddies, nor is that a requirement in their job description.

Competition in free enterprise is the American way. Use it as your motivation and you'll have an edge. Have a keen and healthy esteem for your competition. Respect their work and keep your eyes open: know what your associates are doing by researching online, the trade magazines, creative annuals and directories. Don't be a rubber stamp of the hot new style, but do know what's current. A key to real success is to offer something that's original and fresh—something the buyer can't get just anywhere, from just anybody. And as Matt McElligott says,

"It's vitally important to be true to yourself." Combine this with good service, strengthen it all with determination and forethought, and your competition will not be so scary after all.

And speaking of competition, how do you feel about selling yourself? Aside from your artistic responsibilities, this is a salesperson's job. It's a fairly simple situation, at least on paper: you must bring in the work to sustain the business that satisfies your creative impulse.

### HOW DO YOU HANDLE STRESS?

Keep the following buzzwords in mind when pondering the considerable tensions of freelancing: grace under pressure . . . flexibility . . . rolling with the punches . . . shooting from the hip . . . adaptability . . . creativity . . . thinking on your feet. Hey, I'll stop.

If you rattle like nuts in a jar when the pressure builds, you're going to be in trouble. The landlord is banging on your studio door; you are certain there'll be a horse's head in your bed the next morning if you don't pay the rent. A once generous deadline screams at you from the calendar while that simple watercolor wash becomes a life or death situation. Panicky?

### DO YOU MIND WORKING ALONE?

Hopefully, you have a stunning relationship with the only one who may be sharing your work space—you. Art school is a pleasant memory now—the halls buzzing with kindred spirits spilling into the comfortably familiar studios, a common ground, awaiting the arrival of teachers and students with a singular purpose and shared excitement. That glorious phase of your life's education is over.

At first you'll laugh, as if at a dumb joke, but you'll discover that it's true: you'll need to get out and practice those "real world" skills! Life away from the studio, with friends and acquaintances who make actual conversation (and not necessarily shop talk) helps balance the isolation. Outside interests temper the hours spent hunched over the drawing table keeping your own company. Seek activities and nurture a support system outside the studio. You may well be your own best friend, but don't go it alone.

### HOW'S YOUR ENERGY AND STAMINA?

You do understand that you're going to be working hard, right? You will hustle to the left and bustle to the right. You will, at times, pause for a breath and then sidestep to *manic* in the middle. Your time schedule will hardly be regular; you'll be a slave to other people's deadlines. Sure, there will be moments so quiet you can hear a pen drip, countered by hectic periods when twenty-four-hour days are not enough. "Hustling," as we said earlier, is all relative for the freelancer.

## THE DUDE ABIDES

Are you working an "outside" job? Is the lure of freelance enticing you to turn in your employee ID? Ready to make that break? Don't quit *yet*.

"Day jobs are underrated," says Yuko Shimizu. "I learned everything about how to work efficiently during my day job—how to organize, multitask, make good phone calls, negotiate terms with clients [as well as] bosses and coworkers. It taught me everything about how to run my small business of illustration later on."

Initially, it may be wiser for you to freelance as a sideline with outside employment (full- or part-time) smoothing the rough financial edges. It's no crime to build toward independence rather then leaping romantically, albeit imprudently, into the fray.

And there's no federal law prohibiting you from doing your own projects (freelance or personal) while working on staff somewhere. As long as there are no conflicts of interest with your workplace and schedule, for your employer or house accounts, and your freelancing doesn't interfere with your energy and responsibilities, there shouldn't be any problem. If there is, and you can't abide by these restrictions (for whatever reason) it may be decision time.

So, obviously, first discuss it with your boss. When you signed your contract, you agreed to comply with company regulations, so honor those terms. Don't believe a discreet, covert operation will remain your little secret for long. The world is smaller then you might think; I guarantee that it'll catch up to you.

But only you can decide when (and if) you're ready to make a complete break. Test the water first. *Don't* leave on impulse or in anger. Instead, take a few "casual" assignments and see if you can maintain the correct pace on both fronts. Over a period of time get a taste of the freelance life. When you're fully prepared (mentally, physically, emotionally, financially), simply hold your nose and jump!

See Chapter 7 and our sidebar with Brian Allen.

### SALES ON

Are you one of those artists who feels that marketing their work is akin to putting their children up for sale? First recognize that someone is paying you to produce images for a purpose. Next, know that you are selling yourself as a problem-solver first, and as a person, second. *You're not selling you, in the flesh.*

And if you remember that you are selling usage of the illustration rather than the product itself, this anxiety is easily suppressed.

Here, Mary Grace Eubank cautions you to "realize that you're selling your work, not your soul." So go online or read books on self-projection and confidence building. Possibly attend motivational seminars on sales techniques. Maybe work with a rep and stay in the background until you can develop a more positive persona.

If you dread the thought of selling your work, but feel you're best suited temperamentally to freelancing, Ben Mahan will tell you that you are not alone. "But it's just something that you have to do," Mahan says. "Most artists can sell themselves better than anyone else, and you *must* get out and sell yourself a bit. If you don't like dealing one-to-one, mine social media, work the phones or do it through email and/or the mails. However, ultimately, you'll need that personal contact, so make the connection."

## MAKE YOUR MARK (FOLKS JUST LIKE YOU)

### BRECKENREID: BY THE BOOK

One might say we could make a book on Julia Breckenreid. An avid reader—she says with a laugh that you should *always* choose the book for its cover—she dropped out of school (and moved out at sixteen).

Many minimum wage jobs and seven years of waitressing later (while doing every art job that came her way), Breckenreid, at twenty-five, realized that neither waitressing nor fine art was the right career path. She was accepted at Sheridan College and graduated in 1998. She worked in an art supply store, toiled as a studio assistant, organized shows, and worked on *her* portfolio at night. Clients grew over a period of five to six years and she's still at it.

"I think that from the time I was a student up to my professional standing now," she says, "the business and how I comprehend it has changed dramatically."

She acknowledges that, at this writing, the world of entertainment and publishing are in major renovation (if not flux). With the industry attempting to serve the changing needs and wants of the public (that is: film, books, and games) while still holding fast to traditional markets, illustrators need to advocate for themselves more than ever before.

"In terms of copyright, usage, and fair fees," she says, "you need to be looking at your own future as well as the good of the whole. In my opinion, the latter is of utmost importance and responsibility.

"To be an incredibly skilled image maker is not enough," she cautions. "You must also be part craftsperson, part educator, and part social monster. But mostly, and sadly for many, you must be a successful sales/business person."

Breckenreid will tell you that those new to the business are at a disadvantage. They don't know what is being torn down nor understand what they are due. And she cautions that even seasoned creatives may suffer if they are unable to let go of what they knew and embrace change.

"In the end, this is what change is and has always been," says Breckenreid. "We provide a service and find the places we are valued most, naturally. We are simultaneously

collaborators and entrepreneurial by nature, and must stay on top of that which will serve us well in the unending tide of changes in economy and in habit."

On a more positive side, Breckenreid points out that change is good. It makes the market more competitive. So—slowly, steadily—skill and the quality of the work will win out. "It may be increasingly difficult to determine where that quality of work will be utilized," she says. "It is hard to say, but that is the nature (and the world) of freelance entrepreneurship. It follows whims and allows you to be at the forefront if you can catch a wave."

But beyond this big picture, how does all this drill down for Breckenreid herself? "It's just magic," she says, smiling. "It's storytelling, poetry, and a hammer. You can't keep me away from it. I love the challenge, the deadlines, the public reach. I love my work; it makes me progressively smarter with every job I complete."

## DO I HAVE WHAT IT TAKES?

The beginning of your career, before you invest your time, energy, and capital, is the best time to objectively assess your illustration and business skills (plus personal qualities).

I assure you, this is not as silly as it may sound at first reading. During a crisis, bad year, or crunch time, too many illustrators question their abilities—or worse yet, realize they don't have what it takes—and throw in the towel. Answer this question by breaking it down into parts. Evaluate your:

### EXPERIENCE

Be honest about who you are, what you can do, and how well you do it. This won't necessarily prevent headaches, heartbreak, or disasters, but it will give you a strong foundation to weather the storm. Begin with this self-evaluation:

1. Illustration is communication. Are you an effective communicator?
2. Can you market your work and promote yourself?
3. Can you personally sell your vision to the client while translating your client's needs into dynamic materials?
4. One goes to a specialist for something special—not pedestrian or cookie cutter graphics, but for striking, thought-provoking, quality work. Are you an illustrator capable of leading the band rather than jumping on the bandwagon?
5. Do you understand (and not fear or loathe) the world of business and finance?
6. Experience makes a difference. Do you have enough? There is an advantage to working from experience vs. diving in cold.
7. Why are you going into business for yourself? You shouldn't be doing it if you are motivated entirely by ego.

8. Following up here: don't go into business for yourself if you're after perks and privilege, fame or respect.
9. Continuing that thread, don't do it out of anger.
10. Finally, is your primary motivation to make money (or more money)? Honest pay for fair work is nothing to be ashamed of. Making enough to buy groceries, make your rent, and pay the bills are solid reasons to strike out on your own.

## SKILLS

Knowing that you have the chops to do a job (and do it well) should be a given. You will need to be able to take an illustration from conceptualization to completion, and make sure that all aspects of the project are done right. Your portfolio should reflect this through a variety of samples.

To determine if you have the chops necessary for going it alone, see if you agree with the following statements. Be honest—if you're lacking in any area, you can always work to develop additional skills.

1. I can render a concept and present it to a client through thumbnails, roughs, or comps.
2. I know how to prepare and deliver a print-ready illustration. See # 10.
3. I know how to prepare and deliver a web-ready illustration. See # 10.
4. I can come up with dynamite visual concepts on my own.
5. I can illustrate just as well or better than my competition.
6. I have good organizational abilities. I can juggle several projects at once and keep track of progress on all of them.
7. I am quick and efficient in executing most illustration, design, and production-related tasks.
8. I know when (and how) to suggest more effective conceptual solutions to achieve a client's end goal. See # 10.
9. When necessary, I can illustrate for the audience what my client is trying to reach rather than just execute my own style (perhaps I even know how to identify my client's target audience).
10. I know enough about printing and print production to know when my client's request is not feasible to produce. Likewise, I have a handle on digital production and know when my client's request is not technically viable. In both scenarios I can convey to clients how to better meet their objectives.

## BUSINESS SKILLS

You will need to practice salesmanship, bone up on some basic accounting and maintain business procedures—the kinds of things business school graduates know, but illustrators are less prepared for.

To determine if you have the business and management aptitude necessary for going out on your own, see if you agree with the next statements. Again, if you're lacking in any area, you can always work to develop these skills. There are many courses (click or brick) and books on business management and marketing basics.

1. I have good communication skills.
2. I am familiar with business etiquette and procedures when making written and verbal contact.
3. I can set reasonable goals and follow through on them.
4. I am able to get along with just about anybody.
5. I can motivate others to help me with projects I'm involved in.
6. I can sell an idea to a client.
7. I make decisions quickly.
8. I don't procrastinate.
9. I work steadily instead of waiting until a few days before a project deadline.
10. I can see and understand the whole picture. I don't concentrate on one thing, while ignoring other aspects of a situation.
11. I have good organizational abilities. I can handle several projects at once and keep track of progress on each.
12. I can juggle the projects on hand while cultivating new business.
13. I know when to turn down work (and I know my reasons why).
14. I can keep clients informed of the job's status and any glitches as they arise.
15. I can work with disorganized clients and keep a job on track regardless. (This may mean explaining the illustration process to clients in the effort to teach them to be better clients, thus helping them be more time- and cost-efficient.)

## ENTREPRENEURIAL SAVVY

You will also have to develop strong personal skills. Juggling your illustration, design, and production, as well as your finances is one thing, but you will also need to subjectively appraise your individual strengths and weaknesses. Take stock of your grit, determination, and discipline. In order to determine how you stack up, see if you agree with the statements below (and be honest, you know yourself best):

1. I am confident about my abilities.
2. If my work is not appreciated, I can shrug it off and apply myself with confidence (to the assignment at hand, as well as to other projects).
3. I am a self-starter. Nobody has to tell me to get going.
4. I am highly motivated. Nobody has to tell me to keep going.

5. I can keep working on an illustration for as long as I need to complete it on time.
6. I can concentrate on the task at hand. I'm not easily distracted from what needs to be done.
7. I am persistent. Once I know what I want, or make up my mind to do something, almost nothing can stop me.
8. I am in excellent health. I have a lot of stamina and energy.
9. I can put the needs of my work above my own personal needs when required.
10. I can ask for help when I need more information or feel overwhelmed.

## TALLY IT UP

Only you know the outcome of the above evaluations. And as you'll need these abilities to make your enterprise work, you didn't kid yourself, right?

Score the number of yes and no answers and see how they stack up against your potential for success. All the answers raise issues that are important to maintaining a business. If you answered *no* to only one item in each of the above sections, chances are good that you can go it alone without any help. But if you answered *no* to more than three questions or statements (or more than one in any single category), you'll need to cultivate these qualities through thought and study, homework and training.

# THE SHORT LIST

**Peter Arkle's Wee List of Big Things You Must Do**

➡ Skills needed: Be good at listening, speedy, non-precious, calm, polite. "Write nasty emails so that you feel better, then *delete them* and write nicer ones that you actually send," says Arkle, who strongly advises you to think carefully before hitting send.

➡ Important: "The ability to find fun in a pile of things that might not seem so pleasant," Arkle says. "It is a riot to go to a big, important, bamboozling, exhausting meeting and get your head filled with all sorts of facts and thoughts and complications from all sorts of people. Then you come back to them with something that makes them look at the whole job or issue from a new refreshingly simple and fun angle."

# IS THE OPPORTUNITY TO SUCCEED THERE?

One definition of true success is personally recognizing the type of work you want to do and find professionally fulfilling. To me that's the Daily Double. To do this, you need to evaluate a few things: where's your potential market, what's the size of it . . . is there a niche out there that you think you can fill?

And when you scratch that niche, you'll hopefully discover something that you do well and can make a living at, too; you can stick with it through both lean and green times because you truly love your work.

Ahhh, loving your work. For many, this is the holy grail. Are you cranking out low-end schlock for the bucks when what really turns you on is coming up with higher profile, innovative concepts? This ain't too high on the "Keepin' Ya Happy Fa Long" list.

You need to care for your heart's desire as well as your livelihood if you are to thrive over the long haul—you are your business, after all. Look for the kind of clients who are willing to give you projects that will be personally fulfilling as well as the ones who provide "easy" cash.

There are the basic questions: What type of work do you think you will be doing, and whom do you think will buy it? How many clients are out there? Do you have a realistic picture of what you do best and what you can be doing to get business?

To help guide you in this process, ask yourself the following questions:

1. What do you honestly *like* to do? What kind of illustration makes you happy? Are there any types of illustration in which your skills are not up to par?
2. What's your idea of a dream assignment? Any assignments you would do gratis (just to have that type of work or client)?
3. What's your illustration history—what were your biggest triumphs? What were your most successful projects? What were your near-misses? What were your biggest flops?
4. Do you have existing clients you can probably bank on to any extent, clients you can count on in the future?
5. Are there spin-offs from projects you are currently involved in?
6. Who is your competition? Think about your peers and analyze their work. How many other illustrators are out there doing the same thing you want to do for the same kinds of clients?
7. Realistically assess if you're able to provide more effective illustration or better service than your competition. You don't want to spend valuable time where there's little chance of gaining any traction. Be a tough (but objective) critic: Who blows you out of the water? Who is the cream of the crop? Be mindful of what the competition is doing and frankly evaluate yourself.
8. Are you in a position to fill a void the competition is not filling?
9. What's your current reputation? What do clients and vendors believe you have going for you? On the street, what might people hear about you, think of you and your works?

10. What work have clients seen in print; where has your work been viewed? As nebulous as it all may be, determining where you are outstanding in your field may make the difference between getting an assignment and getting a "try again next time, bud."

### WHERE ARE YOUR POTENTIAL CLIENTS?

After you've taken stock of what you want to do and where you stand relative to others doing similar work, you'll have a better idea of where to direct your marketing efforts.

But you also need to ask yourself some more specific questions about your illustration, production, and, yes, design capabilities. What aspects of a job do you do best? Are innovative concepts your forte, or does meeting impossible deadlines offer your strongest potential?

Likewise, if there's a particular area of illustration that you're strongest in, you need to consider what kind of clients are in greatest need of that skill. Then consider related areas to expand into.

What's your illustration style? Is it flamboyant and brash or sly and subtle? Will your work look dated in a few years' time or does it boast a timeless, classic feel? Do you have an eclectic approach, adapting style and technique to accommodate the project at hand? Indeed, the look of your work has everything to do with where your art is best marketed.

## RESEARCH, RESEARCH, AND MORE RESEARCH

I have some homework for you. Explore websites and blogs. Twitter, too. Head to the library and bookstore to study products, portfolios, and places. Attend industry conferences. Leaf through creative annuals and directories. Kibitz with your friends and colleagues. Tool around the mall. Window-shop downtown. Flip through the yellow pages, too.

Look at who's out there doing what jobs, and who is offering those plum assignments to whom. In your estimation: who makes the A-List (and why)?

Take note of any client info provided by your resources, particularly those illustrators whose work you admire and any companies (including their product) you like. Now evaluate—which clients and what assignments are in sync with your standards and particular vision?

## BRAND ME

"It's funny," smiles Kristine Putt, "you can brand all day long for clients, but it might be challenging for you to brand yourself." Putt goes on to explain that, while illustrators certainly focus on interpreting someone's vision (be it a client's or an art director's), there may be a disconnect between illustrating for

art's sake and illustrating for communication. "One eventually learns this," Putt says. "However, the struggle to define *your own* identity goes much deeper than visual aesthetics."

There are many, many illustrators graduating from art school every year. The competition is fierce and growing more so every day—don't labor under the false impression that your "good" illustrations sell themselves; it simply doesn't work that way. As a new freelancer, Putt asks, how do you stand apart from the crowd?

## WALK THE WALK

So to get off on the right foot, Putt will tell you that, sooner than later, you must think like a business owner and *not* an illustrator. If you freelance because you think that ILLUSTRATION (in all caps) is all you'll be doing, you'll be sadly mistaken.

"Take off your illustrator's hat every day, even for just a little while, and put on the business owner hat," Putt says. "When you're a freelancer, you only illustrate a portion of your day. The rest of the time you are a business owner. And that requires switching gears—a lot!"

An established brand can outlive a product's shelf life. A valuable brand represents the promise of quality, credibility, and experience. *Be your brand.* This is what Rigie Fernandez and Ken Bullock refer to when they label your expertise (and service) as a *commodity*. Essentially, your brand is your visual identity; in other words, you. It symbolizes your image—not your imagery, although there's an obvious connection—and your passion. It embodies the best combination of emotion and devotion through smart problem-solving and high standards.

To establish yourself as a stand-up brand in today's stand-out illustration field, Putt says that beyond your incredible illustration you must establish yourself as a *business*: network, socialize, schmooze with real people (*yoiks!*). Get organized: invoice efficiently, chart accounts accurately, do the books right. Be your own IT department . . . the list goes on. She's saying that to maintain the brand, *you* have to maintain the bedrock of your business.

"There are far too many great illustrators who fail as business owners," Putt sighs with a sigh. "Illustration is 'glamourous,' but entrepreneurship is *hard*. Illustration is 'fun,' but being a business owner requires *focus*."

Realistically, being your own boss—and living the brand—will not be for everyone. Going into freelance requires a certain expectation—what Putt labels as the "I knew the job was dangerous when I took it" mindset.

## THE CHASE IS ON

Shaun Tan feels that it's critical to pursue personally challenging work, and says that small jobs can be as significant as high-profile gigs expressly for that reason. Tan estimates his most significant achievements may well be modest works

created in his parents' garage during his early twenties, work that remains unexhibited and unpublished, of no commercial concern or public dimension.

"A good artist," he reflects, "is an eternal student, and even when most confident, never feels like a master. They forever potter in their backyard spaces, exploring their craft with modest integrity. That's how unusual and original work emerges, not by chasing markets or fashionable movements, or wanting to be conventionally successful."

But, as Tan would be among the first to tell you, for a commercial artist, chasing markets is obviously an essential economic pursuit—the necessary parallel play of a creative practice. However, there's no express road map or explicit directions to get where "there" may be, only a multitude of working destinations: adult, young adult and children's publishing; advertising, editorial, and genre; film, film design, plus animation; theater, fine arts, games, and other forms not yet invented. Most visual artists, if flexible, versatile, and open-minded, can cross over borderlines, especially in a digital, multimedia environment.

"All commercial work is collaborative," Tan says, "thus, communication is crucial, even in our [somewhat] introverted profession. You need to be able to talk, write about, and create in a clear and explanatory way. You help others understand your ideas. This applies especially when concepts are not immediately visible; certainly to non-artists and certain folk who are, for all practical purposes, aesthetically blind. Empathy and patience almost always win the day here, even in tough situations."

Tan's body of work tips the iceberg of titanic vision and tremendous accomplishment, yet he modestly advises you to stay open to discussion, revision, and compromise while still maintaining your own artistic integrity. "These are not necessarily incompatible, as so many people often believe," he says. "It is worth noting that clients may be right about things as often as artists are. Most problems and rejections result from creative cross-purposes rather than actual disagreements. It's important to understand each other's philosophies and criteria."

## STEPPING OUT

Grant Snider tells you that to get off on the right foot and remain professionally horizontal, you must explore and experiment. "Try new techniques," he says. "Sure, lock into your method for efficiency, but if you're not dabbling in new media, you may easily slide into a rut—something that creative folks face almost constantly.

"A lot of times it's as simple as stepping away and taking a break," Snider says. "With cartooning, there are both words and pictures involved. When my drawing is not going the way I want it to, I can focus more on the writing (and vice versa). It's a balance of change up and inspiration."

# ON THE BOARD

## (PROFESSIONAL VIEWPOINTS IN 50 WORDS OR LESS)

Articulate well—clearly, passionately: clarity of focus, clarity of vision.

—Bennett Peji

Be aware of the world around you. Pull from the world; absorb that world, visually—this gives you your tools. Tools are important, but you also learn to use what you got! Understand that growth as an illustrator comes with experience more than it does age.

—Rick Antolic

[Your illustration] is neither good nor bad. It's only effective or ineffective.

—Gerald D. Vinci

I encourage aspiring illustrators to invest in their fundamentals. This allows you to grow as your career develops. I personally find joy in drawing, and every illustrator I know enjoys some basic aspect of illustration, be it drawing, painting, or conceptualizing.

—Charlene Chua

You can't have a business without the desire, without the soul. You have to have the heart and the head.

—Kim Youngblood

© The Daily Dot 2015

© Phil Wilson 2016

There is no substitute for experience. Everybody makes mistakes; you can't escape it. Art is a continuous learning process and it never stops.

—Phillip Wilson

New technology, new ways of doing things, will keep you endlessly on your toes. You don't just master things and you're done; you have to continually learn and expand your skills or you will be left in the dust.

—Nadine Gilden

I had a boss who said to me, "Your problem is that you expect everyone to think like you do." She taught me a big lesson in one sentence.

—Kristine Putt

Develop an understandable process that comforts and educates your clients. We are not "different" or "above the rules." Believe me—I speak from experience—some rules are good.

—Ken Bullock

I'm "old school." We just did things. We didn't "think it through" so much. Illustrators these days are more attuned to a process you go through.

—Ben Mahan

The point is to start—you will grow from there.

—Linda Ketelhut

77

# Chapter 5

# Finances

*It's not quantum physics, it's simple organization. It's add and subtract: "I earned this much money doing this; I spent this much money doing that. This much was left over. Oh I see, I need to be doing this."*

—T. Simon Katt

# THE BUSINESS SECTION

In business, as in life, it's problematic to start out underfinanced. You certainly don't want to spend too much money at first blush. You don't want to get over-extended at any time.

We know money doesn't grow on trees, but financial concerns seem to branch out everywhere: "How much money do I seriously need? How much money can I realistically earn? How do I wisely and efficiently manage my assets (personally and professionally)?" How does one weed out the right answers?

We'll be examining these questions, and more, in the pages to come. A word of thanks here: this critical chapter—as well as other keystone business sections in chapters 4 through 9—was written with the gracious consultation and incredibly generous contributions of many penny-wise (and hardly pound-foolish) contributors. But special commendation must go to my earliest of advisors, Larissa Kisielewska.

Ms. Kisielewska is a past president of the NY Chapter of the Graphic Artists Guild (2000–2004) and the NYC Chapter of the National Association of Women Business Owners (2004–2005). She founded Optimum Design & Consulting in 1992, was National Guild Secretary from 2006–2012, and is currently National Guild Vice President.

You can get this good stuff online as a free ebook. Kisielewska also offers this extraordinary wealth of information in webinars and workshops presented through the Graphic Artists Guild, among other venues. (Please note: you can sign up for that copy of Kisielewska's booklet, *How to Start Your Very Own Communication Design Business!*, on the home page of the Graphic Artists Guild website: www. graphicartistsguild.org.) Look for more from Kisielewska in the chapters listed above.

## GET IT DOWN

What's your business plan for the next five years? For the next year? For the next month? For the upcoming week? Mapping out where you want your business to go is just plain smart. Organizing an action strategy to meet that goal—on a daily, monthly, and yearly basis—is only wise.

This written manifesto can be on the back of a business card, or the size of *War and Peace*, but do it. A business plan is the personal, professional, and financial yardstick that gives you a place to start, helps you focus, and fosters growth.

It's rather a straightforward proposition: Understand your objectives, know your mission, state your goals, *take action*; revise accordingly.

## THE BUSINESS PLAN

So…what do you want and why? Kisielewska tells us that the most important reason of all for having a business plan is that it is the first step you can

take down the path defining you as a small-business owner rather than just a freelancer.

"It forces you to think things through," Kisielewska says, "to answer tough questions *at the outset*, which will help you better position yourself in the marketplace." So before you invest any time into creating your corporate identity, a business plan should always come before starting that business.

"This is always necessary," Kisielewska says, "even if you're a one-man (or woman) band." She will point out to you that one may revel in a romantic concept of a utopian art world free of everyday mundane realities, but you simply must have a solid plan for building and managing your business.

## FOR ONE THING

Your business plan should be a must—if only that, should you ever need to acquire outside financing, those actual providers of capital and services will want to know that you have a solid plan for building and managing your business. Potential business partners and advisors too, for that matter, will feel more comfortable coming aboard behind a well-thought-out plan.

There are many tools available to help you write your business plan: books, software, even people you can hire to write it for you. A good resource for sample business plans (and marketing plans) is www.bplans.com. Kisielewska strongly advises you to follow some sort of guide, rather than winging it on your own.

## THE JOY OF SIX

A traditional business plan usually includes six sections:

1. The Executive Summary: This defines who you are, what you do, and why you exist. You should have a succinct *mission statement* defining the purpose of the business. This will be backed up by what's called a *positioning statement* that concisely defines the selling points of your business and why you are unique in your field. Keep this section to one page as a snapshot of your business.

2. Company Strategy: This section covers your qualifications and the credentials of your business associates and advisors: your accountant, lawyer, banker, and insurance agent. Kisielewska emphasizes that you indeed need these people right from the start. "Even if *you* don't think so," she states unequivocally.

   You should meet with this posse of support about every six months to pick their brains. "Don't hesitate to discuss your problems and challenges," Kisielewska says. "You'll get invaluable feedback and suggestions from them. Treat them to a

dinner meeting in exchange for their time. Don't be afraid to ask questions—that's why they're there. A good mentor early can prevent you from significant heartache."

3. Product/Service: "What are you going to illustrate, and who will you be selling it to?" asks Kisielewska. "Be specific. Know what you are good at," she says. "Although you're probably capable of doing 'all of the above,' there are surely some areas in which you truly excel. Identify them. Focus. Educate yourself on your markets. Learn your industry."

This shouldn't be a stretch for *you*, right? You understand how bright, creative ideas (and diversifying income sources) could generate revenue streams for an enterprising go-getter like yourself.

4. The Competition: Analyze your market and your competition. Because—guess what—there are a slew of other people out there doing what you do. Find out *how many* and *who* they are. Kisielewska advises that you do a scouting report. This is no cloak-and-dagger *Mission Impossible* scenario. However, as Kisielewska points out, you may want to get your James Bond on just a tad.

To begin, you need to check out your competitor's marketing program; it's easy to do in this age of the Internet and social media. We should point out that you're not doing this to steal state secrets or sensitive, classified documents, 007. Kisielewska is not advocating you lift proprietary information (mimic style, copy technique, loot concepts, or otherwise).

You won't suffer double secret probation, nor should you be racked with guilt when you do your field work. If you are uncomfortable taking the covert route—by all means, *don't*. Contact and offer full disclosure; you certainly can simply ask (for any and all info) up front.

Either way, you only want to use this information to figure out *how you can do better*. Then, on your business plan, restate your unique selling proposition in more detail—what makes you different from your competition?

5. Sales and Promotion: Create a marketing plan, your marketing strategy, in detail. Include specific implementation steps, target goals, a timetable, and a budget. There are many books, websites, coaches, and seminars on marketing, including events offered by the good folks at the Graphic Artists Guild and the Society of Illustrators.

"Start thinking about how you're going to get business and how long it might take you," Kisielewska says. "At least 10 percent of your time should be spent marketing.

"Remember that each new contact is a marketing opportunity," she says. "It's important to realize that word of mouth alone cannot sustain your business in the early years. Business is not going to magically fall into your lap. You are going to have to actually market to make things happen!"

6. **Financial Considerations:** If you are looking for outside financing, Kisielewska cites numerous documents you must submit along with the narrative of your business plan: a profit and loss statement (P&L), cash flow projections, tax returns from prior years, an accounts payable list (AP), an accounts receivable list (AR), a list of assets, and a monthly budget.

Heavy volumes have been written on this stuff alone, and it is always best to work with your accountant for sure, so we just touched on the basics here.

## THE PRACTICAL PLAN

Lea Woodward is a business strategist. She's a small-business coach (www.leawoodward.com) who helps her clients bring the big picture of running a creative enterprise into sharp focus, using her new signature system, Values-Based Business Planning.

Woodward will tell you that a practical business plan is about taking small daily steps of practical progress toward a specified outcome. "You walk your talk," she says, "because you can't give what you don't have."

Woodward says that an effective business plan is built on focused intention, and bolstered by knowledge and skills. She suggests a three-point attack:

1. *Assess* who and where you are in the scheme of things (and identify what's missing).
2. *Strategize and plan.* Here, you spitball what you want and decide where you're going.
3. *Implement.* You act. A positive mindset teamed with purposeful behaviors and productive tools work hand in hand to accomplish your goals.

Woodward also says that a sound business plan will reflect a core *personal* practice. She emphasizes three central values to live by:

- ▸ The *freedom* to choose what's right.
- ▸ The *integrity* to do the right thing, even when no one is looking.
- ▸ *Excellence.* "This is a recovering perfectionist's next best thing to perfection," she says with a smile.

### PUSH/PULL

"If you want to move forward," Woodward says, "it's infinitely easier to pull than push." Woodward recommends establishing specific milestones to track your progress. Hit your milestones to evaluate if you've achieved your goals.

"So, what is your mission?" she asks. "Why are you doing this? Where are you ultimately headed? What intentional goals help you to achieve that mission?"

Your choices—how you choose to reach those goals—must facilitate your achievements (of course). But not so fast. "Obvious" doesn't necessarily translate to "easy." Some real questions bubble right up. "How do you achieve each goal?" Woodward asks. "How do you measure success? When will you know you're on track?"

Woodward suggests recording your strategy in the format of an efficient one-page business plan, with your own core values (or those of your business) baked right in.

"First determine your objective," she says. "Where are you heading? What's your *why*? Keep it broad—give yourself options!

"Now think about intentions and goals. Translate your mission into specific goals. Keep them high level. Goals can change periodically. Ultimately, the sum of all your goals should help you reach your mission."

Now, according to Woodward, you have options and strategies. What choices will you make to achieve each goal? Outline all the available alternatives, then choose which ones to target. "These can change," she says, "should a chosen strategy not work for you. The sum of each group of strategies should help you reach each goal.

"Remember, your ideal business plan must feel right for *you*," says Woodward. "Review it every month. Yes, really! This is a fluid plan—it can and should change."

## FITS THE BILL

Illustrator (and all-around smart business guy) Don Arday knows that there's a lot of information available on business planning, but as he says, "We know all too well that the illustration business is different than most other businesses. It is neither a service business nor a business exclusively providing a product—it is both."

So, as Arday points out, business models that only target either services or products, which are most of them, are not a good fit for an illustration business.

### STANDARD ISSUE

As we mention in this chapter, the standard business plan is what's called the start-up plan, and defines the steps for a new business. "It covers standard topics including the company, product or service, market, forecasts, strategy, implementation milestones, management team, and financial analysis," says Arday. "It will include a financial analysis: projected sales, profit and loss, balance sheet cash flow, and probably a few other tables. The plan starts with an executive summary and ends with appendices showing monthly projections for the first year."

## DREAM ON

But Arday recommends what is called a strategic plan, what might be labeled a "hopes and dreams" plan, focusing more on big-picture priorities to provide a framework for making smaller decisions. "For the sole-proprietor illustrator," says Arday, "it is a personal plan that provides a definition of the business and a description of future aspirations. Detailed cost factors, equipment needs, and space requirements are not the focal point of a strategic plan."

Here, Arday asks you exactly the right question: Do you need a business plan? "If you intend to borrow money for your business, in addition to demonstrating evidence of financial stability, you will need a business plan," Arday says. "But, depending on how you look at it, many illustrators do not need to borrow money to start a business. If you don't need to borrow money, a business plan can be an informal one."

At this point, Arday qualifies that whole "depending on how you look at it" statement. "Many illustrators have already taken out a loan for the purpose of creating an illustration business: a student loan for their college education," Arday says. "The debit created by that loan may just well factor into your illustration business operating costs for many years."

I told you he was a smart guy.

## IT LEADS TO THIS

Arday states that a business plan can determine how you will make decisions and conduct your studio. Even an informal business plan can greatly improve the chances that your illustration business will succeed, so it is wise to have one in place.

"Your business plan should be written for non-artists," says Arday. "And as you are an artist, your program can hinge on the strategic plan, a start-up plan, or a combination of the two. It's pure cause and affect: the strategic plan objective provides guidance. Guidance provides direction. Direction leads to a goal. The start-up plan objective identifies needs. Needs lead to resources. Resources support work."

## BREAK IT DOWN

Arday next outlines the basics of the illustration business plan:

1. *Overview.* "The is a brief statement describing your business including location, market segment, et cetera," Arday says.
2. *Objectives.* "A statement providing both short-term objectives (three years or less), and long-term objectives (five years or more)," he says.
3. *Mission Statement.* "A mission statement establishes a business goal and how you intend to achieve this," Arday continues.

4. *Key Advantages.* "A statement or list of the main areas of specialization or expertise you have to offer," says Arday. "What makes your business different from the competition?"

5. *Company Synopsis.* "This identifies a prescribed business structure for purposes of legal and tax requirements and advantages," says Arday. "The types of companies include: a sole-proprietorship (single owner-ship), also called a sole-trader; the partnership (representing a shared ownership); what's called a limited liability company (LLC; and actually another type of partnership); and finally, a corporation.

"Each type has advantages and disadvantages," he says, "and should be thoroughly researched as to which will work best for your business."

6. *Inventory* (assets and liabilities). "*Assets* are things like furniture, equipment, materials, computer hardware," Arday clarifies, "and software should all be included. Inventory items should all be listed as assets and given a value for a loan application if appropriate. *Liabilities*—for instance: computer loans, rent, utilities—should also be listed, and assigned values for a loan application."

7. *Start-Up Requirements.* "A list of all business start-up needs with a description and the expenditures relating to them," says Arday. "List all aspects needed for your illustration business. This includes:
   - office space (including square footage) and arrangement
   - Internet, and utilities needs
   - include equipment such as computers, software, hard drives, printers, scanners, modems, telephones, and copiers
   - list furnishing needs, for instance: desks, file cabinets, chairs, easels, taborets, tables, and bookshelves
   - expendable materials should be listed and costs estimated. This would include computer, art, and office supplies.

   "Detail monetary requirements such as rent and utility fees," Arday says, "don't forget salaries, insurance premiums, and tax provisions, for example, self-employment social security contributions, et cetera."

8. *Support Services.* "List any support services your business relies on," says Arday. "Common support services for illustrators include digital output bureaus, photographers, models, delivery services, web hosting providers, and more."

9. *Pricing Structure.* "This is an explanation of product and services pricing including the method used," Arday says. "Are charges based on a lump-sum payment, or an hourly-wage formula, maybe both? There may be a lump sum charge for the illustration/creative itself, and hourly-wage fees for supplemental services such as meeting time, and noncreative production fees."

10. *Marketing Strategy*. "A statement outlining the plan for marketing your illustration business including media and means," says Arday. "Marketing includes all forms of promotion, both purchased and gratis. Purchased refers to those forms of promotion that you have to pay for, while gratis refers to those where the promotion has no cost."

*Purchased Promotion* is advertising in any form: print or online; direct mail; identification and signage; a web presence that might include a website, portfolio hosting sites, a blog (paid), and a Facebook subscription (paid). "Some less thought of purchased promotions include paid memberships in organizations; entry fees to competitions; and perhaps most importantly, portfolio fabrication and maintenance," Arday says.

Often overlooked, *Gratis Promotion* encompasses plans for encouraging client referrals, leveraging networking relationships, and capitalizing on reputation/acknowledgments. "List all of this," Arday says. "Don't forget that the Internet provides many opportunities for gratis promotion—a free Facebook page, Google+ page, Twitter account, LinkedIn page, Pinterest account, free blog space, membership in online groups, and free portfolio sites such as DeviantArt.

"More and more, new free promotional opportunities are constantly coming available. This continuous change makes gratis promotion somewhat less defined than purchased promotion."

11. *Targets*. "Targets equate to your intended customer base," says Arday. "We're talking specialized markets like publishing or a segment of a market like nature publications; a specific category of work like children's book illustration; a defined location like the New York city area; a list of specifically sought after clients."

12. *Finances*. Says Arday, "An accurate picture of your finances may include: A *Break-even Estimation* that identifies the actual operating costs of a business and the point where earnings represent actual profit and a *Pro Forma Estimation* for cash flow plus profit and loss is based on financial assumption or prediction. It could reflect a past or future financial development. For instance, an expected tax break that will occur at reporting time."

## COUNT ON ME

Take a beat. I'm going to emphatically advocate that, while you keep this book right at hand, you put this text down for a spell and seek an accountant's or financial planner's advice. If you're just starting out, or are in your early years of doing business, you should hire (or at the least, consult) an accountant. A good

accountant can be the lynchpin of your business. As Tom Nicholson says: "Your accountant is probably the centerpiece of it all."

An accountant can set up your bookkeeping system correctly, and be your financial advisor and tax consultant/preparer. "An illustrator can do his own books," says Nicholson, "but you don't want to deal with tax situations on your own. For that reason alone, an accountant is a mainstay of your operation."

Not only that, but an accountant can refer you to most of the other professionals on your team. Need a lawyer? An accountant can make recommendations and referrals. Pesky city or national government regulations prove too sticky to navigate? Your accountant steers you safely in the right direction.

## OL' RELIABLE

Find a person you can rely on year-round—don't be tempted to hire a moonlighter around tax time. You'll need to find someone who is well qualified and whom you can trust, because ultimately *you* will be responsible for this individual's mistakes. You may think you will save some money by going to "Taxes 'R Us" for your tax return, but it may cost you much more in IRS penalties when you find out what Ronald MacCountant didn't understand about tax law.

Whether you are a new businessperson or a veteran, I'd go to a public accountant, an enrolled agent, or a CPA specializing in accounting and tax preparation for graphics professionals and/or small businesses. You want to work with an arts-savvy accountant or financial planner.

Leaf through the yellow pages. Check in with family and friends. Google "accountants" in your location, of course. Consult with your local arts council or BBB. Ask your Graphic Artists Guild chapter for a referral. Research. Just ask. Start interviewing.

## DIY?

So you bought a green eyeshade and you're going to do your own tax return. Here are four well-chosen words: I'd advise against it. I can even make it simpler: *don't*!

Personal tax preparation is elaborate enough for anybody, any given April 15th. And if you're in a start-up situation, you could make some serious mistakes; there may be some advantages, requirements of which you might not be aware.

Besides, you're an illustrator, not an accountant. Maybe you can do the job, but you don't have the knowledge, experience, and expertise to do the job absolutely *right* (this is akin to having some CPA—who boasts about being a great Sunday painter—handle an important illustration gig for you). Oh, yes—and how much creative work will you accomplish away from the board, and what's your time worth?

So, how do you choose an accountant? You'll want to find an accountant or firm with small-business experience. Obviously, if you can, find someone who's familiar with illustrators and designers. It's best to get referrals from others in your situation who have a comparable income to your own.

There are four basic levels of experience that you can use in gauging the expertise of anyone you're interested in hiring: accountant, enrolled agent, public accountant, and certified public accountant (the highest degree of professional accreditation, by the way). Consider at least three to four possible candidates. Talk to both accounting firms and sole practitioners. When you interview accountants, evaluate each by considering your mutual rapport, their communication skills, knowledge, and expertise, plus, of course, fees.

## EVERYTHING AT A PRICE

Let's begin by making this general statement: You have a pool of potential clients with a certain amount of business to give you. Think about the demands of these customers, and how you can fulfill those needs. You're trying to get an overall, realistic picture of (a) how much, and (b) how much service you can offer.

Based on the light soul searching you did earlier in this book, you should now have some idea of what work you could be doing, which skills you should be marketing, and where your services can best be applied. You'll need to have a practical estimate of how much business you can expect, and where it will come from.

Start by thinking how you can build on any existing business. Are there other potential patrons out there for whom you could be doing similar illustration? Do you stand a decent chance of building on your present clientele? Do some research (at the library and online). If this is the case, make a list.

At a cost of, let's say, $1,500 per magazine illustration (call it an average charge and realize this is simple conjecture for the sake of argument; your mileage may vary), what does this come to annually? Figure from there how much of this business will spin off into collateral work for each of those clients and attach a monetary value to all of it.

Do the same projections for any other type of illustration you think you will be doing. Guesstimate how much business in this area you can theoretically rope in, as well as what you are *capable* of doing in a year. Consider individual assignments, as well as annual projection, and after you have made a list and totaled it, divide this figure by twelve to get an idea of what your monthly gross

profit could be. Shoot high or low, but if I'm speculating for kicks and giggles (or practice), the game's much more fun if I'm aiming for the big time.

## MAKE THE ENDS MEET

But soon this exercise must morph into a serious effort to educate yourself and hash out your master plan of global domination (I'm only half-joking here). In fact, after the kicks and giggles, you will need to realistically compare costs and income to see if your business plan is viable. Remember that a lowball or highball scheme built around inaccuracies won't get you far in actual practice, so make sure your eventual projections reflect real-world facts and figures.

Bone-up! Run, don't walk, to your nearest library or bookstore and grab a copy of the Graphic Artists Guild *Handbook of Pricing and Ethical Guidelines*. Research the numbers by networking with both buyers and sellers of illustration. Compare notes with your professional friends; brainstorm with family. Google it. Cruise through the cornucopia of illustration blogs and websites online. Hit that library and bookstore again. Obtain and study any and all pertinent texts and magazines.

You're collecting data because the next step is to create a hypothetical budget. A budget is *important*. It's absolutely vital that you have a handle on expenses and income—and it's best to have it on paper. Otherwise, you'll have no idea how you're doing financially (and why) or where your money is going.

### IT HAPPENS EVERY MONTH

Get a handle on just what it will cost you to be in business by figuring out how much money you will need. Said simply: just look at your annual costs and divide by twelve (or four, of course, for quarterly expenses) to get the average monthly amount due.

Let's elaborate. First, what are your start-up expenses? Start with one-time expenses involved in beginning a business. This means: any applicable licenses and permits; maybe decorating and remodeling; possibly exterior signage; outfitting or remodeling the space (which could include drywall and painting; electrical wiring; cable, phone, and Internet hookup); plumbing; new or refurbishing (including installation of) interior fixtures; certainly utility, cable and phone deposits; beginning advertising and promotion; business cards and letterhead.

Add to these your fixed expenses—rent, ongoing utilities; loan payments (including school and car payments); maybe parking; and your salary (you read that right, more on this in a moment).

Now mix in variable operating expenses (as in credit card debt and the phone bill) plus so-called hidden costs (life and liability insurance policies) and any occasional legal and accounting expenses.

Include any purchases made occasionally. For instance, a container of widgets lasts about twelve months . . . take the cost of the box and divide it by twelve to come up with the monthly cost for this item. Don't forget ongoing costs like advertising and promotion.

Don't space out on operating cash. Do this with all your service charges, equipment and supply costs, and you should have a pretty good idea of what your monthly expenses will be.

A couple of notes to wrap up: If you wear many hats on an assignment and farm these services out, don't declare copywriting, photography, printing, and outside design services in your monthly tally. These expenses should be billed to the client for each job they are purchased for. Saying that, if such services are used for your personal promotion, such expenses are indeed operating costs and should be factored into the equation.

## PROJECTIONS

To better understand the impact of your financial projections, Kisielewska suggests you create a spreadsheet that lists costs down the left-hand side, and the next three years across the top. Fill out your Year One column with the *annual* version of the monthly budget you just created (in other words, multiply monthly figures for each expense by 12).

Now copy and paste this info for your Year Two. Next, examine your costs individually and estimate which ones may increase in the second year of your business. "Will you need to spend more on salary in your second year?" asks Kisielewska. "If so, then alter that line item in your spreadsheet and annotate it with a footnote of explanation. Do you anticipate increasing marketing in Year Two? Assign a higher dollar amount, and then explain why in a footnote."

Do this with each expense, collecting footnotes that are called your *assumptions*; repeating the process with Year Two to obtain projections for Year Three (and generally, three years of projections are considered standard).

What you are doing here is estimating your growth, and assigning a rate of growth—let's say 10 percent, for example—to your income projections. "Hopefully, after plugging in all of the numbers you will end up with more revenue than expenses in Year Two," says Kisielewska. "But if not, just go back and readjust your assumptions and/or your projected rate of growth until you do. Just make sure your anticipated growth rate is believable!"

## IN IT FOR THE MONEY

*Take a salary for yourself.* "I can't overemphasize the importance of taking a regular salary," says Kisielewska. "Don't just dip into your business account whenever you need to pay your personal bills; you'll never have a clear handle on the profitability of your business if you don't include your salary. Even pay yourself during the lean months! Write that check anyway—just put it in a drawer until you have the funds to deposit it."

## A RECIPE FOR SUCCESS

Much of your time will be devoted to the more "mundane" (but critically important, noncreative) activities like marketing and paying bills, invoicing, correspondence, and travel. How many hours a day are you actually at the drawing board?

You may have to work more hours than you'd like simply to get everything done. "Unless you are lucky," says Kisielewska, "you will probably have to make choices between time and money, [at least] initially."

### AN EVEN BREAK

Here's a formula you can use to calculate your break-even point. It's simple math; even for me, and I'm quite the pinhead mathematician.

Let's assume that your expenses add up to $2,000 per month. You know that every week you have to bring in $500 worth of business to just *break even* (or $2,000 every month). The break-even point is what you have to bring in just for your business to *survive*. If you want to end up with a $12,000 *profit* at the end of the year, figure on billing $3,000 every month or $750 every week.

Of course, all of this figuring is done on average. It's impractical to assume that you will bill $750 on a regular basis. More than likely, you may not bill a cent during some weeks, and then bill a number of projects within a given week to make up for the previous week's slack. This is why it makes more sense to figure out what your income will be on an annual basis, then divide this figure by 12 to balance against your monthly expenses.

### CHEAT SHEET

Although pricing by the hour is a bit of a trap, there is a quick, down and dirty formula to figure out what you want to or could earn in a year.

- ➡ State an hourly wage: say $40.00 an hour.
- ➡ Times that by 2 and tack a thousand on the end of that number.
- ➡ $40.00 × 2 = $80,000 a year.

- ◨ Said another way: $40.00 an hour times a 40-hour week = $1600.00.
- ◨ $1600.00 × 50 weeks a year (figuring you take off for 2 weeks in the summer) = $80,000.

Boom!

Pop Quiz: how many assignments at, oh, say, $1,000.00 a pop will you need to do to earn $80,000 in fees?

## GET THE MONEY YOU NEED

With your business plan figured out, proper funding may loom large. Even if you must borrow the money from your granny, have these operating expenses in the bank. Says Kisielewska, "Drumming up new business is hard enough without also needing to worry about keeping the lights on."

So you want to get a loan, eh? It may sound crazy, but as Kisielewska points out, the best time to actually seek money is when you *have* money.

Most loans need to be collateralized—you provide something as collateral: existing assets, like CDs, pension plans; gulp, your home—on a one-to-one ratio. If you go for a $25,000 loan, you'll need to have $25,000 worth of collateral to secure it with. There are always exceptions, such as an SBA loan (more on that later), but primarily we'll investigate a traditional bank loan.

## A LOAN AGAINST THE WORLD

If you're like most people considering possible cash sources, you thought first about borrowing from the bank. Yes, a bank loan is certainly a possibility, but the chances, at best, may be slim. To explain why, we'll detail the process of getting a bank loan, exploring what's involved in proving the viability of your business and establishing your credit and credibility (convincing the bank to loan you money through profit and loss statements or your net worth as you start up the business). We'll look at some other possibilities for obtaining capital, too.

### SMALL FRIES

First off, you'll probably have better luck pursuing a loan from a small bank. And let's be frank, up front, right now. When you ask for a loan from any bank of any size, the first question this institution may ask you is, "Why did you quit your full-time job?" Sit down—here are some other facts of life when it comes to banks and loan acquisition.

Banks look upon a freelancer as a rather unstable commodity, and they are well aware that new businesses frequently fail. Lenders are hesitant—especially in today's economy—to loan any money to a service business because, frankly, there's nothing they can touch should the business go belly-up. You won't be able to use your new studio as collateral for that same reason.

If it's a nonsecured loan (meaning there's no property or holdings to recover in case you default) a bank will be unwilling to "give" you money unless you can bring other assets to the table: a car; *gulp*—your house (as in a second home mortgage); a working spouse (as cosigner); the birthright to your next-born child (only kidding, I think).

If you *can* get a bank loan, you will have to *personally* guarantee it. You may also face sky-high interest rates and/or unfavorable terms.

What all this means is that your chances of obtaining a loan as a freelancer, or as a new, small, independent business owner, drop automatically. But don't totally eliminate the possibility of obtaining a bank loan at some point in the future, after you're more established.

## THE FIVE CS OF CREDIT

When scrutinizing your loan application, Banker Drysdale reviews the following:

1. *Character*: Who are you, are you reliable, and do you pay your bills on time? Do you know what you're talking about when it comes to your business (as in, can you speak intelligently about your business plan?) And you did your business plan before you strolled into the bank, right? "The best way to make this work for you," says Kisielewska, "is to get to know a decision-maker in the application approval process who will go to bat for you. Develop a relationship with a loan officer and build a collaborative process. If the person you are dealing with doesn't believe in you, find someone else who does."

2. *Cash Flow*: Lenders look at historical and projected cash flow to make sure you will have enough money to keep the business afloat and still make your loan payments.

3. *Collateral*: If the business doesn't offer sufficient collateral, the bank will look to personal assets (*gulp*, your home).

4. *Capitalization*: The basic resources of the business, including owner's equity and fixed assets.

5. *Conditions*: Outside factors such as government regulations, industry trends, and economic predictions. Kisielewska speaks from experience here when she pushes this basic mantra: "Know your industry!"

### HOT POTATO

There are certain criteria a lender will use to determine if you're a good risk. Let's say you have one golden minute to state your case. What would a lender want to know in sixty seconds? She'll ask five basic (but oh, so big) questions. If this sounds suspiciously like our five Cs above, it should; we're still riffing off of that:

1. What is the service or product you're trying to sell?
2. What's your experience and track record?

3. Who are you and what's your credit history?

4. What is your ability to repay the loan?

5. What is my security or collateral for the loan?

The first two questions are the icebreakers. But questions 3, 4, and 5 (representing character, capacity—or capitalization—and collateral) are the nutcrackers, what a loan officer dreams about late, late at night. If you have a checkered past with a dubious credit history, that's bad character. If you don't look like you have a good way to repay the debt, that's poor capacity. If you can't bring enough security to cover it, that's inadequate collateral. You're not going to get the loan if you rate poorly in these categories—it's that simple.

## TAKE SOME CREDIT

"The most important thing I tell my new business clients," says accountant Julie Buschur, "is to protect their credit rating at all cost, it will always be their most important asset."

You might want to keep tabs on your credit rating by sending for a credit report from agencies such as Equifax, Experian (the former TRW), and TransUnion. You can find these services online. Even if you have a perfect credit record, sometimes incorrect information can end up in your credit file, so you may want to get a credit report before applying for a loan to ensure that you won't be turned down. Refusals become part of your credit history and several refusals will look bad in your credit report. If you are ever turned down for a loan, make sure you get the name of the credit bureau your lender used. The lender is required by law to make this information available to you, and the credit company is legally obligated to tell you over the phone, free-of-charge, what is in your credit report.

While we're at it, we should discuss Dun & Bradstreet (D&B), too. Dun & Bradstreet (www.dnb.com) is the Experian/Equifax of the business world. These guys establish a credit report on your business, *regardless of whether or not you seek them out*, so as Kisielewska advises you, "You might as well contact them and make sure that they're reporting accurate information about your company to the outside world."

When you open up a credit report with them, D&B assigns you a unique DUNS tracking number, after which they establish your credit report and assign you a credit ranking. By the way, the DUNS number and D&B credit ranking can also be requested when applying for credit at banks or with larger vendors.

And finally, do you know what an Employer Identification Number (EIN) is? Commonly referred to as a Federal Tax Identification Number, this is a nine-digit number that the IRS assigns to business entities. It is your business's social security number, and is required on all legal, tax-related, and financial paperwork. "Getting an EIN takes about

five minutes and is free," Kisielewska educates, "so there is absolutely no reason to use your own social security number for your business—especially in these days of identity theft when you'd rather not have that number on every form you need to fill out."

"EINs can also be obtained immediately and still for free at www.irs.gov as well," Buschur chimes in. She's correct. While the Internet EIN application is a customer fave, you can also obtain your free EIN by fax, through the mail, and over the phone, toll free. (Call the Business & Specialty Tax Line at 1-800-829-4933 for immediate, if not down-right instantaneous, service.) Remember that it is still important to get advice from a professional here though, as you want to make sure you answer the questions correctly.

## BEYOND THE BANK: OTHER LOAN OPTIONS

We can conservatively estimate that it's going to take six to twelve months (or more) of working capital for a start-up business to survive. This is without spending a dollar generated by that business (and don't forget—you'll need living expenses, too).

Not to be redundant, but what are those sources of funds? We discussed the bank as the likely place to start (and developing a relationship with a banker) as you start growing your studio. But we also cautioned that if you're fresh off the bus with no experience, savings, or equity, your chances are marginal. Here's our little top ten list of alternatives:

1. Personal reserves. You could tap into or borrow against your savings; sell off certain assets (stocks, bonds, your other Maserati); take out a home equity loan; or borrow against your life insurance policy.
2. Borrow money from family and friends. Remember: this is still a business loan, to be repaid in a timely manner. Writing up a formal document is a prudent plan here.
3. Credit unions.
4. Get a studio partner and pool resources. Some folks swear by their partners; some swear at them (we'll discuss partners later in this chapter).
5. How about a grant? In my experience (if a grant is a possibility), work with your local arts council as your fiscal agent (they'll take a small percentage, of course).
6. Kisielewska also suggests you put your outstanding invoices from regular clients to work for you. "Pursue factoring," she proposes, "selling your accounts receivable for immediate cash less a percentage fee—for instance, with a firm such as Prestige Capital (www.prestigecapital.com)."
7. A Small Business Administration loan—many banks offer loans backed by the SBA, and if you qualify, this might be just the ticket. Write for

official SBA guidelines or locate a bank that does this type of loan. In addition to backing loans, the SBA provides a wealth of business start-up information on its website: www.sba.gov.

8. Obtain a line of credit—set up specifically to help if and when you need it. "You only have to pay interest on the portion that you use," says Kisielewska. "And if you can swing it, this arrangement is advantageous when dealing with immediate and unpredictable expenses. In addition, a line of credit remains interest-free when you're not dipping into it."

9. Commercial finance or credit companies—your junk mail is already seeded with mailers from such places. But be careful. If you want or need the money badly enough, go ahead, but go in with your eyes open.

10. Credit cards. Literally, a last resort, if there ever was one; but being thorough, you should at least examine this tempting option, square and fair. In a nutshell, this type of financing will be convenient, but exceedingly inadvisable because of extremely high interest rates and invariably ball-busting fine print. If you must, think of your credit cards for short-term financing only. Note: you can build a credit history with credit cards, but be aware that if you ever obtain a bad rating, this can mean big trouble for establishing credit with vendors or when looking for a loan.

## DON'T GIVE UP

At this juncture, we must vocalize a sober, but necessary confirmation. The road to landing a loan is rough, even for those who have been around the business block a few times. With a start-up, it just might be an impossible dream.

If you're still employed and want to begin freelancing, you might apply for a loan while you still have a job, and start your business as a moonlighter. A bank may look at your day job as the capacity to repay a loan. Freelance on the side and grow your business as you simultaneously grow your bank account. Eventually use this reliability, experience, track record, and equity to show a bank you're a good risk.

Although a loan may be out of reach *initially*, look ahead. It bears repeating, form a relationship with your bank as you shape your business and career. While a bank loan might be hard to get at first, it may be a different story once you've established credit, built a good reputation, and a solid business.

Accountant Grant Perks asks us to consider these old axioms: Banks will lend you money when you need it least; borrow before you need it; banks like to loan money to people that don't actually need it (to avoid undue risk). And remember these last words from accountant Gary Teach: "Once you line your ducks in a row, and *if* you succeed in collaring the loan, make sure you obtain the

right amount of money the first time. We've established that getting a loan is no picnic, but going *back* to the well will be hard labor indeed."

### Know the Score

Sponsored by the SBA, SCORE stands for the Service Corps of Retired Executives. It's a volunteer organization of men and women who counsel small businesses at start-up and offer business education programs. It can be a great clearinghouse of information from local professionals. As these folks have been there, they know and can help a small business through the rough spots too. And guess what—their services are free. There are SCORE offices throughout the country, and you can find the one nearest you at www.score.org.

Kisielewska points us in the direction of your local Small Business Development Centers (SBDC). Like SCORE, and also funded by the SBA, a Small Business Development Center will offer free managerial and technical assistance to small businesses. "Located primarily within college campuses," says Kisielewska, "SBDCs combine MBA-qualified consult-ants with a wealth of governmental programs and services. SBDCs are particularly adept at helping clients seek out and apply for nontraditional funding options (meaning that you need access to capital but don't qual-ify for traditional bank loans). Check them out at www.sba.gov/content/small-business-development-centers-sbdcs."

## ESTABLISHING CREDIT WITH VENDORS

You will want to establish credit with your suppliers (a.k.a. vendors). The best way to do this is simple, short, and sweet: *pay up and pay on time*. Develop rapport and a great track record. Keep those bills paid and pay them quickly.

If you're trying to get credit with such providers, many vendors will ask you to fill out a credit form. This form asks where you do your banking and usually requires references (two or three vendors you've used in the past). Once they've checked your references—and you check out—they will extend credit (another great reason to pay your bills on time).

## MEANINGFUL RELATIONSHIPS

To wrap it up, I'm going to wield an old saw that may be long in the tooth, but is appropriately rather long in the truth, too: *it's all in who you know.* Yes, you will hear me (or others) say elsewhere in this book that the truly killer

combination is who you know *and* what you know. And I'm not doing a 180 on that. But in this instance (for financial and legal purposes) as Kisielewska wisely puts it, "Carefully set up your business relationships at the outset, and you will be rewarded by years of good advice down the road." So, who to contact? Call your:

- *Accountant.* Invaluable for recommending legal ways to distribute your income to lighten your tax load, and in many ways, as Kisielewska says, "The single most important business relationship you will have. Find one who doesn't charge you to call with questions between visits," she says, "so you are free to use their expertise whenever needed."

  Consult the Professional Association of Small Business Accountants (www.smallbizaccountants.com). This organization can provide a wealth of resources, from their small-business toolkit to recommending a local accountant from their database. Interview several candidates and ask copious questions; request (and call these) referrals, just as if you were hiring an employee.

- *Lawyer.* Don't wait until you're "in trouble." Securing an attorney's learned and wise counsel before you structure your business decisions can go a long way toward business security. Look for a lawyer specializing in small-business law.

  The Graphic Artists Guild has a lawyer referral resource for members. Another resource is the American Bar Association (www. abanet.org). Legal Shield (www.legalshield.com) and Legal Zoom (www.legalzoom.com) are accessible, lower-cost alternatives. A great source of legal self-help can be found at Wise Counsel Press (www.wisecounselpress.com).

- *Banker.* Perhaps not so critical at the outset, a good relationship with your banker is akin to preventive medicine (or insurance for your financial future).

- *Insurance agent.* "The right broker can help you negotiate the arcane world of insurance," says Kisielewska. "You may be well aware of the need for life and health insurance, but do you know the difference between property and casualty insurance? It is easy to make incorrect assumptions about which types of business insurance are required versus suggested. A broker can advise on what types of insurance are needed by your small business, and can also help find you the best coverage for your budget."

## RAISE THE BAR: FINDING A LAWYER

How does one find a lawyer? This is not rocket science—finding a rocket scientist is for another book—and it's pretty much common sense or, at least, easy research and legwork. Perhaps the best way—if not the predominant method—is to simply ask family, friends, and work colleagues (including your boss) if they know of, have worked with, or have been represented by a lawyer. It's not such a long shot that someone in your circle knows of an attorney who can handle your situation. But even if the recommended lawyer does not necessarily have the chops or savvy required, I'd still take the contact info, regardless. Lawyers know other lawyers. Chances are good that your pal Norm's brother Sam's legal eagle will know someone who does.

There are legal directories you can find at local public libraries. Legal referral services and legal information helplines abound—online and via the telephone.

Other reasonable (potential) sources of information? In no particular pecking order: your kid's teacher or teacher's union rep; charitable organizations you've donated to; folks at your church or synagogue (or officiants and other leaders of religious affiliations); civic groups and community organizations; your local or state chamber of commerce; your local arts council. How about your banker, doctor, insurance agent, or accountant?

# ON THE BOARD

(PROFESSIONAL VIEWPOINTS IN 50 WORDS OR LESS)

I liked the idea of being paid for what I did. The economics fascinated me.

—Kim Youngblood

Security equals how far your savings will stretch.

—Julia Minamata

Financing your business is even more important than your logo.

—Larissa Kisielewska

When I started out I assumed having other income was a necessary compromise, but the right work can be stimulating and a good balance to the peculiarities of free-lance illustration.

—Anna Steinberg

Make peace with the fact that, while you're trying to do something interesting, or different, or challenging, you're doing this stuff for money. Understand this, and it won't be a smack in the face with a dead fish when you get out there; you won't be disappointed or horrified.

—Dan Yaccarino

I very consciously set certain business goals for myself, the first of which was simply to survive for one year and still be on my feet, independent and serving clients.

—Tom Nicholson

© Ken Orvidas 2016

© Bryan Ballinger 2016

Starting out, my goal was to do the best
work I could, no matter what I was charging.

—Rick Tharp (deceased)

Goals and success are tightly entwined.
Be patient. There are many, many things
out of our control. The business is difficult
enough and working behind the curve
(financially) makes it near impossible.

—Brian Fencl

# Section II
# Everything Right In Its Place

# Chapter 6

# Setting Up Shop

---

*A professional working environment, whether in an office, shared space, or at home, can have a huge impact on how you work and the quality of your illustration. Creating a great workspace helps ensure that you are functioning at your best.*

—Alison Miyauchi

# THE SPACE

You need a place to work. In theory, that can be anywhere you can get the work done. But in practice, your studio space must be an affordable place where you can concentrate and have enough room to do the job well. And it must provide a congenial, professional atmosphere, especially if you are meeting or working with colleagues or clients one-on-one.

If you've always worked for someone else or are just getting out of school, you've probably never had to seriously think about what equipment and supplies a studio needs. One of the joys of running your own shop is that now you can have exactly what *you* want—if you can afford it.

Before you run out and rent fancy office space and buy expensive furniture and equipment, you should determine what you need and why. Your first decision should be choosing where you want to work. At home? In a studio away from home? What are the key investments you must make to create a work environment that's exactly right for you?

Whether you find the ideal office, or you simply know your home is just perfect, look at your potential studio and ask some critical questions:

- ◾ Are the space and facilities right for your purposes? How's the storage?
- ◾ What is the state of the plumbing, sanitary facilities?
- ◾ How will you handle cleanup and waste removal?
- ◾ Do you have plenty of daylight, interior lighting, and wiring?
- ◾ Is there parking?
- ◾ What's the traffic like around your location?
- ◾ Is the studio easily accessible by standard modes of transportation?
- ◾ Is there adequate security?
- ◾ What are the facility's hours of operation? (If you prefer to work late at night or early in the morning, will you have access to the building or are there only certain hours it is open?)

You may want to consider a studio that, as real estate agents euphemistically (optimistically?) say, "needs some work." These workspaces, due to neglect or location, are in sub-par condition. If your future office is indeed the notorious "handyman's special," evaluate how much time, energy, and resources will be spent to get the place to suit your needs and—I must emphasize—*safely up to code* (to avoid potential safety or liability issues should you, your clients, or guests injure themselves on the premises). If your goal is to get your business quickly up to speed, I would discourage you from going this route. There's only so much of you to go around, and I believe your energies should be directed toward becoming a freelance illustrator, not Joe Contractor.

You may want to look into sharing space. Leasing from, renting or owning with, another illustrator, designer, or photographer (or an even larger group)

could be the right answer. There are benefits that come with a mutual space: perhaps a common receptionist; maybe a conference room; you could share large equipment, plus split expenses and overhead. Don't discount the valuable camaraderie, in-house feedback, and a ready-made support system.

A business incubator just may work out for your particular situation. Here, single-room offices are rented out to a variety of one- to two-person companies who don't know each other. As in the above, everybody shares a receptionist, conference room, photocopier, etc., but you don't have to find (or know) your office mates first.

## PRACTICALITIES

Some illustrators may feel they must have a fancy address in order to succeed, but that's simply not true. A ritzy-sounding address may impress certain clients, but prestigious digs are not synonymous with quality illustration. However, working in a clean, safe neighborhood will obviously help your credibility. You certainly don't want to set up shop in the heart of the high-crime district or in the middle of a heavily polluted industrial zone.

Your studio's location must also be practical. Consider proximity and access to local clients, vendors, and suppliers (and be sure your studio is within range of those suppliers who deliver). You want to be close enough to your clients and vendors so you can snag supplies or pick up/drop off a job without having to drive long distances.

Your dream studio will be determined by many factors—only one of which will be personal preference. The first hurdle will probably be capital (money, honey).

Obviously, if you can't afford the basics—all necessary hardware and software, appropriate furniture, vital supplies and materials—*and* pay the rent or lease (let alone a mortgage), I wouldn't pull the trigger on ritzy office space. An age-old question somewhat comes to mind here: "My place or yours?"

## WORKING AT HOME

Some illustrators caution against a home studio, citing the major distractions of house, family, and neighborhood. Well, yes, these are solid observations. But I know that a high percentage of artists interviewed for this book work out of a home studio and wouldn't have it any other way. And I'd bet that many—if not most—illustrators anywhere began their businesses working out of their apartments or houses.

### LOFTY AMBITION

I have always dreamed of a treehouse studio. Completely plumbed, wired, and powered up, my fantasy studio even has a fireman's pole as an exit. It's just a fun

idyll for a lazy day, never practical or doable. While I don't seriously entertain this innocent daydream, I do know there are ways around the real challenges of working at home. You don't try to set up a studio in the center of a bustling household. You must have privacy in which to work and a way to protect jobs in progress. You need a door you can close on the illustration world as well as on the living room; that means a separate door to the studio portion of your home (or a studio off your house).

### SAFE AT HOME?

Let's evaluate the pros and cons of working at home. I'm an optimist; we'll think positively first.

Ahh, home sweet office! Really? On the positive side: you don't have to pay for office space, and you won't have extra utility and phone line costs. A home office is tax deductible (for example, a one-room studio in a five-room house garners you about a 20 percent deduction off mortgage and utility costs. See sidebar). You can take care of personal business, home chores and responsibilities. You can save on childcare. You don't have to get dressed up each day. It makes it easier to schedule work to suit your convenience. You're on the spot to take care of those personal emergencies that always pop up in the middle of your workday. You save time and gas money by not commuting from home to work.

Conversely, you can't leave the office behind. Family and friends can interrupt a lot, and housework and the aforementioned family responsibilities can distract you. You may appear less professional to some folks (if you are concerned about appearances). You can spend too much time goofing off—hey, just a few minutes of Facebook can't hurt, right? Let's see what you're doing thirty minutes later. Your workspace may be inconvenient. Your work interferes with your personal life and your personal life interferes with your work.

Finally, consider other core issues when evaluating the home studio: Does your home provide adequate space (and wiring) for your equipment? Can you maintain regular office hours at the house? How well will you be able to deter interruptions?

## MAKE YOUR MARK (FOLKS JUST LIKE YOU)

### GILDEN: NOT DOGGING IT

"The comment I most often get from people when I tell them I work from my home is 'How do you focus?' And then they often protest that they wouldn't be able to concentrate at home and keep to a schedule," says Nadine Gilden.

If this is your problem, Gilden has two tips:

1. Create a dedicated office area. Even if you don't target a specific room as your designated office, carve out an area that will be your office—and only your office.

2. Establish a routine. Get up, get dressed, and "Only work in your pajamas-thing when you are sick," Gilden says with a laugh. "Make sure your clients know you are running a regular business with regular office hours." Just a note here: As Vicki Vandeventer reminds you, make sure your friends understand that, too!

Gilden has never minded working alone, but she has also managed her schedule for fourteen years via, shall we say, a pet solution: her dog! "I have to get up and walk the dog," Gilden tells us, " so that becomes the official start to the workday. Her dinner time becomes the end of the shift."

Of course, there are days when she needs to work "after hours," but Gilden still remains "on the clock." These appointed office hours must be free of interruptions like phone calls and emails, especially if she must work on the weekend. "When it's busy, I avoid taking calls and answering emails," Gilden says. "Dodge this communication if you can help it. Once a client knows they can reach you on the weekend, they will do so repeatedly. Use the time to work without regular workday distractions."

On general communications, Gilden says that it's now much easier to connect with others through social media. "If I need some human contact, I sign on to Twitter and chat for a bit. Here's my water cooler—I talk about books, movies, TV, industry-related things; anything. It's the perfect way to balance working alone.

"It's important to realize," she adds, "that you are going to have periods where you are extremely busy, and times when you can practically hear the crickets. You may work weekends and put in long days, and when it's slow, you may not work much at all. When it is slow, use that time to learn new things—try fresh methods and replenish your creative spirit."

## DEDUCTIVE REASONING

One perk of working out of your home is that you can take tax credit. To determine your home office or studio deduction, first figure out your office's square footage and divide that into the total square footage of your home. Thus, if your studio takes up 20 percent of your home's square footage, you can deduct 20 percent of housing costs and expenses, which may include rent or mortgage, mortgage interest, insurance, utilities, repairs, depreciation, and more. The guidelines are extensive (read, complicated) and tests of this deduction seem fairly fluid to me, so it's definitely best to consult your tax

preparer or advisor, if you do your own taxes. Also check out the IRS Publication 587, *Business Use of Your Home*, and hunker down for a long read.

"This is a popular option with many clients," says accountant Julie Buschur, "especially early on when there may not be a lot of extra money for rent and the like."

However, Buschur always cautions her clients when it comes to the home-office deduction. She educates that it is fine, of course, to deduct direct expenses such as computers and furniture, but when it comes to indirect expenses (like home-mortgage interest, real estate taxes, non-business insurance, etc.) she advises you tread carefully.

"First of all," she points out, "the IRS looks at these home-office deductions. So it must be a *dedicated* space, not a corner of a bedroom or a room shared with any other non-business use.

"And while most do not depreciate a portion of their home," Buschur continues, "the IRS regs say that depreciation is 'allowed or allowable.' So even if the taxpayer does not take this deduction, the IRS deems it taken; thus it is possible that the taxpayer could actually have a gain on the sale of their personal residence because now part of their home is considered business property."

Buschur's advice here is to be careful and consult a tax professional before taking this deduction. "One positive thing with the home-office deduction," she adds, "is that mileage from the home office to your client is not considered commuting, so it can be deducted as business mileage."

## WORKING AWAY FROM HOME

Now let's evaluate the pros and cons of working away from home. Certainly, you have a fixed center of business and communications that provides a professional atmosphere for you, any staff, or clients. Your environment is conducive to work and reasonably free from the disturbances of personal or family obligations. Traditionally, you project a more professional image (if you care about traditions). Your work and personal lives are separate. You may have better accessibility to vendors and delivery services with a location in a commercially zoned area.

But working away from home is more expensive—you're paying rent twice and shelling out extra bucks for utilities and furniture. If you're at this stage of your life, you may need childcare; you may miss your kids and the interaction with your spouse. You may not be able to dress as casually or comfortably as you prefer. Your workspace may not be in your desired location of choice. Time will be spent commuting between your home and studio. You may not have as much flexibility to work when the mood strikes you or at odd hours.

## OPTIONS

"There is the new trend toward *virtual offices*," Ken Bullock says, "and I would look at sharing office space with another small-business owner or creating a space for a home studio."

You need to consider common areas—living room, bathroom, kitchen, foyer, for instance. Navigation to and within your home office will be important. You want any personal rooms multitasking as professional space to be clean, uncluttered, and business appropriate, but as Bullock says, "I'm not saying it needs to be sterile like a hospital. Some of the best home studios are hardly squeaky clean. As creatives, we have some latitude, so definitely display your passion, your image, your brand."

A simple office solution that should not be overlooked is a basic laptop, anywhere, anytime. "This is fine for people who may not have the money up front or the space in their apartments for a full desk setup, monitor, what have you," Ellie Jabbour says. "In fact, working from the desk, coffee shop, and couch allows for more inspiration and flexibility than a traditional office or even a co-working space.

"Honestly, the scenario of a co-working space so someone can answer the phone and take messages for you seems obsolete to me," says Jabbour. "I rarely talk to clients on the phone, as most communication takes place through email. When we do talk on the phone, a cell phone is acceptable and practically expected."

## THE DOTTED LINE

There are places you might not want to locate: next to the Stinky Fingers Bar and Grill, a 24-hour Tattoo Bazaar, the Pocket Change Pool Hall and Escort Service, a Playin' Games Arcade franchise. But you've found this great loft north of Rialto, just off Maxwell Street—very close to Cooper Art Supply. Absolutely right for a studio. Good light, lots of space; that rug really tied the room together, did it not? The landlord smiles and says, "Just sign on the dotted line, Ms. Illustrator; don't worry about all that stuff on the other page. Pay no attention to that little paragraph set in tiny type. Oh, that clause? It's nothing, nothing at all."

Hold on. Study your entire lease carefully. Remember that the lease was prepared for the landlord, so it's written with his needs and not yours in mind. A lease is, however, subject to negotiation.

Even though this space is to die for, show the lease to your lawyer and/or accountant before you sign. Examine the lease together. Be sure you truly understand the terms. Can these terms somehow change during the course of

your lease? Can the landlord wander in and around any time? Can the landlord legally cancel your lease—how and why? Can *you* legally break the lease—how, when, and why? Here's a checklist of points you should be aware of in addition to the monthly rent.

- ➡ What is the length of the lease (shorter is better)?
- ➡ When and how may the deposit be forfeited?
- ➡ Are there restrictions on how you may use the space?
- ➡ What are the zoning requirements?
- ➡ Is there an option to continue or renew the lease?
- ➡ What is the cost for continuing or renewing the lease?
- ➡ Can you sublet or assign the lease?
- ➡ Who is responsible for cleaning and repairs?
- ➡ Who is responsible for what utilities?
- ➡ Who is responsible for maintenance?
- ➡ Does the landlord have the right to move tenants?
- ➡ How are disputes handled?

# ONE SEC—I'M ON THE PHONE

Whether you are leasing space, buying an office building, or configuring a home office, modern technology and current phone services have made global communication far more accessible than ever before. Way back in the day, fax machines and express mail couriers revolutionized the size and scope of the marketplace. Today's state-of-the-art gizmos working an exploding Internet have kindled revolutionary digital information, communication, and delivery systems. As a result, you may physically be a small-time, small-town shop, but you can operate as a viable international concern.

## WHOSE LINE IS IT ANYWAY?

What previously was a small but key concern—the business phone/home phone dilemma—is easily resolved these days. Used to be, BC (before computers), the number of telephone lines needed to maintain business communications (and that all-important professional atmosphere) was a real issue. The balancing act of home and office communications system and communications (telephony and Internet connections) at the cave could get positively prehysterical. But AD (after digital), the difficult juggle—physical or metaphysical—of a home system on the same line as your business system is a thing of the past.

### A GOOD CALL

You can't make or take business calls if you (or anyone else) are on that line in the middle of a personal call. If that business line is also your personal cell phone, this can present other complications as well.

Consider separating church and state: installing a business phone number that is not your cell phone, or at least not your personal cell phone. Family members (or your buds) should definitely not have carte blanche access to your business line and only essential calls from key clients should come to your personal cell phone. Think about it—separate phone lines make perfect sense here.

And of course, you never want to take a chance on missing an important call. Busy signals are not quite a thing of the past, but voice mail (voice messaging) or even the good ol' answering machine can field calls when you're not around or unable to answer.

Modern phone options, cable modems, and caller ID systems also mean it's never been easier to screen calls these days.

## KIBITZ AND BITS

As Brad Reed reminds us, "Almost nobody is saddled with dial-up anymore. Cable modems are almost always faster than DSL and are generally available wherever DSL is available—but even DSL can handle simultaneous voice and data."

As Reed says, DSL (a *digital subscriber line*—or *loop*—providing a connection using a *digital signal line*) permits you to multitask your phone connection, to surf the Net and kibitz on the phone simultaneously. The digital line needs certain ingredients to work, and older homes may not have the correct phone setup. This will require the DSL installer to bring in a digital line, which, of course, can add to the total cost.

The DSL line provides a dedicated high-speed connection (whereas a cable modem is a shared connection) and, for a business, a DSL line may be a smart idea.

But in our current age of cell phones and Internet telephony—VoIP (voice over Internet Protocol)—DSL and cable modems just may be relegated to the status of a snazzy old hat. "And," Reed says, "we should talk about services such as Google Voice, which gives you a 'dedicated' line that rings into wherever you like, and can provide services such as voice-to-text message translation."

### ALL FAXED UP

Do people still fax? Some folks have not sent a fax for years. Are you still faxing? As of this writing, traditional fax and newfangled digital technologies do not play all that well together. You may want to consider two phone lines if you fax frequently, dedicating one line exclusively to your fax.

And you don't necessarily need two analog phone lines to accommodate a fax. Good fax machines will be able to decipher between a fax and a voice message and route a signal to the proper destination—voice messages to the telephone, fax signals to the fax—and a call waiting option as part of your phone service seals the deal.

Let's not forget that even with all our Star Wars–grade gadgetry and Star Trek–worthy communications systems, faxing is still a viable business mainstay. Internet faxing services—electronic faxing, or e-faxing—are provided by many vendors (yes, you send and receive faxes by email or via the Web).

## CHOOSE YOUR SUPPLIES AND EQUIPMENT

"Office supplies will often cost more than you think they will," says Kisielewska, "especially once you factor in ongoing disposables (such as toner or ink). Take your time to set up business accounts at places where you get freebies or credits for bulk purchases. [Staples, for example, offers free shipping options.]

"Business accounts for supplies, services—even local eateries—offer discounts, save a lot of time, allow the bill to be paid when it's convenient, and make it less necessary to keep massive amounts of petty cash lying around."

"Like a kid in a candy store" may accurately describe the illustrator at the art/office supply house, but it's important to realistically assess—and choose—only what you actually need, can afford, and what can fit into your space. Of course, you'll need more furniture, etc., if you're starting up with a partner or associates than if you're all by yourself.

A list of supplies and equipment could go on and on. Here are some obvious wants and needs (in no particular hierarchy):

- Storage: shelves, cubbyholes; closet(s) and cabinet(s); file holders and/or filing cabinets, boxes, etc.; bulletin board(s)
- Drawing table or worktable (and/or conference table) with chairs; lighting and lamps; waste basket(s)
- Basic cleaning supplies and equipment; first aid kit
- Analog art/production supplies (includes paper cutter) and office supplies
- Business package (stationery, letterhead and envelopes) plus business forms; promotional material
- Computer and related hardware, with art, presentation, and business software, plus address filing system (digital or traditional—yes, some folks actually still use a Rolodex)
- Phone system
- Handy to have would be a coat rack, hooks, or closet; additional work surfaces and desk(s); a music system; basic kitchen supplies (may include microwave, coffee, and tea maker)
- Decor: plants, framed work, awards help give a sense of permanence and stability.

## PLAY BALL: OPENING DAY

You'll need to gear up for that first day of business. The preconception that an illustrator can just casually stroll into a new workspace and become a *business* is

woefully wrong. But any dread of the work required—or planning involved—is also unnecessary.

To get a handle on what to do before your doors open, I've grouped items sequentially to help you prepare for your big day. You'll find more information on these aspects of starting your studio in other chapters, so I'll only hit the highlights here. For example:

*Five weeks to a month* prior to opening, you should visit your accountant; work up your first promotion, business forms, cards, and letterheads. If you need permits and licenses, this is a good time to secure all that. Licenses to explore, evaluate, and consider:

- ◗ Business License
- ◗ Fire Department Permit
- ◗ Air and Water Pollution Control Permit
- ◗ Sign Permit
- ◗ County Permits
- ◗ State Licenses
- ◗ Federal Licenses
- ◗ Sales Tax License
- ◗ Health Department Permits

Lay down the rent deposit and get the keys. Nail down your web hosting; secure a domain name; create your website; get online. I'd purchase any listing in your local phone directory at this time, and list your company in all online directories at this time, too.

*One month to three weeks* before opening day, see your lawyer. If appropriate to your endeavor: create your business sign or have it made. Print any promo, business forms, and the identity. Business gizmos (like refrigerator magnets, stickers, etc.) can be done now.

*Two weeks to opening*: mail the promo; place your advertising. Make an announcement via your social media connections; do an email blast. Hook up your telephone system. Hand over your deposits and have utilities turned on; build shelving, etc.

*One week to "D-Day"* (and as necessary): pick up your business forms and identity materials; sign up for cleaning services, etc. You could install that business sign. Alison Miyauchi says to do another announcement at the one-week mark and the day before opening.

Adapt my road map (and timing) to suit your own needs. You will find that following this basic itinerary will get you down the path to opening day easily and efficiently. Of course, you also need to plan expenses carefully so you don't end up over your head in debt before you even open. You don't want your gala opening to be followed immediately by your going out of business party.

# COMPUTERS, "BUY" AND LARGE

## TOOLS

You will surely buy your computer system for a graphics solution. As you will certainly see, it can quickly be a business lifesaver as well. Easy to learn, yet a most challenging work device, your Macintosh or PC provides a happy solution marrying process and appliance that's extremely satisfying.

I suppose there are still some luddites out there who fret and sweat about selling your soul at the crossroads for technology, but why worry? I do love my Mac, but always maintain that digital is not the only game in town. This sentiment is coming from a guy who regards the computer as a gift from the creative gods, but the comment should be neither confusing nor blasphemous.

How so? My Macintosh can never replace the rush I get from the juicy flow of watercolors (or the scratch of a fine pen) on toothy paper. At the same trim, making art on a computer is a serious hoot—much fun *and* ever challenging. The elegant and efficient Mac *is* a high-powered, fine-tuned instrument, but like all my mighty and meager analog toys, it sweetly complements and supplements my entire toolbox.

## BLINGWARE

Larissa Kisielewska will tell you that acquiring the right equipment, that spanky new, top-of-the-line computer you definitely *need* to buy—just for work, right?— is one of the most exciting aspects of starting a business.

"Well," she says, "if you can afford it, sure. But why not start out in a more modest way and keep that capital for a cash-flow glitch? Trust me, someday you'll be glad that you did."

Derek Kimball sees her point. "To offer versatility, quality work, and a stream-lined client experience, an investment into the proper tools is a must," he tells us.

And he agrees with Kisielewska—these tools aren't cheap. Kimball advises you to price shop computers, as well as good, commercial-quality printers, scan-ners, drawing tablets, cameras, professional monitor calibration devices, external hard drives or online storage backup (office supplies, too).

However, he also wants you to consider that the upside to all this is that you are investing in yourself and the future of your business. "While the growth process of any new venture is usually slow and organic," Kimball says, "the reward (if enough hard work is invested) is your ultimate success. Just don't expect it to be easy."

## MVP

Your computer is invaluable and indispensable. A fast, muscular, and versatile creative tool, computers also streamline the business end of your illustration

practice—it's safe to say that you'll buy a Mac or PC (and related devices) for tracking expenses and time; communications and research; billing, record keeping, and project storage.

But Kisielewska's earlier, wise advice is on the mark. A needs assessment can be helpful in determining just what equipment to purchase. Consider what you want the system to do, your available resources (both skill and money), and the time frame available for making the decision and implementing your system.

Yes, timing is important. But waiting for the "latest and greatest" may prevent you from ever getting started. We call for your prudence, but also caution against being a digital wannabe. If you truly *need* the stuff, don't make excuses—jump in.

"Think about what you'll be using your computer for," says Kisielewska, who makes the case that if your work is primarily in, say, Adobe Illustrator, and you rarely use multiple applications, you might not need as much RAM as you drool over. And if you only work periodically in MS Word and occasionally Excel, chances are you don't need a quad-core processor machine. "Be sensible about what you need versus what you want," Kisielewska says.

Let's establish some background about which system can contribute what to your creativity and business. We'll also discuss what to look for and what to ask when window-shopping and then buying (or leasing) a computer. First though, a word of caution. As mentioned above, computer technology roars by the consumer like a rocket. Roger Brucker comments that the velocity of computer technology is on an eighteen-month cycle. "As speed and storage go up," he says, "price goes down." Prices as well as hardware and software will most certainly have changed between the time of this writing and the time you read this. Use this info only as a shopping aid, not as a definitive buying guide.

## TRADING UP

Kisielewska says it never hurts to comparison shop and tells us to hunt for bargains at vendors like www.buy.com, www.amazon.com, www.deal catcher.com, and www.pricegrabber.com. She also recommends purchasing used and/or refurbished equipment—the Apple Store always offers refurbished tech. At this writing, sites like eBay, Craigslist, Mac of All Trades (www.macofalltrades.com), CPUsed (www.cpused.com), and Pre-Owned Electronics (www.pre-ownedelectronics.com) are all places to check out previously owned paraphernalia. Of course, do look into warranties and warranty periods on such purchases.

Perhaps you earn a discount from a local big-box store (or from Apple or another maker) as an educator, Graphic Artists Guild member, or through the BBB, for instance. Maybe you qualify for a trade-in program with the local computer repair shop (or an online vendor).

## THE PATH OF "LEASE" RESISTANCE

Another option is to lease your equipment, especially if you need to simultaneously purchase the computer, a server, scanner, printers, and other hardware (all of which can add up to an expensive proposition). "Some leases allow you to upgrade every few years so that you're always able to use the latest equipment without constant significant capital outlay," says Kisielewska.

Should you lease your equipment instead of buying outright? That depends on your financial and tax situation. There are advantages and disadvantages to leasing. Leasing may give you lower monthly payments over a longer period of time than an outright purchase. You can buy your machine at the end of the lease (terms will vary), renew the lease, or trade up to newer and better equipment. Understand, however, that because you may have to pay top dollar for a system, this can be a more expensive way to go.

Many dealers include a service contract and access to some technical support as part of your lease. Not all do, so be sure to read your lease carefully. Otherwise, you'll be responsible for repairs. The cost of your lease is tax-deductible annually, which may be a better deal for you than taking the depreciation allowance from an outright purchase. If your accountant suggests leasing as an option, check it out.

Look into Apple's financing program or lease third-party equipment from companies such as Rent a Computer (www.rentacomputer.com). You could secure equipment financing from companies like Fidelity Capital (www.fidelitycapitalonline.com). Computer leasing terms can be negotiable, so compare vendors for the best deals and watch for hidden costs (for instance, end of term computer disposal fees).

"Regardless of where you lease from," Kisielewska advises, "Apple's website is handy for educating yourself on various commercial lease options. Apple compares the Fair Market Value lease, the 10% Purchase Option, and the $1 Purchase Option, each of which is best suited for a specific mix of technology strategies and tax advantages." (See Apple's website: www.apple.com/au/financing/business.html.)

## BUYING A COMPUTER: THE BOTTOM LINE

If you check out the first edition of this book, you will find a fairly elaborate computer buying worksheet; but I'm tossing it for this version. Why? Brad Reed boils it down for us succinctly: "My input on the computer buying sheet is that nobody buys a computer that way," he says. "It should start with a needs analysis. What applications do you need to run, how many hours a day will you be working on the computer? Who do you need to interact with and how? Is portability a factor? Then you find the system or systems that best satisfy the needs. And sometimes you have to go with the intangibles—which system suits your aesthetic? Where is your comfort zone?"

# WHY DID YOU BUY THAT?

I initially was going to say that a computer doesn't *inspire* creativity, but that doesn't exactly ring right. The computer is only a tool and, as such, doesn't generate the illustration (no more than a hammer left to its own inanimate self builds the house or a guitar displayed on its stand writes a hit tune).

But certain tools generate a creative *spark* within the craftsman attuned to that instrument. Spiritually, mentally, physically, for whatever reason—be it look and feel; heft and grip; lilt and tilt; the sound, sight, and even smell of it—something connects between head and heart, and *that* thing in *those* hands makes something of beauty, worth, and merit.

The computer is one of *those* "things." However, as Reed puts it, "In terms of expressing the human condition, technology has always been the means, art the ends." You don't need to be the fastest chip on the motherboard to see how right this is, of course. Digital corrections and client changes are faster and cheaper. Designers can show illustrators how "real" type, copy, and visuals look on the page instantly, and explore multiple variations in less time. Indeed, at least theoretically, working digitally enables you to get more done and faster—you cut down studio hours and production costs while reducing paperwork and streamlining procedures. All of this helps you keep up with or get ahead of your competition.

But why did you embrace the technology and buy what you did? At the bottom of it, be it pencil or pixel, the answer that rises to the top should have something to do with *you* making art—and only *you* do that.

# CHIPS OFF THE OL' BLOCK

I'm a certified Mac guy. However, in the interest of editorial parity, I won't beat the drum for either the Macintosh or PC/compatibles. But, if we talk shop, what's better professionally? Is it simply a matter of right brain vs. left? Will the Mac actually be faster and easier to use than a PC? What's the cheaper and/or more powerful system? It depends on how you're most comfortable working and what you want to do.

Just for the moment, we'll enjoy the luxury of speaking in digital generalizations. The illustrators (and designers) interviewed for this book predominately employ a Macintosh as a creative, production, and business tool. Arguably, the Mac is the computer of choice for most illustrators, but do keep reading. The debate about what system is the best is pointless and never-ending; all those experts out there have their own agendas, no lack of opinions and seldom, if ever, mutually agree on anything.

Truth is, over time, the Mac and the PC have moved closer to each other. Powerful word processing and business-related software are available for both operating systems. High-grade product is available on both platforms and

fundamentally offers similar industry-standard results. The distinctions are blurring. It all comes down to an accurate, realistic evaluation of your situation, preferences, time frame for growth, and available funds.

My advice here is that you thoroughly investigate a variety of systems. Today's Macs and PCs offer truly breathtaking speed, awesome power, and amazing grace. As you grow into your business (and skills), moving up into the rarified digital atmosphere has never been easier or more affordable.

## FACE-OFF: MAC OR PC?

Nadine Gilden takes the pragmatic approach and tells us she works in both platforms, but adds, "I dread when I have to use my PC. Just starting the machine up takes twice as long."

But she knows it ultimately comes down to a personal choice. And for Gilden, Macs have a built-in support resource—the convenience and reliability of AppleCare or going to the Apple store. You deal with a slightly higher purchasing structure, but figuring out who to go to and where to get help with her PC has been a bit of a runaround, and for a busy illustrator who needs dependable tools, that's a critical consideration.

Ken Bullock says he's a little atypical of other arty types in the field. "I am PC/Windows-based," he says, "and for several reasons." When he originally started out (back in the early 1990s), Bullock was a zealous Mac aficionado. But a few years into his career, he delved into multimedia. "A lot of the early tools at the time—while available on both platforms—were being designed and developed for PC users, not Macs," he points out. "Compatibility was a major issue. Testing was easier and faster. So I decided to go to the dark side and become a PC user—and have been for the past twelve-plus years."

However, as Bullock will be the first to admit, these days the game has changed, and regardless of all the fussin' and fightin', he says, "PCs and Macs are equal. There is nothing a PC can do that a Mac can't. Plus, these days, Macs will run Windows." Comparing apples to Apples (maybe apples to oranges is a better analogy), Bullock points out that the software works basically the same as well as the final result. "The differences are personal," he says.

Of course, any software you use is directly related to the type of stuff you do. Regardless of what hardware you decide to go with, Bullock's only real advice would be to buy in accordance with your activities and what you want your computer to accomplish. "You may not need esoteric hardware to bang out simple print work," says Bullock, "it'll be a waste of money. You don't need a Ferrari just to drive to the grocery store, but you may want to think Lexus or Acura."

These are all metaphors for some basic facts of any computing purchase: bottom-end computers will leave the starting flag already old and slow when you buy it. The lower the model you buy (of *any* brand), the sooner you will need to replace it. "Spend a bit more money to extend the practical shelf life of your machine," Bullock says. "Planned obsolescence? Sure. And accept that eventually you will have to buy new hardware to keep up with the advance of the software . . . and on and on the wheel turns."

A final note: You may want to consider extended warranties or insurance for your machine. These "protect yourself" offers cost a little extra, but in the long run may justify the added expense. Is it a "no-brainer" or "done deal"? Hardly. Not sure whether to take these warranties? Well, join the big club. My personal experience is that the extended warranties on my computers (it's called AppleCare for the Mac) have been exceedingly well worth it. I've not taken an extended warranty on the peripherals—printers, external hard drives, scanners, etc.—and seldom needed one.

Of course, that's just one user's learning curve, and this is not product endorsement. Savvy shopping, careful evaluation, and some luck, too, will always play into smart purchasing and shelf life.

## PRACTICALLY FUNCTIONAL?

Perhaps it is best to be functionally practical. What types of files will you need to exchange with your clients and vendors; what types of media? Even more importantly, what "stuff" does your service bureaus and printers use?

"Service bureaus and printers significantly prefer Macs over PCs," says Kisielewska. "The Mac has been around in the illustration/design world that much longer—much more development in font management and color matching has taken place for the Mac. Service bureaus can rip Mac files much easier, faster, and with far fewer glitches."

I must agree, but zealots for either system can escalate the debate to DEFCON 3. So, of course, there's always the universal fine print here: your results may vary (and you may just have to be a switch hitter). Do *your* homework, and let's compare notes next week.

Robert Zimmerman will tell you this story: "I'll never forget the first time I walked into the offices of *PC World* magazine," he relates. "I expected, literally, to see a world of PCs, I suppose. What I found was a world of Macs—not one PC to be seen in the entire art department. It dawned on me then that the industry standard for graphics of any kind was Macintosh."

And at that time, Zimmerman never worked with an art director who wasn't running the Mac OS and he doubted he ever would. We'd have to check if his prediction held up, but you might win the bet if you put some money on that.

## SOFTWARE AND TEAR

No matter how fancy the computer system, the most powerful machine remains humbled without the right software. As an artist and businessperson you will need a variety of applications to effectively run your complete studio: obviously, illustration, design, and page layout software; word processing and email software for correspondence; probably a database for file keeping; maybe accounting and/or bookkeeping programs; perhaps organizational software for office management. Presentation software. Web design and site management programs. 3-D rendering applications. 2-D and 3-D animation packages. Great software is widely available and it's a real buyer's market.

Illustrators can pick and choose from many possible options and variations (for instance, considering your needs, a scaled-up Adobe Photoshop or pared down Photoshop Express). You'll find a variety of entry-level, mid-range, and high-end applications (usually determined by a combination of price, degree of difficulty, and features). No matter where you are on the learning curve, you should be able find software to meet your requirements.

"Consider a subscription to a site like Lynda.com for great tutorials," says Jabbour. "I have taught myself programs this way. Also YouTube is a great resource for intro tutorials as well as specific troubleshooting. If you search any issue you're having, along with the program name, chances are you can find a YouTube video with the user's screen showing a step-by-step solution. I taught myself Google sketch-up entirely through YouTube tutorials."

## BIZWARE

What do you need in the way of business software? As mentioned earlier, electronic spreadsheets, databases, communications software, and accounting packages can help the illustrator manage an efficient and organized business. Look into integrated (all-in-one) packages or bundled software that combine the basic business applications—text, spreadsheet, database, and telecommunications. At this writing, some software to evaluate would be Apple's iWork suite (comprising Pages, Numbers, and Keynote), and Microsoft Office.

Specialized programs or general-purpose applications designed to handle most of your business chores can be found right on the shelf. With a bit of research you can get great performance and good value. If you can't get to the store, you need go no further than the current computer magazines or shop on the Net. Window shop a few issues and websites, read the reviews and/or call the mail-order houses for recommendations.

Also at this writing, there is a rush of designers moving their data into the "cloud" and taking advantage of services like Google Drive (and Google Play),

Skydrive, and iCloud. Cloud storage of documents and notes, art and photos, and, of course, music, can be synced across all your devices.

"You should also consider Software as a Service options (SaaS)," Reed recommends. "Microsoft is moving to a subscription service for its Office products, as is Adobe with the core Design applications. Google Drive provides both online storage and basic word processing and spreadsheets for free. Services such as FreshBooks can help with time tracking and invoicing."

Remember, even a bit of information can go a long way; make an educated decision and purchase. Whether you're buying graphics, business, or word processing software, get plenty of input first. Surf the Net, call your friends, call, or email those professional contacts. Consult user groups, chat and message boards, and books and magazines to find out what's hot and what's not.

Compare features and prices before you buy, and always test-drive the program first to make sure it does what you want it to do (and is compatible with the software used by your clients and vendors). Fool around with the program on a friend's computer. Take it for a spin at your local dealer. Borrow from a friend or download a trial version from such sites as Tucows.com.

One last word about buying from vendors: education and computer consultants may remind you that federal law prohibits any return of opened software or other recorded media to the seller, except for replacement with the same title. "However, this is almost a moot point as practically all software is now purchased as a download," Reed points out.

## JUST TELL ME WHAT YOU WANT

Take the time to thoroughly assess your needs before you buy. It will be time well spent. If you can afford the services of one, a consultant is an invaluable ally (see below for more on consultants). Whether consulting the pros or using a DIY method, don't underestimate the time and money involved in keeping your computer system running effectively. Here's an inventory of points to consider and questions to ask before you purchase a computer and related peripherals:

- ◗ Who will use the computer? How many will use it?
- ◗ What exactly will you use it for: creating illustrations, design and page layout, word processing, bookkeeping, typography, etc.? What quality of output do you need? High quality—1200 dots per inch (dpi), mid-range—600 dpi, or low quality—300 (or lower) dpi? Do you need to output color? Is your work for the computer screen or for paper?
- ◗ When do you want to be partially or fully computerized? How much will it cost? What can you afford? Where will you get the money?
- ◗ Where will you do input and output? One workstation or multiple? Will you need to deliver material to a service bureau frequently? What kind of scanning will you do (flat art, slides, photographs, transparencies;

color, line art) and how much will you be doing? Do you need to network your computer to other machines?

▶ Why are you planning to buy—what specifically do you expect a computer to do for you? If you want to improve productivity or cut costs, how will a computer help you do that?

▶ How will your system be supported: who will train you, help you solve problems (technical support) and fix your equipment when it's not working?

## TALK TO ME

Whatever (and wherever) you buy, consider working with a consultant. If you can afford one, it's to your definite advantage to have a consultant on tap. Find a people-oriented expert who knows the hardware and software and who will be there when you need support, training, or advice. To locate a consultant talk to friends and colleagues, consult vendors and user groups—even though it's a slight conflict of interest. (Vendors will naturally promote use of the hardware and software they sell. User groups—in the effort to promote computer literacy and autonomy—will steer you toward what they know and use.)

You may be able to find a Value-Added Resaler (VAR; a person or dealership authorized to sell some particular equipment) who will act as your consultant. These may be small stores, larger operations, or chains. In either event, look for an operation that emphasizes the relationship they build with the client after the purchase as part of the purchase. This is the best of all worlds—sales, service, and support all in one—it's worth the search and possibly higher prices to find such a vendor.

Many experts advise you to go local. Especially with Macs. While it's not a fact of life, chains or superstores may lack Mac expertise as well as critical in-house support and service.

## BUY THE BUY

It's a common complaint that the buyer can't keep up with technology. The lag time in writing this book and when you read it will bear this out nicely. We could wimp out and avoid talking specifics about speed and storage altogether, but let's just fearlessly employ the universal qualifier for all these techy-tacky discussions, shall we? Everything you're about to read is qualified by the statement *at this writing*.

Hardware and software improve so dramatically and so quickly, many users moan that a system becomes obsolete as soon as you crack it out of the box.

Because of this situation, any specific information given at this writing may well be ancient history by the time you read it. Therefore we must approach the market in general terms.

Evaluate purpose—what you want to do—and don't overbuy. Consider speed and power. Mix and match speed, power, memory, and storage with some expandability—keep an eye on your future. Get plenty of memory and storage. By the time we go to print, this data will be out of date. But (at this writing) 4GB (gigabytes; 1 gigabyte is 1 billion bytes) of RAM (Random Access Memory) and a 500GB HD (hard drive) are now standard; 8GB and 1TB (terabyte = 1 trillion bytes or 1,000 gigabytes) is common.

If there's one truism in the world of computer technology it is this: you can never have too much RAM. Invest in this absolute essential (and look into third-party RAM—it's usually a much cheaper alternative to factory-installed RAM).

Another rule of thumb here is that you can never have too much storage space. Get the biggest hard drive you can afford!

Trust me on this—make it a priority; get as much RAM and a substantial hard drive. Saying that, external hard drives are a seriously cost-effective means to beef up your storage capacity.

Oh, yes, my mother would also remind me to tell you to back up your data files constantly and consistently. (Please be a good little illustrator and listen to my mother. Please.) "And a word about backups," says Reed. "Consider a cloud-based backup service such as Carbonite or CrashPlan, or establish a routine of backing up to a secondary backup and storing it offsite. It's no use having a backup of your files if the backup goes up in flames with the computer."

Consider speed and power. Be aware that minimum processor speed increases every three to six months and prices fluctuate with the volatility of the market.

Purchase a monitor with a screen as large as you need. For graphics, a 17-inch monitor is where you start looking, but Vicki Vandeventer says that a 24-inch should be considered the absolute minimum now (there are good buys out there on everything from 19- to 27-inch screens, but they will be more expensive, of course). Most Macs (and PCs) now easily support multiple monitors. How about a two-monitor setup to hot rod your workflow? Or use the primary monitor for all things illustration, with a cheaper secondary for email, web browsing, office apps, and more. Consider a mobile device (like an iPad, iPhone, iPod) to complement your digital arsenal.

## PART IT OUT

So, yes—you're going to toss some coin, one way or another. And here, Reed makes an astute comment. "Rather than focus on system cost," he wisely points out, "perhaps it's better to segment by purpose."

"Desktop systems come in two types—all-in-ones (like the iMac) and modular (the Mac Mini and Pro). The all-in-one iMac takes up less desk space, has fewer cables and connections to mess with, but has limited upgrade options. The Mini is a good entry-level modular system where you bring your own peripherals (monitor, keyboard, mouse, etc.). The Pro is for high-output, serious file crunching.

"If mobility is an advantage, most of the laptops have decent RAM and storage, and can attach to external monitors to use on the desktop."

Just a caveat: Reed's hardware examples above will likely be around when this book is published, but all products and specs mentioned in his comments (and indeed, throughout this entire chapter) are for clarification and explanation purposes only.

### APPLES AND ORANGES

A good shopper, of course, can make the actual numbers (and the ROI—the return on investment) vary dramatically. The scenario for either a Mac or PC purchase will play the same—you pay more for extra and better equipment; you do better if you buy smart and shop 'til you drop.

Where to start your shopping? Do your homework and go on a reconnaissance mission: hit the library, browse the web, talk with friends, buy a few periodicals, cruise the stores, and, perhaps most importantly, check with other illustrators who use computers and software that interest you. Learn what available hardware and software meet your needs and budget.

Then seriously shop around. Many, if not most, vendors offer online shopping. It's easy, fast, informative, and fun. You can buy both software and hardware at that store in the mall, by mail order, or over the phone. You can purchase through a VAR or from a consultant in your local area. Each of these outlets has its fans and critics. Network, comparison shop, research, and read (including the fine print); ask questions. Unless you weigh the pros and cons carefully, and know exactly what you want, you probably won't get a good deal anywhere. But this is true of buying a car, furniture, or stove. The old stipulations apply even more to our new high-tech gear: buyer beware, buyer prepare.

While price is important, it's not the only consideration. A great bargain may not be the best computer for you. Inquire about how long the vendor/dealer/VAR/consultant has been in business. How accessible are customer service, repair, and training centers? Can the vendor/dealer/VAR/consultant supply references from previous customers? Check out the kind of training and support available. Do you get any free training? How much? How long does it take most users to learn this system?

What's the cost of the basic system components (versus your budget and in general)? What equipment is included in that price? What kind and amount of

software is available for and compatible with your hardware—at what prices? What add-ons are available? What are the system's requirements—how much power, space, and ventilation is necessary?

What are the policies on returns? What is the system or software's record for reliability? Can it be serviced locally or will it have to go back to the manufacturer? Are service contracts available and how much will they cost?

Get a sense of the top limits on what your hardware and software can handle (number of users, programs, and projects). How are upgrades (customizing to create a bigger, better machine) and trade-ups (swapping to acquire a bigger, better machine) handled? Can you network your system and software easily? Are there compatibility issues with both Macs and PCs on the same network?

To sum up: Getting the lowest possible price shouldn't be your sole prerequisite for buying a certain computer at a particular store, and you should definitely shop around. For seriously smart and efficient shopping, organize your information to help you pinpoint the best deal. Info on each component can be gathered over the phone, through the Internet, in person, or from want ads and store advertisements. Remember to research both new and used equipment (if available).

### "GAS" THE WORLD TURNS

In my discussions with the illustrators in this book, we identified a malady common to artists everywhere: GAS, or *gear acquisition syndrome*—the craving to have only the newest and best of everything, from electronics to office supplies and furniture. GAS is a natural "affliction" for many illustrators. Is this ailment exclusive to the art world? Certainly not, but let the plumbers complain about it in their own book.

If you have the cash available, an outright purchase is cheaper. (See Chapter 5 on calculating and monitoring your cash flow.) You own the stuff (furniture or equipment) without the hassle of ongoing payments, and there are no interest charges. But will you be able to sell an obsolete piece of equipment, if you can't trade or upgrade it, or used furniture to recover part of your investment?

Is used equipment or furniture a good alternative? That's a big maybe. "Buyer beware" says it best. Cheap, previously owned equipment may look like a bargain; but do your homework and shop around before you say yes. Definitely negotiate for a trial period, a repair warranty, and terms for return. It's also wise to, if possible, have the item thoroughly, professionally inspected before you buy.

Before you decide, get your accountant's advice. As we mentioned before, it sometimes makes more financial and tax sense to finance or lease big-ticket

items. A leasing company may decline to lease you equipment if you haven't been in business a certain number of years (an indication of stability and ability to pay). They may demand a personal guarantee.

Leasing has tax advantages. You can write off your entire payment, and leasing allows you to upgrade your equipment with a minimum of fuss. Often you'll have the option to buy at the end of the lease. Investigate interest rates carefully, especially when choosing between leasing and financing a purchase.

# ON THE BOARD

## (PROFESSIONAL VIEWPOINTS IN 50 WORDS OR LESS)

I had a bedroom large enough to have a distinct sleeping space and a distinct working space, but this actually affected my sleep. I found it hard to "turn off" after a day spent working in the same room I was supposed to be able to relax in.

—Ellie Jabbour

The days of not being considered a true professional (because you work out of your home) are long gone. Your clients don't care when and where you work, as long as you keep in touch and hit all your deadlines.

—Vicki Vandeventer

© Susan Farrington 2016

I wanted to get away from the studio once in a while so I set up in an office.

—Rick Tharp (deceased)

It doesn't matter where I am physically (to do the work), but mentally I need to be in "my space."

—Darren Booth

© Trina Dalziel 2016

© Veronica Lawlor 2016

# Chapter 7

# Managing
## Your Business

---

*What do we want to get out of our business? We must remind ourselves that we got into this to have a little fun—it can be an extremely fun-filled business.*

—Mike Quon

## GET OVER IT

I asked Brian Biggs to lead us into this chapter with something relevant. He came through. For Biggs, freelance *is* business. They're not separate. He tells me that as a freelancer, even when he's "on vacation," he's ready to "do business" all the time. Notice those quotes for emphasis—this doesn't mean he can't relax, doesn't appreciate downtime, and has no personal life. Hardly. He's all over that.

"The idea that selling is bad is, frankly, bullshit," Biggs says. "It's what we do. We make a commodity and we want people to pay for it. If an illustrator has qualms about this, go paint your picture and hide it in the closet. Galleries sell, magazines sell, publishers sell. It has zero to do with integrity or anything else—that's dorm room philosophy junk.

"I won't do work for conservative political causes, and I'm sure there are other certain ad campaigns that might make me queasy, but I can cross that bridge when I get to it. Other than that, *bring it on.*"

## JUGGLER

So you think you're organized? You put it all together (if you could only remember where all the elements are)? Starting and running your own business is rather like a juggling act. At times you will feel as though you're juggling the task equivalents of a meat cleaver, *two* bowling pins, and a lemon meringue pie (my favorite). Just how many minor chores and major responsibilities can you keep in the air all at once? Make no mistake about it, you're going to be so busy you may end up dropping a pin or two.

You know all the clichés: "You're only one person. There are just so many hours in a day. You'll be wearing a lot of different hats." These homilies are time-worn, but (to throw in another rickety catchphrase) right as rain.

In her interview with the *Atlantic*, Yuko Shimizu says, "[Illustration] is art, but it is also about running a small business. You can do amazing artwork, but if you're unreliable and irresponsible or can't keep track of your paperwork, you can't succeed as an illustrator." Shimizu goes on to say that she's in her studio working "a lot," but in reality, "half the time I'm doing paperwork, organizing, and talking to clients. So actually, [illustration] is half art and half running a small business."

## DICTATOR

"Being a freelance illustrator means you are free to dictate what you want to do and how/where and why you do it," says Julia Minamata. That being said, if you *want* to do it all, go ahead!"

But Minamata will also tell you that "Doing it all" can mean running *every* aspect of your business, instead of having an illustration rep to deal with it. It may mean working across a broad range of categories (editorial, book illustration,

advertising). It could mean marketing yourself as an illustrator while also exhibiting in galleries.

"And it can mean much more," says Minamata. "Do as you please. Do what feels right for you at the time. Ask for advice and learn from the experiences of others, too."

Minamata states that it's both harder and easier to be an illustrator at this juncture. "Illustrators used to arrange courier services to pick up their work and deliver it to their clients," she says. "Email has replaced that.

"You had to shoot slides and 4" × 6" transparencies of your work to enter competitions or to deliver to contests. Now we have scanners. If you wanted visual reference you'd go to the library, and now we have Internet search engines.

"Fees for illustration work have either remained the same—and not adjusted for inflation ever—or gone down, in my experience," Minamata says. "The Internet has taken a bite out of magazines sales, which mean fewer advertisers and/or lower advertising rates; something's happened to editorial budgets."

## MANAGING YOUR WORK

Managing your business and the projects you bring in is a matter of zeroing in on priorities. It's also a matter of keeping track of people, services, time, and expenses. To manage effectively you will need to get organized, set up systems and procedures, and maintain records and files on all aspects of your business. It's imperative to keep tabs on any project in order to stay on time. You may need to bring in many pieces to make sure every component of the job is accomplished, and done well.

### JACKETS REQUIRED!

To keep a deadline and overall turnaround time in mind, break each project down into tasks and mini-tasks. George Coghill reminds us here that smart, efficient file organization (of both physical and digital files) is your first order of the day. Establish a routine and protocol expediting a logical system of what goes where; everything clearly and accurately labeled, easy to reach, and always accessible.

This organization also means identifying each task and mini-task, plus assigning an amount of time to each. From there you should be able to come up with a schedule and a completion date for each task. As each task is completed, you may want to record the date, so you'll know exactly when it was done. When a similar job comes up in the future, you'll know *exactly* how long—and what—it takes to do that assignment, and you'll price from experience, not speculation.

Back in those "back in the day" type days you stored this pertinent info in what was called a "job jacket" for each project. Here, in our "we're not so far

removed from all that" days, this can be done digitally of course, on your computer or via an iPad or similar.

But if you go old school here—and these are the "there's nothing wrong with that" days—place your schedule into a binder, folder, or sleeve (the *jacket*) or affix the schedule (along with the job name) on the outside. This way you will know at a glance what tasks still need to be completed on a given job, and whether or not the job is on schedule. Some folks prefer to use a traditional wall chart, blackboard, or bulletin board as a means of tracking the progress of all ongoing projects.

### The Numbers Game

Your job jacket (whatever the format) will serve as Grand Central Station for all project-related notes and correspondence, as well as scheduling and contact information. The job jacket can be organized digitally or in a file cabinet; oversized materials and other project-related art could be stored in flat-files.

Categorize projects alphabetically by client. Assign a number for each project. For example, you did an illustration for the gourmet coffee maker Whole Bean. It was used for an ad appearing in *Grounds Control* magazine, and commissioned by the renowned Design Studio, JoJo MaMa. This might be labeled JoJo/Bean #0420. The roughs and all materials associated with this illustration go into the JoJo/Bean #0420 job jacket. You also did character development and created their adorable mascot, Beanyhead. This job (with support documentation) becomes JoJo/Bean #0421. And so on.

By assigning each project an identifying number, you can easily keep track of the chronological order of each project. Roger Brucker agrees, and offers this variation: "Employ a job numbering system using the first two letters of the client's first name and last name (or first four letters of a single name), followed by a serial number that is next available," he says. "For example: ACLE-1432.

"You could then employ a visual art filing system tied to that job number. All elements—everything from actual physical art to electronic files—are marked with the job number plus date of entry. Once given a number, that element's number does not change. In this way all elements can be tracked back to the master job, even when used on subsequent jobs."

But regardless of your preferred method or combination of methods, you must keep track of all job components from conceptualization and roughs to fully realized final. Getting and staying organized is critical.

### MAKING A LIST AND CHECKING IT TWICE

So, Mom's grocery list is not just for breakfast anymore. It's important to list—yes, make a list—on a daily basis, of what needs to be done. When that list is written is up for argument and grabs . . . at the top of the morning, on the spot,

or freeform; how about at the end of the day? At the end of the shift, you can make a list of tasks for the next day, taking note of priorities and emergencies, tasks that may simmer or stew; stuff that simply needs to be finished now, sooner than later. You could determine priorities by assigning a numerical value to each task (and make sure you tackle the tasks that have the highest priority on a given day).

Keep track of your ideas as well as what needs to be done. You can easily remind yourself about any aspect of a business project or life in general by "recording" it on a central calendar, via your computer or a device (cell phone, iPod, iPad, and its ilk). You could even document information in a traditional pocket notebook, or on a mini digital recorder. Regardless of when, where, and how you take down your entries, simply sync all information to the master planner.

And whatever it's called—planner, diary, scheduler, log—calendars and to-do lists can help organize your tasks, projects, meetings, and other business-related obligations. You'll find that by maintaining some sort of plan book, you'll be able to follow all aspects of your business on a day-to-day basis so nothing will fall through the cracks.

## MAKE YOUR MARK (FOLKS JUST LIKE YOU)

### CHO: COPING AND PLANNING

As with many of us, a big change arrived on his doorstep when Michael Cho became a father. BC (before children), Cho was used to routinely working 14-hour days for the duration of an assignment. It was just business as usual; scheduling was almost an afterthought. "Of course, once I had a kid," he says, "I had to start planning 'buffers' and extra time just in case my daughter became sick or something else happened." So, as with many of us (or at least the ones with their heads on straight), Cho's priority became family first, then work.

"Since then," says Cho, "I've had to teach myself to be more productive in less time." For Cho, that meant learning all those business and time management skills that he'd eschewed in pursuing the "artistic life." One of the things Cho started doing that made a huge impact on his productivity was actually measuring and recording what he did in each day, which the illustrator explains briefly below.

"Every day before I start work," Cho says, "I list in a logbook exactly what I am going to work on that day. Usually that consists of one creative task, which takes up most of my day." (Through trial and error, Cho has found that he can't concentrate on multiple assignments in one day.) "I draw up a small list of office tasks/paperwork/emails that need to get handled. As I check off my tasks, I record exactly how long it took me to

complete those items in my log book. This includes things like brainstorming, thumbnailing, drawing roughs, scanning, and correcting artwork.

"After each assignment is completed and billed," Cho says, "I usually write a short report for myself, breaking down the components of that assignment—brainstorming, thumbnailing, drawing linears, revisions, final art—and listing the time spent on each step, as well as the total time to complete the job. This allows me to get a clear idea and measure just how much time might be needed for similar assignments in the future as well as what I should be quoting as my rate.

"One might think that creative time can't be measured. I certainly thought so, but after compiling a number of these reports it actually becomes possible to estimate such ephemeral intervals with surprising accuracy."

Cho points out that measuring such things only works if you're able to cut out distractions during your work time (such as surfing the web or simply procrastinating through other means). "I know myself well enough to set aside certain long break times during the day to goof off and do such things," Cho says. "But when I get down to work, I try my level best to ignore that 'flight' impulse to check Facebook, Twitter, what have you, and instead just devote my full concentration to the drawing board.

"I'm sure my methods seem primitive and simple to actual project managers or people who have office jobs," Cho says, "but for a creative type like me who was used to just 'following my muse until the job was done,' it's certainly impacted my productivity greatly to approach my work with more discipline."

## PEOPLE WHO NEED PEOPLE

Nobody likes surprises. Keep your client posted. No matter how outstanding your illustration work may be, you will never be able to build a business if you do not have a reputation for a solid (and thorough) work ethic while establishing stellar rapport.

You'll need to communicate frequently and candidly with your clients and develop an understanding up front of what is required of each of you in order to bring about a positive outcome of any project. With every job you have an obligation to let your client know what you will produce in the way of roughs, comps, and final; when you will be creating these; and when he or she will be involved in the decision-making process. It is also your responsibility to schedule meetings and opportunities for client approval. It's crucial to establish this with your client at the onset of a project.

Coghill's rule of thumb: "I ask, 'How often would I want updates if I were hiring someone?'" he says. "I think if you are not in contact every three days at most—without a prior understanding—then you are overdue for an email or phone call."

## THE HISTORY CHANNEL

You might want to develop and document a history on each of your clients. It's not cloak and dagger stuff, Mr. Bond, just facts and figures, background and color: names, address, phone numbers and contact records; a record of billing procedures, perhaps credit and financial information; any information you deem pertinent to the business relationship. Any of the client's personal preferences or idiosyncrasies can be kept track of in this file or database—particularly if your past experience with a client's projects has been fraught with a multitude of time-robbing revisions.

It's best to make revisions early on in the creative process and smart to establish a mutually agreed upon (and documented) protocol covering corrections and changes at the beginning of a project.

## MANAGING YOUR MONEY

Running a tab at your local bistro is one thing. Running a business and not keeping tabs on income and expenses is another. Being a free spirit may definitely be a creative boon, but become a button-down banker with your bucks. It's absolutely crucial to know what money is coming in, how much you have at any time, and where it's going. To do otherwise is simply bad business and financial suicide.

In order to keep track of business income and expenses, it's essential to set up separate bank accounts for your business. Your numbers will vary, of course, but a practical start-up base might kick off with $2,000 to $3,000 in savings, and another $2,000 to $3,000 in a checking account. Online checking is easy, convenient, and efficient, but—at least at this time—people are still writing checks traditionally. (So if you are paying bills the old-fashioned way, make sure you have check writing privileges for approximately twenty-plus checks per month.)

Secure a company credit card linked to those accounts. Shop around for the best deal from the banks in your area. Regional banks are usually the best for setting up business accounts as well as applying for loans (see Chapter 5). Your hometown banker is more likely to loan money to a neighbor, and offer the good service that goes with being a "big fish in a small pond." To compare banks, use account information and total the fees and interest that each bank would charge on the services you need. Break down those fees to determine what your best options will be.

# LAY OUT YOUR PLAN

I would be remiss here if we didn't recap an important section from Chapter 5: the basic concept that managing your studio should start with a solid business plan.

A business plan is a yearly practice. It doesn't have to be intimidating nor require an expensive degree from a prestigious business school. Or any degree, for that matter—it all comes down to knowing clearly *who* you are, understanding *what* you want to be, ascertaining *where* you are going, and figuring out *how* to get there.

As you'll remember, this yearly projection is much like a New Year's resolution with just four basic components—your master plan is actually four mini-plans jamming together.

A business plan can simply be an informal inventory of your *goals*. You might even think of it as a *layout* composed of four basic *artboards*.

### THE LAYOUT

1. You're an artist, so start with the *Artistic* plan (or *Creative* art board). Here's what we play with in the toolbox:

   ➡ *Why* am I doing this? Probably the easiest question to answer: "I'm an illustrator. I want to make a living doing my art."

   ➡ And *who* am I? Your statement here may be something like, "I'm an artist who works in oil pastels with a rather painterly approach . . ."

   ➡ *What* do I want to do? ". . . Well, I want to do children's books or editorial/advertising, greeting cards, (whatever) . . ."

   ➡ *When*? "Now, of course, but this is my plan for 2016–2017."

   ➡ *Where* is my territory (a.k.a. "who is my audience" or "what's my marketplace") and *how* do I get there? This may sound like "Okay, I've religiously studied relevant venues extensively at the library, bookstores, in the mall, online. All this considerable research informs me that I need to target this market segment as a whole, and after that, clients *X, Y,* and *Z* specifically."

2. Next comes the *Personal* plan—your *Lifestyle* art board. Is this you? "I want to live in a small town and navigate at a slower pace." No, maybe this is you: "I need the speed and stimulus of the city."

   Why do you work so much? Why are you not working more? Well, to answer either of these questions, you should reflect on *how* you are working.

   Look at both quantity and quality (actual hours and volume of work). Evaluate your work life in relation to your personal life—do you even have a personal life? Isn't that a *big* reason why we work—to have

a better personal life? What are your personal goals: "I want more work because I want to achieve this ... I want to work less because I need the time and energy for such and such ..."

3. Next there's the *Advertising* art board, your marketing and promotion plan. What is my yearly plan for advertising? How do I get the word out—and when do my clients hear—about my services? For instance, "I'm going to do an email blast or a mailer three times a year. I will maintain a website and a blog or I manage an online portfolio on Carbonmade or Behance.

4. Finally, there's the *Financials* art board. The Financial plan asks you to examine the minimum expenses you need to run your studio. Actual dollar amounts will vary with individual circumstances, but there are definite expenditures common to any business. Cross-reference with Chapter 5 as we look at the basic list:
   - Tax and financial professionals (accountant, financial planner) and possibly a legal consult (lawyer)
   - Marketing and promotion costs (Internet, website; direct mail, email, your portfolio—digital ad/or traditional)
   - Studio utilities (electric, gas, water, sewer) and communications (phone, Internet, cable)
   - Studio maintenance, repair and improvement
   - Rent or mortgage
   - Insurance (personal, health, disability, professional)
   - Equipment, supplies and materials
   - Shipping and delivery (even in this day and age)
   - Travel and auto

   You should set income goals:
   - Figure out how much money you'll need.
   - Estimate how much you think you will/could earn.
   - Compare real-world costs and income with a hypothetical budget. Compare and contrast with real-world numbers. Record keeping is important, otherwise it's all theory.

The questions to be asking here are: "Am I growing? Am I on schedule with my plan? *How* am I doing? Am I on track with last month? Last year? 2012?"

Last, but definitely not least: This may sound funny, especially if you're just starting out, but think about your retirement plan. *Now.* Plan now for retirement. No matter how old you are, or where you are on the professional ladder. Even if you get a late start, something is better than nothing. You might live for today, but save for tomorrow.

## MAKE YOUR MARK (FOLKS JUST LIKE YOU)

### ALLEN: THE METHOD

When Brian Allen first ventured into independent business, he knew the shock of an irregular income was just around the corner, so he planned ahead. He calculated what he spent on average each month (bills plus average credit card bill), and says, "That's how much a wife, two kids, and a house costs!"

Next, he created a business checking account and a business savings account. All of his freelance income would go into the business checking account. At the end of each month, he would "pay" himself by first putting 25 percent of his income into the business savings account (for Uncle Sam), with the rest transferred to his personal checking account. "My system," he remarks, "was to make sure that at the end of every month, after I paid all my bills, that there was still at least $3,000 left in the personal checking account. That way, if the phones stopped ringing for an entire month, we would be able to pay our bills without taking any action. If there was a surplus (over $3,000), we typically put that into our personal savings."

Allen always keeps at least three months of income in the personal savings, just in case a bad month turns into a bad quarter, or worse. So far his system has worked exceedingly well; it reduces any panic during a slow month simply because the current month is essentially already paid for. On the other hand, it also helps Allen regulate what should go into savings during the good or great months. "It forces me to put that extra money into savings," he smiles, "and not into Best Buy."

## MAKE YOUR MARK (FOLKS JUST LIKE YOU)

### STEINBERG: AWARENESS

Anna Steinberg lives and works in London, England. She reminds you to be intimately aware of your competition, but to remember that you are also part of a larger creative community. "Illustrators, writers, photographers, musicians—we all face similar challenges of copyright grabs and lowering fees," she says. "Your actions, both positive and negative will have repercussions for you and others. So keep in touch with trade associations and keep in line with good industry practice. You'll need to be assertive at times, but keep friendly and professional."

Steinberg knows that it's smart to be keenly aware of what's going on in the world of illustration, but, as she says, "Don't become obsessed by it. There's a risk of becoming self-conscious about fashion and mimicking work. The best work comes from honesty.

"Look at contemporary illustration for *interest*. But for *inspiration*, look wider—to the theatre, nature, people, animals, science, history, poetry . . . even your mistakes."

## DANCE AS FAST AS YOU CAN

Freelancing is a bit of a furious ballet—it is a dance of responsibilities that will keep you on your toes. Steinberg says it's unlikely that any one person will relish the total job description, but she advises you to stay the course.

"You must keep steady and learn the steps," she says. "Apart from creative challenges, there are the intricacies of self-promotion, negotiating fees and contracts, good communication with clients, meeting deadlines, and managing your accounts. All this means that you must stay positive and tackle the stuff that doesn't come naturally with strong research and bold effort.

"To keep on top of your work, devise a system that suits you," says Steinberg, who points out that the unpredictable nature of freelance work demands a solid structure to keep it all under control. "For example, mark deadlines on a calendar, keep records of the details of each commission, have a good filing system," she says. "The best illustrator in the world will stumble if she forgets to send invoices.

"People often refer to 'reading the small print,' but this is not enough," Steinberg says. "It's no good reading a contract, not understanding it, and signing off anyway. And reading the paperwork, knowing it contains stinking terms, and *still* signing it, is just as detrimental. You need to read it, understand it, and act on any concerns."

# MONITORING EXPENSES AND INCOME

Income, simply stated, is money coming in. Expenses are obviously monies going out. When you balance your expenses against your income, you end up totaling one column and comparing it to the other. This method is much like balancing a checkbook and is commonly known as the cash method of accounting.

The accrual method, where expenses are matched to, and directly offset by the income generated by the jobs they are spent on, may be somewhat impractical for an illustration (or design) studio—keeping track of watercolor paper or pens used on a per job basis is not practical. For tax purposes you can choose either the cash or accrual method, but you must stay with that choice for at least six months. Your accountant can help you choose which method is best for you.

On the freelance or small-business level, bookkeeping (keeping tabs on expenditures and income) may be the only accounting you do, so keep good records. In fact, keeping track of what you're taking in and spending is crucial in order to supply records to your accountant, bank, and the IRS.

## THE GOING RATE

Rates for a particular job depend on several factors. First, off the top: the deadline. A rush deadline always means more money. Second, the clients: are they local, regional, or national? Third, the usage: an all rights or buy out sale should also mean more money. What does the deal involve? One time or multiple usages? Print, TV, Internet . . . what? This small checklist just gets us started; for more on pricing, see Chapter 9.

## STAYING ON TRACK

Keeping track of your expenses (debits) and income (credits) is easy with a ledger and disbursement journal (also called a payroll journal, or cash disbursement journal) that chronologically lists all business exchanges. The ledger categorizes this information according to IRS classifications for tax-deductible business expenses.

In fact, you can order checkbooks that contain their own ledgers or disbursement sheets. And by organizing your expenses into categories that comply with IRS guidelines, you are also complying with the IRS's requirements for a "contemporaneous log of expenses."

Of course, you can go online or digital with a desktop log—computerize your books! You may want to create an Excel spreadsheet or explore the wide variety of good, small, inexpensive financial programs available for the Macintosh or PC. Quickbooks or Sage 50, what used to be called Peachtree, come to mind. There's the gamut of expensive, high-powered packages, as well.

You could even fabricate a custom-made ledger if you're particularly cost-conscious or the digital approach is somehow too high-tech. However, a simple, inexpensive check-writing program (or online service) may be all—and just what—you need. Old schoolers can use the classic Dome Book (a "general ledger") or another "one-write" traditional system. The good folks at Dome actually advertise with the slogan "No Hard Drive, No Headaches"!

But your accountant may advise you that digital technology greatly improves your efficiency and overall bookkeeping by keeping your administrative time to a minimum. These professionals understand from experience that, while it might be hard to break the habit of writing checks by hand, check writing software or online checking could save you valuable hours in the long run.

I won't strenuously recommend that you toss your checkbook (or get rid of a one-write setup and general ledger pegboard). These venerable systems maintain to this day, and only you can determine what's truly "easy and efficient" for your purposes. I can't say that digital bookkeeping is a business must,

but that grand ol' (and ever so relevant) saying, "Time is money," also carries on. Think it through.

## ORGANIZING YOUR FINANCIAL RECORDS

In addition to your ledger and journal, and above and beyond the decision to go digital there, you will also need to maintain files—both on paper and/or digital—to track client invoices, and any other invoices you receive and pay in the course of doing business.

The digital metaphors of files, folders, and a desktop are not accidental. The real-world equivalents of such office organization established the template, so my generic wording here should make perfect sense. You can manage client invoices by setting up three folders, one each for paid, unpaid, and partially paid. When you receive full payment, note the date on your invoice and transfer it to the paid file. If you receive partial payment, note the date on your invoice and transfer it to the partially paid folder. When you receive the remaining balance, transfer the invoice to the paid folder.

You will also need to set up an accounts payable file. This would include all project-related invoices you receive as well as your business expenses (phone bills, utilities, and rent). One good method of keeping track is to maintain a file for each day of the month, numbered consecutively. When an invoice comes in on the 20th of a given month, put it in the folder marked "20." On the 20th of the following month, before you insert any new invoices for that day, pull the old invoices that you inserted on the 20th of the last month and pay them that day. This method ensures that you pay all invoices on time, but not until payment is due, which as Larissa Kisielewska reminds us, maximizes your cash flow in case of unforeseen emergencies.

You may also want to maintain the following records as a supplement to the accounting systems mentioned above: A cash expense log for meals, travel, and entertainment (if there are no receipts or inadequate receipts); an appointment (and business) event diary as well as a travel log for your car to record business-related mileage and tolls; a method of allocating expenses that are both personal and business (rent or mortgage, utilities, phone, and cleaning) if you work at home. Do all this notation on your smartphone, iPod, or iPad (or similar); on your laptop or desktop computer; or even on paper—but do it.

# YOUR IRS OBLIGATIONS

If you are self-employed, anywhere from 25–40 percent of every profit dollar should be set aside for taxes. Be sure to put money away periodically to meet your tax obligations. You are required by law to file quarterly returns with the IRS on April 15, June 15, September 15, and then January 15 of that next year. (These dates may vary by a day or two in any given calendar year.)

Don't forget that you will also need to pay Self-Employment Social Security taxes, based on what you (as your own employer) owe. Your old employer used to make these deductions from your paycheck, but as a self-employed illustrator, you are now obligated to pay this tax yourself. This tax is paid annually and filed with your regular tax return on April 15.

## RIGHT AROUND THE CORNER

I will repeat myself here; trust me, you'll thank me for it: Plan now for retirement. Deferred savings plans make good sense for your future. But profit sharing is too complicated, and pension plans are right for higher incomes or larger corporations with a great number of employees. However, there are alternatives for the sole proprietor (that's you).

I am not a financial guru, nor do I play one on TV. What follows is merely an introduction to some options, not specific tax advice or financial guidelines. Yes, we live in a great age of information technology. The modern "do-it-yourself, get the job done right" spirit is strong indeed. Maybe you do have the knowledge base and inclination to do your own financial planning. But even the sharpest of my financially savvy compadres seek out a financial professional for current information and expert counseling.

Needless to say, the economic climate and forecast is always subject to change. But the roller coaster ride of our economy can be well managed by those making a living at this sort of thing. And while the best place for your money will vary at any given time (depending on your age and income at that moment), these folks know ways to minimize taxes and provide for retirement.

## HAVE A PLAN

IRAs (Individual Retirement Accounts) currently allow you to save up to some $5,000 of your annual income in tax-deferred savings. SEP (Simplified Employee Pension) plans allow you to invest more than IRAs permit. Available to any self-employed individual, you can contribute up to 13 percent of your net income, and there's a minimum of red tape involved. IRA contributions must be made by the due date of the return, with extensions. Consult with your financial advisor, but check into:

▶ *Roth IRAs* permit you to contribute up to some $5,000, and are not tax deductible on your tax return. The advantage of a Roth IRA is that all the interest and capital gains are not taxable, ever. Regular IRAs are deductible on your personal tax return, but all gains are taxed when you receive distributions from the account.

> ▸ *Simple IRAs* or *Simple 401K* plans. Created in the mid '90s to help small businesses provide relatively inexpensive retirement plans for employers, both Simple IRAs and Simple 401K plans are fairly similar.
> ▸ *Keogh, pension, and/or profit sharing plans* that offer greater tax deductions, but involve more paperwork than the above options. These plans may include:
>   > ▸ *Money Purchase Pension Plans* (MPPPs). These allow you to contribute 20 percent or up to $30,000 a year. When you set up an MPPP, you designate the percentage of your income you'll be putting in each year, and stick to that percentage.
>   > ▸ *Profit sharing plans* are similar to MPPPs, letting you save up to 13.04 percent or $30,000 annually.
>   > ▸ *Defined benefit plans.* Based on calculating how much you need to contribute annually in order to receive a specified amount once you retire. You can contribute any amount of your income, even 100 percent. Costly and complex to set up (an actuary needs to make the calculations); recommended only for those who have high incomes and are close to retirement.

# TWISTER

Health insurance and life insurance and disability insurance. Oh my. Health insurance and life insurance and disability insurance. Oh my. Health insurance and life insurance and disability insurance . . . wait.

Perhaps, when contemplating insurance, one can feel like you've entered the Enchanted Forest, completely ignoring that blatantly ominous sign warning you to KEEP OUT! ADULTS ONLY. Gee, Toto—you certainly won't get much of an argument from a rational individual that the American health-care system is indeed the scary Wicked Witch of the West.

But, insurance is, shall we say, a necessary evil. And that same reasonable soul should carry insurance. Should you use different insurance carriers to meet specific needs? This works for many, but if you bundle plans (life insurance, disability, and health care) together with one carrier, you'll usually get better rates overall. Shop around for the right agent by checking out recommendations and referrals.

Let's skip down the Yellow Brick Road and do a light physical of some basic insurance coverage. And not to worry, you're still in Kansas. Toto, too? Toto, too.

## AN APPLE A DAY

Skimp elsewhere if you must, but get the best health plan you can afford. Don't make the mistake of thinking you can go even a day without medical coverage. You never know when lightning may strike and, with the exorbitant cost

of hospitalization and health care in general, you don't want to have to pay for medical expenses from your personal funds.

Group insurance rates are frequently lower than those you can obtain as an independent. Many group health care opportunities are available through professional organizations. Perhaps your local chamber of commerce can offer better rates than the group insurance available through arts-affiliated professional organizations.

Some have speculated that this situation exists because insurance companies view those involved in artistic professions as a high-risk group. Like it or not, professionals in the creative arts (including the visual arts) have been excluded in years past from the kinds of preferential rates available to other professional groups.

Investigate alternative sources (like locally based, self-insured funds for printers and those affiliated with the prepress end of the graphic arts industry). An independent insurance agent in your area can usually give you the needed information on such group opportunities.

### FOR THE LIFE OF ME

Do you *need* life insurance? A complicated question that demands critical research and solid financial counsel. Life insurance is an investment. As such, life insurance may offer various investment options (even cash accumulations or payments). It can be the financial safety net for your dependents in the event of your death—protecting or paying off a mortgage; replacing your now "lost" income; covering the benignly labeled "final" expenses (funeral, burial, medical costs); paying off debt or real estate taxes, buying a partner's business shares; maybe providing funding for your kid's college bills.

Term life insurance covers you for a specific range of years (typically 10–30) and pays out only during that term. Whole life (also known as permanent life) pays off when you die. Premiums depend, of course, on the type of policy you elect.

As with anything, how much you need varies with an individual: how much you earn and how much you've saved; how much—and what—your family will need and for how long.

### TEMPORARILY ABLED, PERHAPS?

Explore disability income insurance. If you are laid up, you not only lose your salary, but risk losing your business as well. When determining what kind of coverage you should look into, take into consideration all of your personal obligations, such as mortgages and dependents. Shop for the best coverage rather than the lowest premium.

Consider a noncancellable policy with guaranteed renewal. This will forbid the insurer from terminating your policy or increasing your premium after an initial two-year contestability period has passed. Also, check out policies with a cost of living adjustment that will help you keep pace with inflation.

### *The Best Policy*

Finally, if you are in good health, you might even find out from your agent that an independent policy will be a better deal than any group benefits. Ensure you will obtain the best rates by bypassing obvious risk factors (don't smoke) and preventing peril (install safety equipment).

Consider a number of alternatives when shopping for the best deal. For instance, if you feel your only need is to cover yourself in an emergency, you may want to opt for low premium payments on a health policy with a big deductible. On the other hand, if you have a family to take care of, a Health Maintenance Organization (HMO) can provide for emergencies as well as offer reduced rates for checkups and other medical needs.

And once you've found an insurance carrier, diffuse hassles and make sure you are adequately compensated for claims by making personal copies of all claim records.

## COVER ME

When considering the overall picture of insurance for you and your business, investigate these standard areas of coverage when you're starting up, and buy accordingly:

- **Valuable papers:** Compensates for loss of stolen or damaged artwork and files by covering research time, labor, and materials involved. This type of insurance is extremely important when you consider the replacement value of original artwork (digital or otherwise), transparencies, films, and general files.
- **Property and liability:** Covers damage to your studio's contents in the event of burglary, robbery, vandalism, or fire and water damage.
- **Liability:** Covers injury to any nonemployee on your premises. Things can happen, like a client slipping on the stairs, acts of God, and whatnot.
- **Business interruption:** Replaces lost profits if your business is temporarily shut down because of damages to the premises.
- **Auto insurance:** If you're using your car for business and let someone else on your staff drive it, you'll need to add them to your policy.
- **Disability and/or workman's compensation:** Covers injuries incurred on the job to anyone employed by you (required in most states).
- **Computer equipment:** Additional coverage beyond general contents in the event of damage by such things as fire or vandalism. This might also cover the cost of renting replacement equipment while your equipment is being repaired.
- **Finally, if you're working out of your home,** you'll want to add a rider on your current homeowner's or renter's insurance to cover damage and theft of your studio property.

## PUTTING MONEY BACK INTO YOUR STUDIO

Even if you've hit a windfall of profits, you should plan for the future by regularly investing some of the profits of your business in various accounts.

You'll want to invest a portion in a liquid account (a passbook savings or money market, for instance). Although this type of account won't yield a high interest rate, you'll still be getting some return on monies that are just as accessible to you as the cash in your checking account.

From there, check with your financial advisor, but consider divvying up the remainder of your savings into a variety of CD options, stocks, money market accounts, and mutual funds. The best return on any of these investments will vary at any given time, depending on the current economic situation, so shop around and look for the best alternatives to satisfy your short- and long-range goals. Lock in on the best interest rates available for the savings options that fit your unique needs.

## BIG BETTER BEST

No matter how grandiose your vision or how diminutive your scale, you must maintain a high quality in your work—sound advice when you consider that keeping the dollar value of your work up there is the fastest way to get to fat city. High-quality work is best achieved through carefully managing growth. Fail to anticipate and manage your workload and you might be unable to meet client demands.

There's an old axiom that says, "Be careful what you wish for—you just might get it." Many "big-time" illustrators I interviewed waxed romantically about the "good old days" when their rep and workload were more modest: a less hectic calendar, a daily schedule with more breathing room, nominal travel, less protocol. A simpler management style and relaxed procedures, moderate overhead, intimate assignments . . . the list goes on and on. More than a few yearned to downsize, or had done so already. Our economy taught life lessons to some who were financially forced to retrench or cut back. Several cautioned that a loss of quality often accompanies rapid or great growth.

Everybody started on a modest scale, most working out of home. But small potatoes or big cheese, all the illustrators interviewed for this book evangelize about only giving product excellence and superior service. The size of the operation has little to do with success—it's an individual thing.

## LOAN WOLF

See Chapter 5 for our initial discussion about loans. But it makes perfect sense to revisit loan info for this chapter. Remember the essential questions: do you have a good credit history and are of sound character? You may have a decent chance of getting a loan

after having established yourself in business for two to three years; you might be able to finance a small loan for a piece of equipment after one to two years in business.

Start your studio with a solid plan for money management and then consistently follow through to improve your chances of getting that loan, if you need one. Keep good financial records from the beginning so you can easily demonstrate to a skeptical banker why you deserve a loan.

### STEPS

Here are steps you can take to become an educated loan applicant when you need additional funds:

1. Be realistic. The odds are just not good.
2. Go to your accountant for referrals.
3. Shop around. Evaluate at least three separate banks.
4. Build a professional and personal relationship with a bank long before you need a loan.
5. Reduce your overall debt before you apply for a loan. Establish a solid credit history.
6. Do your homework. Write a complete business plan (or, at least, prepare a loan package; see below).
7. Be able to explain why you need the loan, how much you need, and how the money will be used.
8. Know what kind of loan you want.
9. Draft a proposal or create a presentation with facts, figures, and visuals.
10. Know how and when the debt will be repaid. Be comfortable with the structure and terms of the deal.

## CHUNKS

Depending on your financial picture, you could elect to repay a loan as a single payment. Maybe you'll pay off the loan in installments that decrease the principal with remaining interest computed on the unpaid balance.

What you pay on a monthly basis must fit in with your cash flow. A four-year loan lowers your monthly payments, but will ultimately cost you more in interest. Can you pay off the loan early or will you be hit with prepayment penalties?

Evaluate rates, study the language, assess your options. Most loans these days are simple interest loans. Should you go with a variable rate, fixed rate, or semi-fixed-rate loan? If you go with a variable rate, is there a ceiling on how high that rate can go (and a floor to which it can fall)? If you get a fixed rate, will there be an annual adjustment? Does your lender say, "Sure, I'll give you a fixed rate, but I'm going to fix it annually at 5 percent over prime"?

Uh . . . and what the heck does that mean? The "prime rate" is the consistent rate of interest—the oft-called reference or base rate—at which banks will lend to creditworthy borrowers (customers with good credit). Some variable interest rates may be expressed as a percentage above or below the prime rate. Make sure that the "prime rate" you are quoted has been established by the Treasury Index.

While it is true that little percentage points add up to big bucks, you can't predict if (or when) interest rates will go up or down. You could lose your best opportunity by waiting until rates are at their lowest point.

## BRASS TACKS

I must vigorously repeat this: understand your total loan agreement completely. Don't just look at the dollar cost of the loan—it comes down to securing the best rate and terms you can get (and live with).

Turn down the extras. You don't need the bank's credit, life, or disability insurance. These options aren't mandatory and only jack up the end costs of the loan. Decline a loan calculated under the so-called "Rule of 78s," a prepayment strategy—penalty, actually—unfavorable to the borrower. Check your paperwork.

## PACKAGE GOODS

You'll need to prepare a loan package before making your presentation to the bank. Again, please refer to Chapter 5 for more on all this, but here's a check-list to prime that pump. The formal document should cover the last three years (remember the current quarter, too) and include:

- Studio history (one page)
- Your résumé (one page)
- Statement about use of loan process. A simple but specific list of categories and amounts is fine. However, a comprehensive business plan could be a big plus. (See Chapters 2, 3, 5, and 6 for related information.)
- Profit and loss statement, including balance sheets and a record of current accounts receivable and payable
- Cash flow statement
- Three-year cash flow projection
- Statement of your pricing terms and policies
- Personal and business tax returns (ask how many years)
- Equipment index
- Customer and supplier references (three to five for each)
- Personal guaranty. A word here: Unfortunately, most lenders will insist you personally guarantee a loan. It's a considerable risk, but you'll just have to bite the bullet. Look at a personal guaranty as yet another means of showing the bank that you are a good gamble.

# DEVIL'S ADVOCATE

You're no doubt aware that, when starting out, you need to get familiar with laws protecting your copyrights, and gain understanding of intellectual property, fair use, and work for hire. It's only smart. Professional organizations like the Graphic Artists Guild push this all the time.

And Kristine Putt agrees completely. But she's also not afraid to walk a bit on the wild side and says, "However, you should also know when to break the rules." It's a topic Putt says she's well aware of, but something not often discussed (and based on her experience, it's even somewhat taboo). Here's Putt's story:

"When I first started out," she says, "I was a stickler to 'policy' and actually wound up losing clients. Ouch! I thought that maintaining a strict code of ethics was doing the right thing; the only thing. But I eventually developed a rep for being 'difficult.'

"You have to know when to lay down the law, but also realize when to trust your instinct and walk away. Understand when—and where—you'd be willing to bend in good conscience."

Putt admits it's a tricky conundrum, boiling down to knowing yourself, understanding your customer base (and what kind of customer you are committed to serve) plus, as she puts it, "how personally you take what some may deem as—rightly or wrongly—abuse. It may come down to a question of balance—the balance between what you know is right, and what you feel is best.

"We're creatives," Putt says, smiling. "We are emotional. We take things personally . . . and then pretend that we don't. You have to let stuff go sometimes or it will eat your soul. Be flexible. I know it's hard. It can make us feel we've been taken advantage of.

"But you must realistically step away from those feelings and separate fact from fiction. When you make a mistake, just own up when it's your error. Let it go when that's prudent. Learn from either scenario, and then don't allow it to happen again. Go to the mat with a customer when necessary, obviously, but make sure client squabbles are completely and realistically grounded in professional ethics and practice."

And she adamantly advises you to pick your battles carefully. For instance, usage rights must be scrupulously negotiated—and agreed to—before the agreement is signed and work commences. You live in the present, but think "big picture," and plan for the "long run."

Now, when it boils down to payment? Putt steadfastly says to make no exceptions. "Be absolutely ruthless about collections," she says. "I once made a surprise, unexpected visit to a client's office and sat in his lobby for three hours while I waited for him to come out of a meeting, just so I could get my check."

# THE KICK

Are you putting in too many hours, not making enough money, perhaps even overwhelmed with grunt work? Those are problems many illustrators wrestle with when kicking off their own businesses.

You might need to sit back and try to define—or redefine—your role. Write a job description for yourself. What are your strengths? Weaknesses (be honest)? How will you best use your time? Think this out a bit; you may not be able to do everything all by yourself . . . Or are there other issues to resolve?

## A LITTLE ASSIST

At start-up, odds are you'll be doing it all. Salaries can take a bite out of your budget, but at some point you just may need to hire some help.

No doubt, when the time comes, you'll know what kind of help you most need. If you find yourself spending too much time answering the phone, organizing the studio, or doing clerical tasks, you obviously want to free yourself to do the work that generates the income. So it makes good economic sense to cover that crunch by farming out entry- or intermediate-level tasks to a freelancer or staff.

By definition or default, freelance illustrators are solo operations. However, larger, multiple, or complex projects may require you to build a support team and learn to effectively lead, manage, and delegate. This might mean tapping into different creative, mechanical, and logistical solutions. Perhaps adding to your knowledge base will enable you to be more efficient.

# RETHINK

Every year the competition appears to gets tougher, it looks like prices get lower, and clients seem to demand more in less time. What else is new? Snap out of it—it has always been thus and forever will be.

Look at what kind of work you have now and consider the work you want to do for the future—info only you know. There may be bigger fish in the waters of opportunity, bigger projects boasting larger budgets, with stuff of merit, challenge, and substance. What's preventing you from going after them?

Oh, so your portfolio doesn't include work that those clients could relate to? Truth or dare—proactively show what you would do if you had the chance. I'm not talking about working on spec. Work hard to create an outstanding portfolio that showcases your smart thinking and stand-out talent. It's this illustration that can attract exactly the kind of clientele you seek.

Yes, it will take time, but consider the potential rewards, big and small. Not only better budgets and higher visibility, but less paperwork too. What if you sent out six invoices for $2,000 each instead of twenty invoices for $600 each? Wouldn't this make your life a bit easier, your business more profitable, and satisfy your soul? Hey, I'm just saying.

# I'LL MANAGE

Are you able to devote *at least* half your time to actually doing your illustration, especially the type of assignments that tickled your artful fancy in the first place? Your business won't be worth a grain of graphite if you can't *create*. But in reality, some of your time must be spent finding and grooming new clients and doing administrative tasks, otherwise you won't be in business long enough to fund your art.

If you're like many of us, you may find your days filled with minutiae that eat up too many hours (like answering every email that comes your way). Here's one suggestion: triage your email and phone calls. During business hours, only answer those emails and take those calls that are essential to (a) getting new business (b) doing a better job on the business you already have.

Sound simple? Try it! And no tweeting more than three times a day!

## MAKE YOUR MARK (FOLKS JUST LIKE YOU)

### KETELHUT: GOAL!

"Regular evaluation is critical," says Ketelhut. "It's important to set goals and check in with yourself to make sure you're on track and are fulfilled in the work you're doing.

"Be realistic as you go about building a viable career. Maybe you'll find success right out of the gate or there may be ebbs and flows and patching together an income—it's different for everyone. The constant drive to challenge yourself and maintain a balance keeps you on your toes.

"As I grow as a person, so does my art. A market that I once wanted to pursue may no longer be the best fit for me. Being an artist is not easy, if you lose that passion, if it stops being fun without a fulfilling purpose, it's time to reconnect to why you're doing it and see how to get back to a place that makes you happy."

Know your limitations. Get help if you need it. I think you can handle as much as you can handle. For me that means, no—I cannot do it all. I don't want to spread myself so thin that I lose the joy of making art or have no life outside of art.

### IT'S DUE

Talent alone is no guarantee of success. Rather, the key is your ability plus lots of elbow grease, coupled with intensive customer service, energetic marketing/self-promotion, and a sharp business strategy.

And a keen-edged business acumen embraces the chops to smartly discuss estimates (whether you are working with new or established businesses).

Don't be pressured into talking money or cutting a deal on the spot; when you need the time, take it. Don't be afraid to ask for what you need to do the assignment; be prepared to say no and maybe lose the job. Approach all negotiations with open eyes and mind. Remember that negotiation is a bit of a game and it's all a learning process. Nobody's shooting at you. Actually, life is one long negotiation, so you're fairly seasoned already.

Always get a contract on the outset of an assignment and do it from your end. A letter of confirmation may be wise, and it could even be a short thank-you note outlining the terms of the agreement and job specifications. Simply describe what you expect to furnish, how much you expect to be paid, and when—no legalese needed, just plain, polite talk spelling out the agreed arrangement.

If the client looks shaky for some reason and you still take the job (brave soul), you can minimize your risk by asking for payments at various key points along the road to completion.

## SIGNED, SEALED . . .

It's true, you can always build a "pain-in-the-butt" factor into your estimate, raising your prices accordingly to compensate for the inevitable conflict you're about to endure. But why bother?

If your experience, radar, or research tells you that a client is dubious, you don't need the aggravation or the bucks. There is no adequate compensation for time spent in hell, despite the invaluable lesson learned. Better to politely decline and move on. If the potential payoff proves too alluring, know what you're getting into. Seatbelts on! Enjoy the ride and may the Force be with you.

Of course, you must get all particulars down in writing and signed by the client. Make sure your proposals and estimates state specifically what is included in the fee, including the number of meetings and presentations, as well as the number of revisions the client can request.

And make sure the client understands that additional work and revisions will indeed be actually billed as additional, and that out-of-pocket expenses are not included in the fee. Here, professional practice mandates that you can add 15 percent to 20 percent to the price you pay for items purchased on the client's behalf (printing; photography that you negotiate rates for, hire and supervise; messengers and delivery, too).

## . . . AND DELIVERED

Then you have to deliver the goods—and provide clients with the high level of service that should come with a relationship with a real live, professional illustrator, not just an online, anonymous vendor of clip or stock art.

And, of course, make sure you get paid, and paid on time, for everything you've done! Plan and bill your work in phases. At the completion of each phase, send an itemized invoice with clearly described line items—the quoted fee; billable client-requested additions and changes; itemized expenses (marked up); and sales tax, if applicable.

How about uncollected or late funds? If anything goes over thirty days, send the client a friendly email reminder (or pick up the phone).

# ON THE BOARD
(PROFESSIONAL VIEWPOINTS IN 50 WORDS OR LESS)

Selling is not bullshit, it's problem solving.

—Paul Melia

Managing unpredictable earnings means you'll juggle quiet months with big chunks of income (which may have to last over some time). A secondary source of revenue just may be the necessary balance that frees you from saying yes to clients you'd rather say no to.

—Anna Steinberg

Service is the best way to build a solid business. You'll jump off a few bridges to make that happen, but you try to make it look very easy.

—Dan Johnson (deceased)

I prefer to pick and choose my clients. I've learned that I can say "no" to a job, even if it's the only offer I've had for a week. You know, some people are just hard to work with.

—Adela Grace Jackson

© Scott Bakal 2016

Creating your own illustration studio is a permanent ongoing project. It could be the best project of your life. The management part can either be learned or solved.

—Ken Bullock

"Selling it" is less about being a used car salesman, more about meeting people. Be creative about where and how you network. You can't hide in a dark corner, you must engage. Be fluid. Adapt. Respond.

—Allan Wood

© DingDing Studio 2015

© Chris Haughton 2016

# Section III
## Taking Charge

# chapter 8

# clients

Your elevator pitch is not about you. The homepage of your website is not about you. Your pricing isn't about you. Realize that it's all about them—your clients and prospects. Master that mindset and you'll know exactly what to do and say, even in the stickiest of situations.

—Ilise Benun

## MATCH GAME

Our opening quote is from Ilise Benun, who offers invaluable business insights and sharp marketing strategies like this through her Marketing-Mentor.com site.

Finding clients who need your services is a bit like working with a dating service. You're matchmaking, pairing your special abilities with the folks who have the greatest need for them. This sounds simple, but figuring out where to focus your energies involves some thought and planning. It might be best to first break your possibilities down into several categories to isolate where potential business may be. Find out where, and if, the shoe fits. This is a good "problem" to have.

In addition to thinking about where you can market your work, also reflect on your level of proficiency and match your skills accordingly with prospective clients. Consider your illustration style(s) and how this matches up with those potential customers. Does the work in your portfolio display a trendy, freewheeling line style that could appeal to an edgier, younger crowd? Is your illustration tight and lean, maybe traditional or conservative; is it geared to an older market?

If you're just starting out in your career, it may be prudent to sound out smaller, local clientele before you approach national markets (or even larger concerns in your city). While you don't need my blessing, it's just wise to realize that until you've gained some experience and credibility, baby steps are okay and nothing to be ashamed of.

Initially, your illustration skills may be better suited to smaller locals than to big-time corporate yokels (found downtown, worldwide). But I'm rather the gut-level, free-range marketer—so if you tack toward "no guts, no glory," I still say go for it.

## BUSINESS IN MIND

We've talked in earlier chapters about why illustrators may not be as business-minded as they should be. Likewise, many might not be exceedingly functional salespeople either. Perhaps the problem is one of attitude rather than a lack of ability. Maybe illustrators fear the image of some high-pressure huckster peddling substandard, unwanted goods. Perhaps they hold the mistaken notion that any sales activity is below their creative station.

Total bull. In truth, sales are the lifeblood of our business; so how do we get past these counterproductive notions? It might help to understand that you are calling on clients *to see if you can help.* So think *How can I help you?* instead of *Do you want to buy?* Change the mindset from you selling work to you helping with a snag in communications.

You need to sell. If you're convinced that by doing so you're reduced to pushing snake oil, your business will go nowhere. It's crucial that you believe in what you are doing, and what you are doing is solving problems—a most valuable service and worthwhile endeavor. If you must sell something to make a living, creative solutions make for a wonderful product. Don't you agree?

In this chapter you'll learn more about how to sell this potent elixir, where to find clients and how to make effective—no, truly dynamic—presentations. You'll find out how to keep clients hungry for more so you won't have to go out on a sales hunt after every new job. Let's get busy!

## WHY FREELANCE?

Freedom, self-expression, working for yourself, improving as an illustrator. There are myriad reasons why freelancing is a sweet, productive means to a brilliant, artistic end. And clients are at the heart of the creative matter.

"I love working with clients to produce an image that makes us both happy," says Julia Minamata. "The problem-solving aspect of illustration really appeals to me. And I think I'm an effective communicator. I hope I am! The only way I've been able to judge this is if the client is happy with my work."

As Kelly White will tell you, there are multiple ways to find clients. "You just have to offer something they're looking for," she says, "and do it better than the guy standing next to you who's trying to get their business too."

## BETTER THAN THE NEXT GUY

So how *does* one "do it better than the next guy"? One classical approach is to acutely shotgun your customer service. Bil Donovan is of the mindset that, as a professional, his job is to make the life of the client easier. "I know I am there for a reason," he says, "to provide a solution. And if I am there, that means that the client has seen something in my work that resonates with the project and their vision for the project. That will give you some leverage."

Donovan says he's never tried to "sell himself"—it's just not his style. He feels he is providing a service as a commercial illustrator. If he's not the right fit, then, as he says, "Rest assured, the job will be problematic. I am respectful and polite, yet firm in not compromising my work. That is foremost in my experience."

Donovan reiterates that as illustrators, we are in a field of providing a service. "As distasteful as that might sound," he says, "that is the reality of our position. We are vendors. The client is the client. Think of how you have experienced good and bad customer service and treat the client as you would like to be treated."

You shouldn't need Donovan to remind you that politeness goes a long way, that it's counterproductive to be shy about throwing your ideas into the ring, that you must speak up if you feel your work is being compromised. (Yes, this is a delicate balance, but sometimes necessary.) I'll bet you also understand that completely engaging in an assignment will win you the confidence and loyalty of your client. Says Donovan, "I enter every project as if it is the most important job I have ever had."

Do as Donovan does, and on any given day, you will indeed be "doing it better" than the guy next door.

# MAKE YOUR MARK (FOLKS JUST LIKE YOU)

## SHAPIRO: AN ART DIRECTOR'S POINT OF VIEW

Ellen Shapiro is a New York–based graphic designer who's been working with freelance illustrators as long as she can remember.

"I'm always trying to sell my clients on the benefits of illustration," Shapiro says, "but too many of them aren't buying. They are in love with almost-free stock photography, the speed of it, and the vast number of choices."

Shapiro, author of many magazine articles about the business of design and illustration and *The Graphic Designer's Guide to Clients* (Allworth, 2014), tells us that many clients don't want to take the time to deal with what she they see as the "uncertainties of illustration"—deciding on a concept, waiting for sketches, revisions, and finished art. "All along, they're worrying that the CEO or chairman might reject the whole project," she says. "Clients have already gone through the myriad steps of selecting the design firm and they often don't want another layer, another creative to deal with, the unknown illustrator who could be a 'goofy, unreliable, emotional' artiste."

But Shapiro works to make the sale anyway, pushing the benefits of illustration. "I emphasize that illustration is much more interesting. It has style. It is conceptual," she asserts. "But too many clients think that you can just push a button and an illustration pops up. And, unfortunately, with so much free or cheap vector art available, hiring an illustrator is a much harder sell now than it was a decade or two ago."

And that is why Shapiro urges illustrators to be even better at making art and better still at doing business. "When I sell the idea of illustration, the next hurdle is *original* illustration, not stock. I tell them, 'You will get something fresh. None of your competitors will have it. It will distinguish you and your product or service in a way stock could never do. You can be part of its creation.'"

If her clients agree—hallelujah—next comes the hurdle of pricing. Why, clients want to know, should we pay $1,000 or more when there is all that "cool vector art on iStock for one credit, for like $15?"

That's where an art director's power of persuasion has to come in. To promote you, they must deal with all that, get approval of the budget, and then, perhaps, haggle with the client about the concept. Says Shapiro: "It will go something like this . . . Should the bird be in the cage or flying out? Is the heart broken in half or only cracked?'

"Suddenly, every communications manager or business owner is a creative genius!" Shapiro says, with a laugh. "But we have to keep them from getting too creative and make sure they let the illustrator do his or her job. The whole idea is that original illustration, in addition to being beautiful, can be daring, unusual, thought-provoking. I suspect that magazine art directors have an easier time of this than brochure/collateral/website designers."

As Shapiro points out, this is the moment when most clients reveal how much they fear for their lives. "They waffle when the concept isn't something safe and predictable," she says. "I have to be my most professional, experienced, charming, persuasive, and sell the illustrator. And I have to sell the client on the idea of letting the illustrator be the one who will come up with the right concept. In order to do that, I need to be as certain as possible that this artist is going to make me—and my client—into a *hero*, not a laughingstock."

So sketches are important. Art directors can't be left wondering whether they've made a good decision. To Shapiro, the whole illustration business boils down to one thing: *talent.* "Are you able to take a germ of an idea and transform it into something beautiful and astonishing," Shapiro asks, "something exciting that communicates what the client needs to say?"

If the sketches are too rough, if Shapiro can't tell what's going on, she knows her client won't have a clue. And if it seems like you spent more time negotiating the contract and usage rights than doing the sketches, she must then ask you some hard questions: Did you have enough time in your schedule to give this assignment justice? Did you think about it deeply, give the project the attention it deserves? Or did you just recycle one of the old ideas in your portfolio—oh no, not that tightrope again!—or copy an idea from last year's illustration annual winners? "Some illustrators are so good they can communicate a brilliant idea in a scribble," Shapiro notes, "*but can you?*"

Finished art often has its own set of challenges: "Does the illustration actually fit the layout?" she asks. "Is it printable? Did you send CMYK artwork for a two-color job (even though the requirements were clear)? Is the concept appropriate? If not, in the end, it won't matter that your ideas are clever, the style is hip, the colors are beautiful, the characters interesting and diverse," she says. "If the illustration has a 'fatal flaw,' the project will get killed."

However, when Shapiro looks at the projects her firm has produced over the last few decades, it's the ones with original illustrations, not photography, that are the most outstanding. These are the assignments that boast the greatest staying power as *communications pieces.* "They were done in collaboration with freelance illustrators who did their job well, and who ultimately made my client into a hero," she says with satisfaction.

## GET A JOB

"I wish I could say that 100 percent of my clients have been great," Rick Antolic says with a half smile, "but that's not the case." Oh, now don't get him completely wrong. For the most part, Antolic's customer relationships have been super, an experience with clients he summed up as open-minded and flexible; supportive, helpful, and certainly task-driven. "It's been clear that my clients expect me to accomplish a job in a professional manner and operate from this

strong suit themselves," he says. "It seems to me I've enjoyed some near perfect working relationships."

Working from that vantage point, those gigs that fall short of this high bench just may stay with the Pittsburgh native. "I still think about certain projects from time to time," he says as he diplomatically considers previous, shall we say, *educational* encounters with clients. These jobs explored the issues of mutual trust and respect, and prompt Antolic to ponder future opportunities to let go of the end product as the core issue.

Yes—obviously—the client matters, and the assignment does count. Good work is always important, and the finished product is perhaps the actual main event. "But," says Antolic, "what the client does with the art—within the bounds of ethics and legalities, of course, and once it's out of my hands, doesn't have to be the heart of the job."

## BALANCING ACT

There is no such thing as real "job security." On staff or on call, freelance or full-time—with time and circumstance, anything can happen, at any time, to anyone up or down the professional ladder. "The value in having a talent or skill is that you can always freelance at your will if you must keep a day job," says Antolic. "All artists I know who work a day job also freelance on the side.

"There's a positive upside, obviously . . . the extra income, choosing what kind of assignments you take, avoiding jobs that don't advance your career, focusing on gigs that build the portfolio that *you* want.

"But a day job is not for everyone," Antolic says. "If you do have a day job, don't walk away from freelancing." I like that Antolic steered away from the usual advice here: don't quit your day job.

But either way you put it, and especially as a freelance illustrator, you'll have to accept that freedom to do "exactly what you want" isn't necessarily a constant or given. As George Coghill says, "People think it must be nice to not have a boss, but I tell them I have an endless succession of new bosses, each of which I must learn new personalities, idiosyncrasies, quirks, and challenges."

### NO WAY

There is *always* the choice to do exactly what you want—*no* is an easy word to say and spell. And what results after you say that simple no (or yes, for that matter) out loud is, well, what we call life.

You can always just play nice or be difficult; you can follow or ignore instructions; you can decline a job itself. The trick is to thrive in all these situations in any direction. As Antolic puts it, this is not a boring job and never has been.

## MEET THE PUBLIC

An offshoot of all this that can seriously test your power of yes and no is collaboration. Okay, you've already agreed to the gig. Now, can you work together as a team? Move over—and, dare we say it—who's in charge? "Many professionals," says Antolic, "including myself, can work effectively in both situations. Sure, you'll obviously prefer one over the other. Personally, I like depicting someone else's idea more than I like coming up with my own from scratch. I enjoy the opportunity to take the client's design and improve upon it—add, subtract, enhance, or even understate . . . change a little here, a little there to maximize the effectiveness of it."

Antolic recommends you definitely be open to collaboration. "I know this sounds cliché," he says, "but the greatest plus in doing all this is being in the public arena. So be prepared to work for all kinds of folks—Joe and Jane Public."

## MUCH TO DO (LIST) ABOUT CLIENTS

As Peter Arkle says, understanding clients is the most important thing. "I *love* working for clients I've worked for previously as I already know how they think. This makes everything easier."

New clients are an unknown and, for Arkle, more problematic and stressful. He approaches new client work relationships with care and prudence. "I send out feelers, ask questions, perhaps introduce a rough sketch. When I'm clear about what they want and how they want it, then I can have some fun. Hopefully I make them happier than they thought they ever would be."

So to keep and nurture clients:

- Do a job well; do it right; do a good job for them—whenever they need you; whatever they need you to do (within reason; honestly and ethically, of course).
- Deliver on time (or early).
- Check in; check back (even after the job is done).
- Show you care—demonstrate that their best interest is your first priority; listen.
- Reinforce through actions, not words. Show that you want the job to succeed. Better yet, demonstrate that you want the client to succeed—show interest in *their* business. You're a team; you're in this *together*.
- Keep your name fresh in the client's mind. Remind them you're there if they need you; ask how things are going. Wish them a Happy _____ (birthday, anniversary, holiday, whatever's mundane or extraordinary otherwise).

# BUSINESS CHOPS

We examined how to manage your business in Chapters 5, 6, 7, of course, but in light of this discussion about clients and the client relationship, Kelly White chuckles a bit here. "Business skills are extremely important, after all it *is* a business! *Your* business," she says emphatically. So how important are business skills? And what business skills do you need?

It bears repeating that the label *businessperson* may simply speak to your basic management skills (or maybe lack of): Are you forever late? Do you constantly change appointment times? Forgetful? Disorganized? Do you have a bit of a problem responding (to emails or phone calls) promptly?

"No client wants to do business with a person who comes across like they don't care," says White. "The sense of any project kicks off right here. Gain their business by demonstrating your interest and desire to help. *Show* you care about what the client has to say, how they think. *Treat your clients like you were the one calling for advice or help.* Be responsive and respond quickly.

"Work hard to understand the client's needs," she continues, "what they are trying to accomplish—and stress how you can help. Listen attentively and intently. Be open to discussion."

A client's learning curve—and thus, a job's positive progress and successful conclusion—may well be expressly based on what she knows (or doesn't know) about illustration and the illustration process. So the proverbial patience is the notorious virtue.

Along those lines, keep your problem-solving chops honed to a fine point as you'll need to explain options clearly and completely. If you can't, don't, or won't, how can you possibly expect to help your customer? "You must know how to achieve the results that lead to the solution," White concludes.

# ALL ATWITTER ABOUT SOCIAL MEDIA

Using social media is one of the favored methods to find work now. But we don't even need 140 characters to qualify that understatement.

"I think everyone has their own method of finding clients," White says. "Social media is absolutely a huge resource these days." She mentions that, at this writing, Facebook, Google+, Twitter, Pinterest, and Instagram, are all used to find clients. Another resource for finding work would be a local BNI (Business Network International) chapter—people swear by this group, as well as business-oriented social networking sites, like LinkedIn. You build a community around your practice and get people engaged in what your business is about and what's going on.

"Craigslist might come to mind immediately, and most art blogs and design websites have job boards," White says. "I have also heard of people doing searches for freelance jobs while using Tweetdeck (a social media dashboard application

for managing your Twitter and Facebook accounts) or using Google Alerts to find the newest postings of jobs for freelancers."

"I do most of my work remotely," Nadine Gilden says, picking up the thread. "I don't meet with clients much anymore, and I use online tools infinitely more than traditional methods for making contacts." As Gilden will also tell you, this takes some righteous time; you'll need to be "on"—actively engaged and dedicated to—social media, seriously getting to know people. But such concerted networking pays off by keeping you squarely on a client's radar.

"And for me," says Gilden, triangulating off the basic discussion, "when I do need to bring in outside resources on a project, I would sooner hire someone I know through Twitter. That is indeed how I usually find them." Gilden also qualifies that she doesn't do much print work, which she thinks requires more of an in-person relationship than online work.

Ellie Jabbour suggests you consider creating an online portfolio at sites like Behance (www.behance.net). In a later chapter, we discuss such sites as a way to directly present your work to prospective clients, but Behance and its sister sites are also used by clients searching for illustrators.

Finally, Kristine Putt joins the conversation here. Putt makes the point that, suffice it to say, most illustrators could accurately be labeled tech-savvy. So it may be easy to forget that not everyone is comfortable with digital communications, and not everybody will be tech-comfy because that's how *you* operate. "People may hire you for your illustration ability," Putt says, "but they will only be loyal to you for the manner in which you treat them. Make it easy for them to connect with you and they'll be your biggest fan for life."

## ALL JOIN IN

"You know, some illustrators actually find clients through family and friends!" says White. Beyond looking for business potential within your immediate sphere of influence, you should seek specific opportunities for networking that will yield referrals and leads. In addition to providing a good support system, professional groups, (locally, nationally, and globally) provide splendid opportunities to find potential markets in your area or the world.

Don't pass up the rich benefits of simply "joining the club": for example, the Society of Illustrators, Graphic Artists Guild, perhaps your local Art Directors Club, maybe the AIGA. When you attend meetings or events—especially local get-togethers, schmooze. Find out who's working for whom. Get some insider's information: Are the clients busy? What ad agencies and design studios are busy? Let your mates know you're ready to rock and roll, and you'd appreciate their referrals. You're not scrambling for scraps or dredging through the dregs, mind you; networking overflow is another story.

Contact professional groups affiliated with the communications field or other executive organizations. For instance, local groups for editors, writers, public relations specialists, designers, and ad clubs are often looking for support services. Members of these groups, or the organizations themselves, may need your illustration skills. The aforementioned collectives frequently publish and distribute directories for associates and other business professionals as a source of services in the community.

## LEADING INTERESTS

Niche markets, unexpected business opportunities, markets that didn't exist a few years back—all these ostensibly peripheral venues—can be viable.

"A number of my students jump in *before* they graduate," Benton Mahan will tell you. "Licensing is *big*. Internet comics. Character branding and product development. Online shops and convention sales. Web design. Speaker's gigs and self-publishing. Some illustrators are gravitating towards fine arts."

Look for potential business wherever you go. Remember again, that, while you are certainly offering a service, you're not selling that service so much as you're solving communications problems. All invested professionals want to improve their visibility and profitability.

### IT'S OUT THERE

Putting it mildly, the possibilities are out there, waiting for you to muscle in and wrassle 'em down. Think of ways your unique skills could be used to illustrate editorial, advertising, marketing, and promotional material for all types of clients.

At the regional to national, even international, level, possibilities are positively world-shaking. Certainly, it can shake *your* world. On the local level, your options may be more, well, down to earth, but are no less limiting. This may be realtors trying to sell property; restaurant branding, promotion, plus menu design; the oral surgeon struggling to explain procedures to patients and needing a brochure or handout that gently, *visually*, explains terms and practices. You get the picture you could be making—think about where your skills can best be applied.

Seeking out assignments at smaller venues that publish (or post) frequently can help you gain experience and develop skills on the job. "These clients may have a limited budget," Steven Hughes says, "but are more likely to take a risk on new talent."

Hughes tells me that art directors want to see if you can solve the problems *they* encounter on a day-to-day basis. The importance of research and getting to know your target market infinitely maximizes the impact of your portfolio in this regard. "This can't be emphasized enough," he says. "Learning which art

directors work for specific companies, what jobs they are commissioning, and who they are hiring can help you determine your place in the industry."

So Hughes advises you to compare and contrast. Who's doing work similar to yours? Where are they finding an outlet for their illustration? We are all looking at the Rock Star illustrators and seeing the high-profile gigs, but it's important to be realistic in your evaluation of your own portfolio.

And, says Hughes, "You may not be able to work for the *New Yorker* or get a book deal at Chronicle right away, but where can your images be used *right now*?"

## MAKE YOUR MARK (FOLKS JUST LIKE YOU)

### HULL: AMBASSADOR SWEET

Artist's Representative Scott Hull, the proclaimed "Visual Ambassador" of Scott Hull Associates, has been in business over thirty years. Serving over 9,000 customers, he says his agency was put on this earth to help build artists' confidence and creativity. "We didn't invent art, we didn't invent service," says Hull, "but we did pioneer this approach to artistic solutions—it's totally service-oriented. It's more than making pictures. Caring doesn't just make art more fun to create—it gets results, because the human element intrigues and engages people. That's one of those enduring truths."

Another truth implanted in the Hull philosophy is that a caring illustrator does his absolute best piece for the assignment, while at the same time cultivating his own personal style. "That's hard," says Hull. "It's not just worrying about whether your work will be perceived as art, but if it will be perceived as *your* art (while still getting the message across).

"There's an immediacy and an authenticity to the work of a talented illustrator, and it just shines right through. If you bring original thinking to a problem, if you can cause change, artists can be successful entrepreneurs.

"But there are those who might recoil in fear when they find out you're both a businessperson and an artist," Hull says with a grin.

"It's tricky. Illustration is hard to quantify. You can't duplicate the success of a great illustration because you can't duplicate the illustration. You know when you have a good one, but that intangibility—that certain quality of a piece of art that comes from a human being—frustrates the number-crunchers sometimes. It's just not a science, even though some people would like it to be."

Hull advises that we all be more aware of current changes in the creative environment. "Too many of us operate as though it's five years ago—or fifteen—when we need to be responding to changes in the ways people gather information," he says.

But Hull tells us that the movement *back* to organic, hands-on design is only a good thing. "It means that agencies and design groups seem to be searching for a way to connect with their consumers," says Hull, "not just get their attention for a fleeting moment." In Hull's seasoned estimation, illustration is a natural fit.

"Along with that has come a proliferation of illustration styles," Hull says. "There's so much out there now that designers can be specific about what they're after, and make sure they find the perfect art for their application."

In a fascinating juxtaposition, Hull feels that the digital revolution actually *makes* room for organic illustration. "When digital illustration kicked off, everything rather looked the same," he says. "People have a thirst for something unique, something *real*. A beautiful illustration stops people in their tracks now as much as it ever did. More, actually."

## PROMOTE YOURSELF

Self-promotion can take many forms. Of course, a web presence is mandatory. These days an illustrator will most likely promote and network via the ubiquitous web outlets, email, social media, over the phone, and, yes, word of mouth.

But you can still consider advertising your services in creative directories (print and/or online), local business directories, even snail mail. Consider the yellow pages. Roger Brucker feels that a minimum-size listing under ILLUSTRATORS or ILLUSTRATORS & ARTISTS could be cost-effective. "People who have never bought an illustration before may contact you," says Brucker. "You may train them to become good clients."

Illustrators can offer so much, dispatching wildly diverse communications for both electronic and paper delivery. These vivid presentations entertain, sell, inform, and promote—often doing all that simultaneously.

### HERE'S LOOKING AT YOU

Perhaps your first order of business is to look at your marketing and self-promotion as the savvy method to advertise your unique customer service. This will sound familiar: you should promote by posing—then answering—the question "How can I help you?" and not by shouting "Hey—look at me!" Think substance, not flash.

I've always firmly believed that you must show what you love to do as the hallmark of the work you are soliciting. This, as marketing guru Maria Piscopo says, will also bring you clients that love your work.

Choose samples wisely, of course; target your approach and select work of yours that is only the highest quality and marketable value (obviously). Push a

consistent presentation across your advertising ventures. Emphasize straight-forward, solid content. If you're not sure what customers are buying these days, do your homework: look at potential client websites and check out the portfolio pages of your competition. As Picasso may have quipped: "Good artists steal, but great artists *research.*"

# WALK THIS WAY

Promoting on the Internet is, theoretically, more cost-effective and time-efficient. It's quantifiably different in many respects than a pure program of printed mail-ings. Of course, there are still folks who tap into the combination of tried-and-true networking, modern cyber-marketing plus classical direct mail.

You could go the one-stop shop route. Agency Access (www.adbase.com) offers FoundFolios and Emailer. Workbook (www.workbook.com) offers lists, sourcebooks, a blog, as well as a website with "comprehensive features and resources for . . . designers . . . serious about reaching the most active and impor-tant art buyers in their fields."

As just an example, Workbook features Workbook Print (a creative direc-tory also available online), Workbook Portfolio (a fully searchable collection of illustrators and designers), and Workbook Directory (an online resource of crea-tive industry contacts and targeted mailing lists). So, for instance, your options could mix and match the premium Workbook services and self-designed email newsletters as generated through platforms like Constant Contact (www.constantcontact.com).

## THE SELF-PROMOTION PIECE

Back in the good ol', ever so legendary day, we'd be talking about a self-promotional mailer. Literally mailed. You may be of an age when—*gasp!*—there was no omnipresent Internet. Working the mails was the only real game in town. Today, when done with style, wit, and smarts, actual physical stuff—a brilliant mailer (or some kind of drop-off, if you can score one)—can still capture the complete attention of a busy art director inundated by a sea of mundane emails. So regardless of how you promote, and as a nod to a great tradition, let's just use that handy term "mailer" as a generic tag for a convey-ance of business communication.

The primary purpose of self-promotion is to dazzle and entice its recipients and to have them keep your promotion piece around—the fabled and hallowed "keeper." As such, creative license should know no boundaries. This showcase of boundless artistry has exhibited as one-of-a-kind wine and beer bottles with custom labels, gluten-free fortune cookies with clever messages (or delightful surprises) enclosed; even Hula-Hoops have been used to spin a campaign. And these are just some of the milder, actually traditional, vehicles that come to mind.

The play is to keep the format handy and accessible to improve chances that your promo will be on tap rather than tossed.

To make a sharper point: in this jaded, digital age you must take any good, basic concept and morph the idea into something more, something different. And those so-called conventional notions—creating a show reel (also called a demo reel), posters, or calendars—should not be casually written off as old hat.

So say it out loud: "Hmm . . . what can I do with that?" Maybe the mantra is "What *can't* I do with that?"

Make your video portfolio a, well, moving experience. If your calendar concept is eye-catching—as in smart *and* useful—you just could get it front and center on a client's wall or desktop, doubling your promo's visibility (as both a physical reminder and smarty-pants creative showcase).

Really clever mailers (in any incarnation) are frequently passed along. This takes on new meaning in the age of email, links, Pinterest, YouTube, Twitter, social networks, and Facebook. A seriously great piece almost invariably will expand its impact beyond the initial recipient.

If you're looking for inspiration, just fire up your computer and check out your recent email. I'll bet you have more than one email veritably shouting at you to "Check it out . . . you'll love what I just got!"

I would study everything: the daily/monthly/annual incoming tide of digital content, as well as any industry monthlies, annuals, and creative directories (digital and print). You're looking for the most creative and beautifully designed self-promo pieces that come over your transom. Magazines like *CA, Print*, and *How* (as well as most local competitions) include a category for self-promotion. *How* magazine has devoted an entire competition to self-promotion, featuring the winners in an annual special issue.

There are almost as many reasons and occasions—or excuses, even—for mailing out self-promotion pieces as there are types of self-promotion. Consider seasonal (not necessarily just holiday) greetings, a change of address, acquiring a partner, frequenting industry conferences or trade shows you know clients attend. This is just the tip of an iceberg of opportunities for you to showcase your best work in a self-promotion piece.

Self-promotion functions as either a rather blatant or oh-so-subtle means of letting people know you're in business and that you're looking for clients. Either way, you want to intrigue a prospective client with a promo that demonstrates the exquisite caliber of your work. Regardless of how you package and present it, you obviously want it to be beautifully designed and exceedingly well crafted.

## THE CAPABILITIES PIECE

Yes, the advent of the website plus the show and tell of online portfolio sites—like Behance, Carbonmade, and Dribbble (for designers), to name three—has

revolutionized illustrators' marketing and promoting. But even with today's high decibel digital noise, I'm going to make the pitch that you consider some old school as part of your repertoire.

A generic self-promotional vehicle demonstrating your capabilities can certainly be presented in a number of formats. The brochure configuration is frequently used by artists for its versatility. As such, this *capabilities brochure* would provide a tantalizing glimpse of your portfolio by providing a representation of some of your best work.

Sounds exactly like what you want an online portfolio or website to do, eh? And you'd be exactly correct here. But don't be limited by the concept of a de facto online presentation. Nor should you be rooted in the traditional tri-fold, bi-fold, or bound-with-a-cover brochure, if you go that route.

So it could be a compelling online solution, a single, folded 11" × 17" sheet, or some rock 'em, sock 'em custom size, shape, or structure. Balancing creative expression with the information prospective clients need is where experience (or the lack of it) comes into play. If you have worked with many high-profile clients, you'll want to play up credibility. But, if you're just starting out, you'll want to demonstrate potential.

Your self-promotion capabilities *presentation* is an ideal solution to show what you can do or have done. In essence it says, "I made you notice this marketing piece and consider hiring me. I could help you be noticed by your prospective clients." Trust your gut on juggling the desire to demonstrate your creativity with the need to communicate that aforementioned credibility. And do keep your marketing piece clear and concise. "This credibility," says Roger Brucker, "is established by several vehicles; for instance, examples of what you've done, a description of how you do it, or the testimonies of satisfied or delighted clients."

### *Perfectly Capable*
A capabilities presentation will offer some standard information:

1. Client information: You'll want to provide a list of the clients you've worked with, making sure to lead with (or at least include) the ones that have the most—ostensibly, at least—prestige and recognition. If you're just starting out, providing a "glamorous" client list may be difficult to do. But that's not the real point of the exercise and shouldn't present an obstacle; a client list obviously grows as a career takes root.
2. Background: Think of this as your portable résumé. You'll want to include information about your education and your awards. Include any experience or achievements that will enhance your credibility as a creative professional.
3. Capabilities: You want to spell out everything you can do. Leave no stone unturned—if ya got it, flaunt it. If you're also a fine calligrapher,

a great designer, or an accomplished photographer—*and you want to be considered for these gigs*—say so and show that off.

4. Manifesto: your artistic philosophy. This policy statement is where you convince prospective clients that your work can be more beneficial to them than any other illustrator's work. It's a lead-in to introduce your studio to the world at large, setting the stage for your presentation.

5. Contact information: Don't forget your address, phone number, website, and email addresses. This sounds silly, but it happens. Without this most basic info your promotion is essentially useless. Hey, and don't forget your Twitter feed, Instagram link, Facebook page, and any other social media you want your client to follow.

6. Cover: If you're mailing the package, a cover letter, tailored to a company and an actual name, personalizes that mailing and lets you spell out advantages specific to the prospect's needs.

Online, an intro or intro page does much the same thing, but, of course, it cannot be client-specific (you could target a specific niche with common bullet points to address that market, however).

A video clip could address specific viewers (theoretically the party responsible for making the buying decision) personally. Here, you directly tell your prospect why you're most qualified to meet their needs.

## OLD SCHOOL

I am reticent to dismiss any marketing strategies offhand—some practice that seems archaic to me or inefficient to you invariably appeals to somebody else, somehow, someway. Cold calls, for instance. Every time I hear from a source who loathes this practice, I simultaneously come across another smart guy who advises you to hit that up.

The Internet, of course, has spun marketing on its axis, but to give you a well-rounded picture, we're going to look at a number of options.

### COLD CALLS

Let's talk about cold calls right up front. A cold call—person-to-person, by email, letter, or phone—is a contact without request and often without referral. It's essentially selling door-to-door, and as such can be pure frustration. Cold calls are a stellar way to test your tolerance for rejection, and for many art directors, these calls are a certified nuisance. Persuasive (not obnoxious) salespeople may get decent returns for their troubles, but you may equate cold calling with the flood of those "courtesy calls" you receive just about dinnertime every day— sound like a familiar scenario?

If you're intent on this sales tactic, you need to build a list of contacts. Use resources like Yahoo!, Bing, Ask, Google, and LinkedIn like mad. Consult the

yellow pages. Go to the library and bookstore to research annuals, directories, and publications and scan client names. Attend trade shows (and read trade publications). Send for annual reports. Join your local ad club. Join a local service club like the Lions or Rotary. Visit the Better Business Bureau and the chamber of commerce. Take a stroll through the business district. Talk to your friends and colleagues.

I'm not a fan, but cold calls are indeed another avenue for pursuing more business. Getting in the door to see your prospect is the initial hurdle, so getting on the horn is not an illogical first step. However, if nothing else (and even if you never do the deed), the cold call is a great metaphor for solid, general contact communication. Thus, I thought back to (and adapted) my cold call criteria to come up with an appropriate to-do list.

1. Do your research.
2. Be completely prepared. Right off the top, are you contacting the right person? Your contact information (name and spelling of that name, gender, job title, address, phone number) must be current and correct and readily available. Have all your information and record keeping in front of you. Be flexible enough to rearrange your schedule, if necessary.
3. If you land a meeting or score a next step, get the details right—an exact address, good directions, and contact name (and how to say and spell that name).
4. You are never selling anything with a first contact. No pressure now, so relax. Don't get easily discouraged. Learn from your rejections.
5. In closing, says Piscopo, "Plan and prepare your conversations and questions to the extent that you avoid closed questions such as 'Can I call you?' and use open questions, such as 'When is the best time to call you?'"

## MAIL LISTS

Utilizing a "store bought" mail list is a marketing strategy that the Internet has virtually killed (head over to Agency Access, BikiniLists, and Mailchimp, for instance). But if you somehow have the time, energy, and inclination, you could still pursue it to various degrees.

For instance, just by heading over to your local chamber of commerce, you can obtain a list of new businesses and compile an inventory of prospective clients. That's a mailing list. Your mailing list needs will depend on the nature of your skills and on who you think will buy your services. "Depending on your area," Piscopo says, "you may find bigger and better clients in your county chamber of commerce if you feel the city chamber provides too small a 'client pool.'"

Check out the *Artist's & Graphic Designer's Market* from the local library (or just buy it at the bookstore). But, says Piscopo, "The unique aspect of this

directory is that it only lists clients actively seeking illustrators, artists and designers (so it's not a list of everyone)."

You could also consult the various phone directories for possible leads. Head to the library or the bookstore and browse any creative annuals and talent directories and review client names. Special interests and their specific publications may have mail lists for your review (and perhaps for sale). Lists may be available through a list broker.

Purchasable CD databases are long gone. Oh, you might still be able to find a purchasable CD database somewhere, but why bother? These search tools have certainly been replaced by online research and/or email subscription services doing the same thing—providing phone numbers and addresses of all the restaurants, dentists, or ice cream parlors, within twenty miles of your front door, for example.

Note: If you create a list of potential clients, database software (like Excel or Bento) is useful for maintaining, organizing, and evaluating results, as well as for preparing you for sales and follow-up calls.

## TALENT DIRECTORIES

Talent directories may also be called creative directories. These resources—with a national scope, as well as in major metropolitan regions—offer contact info for illustrators, designers, and photographers by service and geography. Art buyers of all stripes can browse through the catalog as an easy way to spot a look, then order the stylist of choice.

As I mentioned previously in this chapter, resources like Behance, Carbonmade, Dribble, and Workbook (www.workbook.com) represent an online approach to this marketing option. When considering these directories, you would want to consider the advantages of such an avenue *for you*. Is this a strong vehicle to push that vantage at this point in your career?

And when you network with other professionals on your home turf, become aware of whether or not a local directory is available in your region. If so, determine how useful it is to you in your community. Again, the insights of other illustrators are your inside line to the best opportunities in your area.

## THE PHONE BOOK

I mentioned a few paragraphs above what is often an overlooked opportunity for taking names as well as representing close to home: the phone directory. And don't pass up the business-to-business phone directory as a ready source of categorized business listings. If you're investigating regional visibility, local accessibility, and plain fact finding, I wouldn't take this route for granted.

## TRADITIONAL ADVERTISING

You may want to consider local media advertising as another marketing and promotional tool. Radio to sell illustration? Sure! A sharp, creative radio spot fuels the visuals of the imagination. If done well, your message will definitely get across. Television time will be pricey, but a good fifteen- or thirty-second spot could be money well spent. Thus, you just might consider an announcement on your cable channel's community calendar or a late, late night television spot (when ad rates are dirt cheap). How about a punchy press release?

## COMPETITIONS

We look at competitions, crowdsourcing, and crowdfunding—with all the associated ups and downs—in and around the book. We won't repeat these discussions or debates here—I simply bring it up as a possible part of a general, potential marketing game plan.

If you enter such a competition and come out with a winner, get some mileage out of this happy event. You could enter your crowd pleaser in other competitions (if you're still buying into the concept) or push the tangential promotional opportunities (including a press release). I am not advocating for these competitions; only suggesting you ride the wave of any accolades and recognition.

## PRO BONO WORK

Lightly repeating what we examined in Chapter 3, *pro bono*—volunteering or donating your time and services—can be an effective means of generating publicity (or simply doing a good turn). While we said that the concept of pro bono work is not universally loved, you shouldn't necessarily dismiss pro bono as a simple giveaway or write it off as merely paying your dues. Establish ground rules, define limits and clarify expectations, and pro bono could be a healthy investment of your available time, energy, and spirit. "Don't forget," adds Piscopo, "pro bono gives you real-client experience, samples, referrals, and testimonials."

## SPEC WORK

Last, and certainly least, spec work. Mock-ups, design contests, and crowdsourcing further muddy the already murky waters. In a word: No. Work. For. Free. No. Spec. (And No. Work. For. Hire.) Don't. Period.

Refusing spec work may be easier said than done, especially if you're just starting out. Professionally, "spec work" rhymes with "risky business." There is a vocal constituency who would use the term "unethical" to describe the practice. Maybe they'd put it even more colorfully, but we'll just keep it clean here.

"Rip off?" You'll hear that one, for sure. A kindred soul may simply label it as a "mistake." As with everything, there are always different takes on the subject, many sides to the issue. But think about it for a second, Antolic asks in Chapter

12 (about competitions) if your plumber would enter a competition to install the pipes in your new home. I ask: will the doctor who performs your colonoscopy work on spec? How ludicrous is that? Am I saying spec work is a pain in the ass? Butt of course.

"A client ought to feel guilty for asking for spec in the first place," Brucker says. "I couldn't advise you to work on spec. But if you are so inclined, I wouldn't do spec unless you can absolutely pin down the requirements," Brucker says.

"That conversation might go like this: 'I'm afraid I'm a terrible mind reader, I can't offer you spec work on this job unless you tell me exactly what you want the person to do who sees the illustration. Tell me the exact mechanical size the final will be. Guarantee me in writing that my work remains my work—I've been badly burned when a client handed over my spec work to another illustrator to finish the assignment.

'If we're agreed to these conditions, and with that information, I think I can give you some spec roughs for discussion.'"

### Sometimes?

I'm not waffling, but I am also not afraid to present another realistic take on all this. Jabbour's career is off to a rousing start, which puts her plumb in a middle-front-row seat for the whole pricing pageant. "Spec work is common in New York. I think it's because there is so much competition and intense demand for jobs. You sometimes need to do it. Of course, I see the negative side, but I have always learned from the experience and stretched my abilities."

We're all professional adults (sic, and double entendre intended). No one should suppose they fully understand what you truly need professionally, personally, and financially. You gotta make the call; so no artsy-fartsy judgments from this end.

## KEEPERS

A silver bullet here would be inscribed with all of one word in it: *Service*. Serve your clients well. It's all about reliability, returning phone calls promptly, following up personably, effectively, and efficiently, personally ramrodding the job. Call it every cliché in the book: going the extra mile, handholding, TLC, bending over backward, doing whatever it takes. Cozy, and oft used, these homilies, nevertheless (if I dare use one more cliché), hit the mark. Some other things you probably know or suspect about dealing with clients include:

1. A prima donna with an I-don't-care-about-you attitude, no matter how good he or she may be, will only generate and keep business for so long. All things being equal, and given a choice, a client will prefer the illustrator known for good work and personal service.

2. Unless they're masochists, people don't honestly want to work with someone who doesn't care about or won't take care of them. Would you?

3. Consider the amount of time you spend in acquiring business, how promoting yourself and cultivating new accounts eats into your time. Getting and keeping clients who keep coming back will free you up to bill out more of your time. Clients who keep coming back because you reliably take good care of them are also more likely to do everyone a good turn by passing your name on to those with whom they do business.

## THE MESSAGE

Allow me to caution you on using proper etiquette when contacting art directors (or potential clients). I trust that you know this instinctively, but I'm going to err on the side of prudent business savvy and play this out with you here.

First, always identify yourself to whoever takes your call or receives your letter, email, phone, or text message. Especially if you can't get through, leave a detailed but concise message stating who you are, what you do, and how you think you can help this individual. If you have made contact, go through the same identifying process, then clear this person's time by asking, "Do you have a moment to talk?" or "When do you have the time to chat?" If the contact is unavailable, ask for a specific time when you can contact her again, and follow up promptly at that time. By doing this, you'll be demonstrating courteous and timely communication skills.

So you landed an actual meeting? Great! Face to face, blend a straight-laced business discussion with friendly, informational conversation. No hard sell—try a softer approach, avoid the sales pitch. Simply chat to learn more about the prospect and/or the project. Your goal is an *exchange*.

Obviously, show your portfolio. Use an initial get-together to present illustration solutions that suggest how you can solve the client's communication problems. Observe closely and keep your ears open. And here's the critical key to the kingdom: *talk less, listen more*. At this point, you're just trying to determine if the potential for doing business exists. So, genially probe for information with phrases such as, "I'm curious about . . . I'd like to know . . . Please elaborate on this . . ." Lightly schmooze a bit with just a touch of flattery: "Tell me more about your good work at Amalgamated Anagrams. What are some of the thorniest communications problems you've encountered?"

If there is a definite assignment up for grabs, you could say: "I'd like to hear more about your great product and what the firm has done in the past. Can you tell me about this exciting project? Why are you taking this new direction? What'll be tough to explain? What are your goals?"

Once fact-finding about the project is over, and if you landed the job right there on the spot, you will eventually have to talk money and inquire about fees. Simple, direct inquiries work well: "What's your budget on something like this?" or "How much do you want to spend here?" The client may volley the ball back to your court and inquire what you would charge for such an assignment. Your reply might be: "All clients are not the same. Every job is different. For projects similar to this I've charged $XXX; this is based on . . ." Then detail your pricing structure and related particulars. By the way, certain advisors tell you to give a range between X and Z, while others warn you to never ballpark—always state a firm figure. You'll have to decide what feels and works best for you.

If there's no gig now, ask for future business at some point. Make it easy for both parties with phrases such as, "Great, what if we . . .? So where do we go from here? Does this sound doable? Let me run this by you . . . Shall we . . .?"

## SATISFACTION GUARANTEED

"Satisfied customers are not loyal; delighted customers are loyal," says Brucker. "You wow customers by exceeding their expectations. When they perceive that they have received sacrificial service from you, they are delighted."

What's "sacrificial service"? Say a client wants a key color illustration. You actually give him that *plus* two line drawings to illuminate the copy. By going beyond the requirements and putting yourself out you increase your possible value to your customer. "Savvy clients will recognize this and be thrilled," Brucker says. "They'll call you again!"

# ON THE BOARD
## (PROFESSIONAL VIEWPOINTS IN 50 WORDS OR LESS)

Don't over promise. Never under deliver. Be on time, always. Be respectful. Understand your contract. If you don't, ask for clarification. If you don't agree, ask to amend the contract. If you can't agree, decide then to accept or decline. Do good work and be paid fairly for it.

—Ken Orvidas

Do what you do; that is why you were hired in the first place. So give it your all; make this job the most important job in your life—until the next one comes along. Understand that the skills we sometimes take for granted can often hold a client spellbound.

—Bil Donovan

In regards to keeping clients happy, one of the most important things to do is simply to check in. Give constant updates. Keep customers informed. Communicate. Respond.

—Nadine Gilden

Help a client turn an idea into a concrete visual. Exceed what they asked for through your own interpretation of the visual puzzle. Deliver high-quality work on time. Be pleasant to deal with, but know when to step away when a client isn't a good match for you.

—Avram Dumitrescu

01. STRUMENTI*

Illustration is all about communication. Like a language. Like a vocabulary. Most of communicating is listening. The other part is picking your "words" wisely. Innovation is good, but predictability is more important for clients. They want to know what they're gonna get.

—Brian Biggs

You're going to deal with the whims of all sorts of clients. My "best" work was actually done for my absolute worst client ever.

—Jason Petefish

The privilege of serving great clients is a given. When our creative work is appreciated, it's like I'm a little kid again and my mom sticks one of my pictures on the refrigerator.

—Nick Gaskins

I have business cards in my bike's seat bag. You never know where or when you might meet your next client. I have a goal to hand out at least one business card per week.

—George Coghill

© Chris Spollen 2016

© Grant Snider 2016

# chapter 9

# Pricing

---

*"Prices? We ain't got no prices. We don't need no pricing. I don't have to show you no stinkin' pricing!"*

—From the lost art director's cut of *The Treasure of the Sierra Madre* (with apologies to B. Traven, John and Walter Huston, as well as Humphrey Bogart)

# EVERYTHING HAS ITS PRICE

Pricing—there's no ancient incantation, secret formula to discover, or tried and true family recipe to fall back on. Many illustrators will tell you that cut rate pricing ("working for chickenfeed") devalues the industry. In the bigger picture, this is absolutely correct.

Just as true is the thinking that lofty principles can't purchase diapers when the baby needs them, buy your meds now, nor make the mortgage next week. This is a tricky conundrum and I can't—and won't—presume to preach. But please keep reading to the end of this chapter.

Freelance rates for illustrators will vary depending on the artist, of course—availability and schedule; time frame, rights purchased, deadline, and budget—many things; but when it comes to pricing your work, is there a "right" or "wrong" way to go about it?

We'll be examining these questions, and more, in the pages to come. But first, some words of appreciation. Like Chapter 5, this chapter (and other critical business sections in Chapters 4–9) was written with the expert consultation of many generous contributors. But special commendation here must go to three gracious, go-to contributors: Don Arday, Gerald D. Vinci, and Kelly White. Their smart, perceptive commentary catalyzed this chapter, and can be found sprinkled throughout the book.

Ms. White is an illustrator/designer whose studio, Up Up Pixel Designs, is based in Kansas City, Missouri. She was one of my earliest contributors and has been a stalwart source of creative support throughout this project. Vinci-Designs & Publishing is a full-service design and marketing agency that provides a wealth of services for a broad range of clients. Mr. Arday has created striking digital illustration used by discerning clients for over two decades. His work has been recognized in national publications, and he's exhibited at the New York and Los Angeles Societies of Illustrators. A battle-hardened educator, Arday now teaches at the Rochester Institute of Technology.

# THE ELEMENTS OF PRICING

In my conversation about pricing with White, we identified several pertinent factors. Here's our pricing laundry list—in no prescribed order at any given time; my priorities are not yours. You must set your own agenda.

1. *Docket*. How many assignments are you working on simultaneously? Multi-projects in progress at the same time might mean someone approaching you with a rush job may get charged more.

   And work, in my experience, has a fine propensity to spawn more work. Stay busy, even if you have to generate your own assignments.

2. *Time.* Charging by the hour can be a bit of a trap. But the reality of it may be that that's exactly how you go about pricing your work. No judgments (but keep reading please). If so—how much time do you estimate you'll invest in a project? How long did you work on a similar job?

"If you have indeed contracted by the hour, and it only took you three or four hours to work on the assignment," says White, "don't be a jerk, charge only for actual time spent on that assignment. It's not fair to overcharge; especially when the other person is trusting you to honestly estimate the amount of time it took to complete their request."

If you are charging by the hour: set a comfortable, fair, hourly rate that is utterly accurate and based on *your* situation and needs. Work with the client and negotiate a livable contract (for both parties). Establish deadlines under the umbrella of a reasonable estimated range. Build in a bit of wiggle room (quote a 12-hour job at 12–15 hours, for instance. This actually can pad everybody's comfort zone). And play nice. To the best of your ability, when and if you can, work with your client's budget restrictions.

3. *Deadline.* The trifecta of due dates, time, and docket! The sweet (or discordant) harmony of this trio makes every job sing a distinctively different tune. Reasonably, theoretically, a screaming drop-dead date *should* secure a much higher fee than a leisurely deadline with a ton of breathing room, right?

4. *Revisions.* How many revisions will you do? This component may involve a somewhat retroactive exercise. Historically, how many revisions have you typically done (for this client; in general)? The more revisions you do—will or might do—the higher the cost.

Revisions can be tricky and may definitely eat up a job and spit out the fee in fugly widdle bits. There always seems to be a catch here or there. Some illustrators throw in a certain amount of revisions *gratis*: for instance, one free round of changes built into the contract, then an hourly or percentage fee for revisions after that. Additional charges kick in only if the client asks for more than a stipulated quota. Each part of that equation is hardly unusual and can work to rein in a waffling, revision-happy client (obviously, your mileage may vary).

Of course, if you blew the assignment particulars in any way, you should eat your mistake and make those corrections with a smile.

5. *Challenge.* We're talking about examining the project itself: what kind of assignment are you dealing with? Is it for a book cover, newspaper article, a magazine spot, poster, advertisement, or . . . ?

"Different projects obviously should be billed out at different amounts," White emphasizes.

6. *Nature.* Be sensitive to the makeup of the assignment. How's it all *feel* to you? Heed your gut. What's your client radar telling you about the customer and the job? Any red flags being thrown? Anything warning you away from the gig or this guy? It may be something you can't put your finger on, but it behooves you to pay attention and ask questions.

   Know that your "Spidey sense" will not be infallible. Here, experience helps; life is a great teacher. You learn—or you'll quickly learn—that a fee by itself is frequently not worth your time, energy, and, yes, sanity. Saying that, if you feel it's okay to throw caution to the wind, charge accordingly; draft a bullet-proof contract, and then it's "brace yourself, my dear; I'm going in."

7. *Joy.* And along those lines, do you see this job offering any fun at all? I'm not saying the *fun factor* should be the only or overriding reason to take a job, although it certainly can be. I'm not suggesting it should be *the* reason to refuse a job, although it should be duly considered; joy is underrated. What I know is that if the project makes me miserable (to any degree, in any way), and if the fee is my sole reason to fire up my hard drive in the morning, that particular paycheck always lands in my bank account with a distinctly hollow *thunk*.

8. *Stature.* An "if-the-shoe-fits" rate structure based on a client's size and position in their market.

9. *Audience.* Pricing based on the intended audience: local, regional, national, or international?

10. *Value.* "When I first started," recalls White, "I remember freaking out and thinking, *Okay…I don't want to charge too much, they won't work with me.* But then at the same time this other thought pops up: *But I don't want to charge too* little. *They'll think the work is going to be cheap looking.*

   "Sheesh . . . it was a constant back and forth. I finally decided, although I was a little uncomfortable doing so, asking my instructor at school what I should charge." And while her former mentor didn't quote an exact price, White never forgets what her mentor told her. He said, "Just remember, this is your art. This is something you worked hard on. If you took your car to the shop because it wasn't working properly, it will cost $75–100 just for them to look around and check everything out—and that's *before* they fix any potential problems.

   "Think about your [illustration] in much the same way," White's advisor continued. "Don't shortchange yourself. You're offering a

service; doing something for people that they can't do for themselves—just as a doctor does, or like a car repair man, or furnace service person."

Certainly, it wasn't the answer White expected, but this gentleman's response made her realize that no one can actually give you an accurate "one-size-fits-all" hourly quote or tell you what to generically charge. White's instructor slyly opened up another learning opportunity for her. She subsequently found that weighing all the factors above made a difference in her pricing structure and procedure.

11. *Money.* Next to last here and patently not next to nothing. So, love, what do you think you're worth? What do you *need* to be making? Trick questions, I know. Charging too little? Perhaps. You'll know quick enough when there's more month than money staring you right in the calendar. Charging too much? Maybe—until your networking reveals you could be charging twice or three times as much.

12. *You.* The gold standard. *If you believe you are worth it*, name your price. Bargain basement fees ultimately only low-ball your self-esteem. Establish minimums, based on your bona fide facts of life, if you need to. If you have to fudge from your baseline, do it by choice, not under pressure or from fear. As Paul Melia says with a laugh, "Hey, maybe you're having a sale this weekend."

## THE PRICE IS RIGHT?

In researching pricing, I found illustrators who priced by rounding figures to whole numbers. I've done that—it certainly makes it easier to split payments (halves or thirds would be typical).

But it never fails, other illustrators dispute this practice, countering that round numbers (oh, say, $600) may be seen as an easy fabrication to quickly make a generic bid. Those illustrators maintained that a more complex number— something like $527, for example—is a better response; such figures appear to be exactingly determined—an ostensibly "bona fide" price.

Regardless, you should strive to be as accurate as possible. Any number that, on paper, looks pulled out of your, uh, hat—$666, for instance—may give the distinct impression that lazy you actually pulled it out of your, uh, hat. Best to slow down and seriously think through your quote; actually do solid arithmetic that reflects honest labor.

That's only common sense. But there's no guarantee, mind you, that such due diligence will dissuade your client from dickering. You have absolutely no control over how a client perceives any quote, regardless of how scrupulously you sweat your math. So, be completely prepared to justify your bid; your client may well ask, "Hey—why does that cost this?" This is not an unreasonable

request; they have every right to do so—and to which you offer a meticulous, rational response.

Many illustrators suggest you try out different pricing tactics for size. Excellent advice, prudent you—test various strategies and evaluate what works best for your business. Nothing wrong with that, rather astute you. Good business thinking, too.

But even your best professional intentions may come to naught. Those rather reasonable rationales. The careful homework. All that transparency. The upfront, straightforward negotiations. *Fahgettaboudit.* The client won't budge from her low-ball offer and your negotiations sputter and fizzle out to an impasse.

When that happens, David James advises you to walk away with dignity. "Explain that your price is as low as you can go without compromising the project," James says. "If it's still too high, maybe this customer is not ready to hire a professional illustrator.

"Whatever you do, don't buckle to their demands to go lower, you'll only regret it. With any client, especially a new prospect, you have to be prepared to walk away if the relationship isn't working—which doesn't bode well from the outset."

## CHECKING IT TWICE

"I price competitively as possible," says Chris Sickels, "you evaluate rights requested, the size of the publication or outreach, the rights needed.

"With advertising it's about specific usage, regardless of how complicated the illustration is. The end use of the visual is more a priority for me; opposed to the time it took me to create it.

"A lot of times I'll tell an art director, 'I'll use the time you give me.' But if the budget is small then maybe we can extend the deadline, or the creative freedom can be a little more liberal.

"The analogy of going to the grocery market is fairly apt. You can go to the store with a big list, but if you only have so much money, you may have to be selective about what goes into your cart. You can't expect the grocer to give you all those items if you don't have the money to pay for them.

## A VIRTUE

Bil Donovan says, "Patience is a *must*. You must also delete the phrase 'not possible' from your vocabulary at an initial meeting. Rather, you must suggest that you will try to find a solution to the obstacle or problem at hand."

In Chapter 8, Donovan mentions that once you win the client's confidence, you will win their loyalty. Here he will tell you to educate your client about your work, and your process. "Some clients not accustomed to working with an illustrator need to have an idea of your process and how you develop the work from start to finish," Donovan says. "This will also allow you to establish a time frame that should give you some flexibility for changes.

"In a typical contract negotiated on my behalf, there is always a clause for changes," says Donovan. "This is a natural part of the evolution of the project. Usually it's no more than two changes during the pencil rough stage and one change during the finish stage, if required."

Due to the nature of his process and work, Donovan prefers to make changes during the pencil stage. Once the pencils are approved, he moves on to a finished illustration without any changes. "It is imperative to address this with the client during the negotiation stage," he says. "Do not be afraid to ask for a fee that is commensurate with your ability and experience. And weigh this against how much that job would mean to your résumé, career and visibility."

Donovan acknowledges that he might be in a minority here, but he always factors into the pricing equation how much promotion and visibility he may gain from doing a specific job. "I have taken some commissions that were high profile, yet low in fee," says Donovan, "but the promotion and exposure I received from taking on those projects created opportunities that more than made up for the initial rate—both financially and professionally. On the other hand, if I see no redeeming value in a commission, then my fee is much higher, and I console myself with the fact that I will be making a few months' studio rent."

But whatever the pay, Donovan refuses to compromise quality on any job. "I only give my absolute best," he says. "I never, ever give substandard work, regardless of the fee or the nature of the job. I am a perfectionist—which, at times, has worked against me as I may spend more time on a job than necessary. However at the end of the day, you have to love what you do and know that your name will be associated with the project."

## RATE HIKES

When you're charging project to project, you are no doubt keeping close tabs on your bottom line. So it should be said that, eventually, you may be in a position where your rates must change to make ends meet.

Your colleagues will bat around what comes next, but I err on the side of solid communication: I think it's good business to let existing clients know that economics have mandated that changes are going down. Of course, current jobs under preexisting contracts are obviously exempted from any rate massage, of course.

Is an apology needed? How about regrets? No and no—this is not an expression of your failure or you admitting some kind of offense. Is an *explanation* necessary? Now here's another point up for debate. Like many illustrators, my thinking is that you're under no obligation to do so, and my feeling is that it's not an absolute necessity. But you may want to extend the professional courtesy *when asked*.

Don't attempt to rationalize a frivolous, for-the-hell-of-it fee bump. But there are valid scenarios for fee increases: steady inflation running roughshod on the cost of living; a change of business direction facilitating a fresh opportunity that requires more expertise—the real world, in other words.

You may just want to give a simple heads up (as in "on September 23, 2015 ..." or "come April 18, 2016 ..."). Optionally, you could establish a time frame and extend a traditional thirty-, forty-five-, or sixty-day notice.

Maybe a system of multiple, timely notifications will be in order: an initial emailed or mailed note with a follow-up reminder (email and/or snail mail); a disclaimer on promos, invoices, and estimates can be efficient; an actual phone call to special clients—if feasible—would be appreciated.

And as your clients are real folks first and, one hopes, hopefully cognizant businesspeople, as reasonable individuals they should at least understand, if not empathize. These guys are also adults. If a client has a problem with your new rates, he or she can move on (as can you). That word "no" is a beautiful and powerful little thing.

## ARKLE ON PRICING

Ahhh, getting paid—what to charge and how? "My favorite questions for art directors who ask if I am available to do a job!" says Peter Arkle. "They rarely tell you up front what they are paying. So that's my first question. I like to approach this matter head on. I offer a professional service. Talking money up front is a big part of being professional."

Initially, Arkle tries to think of the fee that will make him not resent doing a particular job. That's not so wild—call it the bottom line or your comfort zone, if that feels better. He tries not to think about what other people might get paid. "There lies the way to madness," he says, "that's somewhat like asking the person next to you on a plane what they paid for their seat."

Arkle operates from, what he calls, a "swings and roundabouts system. Sometimes I don't mind being a bit underpaid for one job (as long as I like the client) if I just did one that overpaid a bit. Clients need to know that if they treat you nicely you will be more prepared to work for less.

"I love not having to go through a middle person—an illustration agent," Arkle says, "I like doing all the dealing myself. At least if I get something wrong I know it's my fault!"

So for this self-sufficient illustrator, keeping good books is critical. "I maintain careful records of paid invoices. I go through my invoice book at least twice a month and hassle everyone who hasn't paid me for 30 days. Usually one prod is enough—unless I already know that a company has some awful 60-day payment policy . . . or a year or whatever the French seem to be into at the moment! In Europe, people don't have to pay for health insurance and they don't have to pay New York rent. This is why the fees they offer seem so low sometimes."

## PRICING—BASED ON WHAT?

Varying schools of thought address the complex machinations of pricing. If we are first, and rightly, assuming that pricing is the foundation of running any business, Gerald D. Vinci says that it's important to initially define the difference between running a creative business and being a creative freelancer—also known as the proverbial hired gun.

## STANDARDS AND . . .

Solid companies uphold and adhere to relative standards across the board. You should do the same: determine and set costs and provide the same exact level of service across the board. Yes, each job will be different and the scope and scale of services may vary, but your quality of service remains a constant. "Your pricing should not vary greatly for the same end product," says D. Vinci. While comparison shopping can sometimes be in the eye of the beholder, doing the apples-to-apples thing reveals the differences and explains variations in costs. *Transparency* is key in pricing. Do not make the customer wonder or give them the chance to make assumptions.

"By that same token," D. Vinci continues, "if a client tells you their budget is $5,000 (but a typical illustration of this nature traditionally costs $2,500), do you increase your cost to align with their budget? Some creatives will admit to pricing according to your client's budget, but this is not a fair method to establish pricing either. This is more of an ethics question than a pricing question. The obvious answer should be *no*, but many people price according to what their clients can afford. I believe we should charge for the work and time spent and not pad expenses to reflect a customer's budget."

Never underestimate how far the explicit (or implicit) value of *fair* and *honest* can take you.

## ... PRACTICES

When working with new clients, D.Vinci always asks what their budget range might be. Ostensibly, this could determine what to charge, but it's more to come up with a reasonable group of options for the customer within their price range. Asking a client for their budget also determines if they are realistic about the costs associated with developing their project.

"Just a heads up," says Roger Starnes, "clients tend to think that you are trying to figure out what to charge when asking this. I suggest that freelancers explain the question."

## SOME THINGS NOT ALWAYS CONSIDERED. TIPS ON PRICING FROM DON ARDAY.

"Ever wonder why a pair of Levi's 501 jeans sells for $64.00 at Macy's and $44.99 on Amazon.com?" asks Don Arday, who goes on to ponder the numerous reasons why price fluctuations occur. Arday also asks if you've ever considered how the same type of reasoning can be applied to pricing illustration?

Maybe. Maybe not. But as this chapter has been discussing the tangible factors influencing the price of an illustration, Arday has much to add to that conversation.

"Aspects such as how large it will appear, the number of copies that make up the edition it is a part of, how many times it will be used, and for how long, certainly provide a beginning for estimating what to charge for an illustration," says Arday.

"The Graphic Artists Guild's *Handbook of Pricing and Ethical Guidelines* (often abbreviated as the *PEGS*) includes a comprehensive section of statistics and suggestions for what to charge for illustrations that have been commissioned under similar circumstances and for similar purposes," Arday says. "Consulting this resource for suggestions is a great place to begin when pricing an assignment."

Arday feels that, while data provided in the *PEGS* is useful, he comments that this info is, "Primarily based on tangible factors such as usage and market circumstances as they relate to the finished illustration—for instance, whether the illustration is national or regional, whether it will be published singly or multiple times, or whether it will be produced in large or small quantities."

But what about the intangible details that directly or indirectly influence pricing? Here, Arday points out several factors that also impact the cost of an illustration and that should be duly considered:

1. *Turnaround.* "Perhaps the easiest to determine," says Arday. "Turnaround time can drastically affect the pricing of a job and is not only measurable—it is usually foreseeable."

Arday says to ask yourself these questions right up front:

A. How fast is the turnaround time for the assignment?

B. Will it require an all-nighter or two to produce?

C. Will it interfere or compromise other assignments that are in progress or have to occur simultaneously?

D. Does the assignment have a set schedule or is it open-ended?

2. *Scope.* "Not all jobs are created equal," Arday says, echoing Kelly White earlier in this chapter. "Some may require more sketches than are factored into a typical pricing model, while others may require extensive research. Others may have a series of approval stages instead of the standard two."

Here, Aday tells you to ask yourself these questions:

1. Will the job require many sketches?

2. Will the sketches have to be shown as comps or partially rendered illustrations for approvals

3. Will more than one finish need to be provided for the final choice?

3. *Conditions.* "Occasionally there are commissions that require an illustrator to work in a client's facilities to integrate into a project workflow," says Arday. "Maybe you will need to interact with a team of production people or to have your work supervised or directed."

Arday tells you what to ask for here:

A. Will the work have to be produced in the client's facilities?

B. How many meetings will the assignment require?

C. Will you be working under supervision?

D. Will you work as part of a project team?

E. Is there travel time or expense involved with the assignment?

4. *Client.* "Not all clients are alike," Arday says. "There are easy clients to work for and there are hard ones. There are those that will trust and respect your talent and expertise, and there are those that won't and will try to 'direct' your work; even your working method. You may even have your work subjected to decisions made by a committee."

Arday says to ascertain:

1. If you'll be working for a visually educated client such as a graphic designer or an art director or for a nonvisual client such as a company owner or product manager.

2. Will there be a committee of people or a single person involved in approval of the work?

3. Is your client "hands on" or mainly "hands off"?

5. *Overhead.* We're talking your studio overhead. As Arday reminds you, your cost of doing business should be factored into the cost of an illustration, which means *you should know what that is.* "If you reside in New York City or Seattle," says Arday, "the cost of living will be higher, which means the cost of an illustration must also be higher, and clients should understand that. For instance, I can still buy a beer in a bar in Auburn for $2.50, but the same beer in New York City will cost me $6! And so it goes for a can of peas, toilet paper, and so forth."

Arday's list of questions to answer here is spot-on:

A. Do you have a modest overhead or a substantial one?

B. Do you have a home-based studio or do you own/rent a separate space?

C. Do you have an assistant or employees?

D. Does your studio reside in a high cost of living area or a low one?

E. Will you have to acquire special materials or equipment to complete the assignment?

6. *You.* Who you are obviously must factor into your pricing equation. White also points that out earlier in this chapter, and Arday concurs, maintaining that your level of experience and status as an illustrator has worth. "It certainly does affect what you can, and should, charge for an illustration," he says. "This may be especially important if you have invested substantially in a marketing effort to reinforce or enhance your status in the field. This is the theory behind why a Jimmy Choo boot costs $995 and an Ivanka Trump boot retails for $189. It is referred to as *market forces.*"

What Arday says to determine here:

1. Are you just starting out or are you a highly experienced illustrator?

2. How much are you spending on marketing and promotional efforts?

3. Are you a specialist in the type of commission or subject area you will be commissioned for?

4. Will you have to learn or apply new techniques for the commission?

5. Are you overbooked and having to turn down work?

"These intangible factors can't be ignored when it comes to determining the price of an illustration," says Arday, who in conclusion, also asks you to contemplate if the assignment is worth pursuing or not. Think about that one moment—how absolutely critical that one small consideration profoundly impacts your entire negotiation strategy. Arday's pricing guidelines factor in standardized pricing with intangible components to better determine a generically sound pricing structure. "Without a doubt," he says, "paying attention to the considerations above when pricing a commission will be well worth your while."

# A BONNY RATE

Freelancers, of course, can go from assignment to assignment or work for numerous customers. Freelancers, by definition, aren't tethered to any one company. Most likely you will be working for several clients simultaneously, and free to work with whomever you choose. "You are entrepreneurs at heart," D. Vinci says. (I'll take this moment to shill for our Chapter 12.)

Indeed, the costs and logistics of working with you, the entrepreneurial freelancer—the flexibility of pricing and completion times, working one-on-one—look, on paper, to be advantageous to customers.

While you are free to work with whomever you choose and charge whatever you want (per project, per client), freelancers tend to charge what they believe the market will bear—what they think customers will pay. According to D. Vinci, putting a price on creativity is "relatively" easy. In theory, and knowing that pricing can be arbitrary, I see what he's saying (but I don't necessarily agree.) As we've examined in this chapter, it will probably come down to a choice of several methods: pricing based on an hourly rate (prices based on your time), project pricing (still based on the value of your time, however), and, what I'm calling, *multi-factored* pricing (as discussed in our conversations with White and Arday).

## WE'RE OUTTA HERE

You avoid talking about the hours it takes only because clients may not value an hour of your time as much as you do. But: you provide a service, and there's accountability for what that service costs. You establish that your work has value and you confirm a basic cost on your particular type of valuable service.

You identify your target market. You know what it costs to be in business, to stay in business. You get a handle on your workload; evaluate when you're busy, when you are not. Ruling out the simplicity of choosing an annual salary as a basis for your rate per project—you will continually be adjusting and readjusting for ebb and flow.

Now comes the homework: research at the library, attend conferences, buy books, consult other competitors, online forums, professional groups; friends, colleagues, and peers who work in your field. Confer with your local chamber of commerce. Look outside of your own profession for inspiration. Consider any and every resource at your disposal; compare, contrast, and compete. Lather. Rinse. Repeat.

Now find your sweet spot; set your sale price—but be flexible. Budge when and if you must. Come up with a pricing structure that works for you, or call it a starting price and go from there.

## SUMMING UP: EVERY PRICE HAS ITS THING

Pricing is a challenge for everybody. An hourly rate—say, $100—is fine. But as we discussed, most jobs should not be estimated on hourly rates alone.

The fee is based on a combination of factors—including the worth of your perceived value. You can research formulas and suggestions; the Graphic Artists Guild's *Pricing and Ethical Guidelines* book is a good start; and you can network and attend seminars and conferences.

One rule of thumb is: The larger the client, the exposure, the audience—the higher the fee. Set your fee considering those factors, plus the time you will need to put into completing the job beautifully and correctly.

"The best pricing strategy is a mixture of common sense and getting a straight answer from the client," Ellen Shapiro suggests. "Be direct. Ask: 'What is your budget?' If they say they don't know, then say, '$3,500.' All of a sudden, they do know that it isn't $3,500. So what will it be?"

After years of field experience, George Coghill has determined that clients with larger budgets also tend to be easier to work with. "Often they are more seasoned or successful in their field," he says, "know that good talent deserves to be properly paid, and understand that they will get the best work from a well-paid artist.

"They also tend to be less concerned about squeezing every last cent out of the money they are paying you. They are hiring you to solve a situation they cannot solve, and look to you to handle it. The best clients (and businesspeople) know when to properly delegate. You should not only seek these clients out, but be that kind of business owner yourself!"

However, "There is no magic formula," says Shapiro, in conclusion. "Every successful creative knows [what it takes to do] project D by knowing [what] it took to complete similar projects A, B and C."

## NOT WORKING FOR PEANUTS: AN ILLUSTRATORS' ROUNDTABLE

What I thought might be helpful for this chapter would be to offer a rundown of pricing for different types and sizes of illustrations. Cool, let's offer a range of samples and qualify that the illustrator's position on this scale will depend on *blank, blank, and blank* (then we list various factors and scenarios impacting our measuring system).

I approached a cross-section of contributors (illustrators Kathryn Adams, Peter Arkle, Julia Breckenreid, Bil Donovan, George Coghill, Anthony Freda, Dadu Shin, Stan Shaw, and Will Terry) and requested facts and figures. I welcomed point/counterpoint.

The exercise was envisioned as an informative conversation at a friendly neighborhood bar. Nothing extensive; just throw the shells on the floor and whose round is it anyway?

So we acknowledge that such a loose, informal survey could hardly be definitive. We don't want to set prices in stone, just open an informative discussion about the topic among peers.

And, as responses came back, I was sent exactly what I'd hoped for. I edited, juggled, and transitioned comments so as to put everybody around the bar and magically create an exchange between contributors.

Right away, it will be clear that a stock menu of prices, while pure of heart and well-intentioned, is both professionally imprudent and technically impractical. So I tossed most numbers (variable, anyway) to address some basic principles behind the *why* and *how* of pricing. So let's find out the who, what, when, and where of all that. Pull up a stool, grab a mug, and pass those peanuts, will ya?

Fleishman: "Is it possible to list a range of prices for a variety of illustrations; you know, qualify types and sizes and then specify, 'Okay, here's a one-size-fits-all pricing schematic'?"

Donovan: "That is a hard one. Usually, pricing is more about usage than size. A client can digitally enlarge or reduce anything. As you know, editorial work does not pay well, but it comes with free PR you can't buy. The true bottom line of it is that good pricing is about client and client loyalty.

I would refer folks to the Graphic Artists Guild's *Handbook: Pricing and Ethical Guidelines* . . . it's so thorough, and a great resource."

Coghill: "I'd be more comfortable offering specific advice on how to turn lead into gold! Alchemical techniques seem to be a much less-protected secret than freelance illustration pricing methods."

Terry: "I think asking, 'How much should I charge for my art?' is wrong. Asking, 'What's the going rate?' is also wrong.

"You will have many opportunities to work with many different types of clients. Some of them will make you offers up front based on how much they're willing to pay you for your illustrations. Larger clients who have worked with many illustrators in the past already know how much they are willing to pay. They save time by telling you what their offer is, and might be willing to go up by just a little.

"But many smaller clients will be inexperienced in the process of hiring an illustrator. They don't know how long it takes for most artists to create quality illustrations. And in our present world of anything goes, you often will have to educate your client and walk them through *your* process.

Fleishman: "You're saying that *your* fees depend on various factors, looking from both sides of the negotiating table?"

Breckenreid: "Yes. And I agree with Will. It's certainly possible to respond to the questions he brings up, but I'm also going to decline. Like Bil, I would also refer folks to the Graphic Artists Guild's *Handbook*—if they'd like—but generally, I think setting prices for others is not the way to go."

Freda: "I think the *Handbook* is a great resource for illustrators, but I have found that many clients don't care what it says in that book. They give you their budget and say, 'Take it or leave it.'"

Adams: "It's a legally tricky matter to create a fixed 'price' list for illustrators because we are freelancers. Having a set list of specific 'prices' (fees) constitutes price fixing a.k.a. collusion—which is a serious legal matter. There are antitrust laws that strictly prohibit such things.

"The Guild gets around it by surveying their membership every two years and then publishing the unedited data from those surveys. But that system is far from perfect."

Fleishman: "Because clients are aware of the *Handbook* and interpret the numbers as a cap on prices?"

Adams: "Yes, clients do sometimes suggest that illustrators 'can't' charge more than the top amount cited in the *Handbook*, as if it is some sort of ethical violation for an illustrator to attempt to do so. This leads to the stagnation of 'prices.' But there are a number of reasons:

▶ The data takes time to compile and publish, which makes it somewhat stale by the time it reaches print. Older copies already in circulation continue to be used as a point of reference, the data therein being even more out-of-date than the most current edition.

▶ The job descriptions in the *Handbook*, for which pricing is suggested, are broad and do not include the rights that were licensed from those who answered the survey. Those rights *significantly* influence the fee. The suggested prices in the *Handbook* are broad-ranging as a result. I'm not slamming the Graphic Artists Guild. They are constrained by antitrust laws and do the best they can within those confines.

▶ The fee range information published in the *Handbook* is limited to amounts charged by the Guild members who bothered to respond to the survey, not their entire membership. And they are self-reported numbers, subject to error. That makes for a small information source within the entire population of professional illustrators.

"Alas, in a freelance type of business such as ours, there are a million ad hoc ways that folks with little to no business training have, out of necessity, cobbled together a pricing method for themselves."

Fleishman: "And therein lies the rub of a so-called going rate."

Terry: "Let's talk about that so-called going rate. Many artists, in an attempt to do what's right, for better or worse, come up with their pricing structure; they will look to pricing books (or other artists) and ask, 'What is the going rate?' This is a dangerous question, to ask or answer.

"Back in the 1940s, illustrators like Norman Rockwell were creating art for *Saturday Evening Post* covers and getting paid about $3,000 per cover. Today, illustrators compete to be published on some of the world's top magazine covers like *Time* and they get paid about $3,000 per cover.

"This is true across the board in illustration. Rates have remained the same for many decades while the cost of living goes up each year. Back in the '40s the average home price was about $6,500. That meant that an illustrator like Rockwell only had to do a few assignments to pay off the mortgage of a typical house.

"The modern, average home price in the United States is somewhere around $200,000–$250,000. That means that in today's prices, illustrators for *Time* magazine would be getting around $100K for a magazine cover . . . but we're not.

"There will always be people who are willing to do a job cheaper than you. One price doesn't fit all your needs yesterday, today, and tomorrow—the value of any project will constantly fluctuate for you! Asking, 'what is the going rate?' puts you on the same level as any other illustrator. You need a unique price to fit your style, method, workflow, etc.

"To make matters worse, prices are actually reversing for some markets and the globalization of cheaper illustration labor also contributes to the dilemma."

Fleishman: "So, if the world is your oyster, does your place of business—where you live and work—have anything to do with pricing? If I live in New York City, should I charge 'big city' fees?"

Adams: "You know, in one instance, a blog post by a group offering advice to illustrators suggested that our fees should be based upon our 'lifestyle,' or where we live—'rural' dwellers commanding lower amounts than 'urban'—or upon 'how successful the illustrator feels.' All of which are ephemeral or subjective criteria."

Freda: "And the paradox of the digital age is that there has never been more demand for visual content, but everyone wants it for free.

"People are used to just 'borrowing' imagery they find online as if some magical elves are creating this work for them in a land where there is no rent to pay.

"On the other hand, I will work pro bono for like-minded political publications as a public service, but it has to be for a greater cause. I also look at my work for alternative media as volunteer work—but for-profit enterprises are another story.

"Pricing can be challenging. I am often in the position where my rep suggests I turn down a job because the offered payment is too low. I have to decide whether

some money is better than none, or if accepting the assignment would degrade my, ahem, 'status.'

"I was recently asked to design some skateboards. I asked what the budget was and they said 'zero.' I have a ten-year-old son, so I asked if we could trade art for boards, and a deal was made.

"I am happy to revert to the medieval practice of barter, but I will never, ever, ever do a job for the 'great exposure.' "

Adams: "Illustrators are in the copyright licensing business. Our fees are based on the breadth of that license and upon the specific description of the job.

"We illustrators must acquaint ourselves with what licensing terminology means when selling copyright licenses to our clients. There is a glossary of terms in the *Handbook*, as well as sample contracts. Illustrators should take it upon themselves to understand them, if they were not formally taught to do so in school."

Terry: "I agree with Kathryn, and I believe there is a 'Better Way' to price your work. You must look at it like this: it all starts with you. What do you need? What will make you happy? What do you want to avoid in your life? What will you feel like after you accept the assignment? How will you feel in two weeks?

"You and I are different. You might be faster at getting your illustrations finished than me so it might be worth it to you to accept a lower fee. I might enjoy painting fire hydrants more than you, so that fire hydrant assignment might not annoy me like it will annoy you. I might have more time than you (or vice versa). I might have lower monthly bills than you so I might need less money. You might want to do the assignment for your portfolio while I might not care about that. You might like the client more than me.

"We can't charge the same because the assignment will have a different value to both of us. How badly do you need the money? How much do you want to do the assignment?

"And, importantly, what is your bottom line? Ask yourself, 'What is the least amount of money I would be willing to take to illustrate this job?' This figure represents that line in the sand where you're barely satisfied with that number and actually happy to lose the project if they won't pay. Knowing where your bottom line is will help you dodge regret. It will help you avoid taking an assignment that you wish you hadn't.

"This doesn't mean that you should ask for your bottom line—it just means that you now know the low end of what you will accept. You can now ask for more, based on how badly you want the job.

"Thus, if you're busy, you might be willing to lose an assignment by asking for three times your bottom line. If you're desperate, you may ask just a bit more than your bottom line so you don't lose the gig."

Fleishman: "But keep your numbers reasonable and practical?"

Terry: "Correct. Asking for, say, $7,000 and then backing down to your bottom line of $2,000 makes you appear silly and looks like your price has no meaning."

Coghill: "I find that often taking a lower fee makes me resent the work and hurts the art in the long run. As well as my stress levels! But everyone is different. What Will says about how you'll feel about the money you've agreed to is so important.

"Allow for negotiation. I think this is key. This touches on what Will says about lowering fees and looking silly. If you build in the ability to lower the fee by reducing the service (or product) the client receives, then it's not only more fair, but just *feels* better. It's mostly a psychological thing I think, but I don't like to say, 'Okay, you win—I will do it for less money.' That sends the wrong message."

Fleishman: "Phrase it better for me, please."

Coghill: "Say, 'I can do it for that much, but I'll have to reduce concept sketches and revisions to five instead of fifteen.' I want clients to know that they will receive less for paying less, even if it's a bit intangible. I can't do work with less quality, so I have to negotiate on some other aspect. And accepting less money without asking the client to accept less is just establishing a precedent in both the client's mind and your own that isn't healthy, financially wise, or esteem-building."

Fleishman: "How do you price a job, then, George?"

Coghill: "I tend to price from a base rate, then increase from there. I do consult the *Handbook*, but look at the Guild's pricing guidelines as just that. And when I do look to the *Handbook*, I don't always ask for or receive these amounts. An illustrator may not always have the guts to quote at those numbers; asking for those fees may feel out of your comfort zone. Generally, it's probably more practical to base fees on their *ratios* than on the actual amounts, as maybe the clients in *your* range don't have those budgets."

Fleishman: "How does one work this? Based on what?"

Coghill: "Try to get some idea of 'scope of usage' from the client, particularly the larger ones. Take massive product branding (a character for Coke, featured in a Superbowl ad), versus a national but niche product with low or no marketing (say a logo for fishing products to be distributed in Walmart). These different projects won't be priced the same, even though both are commissioned by big, national corporations.

"And a job for such a client will be priced higher than a gig for the local coffee shop, of course. Could be the same type of work, but the bigger clients get more use out of the art, therefore the charge is higher. It's not that 'oh, they can afford it,' but that it has more inherent value for them and their intended use."

Arkle: "I charge a set fee for a small black-and-white spot, no matter how small. Actually, if it's *really* small it might even be harder to do; so, I don't often go below this number.

"Quantity does sometimes lead to me offering a discount. I do black-and-white portraits for *Architect* magazine (realistic looking, not terribly complicated at all). This week I had to do sixteen of them. The money adds up nicely.

"Color spots come in at another, higher range. I'll do color spots for a place like the Sierra Club's magazine for a lower fee because they are a charity I have respect for.

"A full page is calculated at a set range, depending how complicated. I expect to get a certain rate; more, if it's very complex. Same with a double spread: $X up to $Y.

"Covers are rare. Usually I get asked to a do a sketch (which is one of many a magazine may have asked for). However, they usually run a photo, in which case I get paid a healthy kill fee. *Time* paid me $2,000 just for doing a cover idea they never used.

Once in a million years they choose to put my drawing on the cover. Last time this happened, I think I was paid $3,000.

"I had a client, a French magazine, with whom I had to strenuously negotiate a better fee. They had me draw over a year's worth of spots and were always slow at paying me. Perhaps this was a form of revenge?

"At any rate, I couldn't take it anymore. I even had a great confrontation with an art director there. She actually argued that I should be drawing for the pure love of the art. But I strongly disagreed, reminding her that I draw for a living, expecting fair and timely compensation. I wonder if she's ever tried paying a taxi driver months later?"

Fleishman: "Good luck with that; especially in Paris!"

Arkle: "In terms of pricing, other work shakes out at odd places on the scale. Sometimes I think of a number and then get the client to say their number first. I then say, 'Hmmm, that sounds fine.' Especially when they offer me way more than I was thinking of. Of course, the opposite also happens.

"I don't think there is any structure that can be listed. It all depends on a complex equation of how much I want the work, how much I like the client, how much fun the job is, how quickly it's needed, how hard it is to do, and what they intend to do with it.

"I have a few clients who actually let me charge by the hour. These are clients that have come to trust me. This means that I am always paid for whatever they ask me to do. I'm not cheap, but it often means they are frequently surprised by how much I can do in an hour, and how economical things often turn out to be."

Fleishman: "Peter, what are your contracts like?"

Arkle: "A few things I insist on:

"1. A 50 percent kill fee at sketch stage, a 100 percent kill fee if at final stage.

"2. I give them the rights to a single usage (online and in print). If they want foreign rights, reprint rights or anthology rights they have to pay extra.

"3. I offer 90 days of exclusive use. Then, after that, I am free to resell the work (but this rarely happens).

"4. I always keep my copyright of the work.

"Sometimes I offer unlimited usage rights. This means that they are free to reuse my drawing as often as they like in as many places as they like, without asking me. They are not allowed to sell the drawing to anyone else. For unlimited rights I charge the client 100 percent of the original fee again. This applies to the by-the-hour stuff, too.

"I cannot stress enough how much value niceness has. If people are nice to me (in a genuine way) I am always much more open to working for less. If I was a mathematician I would love to create an algorithm that would calculate the exact dollar value of niceness in any project."

Shin: "Prices always vary depending on the client, and in general, illustrators always price based on usage and what rights the client will need. So let's say you charge $1,200 for a magazine full-page illustration. You sell one-time rights only. If the client asks for rights to print the drawing on other platforms—billboards, packaging, T-shirts, etc.—you would charge more, regardless of the size that you're actually working at. So when working with clients (on any job that isn't a pure editorial assignment) always ask exactly what they plan to use the image for.

"Pricing comes down to the specifics of an assignment. Always ask how many images they want, how long you have to complete them, what they intend to use the image(s) for, what rights they intend to purchase, and how long they want these rights. I gather this information and price out from there.

"I use the *Handbook*, too, it's a pretty good jumping point. Jessica Hische actually has a great, in-depth piece of writing on this topic (http://jessicahische.is/thinkingthoughtsaboutpricing). I recommend referencing this article; it's well worth it."

Fleishman: "Absolutely. I found Aaron Mahnke's *Frictionless Field Guides (getfrictionless. squarespace.com)* via Ms. Hische's site, as well. Along those lines, has anyone read any of these? They're reasonably priced ($10.00) and available in three downloadable formats. Very practical reads."

Coghill: "This brings up a good point—networking is a powerful pricing tool to facilitate smart pricing: *Ask.* Have the courage to ask a 'virtual mentor.' Email friends in the biz for rough ideas for pricing. They are always quick to help. Even better: ask a fellow illustrator whose career is a viable benchmark for you. Make contact, ask for specific advice. I don't do this enough. Why? There's a little voice whispering in my other ear that says: 'You're a pro; You are too far along in your career. You should (or do) know this already!' It just stops me cold. This mentality, right or wrong, keeps me from reaching out."

Shaw: "Menu-type pricing is probably more useful to those who have *not* bought illustration than for your peers. A range of prices set out—'it costs $500 to $1,000 for an illustration'—sets up expectations for the art buyer as to how much they may be looking at spending. From there it gets more complex.

"Illustrators often take into account the amount of detail, style, color versus black and white, the physical/digital size—those kinds of things specific to the artifact. Other specific factors come into play: usage, copyright and rights sold (for how long, geographic area of use, online versus print, etc.). Then there are the client/industry factors: client size, budget, industry yardsticks. Lastly, you could consider two other things: the experience and skill of the illustrator plus the intangible benefits of doing the illustration (such as exposure, experience, portfolio, or entry into a new market/client area).

"It's always nice to reference the Guild's *GAG Pricing and Ethical Guidelines*, that's what it's there for; referring to and using it makes it that much more relevant. You have to also take into account regional shifts in prices, pricing and cost of living.

"To top it off, sometimes you may price illustration based on an hourly fee, or use a mix of both hourly and set fees.

"Like Kathryn says, pricing can get tricky, but ultimately you have to ask yourself if an assignment is worth the time I'm taking to do it."

Fleishman: "Thanks, everyone. Okay, who ordered the nachos?"

# ON THE BOARD

## (PROFESSIONAL VIEWPOINTS IN 50 WORDS OR LESS)

I can't clean up the entire industry but I can clean up my corner of it. So can you.

—Kathryn Adams

Is it easier to lower your prices than it is to raise them? Good question . . . how much time do you have? What I can tell you is to always rotate the stock.

—Paraphrasing Norman Fleishman (My Dear Ol' Pop)

The best way to charge higher rates is to obviously earn it—create great work while providing exceptional service—you know what that is, and so do your clients.

—George Coghill

The lower you go, the harder it is for all of us to make a living. People—it's a job, not a hobby. Charge for your work.

—KellyAnne Hanrahan

This is a business; no matter how artsyshmartsy. It's called "commercial art" and it's a real name for something.

—Elwood Smith

"Budget" is the magic word. Try to use "budget" instead of "quote." Lead with: 'Let's set up a budget for this illustration together. In my experience, a realistic budget would be in the range of $X to $Y, depending on complications, unforeseen changes, and so on.'

—Roger Brucker

In any business, whether you are buying or selling, it pays to know how to barter.

—Don Arday

© Fred Lynch 2016

© Corrine Bayraktaroglu 2016

Price too low and they'll question the quality or service. People equate quality to price even though that's not necessarily the case. Understand the difference between offering a fair price and pricing to sell.

—Gerald D. Vinci

Practice "value exchange" when negotiating. A client may want you to reduce your cost. Don't merely agree to a price cut and be done with it. Instead, "exchange" the value in some other way. If the client still says no—walk away. At least you gave it one more shot.

—Kristine Putt

A note to potential freelancers: think about taxes before you spend all those checks. A good rule of thumb is to save 30 percent of all payments for Uncle Sam.

—Roger Starnes

I like Maxfield Parrish's comment on the difference between fine art and illustration: "The difference is about $30,000 a year."

—Scott Bakal

© Greg Pizzoli 2016

# Chapter 10

# The Portfolio

*Widen your scope; see the big picture. Portray the ordinary in an extraordinary manner. The payoff is wonderful.*

—Tom Garrett

## ABOUT THE PORTFOLIO

We make a point back in Chapter 2 that your illustration education—learning the basics, picking up the right tools (creative, critical, and technical)—provides the foundation of your practice. A stellar résumé is all well and good; but you should consider your vitae the supporting act to the main event: an absolutely competitive portfolio.

Most illustrators will tell you *fuhgeddaboutit*—sending a résumé is actually a waste of time, but all illustrators will tell you your portfolio will speak sheer volumes about your chops as an illustrator, regardless of where you are perched on the career ladder. It is the gauge of how a client can benefit from your abilities.

In person or online, a portfolio is a collected display of samples, a planned presentation of your work, used to communicate your abilities—call it your gift—to that potential client. It cannot be said too frequently—it is the portfolio that counts—whether it's digital or physical, you just want someone to look at your work.

When you graduate from art school, your portfolio will be awash with fitting student samples and you'll be faced with a real conundrum: have you done any real work, out in the trenches, under actual field conditions of seriously demanding deadlines and consequences?

And whether online, left with the assistant, or opened across the table from you, your portfolio must offer as descriptive and effective a presentation as possible. The playbook will vary with your method of presentation, so let's open up the book on portfolios, shall we?

## SURVEY SAYS

If you approached a network of illustrators and polled these correspondents about their methods of promotion, one of your immediate questions might explore the current role of the portfolio in landing assignments and working with clients.

Realistically, no matter how great the response, you'd still field a limited sampling of folks out there. You wouldn't come up with the definitive answer to this pertinent query. But knowing illustrators in general, contrasting perspectives would surely provide lively feedback and an excellent opportunity to compare and contrast expert opinion.

### IN THE BALANCE

From my vantage point, I'd downplay any format wars, even dismiss a real "problem." Many illustrators still maintain a physical book, many scrapped them outright ages ago. Some illustrators will relate that they never get calls to send a physical book anymore; some art directors allow that they never *request* a physical portfolio these days.

There are illustrators who hit all the bases: face-to-face, digital, electronic, print, postcards, emails; they will stress the *balance* of submitted formats. There will be art directors who welcome any and all in various combinations. I think the Boy Scouts motto plays nicely here: *Be prepared.* Good sense to the rescue.

Both iPads and print portfolios are employed, and preferences varied per individual. Thus there are illustrators who will wisely counsel you to work the tag team of a physical plus digital portfolio, by request or as necessary. Run both on your "A List"! And why not—either can shine when called on to do so.

In some circles, the iPad represents the logical evolution of (or an out-and-out revolution in) the review process. I learned that, for certain illustrators, print samples—once the life blood of a promotion—are practically relegated to support status: backup, as it were.

John Blumen points out the flip side here. "I feel that if you're seeing a client who will use the illustration in print form, it would be best to show your work with hard copies and not on an iPad or laptop," he says. "Seeing the work backlit doesn't relate to the client's needs."

A few illustrators will tag portfolio reviews (and physical portfolios) as just a secondary resource augmenting their website and/or social marketing piece. Some only use printed books as gifts or for display and leave-behinds at shows or conferences. Along those lines, ready-made and on-demand books (for instance, via Lulu or Blurb) are used by illustrators and welcomed by art directors.

## BUSY BUSY BUSY

Oh, there are artists who push email promos, while others pan them outright. Folks still send cards. Some illustrators will advocate a program of frequent emails *and* periodic card submissions, sent quarterly.

It will be safe to say that all illustrators uniformly recommend a knockout web presence. Some illustrators define their website *as* their portfolio. Art directors might discuss the one-two punch of an email linked to a web portfolio, usually professing a decided preference for a purely electronic review. Follow-ups are just plain smart.

As it has been for ages, what has remained constant is that art directors are overworked. They probably don't have much leeway to see folks in person, and just don't have time to wade through a flood of submissions swamping their desktops (real and virtual). Cards may stack up and emails may wait—and wait—until the rush is over. (Ha!)

Also unchanged: while good research goes a long way to get your card to the right place, inappropriate, mailed submissions are quickly tossed into the circular

file. Sensibly, mass mailings are not "green." Thus, the simple waste factor may be entered into the equation, too.

Some art directors say they don't get or will not receive drop-offs anymore. The glare and function of those plastic portfolio sleeves register complaints by art directors and illustrators alike. Note: these plastic sleeves are earmarked by both art directors and illustrators as the telltale sign of student (okay) or amateur (not so okay) submissions.

Whatever the format, simplicity is regarded as a virtue. On your site and on a device, promote fast, smooth transitions and smart, clear organization; efficient navigation and ease of use.

### FROM A DISTANCE

Most illustrators will call attention to portfolio visits and how invaluable a face-to-face meeting is for both art directors and artists, for newbies and veterans alike. But many illustrators have never met their clients.

And for some, the idea of a traditional portfolio is like something out of ancient art history; they tossed their print portfolio—literally or metaphorically—ages ago. And this is a timely scenario. If you work almost exclusively for the web—as many illustrators do—the idea of print samples becomes an archaic, academic exercise.

"If I had to have a 'classic portfolio' right now, I wouldn't know where to start," says KellyAnne Hanrahan, "especially since so many of my graphics are web-only. I've used my website for a portfolio since the nineties, and I haven't been asked to bring a traditional portfolio into a meeting since about 1996. My typical meeting is the client viewing my website with me at their office—works great!"

## OUT OF THE PICTURE?

Presenting your portfolio on an iPad (or a similar device) is an attractive option. The tablet format offers a convenient, small form factor and boasts the advantages of quick updates, economic changes, and efficient, easy corrections.

But some illustrators will say that print samples may be more impressive. And being practical, until print is truly (and absolutely) no longer viable, the tactile experience and education of print—the technical knowledge acquired via a thorough understanding of the prepress process—still can give you a professional advantage.

And God forbid your electronics fizzle out on you. What's your backup plan here?

# JUSTIFIED

Scott Bakal has taught portfolio for years and makes this comment: "I've always felt awkward having students purchase a portfolio and prints. It's part of our overall curriculum—all the portfolio teachers do the same. These physical port-folios are used for Portfolio Reviews and at Open House, where art directors come and visit.

"But maybe because of where I am in life, using those two events to justify the expenditure makes me feel weird," says Bakal. "I do hope students get more use out of them. Some students will not buy the case and acetate and just bring their iPad. I'm fine with that as long as their presentation is tight . . . and works. Nothing worse than fumbling over technology on the spot."

Steve Hughes joins in here: "Because the financial aspect of putting together a printed portfolio has seemed to be a burden for my students (we also are far removed from art directors), I've started requiring a pdf portfolio designed for one of the self-publishing sites," says Hughes. "The print version is optional. Everyone is required to prepare a digital form as well via web. The pdf at least asks them to put together a clean design and presentation."

## MAKE YOUR MARK (FOLKS JUST LIKE YOU)

### RECASENS: RADIANT

Although you may want to shoot for the moon when creating your book, putting your portfolio together is not rocket science. For Cristina Martin Recasens it comes down to three salient points. "Ask two questions up front," she says. "First: 'where's my best stuff?' Second: 'who sees this?' Next, make this statement: 'Let's keep it brief. I want to show the absolute best I can do to my intended audience with the minimum number of illustrations.'

"It's necessary to understand that most of the time we send our portfolio," Recasens says, "it's to someone who has to review hundreds of them every day. So it's important that your book be shiny and light and entertaining, and *all at the same time*. This will be invaluable and leave the reader with the taste of wanting more."

Is it important to have a definite style and stay with it? "This is a constant debate amongst illustrators," Recasens says, "but not a question or problem for me. I simply find it easier to keep to one path. At any point, if this mindset becomes an obstacle along the way—or if your creative wheels get stuck—there are no traffic laws that say you have to follow that road.

Recasens also believes that while it's important to find your style, furtively chasing down that signature look often leads to creative roadblocks or potholes. "It's great when

style arises naturally," she says, "but sometimes it's necessary to keep moving forward, regardless. Your style shouldn't be forced, and the search for that style shouldn't get in the way.

"The best advice is to keep drawing to gain constant perspectives about your work and you'll make your destination, ready to knock on all the doors with your brightest, lightest and shiniest portfolio under your arm."

## COMPARE AND CONTRAST

Avram Dumitrescu offers this good advice and insight about your portfolio: "A traditional portfolio is more difficult to ignore due to its physical presence," he says, "but also more expensive in terms of making copies and transport. A web link is simple to send in an email, but can be easily deleted, or might even be routed into a bulk-mail folder.

"Both types of portfolio should be carefully selected and presented, and of a limited amount. It's unlikely that your work is going to be the only portfolio the art director is going to look at, so you want your carefully curated selection to stand out and not be overwhelming due to volume."

## THE REAL DEAL

No matter how it's seen, be selective about what you include in your portfolio. Young illustrators tend to show their best work, but dilute it with anything they have that's been "printed" (and here, I'm using the term loosely).

Maria Piscopo asks you to remember that you will not show "everything ya got" unless you are meeting with a rep. "Keep in mind," she says, "that clients only care about what they need from you, so find out what slice of your portfolio pie that is and just show that work."

The number varies slightly from expert to expert, but a dozen of your most representative pieces should be sufficient. An exact setup also fluctuates from source to source, but generally you would organize the presentation so that your best and most eye-catching pieces are the first and last shots viewed. One train of thought says a portfolio—or portfolio presentation— should be viewed as an actual *design* project in itself. We'll play with this in a moment. Your portfolio/presentation can demonstrate display and packaging opportunities as well as showcase your capabilities in this department. It implies an intelligent strategy to market potentially added value—you, as an *illustrator/designer.*

Your portfolio should be neat and well crafted (your online presentation should echo the same). You don't actually need more bells and whistles; you want

less flash and glitz . . . far more substance. This means ease of maintenance for you, ease of use for the viewer.

Al Wasco reemphasizes that some employers still want to see a physical portfolio, "because it gives them a sense of their craft and attention to detail. It may be debatable, but as mentioned above, a back-up physical portfolio never hurts."

Hey, you want be a contender. A sloppy book, or one that is not unified or organized—in execution as well as navigation, and whether that be digital or analog—will get you a one-way ticket to Palookaville. Did you want to suggest that you care little about craftsmanship? Do you intend to convey the impression of an illustrator who doesn't think logically? Will you seriously want the client to say, "You don't value your own work, how are you going to value the work you might do for me?"

## ONE TO TAN

"As a contemporary illustrator a lot can be accomplished by having a good website, and a well-presented portfolio," says Shaun Tan, who tells you to keep both of these simple, showing only your best work. "Young artists always seem to err on the side of excess—as I did," he says candidly.

"A good folio needs only about twelve pieces—be selective, especially if you are presenting in person," Tan says. "These should represent technical skill and diversity, color and monochrome (especially anything featuring human figures, something editors usually look for)."

Tan says that when possible and where appropriate, it is always good to arrange a face-to-face meeting with a relevant editor or art director. "Personally, I've found this useful, to get to know each other as people rather than less memorable email or web [connection]. Success as an artist, especially in publishing, has much to do with warm relationships."

## ASSEMBLING THE PORTFOLIO

This can be debated long into the night, but I'll err on the side of consistency and begin by saying that it's best to present a solid, homogeneous style (particularly at the beginning of your career), especially when selling in the national marketplace.

Now, repeat these three words while putting that oh-so-consistently-relevant portfolio together: "only my best." Generally, small is better and less is more. As Tan recommends, think in the neighborhood of twelve pieces. (If you

need a reasonable range to bounce off of, it's ten to twenty pieces.) Focus. Be highly selective. If in doubt about a particular piece, don't use it.

Nothing less than the crown jewels should glitter as your portfolio opens and closes; you're only as strong as your weakest sample. That one inferior piece sandwiched somewhere in the middle of your book will be remembered first—it will detract from the "good stuff" and diminish the impact of the entire presentation. Don't include anything of which you're not proud. Don't include any style or technique you don't want to do. Don't include work just because someone paid you.

"Never ever put in a sample just to show you can do (whatever) unless it's *great* work," says Wasco. "Don't try to simply show how well-rounded you are unless every piece is absolutely top-notch. It will only call your judgment into question. As in 'why the hell is *that* in there?'

"This applies to anything and *everything*," he says. "Never try to show that you can do it all. It will backfire on you unless you're one of the rare people who *can* do it all. Even then, if you don't love the thing, why show it?"

As you develop, so grows your portfolio (we're still talking quality, not quantity). A portfolio should never be stagnant—update it regularly. Samples must be well-protected but portable, and easy to change and examine. Make it simple to carry (with or without handles), of uniform page size and lightweight. While not terribly fresh, a leather or leather-like ring binder (open or zippered) enclosing transparent sleeves offers the simplest answer here.

There is no distinct advantage to either a vertical or horizontal layout, and it's not written in stone that you must go with a traditional, conservative portfolio format. But your portfolio should not be a lazy Susan or circus ride. By this I mean that the portfolio review should *not* be a physical workout (a compelling, visceral experience is another thing entirely). So, you want to make sure the art director isn't swiveling your book—or his head around—from page to page; have one consistent page orientation throughout. (If this proves impossible, group all horizontal pieces in one section and vertical samples in another. This way the art director only cranes his neck once.) While such good organization is a must, I don't necessarily subscribe to the train of thought that says one must lump all color pieces together (and the same with black-and-white pieces).

It's a given that solid craftsmanship is crucial. "Neatness," as applied to structure is arguably relative, but crisp, clean samples wrapped in a professional package, all presented with style and aesthetics, are the orders of the day—a portfolio cannot be a haphazard affair. There should be a planned arrangement and logical progression to the sequence of samples. Saying that, your credentials will be highly suspect if the presentation shines brighter than your samples.

For identification purposes, the portfolio should be clearly—but tastefully—labeled. No neon lights, just complete identification inside and out. As for the

order of individual pieces, you can approach the pace and flow of the portfolio in a variety of ways. Chronological (or reverse chronological) organization shows progression and development. Organization by subject matter works for many illustrators. You could take a graphic approach and group by technique. You might want to organize thematically and demonstrate problem solving within a specific body of assignments.

Always start big and end strong. After a trenchant beginning, some portfolios will build to a big bang. Wasco says that one rule of thumb is to start with your strongest piece and end with your second strongest (or vice versa). Many books ski-lift to a strong middle and slalom to a solid stop. Others are like an amusement park thrill ride—with (visual) peaks and rests culminating in a fast finish.

## THE ONLINE PORTFOLIO

Wasco and I agree that *all* illustrators will emphatically tell you an online portfolio is *the* critical element of your whole program. It's simple: a web presence is mandatory. The online portfolio helps you promote and market. An efficient, good-looking, easy to find website keeps you ahead of your competition and helps you to stand apart from the crowd.

You may want to consider a blog instead of a traditional portfolio. There will be a host of decisions to make (and jobs to do): doping out smart keywords; using the right domain extension; coming up with a good name; going with the right publishing platform; choosing a killer theme; downloading/installing correctly; selecting plug-ins; organizing structure, navigation, and content; optimizing your imagery; and then savvy promoting.

The topic of the online portfolio is introduced here, but I expand on it in later chapters (particularly, Chapter 14).

## CD OR NOT CD . . .

"Remember those uniquely shaped CDs?" C. J. Yeh asks. "CD was once 'cool,' but it's now a dated concept."

Yeh stopped asking students to prepare digitized portfolios on a CD about five years ago, and, as you know, most new Mac laptops don't even come with a CD/DVD player anymore.

"The way to go is to a pdf file," Yeh says. "Send it through email. As long as you know how to prepare it properly (which may be a required skill for illustrators), the file weight will, or should, be manageable.

"If your work is on a website, email the URL. I've been working with recruiters, creative directors, and art directors over the years, and email is their preferred method of communication."

### . . . THAT IS THE QUESTION

Steven Hughes has also stopped asking students to prepare CD archives or portfolios. "My laptop won't even accept them," he says. "Since archiving digital content has moved to external drives and cloud storage, the common spindle of blank discs is no longer in every student's dorm room.

"In fact, a few of my students have never burned a disc before," says Hughes. "I collect work via a school server and recommend Dropbox as a possible delivery method for portfolio pdfs (if they are unable to create a manageable size for email promotion). But, remember—a web presence should take priority."

## IT'S ALL A BLURB

Ready-made portfolios and on-demand books (for instance, Lulu or Blurb) are used by illustrators and welcomed by art directors. Benefits of these print-on-demand services are straightforward: a fast turnaround; an easy, efficient process; you get a nicely crafted, inexpensive end product.

It's an attractive option (especially for cash-strapped students). Hughes says one issue that usually comes up during preparation of a portfolio printed via Blurb is the twenty-page minimum requirement.

"Students are continually told to only show their best work, and yet will have trouble meeting a twenty-page minimum," says Hughes. "Including well-executed ideation thumbnails, half-size comps, final drawings, or even enlarged details could add useful content to the book while accompanying some, but not all, of the final work."

Hughes says that it's important to think about pacing and not be too repetitive in the layout of the book. "In the past ten years, relying mostly on web promotion, I have only printed books twice myself—once when I graduated (when clamshell boxes were still common) and just this past summer to show at a conference.

"In the newest version I added heft to the book by including informational text that helped the portfolio appear more like an artist monograph. The text side of each spread

might include a quote from a book that inspired a piece or other relevant facts that a reader could find pertinent if they stop admiring the work to read.

"This is a place that you could let your personality come out a little more and help you make a lasting impression. The caveat is that your text also needs to be 'invisible' and let the art shine. If you can't handle typography well, don't do it yourself. Seek the help of a designer or solve the problem another way.

## A UNIFIED FRONT—AND BACK

When the portfolio is presented in an actual binder (or boxed, or within some manner of a container), you must unify format and sizing. The best way I know to unify a portfolio is via a consistent presentation.

Making all the elements consistent means maintaining a steady appearance. That includes mounting and matting, as well as exterior and interior dimensions.

Subtle touches and elegant materials, if you can afford them, add a touch of quality and could convey the image of a successful illustrator who can afford the best. It might be wise to make such an investment if you're trying to impress high-profile clients.

However, as said previously, the packaging cannot outshine the contents. "I've seen too many students spend *big* bucks on a portfolio case that looks cool," Wasco comments, "but not be willing to invest the time and money for flawless printing and mounting of samples."

### MIX AND MATCH

While assembling your portfolio you might want to consider putting together interchangeable components so your portfolio can be tailored to a variety of situations. For example, say you're trying to sell your services as an illustrator of book jackets. You want to focus on examples of the work done in this area rather than, say, samples of greeting cards.

And while not all buyers want to see roughs and process work to gauge how you think, you may want to demonstrate your sketching ability, rendering talent, and even your design capabilities. If so, you could create a page layout showing sketches, a comp layout, and the finished piece in context. This way the client can see how you coax ideas along to become realized finals.

But Wasco suggests you fully think this through. "If I only see a half dozen sketches for a logo illustration I know this student doesn't explore an idea widely," he says. "I've also seen preliminary sketches that were stronger than the final piece—at which I'm invariably told, 'Well, my teacher didn't like that one.' This leads to a discussion about trusting your instincts and/or the glories of presenting multiple ideas."

Which gets us to this: when given the opportunity to discuss your portfolio (one piece or the sum total), we can make a strong case for you to adroitly explain how you solve visual problems—better yet, how you can solve *this particular client's* visual problem. Indeed, some buyers may not be familiar with the illustration process at all (yes; don't assume they're at all aware of what's being commissioned and/or how it's done). Some may just want to know *your* specifics—they want to be assured you know what you're doing every step of the way.

## TARGETING A PORTFOLIO

Should you change your portfolio for each type of market you show it to? A "market" can be many things: the type of industry; a type of client; the style of work; a medium or technique; or the geographic market. Many illustrators work in concentrated markets. Some cannot relate to changing their portfolio à la carte, which is not the same as updating, of course.

If you have many pieces from which to pick and choose, you may want to orient your portfolio to particular markets. There are many ways to approach this: a binder with simple, interchangeable sleeves can easily facilitate this process (heed the aforementioned caveats about a lackluster platform and cheap plastic sleeves, however).

At the beginning, you may not have many pieces targeting your various market options. This means a somewhat generic portfolio that addresses a wider base—not a sampling of divergent directions, but an overview; a portfolio that meets a variety of needs.

Let us again use greeting cards as just an example. Your quirky, hard edge, line-oriented drawing style reproduces great and complements tough, driving news stories. It's strong and compelling. However, the art director at Ballpark Greetings may not relate to your portfolio of black-and-white editorial samples.

If you add color and humor (and present card mock-ups to further sell your case), that Ballpark hotdog could visualize how that type of illustration could work for him. By the same token, your cute greeting card designs for Ballpark may not pass the mustard at *Rolling Pin*, a magazine about marriage counseling. The imagery you show must be in context with the content.

Yes, sometimes different markets overlap, but people will tend to classify your work. It's a little difficult to break barriers and preconceived ideas. The rule of thumb is to always show what's relevant—to the client and for its market.

## LABELING PORTFOLIO PIECES

Let your work sell itself. Saying that, labels could perhaps be employed as efficient identifiers or as meaningful elements of your layout design. Such compositional devices may possibly be effective and appropriate if used with purpose: briefly noting the title, client, and project.

Some reviewers may welcome a short, concise description for each piece: two or three sentences explaining what the problem was, and how your visual concept solved it.

Online portfolios, with built-in caption and labeling options, offer simple, straightforward opportunities to provide valuable information about your process and product. But for physical portfolios, you must think smart about this—any accompanying text (or notes) must enhance the visual wallop that absolutely carries your portfolio.

## CALL WRITE NOW

Next up, we'll chat about presenting a portfolio, which may well be in person—or not. To reiterate: odds are your work will have to speak for itself, so make sure that it does. And that's as it should be.

Of course, requesting and scheduling a portfolio review may just turn out to be two different thingamabobs. Either can be done by letter or telephone. But the request of and scheduling for a review of your book (and/or an actual meeting) are obviously linked; your date with destiny hinges on an affirmative answer to that appeal.

A phone request is informal, even intimate. It's quick and, regardless of the response, right to the point. A written or emailed request can be backed by visuals—after all, you're selling product, not patter. Both methods have their edge, so take some thought to determine how you want to communicate with the art director. Texting feels a bit too casual, but any time you say, "oh, definitively not" (to whatever) you'll hear of somebody, somewhere, making that happen. Wow, there are always surprises, but I wouldn't advise texting to set up portfolio reviews.

Some folks are natural writers; their polished words are powerful and persuasive and not to be ignored. Others prefer the immediate and individual interaction only the telephone provides. As you'll be spending lots of time on the phone and at the keyboard (business generates correspondence and vice versa), you'll have plenty of opportunities to develop the many facets of your communication skills.

## THRILLER

For Peter Arkle, submitting to the *American Illustration* annual competition has become a yearly tradition, something he would do regardless of the outcome.

"I like that it makes me sit down every January or February and look at all the work I did last year and pick out the things that will work in that *AI* context," he says. Arkle

doesn't think *AI* showcases the kind of illustration he does to pay the rent, but is, rather, a fine vehicle for what he labels "the larger, stand-alone, more 'glam' pieces.

"Much of what I do only works in specific context and would never be chosen by *AI*," he says. "I think it's more of a good exercise than a good investment. At least I get to write off the entry fee as an expense. People see my work there and there's a subtle ripple effect as a result. I can only think of one occasion when someone approached me after seeing my work in *AI*.

"Most people tell me they saw my stuff in the *New Yorker*—even though I may not have had anything in there for years. I think they probably saw my work elsewhere and then that was the only publication with drawings in that they could think of. I am not complaining. It's good they thought of me, that's all that matters."

Newbies take note: Arkle feels that entering *AI* for a total beginner is a good thing to do. "I certainly did that," he says. "If nothing else I got a thrill when something was actually chosen, after years, for the first time.

"Thrills are good," Arkle says with a smile. "That was a boost that probably helped me work harder—and smile while doing it. It made me feel like I wasn't just drawing in a void."

# PRESENTING YOURSELF

What happens during a portfolio review . . . it's just like a job interview, right? There are all kinds of "portfolio reviews." The accessibility of your work on your website or blog—think Tumblr, Weebly, WordPress—constitutes an obvious "review" situation. There are dedicated portfolio sites (for instance, Behance, Cargo Collective, Carbonmade, Indexhibit. Designers will find Dribbble) and national, regional, and local portfolio events (as sponsored by the AIGA or Behance, for example). And of course, there's still the classic one-on-one meeting—a real person looking at real stuff (with or without a real you present).

Generally, when and if you can get a face-to-face portfolio review, it's less formal than a job interview. Alison Miyauchi, chair of Communication Design at Alberta College of Art and Design (Calgary, Alberta, Canada), tells her graduates to try to get as many of these "full contact" reviews as they can. "It helps them refine their books," she says.

The game rules don't vary much. Common sense tells us that what counts first and foremost is great work—backed by self-confidence, a positive attitude, and good personal appearance.

But folks have disputed even this. Yep, many art geeks dress rather (expletive deleted) *casually*. However, it would be irresponsible to insist that an iconoclastic dress code will work in *your* situation where *you* live. Sure, your mom's not

dressing you now, but the bigger picture still says to dress appropriately, fashionably, and neatly.

But these days, can you actually get such personal face time? Getting in to see art directors has always been a tough gig; that is, after all, why the demigods of illustration created the Internet for busy, busy mortal art buyers. But regardless of the odds, don't write off the prospects, opportunity, or rewards.

And, just a note . . . don't back away, balk, or bark at personal contact. When you get right down to it, to quote the late, insanely great Simms Taback, "This is still a business of people." I say good people skills will go out of style only when people disappear. So . . . whether a lefty or a righty, carry your portfolio in your left hand; be ready to shake hands with the art director without fumbling or shifting your binder. Eye contact is a sign of confidence—look your client square in the face, open your book, and knock some socks off.

## TAKE A MEETING

They ring you up to come in and actually meet with a real person? Brilliant! Ken Bullock suggests that you should consider your hardware for this important get-together. It can be boiled down to two options:

A. Go with a traditional laptop computer (Mac or PC—your preference). "Bear in mind," Bullock says, "that most of your creative team will be on a Mac, but clients may be PC, so there might be some compatibility issues if you do not plan ahead."

B. Tablet computers. This could be an iPad, Android device, or similar. Yes, there's a "coolness" factor to consider here. Like it or not, it can also speak to your level of sophistication with technology—which comes into play as soon as you pull out your secret decoder ring to drive your presentation.

In either scenario, it's a good idea to trust Bullock's road-tested advice here. He recommends you work out ahead of time how your equipment factors into the course of the meeting. For, as Bullock says, "That coolness factor goes right out the window if you fumble with your stuff or, heaven forbid, your state-of-the-art technology fails! It's not the end of the world, but certainly doesn't help build a client's confidence in your abilities to help them out."

Al Wasco echoes this. "If at all possible," he says, "be entirely self-contained, that is, bring whatever technology you need. The iPad is becoming more common, but bring the correct video adapter to plug into a projector or monitor . . . don't expect the client to have the proper cables/adapters."

Wasco also cautions you to be careful with an online portfolio in a meeting: what if the Internet/wireless isn't working where or when you have your little summit? Be sure to have an up-to-date *local* (offline) copy of your presentation on your laptop/tablet, just in case. Better safe than sorry: have a print version on board if all tech fails. "You don't want to sit there with a dead laptop," says Wasco, "trying to desperately explain how spectacular your work is."

# WE'LL MEET AGAIN

MaryAnn Nichols, C. J. Yeh, and Al Wasco offer these pointers to make a meeting more productive (and profitable):

1) *Do some research.* Who are you seeing? What do they do? Who are their clients (or what is the mission)? What do they need? Can you help? If so, then tell—better yet, show—them how. See numbers three and four below.

2) *Look presentable and be courteous.* You have only one chance to make a good first impression—use it. Always shake hands, make eye contact, introduce yourself, and be polite.

3) *Master the art of give and take.* Both accept and offer suggestions. You are a big fan as well as a great problem-solver. Listen. Counsel. Learn. Educate.

4) *Be confident.* Skillfully (but tactically, tactfully) blow that horn. Self-promotion—it's not just for breakfast anymore. Point out your strengths, have a positive attitude, and suggest how your skills can advance the cause.

5) *Organize.* There is the train of thought that you should keep like assignments together in your book. Don't be redundant—it's not necessary to show the same illustration in twenty different color combinations.

   But many industry professionals prefer to see a portfolio or portfolio website that's not compartmentalized into categories. Instead, they much prefer to see concepts that are executed across multiple formats and media channels. For example, a "360" advertising campaign offering your illustration in print vehicles, video, direct mail, online, via social media, and more).

6) *Be the consummate strategist.* Illustrators today must take on the role of a steady navigator who can steer their art through what is a vast sea of choices. Note here that your mastery of conceptual thinking beyond one given task is essential.

7) *Never apologize for your work.* If you are dissatisfied with a piece in your book, take it out or redo it. Never show anything that is not your best. A few excellent pieces are far better to show than many mediocre ones. After all, your goal is to leave a good impression.

8) *Thank the interviewer.* Always thank the people you have seen for their time and help. Respectful gratitude goes a long way—for both you and your contact.

9) *Leave your calling card.* Actually, remember to provide a leave-behind *and* your business card. This helps the interviewer to remember you and associate you with your work.

10) *Always follow up.* Piscopo recommends *you* ask for a follow-up (don't count on the client doing it for you) with an open question such as "How would you like to keep in touch?"

Then you do just that. This capsulizes the next steps you both agreed to at the end of your meeting. Follow up with a thank-you email the next day, and after that, consider a handwritten note on a card of your own design. Not only will the person be amazed to receive an actual letter in the mail, the card will be yet another sample of your superb illustration/design skills. This abso-posi-lutively needs to showcase your best work.

## A BIT OF A DROP-OFF

Wasco doubts that drop-offs happen much, mainly because it is the age of the Internet and art directors are busy. You respect that, of course. Back in the day, drop-offs could be viewed as simply saving everybody's time and eliminating bum prospects (from the art director's point of view) and uninterested vendors (from yours).

But we *are* cruising at Internet speed. Online is all about efficient time- and energy-saving, plus ease, is it not? However, I never say never, and there *may* be those art directors—if they are looking at physical portfolios at all—who want to look at your physical portfolio right off the bat (and may only look at portfolios at specific hours on certain days). If you are, by luck or chance, instructed to leave ("drop off") your book, you will, well, drop it off—then have to pick it up later, again at a scheduled date or time. Yes, you read right; you won't be there. This caveat still applies everywhere: if you feel your portfolio is not ready for prime time, not strong enough to "speak" for you in your absence, don't show it yet; get that book in shape.

As for any results, if you are requested to drop off your portfolio, there *may* be a written reaction. This just might be impersonal, generic, a photocopied form, or handwritten on Post-it notes; possibly—there are those who will say *improbably*—with a critique or suggestions. If the art director is interested, an assignment might at some point come your way—bravo— or maybe an appointment will be arranged to get together to chat about a job—great!

Or you might receive nary a word . . . no clue about any reaction, and you may have to politely follow up for a response. And even then, you may still get no response. Here, Piscopo smiles a bit ruefully. "And do *not* include the leave behind," she tells you. "It is too depressing when it comes back with the portfolio because they 'forgot' to pull it out and keep it. Mail it after with your follow-up."

As far as portfolio reviews are concerned—no matter how you slice 'em— there are no guarantees, and no obligations. Considering the ROI—your return on investment—what's the smartest way for you to peddle your wares?

# SPEEDY DELIVERY

So your portfolio has to get out there somehow, some way. Snail mail? Your ol' pal, Fred Ex? Shoe leather? For many illustrators, doing the rounds with (or sending) an actual portfolio through the post harks back to the age of the dinosaurs. Some harried Directorsaurus Wrecks gnawing on the delicate bones of your tender binder? Ha—straight out of Drawassic Park! Your online portfolio is vastly preferred.

Indeed, Mark Monlux says, "I haven't [sent out a portfolio] in years. However, I field continual requests for my website, and I point people constantly towards my blog. My online layout and presentation is as important as a physical portfolio and is seen by far, far more people."

Wasco states he'd be surprised if one in a hundred clients/employers asks for a physical portfolio. The online portfolio, in his experience, is virtually *always* the first level of screening. "If your online portfolio isn't good, there's no way you'll get an interview," he says unequivocally. "Like it or not, and for all types of illustrators, a strong online presence punches the ticket."

"Before the Internet," Yuko Shimizu says, "if you made art, you had to physically show it, otherwise people didn't see it. Now, you make art (even if you're a nonprofessional) and you make great art in the middle of nowhere, you put it online. If the work is good, people start talking about it and linking to you. It's as simple as that."

When Shimizu started out in 2002 few illustrators promoted via websites and blogs. "I started out in that transitional period," she said in an interview with the *Atlantic*. "The Internet helped establish me as a working illustrator, to make a living from it. Before the Internet it might take five to ten years to get established, as you had to physically bring your art around to show to magazines and newspapers. Now students do their work, they put it up online, and next thing you know, anyone from anywhere in the world can see it."

## TAKE ME OUT TO THE BALLGAME

But not so fast. I coached Little League, so I'm going to make sure we hit all the bases. We concur about the importance of your fastball (a.k.a. your web presence). But we'll just say it's Spring Training; let's take a practical look at a few other pitches: mailings and cold calls.

### IT'S IN THE MAIL

If you *must* mail portfolio materials to a prospective client, here are some guidelines:

   1. Obviously pack it up right and tight.

2. Organize for a neat, clean, focused, clearly labeled, logical presentation when opened.

3. Send an expendable binder and samples; nothing irreplaceable.

4. Submit work to the appropriate person, when promised. "Find out *now*," says Piscopo, "how long they expect to keep the portfolio."

5. Include a personal cover letter: professional, but brief and friendly.

6. Include an SASE (or a prepaid FedEx shipping label) for its return.

7. Be patient, you won't get your work back immediately. Follow up with a card, email, or phone call. Do not give up, but don't be pushy.

## BABY, IT'S COLD OUTSIDE

A cold call, as you'll remember from Chapter 8, is a contact without request or referral. It could get you a portfolio review without the preliminary wait involved with written correspondence, but cold calls require time and energy you may not want—or have—to expend. Factor in that busy art directors might consider cold calls a distinct bother, and what do you have?

What you have is door-to-door sales, and perhaps pure frustration. For some illustrators the idea of the cold call is unthinkable. Others hate them, but still deem the practice an acceptable part of doing business. Still others view cold calls as just another avenue for pursuing yet more work.

Cold calls are a sure way to test your tolerance for rejection, but a super salesperson may get a decent return for the trouble. What do *you* think?

# ON THE BOARD

It's important to be able to execute the idea, but it's more important to have an idea to execute.

—Veronica Lawlor

Where is that "sly wink"? Imbed a second meaning; convey a dense or heavy message. It's the little twists that surprise or delight a viewer, that compel your audience to look again, to think again.

—Tom Garrett

If I had listened to everyone when I was first looking for a job, I would have taken every piece out—so I decided to go by my own instincts. It's a hard balancing act. Be willing to listen, but [present] your best work and stand by it.

—Elwood Smith

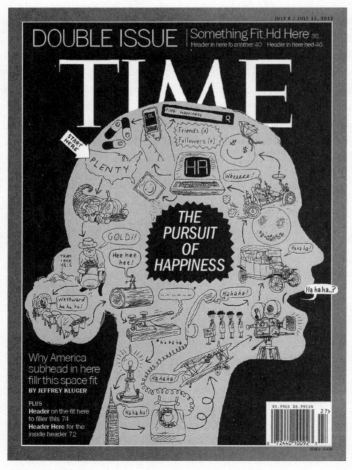

© Peter Arkle 2016

Self-editing is difficult and important. Focus on your strengths and what you do best . . . what you love the most. Resist the urge to include a sampling of everything—as in, "I can do it all!" It comes down to quality over quantity anytime.

—Al Wasco

Having a website is direct—[it's] a portfolio review that is instantaneous and international. Of course, you must continually update and pay attention to all the details and stay on top of everything.

—Isabelle Dervaux

Art directors are looking for good thinkers when they review a portfolio.

—Kathie Abrams

# Chapter 11

# Marketing, Networking, and Promotion

*Online portfolio and image sharing sites plus social networking make it both easier and harder to stand out from all the other creative folks out there.*

—Julia Minamata

## TOGETHER

"The Web has brought people together," says Tom Garrett. "In the past there were major cities that seemed to showcase what illustration 'should' look like: New York, Chicago, Los Angeles . . . those were the epicenters and it seemed like we all were shuffling around being Brad Holland or Mark English clones.

"Since the web, you can reference the world of influence and inspiration and we can honor unique differences and personal perspectives. Peel back the onion, take your time to listen to, listen for *your* voice. Don't assume you are fully formed in college, allow for maturation, integrate change and embrace the search for your artistic strength and visual confidence.

"And don't negate who you are," says Tom Garrett. "How can you be the best at what you do? Is it your skill level, your craft, your point of view? Those are the things that will set you apart from everyone else. Don't shortchange/discount your voice."

## TAKE OFF

Let's begin by stating the current obvious here: if we're talking modern marketing, social media has taken off. Well, duh, and meh, but it's a timely and appropriate lead-in. People are using social media as a means to explore new approaches *and* maintain previous standards. "Same old same old" is now more like "same old same new." So, the same postcard that invites you to a painter's lively, new exhibition points you to her Twitter feed, where you're also directed to a Tumblr of this artist's playful children's book illustrations.

"I talk to a lot of professionals and everyone has a different opinion," says Garrett. "I'm not going to weigh in and say '*this* is THE ONE path.' But there are so many ways to approach promotion now, such varied opportunities to show your work, as opposed to the classic mailer of a decade ago.

"The creative directories are not dead, the mailer is not passé, but my friends in the industry concentrate more on email blasts and Facebook," Garrett says. "They'll maybe send a mailer once a year, not four times a year. Fifteen years ago you'd spend a lot of time talking directly on the phone with the art director. In the last couple of years I think this has happened (for me) on one job. Everything now is quick with an email . . . art directors are juggling a lot more than they used to."

Technology has changed so much: the pace to order, create, and deliver the art is that much quicker. And thanks to the magic—or curse, depending on your point of view—of Photoshop, changes and corrections can now be stipulated and executed seemingly in an instant. "This is for better or worse," Garrett says. "It's never as easy to make changes—as you hope it is, nor as the art director believes it to be—it always takes more time to pull this off. Never fails!"

Sure, there are certainly art buyers who still want to see print material, but what's changed now is that you must always be prepared: there's a leave-behind ready to go; your work is on your iPad as well as readily accessible online (via your blogs and/or website); and you make sure you can show off real samples. Actual, physical art offers a window on what you are actually doing.

While it's true that you need a web presence, you will always be evaluated by your best and your worst. So your presentation—how you curate your best work—is critical. A site that takes forever to open, is too fancy, with slideshows that don't work efficiently on an iPhone—you're not helping yourself here.

But do hold on—there is this danger that you must have the perfect website. This is misdirected, and sets up a bite-yourself-in-the-ass scenario. "*Waiting* to put a website together until you have 'my best work' is counterproductive," Garrett says. "If you don't think it's perfect yet, that's a non-issue; websites must be living, breathing things that should be changed out frequently. Blog away as you hammer out your site, tweaking until you get it just so. Make it easy. Make it accessible. Avoid overkill. Must you show off *every* little thing as you demonstrate your eclectic visual thinking, studio chops, and advanced concepts?" And here, Garrett succinctly puts it all across with two wise words: "Jury yourself," he says. That's your real mantra, grasshopper.

Some art directors inform Garrett that they just don't have time anymore to sift through postcards or promos. Others tell him they still enjoy looking at mail-ins (but obviously, only keep the most meaningful).

Along those lines, Garrett notices the trend to do more with less—bravura on a budget, if you will. The classic "sell sheet-corporate name-on-top" leave-behinds, have become rather dated. "Now, illustrators are becoming more expressive," he says. "Little zines; unique, one of a kind pieces. But again, whatever you send, you want to make it easy for the reader to look through and enjoy."

A final note here: No one is suggesting that the package must be obnoxiously cute or clever. I'm making the point that there's such a variety of visual experiences to offer!

## BEND AND STRETCH

From a student's perspective, they're looking at an audience that's *them*—everyone out there is ages twenty to twenty-three. But Garrett advises you to do something that may be foreign, but is actually brilliant. "[When brainstorming your] promotion," he says, "go out there and stretch or expand that audience."

So do some research. Look at *everything*, all age groups and demographics. Push your comfort zone: put something in your portfolio that you don't necessarily want to do. That's not so counterintuitive, and doesn't actually contradict my advice in Chapter 10. Garrett is saying to rise to a challenge, you just may surprise yourself. There are no pitfalls or pratfalls to stop you. If the final tanks, or isn't up to your high standards, or simply doesn't work in context, toss it.

"And make sure your promotion is backed up on your website and portfolio," says Garrett. "It's one thing for an art director to see a beautiful promo, but when they go and search for you, if they don't see work that doesn't support that promo, they won't follow you."

## ABSOLUTELY

Let's put it out there: there are no absolutes in social media. It seems set up by some mysterious digital cabal: the pressing need to (or "ground rule," as I've even heard it defined) follow less people than who are following you. This balance of power—juggling who you follow with those following you—creates a weird vibe and ethos. However, everyone I talked to stipulates that it's oh-so important to participate. However, it comes down to personal choices, there is no "one size fits all" or "favored nation"; pick and choose, spread it out.

That's a tricky balancing act—not too little, not too much. So are there rules of engagement? Do you *need* to tweet at three different times during the day when those important "certain people" are on Twitter?

"I believe that," Will Terry says. "I think that makes a lot of sense, but if you try to be on everything, all the time, it gets to the point where you can just let it get out of hand. It's good to socialize, but if you are too immersed in this, it can become costly, time-wise."

Terry speculates that, in reality, some folks are actually addicted, and don't recognize any fine lines here. "Some illustrators focus solely on their work," he says. "They post constantly, but don't or won't bother to *exchange*. Do that and you just come off as a selfish poster, where it's only about you or your self-promotion. I see a backlash almost. If you never engage, people become annoyed. They will consider that you're just trying to grab their attention, but never willing to give any."

Postcards are certainly old school, but Terry, like many illustrators, still feels this venerable mailer will be valid for some time to come. "It's not hard for art directors to distance themselves from all the email they get," Terry says. "But a postcard addressed to an art director hits their desk; it's going somewhere. Sure, it may be going into the circular file; that's true . . . it's still easy for a busy art director to throw out a card, that won't change." (And keep reading, Terry has other pertinent comments about the viability of postcards coming up in the next section.)

## WATCH OUT

"Social media has brought an element of fun to sharing," says Linda Ketelhut. "But in terms of that, I find it's helpful to only focus on a few things I enjoy most. And as I work from home, it's easy to always be working and neglect my personal life if I'm not careful. I aim for balance, and that never includes doing it all at all times. Overextending—setting unrealistic expectations—is a recipe for meltdown!"

Charlene Chua maintains that social media has not created a revolution. "It is an excellent window to see what everyone is making, at various stages. It can help you feel less alone. But it can also be overwhelming and discouraging.

"And I don't think social media has, for most illustrators, been particularly useful," Chua says. The vast majority of social content is for personal amusement; even inspiring posts hardly have any lasting impact as they are soon drowned out.

"The exception would be for illustrators who decide to use social media to market themselves as an expert or celebrity, but I don't know if the 'illustrator-celebrity' will be a sustainable career path in the long run."

## COLD PLAY

Terry acknowledges a dilemma that he expresses succinctly: as invaluable as it certainly is, your website can be somewhat cold. "It delivers the information, but there's nothing more than that, there's no engagement," he says. "When people can get to know you, interact with you, they become more interested. A friend of a friend asks a question, this sparks a conversation; that dialogue leads to the sale of a video or they buy an online class from you. And then they'll recommend you to somebody else."

This is somewhat indirect, but a powerful personal connection. Terry doesn't live to sell stuff, but he's a social person and he loves to schmooze. He just simply enjoys talking to people. He knows that sales are a by-product of this.

"When I first started I saw that the percentage of jobs I snared from doing the rounds was way higher than what I pulled from the postcards I sent," he says. "As I said earlier, I feel postcards still have value. But if people feel they have an emotional connection with you they want to work with you more. They get to know you as a person. They'd just as soon hire you, a real person, than someone they encounter off some anonymous postcard."

## KEEP IT SHORT

In Michael Cho's personal experience, art directors at magazines don't mind getting a short, right-to-the-point email accompanied by one or two small jpegs

and a link to a portfolio online. Cho always tells students to keep it short, and, as he says, "Not turn it into a mailbomb. 512k total or less is what I'm aiming for—the idea is to get them to glance at your sample and then hit the link to your site. If they're waiting for a grey progress bar showing your email is downloading, you're already annoying them during a busy day."

The same goes for wordy cover letters. Cho says an art director should be able to scan your email quickly during a break rather than have to wade through five paragraphs of your education history. "Four to five sentences should be all you need," he says.

Regarding portfolio websites, Cho has some strong opinions and solid advice: "Don't join any portfolio site that boasts a stable of 10,000+ artists. That's *not* a positive point." The number Cho brings up is no exaggeration and serves to advance his credible argument. "In my experience," he says, "art directors do not want to surf through a sea of portfolios to find an illustrator they want to work with. They are much more inclined to sift through a tightly curated site of good work than a site that allows anyone to upload a portfolio."

Cho also wants you to consider the kind of clientele who are likely to contact you via such "trailer park" portfolio sites. "Better *professional* clients utilize better professional services," Cho says. "I do believe that you are judged by the company you keep online. That is to say, if you are on a portfolio website with other 'great' illustrators, you may possibly look like a great illustrator by association. Similarly, if your portfolio is on a large site featuring a lot of fan art, you may possibly look like an amateur enthusiast by association."

## HEADS

Chris Sickels regards marketing and promotion as two sides of the same coin. He feels that, heads or tails, it all falls within the realm of networking, staying in the present and keeping your name out there in the crowd. Sickels is generous in his praise of his peers. He's a magnanimous colleague who will recommend other illustrators when he's offered a job that isn't his strong suit.

Sickels's marketing program is consistent, but not regimented or calculated. He is cautious about what and how the Internet impacts his time, energy, and psyche. Wary of grandiose networking simply for the sake of the numbers, Sickels instead advocates for a focused professional network geared to the individual, and that generates positive results.

"There's incredible work out there," Sickels says, but admits that, "If I take in too much of it, it's hard for me to produce. My main focus is to make the best work I can and get it to the right people. Not every illustration will be amazing, or great, or worthy. But I believe that if you create good work, people will consume it.

"Likewise, if you're just sending out every piece you do or tweeting constantly just so people think you're busy . . . I don't see how that's beneficial. I

don't see my involvement with social media as a 'job generator.' Indeed, Tim O'Brien says that he doesn't need to be a hit with 6,000 fans, he just needs to be popular with a handful of art directors that use him regularly. There has to be a level of professional engagement, otherwise you just fall through the cracks."

# TAILS

"You know, if you don't send regular cards, your stuff just gets lost in the bottom of the pile," Sickels says, "especially as time goes on, situations change and things evolve. Eventually, you're forgotten. That's scary and this realization is a bit of a wake-up call. It's not that the art director is a bad person, they're just getting stuff all the time. It's the same with social media and networking, you have to stay relevant; you must keep a feed of your work out there so people can come across it if they want to."

But if one pulled out of social media, would the work flow dry up? "To the degree that your social media is an integral component of your PR machine, perhaps," says Sickels. "It's not just mailers and awards programs anymore. I hear more and more people say that the annuals are a 'day late and a dollar short' because by the time the book comes out the work is fifteen to twenty-four months old. Many illustrators are trying to move forward and a piece that is two years old feels somewhat stagnant.

"Now, saying that, I think that the Society of Illustrators' competitions, their events and openings, are even more vibrant than when I was in school. There's a tremendous tactile quality to having your work shown at the Society and people seeing it. Society openings are 'network heavy.' But on a real human level these events are about building brotherhood and friendship. And *that* is so important. It's more about camaraderie."

There's a delicate balance to networking: you have to be personable, but not get too personal. And you have to veer away from the sheer self-centered blind ambition to "sell sell sell." That means you must promote yourself as a physical person first. You market that to effectively build a professional relationship.

Here, Sickels brought up an interview with Wesley Allsbrook that resonated with him. "This isn't the exact quote," Sickels says, "but a summation of her comments on Sam Weber's podcast, *Your Dreams My Nightmares*."

As Sickels summarizes from the interview, Allsbrook says it eventually came to her she could go to openings and just be herself. She didn't have to pass out postcards; it wasn't necessary to turn a lovely evening into a hiring event. You could just say hello to folks and have normal conversations. "She realized," Sickels says, "that this is how real relationships start to build and these satisfying personal friendships can become gratifying, successful professional partnerships."

Sickels relates completely, citing a number of art directors who have become actual friends. "We've established a real physical connection, and our personal relationship has grown over time to become a real friendship. It's not a huge number; I can probably count them on both hands, but these are some of the longest illustration-based relationships I have. These relationships have gone beyond just job communications."

# SAME OL'

When students ask Sickels how to break into the business, he's quick to put out that, on the surface of it, "Everything's changed. But, in practice, it's all still much the same gig."

Listen for the incredibly relevant segue: "It's much easier to be seen," he says, "there's more immediacy. When I started out there weren't any websites . . . I sent out black-and-white postcards I made at Staples!

"You just use whatever you have access to so you can reach the people you want to reach. I'd go to the bookstore and research names and addresses of publishers. I'd spend several days literally going through every single magazine and pulling out the names of everybody: the art director, creative director, associate (and assistant) art directors . . . usually you could get around thirteen names out of one magazine.

"But at its core, the business isn't all that dissimilar. You research differently now, but you still have to reach out; you still have to send work out, whether that's through postcards, social media links, email, or even cold calls to some degree.

"You're just finding out who's the best audience for your work. Your list doesn't have to be huge. My first mail list was twenty-five names. Small, humble, but targeted. I knew what kind of work they did, what their publication was all about, what kind of art direction they did. If they did call, I could quickly—or attempt to—be on the same page as them."

## UNDER PRESSURE

"And back in the day," Sickels says, "you just had access to a few annuals per year; you weren't inundated with images. Students today see so much. They see a whole world of people doing well, posting so much amazing work on the Internet. And it seems so immediate; like you're seeing incredible posts constantly, nonstop. That could be seriously intimidating to someone starting out. In the face of this, you might just say, 'How do I possibly compete with that? How can I keep up with that output, that consistency, that quality?'"

Sickels feels one answer is to simply have huge respect for such talent (or productivity, or experience) and then consider the big picture. "A lot of people can't see that," Sickels says. "Years ago, Chris Payne sat me down and told me, 'You know if you could illustrate every day for five years, you just might make it.'

"To which I said to myself, *I could do that! I'd love to draw every day for five years.* But when you can't get work, when assignments aren't coming in, how do you accomplish that?"

Sickels tackled this classic conundrum the old-fashioned way: pure head-on hard work. He created his own assignments and, putting Payne's suggestion into heavy rotation, he just drew all the time. "I generated that consistency," he says. "Payne's advice is a metaphor for the fact that building a career just takes time and effort. Not six months, not a year—a block of time until you get 'good.' Rarely do people succeed instantaneously. It happens, but it's not the norm."

## PROPS

In regards to social media, Sickels feels he's hardly an expert. He posts a little on Tumblr. While concerned about the viability of websites, Sickels still updates his site at least every six months. He makes a solid case for adopting a platform you are comfortable with and a routine you can maintain consistently. And what Sickels is most comfortable with is Twitter. "Twitter is more of me offering little hints about what I'm working on," Sickels says. "Facebook [is not my thing]; I don't post on Facebook much—portfolios or otherwise. Twitter, to me, is more immediate; I can get as engaged as I want to on Twitter (or not). And that keeps me more focused on what I do, and actually helps me *not* feel intimidated by what everybody—or anybody—else is doing.

"I link my portfolio to my Twitter account and there's a back and forth here, centralized around my website," he says. "I still do postcards, even though I hear from art directors that they don't want to see postcards: 'Oh, just attach three low-res files of new work to your email.' Hey, that makes sense to me, too, so I'm trying to find that balance."

On the subject of followers, Sickels argues for common sense, relevance, and focus. He advises you to not get too hung up on the numbers. He doesn't concentrate on how many folks follow him (or vice versa). "I don't use Twitter as a political or opinion platform, anyway," he says. "I'd prefer someone maintain, oh, 50 interested followers; I'd rather you follow 50 seriously pertinent guys than rack up 10,000 followers. I have maybe 110 followers (and follow about the same)—it's hard enough keeping up with all of those."

Sickels posts what he calls the *prop of the week*: one item he uses in one of his 3-D illustrations. He'll tweet about concept or scene, fabrication, scale, or general thoughts about illustration itself. "This keeps my little world out there and provides a window into what I do and how I do it," he says.

"I engage selectively, and I guess I engage almost selfishly—my content and my interests are predominately industry-oriented: the work, my peers. It feels like you have to be almost annoying to be 'successful' on Twitter. I don't need to juggle multiple posts so I can capture the lunch crowd, or feed off some huge

number of likes, retweets, and comments. I wouldn't want all that attention (or feedback) because, frankly, (1) my ego doesn't need it, and (2) I wouldn't be able to disengage from it."

## IF A TREE FALLS

When he gets into New York, Sickels doesn't connect with the number of art directors he was able to meet with, say, ten years ago. "Accessibility has certainly changed," he says, "so I don't know that you can—or should—completely divorce yourself from the social media platform. You get a job. It gets published or printed. Then how you share it socially is how it's going to be seen the most. Most people won't see a trade magazine on the newsstands. Most people aren't in newsstands anyway; there aren't a lot of newsstands anymore!

"John Hendrix tweeted, 'If you don't tweet about an illustration, does that illustration exist?' What he's saying is, sure, it gets printed, but if people don't see that magazine, is it really 'real'?

"If you tweet about a good piece in a good magazine for a good art director, people respond to that," Sickels says. "But I, personally, don't think you should worry about statistics and numbers and how many people are seeing that drawing. You should really concern yourself with doing a great drawing."

## FOR THE BETTER

Has social media changed everything? "My work was seen on Flickr and I saw a lot of new stuff there," says Greg Pizzoli, "but Flickr has come and gone. "I know that Tumblr, Twitter, and Facebook have seriously grabbed my students.

"In general, I find that 'the business' has become easier," Pizzoli says. "Social media is shaking it up in many ways. For a while it seemed that publishers and clients—particularly in children's books—expected you to have a web presence with that social media platform already built in. But I think that lately, the audience is simply inundated with illustrators talking about their work all the time; they're blinded by the constant stream of advertising, marketing, and promotion.

"It's funny, I get much more of a response if I show my empty studio or my cat on my bed—if I promote the idea of the lifestyle of an artist as opposed to the art itself."

## POP UP

"At first it was hassling art directors via email," Grant Snider says with tongue in cheek, "then just by putting my work up online and having people share that was a huge change."

Snider is one of the army of illustrators who tell you that the sharing culture of online comics has grown substantially over the last decade. Publishers and art directors are looking for work that is shared by other people online. "If they see something they like or if a name pops up enough," says Snider, "they're going to be interested in hiring that person for an illustration job."

### THAT KINDA RELATIONSHIP

Snider appreciates that the *New York Times* buys illustration in higher volumes simply due to the number of sections and volume of articles requiring visuals. But Snider's gig with the *Times* is sporadic. His contributions to the *Times Book Review* are more frequent.

"We have that kind of relationship where I'll submit a batch of sketches two to three times a year on my own," Snider says. "We've established a connection where, if there is a good concept in a particular submission, they'll accept one for publication. Actually, this is closer to what I'm doing with my web comic."

Snider readily admits that submitting in this manner offers no guarantee of nailing a regular gig. He's only telling us what's worked out for him at this juncture. What he knows for sure is that steadily (and consistently) getting your portfolio to as many art directors as you can is always helpful to build *relationships*. "That's the route I would recommend," he says. "The art director might respond to your email. They may ignore the email. An editor may say politely, 'We like your work; we just don't have a use for it right now.'

"But they are definitely always looking for creators and you have to be the one who gets your work in front of them. So either generating sketches on your own, or sending past work you're proud of, can be effective. It's difficult to say *how much* may become overwhelming, but I know these folks are always open to seeing new work."

## EMPIRE BUILDING

"One of the pressures I've found is that there's a temptation to be super productive, put out continued material, draw more comics," says Snider. "What happens is that, sometimes, the need to publish and have your work seen compromises the quality of it.

"I'm definitely trying to create an online following," he says, "as I'm sure everyone who is trying to make a name for themselves in comics does. But you can't do that by putting up sub-par work.

"Any freelance cartoonist is an entrepreneur. Absolutely. You're in charge of constructing a little creative empire. That's a grandiose term, but you're developing your voice and visual identity and you're figuring out the right way to get your work seen by other people.

"When I started making comics seriously," Snider says, "Facebook wasn't used in the same way; there was no Tumblr, Twitter was a few years out. I had to learn in the process how to publish on Tumblr, how to share on Twitter, how to use Facebook effectively."

For someone going to art school now, such activities are probably second nature. But Snider's generation—and by the time you read this, he'll be in his ripe old early thirties—was probably right on the cusp of utilizing these avenues of social media, which weren't around while he was growing up. Artists of Snider's "certain age" had to learn these social networking services as they were introduced to the world.

"I saw that people were seriously publishing on Tumblr and Facebook," says Snider. "Facebook is more than just sharing photos and connecting with old friends; it has morphed into one of the biggest marketing and media concerns on the planet. Just seeing the power that other illustrators and cartoonists were employing made me realize that I had to do this for myself."

## BY THE NUMBERS

"Social media is a powerful and necessary tool," says Snider, "but you have to go about it in the right way. You still have to be sure that you're putting up your best work. "I try to be consistent. I'll post once or twice a week unless I have an illustration project or a life event gets in the way."

And Snider hits all the platforms. Where he used to only maintain his portfolio on his website or blog, Snider will now post a comic or illustration to his blog, get it on the website, put it on Facebook, tweet it, and place it on Tumblr. According to Snider, the play now is to duly consider the best way to show your work.

"Facebook is the best for me as far as numbers go," Snider says, "it drives the most traffic and views. However, the format in which you're sharing images is not the most elegant way to look at pictures.

"Tumblr is excellent; traffic volume is high and it offers a clear way to publish. However, Tumblr is not great for all formats. Unfortunately, an intricately drawn, horizontal illustration will look crappy on Tumblr.

"Instagram is another way to make sure your work is seen by as many people as possible," Snider says. "There are a lot of options. You know, whatever comes next, people will probably begin using that as well."

# GOOD THINGS COME IN THREES

"The biggest change in the last few years is the importance of social media and a web presence," says James Yang. "More often than not, when I talk to illustrators [who are struggling through a slow period, it is because] they do not have an active presence on social media." Here's Yang's short list of directions leading you to a more effective career:

1. A personal website with your own URL is a must. This site should have your portfolio, contact information, bio, projects, and blog. "The simpler it is for the creative to see your work the better," says Yang. "If a buyer is frustrated with the navigation on your site, they will leave immediately and probably never return."

2. Maintain a presence in social media. "It can be any combination of Facebook, Tumblr, Instagram, Twitter, Pinterest," Yang says, "which is comfortable for you. You must have a regular schedule to post and, in an ideal world, you should be posting something daily."

   Yang stresses that you must find a way to post that is comfortable for you. "If you are not comfortable writing short comments, you can always share links, photos of your work and work in progress, or photos of your life," he says. Imagine you are the editor for your site and are finding posts that interest you and others.

3. Understand that marketing for illustrators has changed and a social presence is crucial. "I know many illustrators who had long careers whose work has stopped," Yang says. "The biggest common thread has been a reluctance to embrace social media. It's important because it creates the idea you are active and viable in the minds of newer art directors and clients. If they don't see work in progress, or posts about you creating online, they may feel you are out of the industry."

## ON NOTICE

In Ken Orvidas's mind getting noticed is part of marketing, promotion, advertising, and branding. Orvidas says that your brand is established over time as recognizable work is repeatedly seen on several fronts.

From Orvidas's point of view, "Marketing, promotion and advertising are what I call *passive* opportunities," he says. "*Active* exercises could be entering juried competitions, paying to put work in illustration directories, and sending promotions to art directors and designers; posting on a blog and subsequently posting on FB and LinkedIn and other social media sites. A passive option

might be when a client enters an image to juried competitions and posts work on social media sites.

"Of course, perhaps the best promotion and advertising is doing brilliant work and having it show up in many good publications. This is both practical and necessary."

## DUST TO DUST

Orvidas isn't certain that having a physical portfolio—by which he means printed images in a case—is necessary anymore. "I can't remember the last time anyone asked me to send them my book," says Orvidas. "Before the Internet, it was necessary to get your work in front of art directors and designers; maybe you submitted work for review via a rep. I used to keep ten portfolios up to date. These days they sit in a corner of my studio collecting dust.

"Now I think the play is to update several web portfolios—this is the necessity today. Current resource books for illustrators also include an online portfolio. Same with other illustration destinations; the iSpot and Altpick, for example."

Of course, maintaining his website and blog is important for the illustrator. Orvidas tries to juggle content with some overlap between various sites. He doesn't want to simply repeat the same imagery.

But Orvidas also tells us that keeping up this site maintenance is a bit of a challenge. "Between working on commissions, experimenting on images for myself and staying on top of promotions, maintaining content on my various sites is the one area that seems to suffer the most," he says.

"I have used publications, email, postcards, resource books, juried competitions and web postings. In an ideal world having all this happen simultaneously and consistently would be amazing. I wish you could, but you also must experiment, explore, and create work for a living."

## IT SELLS

"All artists sell," says Orvidas. "Writers go on book tours. Galleries move painters and sculptors. Illustrators must put work out there to be seen.

"Personally, it's a pain to try to constantly—and actively—push work out to ADs and designers, whether in the form of direct mail print or emails. 1) It takes a lot of time to customize something for an individual and make sure the contact information is correct. 2) I have heard that some ADs and designers don't want to receive anything from illustrators, while some do. As I mentioned earlier, perhaps the most effective 'selling' is answering good commissions with great work that can potentially be seen by many people."

While he acknowledges the utmost importance of having work seen in this manner, he can't say that he's ever received a commission via social media.

(He also has yet to look into job boards as a way to try to bolster publicity or generate commissions.)

While Orvidas hasn't had a rep for twenty years, he wonders if working with an agent might not be a good thing here. And he's honest enough to say that he's actually still on the fence about social networking.

"Certainly, illustrators have been given a huge boost with the Internet," Orvidas says. "Now, I like the fact that more people can see my work and comment on it, however I can't actually point to one online entity and say this one is the silver bullet. I believe that an orchestration of many types of exposure is the most effective. If people can't find your work in various ways you might as well be in a dark room."

## MAKE YOUR MARK (FOLKS JUST LIKE YOU)

### QUON: AT THE DOOR

As Mike Quon sees it, pop art, popular culture, and fine art are just a few steps apart, and doing fine art is sometimes similar to being an illustrator. "Artists like Andy Warhol, Roy Lichtenstein and Claes Oldenburg had an approach to graphics similar to my world view," Quon says. "In fact, Larry Rivers the artist, always seemed to me to be Larry Rivers—the illustrator."

Quon kept his eye on making a switch, and eventually did so. In the process he discovered something important: that fine artists, like illustrators, must continually promote and show off their work. And like the business of illustration, the business of fine art requires a good email list, a persistent drive to create, and suitable outlets for that work. Here, he has three buzzwords for you: "Target. Promote. Advertise."

"Similarly, you should park your ego at the door," Quon says wisely, "it's a process . . . achieving recognition can be slow; work often comes in spurts. You have to be prepared for slow downs *and* celebrate the busy times." Quon comments that you must also enjoy working with people—a critical quality if you intend to represent yourself well.

"Nevertheless, while it may well be a slow campaign, never miss an opportunity to show your work and stay in touch with your contacts," says Quon.

"Save your contact information, people can easily forget about you. One of those chance meetings can lead to future work—you never know, this just might be your next client. If not now, maybe later down the road!"

# ON THE BOARD

## (PROFESSIONAL VIEWPOINTS IN 50 WORDS OR LESS)

Marketing is all about the buyer's problem, not the seller's problem.

—Roger Brucker

A social media presence and personal branding have taken my business to the next level. Through my networking, I have connected with people and projects that never would have been possible without that interaction.

—Rigie Fernandez

So much more can be accomplished today using online tools to complement the advice of professionals, especially at an early stage when it's important to keep costs down.

—Tom Nicholson

My networking is not a huge concern. I've actually landed freelance gigs by chatting with the person next to me on the bus or at a concert. I always talk to strangers. I'm not intending to network; it just happens naturally, which I think is the best way after all.

—Mikkel Sommer

Find the optimal way for you to market your best work. Why not have people come to you? Put your concepts out there; initiate your projects. Don't wait for someone to hire your work. Promote work that you want to do, not necessarily work that you were hired to do.

—Chris Sickels

© Julia Minamata 2016

Unfortunately, many artists aren't inclined to do the networking thing, but it is, by far, the most important thing for your career. Word of mouth is how I get all my new clients. But let me just say this: if I knew how to network better, I'd be a superstar.

—KellyAnne Hanrahan

Winning a competition definitely helps. What also works for me is contacting blogs to feature my illustration in order to reach out to a bigger audience. Last but not least, show your stuff to all your artist/designer friends—they'll help spread the word for you as well!

—Dingding Hu

Develop a persona through postings—James Yang comes to mind. I really enjoy his postings—he's fun, funny and smart. I'm guessing he truly is.

—Ken Orvidas

© Linda Ketelhut 2010

© Scott Bakal 2016

# Chapter 12

# Entrepreneurs

---

*Someone asks you to make a multimedia installation for a gallery? Yes. Paint a sign on a truck? Yes. Animate a video? Yes.*

**—Brian Biggs**

## ONE HELL OF AN EYE

You'll find Mike Salisbury's work everywhere. This is no idle boast or lazy statement—he's the guy behind scores of iconic American brand design and diverse products from the video game Halo to Michael Jackson's white glove to Levi's 501 jeans, a brand that Salisbury created.

He was art director for *Rolling Stone, Surfer,* and *Playboy* magazines, and is a contributing editor and writer for *Forbes* and *Men's Journal.* He's taken photographs for these publications, as well as *Vogue* and *Esquire,* among others.

His design sense and imagery ride roughshod over the motion picture and music industries. Remember the posters for *Jurassic Park* and *Raiders of the Lost Ark?* That's Salisbury. He's done album covers for Beatle George Harrison, James Taylor, Tina Turner, and many more.

Salisbury has taught illustration and design, advertising, and photography. His photography and graphic work are in the permanent collections of the Museum of Modern Art in New York, Library of Congress, National Archives, and the Smithsonian. Both his photography and graphic work have been featured in museum shows worldwide, and Salisbury is frequently invited to speak and consult internationally.

Yep, these bona fides are spectacular. And that's all well and good, but I wouldn't cite Salisbury's client list if it was just some high octane name dropping. Those credentials speak exquisitely to the larger concern of this chapter: to succeed in our business today, classical definitions of your job description no longer apply. You must be an entrepreneur.

## THE SIGNPOST UP AHEAD

What is an entrepreneur exactly? According to Merriam-Webster, an entrepreneur is "one who organizes, manages, and assumes the risks of a business or enterprise." *That's you,* my dear (Mr. or Ms.).

Illustrators creating apps. Illustrators setting up shop to do gig posters. Illustrators creating surface design and licensing same for surfboards, ornaments and wall art, fabrics and food packaging. Illustrators on Kickstarter or IndieGoGo. (What are they pitching? Art and design; comics and graphic novels; books, zines and other publishing projects; animation and video.)

There are pros with big hearts, like Chris Haughton (see Chapter 22), and the fast jumping, gung ho students of Brian Biggs (read this chapter's sidebar *Let's Put On a Play*). And you certainly have illustrators sporting multifaceted job titles like Salisbury: illustrator/designer/brand expert/photographer/writer/teacher. Yo, put *that* on your biz card.

These days, as I paraphrased Elwood Smith in the introduction, changes in the industry have opened the gates to other venues and fresh disciplines that mark whole new opportunities for creative growth. As Smith said, "The Muse

is guiding me into areas I never dreamed of. I am inspired to move into other areas of creative activity that I've been meaning to investigate (but previously too busy to do)."

"I think the whole industry swings in and out, hot and cold," Mark Braught says. "What do you do to stay in those periods where it is a little colder than others? First, I think you look for different markets. I ventured into kids' books—something I stayed away from in the earlier part of my career. At that time, I went after advertising and editorial. Those days, the corporate ladder was just tremendous—ya gotta love the suits.

"I think you have to be an entrepreneur, because there is that business side of it," says Braught. "Some guys are fortunate enough to stay in one genre and they can ride that their whole career, but I think you have to be able to adapt to the environment you're in. And it's become a world environment now. The computer, the whole idea of the Web and that stuff . . . I think it has definitely become a world market.

"The lines are blurred as to what an 'illustrator' can do. We need to get comfortable with the fact that we make images, but one may wonder if there still is an establishment or such a thing as 'mainstream' illustration these days. We can see stuff people are doing all over the world now—and quickly.

"And that's just plain fun," Braught concludes. "You get to see the whole *global gamut* of new talent coming up."

## MAKE YOUR MARK (FOLKS JUST LIKE YOU)

### TAN: VERSATILITY

To Shaun Tan, a true artist forever explores his craft, with modest integrity and immodest intensity. "That's how unusual and original work emerges," Tan says, "not by chasing markets or fashionable movements, or wanting to be conventionally successful.

"But speaking of chasing markets, for a practicing artist this remains, of course, an essential pursuit, if only to survive," he says. "It's the other, parallel course of creative practice: economic sustainability, making money. I think this area is the most difficult to cover with simple advice; there are so many types of working environment: adult, young adult and children's publishing, advertising, editorial and genre illustration, film design, animation, theater, fine arts, games, and other forms probably not yet invented.

"Most visual artists will cross over several of these, especially in a digital, multimedia environment," Tan says. "Therefore, versatility is paramount. That doesn't just mean being adept at working in known styles and media, but also unknown ones—you need to be able to learn and adapt, to remain flexible, diverse, open-minded."

# PIZZOLI

Greg Pizzoli says the map of his illustration gig would show a somewhat convoluted path. "I'm not sure my career could be easily replicated," he says. "I actually studied English literature. I was going to be an English professor and teach poetry and criticism."

But Pizzoli took an art class, and ultimately minored in art "because I wanted to make posters for the band I was in," he confesses. "We had people making these screen printed posters for the band and I wanted to learn how to do that. Some of the posters were amazing, but some of them were terrible, so I just wanted to make some myself. Not that mine weren't terrible at the time either," Pizzoli says with a laugh.

Pizzoli did a two-year stint volunteering for AmeriCorps that landed him in Philadelphia. From there he went on to graduate school for printmaking. "Once I took that first silk screen class, I became obsessed with printmaking," Pizzoli says. "A lot of it was 'illustration' because I was making rock posters and zines. But I wasn't working for anyone whom I would consider 'real' clients—at least not the clients I'm working with today. I was making stuff for folks cause I liked their bands, or because I was playing in a show and we needed some advertising."

## ACT ONE

Pizzoli's backstory is a tale of work ethic, determination, dedication, and chops. We had a fun and easy conversation. I was struck by Pizzoli's open, friendly manner as well as his admirable, humble gratitude (for his good luck) and appreciation (for some opportune timing).

When he discusses his early career and the enticing jump to full-time freelance, Pizzoli is the first to tell you that the move wasn't buffered by the same confidence he exhibits now. "It was definitely a little more terrifying at the time," he says, laughing. "My career prospects were debatable." And as he tells the tale, it was all "very catch-as-catch-can; a pretty slow start."

Let's set that scene: A teaching assistant at Philadelphia's University of the Arts, Pizzoli inherits an adjunct position running a screen printing class for the following fall. This is before he graduates, by the way. He also teaches a continuing education class (again, in screen printing) at night. These are hardly lucrative gigs, but definitely positive steps in the right direction. He has health insurance, and a self-described dead-end job that pays the rent on his outside studio.

It's one of those *wow, it was just meant to be* circumstances. At his evening course, Pizzoli fortuitously meets children's book illustrator Brian Biggs, a student new to screen printing but a decidedly accomplished professional otherwise. Pizzoli checks Biggs out online, and instantly appreciates that Biggs actually enjoys, as Pizzoli says, "The type of career I seriously want."

Through the course of the semester, the two artists network and move beyond the student/teacher relationship to become colleagues. Biggs recommends Pizzoli to his literary agent and the rep begins to mentor Pizzoli.

## ACT TWO

But this is no fairy tale of instant success. Pizzoli does, however, plant the magic seeds of hard work and due diligence. He steadily promotes his work to the industry and solicits the rep's advice. Studiously listening to the agent's feedback, Pizzoli rethinks and refines his portfolio. "It's not like he had a laundry list of what I must do," Pizzoli says. "It was more 'consider this; look at what's out there in the market, but don't mimic.' He was pushing me to be more aware."

Pizzoli's zine, *C'mon Go*, gets into the *Communication Arts* annual and Pizzoli promotes this while pitching his material to children's book publishers. "I wasn't sending out a real book proposal," Pizzoli says. "It was 'I love making this stuff; here's something I made. Please take a look at it.'"

After sending cards and zines for about a year, Pizzoli says it was time to buckle down and make something happen. He's extremely motivated, the day job is mind-numbingly boring. "I *had* to make something else work," Pizzoli says. "I emailed twenty names on my list—the twenty I thought I had a chance with. Five wrote me back.

"My response was, 'Hey, I'm going to be in New York for a couple of days and I'd appreciate it if I could show you my portfolio.' So I met with them. I didn't walk away with a job that day, but I think it did prove to my agent that I was serious."

Pizzoli's *cojones* pay off. Later that week, Biggs's agent offers Pizzoli representation. "We worked together for another year on a few book proposals, one of which was *The Watermelon Seed*." (More on that later.)

## ACT THREE

"So I now had an agent," Pizzoli says. "We're developing book proposals (but no deal yet). I then went to the big Society of Children's Book Writers and Illustrators (the SCBWI) conference in New York. Here, you can submit your portfolio. Actually, it's one framed piece—*one*—that acts as your de facto portfolio. It's now displayed, along with one of your postcards, on a long table and various art directors and publishers are invited, over cocktails, to view the participants' 'books.'"

The reviewers pick one winner and two honor awards. And in his first conference ever, Pizzoli snares an honor award. "I was blown away," he says, "I was in shock!" Four days later, back at his day job, Pizzoli gets an email from an editor at Hyperion, who loved Pizzoli's piece. "Do you have a story to accompany this image?" he's asked. Pizzoli really doesn't (but comes up with the story anyway), and starts working with his editor.

Ten months later, Pizzoli bags a professional development grant from his school to attend the Los Angeles SCBWI conference. He goes to LA and wins another Portfolio Award!

## NEXT UP

Back home, at work, Pizzoli has a decision to make. The powers that be are offering him better money and more responsibilities, but now his head and heart are elsewhere. He recognized the momentum building and realized that "If I didn't take the chance then, when was I going to take it?

"I'm riding this high from LA," Pizzoli says, "and in the middle of the meeting briefing me on the new order of things, I tell my bosses, 'Actually . . . I need to quit.'

"In my best interest, they try to talk me out of it, but I give my notice and I'm freelancing two months later. A month after that I get the two-book contract for *The Watermelon Seed* and *Number One Sam*. And ever since then things have been rolling."

Rolling how far, how fast? I'd say "exploding" is a more appropriate action word. At the time of our interview in September 2014, Pizzoli had just signed his twelfth book contract. He knows exactly what he'll be doing through 2017.

So cool, right? But to sweeten the pot even more, Pizzoli wins the Theodore Geisel Award in January of 2014 for *The Watermelon Seed*. "That changed the entire conversation," Pizzoli says. "*The Watermelon Seed* being accepted by the professional community in this way is humbling.

"It's not lost on me how lucky I am," says Pizzoli. "I firmly believe that the only people who don't make it at the 'Do What You Love' game are the ones who walk away; the folks who stop, who aren't willing to take a risk."

Let's clarify something here. Pizzoli is not advocating you do anything rash or impulsive. "It's *not* responsible to tell a young person, 'Leave that job and forsake your health insurance; quit, you'll probably get a book contract.' I can't do that," Pizzoli says, "I wouldn't do that."

Pizzoli makes no guarantees. He knows there is no Wonka golden ticket in real life. "But my career felt like it was on the cusp for so long, it just felt inevitable," he says. "I took that plunge, and so far, things have worked out."

# IT'S ALIVE!

"In every aspect of commerce, people find faster and cheaper ways to produce. Artists are sensitive to this dynamic," says John Dykes. "After all, it is their personal expression at stake.

"I wish there was ever-increasing room in this field for personal expression— that is, great assignment work—but there is less," says Dykes. "Mix in the ever-growing number of illustrators out there, and clearly, it is a different place."

Dykes, and all the illustrators in this book, know that outside your studio, it's not a controlled experiment. You may well ask how much luck figures into the equation. I'm one of those who believe that luck is that moment when preparation meets opportunity. You minimize the gamble with sweat and organization, but there are no guarantees and lots of variables. You have to be willing to make the wager to reap the reward.

Serendipity—being in the right place at the right time—is your good fortune, but beyond your control. It's nothing to brood over, nothing you can fine-tune. Networking is certainly critical. Knowing somebody (within the organization, on the art staff, from a former job or project) can definitely help, but doesn't always. Your politics don't necessarily enter into the scenario (unless your politics are synonymous with your work).

It's not that they don't like your tie, you certainly won't lose work because of casual (tasteful or otherwise) attire. Unless you give new meaning to bad grooming or dress like you just lost a bet, you *usually* won't lose an illustration gig. Assuming you haven't provoked an international incident or insulted anyone's sainted mother, you won't lose an assignment because "they hate you" (always for some vague, undetermined reason). At some point an artist's demeanor may influence an art buyer's decision (and vice versa, for that matter). I'll come at this by way of the old school that a winning smile is to your decided benefit. Obviously, two parties must interact, so personalities can't be avoided. However, if you don't have the style and skills the illustration task requires, you won't get an assignment on pure congeniality.

Attitude and reputation can be factored into the equation, too. Art directors are looking for skilled individuals who can deliver the goods on time. Your samples may sizzle and glow, but if you're an argumentative prima donna who can't meet a deadline, you're not a viable commodity. Be down to earth, be yourself. Be dependable, be on time, be flexible.

This all makes good sense. However, this chapter is built off the premise that no matter how small the assignment or business, you must dazzle 'em with virtuosity and diversity.

## NEXT STOP

So, go ahead, come up with a hot idea. It might immediately dawn on you that you may need some bucks to make it rise. There is the term "bootstrapping," which Webster's says is "to promote or develop by initiative and effort with little or no assistance." Such a self-initiating or self-sustaining process *could* be labeled as entrepreneurial. But you still need the money, honey.

Finding the necessary capital could just mean a little stroll to the bank (do mosey on over to Chapter 5 please). Or you hit up what's called a venture

capitalist or an angel investor, even your rich Uncle Eddie from Boca. But how's this workin' for ya? Sheesh . . . nobody enjoys potentially losing money, I guess.

In any event, you, my budding entrepreneur, decide to jump all the requisite hoops. So let's see what those hoops might be. Here's a generic seven-point plan; adapt or scale it at will.

1. Be able to pitch your killer concept succinctly in 30 seconds (or less). I don't mean in a tizzy or heated rush. I said *succinctly*—concisely. Better, you can even map it out on the back of a business card in that stomach-dropping elevator ride down to the bar—you're that good.

2. When you have more than 30 seconds, you should be able to demonstrate that you are aware of who your customers are *and* that you have thoroughly investigated the competition. You are on top of both ends of this business equation, inside and out, in your head and by heart.

   You can assure any intended patron (or skeptic) you understand your audience; that you know who benefits, what obstacles you're dealing with, who you are up against. You can fully explain—and easily, too—your client base to anybody. Along those lines, you're prepared to spell out why you shine brighter than the next guy, and why those customers will gladly and quickly open up their wallets to snap up your product or tap into your service.

3. Props and samples sell. A good "Show and Tell" is always effective; you learned that at the Middle School Science Fair. The concept hasn't changed and can help convince whomever that *you* can pull *this* off. *You.*

   Boldly present the compelling value of what you are selling with style, gusto, and panache. Saying all that: humility, sincerity, combined with smarts and rationality, can be persuasive.

4. You must be able to back it up with a realistic business plan and understandable numbers. Reinforce *that* with a solid "Plan B." Foresight equals wisdom. Baby steps are more than wise. This will be most helpful when you target, then ask for, a clearly defined, reasonable sum of money. Clearly explain how and why you're going to spend that money. Yeah, how and why . . . but also who, what, when, and where. This is for your purposes as well as for your future benefactor's needs.

5. Break down any corporate sponsors, professional fans, and personal backers who have bought into (and/or believe in) the dream. If someone else is on board—particularly those corporate someones of note—you will reduce any perceived risk, which can make it easier for somebody to hop on the train.

6. Do dress for success. Exude appropriate confidence. Act like you don't actually need the money (sort of like whistling down a dark alley, or

akin to dancing like nobody's watching). And in light of all this, have I mentioned that humility sells?

7. Regard each pitch like it's the warm-up session for the next; play it like it's perpetual Spring Training—keep pitching; keep improving your pitch.

## THE MORE THE MERRIER?

As with all savvy marketing, an astute future entrepreneur will understand the sale of the product itself. They've done the homework and essential research. They know there's an actual market to eventually sell product to. Obvious preparation and product quality should be a no-brainer, but these hooks aren't always a given. The advantage of a demonstrated track record—either the seller's and/or other products—is certainly a plus.

These days, fund-raising can be pushed as a special initiative, promoted as a special event, or touted as a unique experience. To explore this aspect of financial support, you could also look into current and hot business models (as of this writing): crowdfunding and crowdsourcing.

## FACING THE CROWD

*Crowdfunding* is when a bunch of folks—a "crowd" of investors—finance a project, usually with small chunks of capital. These contributions are somewhat like *stocks* (but are not actual *shares*)—donations that have a face value and ultimately will net you a return in some way. So, a $1 to $10 donation garners you eternal thanks and/or gives you a warm, fuzzy on your insides; maybe it gets you a tangible but modest token of appreciation. The schematic escalates from there. Forking over $25 to $100 ups the ante. A $2,000 to $5,000 donation will eventually get you a platinum this or titanium that. (My quotes here are just guidelines; for example only.)

When evaluating this funding scenario, you should consider the success stories alongside the tales of disappointment. You won't miss the after-burn of lost potential nor the bright glow of triumph that only "full speed ahead" can spark. At this writing, the crowdfunding platform is arguably best exemplified by the sites I mention above, Kickstarter and IndieGoGo, but there are many other crowdfunding tools online.

The accounts of wildly successful initiatives *can* be found. Accounts of whopper campaigns generating serious capital, and fervent interest in a future product, are out there. But, truth or dare, like the California gold rush in the mid-1800s, this is not necessarily the norm. And in the same breath, reports of meager returns (as well as downright futile, dismal efforts) *do* exist. Of course, the sad tales are not a bona fide benchmark of a botched system either.

# DOLLARS AND SCENTS

Bryan Ballinger prepared for months before launching his book project, *Animal Gas*. And for another solid month, while the campaign was running, it became a full-time job managing his Kickstarter initiative. "Maybe even more than a full-time job," he says.

While he surpassed his funding goal, Ballinger raised more than what might be appropriated for a "normal" picture book because it was *scratch and sniff*, which cost more to print per copy.

## A SMELLY OL' FACTORY

The print run was Ballinger's major expenditure (shipping costs being the other). He did a major investigation and discovered the only company in the United States that could do the scratch and sniff component and, as Ballinger says, "Had a bazillion different scents to choose from. The place I used specialized in scented printing and had such a huge library—they had the perfect scents for each analogy I had in the book.

"The book is structured so that there are pleasant odors one page, and then a bad smell on the facing page," says Ballinger. "Each animal claims that his or her gas smells good—like flowers, or baking bread—and then on the next page another animal that is smelling it says that it smells like rotting fish or smog."

## FOLLOW THROUGH

Ballinger researched many effective Kickstarter campaigns and conferenced with friends who also enjoyed successful projects as well. He then trotted out some brilliant, secret weapons.

First, he finished the *entire* book before doing his Kickstarter campaign. This paid off as he could release each page from the book as the Kickstarter went on. "The real key is having enough content to keep posting throughout the Kickstarter," Ballinger says. He adhered to a strict schedule and posted consistently, following a formal list of where to post daily updates and when.

Next, he brought in the troops. "I have a ton of arty friends," he says. "Illustrators, animators, painters. I had a bunch of these talented colleagues each do a tribute illustration to the book. Then I would post one of those each day, and my friends would post them and link to them too. That generated lots of great buzz. (Ballinger posts on Facebook, Twitter, Tumblr, LinkedIn, and more.) They did some hilarious stuff too. I then compiled all of these illustrations into a book and offered that as a reward at the higher donation tiers."

Ballinger offered T-shirts and posters at different levels. He created a series of rollicking, short films with some of his students. "That was so fun," he says. "We have one of the largest taxidermy museums in the country right here in our little town, and we filmed them there.

"I 'released' a new *Animal Gas* short film every few days," says Ballinger, "not only on Facebook, but also on YouTube and Vimeo. That generated some good buzz as well. The films are short and are just quick jokes with a 'rim shot' kicker."

He posted ongoing "the making of" preliminaries: rough layouts, character development, sketches. "Otherwise, interest will wane quickly," he says. Seeking to keep the customer highly charged and fully satisfied, Ballinger now asked several musician friends to help out. These skilled performers volunteered to do tribute songs that were then compiled into a collection that became a reward for certain tiers. "By the way, these tunes are an absolute riot," says Ballinger.

## READY, STEADY, GO

If this sounds both incredibly smart and exceedingly exhausting, you are so right. "Like I mentioned, a full-time job," says Ballinger. "For the months leading up to the launch, especially during the run, and then it slows way down afterward. Until you get the giant shipment of books and have to pack them all up and mail them out."

Ballinger says that the digital rewards—the songs, the pdfs of the books, the interactive iPad version of the book—were much easier to distribute. "You just have to email out the download links and, boom, you're done." We should mention that Ballinger built the iPad version of the book himself (even including numerous fun sound effects).

At higher levels Ballinger offered to do an original digital painting of someone's pet barking up an air biscuit. Animal Gas ringtones were available. And here's maybe the pièce de résistance: one of the higher level rewards was that the contributor earned a spot as one of the characters in the iPad version of the book!

## SHARK TANK

"The reason a lot of Kickstarters fail is that they have a big splash at the beginning, and then let it run on its own," says Ballinger, "but without content and updates, the thing just dies off after the first two or three days."

Organization of the campaign is absolutely critical. It forces you to think about all the tasks to accomplish (and when), so, in essence, you swim, feed, or die. It's creative marketing and promotion on steroids. Notice that almost all of Ballinger's initiatives served a multi-purpose: keep the content fresh, make sure interest remains high, then offer everything as a reward.

The corollary here with running one's business can't be missed. Nor can the networking connections. "I think it also helps to be a general Kickstarter supporter," Ballinger says. "If people see that you've contributed to other endeavors, the Kickstarter crowd will be more likely to support your project. I am a fan of the whole idea of creators being in control of their own work, communicating directly with fans."

Ballinger's Kickstarter also speaks volumes as to how an illustrator's job description (and skill set) has become so radically different and expanded from what it used it be.

"It is a different world for sure," Ballinger says. "And a lot of younger illustrators and comic artists get that completely. I have some young friends who are focused and have built followings on social media (for their web comics and daily illustrations) and they're making it happen. *But it is a lot of work.*"

## THE SOURCE

The term "crowdsourcing" is a mash-up of "crowd" and "outsourcing." The term is attributed to writer Jeff Howe in a June 2006 *Wired* magazine article, "The Rise of Crowdsourcing." Crowdsourcing is inducing folks to contribute to your project via *their* brainstorms or concepts, info or advice, labor or product, testing (and, hopefully, subsequent positive or encouraging results), and so forth.

Let's discuss this by quoting Edison again: "Genius is 1 percent inspiration, 99 percent perspiration." Thanks, Tom. Many are finding value in this, what the *New York Times* has labeled, "new generation of online service marketplaces." That sounds promising, if not downright energizing, right? But for a vocal constituency of disgruntled constituents, crowdsourcing competitions demean makers and lower the value of product and services. Some will tell you that such competitions sound the death knell for the industry at large and decry these contests as a scam, existing solely to steal ideas and product from embattled creatives. Is crowdsourcing a diabolical form of thoroughly modern slave labor?

"Crowdsourcing" as a term is relatively current. But the underpinnings of spec work here obviously cannot be denied—you are competing for work with no guarantees of getting paid for it. So a lot of clients are alternately labeled naive and/or exploitive. Okay, for some clients, it may be the first rung on a hire ladder (sic pun intended. Yes, that secondary pun is intended, too). For many novice illustrators—tagged as naive and/or exploited—it could be their initial steps into the marketplace. And here, Rick Antolic rolls his eyes. "Aaaargh . . . contests," he scoffs with derision. "Don't get me started."

## NO COMPETITION

Why the righteous anger? I say we get Antolic started, indeed. But we should first discuss competitions that are a largely undisputed testament to your capabilities and your credibility. These contests are almost always judged by professionals who are recognized for their expertise and experience.

In addition to recognition from your peers, competition awards attest to the high quality of your work and can ultimately justify a high level of compensation for your talent and ability. These awards also look great (on your wall, flagged on your website, showcased on your marketing/promotion). They are your "credentials"—easily recognizable benchmarks of quality for those who have not yet (or lately) been exposed to the wonderful samples of your craft.

There are competitions sponsored by national magazines (for instance, *How*, *Print*, and *CA)* that publish highly revered annuals showcasing the best of the best. Prestigious national competitions are sponsored by the Society of Illustrators (based in New York City) and the Los Angeles Society of Illustrators, in California, of course. You'll also find a wealth of local opportunities through professional organizations (like your local Art Director's Club, the editor's association). You're probably already aware of many of them; you know which ones offer the most prestige in your area. In many instances, a client actually enters a piece in a competition. This proud client may be notifying you with some good news! But we'll talk here as if you have submitted the piece.

If you enter a competition and find you have a winner, get some mileage out of this piece by entering it in another competition. If it walked away with a gold award at your local Art Directors Club competition, send it off to a national competition.

And don't forget the peripheral publicity that comes with such awards. When you grab this gold ring, let your clients know about it—especially the client for whom you did the award-winning work. You'll want to notify that client personally if this piece has won some recognition. She or he may want to promote the award within their company and industry or your community, giving you additional exposure. If you've produced work for a client whose trade has its own design annual or competition, check if your client plans to enter anything you've done for him in his industry's competition. Let the client know that you value the quality of the work you did together and would appreciate notification of any industry awards that this piece may garner.

And by all means, "toot your own horn" in a professional manner with a press release to your other clients, local news media, national or local magazines, and trade publications. Because you rightly feel that (A) the quality of this piece and (B) the prestige of this award is worthy of further recognition, correct?

## NO CONTEST

Okay, back to Antolic's two cents. Let's say we find out that WidgeCo—who can more than afford to pay a fair price for that illustration—puts that project out there, to anyone, in the form of a contest. And wow; the winner will have their work printed on new mugs and T-shirts, seen all across the country!

Big whoop . . . for as Antolic observes, "If you have the money for national distribution, you have the budget to pay for the drawing." Also to the point, WidgeCo, the model of a successful big business, has enough bucks to hire a few artists to come up with a deck of illustrations, adequately pay any or all of these guys, and select the cream out of that crop.

"But instead," Antolic continues, "they invite Joe Public to submit to this 'contest.' The company pays *bubkis* (zero, nada, nothing) for the influx of ideas they receive, and the 'winner' might get a monetary compensation or equivalent that is a mere fraction of what the illustrator should have been legitimately paid for that work."

Antolic then poses some righteously legitimate questions: What other industry will do work for a big business and not get paid because they want to be a part of a contest? "Would a plumber do that?" he asks. "An architect? An engineer? A doctor? [Righteous expletive deleted.] Not even someone versed in early eighteenth-century romantic poetry and prose would agree to write a classical haiku for a big business for free, through a contest."

Antolic's philosophy is pretty simple. If somebody wants him to illustrate something, he gets paid for it. "I charge fairly," he qualifies, "and I'm almost always willing to work with whatever kind of budget the client has. But I expect to be paid. My 'free time' is not 'free' time if I'm working; that might accurately be identified as 'overtime' and I charge accordingly.

"When I'm not getting paid to illustrate, then I'm attending to other needs, responsibilities, interests, or sleep. Other than the sleep part, I can't attend to those other things without money. If you are asking for my talents and skills, you are asking me because it is of value for you. And my needs, responsibilities, and interests have a value to me. Hey—I'm sure we can work something out."

Let's play devil's advocate: it's not a huge stretch to view the contests as an abundant stock of cheap—or to be polite, "affordable"—illustration. Likewise, it's no quantum leap to look at these competitions as a ready resource for leads or contacts; maybe even a smart way to build an illustration portfolio (if you need to) or a new model of client/creative interaction.

You can't—or shouldn't—avoid the heated debate over ethics and legalities. Let's just say that, at this writing, crowdsourcing as a prolific marketing tool (in various incarnations), seems here for the duration. It's certainly a "for better or worse" playbook; the general model may not be universally loved (for good reason) but has been globally embraced with some gusto (for obvious purposes).

Perhaps we simply must fall back on the old adage: you get what you pay for. There is also this appropriate pair of expressions: "keep your eyes open" and "swim or die." In our age of the Internet, opportunities abound to heed all of the above.

## LET'S PUT ON A PLAY

When he taught, Brian Biggs was surprised at the number of graduates who, as he says, "Had no interest in sitting around waiting for the phone to ring. They didn't care—or try—to mold themselves into something they were not, just to get a $400 illustration gig. They opened galleries, they started T-shirt companies, they did work for their local coffee shops and musician friends."

To some of Biggs's colleagues, the students' attitudes seemed to breed "unambitious illustrators." But as Biggs saw it, like any parent/child relationship, these faculty were just looking at the wrong angles. "These kids wanted everything we wanted, they were just circumventing the system we were describing and making their own."

## GO COPYRIGHT YOURSELF

Let's talk copyright. Oh, have we now reached that time in the program for a little cautionary tale? Not to scare you off, my friend, but only to remind you to be more aware of all this.

Here's a hopefully thought-provoking angle on this rather complex issue: what are copyright laws like in Russia? Arguably a not too user-friendly regime, right?

"The problem is not with the actual copyright laws," says Russian illustrator, Victor Melamed, "but rather a total ignorance in terms of copyright law or the concept of authorship."

Melamed, who works for a number of Western publications, tells us that "People are dead scared that their work might resemble somebody's style. There are a number of popular styles that many people copy, and sometimes artists steal whole ideas or entire compositions—advertising agencies do that [constantly].

"Russian illustrators are still often paid unofficially, avoiding taxes. There were a number of copyright scandals, but generally, copyright complaints are minimal *because there are no legal documents to address*. No one ever reads their contracts, not even the clients!"

Care to work in the Moscow branch, anyone?

## PAIN AND POWER

Kristine Putt has a buddy whose work recently was ripped off. Putt encouraged him to pursue it, but ultimately her friend chose to do nothing and simply let it go. He didn't think it was worth the hassle (lawyer fees, the fuss, etc.).

"I get that," Putt laments. "Truly. It's a pain in the . . . neck to pursue legal action for copyright infringement." But then she pauses, collects her thoughts, and carefully speaks her mind: "There's this precedence thing that weighs in so heavily at this point," she says. "Every time we choose to 'let it go' we are making it that much harder for the next victim of copyright infringement to win a case.

"We owe to the industry," she continues, "but especially to ourselves, to do what is right, just and moral. If not for ourselves, for all the others out there who are struggling with this issue. Only by following through on the principles of an ethical code can we expect to change the mind frame of society that stealing from talented creatives is not only unethical, but downright illegal."

Putt next makes a patently sharp point: "I hate seeing anyone's work—young artists, especially—getting hijacked. And, okay, maybe sometimes experience is a good teacher. But if you don't care enough to do something about it for yourself, then at least do something for the hundreds of thousands of other folks that have been taken advantage of this way.

"It's in your power to make an example from your case and deliver a strong message that stealing is wrong and there will be consequences," she concludes emphatically. "My hope is to prevent, or at least reduce, digital thievery in this way."

## IT'S ABSOLUTELY CRIMINAL

In 2013, Corrine Bayraktaroglu (corrinebayraktaroglu.com) discovered a way to do a reverse image search and—just for fun—tried it with one of her favorite photographs. "That began the long unpleasant journey of discovering just how much of my work had been exploited," she says.

Included in her Walk of Shame are several record labels, a number of famous designers, a glitzy nightclub, Etsy and Amazon sellers, major poster companies, a big-time pop star, prominent bands (and DJs), advertising studios, entertainment gurus, and an overseas publishing house.

It is painfully obvious that Bayraktaroglu gets knocked off prolifically. Nobody is sure exactly why, but something is fairly clear: Bayraktaroglu didn't file copyright applications in a timely manner for art that is incredibly compelling. Case in point: the ostensibly prestigious online gallery that passed off one of her pieces as the work of none other than *Damien Hirst*! Whoa.

"I have always been aware that posting images online would lead to one or two people taking my stuff and using my imagery," she says. "And in the past when it came up, I took care of it."

But Bayraktaroglu tells me that, in the last few years, the scale of infringement has become positively epidemic. The rise of social media, and monetization, scraper sites and link farms (see sidebar) have turned insult into injury.

"This blatant disregard for the rights of others is not being done by amateurs, but by professionals (both individuals and companies) who understand copyright," she says, "they work to protect theirs, but are more than happy to exploit yours."

Through a cease and desist letter, Bayraktaroglu's lawyer, Emily Danchuk, helped the artist get a number of these works taken down. But Bayraktaroglu's legal travails continue and other cases are dealt with on a daily basis. It's an uphill battle. "And it happens all too frequently," says Danchuk. "Post on Etsy or sell on Amazon and I can almost guarantee you some Chinese company trolling the Internet is going to rip you off. It's easy to reverse engineer any product— buy the product and reconstruct it, or just copy it from an image."

### PLAY IT BACK

Unfortunately, prior to 2013, it never occurred to Bayraktaroglu that, as she says, "The many images I had posted on my blog were worth ripping off, let alone getting much notice, let alone worth registering." Bayraktaroglu admits that, on some level, she was rather naive. "My blog doesn't generate substantial heat or traction, thus I never suspected there'd be any interest in my art online," she says. "Certainly not the wholesale thievery that I ultimately discovered."

In fact, Bayraktaroglu was shocked at the choice of images that were taken and used. "But the deal is that scraper sites don't care as long as it directs search engine traffic their way," she says.

So now Bayraktaroglu watermarks all her imagery. She keeps her image files at 72dpi and rarely over 500 pixels, *and* she registers many of her images. "I have seen a dramatic drop in copyright infringement since then and the only images that keep getting ripped off are the old ones, like the spin paintings."

Bayraktaroglu cautions that watermarking doesn't protect you from infringement, but it does advertise that it's your work and protects it from becoming an orphan image (see sidebar). "And if someone removes the watermark, it's a whole 'nother legal ballgame," she says.

## WORTH FIGHTING FOR

Here, Bayraktaroglu takes a beat and smiles. With a *genuine* grin, mind you, no "I-lived-to-mumble-about-it" rueful smirk. Amazingly, she magnanimously insists she's not bitter about the whole aggravating state of affairs.

"Well, it's my art we're talking about, isn't it?" she says. "The control of my work is worth fighting for. Absolutely. So I view this ordeal as all part of the strange, wonderful, creative journey I'm on."

### IT DOESN'T REGISTER

"The smaller creatives are the ones getting hurt," Danchuk says. "Knock-offs compromise the integrity of a product, corrupt a brand, and damage sales.

"If you expose your product at, let's say, a trade show—which is what you need to do in order to sell it, of course—then you are opening the door for infringement."

What to do? Many of Danchuk's clients are *reactive* rather than *proactive*: an artist catches an infringement, then obtains copyright registration *after* they've been knocked off. This, Danchuk points out, is not as effective as timely copyright registration. Timely registration means filing for copyright within three months of publication or before the infringement begins. You'll be entitled to statutory damages (which can be substantial) and can collect your attorney fees, too. Without timely application, you're limited to only your damages or losses due directly to the infringement, and the infringer's profits (both of which are difficult to prove and quantify). Danchuk says that her clients didn't understand the differences between copyrights, trademarks, and patents; they didn't know their rights and what they could do when infringement occurs. They felt powerless.

## TAKE ACTION

So Danchuk created Copyright Collaborative (copyrightcollaborative.com), a resource that works to transform this toxic landscape.

Copyright Collaborative's broad stroke goal is to help artists proactively take action to prevent infringement before it takes place. Certainly, timely copyright application kicks it off, but small, simple actions step up your game. For instance, at a trade show when that rep asks you to send samples, the submission proceeds only when a signed acknowledgment of transfer is in your possession. This one-page, simple agreement just says that your intellectual property will only be used as consideration for a potential licensing agreement, for no other purpose, at any time.

## DAWN OF THE ETHICALLY DEAD

Says Bayraktaroglu about scraper sites and link farms on social media: "These rip-off artists steal all your content. Your image can quickly become an orphan work and open to downloading from free wallpaper sites. Then your image rank on a search engine goes to the bottom of the heap.

"A painting I did with Nancy Mellon (jafagirls.blogspot.com) for her Jackson Pollock workshop was appropriated and was all over the Net, touted as being by Pollock himself and on every scraper site out there. Nobody would know it's ours, especially those who download it from wallpaper sites—they have no idea what they are putting into their computers."

## WHAT IS CREATIVE COMMONS?

The best way to fill you in on Creative Commons is to let them explain the initiative in their own terms. Here's how the website (creativecommons.org) describes this nonprofit organization: Creative Commons "enables sharing and reuse of creativity and knowledge through . . . free legal tools . . . [providing] a simple, standardized . . . public permission [to share and use that creative work] on conditions of your choice. CC licenses let you easily change your copyright terms from the default of *all rights reserved* to [what CC labels as] *some rights reserved."*

The site informs the reader that CC licenses do not supplant copyright, but "work alongside copyright and enable you to modify your copyright terms to best suit your needs."

Furthermore, the website says, publishing under Creative Commons extends the right to "build upon a work you've created." A creator can allow commercial or noncommercial uses of her work. Thus, that CC license can eliminate the threat of copyright infringement (and we should add, waive royalties), as long as specified conditions are followed. You can even "opt out of copyright altogether . . . [allowing] work to be placed as squarely as possible in the public domain."

But also listen to Emily Danchuk when she says: "The premise of the 'starving artist' has developed from an unfortunate, misdirected stereotype. There's this pervasive stigma—'artists are powerless, they're dumb and lazy. They're not worth the money; it's just a hobby or a side project.'

"To me, art is one of the most important aspects of our culture—*it's the glue of our culture.* Art needs to be respected. Hardworking artists deserve to be compensated fairly for their good work."

Does Creative Commons sound like a good plan *for you?* Head over to the website and consider your goals and options carefully.

## RABBIT HOLE

Bayraktaroglu figuratively stumbled upon the practically wholesale theft of her work through what's referred to as a *reverse image search.* "The scale of the theft was mind-boggling," she says, "I was flabbergasted."

To do a reverse image search on your stuff, go to the Google search box > Images to upload one of your online images into the search box. It's easy; you'll discover directions and helpful pop-up instructions if you need assistance.

It doesn't matter what you've named the picture (or what interlopers have called it), Google will look for anything that resembles that image. "It's much like facial recognition software," Bayraktaroglu says.

"There's also a little bookmarklet called Source Image (SRC Img); click on it and it will immediately search for that image. Chrome has a right click search feature as well."

## SMACK DOWN

On the Science Fiction Writers of America website, lawyer (and writer) Ken Liu cogently defines and explains the DMCA—the Digital Millennium Copyright Act—and what a DMCA takedown notice can do for you.

"A DMCA letter is fast and simple," says Liu, "it can be drawn up by a copyright holder without the help of a lawyer. It really is very powerful."

According to Liu, a DMCA takedown notice only has to contain a few pieces of information, and there is no set format; you write up a letter requesting that offending pages are blocked or removed, and include the following pieces of information in the letter:

1. Your signature (assuming you're the copyright holder or authorized agent).
2. Identification of the work that is infringed (or a representative list of such works).
3. Identification of material that is infringing and which you wish to have taken down or blocked and enough information to allow the OSP to locate the material (e.g., a URL to the offending page).
4. Ways for the OSP—online service provider—to contact you, such as an address, phone number, and an email address. Liu says it is best to include all three. By the way, an "OSP" is sometimes referred to as an "ISP."
5. A statement that you have a "a good faith belief that use of the material in the manner complained of is not authorized by the copyright owner, its agent, or the law."
6. A statement that "the information in the notification is accurate and, under penalty of perjury, that the complaining party is authorized to act on behalf of the owner of an exclusive right that is allegedly infringed."

"The DMCA requires OSPs to provide the Register of Copyrights with the contact information of a designated agent specifically set up to receive takedown notices," says Liu. "The Register of Copyrights has published this directory of agents online: www.copyright.gov/onlinesp/list/a_agents.html.

"When you find that someone has infringed your copyright, you can go to this directory to find out where to send your takedown notice (they all have email addresses).

"If the offending page is on [Amazon or Etsy or] a hosted blog like Blogger, finding the right OSP is relatively easy," Liu says. "Sometimes, when the infringer is running a stand-alone website, you'll need to find the hosting company by conducting a WHOIS query or other similar technical investigation."

## MAKE YOUR MARK (FOLKS JUST LIKE YOU)

### BENDIS: PRO, SCRIBED

As a freelance cartoonist/illustrator, Keith Bendis's unique brand of humorous illustration has been seen in most of America's leading magazines and newspapers including *Time*, the *New Yorker*, the *Wall St. Journal*, and many more. His first paid illustration job was as a portrait artist on the boardwalk in Atlantic City. Bendis started freelancing in New York City in the mid '70s, when, as he says, "You made an appointment with an art director and you actually showed your portfolio in person! You schmoozed and got to know each other. Then when you landed an assignment at *Fortune* or *Business Week*, you again went in and talked with the art director and maybe the writer and you sketched ideas in the office until you got an okay."

Bendis says that, while he feels his backstory is a fun read, it's nevertheless, "Ancient history when it comes to talking about how to start your career as a freelance illustrator.

"Obviously there are some basic truths in there," says Bendis, "like, draw all the time and put a strong portfolio together and get it online. And, of course, having a good agent, if possible, makes everything so much easier." Here, he also states that "If you're good and dedicated you can find work and build a so-called freelance career—but I'm not sure anymore. You certainly can't think of doing editorial stuff—all the mags and newspapers are folding or not using much illustration."

Along those lines, Bendis has branched out. I found him on his website (www.keithbendis com) pushing his work as an illustrator, but also promoting his services as a graphic recorder. graphic recording, also known as graphic facilitation, or scribing, is, in Bendis's words, "An innovative, exciting tool that an ever-increasing number of businesses and organizations are using to enhance meetings, conferences, strategy sessions and shows. During the meeting the graphic recorder creates a real-time visual record of the proceedings, capturing the main themes, concepts and ideas, with images and text."

You've seen variations of this practice on TV and online. Maybe you've even been to a conference where a scribe has enhanced the presentation. Graphic recording is not

new, but it's currently a trendy illustration opportunity. But we should also clarify, that it's in demand because the process and concept *work*—and work *well*.

How so? Says Bendis: "Participants immediately 'just get it.' They see ideas captured in front of their eyes. Making ideas visual helps focus and engage the groups as they work. It encourages participation and retention, as participants see their thoughts and ideas mapped out in a continually expanding graphic representation of the proceedings."

Bendis has developed a storyboard approach to graphic recording that conveys the material in a logical and concise manner. He works on large sheets of bond paper (or 30" × 40" presentation boards) using markers and pastels. As each board is completed it's displayed so the participants can see and refer to the information, as the meeting continues. Afterward he photographs the graphic record of the meeting, and creates a PowerPoint presentation that can be posted on the client's website and sent to participants.

Bendis is quick to point out an important qualifier. "The illustration and graphic recording gigs are similar," he says. "You gotta learn how to do it through persistence and contacts. In the end it's just another freelance job."

## PULLING STRINGS

Chris Sickels started out as a painter, doing acrylic on paper. Initially, his promotion was black and line art, simply because it would photocopy reasonably well on card stock, and, frankly, that was all he could afford at the time. When he received a positive reply, he'd forward a mini-portfolio; this time with color photocopies. If there was continued interest here, Sickels would then send a complete portfolio. "These were the days when you'd actually send a real portfolio," he says, "your book would be gone for a week or two and they'd ship it back."

Sickels was involved with puppet theater during his senior year of college, but didn't integrate this 3-D direction into his illustration until some four to five years into his professional career. He continued to market himself as a painter, working with small regional newspapers and magazines (including *HOW* magazine, local to Sickels, then living in Cincinnati). Along this route he reached a point where he thought the 3-D stuff might just make it as good illustration.

"But it was hard to convince art directors that this was a viable outlet," he says. "One factor is time; another was the expense, plus the whole photography thing and making it print worthy. And then, of course, it was trying to convince art directors that, if they liked my painting, why would they want to try something else?"

Sickels says the sea change wasn't painful, but actually, "Just awkward. I was showing the 2-D work as well as the 3-D stuff, " Sickels says. "It was really the

same work, the same ideas. You had two choices, and it ultimately came down to their print process: What kind of reproduction are we talking? Would the 3-D thing photograph better or would the painting hold up better? For instance, newsprint would typically mean painting.

"Eventually, I had a few art directors who took a chance with my 3-D work. It clicked . . . it wasn't the smoothest process, but it did happen. After another period of around five to seven years the demand for 3-D outnumbered requests for 2-D. And I saw that the call for the painted work wasn't for new clients, it was for existing clients, which was fine. However, the painted illustration wasn't going back into my portfolio. It wasn't moving my work forward; so I made the decision to simply stop marketing the painting and concentrate strictly on the 3-D work. It took maybe five to seven years to make this complete transition; it was hardly a quick style change."

## OUT WEST

To make this happen, Sickels had to get his Ansel Adams on a bit. "I was in the Cincinnati area and there were some commercial photographers I'd met through other art directors or friends," he says. "I would do assisting gigs for them: run their cords and load their film. In exchange, when they'd have slow days they would shoot a piece for me. Not necessarily an assignment, but a piece we could explore together (lighting, setup, etc.).

"They were interested in what I was trying to do, so when a job did come in we would work out a shooting schedule and a photography rate. At this stage, I wasn't trying to make an income from the 3-D illustration, I was just trying to figure out if I could actually just get it to physically work."

Not long after that Sickels moved to Los Angeles. He didn't know anybody there; he had to take photo equipment with him, find local labs and local film suppliers. He did the proverbial ton of research and put a lot of calls in to his people back in Cincinnati to pick their brains. "Eventually I figured it out enough to make it happen," he says.

The trek west was a pretty gutsy move for Sickels and family, but heading back home was even ballsier. "We had some promising pitches for animated television shows and we moved out there on the tails of that," Sickels says. "At least, back at the time (circa 2000) you needed to be on the West Coast to do animation.

"But we were only there a couple of years," he says. "I had a few offers to do character design for some animation companies, but when it came down to it, I had to choose between working on salary to do full-time character design or pursuing my own Red Nose Studio. I just knew that the Red Nose stuff was where my heart lie.

"Economically, this wasn't the best play," Sickels admits. "This was not what I would call a smart idea. I was just dumb enough to think I could make this

work and naive enough to stick with it. It would have been much more financially stable to take a salaried job, or get into real estate, but my wife and I had a heart-to-heart, and we decided we just wanted to stick with Red Nose. We returned to the Midwest, and every year it got a little better and better. We felt like we could make it work. And when you're in the middle of it—you don't know any different."

## REPEAT AFTER ME

Roger Brucker says that a great strategy when starting out is to consciously try to generate *repeat* business. Whoa— jumping a little ahead of ourselves, aren't we? Well, hear him out before you dismiss this clever marketing gambit.

"If you live someplace historic, famous or semi-famous, or notable for anything, create an illustrated map of your town or city," says Brucker. "Banks, Chambers of Commerce, and gift shops are your sales outlets. A new map edition every year gets rid of the busted businesses and adds the new stores and buildings.

"Local note cards extend this concept. Illustrate the historic homes, civic buildings, schools, scenic vistas. Every gift shop will sell them and you can drop in every month and replenish their supply and show off any new series of note cards.

"Larger non-chain restaurants may welcome custom illustrated menus, personalized to their important dishes," says Brucker. "Offer updated menus now and then."

"How about hospital board of directors portraits? Or staff portraits (those photo portraits found in every doctor's office)? Big medical practices need to add professional staff all the time—a regular commission may be an illustration of the new guy or gal. Board members and staff turn over frequently. If you get the commission to illustrate new folks when old ones ship out, you can lock in a good income.

"Civic clubs, companies, firms of all kinds, and hospitals would like to have an illustration of the founder hanging in the lobby. An illustration looks classier than a photo, and it makes them look like a going concern."

# ON THE BOARD

## (PROFESSIONAL VIEWPOINTS IN 50 WORDS OR LESS)

I didn't exactly know where I was heading. But, frankly: even when we think we are sure, we never actually know, do we?

—Antonio Rodrigues

Illustrators are entrepreneurs simply by being content creators and the owners of that content. Creative content is a product. Managing the process, the content, the promotion and selling of that content is entrepreneurial.

—Ken Orvidas

Tomi Ungerer talks about creative ideas being like that Buster Keaton film with all the boulders. That was spot on. Success comes when artists pair that passion (and, yes, compulsion) to create stuff with promotion and marketing.

—Bryan Ballinger

I wanted to control my destiny. If I failed it would be because of me. If I were successful, it would be because of my own efforts.

—Tom Nicholson

© Anna Steinberg 2016

© Charlene Chua 2016

Do it all. Don't turn down anything. If you don't know how to do what's being asked of you, tell the potential client that you can, and then either learn it quickly or call a friend who already knows. Have a community and exploit it (but in a good way).

—Brian Biggs

Try to choose a job because you want to, not because you have to.

—Avram Dumitrescu

As an international student I definitely tried to copy whatever looked cool in the western world. I saw that embracing western technique certainly enhances my critical thinking, but I eventually realized that combining this with my own eastern culture and philosophy provides better value to the industry.

—Dingding Hu

This is not a stand-alone business anymore—if it ever was.

—Mike Salisbury

© Trina Dalziel 2016

# Chapter 13

# Digital

---

"A nice black pencil and a white sheet of paper are very nice. But if I had to choose, I would say my computer, scanner, and printer are my most valued studio tools."

—Ken Orvidas

Just a preface to this chapter: For more information about working digitally (and especially if you are not reading this book in any linear fashion), please cross-reference with Chapter 6's section entitled *Computers, "Buy" and Large.*

# WHAT'S THE DIFFERENCE?

"Are we talking 'drawing done on the computer' versus 'painting on a canvas'?" asks Julia Minamata. This is a good place to start: a reasonable question, that. But another starting point may be to ask: in 2016 (by the time you read this), does anyone care? Is it a moot point?"

"It seems to me that questioning the validity of digital is now groundless," says Al Wasco. "Should we still be having this discussion? I suspect it's of interest only to people over the age of about forty (fifty?)."

"I also think the digital question in illustration is completely pointless," says Scott Bakal. "It's over. It's never really a discussion anymore. Maybe once a year, a student would ask a question about whether digital art is valid or not . . . if that. I tell them it just doesn't matter. It's a way of life now and not a thought. Only the 'old-timers' question it."

"I suppose it really depends on who's on the receiving end of that question," says Brian Biggs. "You're right that it's really only us geezers who even think about the delineation. While ten years ago this wasn't the case, there's not a single professional working illustrator who hasn't reconciled with the computer and figured out its role in their work. Some, especially in the children's book world, may just use it to scan and touch up analog artwork. Others use it for 100 percent of what they do from sketch to final."

"The idea of starting with natural media and finishing digitally, is, however, intriguing and valid for a wide audience," Wasco says, "especially for people who are not yet totally sold on digital. There also may be people who do the reverse: start digitally and finish in natural media. So combining the two approaches is compelling. Let's talk about that."

"Yes! I believe that the vast majority of younger illustrators use a combination of drawing/painting and Photoshop that is fluid and interchangeable," says Biggs. "The idea of an illustration being 'digital' or 'not digital' is likely irrelevant."

"Actually, I think we're right on the cusp of this topic not being relevant to those same younger illustrators," says Bryan Ballinger. "It's also hard because discussions on digital techniques and software and hardware can quickly become obsolete after just a few years."

"I think for someone starting out in this field, the discussion would be helpful," says George Coghill. "The issue may be 'settled,' but hearing us old-timers haggle over validity is bringing up a lot of relevant discussion points."

"You know, 'out in the real world,' the debate now has kind of almost sort of flipped," Ballinger says. "Some people out there are asking if working traditionally is still valid!"

"At that point, I wouldn't doubt that we will see a resurgence, even for nostalgic reasons, of traditional media preference in the near future as a backlash

to digital," says Coghill. "We see it already with Etsy, letterpress and hand-crafted items.

"So it's *all* valid. And it all will be digitized eventually," he says. "It's not a matter of *if* your art ends up digital, but at what stage in the process this occurs."

Yep . . . I knew this would be a fun ride. So with that, I threw the general topic out to a selection of contributors. The basic topic of valid-ity made for a lively conversation, and sparked the following roundtable. Participants in this chapter were: Don Arday, Scott Bakal, Bryan Ballinger, Brian Biggs, Darren Booth, Fred Carlson, Charlene Chua, George Coghill, Avram Dumitrescu, Max Fleishman, Tom Garrett, Tom Graham, Chris Haughton, Margaret Hurst, Ilene Winn-Lederer, Stephen McCranie, Julia Minamata, Ken Orvidas, Cristina Martin Recasens, Mikkel Sommer, Al Wasco, Allan Wood.

**Michael Fleishman:** "Stephen, you're one of the younger members on the panel, where do you stand on all this?"
**Stephen McCranie:** "I do feel, as a twenty-something, that the digital debate is over for me, and I have come to see little difference between the two."
**Mikkel Sommer:** "I think it's a valid question, but perhaps not super important. Hmm . . . I'm drawn to the analog, to paint the 'real' stuff . . . I accept that draw-ing is drawing. You make it what it is, whether that is on paper or on a screen. There are illustrators who create in paint, but who work so graphically that they might as well have worked in Photoshop. Then there are people who work in Photoshop who spend buckets of time scanning textures and adding mistakes to make it seem authentic and less generic. I dunno. Is it too colorful to say that it's not so 'black and white,' really?"
**Tom Garrett:** "I tell my students, 'When learning Photoshop, don't try to mas-ter every tool. Consider one of your better pieces. What got you off about this concept, style, or technique? Focus—spend time reproducing that *look*. This will give you the intensity and endurance to learn a new media, *in your voice*.'"
**Charlene Chua:** "I'd hazard the educated opinion that most—if not all—younger illustrators do have some digital experience. I *sometimes* field questions about whether using digital is valid, or a 'cheat' or something—which is kinda dumb, because it's like asking whether airbrush is a real medium.

"In practical terms, as long as the work can be delivered to the satisfaction of the client, it doesn't matter if it was put together with pig spit."
**Scott Bakal:** "I don't think artists should be concerned about using traditional mate-rials or digital media. If you're using the computer as a tool to create art it might be helpful to be educated in the basic foundations of drawing practice and theory.

"Every year, every semester, more and more students eschew the paintbrush and prefer to work digitally. In their 'modern' world, it makes sense to them; they

do not need a physical original to get their creative points across. They just want to create the best art they can with the technology readily available. I'm okay with that."

**Chua:** "I'm not sure about what the overall tone of this discussion means to your book, Mike—is it meant to be more scholarly or more 'how to'? I can only suggest that if it's more a 'how to' conversation, then perhaps it may be good we just clarify any debate on digital versus traditional. But saying that, we can render any conundrum by stating right up front: digital is a *tool* (like that airbrush I mention, or a brush or a pencil). It can be helpful. It's not going to give you magical art powers. Digital opens up other avenues for illustrators—it's a wonderful (and, in the context of art history, a relatively) *new* tool.

"To limit it to just another paintbrush, as many of us do, is really to underuse its potential. Myself, I kinda hope that illustrators in the future will be able to harness the power of tech to bring new forms of visual communication to the table, that's not just limited to a static picture."

**Julia Minamata:** "I suppose coloring something digitally will not teach you that yellow paint plus red paint equals orange paint (unless you have the colors on two different layers in Photoshop and the layer is set to 'multiply,' in which case . . . yes . . . you *could* learn color theory when coloring digitally).

"Yeah, okay . . . drawing skills are drawing skills. And sure, some artist somewhere could get by just fine learning how to draw and paint completely digitally, but painting with actual paint is a lot of fun, and working with the real stuff is a completely unique experience than pushing around ones and zeroes. Neither is better than the other, just different."

**Bryan Ballinger:** "Oh, I agree . . . I find that I get different results when working with both, which makes sense. They are divergent tools and the process and experience impact the art. If you look at my pencil work, it is quite different than my brush pen work, which is different even than my Micron inking work. The medium and tool affect the art. Neither in a good or bad way.

"So neither traditional or digital makes art better or worse, just unique. The one area where digital can win though is in speed, revision, and even experimentation."

**Max Fleishman:** "My process isn't much different when I draw on paper as when I create on the screen. Sketching, layout, rendering, details . . . that's all about the same. My drawing and painting skills haven't diminished, but ironically, I do know I'm branching out even more as a digital illustrator. Oh, I explored with techniques and materials traditionally, but I actually experiment more working digitally.

"Honestly, I felt somewhat constricted working traditionally; if I made a mistake I felt I just had to live with it. That was okay, mistakes are a critical part of the process, but now, with digital mediums, you have the leeway to just go for it.

You have complete freedom, the control—literally, a control-n or a command-z —and the direct efficiency to experiment beyond the preliminaries.

"But let's not place the digital experience on such an impossibly high pedestal. Countless options and endless tools are meaningless if you don't know what you're doing, right? A great tool facilitates your process and education—helps you grow, work faster, be more efficient. If it does that, cost, build-quality, and size, are negligible. Viewed in this simple context, digital is simply a *perfect* tool."

**MCF:** "I wonder if some smarty-pants school somewhere isn't offering a Drawing 1 class done on computers—or would that just be going about the task back asswords? At any rate, fundamentals have been a constant for centuries— foundations are laid by hand with traditional utensils. You progress from doing handwork to power tools."

**Fred Carlson:** "You don't let yourself be trained by the computer; you must be aware that solving compelling graphic problems requires artistic lateral thinking."

**Chua:** "Like Fred, I'm also a firm believer that students benefit from more practice with fundamentals. You should have a good handle on the figure and still life. Students must strive to better themselves at the basics. A good teacher may be able to help point out what is wrong with the work, but it is still up to the individual to try and consciously rectify the problem."

**Bakal:** "At school, I was told time again that, before an artist is able to create a good painting, he needs to be able to create a good drawing. I feel that this still holds true, even using digital media."

**Chua:** "Tell you the truth, judging from the work *I* see at graduation shows for illustration students, I don't think students are overly focusing on computer skills. If anything, some of these students should be using the computer more, to polish up their pieces towards the end.

"It's admirable when students seem to want to hold on to traditional media. This definitely offers a broader range of expression than the currently available digital tools."

**Margaret Hurst:** "For me, the biggest change in the field of Illustration has been the computer/digital presence. This has drastically changed the way art/drawing/ illustration is perceived."

**MCF:** "Okay; so what about *perception*? Is there the baggage of 'good' and 'bad' art that comes parceled with either format, or one format over the other?"

**Bakal:** "We can't blame 'bad' art on the rise of the computer. 'Bad' art happens— it hangs in galleries throughout the world, and is found widespread in print. It could simply mean an inept artist, or faulty art direction; both 'bad' art and 'good' art exist, regardless of medium."

**MCF:** "Margaret, your learning process is based on drawing—which encompasses picture making, design, and communication, correct?"

**Hurst:** "Yes. I feel that drawing is still the basis for problem-solving, whether your art project goes hand drawn or digital. My artwork is definitely hand drawing–based. If I have the desire to, I sometimes will use Photoshop to layer and/or filter my drawing and my color. But the thinking process always begins with drawing; always. There is no substitute for drawing. Drawing, as Milton Glaser says, 'is thinking.'"

**MCF:** "I wonder if this core belief—that drawing as the foundation of knowledge from which all visuals expand (regardless of how you work)—isn't underestimated by some people."

**Allan Wood:** I think that digital technologies are a great tool but may have aesthetic limitations if solely relied upon in the creation of illustrations and design. The end result tends to look 'computer generated'—I can usually tell what Photoshop filters or (Adobe) Illustrator tools have been used."

**Ballinger:** "I have to disagree that you can always spot a digital piece. Sure, you can tell illustrations that are embracing the traditionally digital look—and how's that for an ironic phrase? Like vector-based illustrations for instance. But I've seen many illustrations that are mimicking a traditional look, where it's impossible to tell."

**Brian Biggs:** "I had to create my most recent *Frank Einstein* book completely digitally. Sketches as well as final art. Since I had drawn the first two books mostly with ink and pencil, then scanned and completed the color in Photoshop, I had to make it look consistent. I had to make it look analog, actually. I used some of Kyle Webster's Photoshop brushes (which are amazing) as well as a bunch of brushes that I created to mimic my own way of drawing. You'd be seriously hard-pressed to tell the difference."

**Wood:** "I see what you're saying. For myself, I tend to do a lot of manual mark making (i.e., ink prints, rubbings, splatters), which I then import into Photoshop/Illustrator/Indesign for composition and colorization. For me this brings a more spontaneous and less contrived aspect to the process where you can look for surprises. The ideas of visual interest (contrast, harmony, unity, etc.) and embracing mistakes play a big part in this kind of process."

**MCF:** "So, I'm hearing that it's the *mix* of media—whether that be a combination of digital processes or the hybrid blend of digital with analog tools—that can facilitate a solid art *foundation*. Well, then, is a purely focused digital education defensible? What would we look for here?"

**Wasco:** "I think that a solid digital foundation would begin with learning not only software tools and techniques, but an entire process of working digitally. In my experience this overview is ignored, or at best left to chance in design education.

"To a large degree, as Julia says, drawing is drawing, whether you use a pen on paper or stylus on pad. But there are specifically digital actions, like

combining raster and vector in a single image, using layers and blending modes, masking, and filters in Photoshop. Beyond software tricks and techniques there's the idea that not all images are destined to be printed. Some are created specifically for onscreen use, like animated GIFs and their artistic offspring cinemagrams, which can be quite beautiful and exist only in the digital world. And there's motion graphics and video of course. Illustrators could have a lot more fun if they realize that there's a wide spectrum of destinations available for their work. Most print publications have digital editions as well, and the illustration could—and probably should—be created differently for each medium. Don't think of this as a headache, think of it as an opportunity to stretch your creative muscles!"

**MCF:** "Al, what constitutes a mastery of digital tools? How do we recognize it?"
**Wasco:** "You mean, how do we teach it? You know, in the analog world you look at a physical portfolio and make a judgment. Sloppy mat-cutting, badly-mounted artwork, and bent corners can kill your presentation. We call problems "poor craft" and blame them on carelessness and/or lack of attention to detail. It takes a killer creative concept to overcome sloppy craft.

"Some aspects of digital craft are easily spotted in a physical portfolio: fuzzy 72ppi web graphics on a printed brochure, digitally stretched or squeezed type instead of true expanded or condensed fonts, and Bezier curves with obvious kinks in them, among other issues. But how do we judge craft when looking at an online portfolio? Those Bezier curve kinks that look so bad when printed at 300ppi may not be visible on a screen-sized version. The type issues should be noticeable, but the question of whether the image size and resolution are correct won't be. One tip-off to a poor understanding of image resolution for web versus print is when website thumbnails load slowly. This particular problem is nearly always caused by the designer using high-resolution images, say 2400 × 1800 pixels, and having the browser scale them to 40 × 30 pixels. This takes time as the page loads. The proper choice, of course, is to use images at the actual pixel dimensions needed.

"Other noticeable issues on a website are organization and usability: is it easy and enjoyable to use, or confusing and annoying? The whole issue of user experience is still a challenge in the digital world, whereas in the print world most problems have been solved years, maybe hundreds of years, ago. The first books didn't have page numbers, title page, or an index, yet we now expect these usability aids. The size of a brochure, poster and book are within a standard expected range most of the time. The designer doesn't have to figure this out. Yet for a website the issues are much more complicated and still unresolved. You might browse online portfolios on a 27-inch high-resolution desktop monitor, on your 9-inch tablet or a 5-inch smartphone.

"And finally, a topic that seems extremely relevant for anyone working digitally is the overall process and workflow. This ranges from naming and arranging layers in Photoshop to choosing file names and folder structures. Because digital files are often exchanged between artist and client, and in the case of web design between artist, client, editor, designer and developer, understandable and consistent naming systems make life much less stressful for all. A lone painter in his or her garret can arrange their paints by name, by color, or by size. As long as the system works for them, it works. But imagine someone else walking in who has to find a particular color and match it. Now we have a problem.

"To wrap up digital workflow concerns, what about saving, backing up and/or archiving files? How often, where, and how, are critical questions that are inconsistently addressed by instructors, in my experience. In a traditional studio or classroom, students can see work on paper stored in a metal flat file to archive it; but they can't see how others organize and store their digital files unless they watch over their shoulder.

"Most of us figure out a system, usually based on the painful experience of a hard drive crashing hours before a project is due. Surely there's a better way to approach this as we educate artists who will be working digitally, meaning virtually all artists."

**MCF:** "Slightly switching gears here for a moment: what *is* a 'digital' illustration?"

**Avram Dumitrescu:** "I'm going to label 'digital illustration' as any piece of artwork utilizing a computer in some way during its creation (a digital photograph of a painting does not count).

"I see traditional approaches re-created using non-digital means all the time. Digital illustration can certainly have its own unique look, but often tries to mimic 'analog media.' To me there is no 'positive' and 'negative' here, it's just personal preference. I myself take life drawings and either project this onto canvas to paint over, or bring the work into Adobe Photoshop or Illustrator to color, tweak my line, or add scanned textures."

**Cristina Martin Recasens:** "I concur with what Charlene said earlier: digital is no more than a tool; it's neither bad nor good. A useful tool when used correctly, a tool that can be misused, which also readily and frequently occurs with oil paints and watercolors, by the way.

"Personally I use digital techniques during postproduction, which is time, energy, even material-efficient. But I enjoy analog and love working on paper, too."

**Coghill:** "Computers and graphics software are, in essence—and like Charlene has already said—pencil (and paper). Fancy pencil and paper, but still apt metaphors. And as Cristina points out, any tool—digital or traditional—can be used to create some real crap, as well as some deeply sublime expressions of beauty.

"In some ways, digital can be less ideal than traditional due to the endless revisions and undos. You learn to rely on these as crutches, as opposed to developing a strong practice and technical mastery that allows you to work without those nets.

"But I do love those nets! Here's a basic truth: you will need to have your artwork digitized in the end, regardless of how you created it. Most illustrators just bite the bullet and keep it digital for as much of the workflow as possible. I still sketch initially on paper with pencil, but from there on out it's all electronic. It makes client revisions (and artist revisions) much easier. And everyone wants it digital in the end anyways.

"For me, a huge part of digital isn't so much my preference in creating the art, but in the ability to provide superior service to the client. I can offer much more added value to a project with everything being digital."

**MCF:** "I get that. I'm hardly a purist. Maybe I'm a bit of a sentimentalist. I'm certainly no luddite. But I gotta say that hand rendering on a tactile surface, physically holding the piece to the light, seeing art in real dimensions, is glorious and soul-satisfying.

"And at the same time, if I juggle and jiggle some of those words around, I feel exactly the same way about working digitally: I love drawing and painting on my Mac and iPad. No boutadoubt it, I absolutely adore doing art in all its manifestations, with all the apparatus at my disposal."

**Dumitrescu:** "And if you're working with any type of apparatus—for anyone, anytime—a grasp of mechanics becomes key. Traditional skills are vital, if only to be aware of mark-making. Solid color choices, a compelling sense of movement, shape and space, pattern and texture—all the critical stuff. Did the artist convey the message they were attempting to tell?

"Getting back to what Al was saying earlier about digital craft: from here, a knowledge of the computer side of the equation must then balance it all out. How is your work to be seen? RGB and CMYK . . . do you understand that your illustration can look much more vibrant due to differences between the two formats?

"What techniques are available to you? Just because you know every feature of a piece of software doesn't make you a better artist. Do you realize that you need to scan your artwork at a certain dpi (or work in the correct color mode) to ensure that the Photoshop document you created doesn't pixelate in print because you set the resolution too low? Your stuff may be viewed on a range of devices (desktop, iPad, laptop, mobile) . . . can your artwork be viewed in one piece on that mobile device, or is it larger than the physical dimensions of your tablet reader?"

**MCF:** "Factor in speed and efficiency, as well as the convenience of marketing, producing, and delivering digital illustration. Does this shift mean the eventual death of handmade art?"

**Bakal:** "I'm not sure about that. Speaking for myself, I am one of those artists skipping back and forth between traditional and digital media. What can I say? I like both worlds.

"Using various software, I can easily re-create the coloring, structure, blending, and even the textural look of one of my traditional paintings. The final printed product means the viewer won't be able to physically see the bumps and ridges of the paint on the canvas, or rub across the magazine stock and feel these actual textures. The eyes are fooled into thinking this surface actually exists in the original art, but it doesn't. There is no way to tell if it was produced traditionally or digitally."

**George Coghill:** "Oh, yeah—the tools are so amazing these days, you'd be hard-pressed to tell the difference, unless you have a keen eye for it. You know, it's not a matter of if your art ends up digital, but at what stage in the process this occurs.

"Though, as Avram and Al say, you do need to understand some basic technical stuff for you to initiate a solid workflow . . ."

**MCF:** "Okay, so let's say we want to scan final art in a proper manner. George, can you lay out a quick, down and dirty guide to dpi, CMYK/RGB, and file formats (regardless of the origin of the piece, e.g., analog/digital)?"

**Coghill:** "First I'm going to point you in the direction of the analog artist who scans work in at 72dpi and then dumps his originals. That's setting up a disaster to happen. This would be a travesty for future opportunities. As is the digital artist prepping files at a 5" × 7", 300dpi print size, instead of working much larger to allow for poster-sized reproduction down the line. I have met many artists who made these kinds of mistakes, and man, does it suck to have only a low-res version of a killer piece of artwork.

"The Cliff's Notes, shorthand key to it all? Always work at a minimum resolution of 300dpi. Find the pixel dimensions for the various print sizes (18" × 24" and such) at that resolution (300dpi). Use those pixel dimensions instead of the print dimensions. The pixel dimensions trump it all in the end.

"Then save those as Photoshop presets to cut time. For example: An 18" × 24" image at 300dpi is 5400 × 7200 pixels. That eliminates any confusion. Confusion sets in because Photoshop will allow you to create a 72dpi image at 18" × 24" print size, and those inches can be misleading to the novice. An image set up based on pixel dimensions takes out any guesswork."

**MCF:** "Folks, what of those who view digital work as 'easier, simpler, faster' to create than traditional art?"

**Fleishman:** "It's no better or worse. Certainly *not* patently "easier, simpler, faster." Both are, however, clearly useful tools with advantages and disadvantages. Digital is more accessible, not better. Digital is not a crutch. For me, the advantages are in the editing and corrections, so I've mainly moved over to digital. There's a wonderful, tactile sense of discovery working traditionally, but at the same time, digital can make that discovery process much more streamlined and efficient."

**Bakal:** "Digital illustrators know that this is far from the truth. You still need to know how to draw and blend color, color theory, how to work with tone. All the standard rules apply—it's simply created on screen rather than on paper or canvas."

**MCF:** "It's easy to approach illustration as technology-driven, anyway, isn't it? One can still be a 'traditional illustrator' with a vengeance, if you prefer. The techniques and hand skills that have always driven illustration (and fine arts) are alive and well as a digital illustrator. There's no fear of the watering down of hand skills. There is room in that artbox for both old and new toys."

**Chua:** "I see technology opening some new doors for illustrators by 'blurring the lines.' People combine photography or animation with illustration. Online stock and licensing websites now make it theoretically possible to sell work to a larger audience, although I personally don't think these sites favor illustrators with their current business model.

"Look at how digital is affecting the illustration business: editorial—print magazines and books in print—seems to be waning, yet at present, no one has quite claimed dominance in the digital alternative yet. What will eventually happen there and what will the role of illustrators be then? Will we even illustrate for books and magazines in the future? Conversely the rise of digital technology has made it possible for some illustrators to transition over into video game and app development on their own. In the future, will these be 'legitimate' avenues of illustration?"

**Ilene Winn-Lederer:** "Well, that said—we should also talk about how digital has impacted what I call *derivative* illustration. That is, 'sampling,' as employed by so many great illustrators that do collage art.

"These illustrations are exceedingly well-crafted. But then I began to have questions about the validity of such images. I started to wonder if this is an easy way out to enhance an artist's statement?

"What's up here? I mean, when I use found materials in my own work, I try my best to only use images from my personal collection or images in the public domain. Still, I'm uncomfortable doing so. It somehow feels like cheating! *Why?* I realized that Picasso, Braque and Matisse are among many artists who used collage materials in their work. So, Ilene, why aren't you questioning *that?* Is it because it was all done by hand rather than lifted off of Google or some other virtual source?

"Peripherally, I was convinced—and confident—that making strong images was all about the feel of paint or pen on good quality canvas or paper. This was the essence of creative excitement and fulfillment. But I have to laugh, I now have frequent moments where I question the validity of my own manual skills absent digital enhancement! Where making a strong mark on paper with its inherent flaws was once acceptable to me, I now cannot help thinking that such 'flaws' can always be 'fixed' on the computer.

"But I don't draw on a computer drawing tablet or tablet computer. I have found a livable compromise for my work—I do my drawing and calligraphy on good quality paper with a variety of pens, then scan, edit and enhance this in Photoshop. Doing so allows me to not only maintain my manual drawing skills and create new images, but to adapt them to a wide variety of digital and real venues; granting them a longer shelf life, so to speak."

**MCF:** "Don, you tackle many of these issues in your great blog, *The Informed Illustrator* (www.theinformedillustrator.com). Can you give us some final thoughts on "digital craft" as it's come up in this chapter's conversation?"

**Don Arday:** "Sure. Before the desktop revolution, in decades past in the age of film, an illustrator could be satisfied with solely knowing how to create an illustration. Illustrators would have their illustrations photographed or have original art delivered to a client or printer who would then have the illustration photographed."

**MCF:** "Didn't illustrators like Norman Rockwell do their own photography for setups and reference?"

**Arday:** "Yes, and occasionally, adventurous illustrators would learn enough about photography to photograph their own work. But this was the exception rather than the rule. It was a printer that would scan the original artwork or a photo transparency, and then make technical adjustments to an image, apply crop and registration marks, and generate color separations for printing. Illustrators remained in a technology-devoid bliss.

"Fast-forward to now. When it comes to reproducing illustration, film-based photography is a thing of the past—having been replaced by digital photography, digital scanning, and illustrating completely within a digital environment. Even more than a change in technology, there has been a shift in the relationship of an illustrator to the production environment.

"In today's digital age, illustrators not only have to know the *craft* of illustration, but they have to be proficient with setting up files for a work flow, using digital dimensions (resolution), understanding digital color spaces, making color adjustments and retouching, working with device profiles, and selecting output protocols including digital file formats. For illustrators who work conventionally, it is now a necessity to be adept in recording work and translating it to a digital state, as well as preparing digitized work for output to print or digital media.

"All these areas of expertise are necessary because illustrators are now expected to integrate seamlessly with the work flow of a project. Metaphorically speaking, we are expected to jump onto a moving train and know where it is going. Illustrators must be technologically savvy."

**MCF:** "All aboard! Where do we start? Where do we leave the station?"

**Arday:** "We begin with *file setup*. File setup involves inputting the dimensional specifications for an illustration. This typically requires information provided

by a client, printer, or webmaster including physical image size, orientation, and bleed requirements (if needed), units of measure, digital resolution, and color parameters.

"Illustrators must next understand *image resolution* as it relates to image placement or final output in a print environment or display in a digital one. This requires knowledge of how ppi (pixels per inch) convert to dpi (dots per inch) or lpi (lines per inch) in print or screen resolution for desktop or mobile devices.

"Digital visualization software offers a variety of *color spaces* to suit the needs of digital and non-digital environments with each having its own purpose and uses. A basic understanding of all of the color options is now essential for illustrators. Spaces include RGB (the digital display model), CMYK (the print output model), HSV (the color theory model), Lab color (the color opposition model), Grayscale (the luminosity model), and Indexed color (the web compression model).

"Now it's about *color retouching*. In the past, making color adjustments to images and fixing minor irregularities was the sole proprietorship of specialists such as retouchers and color separators. Now however, illustrators are expected to be proficient in adjusting color and cleaning up images in preparation for display or output.

"To ensure proper display of illustrations in digital environments and for output through print devices illustrators must know how to use *device/print profiles* within their illustration files. A digital device/print profile is a descriptive index that is used by software programs to define properties and limitations of a color space. A profile registry is a set of finite values that create meaning for digital display media or physical output media. Profiles exist for hardware devices, within software programs, and for physically displayed media.

"In many cases, illustrators are responsible for preparing illustration files for final output or display. This involves managing file-handling *output protocols* (including print settings, color handling, rendering preferences) and other parameters that are required by a specific output device, display hardware device or other hosting situation."

## FAST TIMES

Chris Haughton says that it's exciting to think that when the technology is so novel, its makers can't foresee exactly how it will be used. Sir Arthur C. Clarke, the celebrated writer, inventor, and futurist, remarked that any sufficiently advanced technology is indistinguishable from magic. You don't need to be the fastest chip on the motherboard to see that from the actual look of your art (creation, technique, and style) to the back end (production, delivery, and display), our current technology profoundly impacts our modern process.

Ahh, this is nothing new. "We take old technologies for granted and forget that they were once fresh," Darren Booth reminds us. He's absolutely correct. There have been many sea changes throughout illustration history. One might argue that the digital age is perhaps a *tsunami* of change, but not the actual point of the discussion about to follow.

But while we're *here*, consider that technology has always been an evolutionary, if not revolutionary, fact of life for illustrators. One case in point: for most of the nineteenth century, there were not many venues for American illustration, nor any pressing *need* for art, beyond the regional or personal level. As the Civil War loomed, steady advances in printing technology, supplies, and materials created new markets and spawned a burgeoning field.

An information-hungry public wanted news, and toward the end of that century, the photomechanical process of halftone reproduction revolutionized the world of publishing, as well as the business and art of illustration.

This scenario should sound familiar to you (Facebook, Google, Wikipedia, Twitter, Tumblr, Pinterest, Instagram). Sure, the computer has indeed changed "everything" *for us* over the last two decades, but the basic need and response, supply and demand scenario is remarkably the same as it was two centuries back. So if you study illustration history, you'll see this "brave new world" cliché is *business as usual* with every generation of illustrators, in any period, for all genres.

As illustrator and educator Tom Graham points out, "The field *is* different. Since I've been teaching the history of illustration for the past few years (and learning it myself), I realize it has always changed, sometimes radically."

So, maybe I understate it above; perhaps we *are* plumb in the middle of history in the making? "Well, if you examine illustration history," Graham says, "it's clear that the artists who succeeded best were ones who adapted to and mastered whatever technological advances were coming."

There's only the here and now for you, kid—this is your best time to be an illustrator. And like Howard Pyle, who was all over that new fangled halftone reproduction and took the then state-of-the-art technology to greater heights, you're going to make the most of our brave new world.

© John Blumen 2016

© Eliott Lilly Art LLC 2016

© Brian Biggs 2016

# Chapter 14

# On the Web

*My Web site is the best self-promotion I've ever done.*

—Randy Glasbergen (deceased)

## THRIVE

At school, Lori Osiecki knew immediately that she wanted to be "a *thriving* artist, not a starving artist. The business aspect of being an illustrator is *so* important, and it's something that wasn't emphasized when I went to college," she says.

Osiecki was an illustrator at Hallmark for ten years (see Chapter 2). It was a helluva great ride. But along the way she realized that she wanted to create *products*. She was into "that whole 'idea to counter' thing," she says. "Learn how it's made. What does it take to get it to market? The entire process fascinated me; I was always looking for that business aspect."

On her own path, Osiecki fully embraced sales and promotion to pitch her product and grow her business, to get her product out. "But back in the day, before the Internet and the rise of social media, it was limited," she says. "You had to promote and market, physically send out or present your book—it was decidedly one on one. Today you can score a thousand eyeballs at a time. It's far more convenient for people to have access to you and it's easier to reach people now. I should say it's easier, *if* you know how to set yourself up.

"Part of that business sense today means learning how to build and maintain a website," Osiecki says. "I can code, and have done so for clients; I know how to write HTML. But these days it's so incredibly fast, easy (and affordable) to build a website with robust platforms like Wix and Weebly."

"The flip side of all this efficiency is that everybody's out there scoring those same thousand eyeballs," she says. "What can you do to stand out, to make yourself different? It's a slightly perverse irony that a physical self-mailer or actual postcard might be considered a novel promo that stands out from the proliferation of online advertising."

## SOCIAL

And what about apps? "As far as app development is concerned," Osiecki says, "the visuals are critical—creatively you can enhance any idea." Forgive the cliché, but Osiecki is here to tell you that content is king. It's all about, as she puts it, "grabbing our lovely thousand eyeballs and gaining traction." And how do you do that? Content, of course.

And the next trick—yep, that's right—is the promotion and marketing of the thing: what is that app, what is that trend, what are people looking for? "Unfortunately, this is rather hit or miss," says Osiecki. "You can hang at app developer and marketing conferences. You could offer a 'freemium' option and attractive add-ons or upgrades to entice customers, but honestly, it is difficult to figure out what people want ... how does this app benefit, what does it offer, how does it get you involved?"

Ironically, binge-watching on Netflix just may support proclamations that folks today are actually more selective in what they watch. To capture your picky audience, a perfect marketing tool is to provide online content. "Go out and play on your iPod," Osiecki suggests. "Mingle in a crowd and get people to fool around with your app. Film their reactions. Post it on YouTube and Facebook as a series of short videos with catchy, fun titles."

Osiecki presses her point and stridently advises that you *get that content out there*. Refresh frequently (in other words, continually offer new material). Make it interactive: Work up a compelling teaser: "Guess what happened when we showed the app to her mom yesterday? Check it out!" Or: "Hey, we're all meeting Friday on the four corners of Goodman St. and Moore Ave. to play my app, *Mark It Zero*—be there!" The more content you get out, the more you constantly and consistently update, the better the outcome. And by the way, crazy is good. All it takes is someone to say, "Wow, that's crazy! I like that, where can I get this?"

Osiecki's research indicates that you must actively post—at least ten posts a day, she says—for this to be an effective marketing tool. Ten posts a day is a lot of work! Nolo contendere, but Osiecki emphasizes that this is a key element of the new marketing paradigm.

Another marketing and promotional tool Osiecki highly recommends is Twitter. "Here's how it works," she says, "go in and find like-minded people with the same interests. Follow them. The trend is that they follow you back. The cool thing is that, then, you get an email that effectively states, 'Well, as you followed Walter, we think that you'll enjoy following Donny.'

"You now get this list of folks who Twitter thinks are in your same category or have posted stuff that you like to post. You begin to build a sympathetic energy, back and forth, as you start to follow these folks. Eventually, you become more selective about who you follow, and you start building your audience— remember that when they follow you, whenever you post, your stuff shows with their posts.

"Social Marketing is *The Way*. It's where you have to be," says Osiecki.

## CRAZY AND COOL

Penelope Dullaghan graduated with a degree in graphic design and started her professional career as an art director in an ad agency before becoming an illustrator. "That's how I thought I could pay the bills," she says. "I discovered illustration while at the agency, hiring illustrators, and I realized what they do is *crazy* cool. 'I want to do what they do,' I said, and started moonlighting. Working on my illustration at night and after about a year, I transitioned into illustration, full-time."

Initially supported by the steady income of her husband (a writer), Dullaghan found it tough going at first, but persevered through the early, lean years as business steadily improved.

And as business grew exponentially, so did Dullaghan's sense of purpose, place, and community. You may know her as the creator and organizer of *Illustration Friday*. It was, according to its founder, an absolutely wonderful ten-year run, and when Dullaghan nurtured the popular online community to its full strength, she sold the site to focus on her own projects.

## CONNECTIVITY

As both an arts community builder and a busy member of this collective, Dullaghan is in a decent position to evaluate the comings and goings of that circle.

"It's now far more evident how many artists are out there," Dullaghan says, "especially since the rise of social media. They're prolific, accessible, and available. These illustrators promote via social media, and promote *a lot*. This could just be my perception, but the competition certainly *seems* intense.

"I don't know if art directors are even looking at the 'old style' of promotion these days," Dullaghan says. "The creative annuals, the workbooks; they're all so expensive. Myself, I don't do this anymore.

"You kind of stumble around the Web, putting your work across in multiple facets. I don't have a personal program of promotion," she says. "I don't promote in that way. I just talk about my work (on Facebook, for instance); I don't send out flyers or postcards. My work is on my website, of course; I promote it on Facebook, Instagram, Tumblr. People follow you and that's a good way to put your work out.

"I'm a big fan of Instagram. I'd rather post images with fewer words and Instagram is a perfect venue for that. You can provide content in a friendly, community format. But the various social media outlets often tie into one another," Dullaghan says. "Different people look at different formats for different things; working over a variety of formats makes sense."

For someone just starting out as an illustrator, Dullaghan points to simple word of mouth as a powerful tool. "You put your work out there, and a friend talks it up: 'Oh, look at this cool thing this person is doing.' More people then get on that—especially if you're passionate about what you do and it's obviously a big event *for you*," she says. "If you don't care about your art, people pick up on that stuff. Be invested in your work. Be engaged. Be *connected*. Be excited about it and others will be excited, too. You don't have to be published; the work doesn't have to be commissioned—that can come later—show illustration that you personally *care* about.

"At least in my case, the commissioned work seems to come from work I do for me," says Dullaghan. "Somebody sees a post, a project that I'm

personally interested in, and they pick up on it . . . 'Hey, I can hire her to do *that.*' Hopefully, art directors have the vision to see how that translates into what they need—this is part of what they do [or should be doing], of course."

Some years back, Dullaghan shifted her focus somewhat. She made a purposeful, principled decision to work with companies who are, in her words, "Trying to put some good out into the world. I'm not just taking any old job that comes along. I don't want to work with folks whose motivation or agenda I don't agree with.

"And my creativity branches out into all aspects of my life," Dullaghan says. "This connection to my family and my ethics actually makes me even more creative, as everything all blends together in a beautiful way. So I can find creativity in cooking, or sculpture scavenger hunts with my kiddo. My creative life is not limited or segmented."

## BACK IN THE DAY

"A lot has changed in how I market myself and promote my work since my school days," Rigie Fernandez says, as he joins the conversation. "Before, all you needed was a good portfolio and the necessary contacts to promote your work (and get clients).

"Now, aside from a solid Web portfolio or a website, one should have a strong web and social media presence and personal branding," he follows up. "It's not enough that you're an illustrator with a solid portfolio—that's simply a given—you must be visible on the web. You should have a blog. You need to establish an account/page on Facebook, Twitter, Google+, LinkedIn, Pinterest, Tumblr, etc. . . . you should network with a lot of people to gain visibility and snag clients."

Isabelle Dervaux agrees. "Yes, these days, having a web presence is direct—an online portfolio review is instantaneous and international. It's hard to get appointments with art directors now to show your book. Art directors just aren't doing this anymore, they don't have *time* to see you. They'd rather check your work out on the web or *maybe* look at print samples.

"But of course, you must continually update," Dervaux says. "And if you are marketing over the web you must pay attention to all the details, be sales-oriented, and stay on top of everything."

## VISIBILITY

As Fernandez, Dervaux, and Osiecki advocate above, visibility on the web is crucial in getting clients, and social media is extremely important when promoting yourself as a contemporary illustrator. "If you want to go viral," Fernandez says, "you must get into social media."

Fernandez isn't talking about simply signing up for an account somewhere. You should set up a page dedicated to your brand (and that's *you*). Sure, create a page in the major social media websites. That's great. But creating a page is not enough, you must gain followers. How?

"Post consistent and timely content that will interest your followers," Fernandez advises. "Interact with your followers—your page going viral depends on this. The more you interact with them, the more visible your page will be. You should have a carefully planned social marketing strategy."

Fernandez tells you to consider that video content may attract even more attention than still images. He also says that your blog is probably still your best bet to create relevant content. "Don't forget to integrate that on your social media account," Fernandez points out, "and link it to your website."

## DEAL DIRECT

"What we are beginning to see," says Rebecca Hemstad, "is the realization that websites must work on *all* devices; it's increasingly becoming a necessity." Hemstad was originally an aspiring historian; she switched career paths when, as she tells us, "Computers emerged on the scene."

Her foundation is in print, but she embraced multimedia/web from the beginning, working on desktop software design, digital publications, web application design (and most recently mobile application design).

"But there is no long-term future in print collateral," Hemstad says somberly. "In twenty years' time, will you still be reading printed newspapers, brochures, magazines or books?" she asks. That, indeed, is the Final *Jeopardy* question. You supply the incredibly relevant answer (but bet wisely).

## CALL AND RESPONSE

Hemstad refers to an overall cultural shift to mobile computing and a general perspective that the field is, putting it mildly, in flux. This is due to significant technological changes and more importantly, cultural changes in response to that technology.

She tells you that this cultural metamorphosis means that marketing on the web nowadays no longer relies solely on traditional email marketing and web ads. And here, Hemstad also tells you that one of the biggest debates on the web—again, as I write these words—has been over the question of whether Google and Facebook will actually be dead in five years. And finally, consider this: paraphrasing writer Vincent Flanders, Hemstad points out that "Nobody cares about you or your site. Really. What visitors care about is solving their problems. Now."

# CODE IT BE MAGIC

WYSIWYG (what you see is what you get) web page construction is nothing new (see Lori Osiecki's comments earlier in this chapter) but, according to C. J. Yeh, computer-generated code is not clean and when you look under the proverbial hood, not technically efficient.

This I think is more of a professional conundrum for designers, but do *illustrators* need to learn how to code? Now, *there's* a discussion just waiting to happen. Educator C. J. Yeh tries to make it simple. "If you are an industrial designer who designs cars," he points out, "you are not going to be the person putting the nuts and bolts together, but you do have to have an advance understanding of how car mechanics work under the hood. Otherwise, you are just drawing pictures of a fantasy. Same thing with [programming], if you do not have an understanding of the technology, you are just drawing pictures.

"Learn programming," Yeh advises. "Learn a new way to think [visually]. Allow yourself to be inspired by the media as well as your craftsmanship. The Bauhaus Manifesto discounted any essential difference between artist and the craftsman—the Bauhaus Movement regarded the artist as an exalted craftsman, recognizing that proficiency in a craft is essential to every artist." And therein, Yeh says with a smile, "lies the prime source of creative imagination."

However, Brad Reed fundamentally disagrees with Yeh. "[Illustrators] absolutely need to know the code is there," he says, "have a general idea of how it works; understand there are options. But if you apply the same converse logic—what if the coders all learn 'to illustrate,' or 'to design'—where does that leave you, the illustrator or the designer?"

And the Bauhaus movement? "Legendary, and much revered, yes," Reed comments, "but it resulted in drafty, unlivable houses filled with furniture no one would sit in."

Ultimately, the inevitable predicament may not be about how much code you should know, but the real argument is, as Rebecca Hemstad puts it, about visual literacy itself. And as Hemstad also tells me, maybe the new literacy *is* code (and, as I say, however you find it).

# WEB PRESENCE: THE GOOD, THE BAD, THE UGLY

A big thank-you to two of our chapter gurus, Rigie Fernandez and Rebecca Hemstad, for brainstorming the following pointers for this sidebar:

## THE GOOD

1. Having a web presence means you can promote yourself without maintaining a physical presence. Your website, blog, Facebook page, Twitter and LinkedIn accounts work together to present a marketing tool promoting your brand and services 24/7.
2. Create a responsive website/portfolio. Make sure this site can be easily viewed on all devices (desktop, tablet, and mobile). Hemstad tells me she's even heard the argument for a responsive résumé.
3. Maintain a blog and promote your work; it adds traffic to your website and is a good outlet to practice your writing skills.
4. Be a social butterfly. Establish your own social media page and post useful, consistent, and fresh content. This material—and how you interact with your followers—can build your personal brand.
5. Network. Connect with other illustrators; designers, developers, marketers, and clients, too. Whether in social media or face-to-face interaction, network contacts can help you navigate the course of a tricky assignment, offer you a much-needed job (or refer you to someone who may need your services).
6. This is a real moment for the web. Seize the day. Rising statistics of Internet users show more opportunities (and work) for you. Of course, a lot will depend on your expertise and what you want to pursue.

## THE BAD

1. The web moves on a fast-paced track; if you can't keep up, you'll be left behind.
2. You have to be up to date and updating in an instant. Timely, yes, but also expedient. Think fast, faster, fastest—like it or not.
3. Appreciate cross-browser compatibility. Understand that the failure to thoroughly test your website on all browsers (and on different platforms—PC, Mac, tablet, mobile, etc.) is a fatal flaw in your master plan.
4. Keeping your eye on project timelines and the budget will be critical. Don't blow a deadline because your technology architecture is faulty (or you didn't allot enough time to fix bugs or other technical issues).

## THE UGLY

In reality, the following bits are not *so* fugly in the actual cosmic scheme of things . . .

1. Hemstad makes the point that today the terms web "sites" and web "pages" are fast becoming obsolete—what we are beginning to see increasingly is the design of web "systems."

2. Gaining web presence is all about *content*—what you post and the personal branding you want to promote. The savvy Hemstad wisely cautions, "It's about solving your user's problems. Remember—it's not about *you*."

   Your site needs to focus on compelling content, everything easily accessible through smart design and functionality (see below). Speaking of functionality: it's too easy to fall into the trap of producing a visually engaging website that reeks of poor web structure. An engrossing site needs to serve your content. As Hemstad says, "It cannot scream 'look at me, look at me—am I not cool? Am I not a cool illustrator? Don't you want to know ME?'"

3. Don't forget that a website is not only about visuals, but also about the user experience (read #2 above again, please). Any website that is not driven by user experience design principles is poorly designed.

   Good web design means a solid (and planned) information architecture, a user-friendly interface, and straightforward navigation. Brand/service must meet user experience head-on for serious communication.

4. It's a nonstop learning process. You not only need to learn how to create a website, but can you say plus spell—and fully understand—the terms SEO (Search Engine Optimization; for web, mobile, and social media); HTML5; SMA (Social Media Application); CMS (Content Management System), video, 3-D, etc.

   Traditionally bound applications—once only tendered as stand-alone desktop software—are now being delivered (with HTML5/CSS3) via the cloud. "This means we are going to increasingly see more and more sophisticated web applications," Hemstad says. "This is the future of software."

5. Accessibility compliance is becoming vital, and backed by legal requirements in many countries as well as for certain industries in the United States. Websites that fail to meet accessibility requirements are coming under more scrutiny (let alone, litigation).

# THE PORTFOLIO ONLINE

Ken Bullock feels that a great portfolio is right up there with a good work ethic, talent, and a love of design . . . yes, illustrators—a love of *design*. For Bullock, a designer and art director, the word "portfolio" means so much more these days than it did when he was coming up. As Bullock ponders, "When I graduated, a

portfolio was a bound (usually leather) book or case with a bunch of blackboard mounted pieces. These days when I am looking at an illustrator, I still want the book when they come to interview, but I want a web portfolio even more so."

Bullock looks for a URL on correspondence (including snail mail or email, a leave-behind or business card; résumés, too) so he can instantly preview what the illustrator has to offer and catch a sense of style and presentation skills. "I'm actually a little worried about someone who doesn't have a web presence of some sort," he says. "I think to myself, 'Really? In this day and age . . . you don't promote yourself or showcase your portfolio online?'"

Consider this for a moment. As a professional, you are all about image and promotion. Your ultimate charge is to make the client—the people, the company—look great. But your first mission is to make *you* look good. "You have to appear legitimate and professional. If you can't promote yourself, how can you help me do the same for my client or their product or service?"

These days it's so easy to have an online presence, so *important* may be too tame a qualification. "Having a web presence is a *requirement* today," Yeh sums it up. For more of the nuts and blots here, keep reading this chapter.

## SOME THING

"It isn't like it was years ago when you had to code, or slice and dice imagery," Ken Bullock says. "You don't even have to have web hosting; not with services like Behance, DeviantArt, ArtStation, Weebly, Wix, or WordPress (even something as simple as Snap-Fish or Flickr)."

Yeh recommends WordPress. Reed tells you to head over to Weebly or Squarespace. "A customized, personal URL is a nice thing," says Bullock, "but even some of the previously mentioned services allow you to do that for free. Having a web presence isn't asking too much from anybody." Here, Al Wasco says that having your own URL speaks volumes. "It may cost extra, but definitely pays to use your own, rather than 'something.wordpress.com.'"

## NAME GAME

Reed brings up the point that in 2014 a whole raft of new domain extensions beyond the familiar *.com, .net, .org,* and two-letter country codes became available to web hosts. Illustrators can now choose from:

*.agency*
*.cards*
*.gallery*
*.graphics*
*.media*
*.photo*
*.pics*, and
*.tattoo* (to select some of the more obvious ones)
"While *.com* will always be the commercial gold standard," says Reed, "these new top-level domain extensions open up vast new ecosystems for creative (and appropriate) web addresses outside the overcrowded .com space."

## THE ONLINE PORTFOLIO, STEP BY STEP

Just a preface: It made sense to me to introduce this topic in our previous Chapter 10, "The Portfolio," and expand on it for this chapter. Here's the detailed discussion, as promised.

## THE CRITICAL LIST

Illustrator (and designer) Mega and Al Wasco tell us that launching an online portfolio is a pivotal component of both your creative and marketing programs. It's an easy call: these days, a web presence is mandatory, a simple artifact of the modern *vita illustrativo*. However, let's not be too quick to assume the obvious, okay?

"Many illustrators don't pay attention to their website," Mega fills in here. "Some don't even have one! Big mistake. An online portfolio helps you promote your art, and brings in potential customers—often the first thing a future customer sees from you. Put up a slow, ugly, and messy website, and viewers may assume you're simply not serious, maybe even unprofessional."

Yes, you could use a simple image service (like Flickr, Instagram, or Pinterest), but to stand apart from the crowd of illustrators in the marketplace, here's some solid advice on creating an efficient, good-looking—and best yet, easy-to-find—website that will distinguish you from your competition.

## LIKE ROLLING OFF A BLOG

Actually, Mega recommends that you create a blog instead of a traditional portfolio. Why? Two words: fresh content. Let's say you have an online portfolio somewhere, and perhaps this is complemented by a social network where you interact with colleagues, friends and family, and hopefully clients, too. This interface is a good thing, but, according to Mega, not enough.

"How often do you update it?" Mega casually inquires immediately. "Be honest and critical. Ask yourself, if I saw your portfolio once last year, why should I return? Why do I want to come back? And if I don't come back, why would search engines, like Google, do that?"

The problem is that if normal, but obviously critical, viewers don't—or these all-important search engines can't—visit your portfolio regularly, you'll quickly be missing in action. And you do not want to become impossible to find.

## IT'S ABOUT THE CONTENT

The letters SEO mean Search Engine Optimization, and we're talking about the science of jockeying for the best spot (a.k.a. ranking) with search engines such as Google. And that's actually a good thing.

We'll conversate—I know that's not a real word, I just like using it in polite conversation—about inbound links, alt text for images, yada yada yada, later in the chapter, but Wasco points out that there's a lot of confusion about SEO since you'll constantly be bombarded by folks claiming they can get your site to the first page of Google. "I'd say that content, inbound links, and alt text are the most important areas under your control," Wasco says, "Pay attention to them!"

Also important are page titles, which should be unique and related to content, and the meta tag "description," which is what shows up as part of the search engine listing. "They may not be a big influence in SEO but definitely add to user-friendliness," Wasco says.

A word about those page titles. Wasco contends above that every page title should be distinctive (never the default "Untitled Page:") but also include common elements. For example, "Humorous Illustrations by T. Simon Katt," or "Editorial Illustrations by Max Fleishman, designer and illustrator, Enon, Ohio." "The idea is to accurately identify the specific content using potential search terms, e.g., 'Humorous Illustrations' and include your personal keywords (name, location, specialty, etc.)," Wasco says.

"By now most people should be aware that adding the meta tag 'keyword' and including a bunch of keywords is a waste of time," Wasco says. "Search engines have ignored this for awhile since people abused it by cramming tons of irrelevant keywords into each page. The meta tag 'description' on the other hand, may be the text the search engine displays below the link to your page (but not always the case). Write an interesting and compelling description of the page's content to lure people in."

Of course, offering a premier showcase of work that viewers will positively buzz about is the main key to success. "It should be obvious," says Mega, "that beyond the SEO, what your viewers want (and what your search engine must reveal) is great content—creating amazing art is your job; *that's* what people will talk about."

You want to give your beautiful work the best possible exposure you can. Thus, it's wise to learn a few basic tricks of optimization. Both you and your users will benefit.

Establish the proper environment to efficiently show off your material by learning good production habits from the onset. If your imagery loads fast and your pleasing site design boasts effective navigation, you control how your good work is seen. You'll be in the ideal position to shoot for a big, bigger—the biggest—audience. Read that: maximum exposure and repeat customers. Let's see how we can do that.

## A HOST OF DECISIONS

Start off by choosing the right web host (the place where you will store your website, sort of like the house where your blog lives). "When I started my own art blog," Mega remembers, "I didn't know about hosting, and chose a local provider. This eventually proved to be a bad move—ultimately too expensive and decidedly unprofessional."

Aha! Cheaper does not always translate to mean a bargain. Just as expensive isn't always better. But no matter the costs, nobody wants to live in a dilapidated structure. So how do you find the best host for you? Here are a few items to consider when choosing the right match:

1. It's not a bad idea to go with a big, trusted name. "Look for the heavy-weights," Mega says. "Mr. 'Big and Famous' didn't become respected and well known through sheer luck. Great customer service is vitally important and can't be underestimated. You want (and need) fast and efficient solutions—a host who will reliably help you solve the inevitable problems."

   Here, Wasco advises you to pay more, if necessary, for 24/7 live phone support, especially if you're new to web design/hosting. You probably don't need to be reminded that tech support can be agonizingly slow and frustrating, especially if your problem isn't fixed on the first go 'round. "There's no substitute for talking to a real person," Wasco smiles, "when it's 4 a.m. and your website is down for no apparent reason."

   Wasco also imparts a good test to try before you sign on the dotted line with a hosting service. Try to find the Tech Support phone number. "If it's hidden away somewhere," he says, "that's an indication they don't want you to call. Now when you've found it, call and see how long it takes to reach a human being. Ask some beginner question to see whether they're willing to help you or only offering gobbledegook. If it takes too long to reach a person, or you can't understand what they're saying for any reason, keep looking."

The more established hosts have built solid reputations over the years only through superior customer service. This reliability translates to user satisfaction. Everything is hyper accelerated in our Internet era; if a provider's products or service are bad news, there *will* be talk—fast, deadly, ubiquitous—and it will catch up with potential buyers. It's a pretty simple math, so keep the above equation in mind: do your homework to narrow your field of choices.

Look for chat support, too, and do the same experiment there—try to see if you can get answers quickly. "A good host will have a great chat support," Starnes says. "It may be difficult, but see if they can speak and understand English efficiently, too!"

2. The aforementioned "house" you're building needs a substantial foundation (a good server), solid doors (security), and a waterproof roof (as in spam free). "And you want to be able to repair your plumbing (infrastructure, general settings of the website like redirecting a page) if needed," says Mega.

And let's mention that you need those pipes (and any ductwork) to work smoothly and productively. In other words, your site should run fast. Downtime or slow run times most likely point to server (mis)management. There's not much you can do about that, but the unfortunate outcome will be disgruntled, impatient viewers who may never come back. A way to prevent this is to hitch up with a trusted and reputable host with a proven track record.

It's also to your advantage to see how much you can add on to the site if you need it. Some questions to consider: Does the host offer SSL (secure hosting). Reed emphasizes the importance and protection of an SSL (Secure Sockets Layer) and brings up the hackability of non-SSL sites. Do they offer e-commerce solutions that you can add later? Do they offer email; and, if so, how easy is that to add on?

3. Be a savvy shopper. Reliability, tech support, and cost are the most critical issues. Don't worry about how many email addresses you'll get. "A handful is seriously all you'll ever need," says Wasco. Don't covet oodles of disk space. "Unless you plan on uploading hundreds of large images, zillions of gigs are unnecessary," he adds.

Good hosting need not be expensive. It bears repeating: expensive doesn't necessarily mean better; and cheaper may be too costly in the long run. What you'll find is that reasonable, quality service can certainly be found (and the research here worth all the necessary time and effort).

At this exact writing, I have been able to find great price breaks for excellent hosting packages. This money spent should get you up

and running quickly and efficiently. The companies I researched—and there were many—reviewed well and boasted strong reputations. They offered valuable services, good customer support, and the abilities to grow with you.

## BUILDING YOUR BLOG: THE RIGHT STUFF

You found the perfect host. Time to create your blog and upload killer content. Keep these tips in mind:

### 1. Smarts

Starnes leads off with this simple, but absolutely critical piece of advice: "Keep your hosting info in a safe place, and be aware of updates and renewal times."

### 2. Keywords

When choosing a URL, create a catchy, short and indelible URL by using memorable keywords that best describe your activity, in the right position. "Put the most important term first," Mega advises. "Then the second, etc."

Wasco tells you to try for something that's easy to spell—a seemingly simplistic but intrinsically perceptive thought. "Imagine telling someone your URL over the phone," he elaborates. "You want it to be absolutely straightforward: easy to spell—and remember.

"CuyahogaValleyNationalRecreationArea.org, for example, is a tricky mouthful, and CVNRA.org is eminently forgettable," Wasco rightly states. "Instead, they use 'dayinthevalley.org'. It's easy to remember, easy to spell. By the way, Cuyahoga's URL redirects to http://www.nps.gov/cuva/planyourvisit/events.htm—which of course no one would ever remember handily."

### 3. Domains

The preferred domain here is obviously .com. If you can afford it, Starnes suggests that it's wise to spend the extra bucks to get other "default" domains. Consider a .org site, as well as .com, and .net domains, too. "They can point to the 'real' site," he says. "This protects you from others buying these domains later and sending your users to bad or competitors' sites."

But Mega cautions against .net and .org if you want to target a global audience. "Most people assume that .com is the place to go," he points out. "Don't lose them. To achieve a good position with your country name, buy both (i.e., .uk and .com)."

Sifting through the points and counterpoints, both Mega and Starnes are saying to use the appropriate domain extension. A regional domain suffix address (one that ends with .fr, for instance), according to where your activity is located, is okay and will make your blog easier to find in your own country.

## 4. Naming

Be distinctive, but it's still best to choose a simple name. "Set yourself apart," says Mega. But keep in mind that hyphens and numbers may be hard to spell (or keep track of and remember), and terms like top or best are too generic. There's no real advantage here.

Check to see who is using similar domains already. Why? If a user mistypes your URL, what will they see? "You don't want to choose 'cmm. com' as users may go to 'cnn.com'; it's simply too hard to hear the difference if spoken out loud," Mega says.

## 5. Platform

Now choose the right publishing platform. There are lots of fine and favored choices (Weebly and Squarespace come to mind. Tumblr and Instagram are hot with illustrators interviewed for this book.)

Just a note: Mega prefers WordPress. Starnes likes WordPress, too. And, obviously, Mega's tutorial here is based on his best professional practice, his long work experience, and, yes, personal bias. Many of the web designers contributing to our sister title, *Starting Your Career as a Graphic Designer*, use WordPress. But you have other great choices out there (and you don't have to be a web designer to create solid, exciting content with these tools).

We're not saying that you *must* use WordPress, only that Mega does and he eloquently talks his walk. So, about WordPress and its bandwidth of brothers . . . WordPress, and any platform mentioned or suggested, are not unequivocally, universally loved. Every platform may be widely admired by a legion of fans, or panned by an army of critics. All the platforms we're discussing—WordPress, Weebly, Squarespace, Wix, as just worthy examples that come to mind—are flexible, good looking, feature-rich, and competitively priced. They are updated and maintained regularly; simple, user-friendly and cross-platform (meaning they look beautiful on desktops, laptops, iPads, and iPhones or other smartphones), and even on your TV.

### TAG, YOU'RE IT!

Roger Starnes suggests you consider the differences between labels. Tags in question are "platform," "solution," or "service." "One may see 'platform' as the server," Starnes says, "For instance, LINUX or APACHE, or the software it runs on—such as PHP, ASP, dotNET, etc. Others see 'solution' more as WordPress, Joomla, etc."

### 6. Download and Install

Download and install your chosen platform on your server. It will probably take only a few minutes; you won't need to be a technical genius. At this point, we should make a strong case to learn and fully understand your chosen platform.

For instance, if you go with WordPress for your CMS (Content Management System), when you log in for the first time, you'll encounter the Dashboard, which is the place where you track your recent activity, manage your visitors' comments, and create content. You will see sections called "Posts" and "Pages." What's the difference between these? "A post is an entry on your blog," Mega instructs, "where you talk about new artwork, a new exhibition, or other daily news. A page is something static like the 'About me' section."

It's also wise to note that good hosts should offer a "Quick-Install" function for adding WordPress (or Joomla, etc.). Don't forget that these programs will require the host to support that solution, and perhaps require a content database with user name and password. And, as Starnes cautions: always keep that login information handy.

### 7. Choose a Theme

A "theme" is the basic look of your blog. Choice and variety are the name of the game on all worthy platforms. WordPress offers seemingly millions of themes created by users. You can fashion your blog (or site) pretty much any—or exactly the—way you want to, but Mega wisely cautions you here.

"Hold on, don't go crazy," he says. "While there are a lot of themes available, stick to the basic, default option. You don't want to put a Ferrari in your garage when you don't know how to drive it. It might sound cool to have a fancy car, but what about in the future— when you have to replace a wheel nobody sells?"

In WordPress, Mega and Starnes advise you to start by checking if the current default theme fits your needs. A theme created by WordPress (WP) means they'll fix any potential bug, update it frequently, and that it is secure and built on solid code.

### 8. Select Your Plug-ins

A "Plug-in" is a tool created by a user that offers something extra for your blog (like a badge or action). In WP, Locate the Plug-in section of your Dashboard, and then click the "add new" button; it's pretty simple.

Putting it mildly, a wealth of plug-ins are available, but once again, stick to the basics. Plug-ins present a ton of potential features, but you won't need most of them. "Plug-ins will make your website slow and messy," Mega says. To name only a few, he recommends, "*WP Google Fonts* (an easy, simple, and efficient way to choose a great font for your blog.

Your blog can look pro without complicated coding); *Digg Digg* (so visitors can share your content on their social network); *FeedBurner* or *FeedSmith* (which create an RSS for your blog); *Google Analytics for WordPress* (which allows you to see how many people visit your blog every day); and the best plug-in on WP: *WordPress SEO*—the perfect SEO solution to help you check your content and much more. A must-have."

"*Akismet* and *Captcha* are good plug-ins as well," Starnes adds. "Both help users reduce spam that will come with any measure of user attention."

**9. Get Organized**

Your blog should now be ready to rock and roll. Here's a good thought about structure and navigation: choose your categories and tags wisely and properly. Consider the following suggestions for choosing your categories and tags.

A. Define your categories. For instance, in WP, categories mark the sections of your blog (e.g., a "Logo" category, a "Poster" category, etc.). "Stick to four or five categories," Mega says. "Don't create a new category every week because it will confuse visitors. Future content should be relevant for each one of those categories." A little tip: Add a keyword in the name. Use labels like "Fleish Business Cards" instead of simply "Business Cards." "This will add a tighter focus," says Mega.

B. Tags are complementary information. Search engines rely on your categories and tags to define your page content. For a "Poster" category, a tag could be a sub-category like "Music."

"After publishing posts, you'll have a selection of tags listed in the 'Choose from the most used tags' somewhere," says Mega. He advises you to stay with this automatically generated selection instead of creating new tags. Having a "Logo" tag and a "Logos" tag creates two lists of posts for the same topic. "Be specific: choose 'Logo with paintbrush' instead of just 'paintbrush.' Go to the 'Tag' and 'Category' sections in the Dashboard and add relevant and precise descriptions for each element."

**10. Organize Your Content**

You obviously want to create successful and compelling content. On a blog, new content is called a "Post." The common mistake is to upload a lot of unrelated content at one time. The result is a messy portfolio that visitors have a tough time figuring out, which is also indecipherable for the search engines. It will sound like a lot of work—and to be honest, it is—but follow these recommended practices to ensure optimum results. Every time you upload new stuff, you should do the following:

A. Come up with a descriptive title. Instead of "Cool New Designs," go with "New promo for the TV show *Ancient Delaware Cook Pot*

*Roadshow.*" Viewers and search engines should easily understand what you are talking about.

B. Tell what the post is about. Begin with "I designed this promo for a PBS Television special that examines long-buried cooking utensils accidentally discovered on farms near Milford, Delaware."

C. Do the same for the "ALT TEXT" associated with each image. "ALT TEXT" describes the image for visitors to your site who can't see. Your alt text will be read to visually impaired people and, equally important, will be used by Google and other search engines for image searches.

"Most of my Google-based traffic on my own website (www.theview from32.com) comes through image search," Wasco says. "Good, descriptive alt text is critical."

D. Make it enticing so that I want to read your post. Highlight important information and organize style and content with bold and italic emphasis.

E. Don't be too brief. Explain why I should care—who, what, when, where, why. Mega will tell you to write at least three hundred words of relevant information in every post.

F. Use relevant words or phrases people would search for in Google (but keep a natural tone). Use proper grammar and spelling, not slang.

G. Be polite. Be unique. (Credit images you borrow. Never copy and paste content from other blogs, but if you do, cite your sources and always credit images and photos. Stealing is a no-no.)

## 11. Quality Control

"Quality content is everything," Mega tells us. "Create at least two new posts per week. There are no secret strategies to attract visitors and rank well in Google. Interesting content is the most important aspect of your online success."

To which Wasco adds, "Don't try to make it 'cool' or 'high-tech' unless that's your area of expertise." To which I would throw in, think substance before flash. Relevant content trumps pure razzle-dazzle every time.

## 12. Optimize Your Imagery

"Not too large, not too many. Not too heavy, a proper title, captions, and tags," says Mega. But how large is too large? "That's tough to say," Wasco joins in. "In most cases an image roughly 600 × 800 pixels should be fine." In regards to file size ("weight"), Wasco tries to keep imagery from 100–500 kilobytes. He cautions that folks must pay attention to optimizing their images, and choosing between the JPG or GIF formats can make a huge difference in both image quality and file size.

"Remember that even though we assume fast Internet access [is ubiquitous]," Wasco says, "work to keep file sizes as low as possible, in order to

keep your site fast. Sites that are slow to load will annoy the hell out of visitors, and if you have a lot of images on a page, this can be a real problem.

"Some people go all GIF or all JPG," Wasco says. "Big mistake!" Why so? The play is to experiment and evaluate which file format works best for each individual image, as there can be dramatic differences between the JPG and GIF (and PNG) formats. (Hint: Photoshop makes it simple; you can fool with the "Save For Web & Devices" command and explore multiple formats and sizing easily.)

Starnes has a problem with a "use all" method for imagery. He recommends users go with the most appropriate image format and stick with what works the best on all devices and browsers. "There are places where a 24-bit transparent PNG is ideal," he points out, "but it results in a larger image size and older browsers [or] users may not be able to see it."

Along those lines, when using the JPG format, the quality ranges from "0–100" (sometimes shown as "0–12"). Wasco tells us that he has optimized thousands of images and has found that for most images a setting of 50–60 (6–7) is more than adequate. "Using a higher setting yields larger file sizes with little or no visible difference," he states. "Multiply this unnecessary increase in file size by dozens of images, and your site can slow down."

"When using Photoshop," Starnes instructs, "users can see the preview of what the image will look like for each image setting. If the image is starting to blur or distort, consider using a higher setting."

"Many hosting platforms will automatically optimize your images as you upload them," says Brad Reed, "creating large, medium, and small versions to be used as appropriate, based on your audience's browser and bandwidth. Yeah, they can tell."

"Viewers don't want to wait around for your huge website to load on an iPad with their data plan expense," Rebecca Hemstad adds, candidly bringing to your attention that "you will not be that important to them."

## SELL IT, BABY!

So it's time to tell the world about your portfolio. Here, Mega and Wasco weigh in on promoting your blog. While the two designers are not in complete accord, they still offer a pertinent overview and solid, valuable advice. Let's hear them out.

1. Mega says that, whatever "SEO experts" tell you, links don't matter (much). If you create quality content, you will get a good ranking. He cautions you not to obsess over links. By that same token, don't exchange or buy links. "If people enjoy your blog, they will link to it; it's that simple," he states.

   But Wasco disagrees. "You have to work to be found among the millions and millions of sites out there. My website typically gets

sixty-ninety visitors per day, and a link from a hot site will instantly ratchet it up to 800 visitors (or more).

Wasco does tell you to be *selective* about asking people to link to your blog. As he instructs: "Find the best illustration sites and contact them with a brief, personal email asking them to look at your work and link to it if they think it's valuable."

2. According to both guys, it's smart to get natural inbound links (links pointing to your blog); to find applicable outbound (links to pertinent external sites) links; to cite appropriate reciprocal links; and to create internal links to your relevant previous posts.

3. Both Mega and Wasco will tell you to share and promote. Use social networks, related forums and websites, and share every post you create on your social networks. Create a newsletter (for instance, on www.MailChimp.com). Don't put your link on unrelated websites. Spamming is bad!

4. Both gentlemen think it's a good idea to add your website URL to your email signatures.

## POINT/COUNTERPOINT

Wasco suggests you knuckle down. "Work at it! Find the sites you like and contact them. With a little luck they'll link to your site." Wasco tells you to post links to great illustration-related content, then contact the creator of that content (designer, writer, artist, whomever) and tell them. Obviously post great content on your site, but write about illustration, as well, then send links to your content to those other great illustration sites. "There are so many illustration sites out there," Wasco says, "you *must* actively let people know about yours. In the real world, networking is critical. This is simply online networking."

But Mega says to sit back and relax. "If you create good content, they will come. Don't give up! Your blog will not gain a good rep in one week. You gain trust once it has been around for a while. Hang in there—popularity and authority loom large at your doorstep."

# THE NOW

As Yeh will tell you: digital is no longer the future. It is how *everything* is done now. It's probably a no-brainer that the market is saturated with young illustrators who have grown up on the web, with some kind of a device in or on hand. If their education was spot-on, however, these illustrators should know how to do both digital *and* print. It just makes strong sense that young illustrators looking to break into the industry would be smart to show what they can do on any platform.

But what Yeh and his colleagues hear is that, based on portfolio reviews, there is too much focus on struggling platforms (e.g., posters and publication)

and not enough on new media. They are told that digital work and a corresponding, practical education for a digital world is deemed crucial; that [gearing up] for the web is seriously important; that a lack of web smarts in a portfolio gives the distinct impression of an incomplete submission.

"Clients are looking for illustrators who know the web," Yeh says, "this will give your best shot in today's marketplace."

# NOT FOR WEB DESIGNERS ONLY

I gathered this information for *Starting Your Career as a Graphic Designer*, but I found it relevant for illustrators, and I hope you will, too.

Right off the bat, if you were primarily a web designer, you'd surely be using current industry best practices in design and coding. As of this writing (2016) the hot buzzword is "responsive," meaning that the best websites automatically adapt to different devices: desktop, laptop, phone, tablet. Your illustration must dovetail into this construct, too.

"Simply being able to discuss this will help your cause," Wasco says. Not to mention, being able to implement the mechanics. Stay with this: (A.) Wasco suspects that in a couple of years designers will need to design every site for *touch* since more and more people are accessing the web with phones/tablets. (B.) At that point, designers don't—or won't *have* to code, but it stands to reason that if they have a solid understanding of HTML and CSS, these designers will decidedly be more employable. (C.) The trickle-down theory postulates that if *you*, the illustrator, know how to work efficiently with these designers (and for this content), *you* will decidedly be more employable.

*Dreamweaver* would be the current software of choice for the Web and you may want to consider this—or similar software—for your skill set, too. Designers who can *only* create a website with *Dreamweaver* are less valuable to most employers, but that's not your problem. Good tools are not only useful, but fun. As it says on the comic book ads: collect them all, tell your friends.

You can also explore web fonts to create beautiful typography. Check out font services, such as Typekit, Fonts.com, Font Squirrel, and Google Web Fonts. A *relatively* recent (it's actually been around since the '90s) technique—called a *rule*—that you should be aware of is @font-face. Look into it; @font-face may be particularly helpful to tap into "web-safe" fonts.

By the way, this whole shebang comes with controversy and politics. Type foundries (font creators) have an issue with @font-face: the basic conceit—the logic that governs the concept—is that font data would be free to download. No DRM (digital rights management)! Ahoy, matey—can you spell the word *piracy*? Web designers want easily accessible fonts that legally, and shall we say, economically, don't bust EULAs (End User License Agreements). Yo, bud—can you spell the term *trust*?

## PLAY = WORK

There's much involved in art and design outside the digital medium and Gerald D. Vinci is much the creative pragmatist. He sees digital design as just one extension, one arm with which to communicate an idea. He will tell you that an effective digital designer needs to be well versed in *all* areas of digital design; that you cannot—or certainly should not—function as *only* a digital designer. I think this is also the vantage point for illustrators working in digital media, too.

1. I'm going to suggest that your process starts by playing with your toys. Understand and become familiar with all types of display devices that could potentially display your project. Illustrators (and designers, too) often spend too much time focused on creation and do not play around with the end product as much as they should.

2. Next, you offer full service, which, to my mind, means you develop a diverse skill set.

3. Get help when needed. "When learning or adopting additional skills is not possible," D. Vinci says, "partner up with a reputable colleague who can help offer this skill set."

4. Research. "Spend at least an hour a day educating yourself on the latest technology, products, software, tools, and techniques," D. Vinci says, "this will just lead to more services or features to add to your bag of tricks. A note: Hemstad advises you to continue this important practice, even if (or after) you are employed and even if it means nights and weekends. She does her research on her lunch hour.

5. Illustrate responsibly. Keep the project focused on the customers' needs and expectations. Always think about UI/UX (user interface/user experience). Digital design is more about form *following* function as opposed to form *over* function. Illustrating for digital design must serve that purpose, otherwise the end user will be disappointed.

6. Network and contribute. "Establish a strong network of peers you can bounce ideas and projects off of," D. Vinci says. "Having an unbiased group of professionals who can help you weed out good or bad ideas can be a lifesaver when you are stuck on something. Don't forget to contribute to this group so they won't think twice about helping you when the time comes."

7. Adopt forward thinking. Plan. Your illustration must conform for the device or devices displaying it. Think ahead, because certain devices that are *not* displaying it now might be soon.

8. Remain in circulation. Continue to embrace and educate yourself on the latest technology, software, techniques, and methods out there.

9. Pay attention to what others are doing to stay current.

10. Educate your clients. "What makes the most sense for the project?" D. Vinci asks. "State your case with the customer's best interests in mind. Show them."

## FLATLINE/FLAT OUT

It should be said that the whole UI/UX thing is a hot corner of the playing field. And take note of a rather hot spot of that warmy warmy corner, trending at this writing: the prolific rise of *flat design* to enhance the user (or call it human) interface.

The move toward flat design is the direct counterpoint to *skeuomorphism*. Skeuomorphism design assimilates the textures and evokes the look and feel of the object rendered. You know these. Digitized versions of rich, stitched leather-bound volumes on a sleek, oak bookshelf, or a calculator with raised backlit buttons that appear to depress, are just two of the usual suspects.

The movement toward stripped down flat design focuses on clean and smooth: pure color; simple icons, lines, and shapes; basic type—a straightforward, minimalist utilization of UI elements. We're back to essentials with the accent on functionality: no embellishment, no conflated 3-D.

They say a new car depreciates drastically as soon as you drive it off the lot. And just like that, flat design, it is argued, is now passé. Well, that was fast. "What it comes down to is addressing user needs," Hemstad says. "Designing a site to meet the hottest and latest thing won't work. The content is all about solving user problems. Illustration should serve the content."

## THE TOOL

"Ahh, the Internet," says Mikkel Sommer, "it can seem intimidating at times: all those images, all the hundreds of illustrators online, locking horns. It's hard to maintain a visual identity and a style when there's such an aggressive flow of information and images passing by us every day.

"Likewise, I'm sure social media works for some people. However, I feel it would steal too much of my time, and pull some focus away from the actual work itself.

"But of course, the Internet is an incredible tool for illustrators today," Sommer says. "To network. For inspiration. Getting your illustration out there. Just about all my work comes off my blog or website, or someone seeing a link to my illustration somewhere. I've also done many illustrations and short comics that were just for myself. They are all online, and not in print. This is what got me started in the first place."

# ❝ ON THE BOARD

## (PROFESSIONAL VIEWPOINTS IN 50 WORDS OR LESS)

Online portfolio sites, image-sharing sites, and social networking make it both easier and harder to stand out from all the other creative folks out there. Technology has helped sites offer just about anything. It's a great opportunity for artists to make money from their images.

—Julia Minamata

Social media—Facebook, Twitter, Google+, LinkedIn, Pinterest, Tumblr, etc.—are now tapping into millions of customers out there.

—Rigie Fernandez

I only have my web site now. I no longer have a portfolio.

—Peter Arkle

I tell my students who are doing online portfolio sites not to include "everything and anything." Express the essence of your personality but remain professional. Focus on showcasing your capabilities to solve problems. The play is not to overwhelm. Provide enough to get invited back.

—Rebecca Hemstad

© Don Arday 2016

© Mega 2016

Prune your site so it represents the best of what you do (everything else can go onto your blog).

—Avram Dumitrescu

Embrace social media, put yourself out there, be somewhere where people see you and know you. I see my colleagues less than I did before the Internet, but I communicate with them much, much more.

—Brian Biggs

© Penelope Dullaghan 2016

# Section IV
# To Market

# Chapter 15

# Sequential Art

---

*Hey Kids!! Comics!*

–Blaring out from signage atop spinner racks!
USUALLY IN ALL CAPS! With lots of exclamation points!!

## ART IN SEQUENCE

As you've been reading this book, you've heard numerous professional testimonials about how the general field of illustration has been changing. Comic books (as well as cartoons, and comic strips) are certainly a specific venue witnessing a remarkable metamorphosis clearly making that point. They just don't make 'em like they used to? Well, they don't.

In some circles, the terms *comic book, cartoon,* and *comics* may still be considered lowbrow. The phrase *sequential art* was coined by the eminent Will Eisner in 1985. Eisner is the veritable father of the *graphic novel* (another tag elevating the cachet of the ostensibly humble *comics* or *comic book*).

Designers might say that comics, cartoons, and comic books—sequential art—is an angle tacking more toward illustrators. On the surface of it, I tend to agree. But actually there's a @&#%! load of design involved: cover, page, and typographic design; characterization (character design) and color styling; illustration style and technique, plus visual treatment. And while not under the design umbrella per se, writing and editing—integral and inextricably linked to the comics design process—must be mentioned here, too. *Shazam,* y'all.

We'll do a decent analysis here, but one chapter won't begin to do this marvelous topic justice, true believers. Please dive deeper into the pool of graphic novels, comic books, and comics for yourself. I also have some other reference to recommend later in the chapter.

## FUNNY BUSINESS

There was a time when cartoonists and comic book artists had a rather specific venue—print. You had what was tagged "the funny pages": newspaper syndication, comic books (obviously), magazines, and then zines and self-publication. You were faced with intense competition and limited, though I wouldn't say *limiting,* options.

The rise of the Internet and webcomics as a medium changed all that (uh, maybe not the intense competition bit). At this writing, print is not yet dead. And in fact, it could be said that print comics are actually *thriving.* Flourishing faster than a speeding iPad, more powerful than the locomotive of digital media; able to leap tall measures of quality and quantity, print sales seem to keep heading up, up, and away.

While we certainly want to point you down the right digital path, we also want you to practice some positive, big-picture, splash panel–style positive thinking. Can you say *crossover,* boy wonder? Let's predict the success of your webcomic and visualize the great demand for all those eagerly anticipated print spin-offs of your wildly popular work (books, calendars, posters, greeting cards, etc.).

At least, for now, it will be prudent to design simultaneously—and establish a workflow—for print *and* digital (and in that order, print *to* digital). As you produce your hard copy image, routinely convert the design to digital. No redraws; no bulk scanning saved for a rainy day or slow week. Safely store and organize hard copy and electronic files for easy access when you become the queen (or king) of all media.

## THOUGHT IN ACTION

Do students not want to think? Now there's a concept for you. The study of concepts doesn't feel natural at first. Metaphors, patterns and systems, subtext; hidden and second meaning—it's a lot of work. No doubt, there are extraordinary illustrators who are incredible technicians but prefer to simply have a concept handed to them.

"That's a nice job if you can get it," says Tom Garrett. "However, practical students of sequential art (and any genre, for that matter) should be aware and fully understand that form plus interpretation plus structure *work together.*"

### FROM SCRATCH

It's this heavyweight collaboration that enables the illustrator to scratch off the glossy veneer of the "pretty picture" and expose the grit of a truly enabling work.

The concept piece, to Garrett's mind, originates with Magritte. "Take unrelated elements," he says, "add two metaphors or symbols, now put them together to actually communicate something far better.

"The roots of the classic op-ed is here; how you take one simple thing—your basic tree, a rudimentary maze, whatever—and how you spin that into a narrative thread, a story line, an emotional thread . . . what values are expressed?" Garrett says quizzically. What are you tapping into?

"When people use the word 'concept,' they're not saying 'this is a technique I'm using,' they're asking 'what are the feelings, the messages, the underlying sensibility of that?'

"It could speak to a story, but concept doesn't have to shout out 'Look at me—I'm an *idea!*'" says Garrett. "Concept can be all about subtleties and all over the nuanced relationship between, say, color and emotion."

## THE BIZ

How and where to break in? True, at this writing, the newspaper industry appears to be in dire straits and newspaper syndicates are faring no better. (Again, we can blame or applaud the Internet for this game-changing business model.)

But currently, *there are still newspapers*—traditional and alternative—as we know them. So, yes, stay the course; one can still submit a cartoon feature to the syndicates (or self-syndicate) the "old-fashioned way."

Traditional print comic books are exceptionally viable; and the path to publication remains equally established. Here, the same o' same o' remains operative: you submit to publishers (note: small presses here may be the way to go); you schlep your stuff to comics conventions and book shows; you network with pros. You promote.

Web comics have busted out: self-publishing is enjoying a true renaissance—create and post your own comic. Do some research; you'll find comics creators (or hopefuls) discussing the importance of building a fan base and reputation online as well as cultivating interested, and interesting, European markets. Comics have always been big the world over.

Approach the online syndicates, those digital sisters to traditional newspaper syndicates. There are organizations dedicated to the webcomic venue, and news and networking forums are mere clicks away.

As with traditional print comics publications, the basic legwork mentioned above remains the same. Do consider advertising. Think about possible merchandising. Don't forget copyrights—officially registering your work, not just posting © notification. You get good; you get known; perhaps you'll get a distribution deal.

The debate over competitions remains in full swing or you could enter contests, if you're of this mind (but please read our earlier chapters for more about all this). And, of course, while it's never been easier to promote and market, getting noticed and making a living at all this—via any route—may still be a job for Superman.

## WHAT A KICK

"If we're talking about self-publishing, we should mention crowdfunding again in this chapter," says Lea Kralj Jager, an illustrator and animator from Zagreb, Croatia. "For instance, Kickstarter . . . Most of the 'self-published comics' are stories that have been alive on the Net for some time; fans want the physical copy of it and are ready to chip in and fund publishing.

"It's also important to note that a crowdfunding campaign gives the public the chance to *participate*. The Internet made it possible to interact directly with the author, and people like to get involved with what they love."

# MCCRANIE

Bryan Ballinger recommended I talk to illustrator Stephen McCranie. "He's a young guy, but pretty dang wise beyond his years," Ballinger says. "He started doing these inspirational comics about being an artist and releasing them regularly. And they are good."

So I checked him out—and you should, too. McCranie's *Doodle Alley: Comics That Nourish* deftly lives up to the promise of its subtitle. Beyond his nimble drawing chops, one of McCranie's strengths is that he cleverly taps into some basic truths about the creative life. And he built a following by consistently releasing web content that was rooted in a few simple statements: "Find what is true, good and helpful," McCranie says, "and then make it easy to access, pleasant to consume, and simple to digest. That's my mission."

McCranie packaged his web comics into a graphic novel and did a Kickstarter, which earned enough money to allow him to keep making more graphic novels and do more stories, full time.

"Prior to that, he did a web comic series called *Mal and Chad,*" says Ballinger, "and did that diligently and regularly." *Mal and Chad* was ultimately published by Philomel (an imprint of Penguin) who commissioned a three-book series. "And Scholastic eventually carried the first two books in their book fair," says McCranie.

## IMPACT

The title of McCranie's new comic essay project is *The Art of Impact—How to Be Heard in an Age of Noise*. McCranie became excited when he realized that found within the logo title head he designed is the word 'Heart.' "Which, coincidentally," says McCranie, "is a huge concept in the book—the idea that all our actions flow from our hearts and can be explained by what's in our hearts."

Indeed, McCranie's work has *a lot* of heart. The focus, in McCranie's words, "is to create comics that nourish. I can't prove it, but I do believe that truth exists out there—and my goal is to find it and share it." This outlook informs all of McCranie's comics, both nonfiction and fiction. The comic essays he writes are his chance to relate his core concepts with openness and precision. "I don't get a chance to be so precise with my story-based comics," he says, "but it's still just as powerful a chance to say something important.

"Essays describe ideas, stories make you feel the ideas. I have an extensive process of collecting ideas—when an idea sticks out to me, I'll write it down somewhere to keep track of it. Then later I'll revisit it . . . if it's worth remembering, I'll make it into a flashcard and quiz myself with it and put it into my long-term memory."

## NOISE

"We live in an age of noise," says McCranie. "Everyone has become a broadcaster, an advertiser, a self-promoter, and so it has become increasingly difficult to stand out." McCranie's *The Art of Impact* delves into how to be heard. But in this age of viral social media, how does one do that?

McCranie feels that social media is a double-edged sword for cartoonists and illustrators. He tells you many people think that social media is a perfect filter for content, but that, as your friends actually, but indirectly, decide what you see, you are more likely to only (and ostensibly) see "something good."

"The problem," says McCranie "is that social media doesn't necessarily spotlight 'good' content, it only and always spotlights *viral* content. Those things aren't necessarily the same thing. If you're an artist and you create something beautiful, it might not float at all in the social media ecosystem. I think the trick for artists these days is finding a way to give their work a hook, something that makes people want to share or click on what you've made."

But then again, if you're an artist and you create something beautiful, it might not float at all in the social media ecosystem. "Sometimes beauty contains elements in it that are not viral," McCranie says. "And certainly, in today's social media ecosystem, viral content will always find you, but not necessarily important content."

## THE COMICS GIG

*Gatekeepers* are people who decide who gets into a network or platform or business. The gatekeepers are still around, and they are still necessary for some industries, but for comics and cartooning, their role has been redefined.

In my conversations with McCranie, we spent some time discussing the comic book gig; how cartooning was totally different for artists. This, certainly, five years previous; definitely, ten years back; and, dramatically, twenty years ago. "Some cartoonists had a hard time adapting because they worked for twenty years in a different system," McCranie says. "It's hard to change after all that." By that same token, if you were simply a player in this field 'back in the day,' making a go of it in that environment was a different proposition.

Newspapers, at this writing, are folding left and right, and, as a result, traditional comic strips (and cartoonists) have started disappearing. "Cartooning as a job," says McCranie, "has changed drastically. However, good *content* has a long shelf life," he comments.

"And you know, the Internet has also basically gotten rid of political cartoons," McCranie says. "In my observation, there are a lot less political cartoonists around these days. When was the last time you read a political cartoon online?" he asks.

**"The thing about the medium of the newspaper was that it brought together both sides of a debate,"** McCranie says. **"A political cartoonist might draw something you disagree with, but you couldn't click away or anything—you read it because it was there. In the 'good ol' days' a political cartoonist could publish a comic and have it stay relevant for a few weeks; it took everyone a while to hear the latest news.**

**"But now, we only see content that is viral,"** McCranie says, **"clickable content we agree with. That's because we have such good filters set up—you [essentially] see only what your friends see. And nowadays, news updates so fast, it's hard for a cartoonist to comment on anything without their comic's shelf life expiring *in minutes*.**

# JAGER

"Modern comic authors are using the digital platform in a way to make their comics animated and cut that extra edge you can't get in print form," Jager says. "The 'kids' these days are brilliant at pushing the envelope and finding new ways to express themselves.

"But if you're trying to have an Internet presence, have it—don't half ass it," says Jager, who has much to tell you about the importance of not giving up, and sticking to the story *you* want to tell and being consistent. "Don't worry if you're original or good enough, just work," Jager says, "you're the only one that can tell that story in that way.

"I have a feeling I'm channeling my inner Neil Gaiman with this right now," she says, "but I know many people give up on their web comics because they don't get a large fan base in a short amount of time. They get the feeling they're pretty much screaming into the void while their 'neighbors' get recognition at an eye bat (something that's not true at all).

"The worst feeling one can get when putting stuff online is that you're talking to yourself. But this simply falls under the general auspices of 'getting started.' All the good authors I follow started small but kept on pushing, and it led them to where they are now.

"Be ready to invest all your working hours into it," Jager says. "Don't expect to make any profit for at least the first year or two. Honestly, these odds make it easy to quit, but *if you want it* you need to persevere. Web comics can open a door for you professionally. Your online work gives a potential employer or publisher a look into your work ethic and gauge how much you desire to work in the field.

"Make it for yourself and do it as best as you can," Jager says, "you will get better with time; your hands will loosen up and follow your mind all the better.

As you do it, people will notice and start following you. Don't lose your faith, simply keep working."

## TROLLS AND ASS HATS

Jager's tenure drawing comics for the web was predominately positive. She is an enthusiastic evangelist for the format, but is also aware of a troublesome weak spot—what she labels "the bad side of web comics"—but fortunately, this has been largely secondhand.

Jager's own comic has been online for some time, but she put this work on hiatus to direct all of her time into finishing college. "Here, to graduate from the Academy of Fine Arts as an animator, you need to make an animated short," says Jager. "That takes *a lot* of time and work, so it doesn't leave much time for anything else."

Jager deems her own experience just fine; she found an audience and plans to continue the story at a point in the future. "My readers were awesome," she comments. "But saying that, I've been exploring, reading, and following other authors for a long, long time. I've seen the good, the bad and the ugly side of it."

What's particularly unsettling—for Jager, and for all of us who appreciate the depth of what is a repugnant problem—is that her research indicates most of the bad experiences have been documented by female authors. "The first thing you need to understand," she says, "is that the Internet is a brilliant platform to publish your own work. You don't depend on a publisher; nobody can turn you down because the concept of your story doesn't sit well with them. The Internet gives the public a direct and "intimate" ability to communicate directly to the author. I see the Net as one of the biggest reasons the door of opportunity has opened for so much new female talent in the comic industry."

But with the incredible positives often come the unfortunate negatives. Jager tells us that this same door also swings wide to let in the disturbing behavior and misogynist attitudes of a contemptible, vocal crowd. "Artists have been stalked, sites were hacked, and authors threatened because somebody simply didn't like something [these authors] wrote," Jager says.

"It's pretty easy to find personal information on the Net," she says, "so somebody publishing your address and a picture of your house while threatening to rape and kill you is nothing new. I've seen the latter more in the YouTube community though, but it's sadly intertwined with the rest of the Internet experience."

Jager tells us that she's also seen many authors disable the comment section under their comics because (a) the fans would actually fight among each other or (b) the massive overload of negative feedback. "This is way out of control," says Jager. "It's miserable that it's the negative feedback that stays with us much

longer than the positive. I'm not referring to constructive criticism (which is always good and welcome), but downright *bashing*."

Here, Jager is quick to point out the strength, composure, and downright resiliency of her fellows. "Of course," she says, "this should not scare anyone away from putting their good content online; it should just be a cautionary tale. Be careful, be ready, but always be yourself. And don't let a couple of jerks stop you from publishing your work online."

## MAIHACK

Another friend of Ballinger's, who, as he says, "is on top of things in this realm" is Mike Maihack.

Discussing how to break into comics is an interesting proposition for Maihack because he doesn't feel there is one standard, defining experience to point to.

"The last thing I want to do is misinform someone," he states. "There is no 'this is how you do it' pep talk. But regardless, I can say that my big break came from self-publishing." When he says "self-publishing," Maihack means having actual physical—printed—books available along with a simultaneously available webcomic.

"I wasn't drawing the webcomic out of a desire to do 'bigger' things," Maihack comments, "but I did consider that if any work came my way, it would be because of the webcomic."

After all, as Maihack estimates, thousands of people around the world were reading his webcomic while the printed books just sold here and there at various conventions. But it was one of these conventions (the San Diego Comic-Con, in fact) where one important publisher did pick up the print version of that webcomic, saw something he liked, and precipitated Maihack's blossoming comics career.

"Hey, I'm drawing comics for a living!" he smiles. "You could say, 'right place, right time'—which would be true—but had I not put the product out there to begin with, no specific time or place would have mattered."

## SOMMER

Mikkel Sommer began his professional career around 2008 and his most personal works are the comic books he writes himself.

He initially wanted to be an animator, but switched directions quickly. He did, however, make some business contacts during this short stint at animation school, and was later hired to do character design on a few productions.

"Then I thought I was going to be an editorial illustrator," Sommer says, "but this didn't fit me well—too stressful and the gigs themselves are so short you rarely can dig deep into the subject matter. I was lucky to draw for some small magazines and good newspapers, but my editorial work is minimal.

"Eventually I was approached by a writer whom I had previously worked with on a graphic novel," says Sommer. "He primarily works in children's books and had a lot of contacts in publishing already, so my entrée into this field wasn't too complicated."

Sommer observes that there's heavy competition to do children's books, but he's generally found the playing field to be, in his words, "nice and warm."

And comics? "Comics get complicated," Sommer says. "You can work with a writer; you can merely clean up lines or do the colors; or you can work with your own stories to create something independent." Indeed, Sommer's most personal work are the comic books he writes himself.

With online comics, Sommer tells us that it's all about the publishers. "Most of them pay badly," he says, "but some of the smaller publishers will give you more freedom for that very reason. As soon as you've done one book, it might be easier getting more out, with the same publisher or others. It's like a Mafia family in a way."

## TODD

Mark Todd says drawing is about communication; but it's not such a colorful dilemma, nor is it so black and white. He likes to engage the viewer, who will be visually and conceptually challenged to answer questions about the work, about its meaning. "Especially the gallery paintings I do," says Todd. "I don't intend to tell the viewer what the pieces are about. I want them to have a dialogue with the work, a running commentary. I want viewers to ask lots of questions, and *perhaps* arrive at as many answers."

Todd is not the type of illustrator who likes to just solve a problem through straightforward imagery, even in his editorial work. "I don't go for the simple, the obvious," he says. "I want my work to have more feeling and emotion to the piece than that."

Todd always believed that one should know the rules before you try and break them. "And when I tell that to my students," he says with a smile, "I comment that there are artists with no formal training who can often create something beautiful."

How does that happen? "An innocent stroke of color and an awkward and unsure line can look *amazing*," says Todd. "Life is full of contradictions. I believe that as long as there is true passion in the work, something good will creep out of it. Even the most highly trained painter can create crap."

### GO TO THE EXTREME

Todd's comic book–related imagery is rooted in ongoing, consistent themes. "I enjoy it," Todd says, "and people are attracted to this work; it's generated lots of fan mail as well as sales.

"You know, it's often a question of how long one can stay interested in a particular subject," he says. "When you can explore something to an extreme, it comes back around; you push it to the limit and you start doing interesting things. I feel I could be doing this imagery a whole lot longer."

# CHO

In Michael Cho's experience, webcomics are best for building an audience and recognition for your work, not as a means to a profitable career. "I can count the people I know who can make a decent living off webcomics on the fingers of one hand," Cho says. "And those people spend 24/7 working it to make that living—it's a serious, full-time investment to actually make a webcomic a profitable enterprise.

"You cannot half-step it and expect this to pay off," says Cho. "There are just so many webcomics. Audience expectation is for free content at all times, so you have to hustle with the merchandise to make it pay off if you want to support yourself."

## REALITY CHECK

In Cho's opinion, the other critical downside of webcomics is that while there are literally thousands of webcomics out there, there are, as he says, "Only a handful doing anything unique or different than the masses.

"If you are considering starting a webcomic about (1) doing a webcomic, (2) videogames or videogamers, (3) cats or (4) your sci-fi (or D&D campaign) spun into a serialized story—*don't*. It's already been done by at least 100 others. Especially the first two categories!"

# BREAK IN

In terms of breaking into the comics business, Cho is in complete agreement with Maihack. "His assessment is dead-on," Cho says. "Nothing works better than just hard work. There's a simple way to become good at drawing comics: you just draw 100 pages of comics. It works itself out."

Which is pretty much exactly how Cho established himself. He understood early on that perseverance is the key. In Cho's estimation, editors at mainstream comic companies want to see that you're serious; not just a guy who's dabbling in comics because he thinks it's an easy gig.

"That means that when you bring your portfolio to a convention and you get the hard hitting critique, you come back at the next show incorporating their suggestions into your subsequent batch of samples. This also means that you go and actually draw a twenty-two-page story and print it through some print-on-demand system and show that printed copy as your sample rather than six pages of pencil on bristol board."

Cho emphasizes that the more dedicated you are, the more people will take you seriously. He personally knows several artists who were initially rejected by comics publishers and just kept coming back—over and over, with better stuff each year. "Eventually, they'll remember your face and realize you're committed to comics," he says.

## MILLIDGE

Interviewed for C. Addison's blog, *Imagination Is Spicy*, Gary Spencer Millidge saw the proverbial cards on the table. Self-publishing once or twice a year wasn't enough to survive on by itself; certainly not enough to support a household. But Millidge felt that there were promising possibilities to find freelance work within the comics industry by building off his own material to supplement his income.

"However, I ended up losing a sizable chunk of a year being invited to pitch for a couple of publishers on projects that weren't eventually picked up," he says. "The editorial feedback was positive, but for whatever reasons it didn't happen."

What did happen was a gig to do a couple of how-to-draw books with another illustrator, and another proposal for a book on self-publishing comics that didn't pan out either (but ultimately led to Millidge's great *Comic Book Design* for the same house).

"Everything I do turns into an insane amount of work," Millidge says, only with half a grin. "It's in my DNA. If I'm set a task, I try to figure out the most complex, time-consuming way of completing it.

"But I think it's important to try to be yourself, and to allow your personality to show through in everything you do," says Millidge. "I don't see any benefit in trying to replicate someone else's style because you inevitably end up being an inferior version of that writer or artist."

However, this author of two terrific how-to books doesn't study those things. "I buy all of them and flip through them," Millidge says, "but frankly, it all sounds like a lot of hard work.

"That's why I didn't attempt to lecture to anyone on 'how to draw' in *Comic Book Design*. You either have the aptitude and patience to practice and figure it out for yourself, or you don't. I'm sure there are people who will say I ought to read a book on how to plot properly, or whatever, but I always want my work to be nonconformist and quirky."

So, in his *Strangehaven*, Millidge never wanted to tell a story the same way as everyone else. And he can't help thinking that some how-to books lay down too many rules, which can actually stifle intuitive creativity.

Millidge also believes drawing itself should be rather instinctive. "I don't think you need to create precise measurements and lay down dozens of construction lines to figure it out," he says. "The American comic book page is pretty much based on 'Golden Section' proportions. It's a fascinating subject because it's also

found everywhere in nature, in things like flowers, shells, DNA and galaxies. The common tendency to split the page into three tiers follows these classic rules—the nine-panel grid splits each tier into three again, and so conforms to the ratio.

"But if you have any organic design sense it comes naturally," says Millidge. "You know, in *Comic Book Design*, I analyzed a Gilbert Hernandez panel which conforms beautifully and precisely to the Section, which I then prove with the use of an overlay. A while after the book came out, I saw Gilbert at San Diego Comic-Con and told him that I'd used his work to demonstrate the famous ratio. He said he'd never even heard of the Golden Section."

## GO NO FURTHER

"It is only good and logical to advise people to bone up on their basic anatomy," says Jager. "Art education can take many forms. You actually don't need to go any further than the Internet—just look up tutorials; there are so many venues on the Net! Find ways to learn and make your craft better; it's foolish to simply rely on yourself. Your innate inner design sense is all well and good, but, frankly, this can only take you so far on its own.

"I share a studio with older, accomplished comic authors and they still share tutorials among themselves on how to improve their drawing chops—even now, when it looks like it comes easy and without thinking.

"So I completely agree and absolutely disagree with Millidge," Jager says with a smile. "When you have the rules internalized, breaking them is much easier. You 'just'—as if it's that easy—need to be able to break away and shape those rules to your own style. But, honestly, that kinda sorts itself out when you stop worrying if your individual style is all that individual."

## STATE OF THE ART

In an interview for Nevs Coleman's blog, *No One Is Innocent*, Millidge was asked to evaluate the state of the comics industry. Here are his opinions on the subject.

"I reckon it's in pretty healthy [condition]," Millidge said. "Sure, there are challenges, and the marketplace is constantly shifting, but doom mongers have been announcing the death of comics pretty much for as long as I can remember.

"Has there ever been a more diverse or prolific time for comics?" Millidge asks. "Yes, the direct sales market is shrinking, and the product is getting ludicrously expensive. Marvel and DC are primarily character licensing entities these days. Image, though, has been a revelation in recent years—they are producing some beautiful material, allowing seasoned professionals to do what they want to do, free from corporate restrictions and pointless cross-overs.

"The growth of independent book publishing and the diversity of material they are producing—particularly in the UK—is astonishing. The sheer number of lavish hardcover graphic novels and ongoing archival projects is mind-boggling. Who the hell is buying all this stuff?

"The growth of digital platforms is something I know little about, but that all seems promising as well.

"Never in the history of this medium has a potential creator had such sophisticated professional tools at their disposal and so many publishing outlets for their work. It's bringing out unprecedented numbers of fresh and exciting comic creators into the public gaze.

"I'm excited," Millidge says. "Aren't you excited?"

## ALTERNATIVE THINKING

I highly recommend two outstanding books, both written by Jessica Abel and Matt Madden: *Drawing Words and Writing Pictures* and its follow-up, *Mastering Comics* (both First Second). Beyond standard, old-school submissions, if your traditional marketing comes up short, Abel and Madden suggest some alternative means to get your work out there. Let me paraphrase some of their best advice:

- ▶ Consider trading with your colleagues and donating to schools and libraries.
- ▶ Send your stuff to established comics artists for possible feedback and inspiration. I'd inquire first before any blind or cold networking, however. (Always err on the side of personal and professional courtesy.)
- ▶ Dream global/go local: sell to your hometown bookstores.
- ▶ Attend and/or exhibit at comics conventions. Speak on a panel and/or offer a workshop at comics conventions. For that matter, organize your own convention!
- ▶ Launch your website. Join an online portfolio galley. Kick off a blog. Tweet. Do a podcast. Obviously, create your webcomic; sell and distribute it ASAP online.

## GRAPHIC NOVELS

Okay, we begin with the obvious: what is a "graphic novel"? I'm going to refer you to an artful resource that efficiently and elegantly tackles the question.

It is called, of course, *What Is a "Graphic Novel"?* and I found it on Madden and Abel's website, *Drawing Words & Writing Pictures* (dw-wp.com), a tremendous treasure of information for those seeking to learn about, make, read, and teach comics.

*What Is a "Graphic Novel"?* was drawn by Abel in 2002 for the site artbomb.net. It's a brilliant, yet economic visual treatise about, as the authors say, "what comics are, how they work, how to read them . . . and a marvelous introduction . . . into the world of graphic novels.

"Use it in your classroom or library, when giving someone the gift of their first graphic novel, or even put it to personal use when trying to convert a skeptic to appreciating comics," say the authors.

Or refer to it as I'm doing here: to help flesh out the term itself. In her two-page spread, Abel adroitly addresses comics fundamentals (for instance, page navigation) and common graphic denominators (like panels, word balloons, and certain themes). She analyzes—and disputes—definitions, too (so you'll learn what a "nested system" is, and more).

The thing is, as Abel says, this is all often confusing, even for newcomers or veteran comic book readers and cartoonists. But that, "the great thing about comics is, you can get an idea of their content just by flipping them open!"

So for a wonderful graphic novel experience that goes beyond the mere definition you'd find in these pages, put this book down for just a few panels and click over to Madden and Abel's website. I'll be here when you get back.

## BUSY BUSY BUSY

Ahh, you're back. As I said previously, a graphic novel is a gig that will tip all your hats: Writer. Penciller. Colorist. Inker. Letterer. Layout artist. Designer. Editor. Publisher. Promoter. You certainly don't have to do it all, but mix or match, the job *will* keep you busy!

You can always approach publishers (both mainstream and indies), and create under their brand. You can sell to the *direct market*—the dominant distribution and retail network for North American comic books (comic book shops are part of this mix). You could aim high: try to snag a grant or snare an agent.

You can do it yourself: perhaps as a feature for an online magazine or serialize on your blog or website. Maybe you are compelled to produce your own e-magazine. However, do you *want* to run the whole show? Producing an entire magazine is a massive undertaking—not highly recommended for the faint of heart.

Saying that, self-publishing is enjoying a revival; it's never been more convenient or affordable. But that's still not saying it's *easy*. Of course, tap into social media (essentially word of mouth on steroids and another revolution in marketing and promotion) to get the words out.

If "just" getting your opus to print is your goal, twenty-first-century technology is certainly on your side. Modern photocopiers and general *print on demand* (POD) capabilities make self-publishing a viable vision.

## VISUAL THINKING AND TRANSLATION

Veronica Lawlor reminds you that, ideally, even in a graphic novel, there should be a component of communication that words *cannot* convey. Because, shouldn't the nature of *illustration* be all about communicating a concept without words to an audience?

"Visual thinking and translation applies in all areas of the visual arts," Lawlor says. "You're trying to reveal some kind of feeling or intuitive thought that the picture projects to the viewer. Your technique, including your point of view, color choices, textures, etc., all of these can be the tool of that concept. It's important to illustrate the text, but also to communicate the deeper meanings behind the text."

## IRONIC

Russian illustrator Victor Melamed draws for, among other Western magazines, the *New Yorker* and *Rolling Stone.* His fine work taps into seriously striking geometrics; the sculptural elements playing off some rather bravura shading and textural techniques, to boot. Irony (both visual and conceptual) plays a big role in his caricatures. To which, Melamed comments: "Irony is the only vaccine against propaganda. Without it we all would have our brains fried long ago. So yes, [I do] foster it. But caricature has a different nature I think, because it scoffs, rather than smiles, and it's tightly related to propaganda."

Melamed recently realized that, as a kid, he was heavily impressed by Kukryniksy (the famous Soviet caricature trio), as well as Soviet propaganda posters. He saw that his own work was an unconscious attempt to crossbreed the two. "I actually did some portraits for an opposition paper, which I never thought I'd do," he says, "given that Russia's current authorities hire the Soviet Union's worst illustrators. Now *that* is definitely ironic.

"So, I am continually asking the same question," says Melamed, "but I always wonder if I'm right in thinking that disguising messages—using irony—is a playful part of the Russian illustration style.

"There probably was a certain escapism in Soviet animation and book illustration," says Melamed. "In the '80s, there was a lot of experimental animation (which still looks impressive), although we had no idea, back then, how much of it was simply recycling ideas from Western graphic art we had no access to.

"By the way," Melamed says, "Saul Steinberg [was embedded in] Soviet visual culture through the films of Vladimir Zuikov and Fyodor Khitruk . . . who were heavily influenced by the Zagreb animation school, which was, in turn, influenced . . . by Steinberg. But his work wasn't really plagiarized. The Soviet works are actually more of a tribute to Steinberg. In fact we even pushed it further. And that was such a breath of fresh air."

## SIDELINES

Publishers are enthusiastically tapping into the burgeoning world of apps, digital books, and cards (as eBooks and eCards, obviously); online magazines and news reporting.

Illustrators considering alternate jobs in this field might explore careers as editors; web software and app designers; typographers; as distributors or even publishers (but do see my previously mentioned comments).

Last but definitely not least, think about teaching (and read Chapter 20). Illustrators—with the right chops and appropriate credentials, of course—who can teach animation, effects, game and character design, as well as graphic storytelling, may be a hot quantity.

# ANIMATION

At this writing, animation (rather a pioneer of sequential art) is enjoying a true day in the sun. It may be old school—stop-motion, claymation; traditional, often called classical, animation—but the frame by frame/cel by cel technique has not exactly given up the ghost. And computer animation—and general CGI (computer-generated imagery)? We're smack in the middle sprocket of a *reel* golden age.

Illustrators with the right chops are finding opportunities on the web; for video games; in the creation of software; for film (features and shorts) and television (on commercials as well as programming); for hardware simulators and software simulation; in the fine arts; and for print (advertising and editorial).

An animated project, like a graphic novel, may require a creator to wear many hats. Indeed, the scope of an animation project may just be way too big for one individual to pull off. Oh, in a perfect world you'll be fortunate enough to have a generous grant, a cushy budget, and the perfect crew to comfortably realize your vision—and even with adequate resources it will still be a massive undertaking. Odds are, before you hit that enviable big time, you're going to invest *mucho* sweat equity, as well as the necessary funds. Your workday is going to be *animated*.

Take a right turn off the animation down ramp. Get off at the Game Design exit. Maybe cruise down the fast lane of the special effects freeway (or other busy avenues of sequential art). You'll visit the same destinations mentioned a few paragraphs above, probably getting off before the print and fine arts interchange.

Obviously, coverage of animation, effects, or game design could go much further and deeper, but not entirely necessary for this book—I'm sure you get the moving picture.

# YOU BET

Eliott Lilly tells us that working with a studio in the video game industry means a commitment of an illustrator's talent and time as well as an investment in that company and its success.

"Understanding what a studio means to your career becomes intertwined with the success or failure of a project," Lilly says. "It's obviously mutually beneficial if that project goes well. But if it does poorly, or if the studio has layoffs, then you may have bet on the wrong horse."

## GOOD RELATIONS

The first thing Lilly instructs you to consider is the relationship between a studio and employee. If a project succeeds, this union may endure a few years at least.

It should be obvious that you have the professional competence to handle the various goals, assigned tasks, and even the ambitions of the studio. But in this industry collaboration will be a critical element in the success of a project and subsequent profitability of the studio.

With any luck, sales will be brisk, and the company will recognize this as a direct by-product of your gift as a problem-solver and valuable team member.

Lilly emphasizes that attitude and personality carry the day, and can almost predetermine your outcome at any given studio. The play is to stay positive, engaged and perform your duties to the best of your ability. "Like any relationship, you will need to work at it," Lilly says. "Talent is not enough to carry you in this industry. In fact, you can be the most amazing artist, but if you're an all-around asshole, no one will want to work with you."

## ROLE PLAYING

"The studio promises a steady source of income (and benefits) in exchange for your time and commitment on their project," Lilly says. "They provide you with the tools, a voice, plus a plan to ship a video game title by a certain date that, again hopefully, will make a profit."

It is a given that you need to be working on a shippable project, but Lilly also makes the case for a basic bill of rights here. No one wants to work at a company that abuses its workers. Excessive crunch times, poor management, and outdated facilities are not mutually beneficial to either artists or the company. The opportunity for growth and a creative outlet for ideas that are heard coalesce into a sense of pride in everybody's contributions.

# PLAYERS

Lilly lays out the different types of game studios in this industry.

1. The First-Party Developer

"A first party developer is a studio that is partially or wholly owned by a company," Lilly says. "They manufacture console hardware and develop games exclusively for that piece of hardware (think Sony, Microsoft, or Nintendo). First party developers may also have been an independent studio at one point, before being acquired by the console manufacturer, such as Rare, Epic, or Naughty Dog.

"These studios are fairly safe from unexpected layoffs because they benefit from the financial backing of giant companies."

2. Third-Party Developers

"Third-party developers are studios that partner with publishers to develop a title for one or more console systems," Lilly says. "Both publisher and developer have input into the game's design, but because they are paying for the game, the publisher usually has final say.

"Unlike first party developers, third-party studios have a contractual obligation to deliver new content on predetermined dates, called milestones. By meeting these deadlines, it proves to the publisher that the game is on target to meet its ship date. After each milestone, the publisher agrees to pay the studio an advance on its royalties and/or earnings.

"Third-party game development can be volatile by nature," Lilly says, "since small developer studios may be dependent on income from a single publisher—if that game gets cancelled, it can be devastating to the entire studio."

3. Independent Developers

"Independent developers are software developers who are not owned by (or dependent upon) a larger company for support," says Lilly. "They tend to be smaller companies who self-publish their own games, relying on word of mouth and the Internet to advertise.

"This absence of a parent company means the independent studio can retain full control of their own product, but their game may receive less recognition due to the significantly smaller marketing budget and distribution channels."

## FUTURE OPPORTUNITIES

Lilly tells us that, right or wrong, on job interviews, you may often find your skill set—and therefore, your perceived value—is directly proportional to the successes or failures of your last studio.

"If you decide to leave your current studio when they are at the peak of success, doors may open up for you," Lilly says. "Other studios will clamber at the chance to acquire you in hopes that you will bring the lessons learned and experience gained to the new job, making their project more successful. You'll hear things like: 'Ooh, he's from XYZ Studio, so he has to be good!' Or: 'Hmm . . . she's leaving XYZ Studio . . . she can go anywhere.' Therefore, the better the track record of the studio, the more opportunities you will have when trying to obtain your next job."

## EXPOSURE

Working on a big title means your work and influence will be seen by millions of people, which, Lilly says, comes with big benefits. "When you are able to publicly promote the work that you did on such a project, you're likely to have instant fans—both consumers and industry professionals alike," says Lilly. "You may become more desirable and companies might pursue you to join their team. This effectively puts you at the strongest negotiating position; there's a huge difference in salary negotiations when you approach a studio looking for a job versus the studio approaching you."

## CAREER PATHS

Each project you work on hones specific skills needed for that assignment, so, obviously, your subsequent body of work will reflect that. If you create concept fantasy environments, it stands to reason that, over time, you will seriously grow here, but as Lilly says, "you'll only improve in that area."

Lilly asks you to keep in mind that, naturally, these environments will be in your portfolio to land your next fantasy job. However, if you want to work on, let's say, a sports game next, your portfolio will not have work that reflects that. "Make sure you choose each job wisely so that you are always in the right line of work," says Lilly.

# BURNOUT

"As illustrators, we pride ourselves on the art that we do," Lilly says. "Such confidence often defines us as individuals and can run to the core of our being. Therefore, it needs to be nurtured and protected.

"If your work tenure is a continuous grind of grueling, stressful, and unhealthy experiences, then you may find yourself 'burnt out' or unmotivated to do that. This emotional state can be brought on by your negative feelings toward the current state of the project, anger toward management, or even anger toward fellow coworkers. It can affect how we view, and in turn, value ourselves."

As Lilly points out, working for a company where you experience burnout—or, worse yet, several companies like this—can potentially damage

your perception of the industry and your motivation to be a part of it. "I have heard of artists whose entire careers are filled with unshipped and cancelled projects," Lilly says. "After a while it begins to feel like a curse and sucks the creativity from your soul."

# "ON THE BOARD

## (PROFESSIONAL VIEWPOINTS IN 50 WORDS OR LESS)

Sequential art—It's all about the components. Artists working in this field must wear many hats. You must be good storytellers, designers, and illustrators. If not, the whole work suffers.

—June Edwards

You know, if you look at the amount of books Kickstarter funds each year, you could say that Kickstarter has become one of the largest comics publishers in America.

—Stephen McCranie

Motion. It's just exciting to be able to re-create—or convincingly simulate, anyway—real life's actual dynamic nature. Video, iPads, mobile, gaming, the web . . . images move these days, and it's fun to see. Video is the new audio.

—Scott Hull

© Michael Cho 2016

For better or for worse, much of my work is more literal than conceptual, and to compensate for this I think I tend to try to build little stories around whatever I'm drawing.

—Charlene Chua

You know, a book is sequential. Style and characters have to be consistent, as does the palette. And of course, there must be an idea or story.

—Ken Orvidas

I have a background combining advertising and illustration, so I am mostly interested in animation for advertising. Currently I am focusing on storytelling through animation, but I'm still trying to figure out my path here. I am more digital than print—I like things that move.

—Dingding Hu

# Chapter 16

# Magazines, Newspapers, Books

*I used to say, "I'm an illustrator" when I started out, and I realized nobody knows what illustrators do (unless you're a children's book illustrator). So now I say I draw pictures for magazines and newspapers, which people seem to understand.*

—Yuko Shimizu

## IS PRINT DEAD?

If you're reading these words by flipping pages, obviously it ain't done yet. That's not to ignore the obvious—nor the handwriting on the south wall of the *New York Times* building—but we're going to turn the page and look at this market with an open mind and cautiously optimistic outlook.

"Print *is* dying," says Peter Arkle, "but in a slow complex way." Here, Arkle suggests the musical metaphor of an opera singer singing bass, hitting profoundly low notes: "There's still lots of fun to be had on the way down," he says.

"Drawing for glossy college alumni magazines—which seem to be getting fancier—is great," says Arkle. "Sometimes I am paid well to do illustrations that are published so small no one will be able to see them. Of course, sometimes, I have to remind art directors that just because a drawing is tiny does not mean it takes no effort to create it.

"Working for magazine publishing (online or in print) is far more fun than working for book publishing," says Arkle. "Books offer the lowest fees ever. They all act as if they are charities and that they are doing you a favor by letting you appear in their pages. But, I am still happy to do it. It's just nice to be published in a place that won't disappear in a day or two—even if underpaid."

And finally, as Avram Dumitrescu says: "Is print still viable? I hope so, for many reasons. Yeah, it's more difficult to be published in print. On the web, I can easily set up a free blog and post artwork without any form of curation. But I want physical print to always be there.

"Magazines and books require no power source, don't cause eyestrain, do not shatter when you drop them, and can be seen in direct sunlight," says Dumitrescu. Paper textures are also something that currently cannot be replicated, at least not yet in a tactile sense."

## MAGAZINES

## TRANSITION

"It's true that magazines are in a state of flux," says Michael Cho. "It's been true since the crash of 2008 and I'm still trying to figure out what form the industry is going to finally take."

The only thing certain for Cho is that *content* will last, but how that content is curated will change. "Most people who read magazines digitally don't seem to want curated content," he says. "They want to be able to pick and choose and filter their own 'personal' magazine. The idea of a general-focus magazine with content decided by an editor doesn't seem to hold as much interest to people as it used to."

Cho is convinced that this situation will only escalate in the future. As an expert observer of (with an obvious, vested interest in) this venue, he feels that

many magazine readers digitally collect content now, and make it their own. Newsfeed readers, RSS aggregators, and the proliferation of news apps only galvanize the process and make digital news reading increasingly user-friendly.

"Making a digital magazine that is an exact replica of the printed copy of the same magazine seems to be a solution that isn't as popular as some publishers desired it to be," Cho says. "People don't seem to want walled gardens in their digital reading experience—they want links and the freedom to use the full resources available on the Net.

"For illustrators, the transition seems easier to make than for designers," Cho says. "Our jobs are to illustrate individual pieces of content, rather than design the layout of a collection of content.

"Still, flexibility is the key; be prepared for your illustration to be retasked in many different ways, and in all kinds of layouts, including wholly automated ones."

## TYPECAST

How many different types of magazines are there?

We can approach this from a historical angle and accurately state that the golden era of the magazine is, after all, *ancient* history. You could cite the numbers and point to the hard reality that, at least as I write this, magazine newsstand sales have been crashing while digital circulation is, putting it mildly, soaring. I am not a scaremonger—I only report some research. By the way, single copy sales are the key factor when publishers establish ad rates and a traditional benchmark for this industry. At the same time, current overall circulation looks good, due to subscriptions and strong online sales.

Rather than being an alarmist, one could quit sucking on the lemons and offer the lemonade of heroic optimism—new magazines are still starting up and taking off. It looks like magazines are, *at least*, doing better than newspapers, and novel form factors (the iPad, for instance) offer fresh opportunities and revitalized hope. Along those lines, modern technology is prompting publishers to push the envelope of subscriptions, explore branding and licensing, tinker with design formats both online and in print. Publishers are in a position where they must now examine diversification, and explore innovative business models.

Maybe the better answer to my original question is that there are only two types of magazines in any platform: those that take your illustrations and those that don't.

## TYPE CAST

Yes, magazine newsstand circulation looks to be on life support or even flatlining as readers migrate online and advertising bucks are thrown at the Internet. But

the pool of the magazine market is still wide and deep, and the depth of basic categories remains constant no matter how you swim to the content.

The following brackets are real, the titles are all fictional. You'll find: local and regional publications (*Delaware Every Second, Yellow Springs Today!*), trade journals (*Velcro World, Industrial Strength*), general audience or consumer periodicals (*American Laughstyles*), special interest magazines (*Spelunking Gerbil, Contemporary Antiques, Starting to Stop*), and in-house or company organs (*Inside This Company*).

## ZINES OF THE TIMES

Online, oft called digital, magazines are, obviously, produced on the web. These serials may be called *webzines* ("web magazine") and I have seen the tags *cyberzine* and *e-magazine* also in use, as well as various alternative spellings in play. There are *e-zines*—smaller forums or newsletters that could also go out via email—and blogs as well as online newspapers that plainly tap into the magazine format.

As mentioned above, the big fish are diving into the waters online and offering digital variants of their print titles (in both HTML—which mirrors conventional web pages—and Flash versions, which boast fancier graphics, navigation, and interactivity).

As with print publications, online magazines are directed to a particular reader. And like their print counterparts, these Sisters of the Immaculate Pixel are bellwethers of society and culture, academia, science, and politics; as well as first alerts for trade or industry.

## THE LOOK . . .

Different magazines require different kinds of design. For example, even though the *Saturday Evening Post* has been currently reconfigured for today's demographics, you won't find the unorthodox aesthetic of *Juxtapoz* within the pages of the *Post*, it simply wouldn't mesh with a more conservative audience.

Every magazine—digital or analog—has its own editorial tone and visual tenor. There will be magazines (consumer, special, and general interest publications) that lean toward a conceptual approach. Some periodicals, such as regional and trade magazines, will be journalistic in nature.

Some publications ostensibly focus on a specific genre, but offer a much wider palette; *Rolling Stone* comes to mind here. Safer to say that design, art, and text must zestfully blend together to consistently enhance the flavor of the magazine and appeal to the general, but particular, tastes of its readership.

### . . . AND FEEL

A magazine must establish a consistent, distinctive look. Its style—the "tone"—should be evident at first glance.

When you go to the library, look at all the recent issues available. At the bookstore explore every magazine displayed within their category. Consider editorial content, think about the subject matter. Is the magazine conservative or progressive? Hip or traditional? Is it politically left or right? Does it specialize in hard-hitting exposés or typically feature lighter stories on food, travel, or fashion?

At the same time, study the art (both illustrations and photography) and examine how it's used. Are the visuals appropriate? Are art and photography conceptual or realistic?

Compare any two magazines (*Automobile* to *Sports Illustrated*, for example), and you should instantly get a sharp impression of what these periodicals are all about—and how it uses art and design to directly address its target audience. If you don't (and it doesn't), the magazine is in trouble (or will be).

## WHAT MAGAZINES NEED

Design, copy, art (illustration and photography), and ads share the pages of any magazine. Currently, to varying degrees, a magazine may employ illustrators, cartoonists, designers, and photographers; stylists (hair, food, fashion); prop builders, prop masters and model makers; production artists; typographers and calligraphers; editors, copy editors, as well as copywriters.

The Internet has certainly altered, morphed, distorted, or simply bumped off the above job titles, but regardless of the current true nature of the job descriptions, you just may have to be hands-on for any or all job-related tasks. Back in the day, a tight schedule was simply business as usual. In our Internet era, this frame of reference is hyper-accelerated, and you still must deliver the highest quality, whatever you are asked to do, in whatever time given.

Many illustrators take graphic design jobs between illustration assignments. The paycheck is vital, but an added bonus is that this design work may provide contacts that lead to illustration jobs. Freelancers are usually called in when the workload is heavy: versatility, speed, and accuracy are critical. If you, Ms. or Mr. Illustrator, can create strong informational graphics or lay out an elegant page (including text and various components), you could be in greater demand.

A thorough knowledge of page-layout software with a command of appropriate keyboard shortcuts can only help the cause. If design is all or part of the challenge, "Your initial job with a company will let them know how efficiently you work," June Edwards says. "Dependable and talented freelancers will receive many repeat calls, and eventually can be selective and only take the most rewarding jobs."

## RESEARCHING THE MARKET

How to find out if a magazine is looking for freelance help? Whether you're digging for an illustration gig, or if you're looking to break in as part of the design

staff, this homework has never been easier. First, simply open your eyes, grab a pencil, and take notes: surf the Internet and browse the library and bookstore.

Grab some magazines. Check the masthead. Read credits and bios; explore what work is done by staffers or contributors. Make contact. Email, call, or, yes, even write to the folks at the creative helm—editors, art or design directors, the art staff—and simply ask.

Consult references like the annual *Artist's and Graphic Designer's Market*. Scour creative annuals and trade magazines. Pore into content (including interviews, promotion, and advertising). Look for any client contact info to cull an informal catalog of potential business. Another plus—looking at all this wonderful illustration and design while studying the great creators behind that work will be very inspirational.

## RECON

Remembering that you're not at the public library, you shouldn't have any trouble doing research in any bookstore (or newsstand) where browsing is welcome and accepted.

The goal is to discreetly jot down information about a new publication. Take a moment to clear this with the clerk or owner beforehand. Introduce yourself, state your purpose, and express your thanks.

And speaking of which, listings of magazines can be found at most libraries. Consult the following: *Artist's and Graphic Designer's Market, Writer's Market, Children's Writer's and Illustrator's Market,* the *Standard Periodical Directory, Gebbie Press-All-in-One-Directory, Gale Directory of Publications and Broadcast Media, Ulrich's Periodicals Directory* and the Standard Rate & Data Service (SRDS).

Here are some folks who cover the magazine industry: *HOW, FOLIO, Print, Graphis; Advertising Age, Ad Week,* and *Communication Arts.* It would also be worth your while to research the classic but, alas, defunct *U&lc (Upper & Lower Case,)* and *STEP Inside Design.*

## THE APPROACH

Most magazines will have an art director or creative director (perhaps this person is called the design director). Depending on the size of the publication, there may be someone with the title of *associate* art director or *assistant* creative director. They'll obviously have an editor or publisher, often one and the same person. Dope out who reviews art submissions and send to the big Lebowski. Just a thought here: as Stan Shaw wisely points out, "Do keep in touch with the little Lebowskis as well. They often grow into big Lebowskis."

If you're sending some kind of hard copy (or a physical portfolio) and you want it back, include return postage—an SASE (or a prepaid FedEx shipping label) for its return. If not, leave it and trust the disposition of your submission up to your contact. It will either get filed, tossed, or tacked.

Don't send an unsolicited portfolio (returnable or otherwise). It bears repeating: Do your homework and establish the appropriate contact, with a specific name plus correct department. Some active research—a phone call or email—should do the trick.

If you cannot come up with a name (perhaps the position or its occupant are in transition) you could label your stuff "ATTENTION: ART DIRECTOR" (or "ART DEPARTMENT" or "ART BUYER"). At the outset, if you have no recourse, this is okay, but not highly recommended. When you want to establish a personal connection and maintain communications make it a priority to get the name of the art buyer as soon as possible.

## STARTING BLOCK

Where to begin? Which type of magazine would be good to start with? Think about the publications you enjoy most. Browse around, look all over, then dream a little—visualize where you'd like to work, with whom you'd love to work.

It can well be argued that there is no "best" place for the beginner to start; that all the markets are good. Hey, if you're good, why not start right at the top? But trying to start your freelance career at the *New Yorker* will probably be like kissing the business end of a shark—best of luck to you, matey.

We could recommend a conservative gambit. Start with local periodicals; work your way up to mid-level—okay, lesser-known—mags, and eventually to larger or more prestigious publications. Begin with small staffs, operations where you won't get lost or mired in the red tape of the big companies. Work at the modest end of the scale. Initially accept low fees to get published credits, and gradually breast stroke up to the churning frenzy of Shark Week.

### VARIETY

You won't limit your submissions to one type of magazine, or worse yet, one magazine only. Approach as many magazines as you have a mind to, as many as you can.

Freelancing is a numbers game—your livelihood depends on the bigger picture of how much you sell. In all likelihood, one client (or type of client) won't support or sustain your business. The term *exclusivity* is pretty much inoperative in this market, and the illustration field in general. Your style must meet the needs of a variety of magazines, if you're to succeed.

## GOING POSTAL

Art directors are incredibly busy people, so receiving samples through the mail will probably *not* be a rather efficient use of time—yours and theirs. I say *probably*, because there may be those art directors who might prefer to initially review your actual work in their hands. *Maybe.*

But I will bet that if they are not inundated with submissions from all angles, they obviously have other things to do—like, umm, art directing the magazine, for instance? Plowing through actual portfolios stacking up on their desk won't be high on the bucket list.

Safer to say, the initial review of your work will be via your website, blog, or online portfolio gallery. This has everything to do with time, energy, and finances. It's much cheaper and easier and far more time-efficient.

If something clicks, you might be asked to send a follow-up whatever. If you're local, you may be requested to come in, bring your book; perhaps discuss a bona fide assignment. Of course, there are no guarantees you're going to get a job out of this communication, but that's what's called doing business.

## ORGANIZATIONS

Professional organizations to reference and research: The Graphic Artists Guild, Society of Publication Designers, and American Institute of Graphic Arts (AIGA). You could consult the City and Regional Magazine Association (CRMA), the Society of Photographers and Artist Representatives Inc. (SPAR), Society of Typographic Arts (STA), and your local Art Directors Club.

# NEWSPAPERS

## FRONT PAGE NEWS

Many cities are losing the daily newspaper as we once knew it. As newspaper operations close, scale back, or change business and presentation models, it's evident that this market is changing and business is down (understatements to some analysts, complex exaggerations to others).

Blame it on the economy and/or digital media, but don't sound the death knell or break out your black duds yet. Are you a veritable news junky who feeds a daily fix at the local library? Or perhaps you're just someone who enjoys perusing the *Sunday Times* over a lazy brunch? Whatever your habit (and there are far worse addictions) folks want—still *need*—to get the news. Journalists still get

out—want to *report*—the stories. But how those bulletins break and get delivered is at the root of the real conundrum.

## SAVING TREES

Cable television news is hot. On the web, news sites and news apps for mobile devices are revolutionizing news delivery and consumption. Ad revenues are migrating to the web. But you hardly need me to tell you all that or how. I made the statement previously that, here and now, newspapers are faring worse than magazines. What's black and white and maybe read—even red—all over?

Technology will ultimately write the headline with a happy ending dependent on what side of the story you're on. I myself optimistically adhere to an earlier sentiment: that embracing new-generation opportunities may actually offer revitalized hope for a challenged market. I don't think it matters much if management failed to see (or ignored) the writing on the screen. Will the evolution of technology give literal meaning to the old ink-stained declaration of "Stop the Presses"? Perhaps. But I'm betting that the *news* simply survives through innovation and a different business protocol.

## START SMALL

Here's a riff on an earlier, simple train of thought: there will only be two types of newspapers: those that embrace your visual aesthetic and those that don't. Makes it easy, doesn't it?

But of course, you might just engineer a modest career track; beginning with a community newsletter then working your way up to the local level and beyond. You start with small-staffed operations, work at the modest publications. You may have to accept low fees for published credits. Rack up experience and gradually climb the ladder. Consider pro bono: think about doing a few freebies, as long as these loss leaders are not with highly capitalized, major-market players. Understand the arrangement and make sure there is a measurable benefit from giving away your work (and refer to the index for more information on pro bono throughout this book).

I can't say that *all* roads lead to the Internet, but it looks like we're getting there, and when in Rome . . . With print formats currently offering a bumpy career ride, it may be easier to market your illustration services, full-time or freelance, to web news outlets (and magazines). But certainly—and always with the caveat, *at this writing*—don't write off the print market yet.

Regardless of format, content will be the wildcard, Ace. You're going to find neighborhood newsletters, local and regional news (*Dayton Daily News*), big city newspapers with a national circulation (like the *Times*), newspapers with a national scope (*USA Today*), tabloids (the *Enquirer*), plus general or special interest newspapers (*Funny Times*), and online news services (*The Daily Dot, Mic*).

Wrangling the pages of any news site or newspaper will be, as Robert Zimmerman tells us, "extremely busy people working on tight deadlines. They do not want to be guessing as to style. They'll handpick the person who best suits the assignment. Whatever it is you do best, that is what you should offer."

## NAME THAT TONE

The basic structure of a newspaper—digital or traditional—doesn't vary much from one to another. In that the primary function of a newspaper is to report some kind of news, even the *New York Times* and the *National Enquirer* are still editorial sisters under the skin. Okay, I'm snickering, too, but without comparing apples and oranges, do their websites honestly look all that terribly different?

Compare two newspapers (coming down to earth somewhat, the *Washington Post* and the *New York Daily News*, for instance) to contrast those qualities that make each publication unique and individual. Determine a newspaper's philosophical content and political position. Analyze subject matter while examining writing style. Do you agree with the editorial stance?

Evaluate all the visual aspects—illustration, design, photography, infographics—is the art conceptual or straightforward? Do art, design, and copy elegantly harmonize to better convey content? In your evaluation, does the general illustration and overall design ethic succeed here?

Tom Graham says, "I think it is important to objectively analyze the look a newspaper is currently printing. Chances are, they will not stray far afield from that look. If what you see turns you on, and you feel you would fit right in— maybe even do it better—then proceed."

# SKILLS FOR NEWSPAPERS

Art, design, copy, photography, and advertisements share the pages of the newspaper or news site. Someone is certainly working as a page designer; there will be production artists.

Depending on the size of the operation, the person who does layout may be doing the graphics, as well. "Doing graphics" could entail illustration or calligraphy; perhaps photography is part of that mix. Maybe they produce infographics (maps, charts, and diagrams), too. There could be some project research and development; perhaps a bit of writing even. Online, these job descriptions may morph or blend out of necessity and economics.

Way back in the day, black and white was the bread and butter of newspaper illustration, but thank the influence of *USA Today* (and the computer) for the explosion of color as we know it in the newspaper industry. However, "retro" (the large dot, halftone look, including that intentionally off register thing) is popular. Black-and-white imagery abides.

A staff designer just might field the daily grind—which could actually be a daily, but maybe weekly, semiweekly, or sporadic grind—of any illustration on-demand. Surely, fast, fast-breaking stuff and extremely tight deadlines will be handled by staffers. But another side of that coin is that late-breaking jobs *are* often assigned to those freelancers with a rock-solid rep for dispatching short turnarounds under high pressure. Especially in an overload situation. When there's way too much on the drafting table, reliable freelancers (illustrators and designers) will be brought in to relieve the stress and strain. "However," says Shaw, "as in the past, and even more so now, you have to be quick on the draw. Pun intended."

Features or magazine sections that are planned well in advance of publication (and most likely dealing with upcoming events, ongoing trends, or timely ideas) also are freelance possibilities.

## SEND IT TO ME

Do you send samples to the editor or the art director? As a general rule of thumb, you may want to send samples to the art director or design director, unless instructed otherwise. The "unless instructed otherwise" is the key, as it's okay to submit samples to the editor, publisher, or a designated staff contact.

The editor or publisher are one and the same person at some newspapers and news sites, especially at the smaller ones. Likewise, small operations may not have an art director. Maybe job titles and administrative responsibilities are coordinated, shared, or rotated among staff members. A chief designer acts as art director. The assigning editor also designs. Establish the appropriate contact at the newspaper by doing your homework. As said before, don't forward a portfolio unless you have a specific name or know the correct department accepting submissions.

## CHECKING IT OUT

How to find out if a newspaper accepts freelance work? Call, email, or simply ask the art or design director (or staff). Consult *Editor & Publisher* (www.editorandpublisher.com). *E&P* is "the authoritative journal covering all aspects of the newspaper industry, including business, newsroom, advertising, circulation, marketing, technology, online and syndicates."

You could contact the Society for News Design. The SND ( www.snd.org) is an "international organization for news media professionals and visual communicators [whose mission is to] enhance communication around the world through excellence in visual journalism."

Also consult the *Artist's and Graphic Designer's Market*; the *Writer's Market*; *Gale Directory of Publications*; and the *Columbia Journalism Review*.

## BOOKS

## BY THE BOOK

Forgive the clichéd heading. It was so obviously *obvious* that I fearlessly gave into the foolish inevitable. Feels a bit liberating, actually.

The book market offers a rich and rewarding arena to practice your craft. To begin, let's discuss conventional differences between traditional trade books, textbooks, and mass-market books.

According to scholarly glossaries, trade books are "books intended for the general public, and marketed through bookstores and to libraries, as distinct from textbooks, or subscription books." A textbook is "a book used for the study of a particular subject; a manual of instruction."

Textbooks are educational materials, sold directly to educational institutions. Trade books are sold at retail and appeal to a select audience. They can be scholarly works or professional titles, special interest books, instructional manuals, biographies, serious fiction, larger format books, cookbooks, and juveniles (often, but not necessarily with a teaching motive).

Mass-market books are sold at newsstands or bookstores and other retail outlets, and produced in high volume at less cost (to hopefully generate big sales). These books are more commercial looking and created to appeal to a large audience. Mysteries, spy novels, gothics, fantasy and science fiction, historical and modern romance novels all fall into the mass-market category.

## EEEEE, BOOKS!

An electronic book is a book in digital format. Well, that was plain enough. What makes for a good ebook? The same stuff that makes for a compelling read in hard copy applies to ebooks—distinctive content.

Mobility; availability; shelf life; ease of use; ebooks create a delightful reading experience for couch potatoes and hot trottin' taters on the go. Devices like Amazon's Kindle, Barnes & Noble's Nook, Canada's Kobo, and of course, the Mac Daddy of them all—the iPad—are driving booming ebook sales off the charts.

The obligatory turf wars (embodied by proprietary hardware and software like Apple's exclusive app for ebooks called iBooks and its sister sales service, the iBookstore) led to new models of production, costs, sales, and distribution. Consider the art of navigating business deals for this new sales direction, and throw in the hot button issue of Digital Rights Management, and we've built a platform that becomes all the more interesting for consumers and creators alike.

## IN THE HOUSE

A publishing organization, with its various imprints and/or divisions, is called a "house." Several different companies may be found under the central umbrella of a publishing house. For example, take the fictional house of Caputo & Sons Ink (C&S). This company, now based in Delaware, has been in business since 1988, and owns a number of imprints. C&S subsidiaries publish a wide variety of books covering diverse topics, publishing everything from cookbooks to spiritual nonfiction. For instance, Moitz Press, one of its imprints, out of Ohio, specializes in art and design titles.

## PLEASE ALLOW ME TO INTRODUCE MYSELF

What is the best way to break into this market? Let's assume you've looked at books. You've done your research by patronizing the library and the bookstores, browsing the newsstand, visiting schools, and attending trade exhibits. You've studied covers, interior layouts, internal illustrations, and technical drawings. You've analyzed book design—compared trade books and textbooks, children's books and adult titles, and examined the mass-market paperbacks. You've located addresses, names, and phone numbers, and are ready to mail your promotional pieces.

What—and how—to send? "I would definitely advise not using snail mail to send samples of your work for the publisher to keep on file," says Vicki Vandeventer, "unless of course it's a promotional piece designed to get some extra attention. I absolutely think that the best contact method is email. I would include a brief introduction in your message with a link to your website, which should contain an 'about' page (which could include a résumé or bio). You can also attach a pdf file of a few appropriate work samples to your email," she says, "but as an art director myself, I want to study your website."

What you show (and/or send) obviously must address your strengths, but it's continually up for debate whether art directors prefer working with specialists (see Chapter 10, The Portfolio). Publishing credits can add credibility. Parallel experience is a plus—any work that even remotely resembles your contact's bailiwick can only help. Follow up with a phone call or email at some point shortly thereafter. Ask if they'd like to see more or talk further; perhaps in person with more work in hand?

It breaks down to this: determine where you fit in; then get your marketing and self-promotion in gear. And while it never hurts for you to have a spiffy interview outfit hanging at the ready (and to polish your in-person routine), Vandeventer confesses that, at her staff gig, she actually never uses the phone on her desk. She'll speak with a freelancer occasionally on her cell, but all communication with outside vendors, including printers, is accomplished through

email. "It works great, and I think it's the most efficient way to communicate. You automatically have a record of everything that's discussed, which often comes in handy down the road."

### COUNTERPOINT

But here we should also listen to Kristine Putt, who says, "Many freelancers operate under the notion that they can communicate with clients *strictly* via email or social media. A friend of mine tells me, 'If I need to talk to a client on the phone, I don't want their business.' I don't believe this attitude is smart freelance/business management."

Putt feels that you can't force clients into communicating with you solely on your terms, and still expect to be appreciated. "You need to be flexible and meet customers on *their* terms. Some people simply prefer to discuss projects via the phone. If you want their business, you need to make it easy for people to connect with you, and they will love you for it and refer you to their colleagues."

The outcome? Telephone and in-person meetings may create a solid, more intimate relationship between the illustrator and client, establishing a personal connection that reduces the chances of conflict and chaos.

## WHOM TO CONTACT

Hmm . . . editor or art director? Research, research, research (see our sidebar on the following page). If you can't initially find the person's name, dig deeper: send emails, make calls—ask questions. Find out who accepts submissions and ask specifically for that person's name, title (editor, submissions editor, or art director) and department. Get the correct spelling of anything and everything.

The editor probably has more control than the art or design director. But the art mafia may be more supportive of your cause, and dealing with them (if they like your work) may be easier. In general, I'd say send an art submission to the art director.

### LOCAL FIRST?

Although unlikely, there may not be a publisher in field goal range and you'll need to punt. And I bet you can make that long kick. Homegrown is neither completely necessary nor mandatory, and working with "out-of-towners" is common practice, certainly these days. But I always feel it is best to start locally— simply because, well, you live here, right?

If nothing else, your shot at person-to-person, live contact and interaction is more feasible. And there is the thinking that publishers may try new or inexperienced people exactly *because* of their accessibility. But regardless, as a stranger, newcomer, or unknown quantity, if soliciting your work to publishers anywhere and everywhere, make sure you offer experience and chops the publisher needs (and/or may be unavailable locally).

# HOUSE HUNTING (DIRECTORIES, ORGANIZATIONS, TRADE MAGAZINES)

How do you locate those publishers that best suit your talents? You could approach a publisher directly and request a catalog. You can always look online to see if that catalog is just a click and close. As Vandeventer tells us, "the best way to do research on publishers is to look online. All publishers have a company website these days." Look for work that resonates with you—chances are, if you like their work, they'll like yours.

You can always haunt the library and the bookstore. But Vandeventer points out that it may not be so easy to find a big bookstore and wander around anymore. "However," she says, "you can do that online via Amazon; it's a great resource!"

There are various directories and publications you can scour for possible contacts and contact information. Explore the *Literary Market Place (LMP)*. Research the *Writer's Market*; *Novel and Short Story Writer's Market*; *Poet's Market*; and *Artist's & Graphic Designer's Market*. Check out *Publisher's Weekly*; *Writer's Digest*; *Print*; *Communication Arts*; *How,* and *Graphis*. Write to the Children's Book Council.

Here are some good links to publishing organizations:

➡ Book Industry Guild of New York (formerly Bookbinders' Guild of New York), www.bookindustryguildofny.org

➡ Bookbuilders of Boston, www.bbboston.org

➡ Midwest Publishing Association, www.mipa.org

➡ Publishing Professionals Network, www.pubpronetwork.org

➡ Association of American University Presses (AAUP), www.aaupnet.org

➡ Publisher's Marketplace, www.publishersmarketplace.com

➡ Society for Scholarly Publishing, www.sspnet.org

Check out your local Art Directors Club. Other organizations you may want to join, network with, or simply be aware of are: the Graphic Artist's Guild, American Institute of Graphic Art (GAG and AIGA boast local chapters and a national membership); Society of Children's Book Writers and Illustrators; Guild of Book Workers; Boston Book Festival group.

By the way, the Publishing Professionals Network mentioned above is a nonprofit organization founded as Bookbuilders West, and rechartered as PPN in 2012 to "reflect the changing nature of long-form content publishing and embrace all the partnerships that exist within our industry [and provide] educational resources and opportunities for all individuals involved in book and book-related publishing." Talking point: is this change in monicker a handwriting on the wall scenario, anyone?

## BOOKED SOLID

Other than books, what do book publishers produce that might require freelance help? Beyond illustration for interiors, jackets, and covers, book publishers need freelancers to work on ads, direct mail and promotional pieces; newsletters, brochures, and catalogs, and point-of-purchase displays. Many book publishers also produce activities (coloring books, for instance), educational aids (flash cards), games, and posters.

You'll find that most publishers use this freelance help, especially the larger houses. The easiest way to verify this is to contact an art director and ask. "I'd recommend sending an email instead of calling," Vandeventer tells you. "The in-house staff at a publishing company is much smaller today than it used to be. The good news is that freelancers are used extensively, both for illustration and design. The bad news, possibly, is that no one has time to talk on the phone with prospective freelancers. But if you email something to an art director, it will definitely get looked at."

Digital submissions are the way to go. And this definitely makes it easy to work long distance with a publisher. Usually, deadlines are reasonable to generous in book publishing, and book projects are typically extended affairs—rarely rushed into, seldom rushed through.

The house publishes many books, and evaluates far more than ever see print. A prospective manuscript may be tied up for two months or more while it is reviewed and evaluated by any number of people, before a decision to publish is made. Matching appropriate writers, illustrators, and designers with the right project is done thoughtfully and over time. Electronic and online submissions dovetail right into the work schedule of an extremely careful, but exceedingly busy art director.

## MAKE YOUR MARK (FOLKS JUST LIKE YOU)

### HODGSON: DOUBLE AGENT

"I have a strange double life as an art director at a publishing company and as an illustrator," says Rob Hodgson, "so I've seen both sides of the portfolio. When I'm looking for new illustrators to work with I like to see a portfolio on the web with lots of images—big ones that are easy to navigate.

"I love a website you can spend a little time at," he says, "getting lost in projects, both commercial and more personal ones too. Diversity is good. I think it's important to see how someone works across different contexts and approaches different projects.

"When showing my own portfolio," says Hodgson, "leaving out anything that I would never want to do again is a good idea, but don't be coy and only show your best three images!"

# INTRODUCTION

There is not a large market in *all* cities for book illustrators, and, as said previously, it's a toss up whether publishers prefer their talent to be local, if not in-house. And when book publishers do look out of town, it's arguable if a house will prefer to hire freelancers from bigger publishing centers (say, New York, Boston, Chicago, Los Angeles).

Yes, these cities employ a lot of illustrators, and those folks work with all the major publishers in those areas. "But I don't think you need to live in a big publishing center or even a major city to make it as a freelancer," Vandeventer says. "I do think you need to have experience working with a publishing company or two to be taken seriously. That should prove that you know what you're doing, and it will also give you a lot of good contacts in the publishing business."

To introduce yourself, focus on examples of illustration that seamlessly sync with typography as the crucial design element, and present this body of work to appropriate art directors or editors. Actual, produced work will be best or better, but bright ideas and enthusiasm may be appreciated. However, keep in mind that visual smarts coupled with technical knowledge and practical experience are what the publisher needs and demands.

## INSIDE JOB

"I've never found that a publisher actually prefers to hire one *designer* for both the cover and interior," Vandeventer says, "but I'm not sure it's a given that a chosen illustrator will do both cover and interior illustrations.

"I've always thought that was unfortunate, but maybe there are specifics to the education and children's market, where function can dominate form and budgets may be minimal.

"About *design* . . . these days, simple book interiors are often template-based; the typesetter just follows the template. This is obviously not ideal and is not the case for books that contain a lot of art, but it's the norm in scholarly publishing at the university level. Elementary, high school, and college textbooks are more complex and are more likely to be individually designed."

# ON THE BOARD

(PROFESSIONAL VIEWPOINTS IN 50 WORDS OR LESS)

Address the needs of this marketplace. Accept the fact that you won't get the big money or high-profile work right away. Get exposure, but more importantly, explore your media and the way you see the world.

—Sam Viviano

Retail brands, corporations, and other nontraditional publishers are creating their own print and/or digital magazines to control their content and reach consumers. These offer opportunities as well, and have a distinct visual voice.

—Stan Shaw

I believe 100 percent in the basic necessity of a story: a beginning, a middle, and an end. And your form of visual communication—illustration—is a necessity. Be true to yourself; otherwise, you'll have no passion for what you create. And passion is what drives you in your life's work.

—Margaret Hurst

Concentrate on a standard of excellence and keep it up. It doesn't matter which media—magazines, newspapers, books—you work in.

—Bill Mayer

© Giovanni Da Re 2015

© Mike Quon 2016

Curiosity is the most important quality you need to succeed in this marketplace. If you aren't endlessly curious, wanting to know how to do things and how things work, you might get frustrated by how quickly this industry can change.

—Nadine Gilden

Remember that magazine, newspaper, and book publishers don't ask much—only that it's absolutely clear you know how to illustrate for their product. No sweat, right?

—T. Simon Katt

The world of print has greatly diminished. The trick is to learn motion, to keep the packaging of information uniform, readable, and creative within those formats—fresh and educated. There is hope.

—Mike Salisbury

© Ellen Weinstein 2016

# Chapter 17

# Paper
## Products

---

*You may be really good at greeting cards, but don't limit yourself to just that. Take advantage of every opportunity.*

—Randy Glasbergen

## POWER ON

"What's exciting about [this] creative work," says Shelley Brant, "is that I'm steering the ship! If I feel like crafting one day, that's what I do; if I have a new drawing style I wanna try out, I do it."

Brant says she has more ideas than time and being in control of her own schedule has allowed her to "really switch on the rocket boosters. Every day is different. That in itself is very exciting to me!"

## OVER THE MOON

Likewise, Alex Colombo taps into her twenty-year experience in textile, interior, and graphic design, and is busy working on new collections, art submissions, and ongoing licensing opportunities.

Formerly from Milan, Italy, and currently stateside, Colombo is now an illustrator, and is, even in the middle of all her artistic endeavors, something of a social media guru. Colombo has fun marketing her work, but also loves to pay it forward. In her popular blog, *The Moon from My Attic* (a fountain of great advice and valuable tips), she frequently promotes and showcases other creatives.

Colombo's blog introduced me to, and inspired me to discover, a segment of artists producing a rich variety of ventures. I noted various themes we should elaborate on, particularly in this chapter on paper products.

## PASSION PLAY

For these artists, I saw that passion plays off experience—at any level of expertise, on any rung of the ladder of success. Design "sophistication" is a relative term; many artists who work in a traditional vein counterbalance this approach with a whimsical touch or even a funny flip side. Serious fun, anyone?

As mentioned previously, Simms Taback once said that this is a business of people. So it obviously behooves illustrators (and designers) to be highly functioning businesspeople. I was pleased to find this mindset a simple *been there, done that* fact of life for the decorative artists I discovered. For some, this business acumen wasn't the easiest aspect of their creative operations, but all rattled their inner shark cage with efficiency, if not gusto. Obvious to even a casual observer, these were arty folk who understood how to maintain a creative business.

Helz Cuppleditch says that, in her opinion, *the* most important thing any artist can do professionally is to educate yourself with that business side—particularly for art licensing. You must know the lingo, understand contracts, and keep solid accounts. Be on top of your marketing and promotion, as well as how to display *your* work.

# BEYOND THE OBVIOUS

Illustrators (a.k.a. illustrator/designers) licensing decorative arts are firm believers in the power of communication through socialization, networking, and education—the concept that an independent artistic spirit can be nurtured by diversity and collaboration.

Style? Representation and interpretation mix and match. Retro, traditional, and contemporary styles are right at home with old school and digital techniques. All play well together (or in tandem), and coordinate for modern production.

I've mentioned in previous chapters that inspiration is everywhere, and Colombo's respondents adhere to my thesis. Rebecca Baer, for one, believes we are surrounded by inspiration and need only to recognize it. "I look beyond the obvious—like flowers—to the oft overlooked elements," she reports. "A pile of rocks will reveal beautiful shapes and hues that become fodder for a background treatment or a tone-on-tone color palette.

"With that in mind, I study elements that make up larger objects. For example, in a crumpled piece of paper I look for shapes, shadows and lights or perhaps objects that seem to take form within the larger object. Not only does this practice provide me with unique and ever-changing inspiration I am also able to avoid being unduly influenced by all of the wonderful art created by my peers."

# BLESS HUE

Colombo pointed me in the direction of Keiko Suzuki, who discovered an innovative newspaper collage technique that revolutionized her process and revved up "a personal creative frenzy driven literally piece by piece."

Suzuki kept driving. She opened her first Etsy shop, Bless Hue, in 2012. Allowing for what she labels "a grassroots type of growth," Suzuki protected her work through copyright and established relationships with different online vendors (all the while, reveling in the tangible encouragement of royalties).

She may be a self-proclaimed newbie in the art licensing field, but Suzuki is wise enough to understand the power of a good mentor. In this case, a world of advisors—Suzuki enjoys the pointers found on the Surtex Webinars and the many art licensing market forums she visits. Thankful for the shared expertise of experienced licensors, and ever grateful for those generous details, Suzuki remains curious about the ubiquitous opinions she inevitably runs into. She is always open, but nevertheless, discerning; taking all and any advice, as she puts it, "in stride."

# BAER WITH ME

Baer's licensing journey began, "When an agency contacted me, and asked if I'd be interested in representation," she says. "I stayed four years with these folks. At the end of 2012 I made the decision to strike out on my own, independent of that agency.

"You make such a major change, and you always wonder if you are making the right move. I now have many years of self-representation under my belt and I love it! The one-to-one interaction and responsiveness is very rewarding. I recognize that going it alone is not for everyone but, as an independent business owner, I felt once-removed with an agent as the go-between.

"And I have seen my work evolve since entering the field of art licensing," Baer says. "I've discovered a new creative freedom, a freedom that reflects back to the materials that I continue to use for the DIY painting market."

Just a word of explanation here. Baer began with paint and a brush, but technology demanded that this successful licensing artist be proficient with a computer as well. She advises the same course for friends and colleagues who begin their journey of pure hand painting while evaluating the prospect of a career in art licensing. "When asked for advice," Baer says, "I focus on the importance of developing or refining their computer skills in order to create layered files so often requested by manufacturers."

## MUM'S THE WORD

Cuppleditch is an illustrator based out of the United Kingdom, developing product for paper craft and fabrics; greetings cards, calendars, and stationery; gift wrap, gift bags, and packaging. Cuppleditch unequivocally tells you she's living her dream: being "Mum,"while working out of her studio at home, and running a wholly satisfying business operation.

Initially, Cuppleditch didn't realize that art licensing was the 800-pound. gorilla sitting atop her portfolio. "That sounds naïve," she says, "but after I started licensing my stuff for greetings cards, it hit me that my work could be used for other products. So I investigated and educated myself about this wonderful world of licensing."

A lot of her work is still used for greetings cards, but Cuppleditch also creates collections for other products. A big leap forward for her came in 2009 when she was commissioned for a rather successful paper craft collection in Europe. This led to other manufacturers and more licensing (and more illustrations for other surfaces).

She's done a few illustration projects, and enjoyed some advertising agency work for global brands, but Cuppleditch says, "I admit—my work is decidedly feminine and whimsical." She muses that, as such, and again in her estimation, she's somewhat limited to the established markets of advertising and editorials, so she's happily pursuing art licensing.

## RUNNING THE SHOP

A former product designer for a large chain of art supply stores, Brant worked her way through a slew of art-related jobs and eventually became a product

designer for Michael's, North America's largest arts and crafts specialty retailer. This wealth of experience was the perfect preparation for the job she has now—running her shop, Figgy Pudding Designs.

"Everything I do for Figgy Pudding is done in Adobe Illustrator," she states. "As a product designer who has worked with a variety of purchased art—some good and some not so easy to deal with—I want to supply clean vector art that's easy to alter and adjust to suit a number of different uses." But as she's quick to add with a smile, she also loves to paint and will forever be hot gluing, sewing, cutting, and crafting.

Currently Brant is working with overseas manufacturers, helping them understand trends and design for an American consumer. "Art direction," she says, "has always been a daunting process to me. I feel as though design is such a subjective thing; who am I to say what's good or bad? I feel like I'm learning with every assignment and the research and development involved have been invaluable to my growth on the whole. Sometimes analyzing and researching colors and trends and new products feels like it takes too much time—hey, you'd rather just get to drawing—but it's something you must do to make sellable art."

So far, Brant's art licensing experience has been just great, thank you. She values the many resources she's enjoyed, and cites a community of involved people, open to sharing experiences. "Plan and research all you want," she says, "but until you start, you'll never know what you don't know—I've learned more in the last eight months (through networking) than I ever imagined I would."

## SHINE A LIGHT

Tammy Smith is a mostly self-taught artist and surface designer who grew up, and still lives, in Kansas City, Missouri. Smith began her career at Hallmark Cards and over the years she's also illustrated children's books while working in many different mediums, including ceramics, wire, acrylic painting, and 3-D mixed media sculpture.

Her online shop comes after entering the licensing field from the corporate world about three years ago (at this writing) and she says she's learned that licensing is a marathon, not a sprint.

"A conversation leads to concept development before signing a contract," she says. This is where she says you have to be comfortable essentially working on spec. "After completion it's usually months to a year before the product is actually introduced for sale in the marketplace," she tells you. "If you're not patient—like me—that wait can seem a long time—but it is exciting when you finally see your product on the shelves!"

How about financial returns? Licensing means you'll be playing the waiting game here, too, so Smith advises multiple income streams. "It's best to either

have another way to make an income or have money saved that will keep you afloat," she recommends. "Many licensing artists I know also do graphic design or book illustration while pursuing licensing deals. I think that just makes you a stronger designer and adds more images to your portfolio."

Another advocate for social networking and the world wide web of education, Smith says that reading licensing blogs provides a wealth of useful information. And the old adage "one thing leads to another"? Quite apropos, according to Smith. "One other important thing is to find what makes you unique," she says. "What makes you different from the crowd? For me, it was in the materials I used. I'd been making and selling my mixed media wire sculptures and lamps (under my previous business name 'Homemade Circus') so I brought a wire lamp to my first Surtex show.

"That lamp sparked a conversation with various buyers, and this led to a wonderful partnership. My new line of wire pieces debuted at the January 2014 Atlanta Gift Mart. This wouldn't have happened if I hadn't brought the lamp!"

## MAKE A LIVING

While Joan Beiriger is not connected with Colombo, she shares the same admirable work ethic, chops, and business savvy displayed by the other artists profiled above. Beiriger says that one essential question artists interested in licensing their art must ask is: "Can you make a living licensing art?" She tells you that before the recession of 2007–2008, lucrative licensing deals were common and, yes, many illustrators could actually make a living licensing their art.

But at this writing, it's a different industry and a strapped economy. "Because of the shift in the economy and consumer spending," she says, "fewer artists are able to make a living *only* from licensing their art. Most of the artists that do make a living by licensing have been doing so for years. They've built a consumer following, and have a solid relationship with the manufacturers that license their work."

### THRIFT SHOPPING

Beiriger cites research pointing out that the current dicey economy is forcing consumers to spend differently; to shop for bargains, and to *expect* these discounts from retailers—there's no serious splurging; you normally will buy only what's needed. She states that current predictions indicate that these spending patterns aren't likely to change anytime soon.

We all love bargains and retailers obviously comply and provide. The one-stop-shopping experience abounds (think Walmart and Target) and, as Beiriger says, "retailers not only have brick-and-mortar stores but also sell their products on the Internet."

And here's where Beiriger gets us right to the heart of the bargain basement. "Of course," she says, "the shift in consumer spending has a huge impact on the

art licensing industry." Beiriger goes on to say that retailers buy less product and often discount seasonal items way before the end of the season. This means manufacturers cut back on production and pump out less stuff. As a result, artists get less revenue for a design that—even with a multiyear contract—may not be produced again the next year.

## TRICKY BUSINESS

Beiriger smiles when she says, "Licensing art has never been easy. And it has gotten harder. The term often heard in art licensing, 'don't quit your day job,' is so true.

"[One of the keys] is to not just license your work, but to also sell it," says Beiriger. "Not all artists can earn enough in licensing and they need other means of revenue to support themselves. Some have full- or part-time jobs that may or may not be related to art. Some sell their art in galleries, at art and craft shows, or do commission work. And, others sell their art on Internet stores. There are pros and cons to having a POD (print-on-demand) Internet store, but this should be considered, too.

"What worked previously in successfully licensing art does not always work now. There are *less* retailers purchasing licensed products while manufacturers have much *more* art to choose (because there are more artists licensing their art)."

So the shoe drops. All this means that the number of available licensing deals are less, and spread thin over an ever-wider pool of artists. And the bottom line for you? "One may not be able to make a living just by licensing your art even as the economy improves," Beiriger says. "Licensing art can be a good way to bring in revenue but you still may need additional ways to make a living.

"Artists not only should, but *must*, change the way they approach licensing. Getting licensing deals is competitive. The more you stand out (by offering the right art and the willingness to satisfy a manufacturer) the better chance for you to license art."

## THE BEIRIGER IMPERATIVE

Beiriger offers a ten-point plan to land a licensing deal. There are no warranties or guaranties, but it's a sound approach that is both realistic and optimistic.

1. Create art that the consumer wants on products. Do your research; study the hot themes and color combinations that compel consumers to buy industry wares.
2. Send art that fits a manufacturer's product line. Analyze why your art fits or not. Be able to pitch your art and why it should be licensed.

3. Forward art for licensing consideration in the proper formats. "For instance," Beiriger advises, "don't send horizontal or square images to flag manufacturers who need images formatted vertically. However, if this manufacturer also licenses art for floor mats and/or mailbox wraps, then an image formatted horizontally is not only appropriate but wise to send with the vertically formatted image."

So, art for decorative tiles should be formatted in squares or facilitating an easy division into squares for murals. Coasters are either round or square, and should be submitted in the manufacturer's correct format.

4. By this token, be willing to edit art to manufacturer specifications and tell them so when you submit the art.

5. Consider sending high-resolution art to manufacturers when requested for client presentations.

6. But a warning here: while many manufacturers presell their products before producing them, such requests for hi-res art are without any assurances that this art will be licensed.

7. And remember, you're sending the art without a contract, so you'll need to trust that manufacturer before sending the images.

8. Send collections of art to manufacturers that require multiple images for their products. For example, images for tabletop ware often require a collection of multiple central images, borders, and patterns. "A greeting card only needs central images," says Beiriger, "so no need to send patterns and borders with the central image to greeting card manufacturers if that's their only product."

9. Send mock-ups of the product if appropriate. "As an example, greeting cards and flags do not need mock-ups," says Beiriger, "but it's advisable to send mock-ups for a collection of art to tabletop manufacturers."

10. And, finally, and most importantly, build solid relationships with manufacturer art/licensing directors and follow up after submitting art.

# DALZIEL

Trina Dalziel has worked as a freelance illustrator for over eighteen years. She's recently crossed over into surface design. Originally from the North of Scotland (where she grew up on a tomato farm), Dalziel now lives in London, England. We talked about process, product, and tools.

"If it's a text/editorial type project I come up with sketches and ideas first," Dalziel says. "These sketches are rough initially, but I'll then refine them a bit and send them on to the client for approval and selection."

Dalziel truly relishes the idea stage of a project. And she loves the mental exercise of finding a visual solution for a dry text or technical idea. "When that is next combined with the physical challenge of incorporating a new technique, understanding it, and coming up with a clever interpretation," she says, "that's very special."

At the outset, Dalziel's artwork is hand drawn with ink, pens, and brushes, then scanned and colored in either Illustrator or Photoshop. "If it's a more decorative project," she says, "I'll allow plenty of time at this beginning stage to draw and explore the subject matter before planning a layout.

"I like working with clients who I feel aligned with philosophically, ethically, or intellectually," says Dalziel. "It's also a big treat when a company makes the effort to involve me in color checking and proofing. And, of course, it's always a delight when those end products are well crafted or printed."

## TOOLS

Her tools are important. Dalziel takes the time to find the tools that fit. But she understands that, also with time, the right tools can rejig as style and aims change. Dalziel can also be a little superstitious in regards to her tools. "Once when I found a pen was being discontinued," she remembers, "I made a crazy dash from shop to shop across London."

Dalziel knows now that there are always substitutes, and that being challenged to use new tools can actually open up and develop work. Yet she still frets a bit. "Will I be able to create with something else?" she asks. "Or is this just a lucky brush? A charmed position for my desk? I realize these thoughts are irrational, but I'm always reassured when I read of other creators with similar quirks and superstitious attitudes to creating."

## USE IT WELL

"I'm sad when I hear of people who are daunted and held back by their lack of knowledge and mastery of software," Dalziel says. "I worked in Adobe Illustrator for over ten years and I counted up how many different skills/tools (in the software) I could use. It was less than ten.

"There's something else to consider here: I'm certainly interested in learning what's new in Photoshop and Illustrator if I can actually use it productively in my art," says Dalziel. "This is a personal reflection on how I work and learn and assimilate information; it's not instruction or advice to other artists.

"Some people can learn lots of technical information in advance and then call on it, incorporate it later—just not me. Digital skills can be learned in bite-size bits as needed. Sometimes successful artwork is created by artists who embrace only a modicum of technical skills. They know just enough to expertly create the look they want."

## IT'S ALL GOOD

So what's more important: concepts or techniques/hand skills? "Both in tandem," says Dalziel. "Neither is much use without the other. If you are a great drawer, you are an artist. But to be an illustrator you need to have excellent ideas *and* the ability to explain ideas visually; good illustrators have the ability to do this combined with top-notch skills.

"Looking back at my early commissioned work (in the late '90s), I'm amazed that I wasn't pulled up on my poor drawing skills," Dalziel says, "things got published that I cringe at now.

"With those first commissions, I used to always feel intimidated, wondering if I could do it well enough. Now—although I don't take jobs if I know I'm not suited—I do feel more confident and willing to step up to a challenge.

"I also used to believe that my visual lexicon came totally from myself, and on a direct trajectory from my student days. But now as I look back, I realized I appreciate talented designers and editors I've worked with who—in the early years—greatly contributed their ideas and direction."

# TRIGGERS

In her words, Tara Reed was just a creative gal into scrapbooking, who then fell into designing for scrapbooking—a conservative mom from Pennsylvania with a marketing degree whose idea of becoming an artist in a bigger way triggered her. "And triggered me good!" Reed says. "To say I was an artist and put my work out for the world to see? *C'mon!* Who would want my work on products?"

A lot of Reed's fear came from her belief that making it as an artist meant you had to have an art education. "And you had to be beyond amazing. You had to dress cool and maybe even smoke!" says Reed with a laugh.

Yep, Reed also believes she saw too many movies with stereotypes about artists, but she eventually shared a booth at the Licensing Expo in 2004, and the rest is history.

## SEAT OF YOUR PANTS

Accompanied by a friend (who actually was the catalyst for this fortuitous turn of events), Reed went into that show with little understanding of what to do, how to present herself or what to say. "It was basically an educated guess combined with a 'wing and a prayer' business plan," Reed says. "My nerves were so bad the first morning I wasn't sure I would make it out of my hotel room. Thankfully I did because I had invested a lot of time and money in the show and was motivated to see if this could work."

## PROOF IN THE PUDDING

Exhibiting at trade shows works—Reed is proof of it. Since that first show in 2004, she has exhibited at over fifteen art licensing trade shows and attended

dozens of industry-specific trade shows to meet with clients and connect with new companies. Over 75 percent of Reed's business and income can be traced back to a first meeting at a trade show.

## BRANDING

"The goal of a brand plan is to increase credibility, get business and create loyal clients," says Reed. "You do that through increasing visibility and understanding of who you are, what you do and how you can help others."

A brand plan includes, but is so much more than—a business name, logo, tagline, and color scheme. Here are five items to consider when building your brand plan:

- ▶ Who is your target market and why will they be attracted to you and your art?
- ▶ What are the needs—as far as imagery and skill sets—that your target market needs?
- ▶ What will the "look" of your brand be—the colors, imagery, and font style? "This needs to be consistent so your brand becomes recognizable over time," says Reed.
- ▶ Create a tagline. "Nope—'I'm an artist' won't cut it," Reed says. "[Come up with something that] makes you unique and put that into a few words that make sense as a catchphrase."
- ▶ Think long-term. Create a brand that gives you room to grow and evolve. "Just because you like to create daisies today doesn't mean you won't expand your offerings into flamingos tomorrow," Reed says. "Branding should be more about you and the 'experience' you want your customers (both manufacturers and consumers) to have, and less about subject matter."

### ALL AT A STAGE

When it comes to building your brand, Reed offers some practical advice. It boils down to four main events:

1. Awareness. The first thing that has to happen is for people to become aware of your brand—or your art—as an option. "Showing up and exhibiting at an art licensing trade show definitely builds awareness," says Reed, "but you can do things to build awareness *before* the show so you can move on to higher levels *at* the show."

2. Positive Feeling. This isn't a guarantee but definitely your goal. "You not only want people to become aware of you," Reed says, "but [you want them] to feel good about you, what you offer, and what you represent."

3. Understanding. Now you are getting into more meaningful levels of brand building. "Once people know about you and have a positive impression," says Reed, "they will begin to learn more about you, and move beyond the surface stuff. You need

your brand plan to help move them into a better understanding of who you are and what you offer."

4. Decision making. "Only after someone moves through the first three levels of your brand can they get to the sweet spot—the decision-making spot," says Reed. "That is *the* real brass ring after all, for them to fall in love with you, your art and to decide to license your art for their products."

   Is it a slow process moving someone through Reed's four stages of brand awareness? No, not if you offer strong visuals and a clear, consistent message; it could only take a mere glance, maybe a New York National Stationery Show minute. "If there's an overwhelming, immediate, and urgent need for *your* art, it could well be at light speed," Reed says. "If there's no rush or your viewer is more of a methodical decision maker, it will obviously take longer."

## LONDON TO BOLOGNA

Going global? When I wrote these words, there were two main trade shows to consider: the Brand Licensing Europe show in London and the Bologna Licensing Trade Fair in Bologna, Italy. Colombo tells us that the Bologna show is the only trade event in Italy dedicated to the business of subsidiary rights, with the participation of the main Italian and International licensors and licensing agencies. By the way, the licensing Trade Fair takes place at the same time as the prestigious Bologna Children's Book Fair. You may want to do both.

## GREETING CARDS

### A ROSE BY ANY OTHER NAME

A point of clarification, folks: in the greetings industry (as in the paper products industry in general), a design is essentially the same as an illustration. Splitting one wild hair, a design represents the idea (or concept) expressed through the visual (and not always an illustration) as the finished product.

Let's elaborate a bit here: The term "design" refers to the visual element that accompanies the editorial (the copy) on a card. This artwork may be used for a single purpose—a select card, one page or individual spread in a booklet or calendar. The design may be a basic character study, a particular scene or still life. It

could be an abstract composition, a simple pattern or border; perhaps a concept composed entirely of calligraphy or type.

Any medium can be used for a card design. You'll find designs done digitally, of course; prepared in pen or pencil, water-media (including acrylics and gouache), cut paper/fabric collage, and embroidery. A design could also be paper or clay construction, or hand-tinted photography. It could even be executed entirely in what is termed "finishes"—gold leaf, die cuts; even embossing.

## THE COMPANY YOU KEEP

Bill Abbott has licensed stateside to greeting card companies like Renaissance, Marian Heath, Pictura USA, and internationally to Hallmark UK, and For Art's Sake (Australia). I consulted with this pro on a market segment he says is still financially rewarding, but nonetheless, in a period of slow change.

The first item of business we discussed was how a greeting card company chooses the cards it will publish. From my experience, a card company targets production to selected markets, such as the young and trendy in specialty shops or the generally middle-class shoppers at, say, Walmart. Keeping a deliberate finger on the pulse of current popular culture, card and paper product companies do extensive market research to determine what categories of cards the public wants to send. Pre-market testing determines which visual styles and messages the buying public prefers.

Abbott cautions here that it's critically important to remember one simple fact of life: a greeting card isn't being produced to highlight your art, your art is being used to sell the card. If your art doesn't work within their framework or context, you're barking up the wrong tree.

"Provide card companies with artwork tailor-made to their needs," he advises, "and they'll come back to you over and over as a reliable source of good, functional material well-suited to their buying public." Typically, a submission of six to twelve samples is ideal. Too few and the creative decision makers can't develop a feel for your work; too many becomes unwieldy (considering they've likely received hundreds or even thousands of other submissions that month or even that week).

## WHAT TYPE OF CARDS ARE THERE?

Basically, card companies produce two types of product: occasion cards for standard holidays and established events (birthdays, graduation, anniversaries, friendship, sympathy), and non-occasion or everyday cards.

Within these two primary lines, look for these general categories:
- Traditional: an established, long accepted, and rather realistic approach
- Studio: contemporary and sophisticated with biting wit

- ◼ Humorous: also funny, but usually simpler and not as caustic; leaning toward the cartoon
- ◼ Romantic: hearts and flowers, decidedly sentimental
- ◼ Juvenile: appealing to children
- ◼ Cute: adorable characters in charming situations
- ◼ Stylish: a modern and chic look
- ◼ Alternative (see below)

I've seen statistics that say a good 80 percent of the card buyers are women, and Abbott points out that the most abundant card-buying demographic reflects women over the age of fifty. "The younger generation tends to be less interested in cards as a form of expression," he says. "Many billions of dollars are still spent on greeting cards each year (over $4 billion sold by Hallmark alone)." For the big picture and some relevant facts and figures, go to the individual websites of the GCA (the Greeting Card Association; as located in the United States, United Kingdom, and Australia).

Abbott will tell you that publishers like Hallmark and American Greetings aren't sitting still, waiting to see what happens with the changing face of their market either; these industry leviathans (as well as their competition) are aggressively seeking new opportunities to bring social expression into the new millennium.

### DIGITAL

Often free or for a nominal fee, eCards are hardly worth the paper they are printed on. That's a joke, kids. Being serious for just a moment, eCards (electronic greeting cards) are a booming product line for card companies.

This is smart marketing. ECards paint a positive, tree-hugging picture of an environmentally conscious greeting card company—and you, by (or buy) association. ECards are also a savvy loss leader attracting viewers to the company's website. The need for artists and animators to create them grows exponentially.

## CARD ALTERNATIVES

A note here: The term "alternative" actually has a, well, alternative definition in our present era of environmental awareness. *Alternative* products (and production processes)—a.k.a. "durable and functional," as in recycled or recyclable—are high on the agenda for eco-sensitive companies seeking to utilize resources responsibly. At this writing, and as print is not dead yet, this is only a good thing.

Let's spin the terms back again, shall we? For a company to sell more *durable* (as in shelf life) and *functional* (as in user-friendly, commercially viable) product, their cards must reflect contemporary subject matter and topics of special

interest to the card buyer. Current trends and the changing lifestyles of American consumers dictated the development of a genre that stretched the parameters and attacked old taboos: the alternative card.

The alternative market is not so new, now. Almost every company markets so-called alternative cards, so it's safe to say that the label is somewhat inoperative. The alternative card phenomenon gave us cards dealing with left—and right—wing politics; women's rights; gay and lesbian lifestyle; gay marriage; the dysfunctional and/or extended family; the singles scene, as well as divorce and remarriage (for all orientations).

There are cards helping you cope with everything from poor service to retirement; celebrating, or commiserating, about your diet; congratulating you on that promotion. You'll find discourses on technophobia, rants on high (or low) finance, and soft testaments mourning the death of a beloved pet. If the subject is somehow relevant and current, chances are you'll now find a card addressing it.

Yes, you'll still find the "warm and fuzzy" cards carrying cuddly or bubbly copy, and heartfelt messages of hope. But today's product lines also approach subject matter with new, deeper sensitivities and frank, honest sensibilities. Modern cards also act as small doses of psychotherapy, delivering concerned counseling or gentle expressions of advice, support, and compassion.

Of course, and I say this with a smile, "naughty" sentiments have been a sly staple of our culture and society, as well as the publishing industry (under or over the table) since the birth of publishing. There are practically no limits here; today you'll see cards catering to all manner (and levels) of erotic tastes and practice. I phrased that delicately, didn't I? Hope I didn't screw that up.

### TAKE MY CARD, PLEASE

Look out—cards these days are rife with sly wit, biting sarcasm and decidedly offbeat (even downright strange) humor. Want 'em coarse, shocking, in fifty shades of grey? Not a problem. They may make you blush, and you'll read language previously found only in graffiti.

Make no funny bones about it, humor sells in this market. Do an online search; you'll find busy and talented creators whose quirky (and exceptionally funny) portfolios generate big laughs and bucks in the greeting card market.

"If you can't find your sense of humor with a GPS, but can create aesthetically pleasing images, all is not lost," Abbott says. "Work with a gag writer and either pay them a flat fee for gags sold or arrange a royalty. Do an Internet search for 'gag writers' or contact groups like the National Cartoonists Society for members who offer this service."

## AT VERSE YOU DON'T SUCCEED

Here's a logical question: generally, should you write copy or verse to accompany your samples as a way to demonstrate how your designs can work in a greeting card format? Humorous copy ideas can be submitted in the form of a card dummy with rough art (especially if the visual sets up the joke; when said words and visuals cannot be conceptually separated).

Mediocre verse or bland copy as placeholders won't sell the design—you're not promoting yourself as a wordsmith, correct? Thus, if you are talented with text, and wish to be considered as a writer, make this perfectly clear in a cover letter (sent to the right person at the appropriate department, of course). Create a separate package of sentiment or verse suggestions, and make sure your lines are strong enough to stand on their own two syllables. Supporting visuals here may be an added-value option, but generally, serious copy is submitted on its own merits. And in this instance, you're not selling art, right?

## SUITABLE ART

The greeting (often called the sentiment) in a card defines the art and of course, vice versa. Different art styles are preferred for different types of cards. Think *South Park* as done by Norman Rockwell and you'll easily get the point. Actually, that might be a major hoot.

A card company must consider its entire card line when choosing what to publish. The aim is to achieve an overall stylistic balance, both visual and editorial, throughout the product line. Visually, you will find a range of the highly traditional to the oh-so hip, and a great variety of art styles and media in between.

The trendiest, most avant-garde or ultra-sophisticated modes may not necessarily be incorporated into a product line, however. Subject matter (for example, unicorns or teddy bears), a particular style (a minimal drawing approach) or technique (digital caricature) must prove to be more than a fad to be considered for the line. Greeting card art directors and designers have often looked to the fashion and interior design markets to gauge the success of an available look or theme, or even of a color palette.

Smaller card companies are often on the cutting edge of new trends. A smaller card line means shorter leadtime in preparing product. This translates to a much slighter financial risk should a fad prove short-lived. Because of this advantage, these small mavericks may set the pace for the industry at large.

# MANY HAPPY RETURNS—RESEARCHING CARDS

How can you research what type of cards a company produces? Abbott responds: "You can't go to your local chain grocery store, major national retail stores, or mom-and-pop gift shop without encountering racks of everyday and seasonal greeting cards!"

Abbot's reminder points us to this obvious first wave of research that, arguably, may be the best method to check out greeting card wares and markets. I can't say "hands down" here—initially, an online exploration will be more immediate—but logically, a *hands-on* experience with this type of product is still smart (and a good thing).

Go to every outlet you can find (some shops may carry one company exclusively, but most stores carry lines from many different companies). Spend a lot of time at the card racks investigating the type of cards each company offers. "See any cards that present a style similar to yours?" Abbott continues. "The names of the manufacturer are printed on the backs of the cards. Is there more than one card company where your artistic style might be suitable?"

Buy the cards you like best and that seem closely related to your own style. Check logos and get a feel for which companies put out the kind of cards that most appeal to you. If you're not purchasing today (or didn't record pertinent info from an earlier visit to a company's accompanying website), jot down the corporate data while browsing.

"It's worthwhile to have a pen and paper handy to gather information," says Abbott, "or use a device such as a smartphone with a notepad function to record your observations. When you get home, visit—or revisit—the websites of those card manufacturers and seek out their submission guidelines, usually provided somewhere on their home page."

A few notes here: Your fact finding shouldn't be a problem at the store, but always clear your intentions and actions with a clerk or the owner at some point. You won't have any trouble if you just introduce yourself, state your purpose, and express a small bit of thanks. Oh, yes—come prepared—don't borrow envelopes for notepaper.

## PAPER CUTS

A first visit to the company's website or the card shop will give you an initial overview of their product. If for some reason you can't find a particular company's wares online or at the stores, call or email them and ask where to find their cards in your area.

You could also write to the company's creative department. Blasphemy—a real letter!? Sure, send them a custom greeting card; use the opportunity to market a mini-portfolio, as well. When writing an actual, more traditional type of note, use your letterhead, enclose a business card; toss in an

appropriate promo piece—this will provide the reasonable evidence you're not a spy for the competition.

To research virtually all the greeting card companies at once, attend the National Stationery Show, held in May at the Jacob K. Javits Convention Center in New York City. Here you can interview and show your portfolio, market and promote your work, network, and examine every aspect of every company—all at one time, under one roof.

## PAY ME NOW OR PAY ME LATER

Let's discuss royalties vs. flat rates. Typically, greeting card companies pay creative providers via one of two forms: flat fee or a royalty percentage (and often with an advance).

"Flat fees will vary and could be negotiable, depending on the company," Abbott says. The benefit of a flat fee is knowing precisely what you'll receive for your work, and that you'll receive it (usually) upon delivery of the completed art. The downside, when compared to royalty-based arrangements, is that there's no follow-up income from that sale.

With a royalty arrangement you earn a percentage of net sales. This, in Abbott's experience, has been anywhere from 4–10 percent and is usually paid quarterly. Additionally, you may receive a modest advance on royalties (for Abbott, this has ranged from $150 to $300 per design sold). "This is sort of a guarantee for your efforts," says Abbott. "Once sales surpass the amount of the advance paid, you will receive the quarterly royalties for as long as the card remains in the marketplace. If the card sells well, you may continue to receive payments for many years after the initial sale. Should you have the good fortune to have multiple cards under license, the quarterly income could be substantial."

## RIGHTS (AND WRONGS)

"Among the more critical elements to the business end of your art are the rights associated with its use," states Abbott. Should you sell all rights to your design or negotiate for royalties?

It's hardly uncommon for card companies to purchase all rights to designs. Let's examine the company's rationale behind this. Let's imagine the negotiator—for, let's say, the fictitious Has Bean Greetings—handling such a sale: "Card designs are invariably done quickly and in volume," she might say. "We don't see your design(s) offering much marketability in other areas, and we don't usually sell an old design to another company. You're not offering us a unique character or fresh concept, a hot look, or a style that is well known . . . but we like your stuff, and we want to buy your card designs outright." Do you buy into this buyout?

What about royalties? Keep in mind that royalties on a single design could add up to less than an outright sale. Now, a *line* of cards (or products utilizing your imagery) is another story. If control of your artistic vision in either scenario is justifiably a hot button for you (and it should be), selling all rights is certainly not *your* best deal.

Ilene Winn-Lederer tells us this: "In the greeting card industry, where so many images are continually produced, it is difficult to consistently follow up on what royalties are due ... especially if you are working with a small company that may or may not maintain diligent records. Large companies often have formal accounting procedures, and they will send regular statements. Nevertheless, I prefer to get paid a fair use price up front whenever possible."

"The early stages of courtship," as Marti McGinnis labels beginning negotiations, "is a good place to determine just what kind of rights the greeting card company expects.

"In gentler times it was no problem to retain the copyrights to their work," she says. "But with the explosion of corporate giants and global marketing on the Internet, it's getting increasingly common for large and small companies alike to demand 'All rights throughout the universe.'"

No, she's not making this up. Don't be a space cadet, however; fully understand this little licensing moonwalk. "If you're willing to grant a package of 'universal' rights," says McGinnis, "Make 'em pay up!"

What's that you say? You don't mind seeing your creation become the next hot fashion trend? Okay ... sign off on all rights for whatever it is they're paying you per T-shirt design and watch them—not you—rake in any licensing royalties.

McGinnis isn't telling you to be contrary or forfeit the deal if you can help it. If there's no extra money to make it worth your while, then make other reasonable demands: perhaps it's your signature as part of the design (at least your name gets out there every time they use your creation).

McGinnis also has this wise advice: No matter how wonderful the art director may be (and you will work with plenty of absolutely great people), the paperwork will be issued by company lawyers protecting corporate interests. These people generate a distinctly anti-artist document; they often have no idea (or plead innocent or play dumb) as to what it is they're asking you to agree to. "They may not—or will not—be ready to comprehend your concerns for your rights as a freelance artist," McGinnis says.

A good contract is an artist-friendly contract. Educate yourself as to what this means (and means to your career). Refer to previous chapters in this book to begin your contracts homework (listen up; there is reading and writing involved, and there *will* be a test when you negotiate your next contract).

Read up on licensing online, at the library, or bookstore. Consult the *Graphic Artists Guild's Pricing and Ethical Guidelines* and look for Caryn

Leland's *Licensing Art & Design* for great, practical information and an extended discussion on this subject. It's slightly dated at this writing, but nevertheless still comes up as your first choice on an Amazon query and is a good place to start. Another positive thing you can do for your business education is to become a member of the AIGA (www.aiga.org) or the Graphic Artists Guild (www.gag.org).

## SWING!

The majority of US greeting card markets, in Abbott's experience, are royalty-based. Here, possibilities across the spectrum of card companies (and their outlets for distribution) are remarkable. Do the math: A greeting card that nets you, let's say, royalties of $300 per quarter means $1,200 per year. Let's go big or go home: if you sell 50 designs—each earning $300 per quarter—you'll earn $60,000 a year in royalties.

This simplified scenario would be a real home run, but it just establishes our field position. Your batting average will vary wildly depending on a score of factors, but Abbott reasonably argues that it's a fair scorecard. "If greeting cards represent only one facet of a well-rounded business," he says, "a comfortable living is certainly within the ballpark."

## EASY AS PIE

"When you think of rights," Abbott advises, "imagine them as slices of a pie. You've created a design that might be viable in a number of markets, one of which is greeting cards—one slice of a much larger pie. If you license your work to a card company, and they don't already specify it in their agreement, seek to offer *greeting card rights only*."

This is wise counsel.

Abbott is suggesting you get the most financial mileage out of your work—you may also be able to license your art in other categories, exponentially expanding your sources of revenue streams. "If you don't," he continues, "and the agreement offered by a greeting card company states *all rights*, that work has run out of gas as a vehicle for income, and it didn't travel far."

Another stratagem is to negotiate a time limit on rights offered. After a mutually agreed, contractual period, the rights revert back to you. "Remember," says Abbott, "you own the art—you don't have to agree to *anything* you're not comfortable with. But of course, once you sign on the dotted line, it's too late to rethink how you really wanted the rights used and for how much."

## UK MARKETS

Abbott says that the larger, more established greeting card companies in the United Kingdom tend to offer a flat fee rather than royalties. This may initially seem a disadvantage (when compared to US markets), but it's not uncommon for rights to revert back to creators after a relatively short, contractually designated period of time. So, the deal for a popular design will be renegotiated and the company will offer further compensation, or you are free to shop the design around elsewhere.

## SUBMIT

Regardless of how you submit, your samples must demonstrate your excellent color and design sense plus the superior technical chops you've honed to perfection. Showing off good drawing skills wouldn't hurt either.

Compile imagery pertinent to cards and to the particular recipient (determined by your exhaustive research). If your art style, personality, and creative wits are suited to greeting card work, it shouldn't be a big chore to determine which of your samples are appropriate to send.

If this chemistry is right, the only inappropriate samples are those irrelevant to this field. Let's say you do meticulously detailed line work. If all your samples are cross-sections of airplane engines, don't expect many assignments from a typical greeting card company. You don't necessarily need a track record of sales or clients, and if you have the chops, you can score a deal. At the card shop, you'll see some cards done in black and white, so black-and-white samples are okay for showing line work, but by and large, you need to present color. Samples of layouts are not helpful, unless you're applying for a position as a staff designer (or in the production art department, a crucial part of any card company, by the way).

You know the drill. Busy art directors need to get a sense of your style and skill. A first contact should be prefaced with a query letter. And while it's up to you to follow through with periodic updates, don't pester. They don't have a lot of time to view portfolios, read your chatty emails, or gab on the phone at your convenience.

About hard copy submissions . . . yes—there are card companies that still request physical samples: brochures, tear sheets, postcards, even photocopies and photographs. Often, copies are made for the files, but if you're sending hard copy, it's best to send samples that the art director can keep. If you want something back, say so, and include an SASE. They won't have any time or inclination to

return samples sent without sufficient return postage (and don't make the unreasonable request that the card company insure the return package).

If you're worried about the security of your submission, copyright your stuff and/or submit a nondisclosure agreement (however, there's no guarantee that they'll sign it).

## COMMISSIONED DESIGNS

Card companies are open to submissions, but marketing single concepts can be a tough sell. You may have a bright idea for a single card (or theme), but that doesn't mean it will fit the company requirements of the product lines currently being assigned.

Card companies, as opposed to buying over the transom, usually *commission* designs. Company policies may vary, of course, so check with each. Each company has an individual philosophy and program, every studio has their own way of doing things, so it's not so prudent to create finished art and try to sell it for publication.

A series of cards within a consistent theme is called a *card promotion*. A company must devote a larger share of its new designs to a single, specific look. Marketing a series is risky to the greeting card company putting many of its eggs in your one basket, so it's not always desirable. If your card promotion is your initial approach to a company, you may not get far.

A company's entire product line—for instance, counter cards, promotions, designs by caption category (birthday, anniversary, and so forth)—is all determined by management and marketing and based on a myriad of decisions. Except in small operations where two or three people run the whole show, the creative staff is never totally in control.

Staff art directors and line planners give out the assignments, and are, presumably, well paid to develop ideas for promotions and other products. It may be difficult for you, a raw unknown, to usurp their function.

## THE BACK DOOR

It might be more efficient (and smarter) to actively pursue assignment work first and parlay that into commission work with Has Bean Greetings. Become an indispensable freelance hire, while developing lines and themes on the side.

A fruitful (and hopefully, long) business relationship with any company can begin when you receive and complete your first assignments. Show that you're competent, dependable, and a pleasure to work with, and I bet they will be open to your bright ideas. If you're reliable and your work is good; if you can follow instructions without being heavily directed; and if you can still add your own special touch to your assignments, they may look to you for new product concepts.

When you've established a track record with this studio, present your designs with your foot firmly in the art department door. This could be a more fruitful path to success without undue heartache.

Now saying that, if you're convinced you've developed an absolutely killer idea for a promotion; if you have absolute faith in this concept, don't sit on it. Keep in mind that you buck the odds, but full speed ahead—submit your brainstorm or mention it in a submission for future consideration.

## USING FREELANCE HELP

Generally, small companies use freelancers because their output can't support an ample or full-time art staff. But many small companies are literally small operations, and maybe one-person operations, at that. There are also complaints that small companies don't pay as well and may not pay promptly.

Large companies may use fewer freelancers because they have extensive in-house art staffs. If you're right for Has Bean Greetings, you may get the nod for a particular job; but you could indeed be viewed as the proverbial "little fish in the big pond." When you walk with the giants, size does not always equate with monster job opportunities (or harmonious relationships), and the red tape can be particularly colossal and frustrating.

The medium-size competitor is probably your most dependable and reliable source. Since they're slugging it out with the big kids in certain product areas, these mid-range companies have busy staffs; they may actively welcome and court outside help—card designs are always changing and the demand for new art, plus the desire for a variety of looks, is often more than the in-house staff can handle.

The greeting card industry has a voracious appetite for bright ideas and innovative stylings. According to the Greeting Card Association in Washington, DC, greeting card publishing is the largest user of creative talent next to advertising; and freelancers may well be considered the fresh air that keeps the card industry breathing.

## JUST ASK

The easiest way to find out if a company uses freelance design is to simply contact the company. Check out the website (it's common to list job opportunities and guidelines online). Send an email (or call the personnel office or creative department) and ask directly: "Do you use freelancers? To whom do I send my samples? Would you please send artist's guidelines for submission?"

Another avenue to gauge the size and dependability of a company may be through researching blogs that cover the field and industry organs like *Party & Paper* (www.partypaper.com). You can find listings in the annual *Artist's and Graphic Designer's Market* (North Light Books*).* Card companies that don't have a listing here are not likely to need much freelance help.

## CARD FORMATS

Abbott says that card companies need new and engaging art throughout the year to keep their various lines fresh in this highly competitive arena. Submission guidelines are typically specific and should be used as a template for presenting your art to their creative teams. "An important element to consider is the layout of your art," Abbott states, "the needs of which are entirely unique to this industry."

I'll go out on a not too dangerous (and level) limb and say that while most designs are vertical, you will see some horizontals. But when you look at a card rack, which portion of the card is visible to you? Answer: generally, it's that third to upper half. So when creating for greeting cards, this consideration should immediately top your list of design concerns.

And just like at gym class, sizes vary; but we're talkin' card size this time around. There is no true standard for the industry. Submission guidelines will instruct you as to that company's size specifications and requirements. In general, it will be in proportions similar to a 5" × 7" format.

Create with the caption in mind. No matter what the format, design around the part of the card that will show in the display. This top third to half is important and must look particularly attractive.

"And if the upper half is devoid of interesting elements or color," says Abbott, "what compels consumers to pick the card up and look closer? While you may be exceedingly proud of your portfolio showcasing card designs in a modernistic, square format, your slick creations can't be reduced to the typical greeting card dimensions—you're wasting your time, as well as the time of an extremely harried creative staff (which won't help endear you to the review team receiving future submissions with your name on them)."

The vertical card has more "rack appeal" because the vertical format best displays captions clearly. Not to fudge the point, but with that (and modern display cases) in mind, layout may simply be a matter of company preference. However, certainly consult the individual artist's guidelines for this pertinent information. Of course, if you have the right look for the line, an art director will direct lucky, talented you on these specifics when you get an assignment.

# OTHER PAPER PRODUCTS

Many greeting card companies also produce other paper products (such as note cards, stationery, party goods, and gift wrap); even collectibles. For example, our Has Bean Greetings offers their card vendors a complete line of paper products and certainly wants to fill all the product space in their shops (remember, such vendors may be called *card* shops but they invariably carry a wide range of eclectic items).

But if Has Bean only makes cards, the stores they service will buy other merchandise from the competition, who we'll call Maxxed Out Designs (MOD). If MOD produces cards and more (including collectibles), they will likely snatch a larger share of the card shop trade.

Depending on the specific company, freelancers may or may not be utilized as frequently on these other paper product lines. But just as you may find a company who produces only greeting cards, there are folks who specialize in stationery and note cards, gift wrap, or party goods. These may be better outlets for your art.

## TRENDS

To research greeting card trends, look at fashion, home decoration, and furnishings, plus advertising in general. When the research gets tough, the researchers go shopping. Get out and have some fun: to truly study current design, graphics, color, and pattern, you must visit the penultimate consumer-testing laboratory, otherwise known as the shopping mall.

Of course, you can obviously go online! But wherever, whenever . . . the play is to keep your eyes on popular culture and your mind open. The keys to the kingdom are available merely by being alert to what's happening all around you, in your neighborhood and across the globe.

So, here's more entertaining homework: watch television; read for both news and entertainment, business and pleasure. Especially look at women's magazines, since the target market for cards is female, 18–40 years old. Play at the toy store. Listen to the radio and go to the movies; observe popular local, national, and international celebrities. Talk to friends and family about feelings and values important to them. As mentioned before, for an overview of what's new and hot in the industry, go to the National Stationery Show in New York City. Other gift shows are held in other cities around the country, too.

# THE WORLD FROM YOUR OWN BACKYARD

I'll head to the finish with this: we work in a truly global marketplace. As I've said previously, in our digital age, technology has spun creative process, product, and delivery completely around on the axis of opportunity.

As Abbott reminds us, wireless connectivity to/from virtually anywhere and instant communication means that there are no cost-prohibitive geographic limitations on where you could be submitting your design. The United States has a massive greeting card market, but we're not the only game in town. English-speaking greeting card markets—the United Kingdom, Australia, New Zealand, and Canada—have a voracious appetite for quality art. "Add to that," Abbott says, "European creative directors you can connect with online via a medium like LinkedIn.

The Greeting Card Association, a tremendous resource in the United States, also has equally helpful chapters in the United Kingdom and Australia. On their respective home pages you'll find links to their members and to those that are actively seeking submissions. All this could yield excellent results."

# INDEPENDENCE DAY

Finally, truth be told, do you even need to deal with the middleman of the greeting card company? How about going the independent route? Could your interactive web storefront combined with solid content, good search engine optimization, and diligent social media marketing map your progress of world dominance in the greeting card market? Think about it. As Winn-Lederer says, "Since print-on-demand is so affordable, illustrators doing their own greeting cards would be better served marketing their wares on their own websites or shop sites like Etsy."

And as Allan Wood tells us, "More so than ever before, being an independent card designer/producer presents a viable prospect. The advent and accessibility of high-quality digital printing presses that can produce on a variety of paper/card stock makes generating small runs of cards a reality, both practically and financially."

Wood also points out that there are also many quality offset printers who can produce runs of as little as 250, at cost-effective prices; do your research and shop around. With small print runs, it's also a practical option to incorporate mixed media (paper cuts, glues, stitching, or foiling) along with unique cutting and folding techniques. "Finish your card off yourself—by hand; this could be just the thing to differentiate yourself," Wood advises. "Marketing your work may be all about fulfilling a local niche market—talk to your local florist, national park or tourist center—as the place to begin your card business."

# ON THE BOARD

## (PROFESSIONAL VIEWPOINTS IN 50 WORDS OR LESS)

The editorial market is shrinking. Now a section of my output comes from stationery, art for products, more decorative type material. This is all less idea-based. While I enjoy this, I still very much want to be stretched by ideas and conceptual work.

—Trina Dalziel

I've been a freelancer doing greeting cards for years, and lately have been exploring ways to both reinvent myself and venture down other creative avenues. I strongly suggest you investigate possibilities and opportunities you have not yet explored—for instance, I am trying my hand at writing cards as well.

—Tim Haggerty

© Lori Osiecki 2016

Service centers not usually associated
with the selling of products are now sell-
ing items related to their service, such as
T-shirts at exercise centers. Even the US
Postal Service offices sell greeting cards
and other products!

—Joan Beiriger

Grand Family Day 2014

© Rigie Fernandez 2016

© George Coghill 2016

400

# Chapter 18

# Design Studios
# and
# Advertising
# Agencies

*Be there when the job is there—you cannot create the job.*

–Dan Johnson (deceased)

# MUCH TO DO

The days of the dedicated art studios, generating just that—art, usually in the form of illustration—are behind us. I am not the all-powerful head know-it-all around these parts (and Murphy's Law says that I'll be proved wrong just by writing these words), but I believe you'll find this to be a fairly accurate statement.

Design studios still flourish, however. As do advertising agencies, of course. A design studio concentrates on visual communications that utilize copy, illustration, and photography. The design studio conceptualizes a piece, designs it, commissions the copy, and farms out the art and photography, as necessary.

What does an advertising agency do? That depends on the agency, of course, because no two agencies are alike. In general, advertising agencies solve marketing problems by communicating what the client wants (and needs) his market to know.

To do this, ad agencies, like design studios, fashion appropriate copy and graphics for web-based, multimedia, and interactive resources. They develop marketing *collateral* (the collection of media propping up product sales or client service), as well as run the gamut of public relations to market research.

Ad agencies and design studios generate newspaper ads, radio and TV campaigns. They create lettering, logos, and branding; signage and billboards; packaging and product development. Both agencies and studios probably produce film and audiovisuals; sales catalogs, brochures, literature, and direct mail. They shape book and magazine design. Studios and agencies are wordsmiths of internal corporate communications; they may possibly be sales directors, masters of marketing and promotional channels, as well as social media gurus.

## WHEW!

A full-service agency is a multimedia juggernaut that, as the term implies, does it all—broadcast, print, and online. A majority of agencies make this claim, but it could be argued that few perform equally well in all areas.

And what's the difference between an ad agency and a public relations firm? Public relations firms assist clients by increasing public awareness of their clients' existence, presenting a new image, or even polishing a tarnished reputation.

PR firms attempt to keep clients in the limelight with reportage (reporting news online, for the press and broadcast media) and interviews, lectures, events, book signings, and autograph sessions. They'll even *create* media events, publicity stunts, and may handle social media marketing. The hopefully high profile created by a PR firm helps

position a client favorably in his or her particular market, works to counteract negative publicity, or establishes a new career direction for that client.

Public relations firms produce "indirect advertising." Often, assignments from PR firms parallel those of ad agencies. Since the full-time staff usually concentrates on marketing research and consulting with clients (and generally don't have art departments), PR firms may be good places to get work and would be more likely to use freelancers.

Since many agencies partner with PR firms, rather than offer PR services themselves, PR firms can also be a direct network to ad agencies or design studios.

## LOCAL

Just about any town of almost any size is likely to have an agency and studio somewhere nearby. I'm not really trying to hedge my bets with that broad statement, but it bellies up to a reasonable question: do local studios and agencies— wherever that locale may be—work primarily with local talent?

This, to me, is a toss-up these days. I think there may be advantages for local talent if face time is a factor to a client, but if you live on the corner of Reliability and Efficiency, modern communications and delivery systems make distance or location virtually a non-issue.

The flip side to that is that I wouldn't pigeonhole my marketing locally and I wouldn't limit myself to only regional agencies and studios. If you're just starting out, perhaps your track record, confidence level, or comfort zone indicates where you'll be working. In these instances, one-on-one with local studios is certainly reasonable (and makes sense). But certainly keep your eyes peeled beyond your city limits. Once you've established yourself (emotionally, mentally, physically, professionally), it will be easier to expand your horizons.

### LOCALE

In advertising, time is of the essence. How true. It makes sense that local talent may be sought out (perhaps even preferred), especially if you're needed on a regular basis or to meet tight deadlines. But, as Robert Zimmerman points out, "Today, [studios and agencies] are looking for an exact visual fit for their client. They don't give a hoot where you live."

As freelance assignments may develop very quickly, art directors soon get to know who's good, who's dedicated, who's reliable, and who's available. Location will be a distinctly non-issue if you offer and routinely demonstrate just that. Conversely, if you live next door, but can't deliver, you won't rise above the friendly neighbor status.

# WANTS . . .

Agencies and studios like to see the way you "conceptualize." "Conceptualizing" is the vision to see—and show—a sparkling diamond in chunks of raw coal. To sweeten the deal, some general skills you must bring to the table are: speed, intelligence, style and technique, and a unique point of view combined with a fresh approach.

Both ad agencies and design studios—and, sure, any art studios still out there—will demand solid layout capabilities, exceptional computer savvy, and sharp rendering skills (and that includes executing thumbnails and roughs).

So what's your specialty? What's the hook and bait that reels them in? Is it a pervasive visual elegance or does your visual aesthetic blatantly challenge the viewer smack in the (type)face? Maybe your "look" skews toward steady, traditional, and reassuring; even practical. Perhaps your illustration is positively snuggly and cozy; down-home and folksy even? Loose, casual? Or is your stuff whacky or whimsical? Bold, flat color or nuanced and textural? Busy, busy, busier? Stark and minimal? Do you love collage? Adore old-school retro?

Whatever your bent, your portfolio must showcase ample evidence of an advanced technical prowess stamped on every piece. You could offer a range of looks or a focused approach (see Chapter 10). It's whatever gets the job done, but it must be obvious your individual touch is all over some finely tuned skills and design sense. This savvy makes for an excellent calling card.

## . . . AND NEEDS

Small agencies and studios might need a range—and varying quantity—of freelance illustration. Big operations may use illustrators with more frequency and offer better opportunities; size matters, obviously, but you just may find that the "fun stuff" stays in-house.

Small or large, agencies and studios may very well rely on good freelance illustration when that "special look" is needed on jobs of any size or significance. You could get an assignment when a staff illustrator or go-to freelancer is unavailable (too busy, on vacation, off sick, or on maternity leave, perhaps).

Maybe a studio gets an overflow of work, and—good for you—they simply need your considerable talents. For instance, upcoming holiday seasons, like Christmas, could mean a busy agency with many retail clients will be inundated with projects. Obviously, when peak seasons pass, work levels will most likely revert to "normal" and extra assistance may no longer be needed.

But maybe not. I am told that there is a trend in smaller agencies to become "virtual"—that is, they maintain a small core staff, and use contractors or independents to provide nearly all creative and production work. "This shift has been enabled by wireless technology and 'the cloud'" says Deborah Budd. Budd, a thirty-seven-year veteran of the advertising business, now focusing her energies

on developing web content for her company, Second Wind Ltd., tells us that "Here, agency staff may work seamlessly with remote employees and clients over the Internet."

## DO THE DO

In this day and age, finding out what a particular agency or studio does (and who their clients are) won't take much digging. First, you network. Start with the Internet—this is an enormous resource for such information. Be sure to explore websites, including the prospect's Facebook, Google+, LinkedIn, Twitter, Pinterest, and other social media pages. You could phone (or visit) the chamber of commerce and Better Business Bureau for facts and figures. Talk to your colleagues, check with printers; touch base with businesses that advertise (and isn't that everybody?). Ask around; get as much background information about the local scene as you can. The next step is to contact the agency or studio yourself.

Again, begin online. If you can't find what you need on an agency's website, you could call them. You don't even have to ask for the art director initially; talk to the receptionist. If he or she doesn't have the answers you need, you'll be directed to someone who does. Simply ask, "What are your specialties? Can or do you use freelance illustration? In what capacity?"

Remember there are three distinct virtues when selling yourself: be persistent, be polite, be positive. If your communication skills are professional, you shouldn't have any problems. You'll find most people are friendly and helpful. Zimmerman agrees and says, "I would suggest a fourth virtue (even though this truism doesn't contain the letter P): do consistent, excellent work." He's right. Without good stuff, persistence may be deemed annoying, politeness only gets you in and out the door, and being positive won't compensate for quality.

On the website you'll be able to see the agency's book—and all the work that snagged all those awards last year. See what the different agencies are doing, then make up your own mind. Once you evaluate the nature (and caliber) of their product plus the measure of their clients, some decisions will be made for you. But remember, ultimately, someone at the agency—usually the creative director or art director—will determine whether or not *your* talents suit *their* needs. However it works out, make sure you're aware of the players first so that you can get into the game.

### DO TELL

How to tell if an agency or studio works with freelancers? How do you know when they *need* one? It might depend on the size of the place (a large agency doesn't use—or need—as many freelancers as a small one), but the answer to both questions is simple: ask them—make inquiries.

It's yin and yang, really. You won't know when they need a freelancer until *they* do. You do the requisite homework; you gather the necessary background info. Your stuff is out there online.

Maybe you've had a shot at showing your book in person. They may share your interest in producing work for the agency. After all that, they certainly have a good idea of your capabilities. Theo Stephan says you can drop the art director a short note of thanks after a meeting, but a common rule of thumb is "Don't call them, they'll call you. You don't grovel; no starving artist's war stories. Act successful! Everybody likes working with a winner."

## PLAYING THE FIELD

There's at least one art director at an agency (and big agencies often have a number of art directors). The art director may answer to the creative director. Whom do you talk to?

Again: ask. One email or phone call, and you'll know for sure. If you have to dig a bit, don't sniff your nose at asking the receptionist who the art buyer may be. The more people who know you—or know about your abilities—the better. "The first person to try is the creative director," Michael Wooley (a creative director, himself) recommends, "but also contact art directors, production artists, copy chiefs, and copywriters." You might also ask about the production manager, who may be responsible for calling in extra freelancers.

Obviously work for as many agencies as reasonably, humanly possible. Get as much work as you can, when you can, where you can, depending on the size of your town and the temperament of the advertising community.

One caveat: it would not be wise to do an assignment for one agency, then go directly to the competition and create a mere clone. Your trademark style is one thing, but don't get lazy.

And along those lines, Budd was very adamant that we make a strong case here for an absolutely critical bit of business: be extremely careful about including work in your portfolio that is not, shall we say, "entirely yours." Art directors, and especially small-studio owners, are sensitive to plagiarism, which abrasively scratches against the unfortunate tendency among some folks to be less respectful of intellectual property.

"We owe this to the 'free' and 'open' Internet," says Budd, "and the sense that 'copying' and 'referencing' are the same thing. When we share ideas online, they become temptations for nonprofessionals to 'borrow.' For a true professional, this is a cardinal sin and career suicide.

"If an idea is not yours don't include it," Budd continues. "If you're unclear what constitutes plagiarism, do some reading and educate yourself."

# MAKE YOUR MARK (FOLKS JUST LIKE YOU)

## ORVIDAS: BEEN THERE. DONE THAT.

"As far as being an illustrator goes, I am a late bloomer," says Ken Orvidas with a smile. Orvidas was an art director in advertising and burned the weekend and midnight oil getting his drawing into shape. Once he did, and began getting consistent illustration work, Orvidas quit his ad day job and focused on getting his illustration career off the ground.

But, nevertheless, he burned no bridges. "I also freelanced as an AD," he says, "and did so for quite some time." Eventually, Orvidas moved to a new market when he was offered another day job. "I worked here for several years while playing around with illustration," he says. "After a few years I went to full-time illustrating and have been doing it ever since."

Orvidas says that being in advertising definitely helped. "I worked at some very good agencies where strategy and the idea was the focus. I have applied that thinking to my images. I am a conceptual illustrator so I always lead with the concept.

"Working with ad agencies involves more process. In my experience, the art buyer is the first point of contact. He or she gathers several suitable illustrators for the project. Creative options are usually flagged by the design team and presented to the client, who then weighs in with their pick.

"Often there is a conversation about usage, budget, and timing before the client chooses. Once chosen, there are briefs to read, directions and discussions between the illustrator and creative team.

Then comes the sketches, which are reviewed by the agency and at times not sent to the client right away. "There may be several rounds of sketches before the client sees the recommended sketches—and sometimes after the client reviews the sketches everything starts over again. Eventually the green light is given and final work is finished. You see what I mean about more process.

"Design Studios? Either way, there is always a discussion about usage, budget, and timing. But depending on the size, a design studio approaches an illustration project more like a typical editorial assignment. In fact, they may really be more like a larger ad agency."

# COMPS

Agencies and studios use a lot of scoreboards, idea boards, and layout comps (comprehensive sketches of a concept) during project development, client presentations, or when pitching a concept. If you are good at this particular specialty, including examples in your book would be an apt way to get your foot in the door. Use these skills to carve out your niche here or pave the way for ostensibly bigger, better, and more diverse assignments.

## PRESENT

How do you present yourself to agencies and studios? One solid piece of advice I've been told is to first *sell yourself*. This begins with making the other person comfortable. Project a feeling of respectful confidence plus well-being, and the prospect feels good about you.

Next, observe closely and listen carefully. Talk less, listen more. If you are asked, "What do you do?" you might answer with a layered response: "I'm an illustrator. I draw for clients like (so and so). I've solved visual problems for (such and such); please take a look." And out pops the killer portfolio.

The key is to make meaningful contact. Remember: you are not selling an illustration at first blush, you are shooting to make a good impression that generates further interest.

Tom Graham says, "A good question to ask of an art director is 'What are you working on?' or 'Working on anything interesting?' Chances are they'll love to talk about their latest project, maybe ask what you think. This takes the focus off you for a bit. My experience early on was that I was nervous and talked too much."

It's not so much where you are on the ladder, but how you communicate who you are and where you want to be. Selling yourself has actually little to do with selling illustration. It has to do with people. Selling, as it's been said, is a person-to-person activity.

You know best where your strengths lie. The trick is to stay busy, but enjoy what you're doing. You know, some agencies and studios find a comfortable niche and stay there, believing that specialized experience allows them to create better work. This can be true, but there is a danger of falling into a rut.

This also holds true for the freelancer. Don't limit yourself. More flexibility means a wide variety of assignments; greater assignments mean better money. Keep all available doors open; flexibility and variety will allow you to gather pollen from a wider range of flowers.

## PLEASE ALLOW ME TO INTRODUCE MYSELF

If you are new in town or just starting out, obviously establish a web presence; that's just de rigueur, a given. Crispin Prebys advises you to ask for a simple portfolio review with a mailed query letter—you're not asking for a job at this juncture, just a look-see and advice—and then follow up with an email or phone call.

I've mentioned this previously, but your résumé is not so critical—credits and work experience can be hyped—it's the portfolio that counts. Your website sets all this up—the proverbial one-two punch. First, grab their attention with your eye-catching, captivating online portfolio and get your foot in the virtual

door. Then, the quality of the work within shows off your effective communication skills and technical chops.

"Consider blogging as a good way to build your online reputation," Budd recommends. "Write about work you do (respecting client confidentiality, of course); illustration, ads and design work you like; your influences and heroes; industry issues. Promote your blog on LinkedIn, Facebook and Twitter. Try emailing agencies you want to work for and share your latest blog posts or new work."

Networking is always smart. Cultivate referrals; drop names. Put your self-promotion and marketing plan into action. Establish contacts, and then don't let them forget you—follow up; stay in touch! Maybe join the ad club and any organization frequented by local art directors and creative individuals (consult the chamber of commerce regarding the names of such associations, meeting places and times).

Budd reminds you that if you have the budget, clever direct mail promotions can also open doors. "Try creating an intriguing mail piece (possibly with a 3-D element)," she suggests. "Selectively mail one or two agencies you want to work with each week, and follow up with emails or phone calls asking to meet face to face."

"There are always several people who can do the job besides yourself," said Dan Johnson (deceased). "So you have to be in front of the contact's mind, or you have to be there at the right time. Now factor in talent, speed, and competitive pricing—these are some of the best ways to [introduce yourself to] this market."

## 'ROUND . . .

Thinking about sending a disc or other media? You can board a couple of trains of thought here. Once upon a time, forwarding media that was packaged attractively and prepared correctly was a fine option, and just may have garnered your great work the stand-out attention it deserved and needed.

Or it could've turned out to be a clunky and terribly time- and cost-inefficient exercise for all concerned. Not to mention a disaster. Often, with all the ugly, rampant computer viruses out there, strange (as in foreign, not weird) media represent a real danger for the recipient. So, boom, swish—nothing but Net: your disc (or flash drive) goes right into the circular file. "Bulletproof " Macs notwithstanding, how many gigs (job bites, not bytes) will you get from a client whose computer crashes when they insert your funky disc in their precious laptop?

## . . . AND 'ROUND . . .

Back in Chapter 10, C. J. Yeh and Steven Hughes put the whole question in proper three-point perspective. "CD was once 'cool,'" said Yeh, "but it's now a dated concept. "The way to go is to email a pdf file," Yeh says.

For one thing, as you probably know, most new Mac laptops don't even come with a CD/DVD player anymore, and, as Hughes added, "Archiving digital content has moved to external drives and cloud storage. I recommend Dropbox as a possible delivery method for portfolio pdfs [if file size is an issue]. Remember—a web presence should take priority."

## . . . AND 'ROUND

A prospect may ask for a portfolio—or request a follow-up—on disc. By all means, go for it, but take pains to create a dynamic and expertly produced digital portfolio a client will ultimately swear by, not swear at.

If you are mailing your work, make it easy—and safe—for your prospect. You could mail (or email) a sample and tag it with a link to your online portfolio, or send the sample and follow up with an email that offers the link. Or, as Budd suggests, try an email with a really clever headline and a great image, plus a link to a customized slide show of some work that "fits" what you've learned about the studio's work or client base. Better yet, make the link a video of you talking directly to the studio owner and sharing images of projects you feel are relevant to the studio, with an invitation to follow up. Whoa . . . a pitch disguised as a portfolio—sweet.

# BUYOUTS AND WORK-FOR-HIRE

*Buyouts* are frequently requested in advertising. In writing your contracts, decline to use this term. State the sale as a package or bundle of specific usage rights that are carefully defined. There is no true industry consensus about the definition of the word, only confusion. The term needs to be defined specifically, and include the precise usage rights the client wants to buy.

In a "buyout," the client controls and determines how, when, where, and how often your design can be used. You're invariably forfeiting all rights of ownership and subsequent compensation for continued use, plus you'll have no say in the fate of the work (remember, the buyer owns all reproduction rights).

If you can't negotiate out of a buyout, and the client insists on owning all rights despite your best efforts to sell only the rights that are needed, you can:

1. Say "No thank you" and be prepared to walk away from a bad deal.

2. Accept a trade-off, if you can live with it, and if it's to your advantage for the future. Is it just impossible to resist: a super credit to have or a sweet vehicle for your work? Will it be a dynamite portfolio piece? Is it an entry into a new market? Is the art so specific that you are unlikely to be able to sell it elsewhere after the terms of use expire?

   Be fully aware that it can—and will be—argued that *none* of the above fallback positions are acceptable or credible. So if you accept a buyout (for whatever reason), my sincere wish is that you . . .

3. Make it worth your while. Remember, the more you sell, the higher the sale should be. Don't be shy or afraid to price accordingly and with prejudice.

The illustrator should also be aware of the circumstance known as work made for hire. In a nutshell—*and in the eyes of the copyright law*—a work-for-hire contractor effectively becomes an employee without any employee benefits. As the creative's "employer" the client owns the hire and controls the copyright. This is unfair at best, but perfectly legal; the work-for-hire provision robs you of your just due and is definitely a worst-case scenario.

Budd weighs in here: "Please note: Work-for-hire should only apply if a freelancer is hired as a *temporary* employee—for example, to fill in for someone on leave-of-absence, to work regular hours on multiple projects just like a full-time employee. "Contract language should explain when work for hire applies," she states. " If the freelancer is hired via purchase order for a specific assignment, the freelancer remains a contractor and should be able to dictate terms on copyright."

And do remember: *Full copyright is never transferred except in writing by the artist*—and the artist sets the price as well as the terms of use. You probably don't need us to remind you that, should a purchase order stipulate a full buyout, negotiate the price accordingly. "Most agencies and studios know about work-for-hire at this point," says Budd. "Those folks who attempt to circumvent copyright law should probably be avoided in future."

But, sigh, this is still the real world, and if your baby is down to her last diaper just when you're offered a work-for-hire contract, you may understandably be tempted to take it. I would never preach to, or condemn, those artists who accept these deals. Don't rally behind any cause if you can't reasonably justify the principle. Just know what you're getting into, and accept the consequences of your decision in the light of your situation.

# "ON THE BOARD

## (PROFESSIONAL VIEWPOINTS IN 50 WORDS OR LESS)

Put yourself in your clients' shoes; [try to] see from their standpoint what they are looking for. Set up the situation that says, "I'm the expert—let me do my job." However, it's crucial to get the client involved, to establish their ownership.

—Bennett Peji

Agency art directors say, "Beautiful work, but how can we use it?" And you think, "What's wrong here? It's the art director's job to visualize how a particular style would fit into their work!" But it's one of the best pieces of free advice I ever got.

—Mary Thelen

© Brian Allen, Flyland Designs 2015

Convince an art director that she needs you; demonstrate your creative process to offer an equilibrium of ideas and techniques—your style. The art director wants to pigeonhole you. Make it easy for her; emphasize consistency.

—Chris Spollen

© Melanie Reim 2016

© Greg Pizzoli 2016

# Chapter 19

# Small
# Business

*Many people don't realize that a good illustrator can, with the right informa-
tion, draw just about anything. It's your skill at defining the problem—and
your ability to creatively solve it—that you're selling, not just your ability to
put pen to paper.*

—Vicki Vandeventer

## RIGHT AT HOME

"Working with small local businesses can be a real education," says Ilene Winn-Lederer, "providing opportunities to sharpen both creative and business skills."

Winn-Lederer points out that small businesses are often naive when it comes to advertising their goods and services. They will admit their dependence on freelancers to enhance their "look," but might not have a reasonable budget to entice them. And those in charge may even misunderstand the creative process.

"It may take great patience to develop a relationship with such a client," Winn-Lederer says, "but once convinced of your value, such clients will, in time, allow you great creative freedom and may end up being an important link in the network of your future."

## THE LONG RUN

Illustrators or designers just starting out may find the old axiom "less is more" an appropriate business metaphor. One might think established businesses would be the best bet, but that keyword "established" does not necessarily translate into more opportunities for creative freedom. Indeed, your fresh, bold ideas may find a happy home with small businesses.

"Right from the start," says Allan Wood, "I knew I wanted to run my own business. The main question was 'where was I going to get the most comprehensive experience to develop the skill set necessary to do that?'"

For Wood, the answer was working for a small print shop for a few years. "This, as opposed to working within—or for—an agency," he says, "where more often than not you are a link in the chain with little exposure to the entire process."

Wood found that working *within* a small business, by necessity, gave him firsthand experience in every aspect of both illustration and design. "My responsibilities ranged from dealing with clients, developing briefs, running quotes; and designing press-ready artwork," he says. "I benefitted immensely from the whole prepress experience and gained invaluable knowledge of print, binding and finishing techniques. I did everything from digital and web to sourcing and negotiating with production/supply specialists (and troubleshooting the myriad issues that naturally arise). For me, this formed a rock-solid foundation that still serves me well today."

## WHAT TYPES OF FREELANCE HELP DO SMALL BUSINESSES NEED?

More than a few folks consider working with small businesses to be bargain-basement grunt work. Well, we can be more creative and industrious than that, can't we?

"When I started out," says Wood, "I decided I wanted to specialize and provide my services to small businesses. For me, small-business clients play a large

part in our local communities. They often provide niche or unique resources; they help create diversity, both in choices and culture, and are usually members of the local community itself.

Wood also saw this as a proactive and subversive move against big business, but maybe he's just an activist at heart. "All those small businesses along the street are just blank canvases waiting for you to draw on," he says. "You can transform the world one shop at a time."

## STRAIGHT UP THE BLOCK

All small businesses have some sort of visual needs, from simple stationery and business forms to advertising and marketing, display and signage.

It could be drawing a logo character (or creating the logo itself) for the comic book store in town, Buy the Page. You were savvy enough to negotiate a fine—and honest—multi-usage deal, so that logo will anchor their new business card, business package, and website. They also need your visual(s) for an upcoming newspaper ad (and you'll reconfigure that ad into a direct mailer). In addition, the store is asking you to work up an illustration for a poster at the same time.

From there, you're going to design and paint bold interior signage, *plus* attention-grabbing display, wall and window graphics. The store will most likely be utilizing that new logo for the shop's exterior sign, too!

You get where I'm going with this. Small businesses are not just the little hardware store around the block. There are a lot of independent companies out there that are truly thriving enterprises but quite small, and, yes, these small businesses can literally be right down the street.

### IN DEMAND

As local talent, you're able to meet tight deadlines and your hometown sensibilities are a big plus on regional projects. The same thing applies for neighborhood newsletters, town newspapers, and city or regional magazines. Often these publications will only work with regional talent because these artists are neighbors who understand the issues and the current events that affect the local population.

Advertising agencies and design studios in town want you (see Chapter 18). Not every small-shop owner's promotional budget will justify hiring a freelancer, but (and it's a fun oxymoron) the small-business market presents a big opportunity—you should go after these vendors in earnest.

Let's brainstorm: A shoe store employs you to devise caricature-based buyer's incentives. One happy customer, a restaurant manager, loves the gimmick and asks you to draw/design something similar for his bistro. A vendor for the eatery enjoys the concept so much she hires you to do the same for her business (and even commissions a personalized version for a family event).

Think of it as a grand illustration block party! Your whole town is fair game—the public television station, the local community college, a favorite deli, even your dentist. Any small or local business with communication, marketing, and promotional demands—and that's every business that advertises, generates correspondence, and interacts with customers—can use your help.

These prospects are no small potatoes in the bigger stew of your business. Good assignments are where you find them, and some tasty ingredients for success are rooted right in your own backyard.

## INTRODUCTIONS

How do you find out if a local business needs freelance artwork? The best way is to simply introduce yourself by publicizing your services. Yes, marketing and self-promotion again. Your local program is important. You have the decided advantage and incentive of knowing the home turf, so take a direct and aggressive approach.

"Aggressive" does not mean obnoxious or overbearing; it means a keen and concerted effort. Establish and maintain a web presence. Advertise in city (or regional) newspapers and magazines, plus neighborhood weeklies or monthlies. Mount mini-posters on bulletin boards; mail your brochure. Follow up with postcards and/or phone calls.

Again, you're figuratively, if not literally, in the neighborhood, so don't let a contact go cold. Stan Shaw says he even knew an illustrator/designer who would leave business cards with owners thanking them for *their* service.

Chatting up the main avenue of the business district will probably take no more time than your usual stroll when shopping; it could be the most lucrative window shopping you ever do.

If you're out and about, ask for a store owner or manager. Introduce yourself. Make sure a mailer arrived (if you've done some preflight strategy) or trot something out at a first introduction. Tell this person you've been making the rounds and took the opportunity to say hello. If the timing is not good, indicate you'll be back in the neighborhood on a certain day, at a certain time. Ask if it would be okay to return and schmooze, perhaps show some samples too.

You're obviously after an affirmative response. But even if there's no job—when you get some sort of a positive reaction, simply gather information.

Deborah Budd suggests you direct the prospect to your blog (ideally, one that has resources and suggestions for local business marketing). Definitely share the URL on your business card, mailer, and leave-behind. And when you do get a shot, bring your portfolio. Just for now, forgo the big sales pitch; lay the groundwork for a continued promotion. Chances are, when there is a need, they'll remember that person with the pleasant smile and beautiful art.

## NO THANKS

Of course, if they ask not to be bothered, believe them. These are busy people, so don't pester. Say, "Perhaps another time, if this is inconvenient?" or "May I keep you on my mailing list and call again for a future appointment?" Obviously, if they instruct you to *never* bother them again, take that to heart. Here's where you decide to be patient, persistent, or practical.

---

### FINDING NEW BUSINESSES

How do you find out when a new business is about to open? New construction or reconstruction is an obvious tip-off. Keep your eyes open, wade through the dust and make inquiries.

Check the yellow pages for names of local businesses. The chamber of commerce and the Better Business Bureau should be able to supply you with a list of new businesses in your area. Business trade publications in most markets publish corporate announcements; business magazines on a local level like to welcome new businesses to that market. New businesses about to open often issue press releases to the local media; watch for that. Check the newspaper for grand opening announcements or lists of incorporations. Join your local Art Directors Club.

Who to contact at a new, small business? The store owner or manager is your best bet. A sales clerk, while receptive, won't have the authority to commission your work. However, as sales staff have the ear of the store owner, they could be allies to your cause. If the boss is presently unavailable, begin with the clerk and make a date to return when the boss is likely to be on site.

---

## SAMPLES

The small-business person is interested in how you can help the store, so your samples will have to generally relate to the business environment. Fred Carlson says, "I've found that, while some clients buy style and some markets buy subject matter, they're probably more subject matter–oriented—small businesses buy subject matter that relates to what they're doing.

"The visual should be easy and economical to make, online or on paper. You can't present an extremely complicated, tricky-to-reproduce image to a small-business owner; they're not going to spend the money on those kinds of things.

"Small businesses have fairly simple needs and relatively small budgets," Carlson sums up, "so show illustration that fits in with lower budgets."

# AWWW, GO DIRECT YOURSELF

Small businesses generally don't have an art director. This could mean that you may have to not only create the illustration *and* get it published (print or digital). Hold on—don't pass up an opportunity to work with a printer because "it just means more work (grumble, grumble)."

If you're at all worried about the finished product or merely want to further your graphics education, it's to your distinct advantage to see the job through to the end. Why not factor added responsibilities into your estimate and have a fun learning experience at the same time?

As Carlson says, "You might well be asked, 'You can draw the thing, but will you also design it, and can you get it printed?' This could fall into your lap because the buyer isn't that sophisticated about the division of labor in the graphic arts. They might just assume that you would—or should—know all these other things. What you should say is: "Sure, I can do all those extra things—it will cost you, but I'm certainly willing to do it.'

"If you maintain such a relationship with certain local clients, it can keep the checks coming," Carlson says. "The more you specialize, the less chance of a relationship with a small business. They're going to have the most basic needs, and if you can service those basic needs, you're going to do all right."

And let's not give the wrong impression. Understanding how to get a piece effectively published online is one thing. Knowing how to get it printed correctly is not merely a matter of putting in a little extra quality time at the printer's.

As Matt McElligott says, " In terms of print, a knowledge of inks, separations, dot gain, line screens, and film all contribute to getting a piece done right. A well-rounded illustrator will understand all this, and should learn those ropes."

# LOCALS PREFERRED?

Are small businesses open to freelancers who *don't* live nearby? Realistically, nowadays, you don't have to live down the block from the store to service a small-business account. However, if your distance from any theater of operation complicates the job or delays completion of an assignment, location can be a liability.

And maybe you know several local businesses that assign their work to design studios. Does this mean they wouldn't need any freelance help? Not necessarily. This shouldn't discourage you from showing your work to a small-business owner (the owner may even encourage the studio to use you for some aspect of a job). Find out about that same design studio and show your work, it will certainly help the cause. If the studio doesn't have an exclusive arrangement with the store, you may want to approach the owner regarding other graphic needs around the establishment.

## PRINTERS? YES, PRINTERS

As I write this chapter, print is still not dead. And at this writing, the print *business* is also not terminal. So let's ask this question: Do printers need freelance help? Not really. By and large, if a small business goes to a printer to get the complete job done, the outcome is probably going to be very simple. The printer's not going to want to spend a lot of money on a creative solution, so they tend to price out low and zoom through the aesthetics. Chances are, they'll probably use somebody on staff.

"I have found there to be a variety of opportunities in *networking* with local printers," says Wood. "They sometimes get inquiries about work they don't do and may refer the client to you. Or they might get busy and need some projects accomplished. I've done many freelance jobs and obtained quite a few new clients this way. This has really helped maintain cash flow."

Printers can also be clients. Even struggling printers must practice marketing and self-promotion. You may be asked to sparkle up a catchy promotion piece, and can barter services with this shop. Perhaps it's an even exchange for their producing *your* promotional brochure. Getting your work printed on a slick promo is still good advertising for both you and the printer.

## MAKE YOUR MARK (FOLKS JUST LIKE YOU)

### LAUSO: START HERE . . .

In the early part of her career, Judith Lauso worked with a local community newspaper, where she was lucky enough to be exposed to industry-grade layout processes and organization.

Working for a professional publication helped her blossom. The creative elements of illustration and design, the feedback from peers as well as the readership, the satisfaction of knowing that her work was being distributed to a wide audience—all of these things provided an environment where collaboration, common goals, and the inevitable education that results, prepared her to enter the freelance market.

Based on her exceedingly positive experience in such a situation, Lauso tells you that the opportunity to express her artistic side (while communicating important messages and ideas on the ground level) was invaluable.

"Today, I enjoy working professionally at something that I truly love to do," she says. "Each job allows me to grow and learn about whatever subject matter is currently in front. Working independently and choosing my own hours are features of freelance that I like."

## . . . AND END UP HERE

At the beginning, your first position could be as an intern or even working as a consultant. "You will learn to be honest and sincere rather than saying what you think the client or boss wants to hear," says Lauso.

"A stalemate about a design issue or content gives you the opportunity to be honest with your thoughts on technique and honest with yourself about dealing with the client's wishes. You try to compromise and remain within the client's overall plan; all the while tactfully explaining the ifs, ands, and buts of why the project should be done differently."

This is all part of developing a process that helps you maintain a productive workflow. It also allows you to maintain positive relationships with clients and your collaborators. Without such organization—which also encompasses the organization of time, materials, and costs—frustration (for any and all parties involved) can set in.

In other words, educate and share. Lauso's point here is that, when working in a creative field, it is absolutely essential to share your talents with others. With clients and employers, obviously, but this includes taking the time to advise, mentor, and assist colleagues and those new to the field.

And with this education and good work—in such a profession of people, process, and product—will come the inevitable opportunity to learn and grow through failure and rejection. "There will be moments where you will not, let's say, achieve the outcome you desired," Lauso says, smiling. "But this is not a time to quit or become discouraged. Rather, it is a chance to improve your craft and benefit from the experience. Decide what didn't work. Always make it a point of learning."

# MAKE YOUR MARK (FOLKS JUST LIKE YOU)

## GILDEN: IT'S A SMALL WORLD AFTER ALL

"Most of my clients are smaller businesses," says Nadine Gilden, "and I think many of these people want a flat rate. Because they have a budget, they want to know how much it's going to cost them before they get involved—that's important to them. I screen clients and try to work with only those who share my aesthetics and are comfortable paying my rates; I've learned to walk away from those clients who don't meet these critical criteria.

"But you haven't proven yourself in the beginning," Gilden states. "People don't have a reason (yet) to pay you an industry-standard wage. Until that happens, you come up with ways to give yourself more work. For instance, you could offer your services to a nonprofit. If you're going to work for free, at least it's for a worthy cause."

Gilden also makes the astute observation that, with seasoning, you will come to realize that it isn't actually about you and your fabulous talent. It's not even about the client . . . it's about how best to serve their audience, their readers, and their customers—all the while representing the client's brand in the best way possible.

## MAKE YOUR MARK (FOLKS JUST LIKE YOU)

### COGHILL: ONE TON

"Most of my clients are small businesses," says George Coghill, "and to be honest, I am continually surprised by the volume and variety of small businesses out there that become clients. They are not to be overlooked."

Coghill will tell you about the multitude of benefits that small-business clients have over larger businesses. "There are a ton," he says. "They pay more quickly; you are typically talking directly to the person who makes decisions; they are often very friendly. Since they are in the same boat as you (you are a small-business owner yourself, after all), you are on the same page for a lot of things. The best ones plan ahead and have comfortable, loose deadlines; they allow more forgiving time frames that go past initial estimates."

That said, Coghill also acknowledges some downsides, too: "Often, you are educating them from scratch on hiring an artist," he says. "Few have any design or artistic background, so often you will need to make revisions based on their preferences rather than what you as a professional feel is the ideal solution. They typically have smaller budgets, and repeat work isn't that common (clients often aim to keep costs down and do things themselves, just as we, as self-employed artists, do)."

Coghill points out that your personality will also play a big factor here. "If you want high-profile clients, with lots of media exposure and work you can point to on a billboard," he says, "this isn't the avenue for you.

"However, I get a big kick out of my smaller-business clients who tell me how much more excited they are to make their new venture happen with a logo that has exceeded their expectations. The work you do can have a real and noticeable effect on a smaller scale."

## CAREFUL DOES IT

It behooves us—I do love saying that—to close with a bit of brass tacks. Jamie Sharp asks you to soberly evaluate your pricing. "Be careful about underselling," she says. "It can do a disservice by devaluing your work and the industry as a whole."

When Sharp offers a price break, she indicates what the full price would have been, and teaches her clients about the value of high-quality work and exemplary service.

"For any potential customer," Sharp continues, "it is important to do your homework and familiarize yourself with the lingo and buzzwords of their industry. Set yourself up as an expert—someone who can speak to their audience and portray them correctly."

This gives the client confidence in you, and is especially true for small businesses that, in all likelihood, have never dealt with professionals. "You don't have to beat them over the head," Sharp says. "Spelling out the time requirements, fees and any potential extras (like changes and corrections) in your quote helps the client see your value, which only supports the long-term viability of visual communication as a career."

# ON THE BOARD

## (PROFESSIONAL VIEWPOINTS IN 50 WORDS OR LESS)

Be prepared to do a lot of educating when dealing with small-business owners!

—Marti McGinnis

I have a responsibility to the profession as a whole. For many clients, I'm their first experience; I represent the field at large. And somewhere out there, there's someone else representing me. What goes around, comes around.

—Matt McElligott

Style has everything to do with vision— and this is never 'small.' It's the way you analyze what you see; the way you put that down on paper. Every single job should be an enormous learning experience. Make this personal growth a career-long goal.

—Sam Viviano

The thing about connections is, I'm not sure you have to work with anybody who is, quote/unquote, really big. There are so many great, tiny businesses that are doing good things and offering cool collaborations. You know, the big clients don't necessarily have the big budgets, either!

—Penelope Dullaghan

When working with small businesses, one challenge is convincing them that your rates are fair and reasonable. How you convince them is an individual matter, depending on your style of work, the temperament of the client, and other pricing examples you can point to.

—Randy Glasbergen

© Tom Graham 2016

Whatever you can do to get your foot in the door is a step in the right direction. I think it's best to build up experience at a local level. Work with people who are right near you. [Establish] a back and forth; a give and take.

—Roger DeMuth

Word of mouth has played a large part in helping me to create and sustain my practice. Referrals have turned out to be some of my best clients as they know what I do and want to work with me.

—Allan Wood

In working with small businesses, the bottom line is all about respect. Respect your clients and they will respect you.

—Ken Orvidas

# Section V
## On Your Way

# Chapter 20

# Teaching

Yes. Maybe at times, the saying, "Those who can't do, teach" is true. However, in my experience, I've also seen that "Those who can do, can't teach." Professionally, how do you transfer your skill and knowledge from one to the other?

—Bill Jaynes

## NOBILITY

Charlene Chua regards teaching as a noble endeavor. "People acquire knowledge through much trial and error," she says. "That knowledge becomes a precious thing you pass on to the next generation, to save them from some of the trouble you had to experience so that they may go further and achieve more—that is a noble aim.

"Perhaps I'm romanticizing things here," Chua says, "but when I think about the teachers I respected, there's something they all had in common. They may not have been the best in their field; they were certainly not prize-winning scientists or scholars, but they all had a *spark*. They *shone*.

"They believed in what they taught, and that, in some way, what they taught mattered to their students. Mattered in a way that meant more than test scores or whether you'd get a good paying job later. These teachers believed, somehow, that what they enjoyed mattered, and that if they could share just a spark of that with their students, that that would make a difference in their lives.

"Not every student responded to it, and not all of these instructors were paragons of patience, but that spark was positively infectious. Their interest was my interest, or at least, some part of it was."

## ADORABLE

Perhaps like Ken Bullock, you simply adore *learning*. The phrase "Be a student of life" fits the guy. That's cool. Could be, you too have always been hungry for knowledge. And maybe you simply love sharing what you know and helping enlighten, educate, inform—even in some cases to lift up—the people in your life. If so, teaching, formally or informally, will not only be incredibly gratifying, but the ideal way to pay it forward.

## JOY AND EFFECT

Bullock enjoys teaching and has done a lot of it. He points out—and experience has shown him—that, if you know something, and know it well, you just may be an effective teacher.

"Teaching brings a different level to your knowledge," Bullock says. "In your practice, you've figured out what works best for you. But when you teach, you must be able to come at a problem from multiple angles, not just the way *you* solve a problem or learn. If you don't, there will be a student out there that challenges you on it. There's always more than one way to get a thing done. As a teacher, your job is to enable your students to figure out what works best for *them*."

## BE PREPARED

Bullock has approached this challenge long enough that he understands teaching is also about preparation—something folks who don't teach rarely see (nor fully appreciate).

He's been there. He knows that most great educators spend numerous hours preparing to teach. Outlines and lesson plans; working up handouts and developing demonstrations; devising curriculum and generating assignments; strategies for questions (and answers); contingencies . . . all create a road map for the teacher to better lead students in the best direction.

And of course, the longer you are at the front of a class, the more preparation. A two-and-a-half-hour studio twice a week over the course of a sixteen-week semester takes a lot of prep.

## SPECIAL

"It takes a special person to be a teacher," Bullock states. He doesn't say this to snag a pat on the back. He only considers himself a part-time academic. You'll need extended or specialized training and designated certifications.

We should point out that the money is generally, uh, not so great. But Bullock embraces teaching because he loves it. And, if you're of a like mind, so should you.

# MARKS, BROTHER

As a teacher and illustrator, as well as a writer, I am rather a full-time evangelist for visual thinking and translation. At the base of that lofty perch is the *mark*. That mark is the core fire of what might be called *illustrated communication* (designers may tag it *communication by design*).

Your marks should unmistakably reveal your thinking (and your world). I believe you must love the life of the "mark" and the creative passion it ignites. One might say that the mark sparks—the rhyme is unabashedly intentional—the flame of creativity. To fan that flame, you should tell a visual story that invests the viewer in your narrative process.

Empowering the audience in this manner gets you one step closer to making the art you are meant to do (more on that later). You strive for meaning and relevance by getting to the marks directly, through open reflection and hard work.

So, as an academic and an illustrator and writer too, it is important for me to teach—and for students to reconcile—the mechanical with the intellectual process: why we draw (or paint, or whatever) is often what and how we draw and paint. I am frequently asked the million-dollar question: "Can you teach me how to draw?" The answer: a teacher's real charge is to show students how to make their own marks from personal observation, particularly not to mimic

the instructor and certainly not to ape the currently popular illustration trend or hot-wheeled scribbler. Becoming a real artist is an exploration that's not taught, but rather developed, encouraged, and coached.

## STAY THE COURSE

So, if becoming a true artist is an exploration that's not taught, but rather developed, encouraged, and coached, then it's reasonable to assert that teaching is a collaborative affair, and this approach must then take into serious account the big responsibility falling to an educator asked to create a class of lasting value.

I think a teacher's job is to empower students and get them one step closer to making the art they are meant to do. Thus, "teaching," to me, must be a two-way street between student and instructor. Taking that even further, Brian Biggs says, "A teacher has to listen more than he has to speak. Counterintuitive, but correct."

I believe a strong art course is structured to teach fundamental principles through an empirical series and wide range of building experiences. A "good" teacher exuberantly relays information, sure, but he or she mentors knowledge of craft and technique through solid example and deep demonstration.

It's not just preaching from the pulpit, either; you reflect on what you know as the grist of what students are learning. You inspire, engage, and encourage with wit, a thorough command of your materials, and a keen grasp of the challenges of *communicating* to students—in other words, you understand the market; you know your audience.

## MAKE YOUR MARK (FOLKS JUST LIKE YOU)

### HOLZER: SALES JOB

Margie Holzer will tell you about a defining event in her long ago childhood. "When I was about eight years old," she remembers, "I had an art teacher who made it clear that I had 'not one ounce of artistic talent whatsoever.' And, sigh, I believed her."

So it was, as Holzer says, "Smiley faces and stick figures for the next thirty-two years. Teachers do not realize how powerful they are." Holzer ultimately found herself as an administrator at a small school. A nonexistent budget meant she was also the de facto marketing director—responsible for the publicity: flyers, bulletins, or booklets.

She took a class and rediscovered her joy for art. Another class, and she had the confidence to rail against her old teacher's notion of her talents. "I am an artist!" she proclaimed, and realized that—both professionally and personally—her creative self

was who she enjoyed the most. At the young old age of fifty-eight, "I decided that if I ever wanted to pursue a new angle on my future, it was now or never." She enrolled in a continuing education certificate program and feels like she's finally found her real niche.

But let's be honest, such life-altering realizations are never without complications. For one thing, learning the technology was a real challenge for her. "I am not computer-phobic, but using new programs does not come second-nature to me as it does those who were born with a mouse in their hands."

"I have been told that my strengths are my tenacity and my presentation skills," Holzer says. "My many years of teaching are probably to account for this. Skills gleaned from the creative side of teaching—the ability to invent visually appealing and appropriate materials that motivate students to learn—is only a different piece [of the puzzle].

"I just have been selling education all these years. I have no doubt that I will be able to prove my abilities out in the field. After all, I have proven them to myself, and that's the hard part."

## WAX ON

From the other side of the teacher's desk, I believe that illustration students are obviously burgeoning professionals, and they have to reach high. They must, or we are not tracking a basic definition of the word "professional" itself.

I also believe that making art means you must exercise all your strengths—the physical, mental, and emotional muscles that will power up your career as well as enable you to stretch (as in head and heart).

Old elitist paradigms don't work; selling is not selling out by simple definition. If you embrace illustration as a calling, if you make art because you have a primal need to do it, then you will create regardless of compensation. Being paid for your passion is honest motivation.

When students question why we create, I put it this way: as a kid, a box of crayons and a blank sheet of paper were probably all you needed. A new box of crayons was downright thrilling.

Current art technology is our veritable big box of sixty-four crayons—and just as exciting, no matter what your chronological age. Add in any classical training and the study and exploration of modern visual communication is like discovering that crayon sharpener built right into the back of the box. How cool is that?

It's about seriously listening to your inner voice and determining what drives your process of self-realization, knowing and reaching for what you want. But you have to be committed to continued learning through a lot of investigation and hands-on practice.

## WHERE TO START

To kick-start any creative journey, I always advise all within earshot to employ an elegantly simple (and simply elegant) mantra I learned from my colleague, Jenny Kostecki-Shaw. It's just two wonderful words: Begin anywhere. But on the practical note, to obtain a teaching position at the schools Fred Carlson lists in Chapter 2, we need to filter Kostecki-Shaw's lovely mantra a bit. June Edwards helps us here.

"In general, search committees look for candidates who demonstrate experience and skill in the discipline," she tells you. "Résumés and portfolios are examined first, and applications that do not meet the minimal qualifications will be set aside. The quality of work in the portfolio, and work/publication/exhibition experience will be considered for each candidate. A teaching philosophy, artist's statement and references are usually required. Teaching experience is a plus, and if you taught courses similar to the ones listed for the position you will have an advantage. The strongest candidates will be contacted for an interview and often a teaching demonstration."

Please note: At four-year state-affiliated colleges and universities, and at most private four-year institutions, a terminal degree is required. An MFA is the terminal degree for the arts (most schools do not accept an MA). If you are hired with an MEd, MS, or a similar degree you will need to obtain a PhD or an MFA to gain tenure. Tenure and promotions are based on three components in state-affiliated schools: excellence in teaching, scholarly growth, and service (for example, committee work). Private institutions usually require less service or committee work.

"At community colleges, two-year-degree institutions and online institutions, either a master's degree or PhD is required," Edwards says. "A stronger degree might be the deciding factor if there are a lot of applicants for a position. There are usually fewer full-time positions available at these schools."

## FLEXIBILITY

As a teacher, Ellen Weinstein encourages her students to find their own way of doing things. She serves to guide them along that process of discovery.

For Weinstein, the challenge for professionals and students alike is, as she says, "To continually find what will nourish you creatively and what will financially sustain you for the long haul.

"I try to instill in my students the idea of being flexible. You don't want to get too attached to a particular way of working or work only in specific markets."

## THINKING AHEAD

"I design projects that open to a broad range of interpretations," Weinstein says, "so primarily I'm trying to get students to think; I'm actually teaching conceptual thinking."

Toward that goal, Weinstein gives students projects based on a premise to jump-start the thinking process. In fact, her sophomore assignments are not illustration assignments based on commercial projects at all.

"Class critiques are structured to highlight the successes of each piece (concept, color, craftsmanship and composition) and what can be improved," Weinstein says. "It's imperative that each student feels supported and encouraged in the classroom and it is incumbent on me as the instructor to establish that environment."

Weinstein also bans her sophomores from working digitally. "The computer is a great tool," she says, "but a terrible place to learn. When we are doing assignments in class, having a classroom devoid of phones and laptops leads to more focused working."

## IN AND OUT OF STYLE

"Often someone will be struggling to find their 'style,' a term which I loathe," says Ellen Weinstein, unequivocally. "Style is what we do naturally, combined with what we struggle with and ultimately what we do on our own, in a sketchbook and when we think no one is watching."

According to Weinstein, style isn't an artificial look or flavor of the month. "At least not for the long haul," Weinstein says. "One of the biggest contributions I can make along the way is to serve as a model of a professional who is passionate about my subject (illustration), knowledgeable about the industry, and sincerely invested in success."

## LIFE IN THE CLASS LANE

Bill Jaynes cautions that from the outside, teaching looks easy. His initial thought was "Hey, I know this art stuff—I've been to art school." That's when he found out just how much work goes into creating and instructing a class.

"You learn that your meticulously prepared lesson plan only covers about half an hour of a three-hour studio," he says. "Eight hours looking for the right sample may translate to a mere fifteen minutes of class time. And this doesn't include grading and critiquing or working with students *outside* of class."

And then there is the problem of actually finding a way to enable student learning. After years as a practicing professional, Jaynes states that "seeing as a

beginner," is not an easy task. The focus must be on the students' work, not your own. "You're not the star," he points out, "you become the humble facilitator."

Jaynes wisely (and honestly) points out that balancing the professional gig with an academic career is problematic. Perhaps it's because the same type of creative energy fuels both endeavors. "There is a fight for attention much like romancing two lovers at the same time," he muses. "You can end up just tired and heartbroken.

"But I've found that art making makes me an authentic teacher in the classroom. During periods where I'm not doing pursuing my craft, the teaching becomes hollow."

## WHAT ARE YOU TEACHING?

So why attempt this tough juggling act? Why teach? Well, many consider teaching the ideal way of giving back; the rewards from this gig are, in fact, tremendous.

For some of us, it is all about carrying it forward. "Certainly, I recognize the need to be a role model and a facilitator for my students," says Lampo Leong, "demonstrating my passion and devotion to *my* art, while at the same time communicating as clearly as I can in order to challenge and inspire. My ultimate wish is to open a path for students that will lead them to discover and actualize their own values."

It's much like solving a puzzle; a commissioned illustration is always about communication. Fundamentals, style, and technique are only the underpinnings to the creative event. Brainstorming is the place where the vision comes to life, the first step—where the artist revs up his thinking and gets her creative juices flowing. Roughs and thumbnails, and comprehensives could be tagged as the place "where the ideas live." These preliminaries kick off the life cycle of most illustrations. An illustration begins, takes shape, and gets refined here on the way to complete the journey: the final.

I mention all this because, in my teaching philosophy, *what* we are illustrating—the subject matter—may well be the major focus of the whole exercise. Whether your art hawks bottled water, whips up emotion, or pushes opinion—even if the illustration is simply a mechanical workout or an exercise in pure concept—"What's this picture all about?" should indeed be a core issue of your education.

But just talking "subject matter" means we are only examining a big picture in a wide frame. Subject-making presents the opportunity to address that million-dollar question in the paragraph above. It's the chance to grab the viewer's or reader's attention, to be a strong *communicator*. Visual translation should work to amplify or clarify concepts. Concept spins both composition and mechanics and confronts process and product. Conceptual skills are all about

communication and problem solving. Creative expressionism, both intellectual and technical, is a visually active idea. This art tests interpretation, often offering unexpected insight and meaning.

For me, at the heart of the exercise is a welcome test intrinsic in every assignment: a learning opportunity for *both* illustrator and audience. Making art is a euphoric exploration to push forward. Teaching art extends that ambition. The teacher teaches the teacher and the student simultaneously.

A teacher's technique and imagination are charged to find the best way to help the student make their statements, even if it means simply getting the hell out of the way enabling the students to do what they do best. Making that point effectively can be the real fun. There is the real excitement of problem solving.

My language here is purposely ambiguous; those last two sentences are relevant from both sides of the teacher's desk. Student and teacher work together to articulate what the illustration is all about—what's really said—and to enable the student to distill ideas and get these concepts across with minimal, effective language: to entice an audience and maintain viewer interest, not say too much while saying just enough. The teacher facilitates the hand off of inspiration to concept, the segue of composition into technique, the juggle of representation with interpretation.

Even the most straightforward answers can involve exhaustive process (and perception)! There must be a pure dedication and a consistent commitment to successfully catalyze these tasks. It's easy for some students to misinterpret the intentions of a so-called tough teacher and view a rigorous classroom regimen as restrictive. But the challenge of creative restrictions and intense process produces results and expands your boundaries. A demanding instructor should always take students in a different direction if the goal is to push them toward the possibilities and open doors as a result.

Perhaps you're just enabling students to explore the stuff of it: the toys, tools, and materials. That's okay; go right ahead: have them fool with concepts and play with rules. Revisiting what we discussed back in Chapter 2, this ultimately begs only relevant questions: "What did you teach here? What did they learn here? What did I learn as a result?"

And (again reiterating Chapter 2) remember also that, on his way to turning on the lightbulb, Thomas Edison regarded each failed experiment as simply what not to do again. A brilliant mantra that brightens up the classroom, say watt?

## THE TEST LAB

Art teaching offers a nice little perk: a wonderful give-and-take that sweetly enhances your professional practice, if you're doing it "right." As Alex Bostic tells us, "Art is one of those things where you have to do it to teach it well. You have to be 'in the trade' to know what you are talking about. You have to be in the game.

"Teaching (and working with students) brings a distinct vitality to my life," Bostic says. "The isolated artist who stays in his shell, enjoying little or no personal contact, often struggles with the outside world.

"I understand my business as well as academia. I have my routine," Bostic continues. "It's *the students* who bring fresh challenges into that mix. Problem solving for the classroom can cast a new light in the studio. Helping students solve problems helps me solve my problems as well. I see teaching as a constant learning process.

"Students are looking at everything in a new way. To keep up, *you* must also look with that fresh perspective. This forces you to evaluate the state of the art, to appreciate change, as well as the here and now.

"Students want to know what's going on, so I have to know what's happening to report back. Without a doubt, students are *my best* learning tools."

## WHOSE LEARN IS IT ANYWAY?

Matt McElligott agrees. He thinks that working with students has opened him up to new ideas, new approaches, and more. He's discovered that teaching, not surprisingly, has been an excellent education in itself. "As anyone who's ever tried it can tell you," he comments, "there's no better way to learn something than to try to show someone else how to do it."

Let's flesh this out a bit. When students focus on something they haven't seen before—the new or unexpected—great change can occur on both sides of the teacher's desk. A truly savvy educator should be open to learning from students and recognize that teaching is a great counterbalance and outlet. In fact, at the end of an earnest day in the classroom, it could be difficult to say who benefits more—the pupil or the professor.

I've always felt, wholeheartedly, that one learns so much from whomever *you think you are teaching*, whether that be a parent with his child or some seasoned career pro working with a newbie. I can't imagine a smart teacher refuting that; not many folks are so pompous that they think they teach and don't learn at the same time.

## WORKS FOR ME

For some, teaching simply rings just right. As Stan Shaw says, "Teaching allows me to indulge my love of history. The research and reference combined with my personal, creative experimentation gives me some insight into how I work.

"I also get to see through the eyes of the students, who may or may not be familiar with what makes a 'good' or 'successful' piece. The constant job of breaking down what I know, taking a good look at it while quantifying for those students, provides a fresh take on this process."

Greg Nemec tells us, "I used to tutor inner-city kids in reading and writing. I was always attracted to igniting that spark of learning. There's a quote that resonates with me here. It goes something like, 'Figure out what you're passionate about: do it, and the money will follow.' However, it took me a long time to figure out that I should be teaching these same age kids to make *art*. So I then started art classes for local grade school kids.

"I tend to dive into preparation, research and learn as much as I can before I switch over to the intuitive side and start being creative. I need that foundation to begin. With teaching I am less structured.

"I always draw from my experience, knowledge, and prep," Nemec states, "but I like to see what organically unfolds in the classroom—let that influence what we do next. One thing just leads to another. Teaching kids has helped me be more open to change and unpredictability in my own work."

### COME ON IN, THE WATER'S FINE.

Isabelle Dervaux was new to teaching when we first chatted about the subject. "I was a bit afraid," she candidly admitted. "You jump through all these hoops: maybe I'll have the wrong mix of students; I won't handle it well . . . I'm out of my league—I'm not cut out for it."

But friends convinced Dervaux otherwise. "It's fine; just go ahead," she was told. And Dervaux was glad she listened to them. "I got a lot out of it," she says, "how to articulate or think; how to say something, in plain words, logically, *out loud*. You see that what you learned along the way is tremendously valid, that what you're doing is honestly good, and you feel more confident. You notice that you know *much more* than you think. You gain new perspectives . . . a fresh look.

"I didn't expect to enjoy teaching," she says with a smile, "but I actually loved the connection."

## THE FRONT LINES

Developing content for your class can absorb a great deal of time. Within the parameters of any subject are a wide range of possibilities to be explored.

Edwards says to compose a course description and draft an outline that initially gives you an idea of what should be covered in the class (and summarizes, of course, the critical information ultimately offered to your students).

"A big part of your job is to make that content relevant and interesting," says Edwards. "The more you explore and plan, the better your class will be. If you are excited about what you present in class your students will likely be excited as well, and will produce better work." Real world alert! Make sure you include information learned from working with clients and art directors: your students will gain a deeper understanding by hearing about your practical experiences. Flexibility is also important. As the semester progresses you might decide to

scrap some of your original plans to incorporate an idea better suited to your students' needs and interests.

If you are teaching a class for the first time, Edwards reminds neophytes that it is always best to take a few months to prepare before classes begin. In addition to determining what should be covered, creating a logical sequence for that content is key. Sync with the school calendar to decide how to fit the various units into the semester.

Is it a no-brainer to remind you that your approach to the content of your class should reflect the needs of your students first and foremost? "Find out as much as you can about them," Edwards says. "Do they all have the same technical skills? Are they all at the same level and in the same program? If your assignments require specific technical skills, you might develop a short questionnaire for the first day of class to determine if you need to include additional technical content."

Next, decide how many projects you'll assign and what the grading rubric will be for each: students should have a clear understanding of your evaluation system. If you will only include a few major assignments during the semester, consider breaking projects up into two or more grade modules, providing early assessment and progress checks for each student. "It is best if grading occurs early and often during the semester so students have a clear understanding of how they are doing in your class," Edwards advises. "You could also give grades for the various components of a finished project. Your final grades will be that much fairer if students are given a variety of opportunities to succeed."

Critiques, obviously, are an important part of the evaluation process. Students need to have the experience of presenting their work, absorbing (and processing) feedback, and assessing the work of others. The tone of a class critique should be non-threatening and positive; however, students must be led to recognize the successful components of a project, to identify areas that fall short—and how to improve these areas. Creativity and effort should be acknowledged and encouraged. "Discussion and analysis leads to a deeper understanding of the illustration process," Edwards states. "This helps your students develop the skills they need to succeed in a competitive field."

Most colleges and universities have a system for students to evaluate the effectiveness of each class at the end of the semester. Which projects and presentations were most effective? What information was vital; what wasn't? Any problems? As part of the evaluation, students should also be asked to evaluate their own performance in your class. How well did they fulfill their responsibilities: attendance, preparedness, and effort?

Just as students must find their own voice, teachers must also find their own creative way to communicate ideas and information. "The best classes are the ones taught by artists who recognize the craft of teaching," Edwards sums up.

"These teachers are always learning—seeking new and better ways to engage both clients and students in the process of illustration."

## IT ALL FITS

"Everything you do in life can be a learning experience," says Veronica Lawlor, "if you're open to it." In Lawlor's opinion, a good teacher is one who brings the best out of their students, gets them to go beyond what they thought was possible. "Good learners," she says, "usually make better teachers, since you have to adjust your methods to reach each student. It's definitely a learning process." It's a win-win, give-and-take education: without that yin and yang, communication is difficult at best.

So, what, then, is a "bad" teacher? "I guess a bad teacher," Lawlor says, "would be one who treats students as if they are interchangeable. Fortunately, I haven't seen it that often. If you teach, generally speaking, you do it because you care."

Lawlor says she puts the major focus of the whole academic exercise on the *individuality* of the student—what is it that *that* person can offer, that is unique to them, and how can she help them bring that out through their art.

### ART ED

If the art and act of teaching intrigue you, what would a proper education or training look like? Lawlor tells us that it should start with drawing. "Not drawing as a method of replicating the world, although that can be a part of it," she says, "but drawing as a method of visualizing thoughts and ideas, or translating what you see into your own language. Training in drawing strengthens your skills of observation and refines your unique sense of taste and design. Your preferences come through when you are drawing, you are constantly making decisions, and eventually your personality—or so-called style—will emerge. There is no shortcut for this.

"Your students need to be presented with different situations and problems to react to and comment on with their illustration," says Lawlor. "That's why I like taking students on location to work. It can remove habits or preconceived ideas of what an illustration should be, and fosters an individual approach."

Lawlor points out that the same goes for mediums, from traditional to digital: students need to become familiar with a wide range of tools. "Young illustrators today are going into a different world than when I graduated from Parsons," says Lawlor. "They have to know all of the computer programs as well as traditional drawing and painting, and be proficient in sequential and moving images, as well as single frame illustration. They should be working with type as well as 3-D and graphic design. It can be a lot to learn, but I believe it offers them so many more exciting opportunities. I also think it's extremely important for young illustrators to become voracious readers—without ideas you have nothing to say."

Lawlor reminds us here that one learns while doing—arguably the best way. So while theory is wonderful, and practice is important, it's the combination of theory and practice that creates the breakthroughs.

And here, motivation becomes an important keystone. Without motivation, breakthroughs are rare. "Find what motivates your students and give it to them," Lawlor says. "Drive will take a moderately talented artist to the top, and a brilliantly talented artist with no drive may unfortunately wind up going nowhere."

## HOW TO GROW

Looking at it from both sides of the drawing desk, Lawlor feels that teachers must be facilitators of growth. She makes the analogy that students are like plants: teachers water and fertilize them, put them in the sunshine, and prune them back when necessary.

"Sure, students look to teachers as their role models," Lawlor says, summing up. "And, certainly, it's an important responsibility to take on when you teach, and you can't ignore that. But ultimately, it's up to the student."

# GOOD/BAD

In a bit of a nature or nurture moment, I asked Greg Betza the same questions I asked his studio mate, Veronica Lawlor: what makes for a "good" teacher? What makes for a "bad" teacher?

"A good teacher is someone who can bring out and develop the uniqueness of their students," Betza says. "The one thing each illustrator has that no one else can duplicate is their identity. Their interests, their history, and their personality are going to determine what type of artist they become.

"I define a poor teacher as one that only develops a student's technical skills. One that is more interested in the polish than the process. School should be a place for experimentation, a place to try . . . and fail. I have also never understood the immediate, intense focus on 'style' in school. Students should work toward a style, or not, and be given the opportunity to develop a way of problem-solving that is truly their own."

## NO EASY WAY

In response to the unfortunate mindset (for those who actually have no clue) that teaching represents the easy way out, Betza scoffs and says, "Teaching is easy? This is laughable and it's a shame that anyone who may think this way could obtain a job at any institution.

"With that said, I don't understand how someone who "can't do" could possibly have anything of value to share, aside from how *not* to approach their career. If *you* can't, then how can you teach someone to succeed?

"[Successful student learning] means giving the student the freedom to fail, over and over. Allow a student to work however and whenever they choose as a means of fostering a sense of responsibility and ownership of their work. Allow the student to make these choices for themselves. After all, part of their education is the development of self-discipline. In the class where I was given no homework, I did the most homework, because I wanted to. I was interested in what I was doing because I owned it, and I worked at it every chance I had."

# ON THE BOARD

## (PROFESSIONAL VIEWPOINTS IN 50 WORDS OR LESS)

If you maintain a creative and flexible approach to the communication of ideas, if you love what you teach and enjoy working with people, your enthusiasm will be communicated to your students. They will respond and will be creatively engaged in your class.

—June Edwards

Teaching should be about eye opening; giving views on illustration that students may have never seen before. Encourage your students to question—this widens their point of view, at their own pace and on their own path.

—Stan Shaw

Is teaching the easy way out? Out of what? No, I don't think so. There are those who can't do, but DO teach. They probably don't teach well. There are those who get into education for the wrong reasons—and will probably be terrible at it.

—Brian Biggs

I personally hate this saying, "Those who can't do, teach." I find that the opposite is true—you find yourself learning to do more, so you can teach it to your students. You've got to be current and a step ahead, or you will not be effective as an educator.

—Veronica Lawlor

© Rob Hodgson 2016

444

Talking to students revived my passion for the career. I heard myself talking and realized how much I had invested in that career, and how much I knew. It was a pivotal experience.

—Lizzy Rockwell

Fine teachers promote other avenues of thought—you learn from each other. Training and learning never stop; art education is a two-way street. I learn more from my students than they learn from me.

—Paul Melia

When I first started teaching, it was a way of giving back. You have to have something to teach and it's not so theoretical.

—Alex Bostic

A good teacher pushes you forward, providing critical feedback you cannot get while working on your own. School provides a sense of community and networking—eyes, ears, and minds that can help students set their work free.

—Ulana Zahajkewycz

© Stan Shaw Illustration LLC 2016

© Peter Arkle 2016

# Chapter 21

# It Happens

*I've lost dexterity, hand-to-eye coordination, and my power of concentration is shot. I need eyeglasses to draw; I've dealt with a frozen shoulder on my drawing arm all year. Every panel takes hours—when I'm done, I hate everything about it. So, pretty much business as usual.*

—Gary Spencer Millidge

## I GOT MY REASONS

I want to tell you something. While I haven't taken a poll, I believe most creatives I know will say the same: friend, this is a tough business. That begs a fair question: if it's such a hard slog, ya gotta ask: what are the reasons I'm doing this, then?

I do what I do because I adore making art and always have. And if I could make some money following my dream and passion, that'd be the icing on the cake. I saw that if I wanted to stay in there for the long haul, which eventually became the realistic desire to support a family, I needed to diversify, stay flexible and wide open to inevitable change (a.k.a. growth). And I soon realized that I needed to be an entrepreneur—even if I couldn't spell or pronounce it correctly—now, more than ever.

Coming up as a kid, art was "my thing." In school, I wasn't a scholar, and not much of an athlete. But I could draw with the big dogs. It made me feel better than anything. If you think and feel the same, then no matter how difficult it is to "break in" and stay put, you must go for it. Repeat that please: "go for it."

Notes to myself and you: Have a plan; be determined, stay focused, learn to bounce softly—be kind to yourself. I don't mind spewing the traditional clichés here to make the point: you're the best you there ever was. Love that guy (or gal). Make him *work*; but keep reminding him that if it's not fun, if it doesn't make him happy, there are always options and choices—you can move on. After all, life is the big box of crayons, isn't it?

## IT'S PERSONAL

It's hard not to take the ups and downs of this profession personally. But maybe "taking it personally" just means personally taking it in a positive direction. You can succumb to the hard knocks, or look at a downturn as the trumpet to charge. Either way, you'll have to approach your challenges from left or right of that center.

"It makes sense to explore . . . Change is refreshing," Mike Quon says. "My career dream was to be an illustrator and a designer. I realized that dream by working almost continuously, juggling the creative side with a heavy dose of promotion and marketing.

"But when my illustration and design business grew to where I was spending more time selling and managing than I was creating or working on other parts of my life, I realized it was time to downsize."

Whether it was having a smaller shop or the perceived "downturn" in the industry, a less consuming work life made it possible for Quon to start a family and do all the things that go along with having kids and a home life. "A new approach to work can help you answer some tough questions about what you really want your life to be about," Quon advises. "What is success? What do you really want? For me, it was realizing that raising children was my biggest project—too big to miss."

Quon certainly advocates you going for the proverbial brass ring. He's telling you to take the chances, but to have the nerve to move on to something else (big or small). Keep moving, learning, and making adjustments; keep fine-tuning it. Remember, it's all an experiment anyway. And it is about the journey as much as it is about the destination.

We know life's not fair. There are a lot of talented folks not making it. Quon knows a colleague who works at Home Depot in the evenings to make ends meet. Here, Quon says so be it. "This is only a discouraging story to me," says Quon, "if he stops making art due to this outside employment. Honest work, if done because it's part of your action plan, is just part of keeping the machine moving forward." I agree with Quon wholeheartedly. Keeping diapers on the baby, putting food on the table—making all the ends meet honestly—only makes you a big mensch in my book.

"Remember it is about creativity," Quon says, "and creating keeps you evolving in so many different ways. It *might* mean doing something new, instead of the same thing you have been doing for all those many years . . . what a concept! Just make sure you are doing enough of what you want."

"And," as Quon sums up wisely, "do be careful what you wish for (you just might get it)."

# FREDA

When Anthony Freda graduated from Pratt Institute, he entered the "real world" coated in what he calls, "a surface patina of confidence that belied an inner core of fear and inadequacy.

"I had learned from great artist/educators many lessons about art and design," says Freda, "but nothing about how to make a living making pictures."

Freda's first illustration gig came by way of a portfolio review with a regional newspaper called *Newsday,* which to his delight, resulted in an assignment. He did the job and after waiting for what seemed like years (it was actually months), a check arrived in the mail for the princely sum of 50 bucks.

"Of course, during this time I was sending out mailers, and dropping off portfolios on the drop-off days, and picking them up on the pickup days," he says. "It was before the Internet, so I was physically trudging my work all over New York City, uphill both ways, in the snow!"

Freda soon saw that he was spending more on promotion than he was earning. "No financial genius, even I knew this was not a profitable equation," he says.

## ROCK IT

His family was full of helpful ideas on how to make it as an artist. One uncle suggested Freda paint lighthouses on rocks and sell them at the mall, or maybe dabble in "string art." Another uncle told him that he knew a guy who

sold similar creations *for a whole $5*! It was at this point that Freda started to panic.

"Did I waste those four years of art school (and the overpriced tuition) for nothing?" Freda asked. "Was I a chump in some art college scam?" Indeed, Freda wondered if he would wind up working in a gas station, but was way too stubborn to admit defeat—*yet*.

So it was at this nadir of his nascent pseudo career that yet another uncle told Freda of his friend who owned an advertising art studio in Manhattan. Freda went in for an interview, and the owner told him he had some talent, but he was really giving him a job as a favor to Freda's uncle.

"Who cares?" Freda thought. "$250 a week, and working in Gotham, I hit the big time, baby!" Freda says with a laugh. "I learned more about the reality of working in the applied arts there than any art school can teach. I was on my way."

## ORGAN RECITAL

Around Thanksgiving of 2010, life got seriously in the way of *everything* else—I had a chunky ol' heart attack and angioplasty procedure (two stents). This event was more than a profound shock as I was (and am) in good shape with a decent lifestyle. But it runs in my family, so that's the wildcard. My angels were watching out for me from all the angles—the coronary actually happened *at the hospital while waiting for a stress test.* It all went so very well, which is a glorious understatement, as I am, at this writing, still here to tell you that news. My care was incredible; my lovely wife, Joanne, was—and is—the head guardian angel.

The big bounce back bounced big time. You take it low and slow at first; then keep it steady as you go. You build shelf life and oomph, with everything constructed around (and informed by) what I call the flab four: diet, meds, exercise, and stress relief. Reasonably, you understand it's always "so far so good," but you *must* make the commitment to firmly go the greater distance.

Yes, there have been a few more quirky rides on the cardio roller coaster, and I work daily with natural wear and tear—we are amazing, albeit imperfect machines—but my heart is fixed. And I can honestly say my recovery has been an unequivocally life-affirming, game-changing journey of positive outcomes.

## RUST

Beyond the daily stresses of being that "best you there ever was" and the logistical challenges of putting bread on the table, there are the physical manifestations of a (potentially) long tenure at life's drawing board. It's inescapable—we all rust or flame out. And then stop.

In discussions of this sort, the sports metaphors don't just border on cliché, they annex the conversation. With luck and maintenance, you'll run comfortably in what is indeed a marathon and not a sprint. But physically, mentally, and emotionally: how *are* you running your race?

Over the years, on the road to knocking out a career, you will no doubt swerve on a slippery patch of health, professional, and personal challenges. It will seem like the events hit like buckshot, but one hopes you will gracefully dodge any truly big bullets.

So what's my point here? Besides fully acknowledging life's little blessings, if nothing else, you will be reminded that control is ephemeral, fleeting; that it takes only one moment for "all that" to change to "all this," and then you have to just deal.

If you have to, please accept help with gratitude. As you must, try to be more aware of what you can do and *not* do and work to keep each action in their own state of grace. Acknowledge frustrations and own your fears and attitudes. And in the middle of that little run of bad luck, remember that maybe it seriously could be really, truly, absolutely, much worse.

## DESPAIR?

"As long as you are doing something," says Shaun Tan, "even if it isn't successful, you are not wasting your time." Tan feels that the greatest achievement of a creative life is "simply finding time and dedication to do it—especially when it seems difficult and less than enjoyable, particularly as almost every project seems to involve some kind of confidence-wounding crisis."

Indeed, Tan tells us that he measures the quality of a project by its number of creative crises, what he calls the critical tests of stamina and purpose. "All your good ideas and talent aren't worth much if those commodities aren't put through "the wringer of actual hard work, worry, and deliberation," says Tan. "I actually get suspicious when things are going too well!"

## BETHANY

For some people the superlative "worse" is sincerely relative. Bethany Broadwell said that she was one of a fortunate few who could honestly say it was a practical decision for her to go freelance.

Broadwell, who died in 2009, two years after I interviewed her for an earlier book, was in her thirties at the time of our chat, weighed a mere forty pounds, and battled a neuromuscular condition called spinal muscular atrophy. The disease progressively weakened Broadwell's physical strength and caused her to rely on a wheelchair for mobility. Simple tasks like speaking on a telephone or

arriving to an appointment on time involved massive organization and planning. Completing every aspect of even the simplest effort usually meant she was forced to depend on someone to help.

"I need enough flexibility in my work routine to maintain my stamina," she said. "It made sense for me to seek out home-based employment that can largely be accomplished in front of a computer."

As her arm and hand movement was extremely limited, technology made it feasible for Broadwell to circumvent her challenges. Her fingers never passed over a keyboard. "I strictly use the mouse and click key-by-key on a virtual, on-screen keyboard," she told me.

"Once I am positioned in front of my system, I can work independently for the most part," Broadwell continued. Her favorite communication methods were email or instant messages, both of which would offset her slightly unclear speech and allowed Broadwell to interact with clients.

Working on a project basis gave Broadwell the leeway to attend to any personal care needs she may have had. "As long as I keep careful watch on my deadlines," she stated, "I can complete assignments at my own pace. Providing I meet or exceed my clients' expectations, the matter of how or when I accomplish their project is immaterial."

Pushing practicality aside, however, Broadwell felt it was better to reflect on why artistic freelance projects can be a good match for people with disabilities. "In my case, the main philosophical reasons have to do with the three Cs of control, connectivity and continuance," she said.

But no, she wasn't a control freak. As she told me: "The reality is I can get a little down if I dwell on my physical condition being out of my control. When I am disheartened by my limitations, my art can help me cope with these helpless feelings. It gives me the power to shape images into the creative arrangement of my design. I have an outlet I can mastermind."

Broadwell professed that her work also pushed her to be more outgoing. "A disability can contribute to a sense of separateness and inadequacy," she said. "In order to keep my flow of projects steady, I am constantly networking, brainstorming, and asking questions to stockpile creative leads for future endeavors.

"I am put into a position of needing to take initiative, exude confidence, and demonstrate my capabilities. The repetition of these tasks helps me become a more vibrant, positive contributor."

Did she feel she had a calling; was she "making a difference"? "This is the mission of all kinds of people," she pondered. "As someone deemed 'frail,' the idea of impacting others is a factor I contemplate. How can my small self influence others in a positive way, when my existence itself is so precarious? Through art, I am comforted to think I am creating a means of continuance. Whether I am here or not, my perspective is established."

Although gone, Broadwell's poignant and inspiring message still resonates and lives on, as does her powerful and determined spirit. Thank you for your not-so-small self, Bethany, we miss you.

## ERIN

If you want to talk about coping skills, and bouncing back, we should chat about Erin Brady Worsham, who points out that disability is a possibility for all of us. My friend, *The Strength Coach*, Greg Smith, has been evangelizing this sober, but actually mind-opening message for years.

"If nothing else," Worsham says, "it brings about the profound realization that art was never really about the pencil and paper or the paintbrush and canvas. Whatever the challenges, artists will find a way to express themselves."

It's not just happy talk and another smiley face moment, folks. Worsham knows. "I was an artist before I got sick, but my work lacked focus," she will tell you. "When I was diagnosed with ALS in 1994, I knew it was only a matter of time before I would no longer be able to use my hands, and I lost the need to create."

Only after Worsham found out she was pregnant did she recognize her desire to live and make her mark on the world for her child. "Thinking that visual expressions were beyond me," she says, "I began to paint images with words on my communication device in a journal for my son. I think this was an important period for me, because it forced me to fine-tune my descriptive skills.

"In 1999, when we discovered how I could work on the computer, my mind went wild with the possibilities," Worsham remembers. "I had taken the simple act of putting pencil to paper for granted. Now I have to use a painstaking process with a sensor taped between my eyebrows, but it seems a small price to pay to draw again.

"I am confused when people ask how I cope, because I don't see the alternative. I am as I am, and I am who I am—and that is an artist," Worsham flatly states. "My art has given me an identity outside of the ALS. It lifts me above the physical limitations in my life to a place where I can work—just like any other artist."

## MAKE YOUR MARK (FOLKS JUST LIKE YOU)

### DOUGLASS: REST, REFRESH, RELAX

Ali Douglass's creative vision is 100 percent, but she was having some physical issues with her eyes. Her condition affects her work, but while obviously connected, is not directly *because* of the work.

In her care and treatment, Douglass discovered that her optical problem was a learned behavior caused by staring at the computer too long or focusing at her drawing

board so intensely. She ultimately learned to take a break every twenty minutes and focus farther out, thus protecting her precious eyesight. That was something she had to practice, she says; reminding herself to take five; stretch her body out, concentrate somewhere else beyond that visual hot zone.

"I was twenty-nine years old at that time," she remembers. "And I felt like I should be invincible. But of course, I'm not." And to the reader of these words, a friendly caution: let's make this perfectly clear (my apologies to Douglass, and pun intended), you are not, either.

# SISTER ACT

Without minimizing the very real impact of these conditions, let's talk about some lesser demons, and only on the cosmic scale of things. You know 'em, you love 'em, you deal with 'em every day—the sister act of mistakes and failure, often in cahoots with their little brothers: panic, anxiety, and insecurity.

"Usually the first thing I do after reassuring the art director that I can handle this job—*hey, no problem*—is panic," says Tom Graham. A seasoned professional, Graham is reticent to admit it, but doesn't deny this fact—the anxiety of "being in deep water, up to my eyeballs" is *very* real.

After about an hour, Graham says he settles down. "I read the text, and start thinking—rationally and objectively. I again realize solving an illustration problem is an *intellectual* as well as an *artistic* job (maybe more so)." And then the fun kicks in and his confidence returns.

Scott Jarrard also owns up: "I totally fear failure," he says. "I want to succeed. I want to be the best I can be. Failure is not an option. I keep on moving. I deal with failure by working harder. By taking a deep breath. By taking a break, pondering; doing the dishes, going for a walk. I'll do something else—and then go back and rework whatever my problem is."

Ken Meyer, Jr., says that if you always succeed, you are not really learning. And Lizzy Rockwell has learned to walk away from a problem when the answer is not revealed after an honest effort. "It is impossible to be creative and frustrated at the same time," Rockwell says. "Frustration can be agonizing, but I trust the solution will ultimately come to me."

"I absolutely hate to fail," says Vicki Vandeventer. "Who doesn't?" In her twenties, Vandeventer approached projects—and as she says, probably life in general—with the prospect of failure foremost in her mind. But at some point she realized that "If you are not experiencing failure periodically it really means that you're not trying new things and you're not taking chances; you're playing it safe."

Vandeventer echoes all the above smart folks when she points out that you can't be instantly great at everything, and once you realize that a certain amount

of failure is actually a good thing, you won't worry about it. "Well, at least not much," she says with a small, wise smile. "Oh, I still don't like it, but I know that it's necessary; it's how you learn."

# BURNT

Brie Spangler's career was off and running. She says that she was no wunderkind, but efficiently grew her business as a steadily working illustrator. After graduating from RISD, Spangler found a path to full-time freelance that built with each job she landed. "I was eager to do it," she says, "which is a huge part of the battle. But honestly, maintaining that eagerness is one of the hardest things to do. I loved—underlined, bold, and in italics—loved to illustrate when I was first starting out."

For Spangler everything was done with gusto, all the way. She scored a lot of work, but gradually sought more inspiration. The "grind it out to pay the bills" routine wore on her. Fast-forward some years later: "I was more burnt than a piece of toast stuck under the grill," says Spangler, "pure carbon."

In addition, Spangler slammed headfirst into one of the worst financial crises of our time: the collapse of 2008. Spangler weighed her professional options and, in her words, simply threw in the towel. "Bad idea!" she says. She also had a baby and started a family, which, again in her words, was "pretty cool. *Great* idea!"

"If there's one thing I wish I'd done," Spangler says, "it would have been to keep making work. In hindsight, the play is to step away from the stuff that merely keeps you afloat and run toward making work that makes you happy.

"Obviously, I should have been making my 'happy work' all along, but that's a realization that only gets sharper with age. You must learn to cope with the ups and downs of your career by doing art that speaks to you. Show it, don't show it; it's yours to do with it as you like. Just make sure you're making it! It's the kind of art that strums your heartstrings. Invent a new style. Crash a fresh medium. Try something new and see if it clicks.

"Worst case scenario, consider that you're working to pay the bills. *Focus on the success of that* and don't hate it that you're human. Spangler advises you to be kind to yourself. If you feel like you need to drop out from illustration, take some time, do it; but create a plan to come back. "Put up a notice on your website that says 'New Work Coming By _____' and state a return date. That way you're holding yourself accountable to being present in your industry. If this 'x-date' comes and goes and the thrill is gone, never to return, address it then and be truthful."

Even though she pressed pause to happily start her family, Spangler admits that "The hardest thing has been coming back with a new portfolio and expecting the same results I had before." If you're in the same situation, she says again to "Be good to yourself. If you want it, it will come. It's like starting all over from scratch. Approach it like a pro and allow some time to build up to a station you're happy with. And above all, don't stop making work you love."

## MAKE YOUR MARK (FOLKS JUST LIKE YOU)

### MINAMATA: GUMPTION

"I'm not good at change," says Julia Minamata. Sound familiar? While Minamata strives to be open and adaptable, she feels that part of her difficulties with change is that, like many folks, she's very stubborn and determined. "I want to keep trying and trying and trying until I break through and succeed at the task at hand. I get very focused and don't want to deviate. This can be a virtue and a drawback."

Thus, Minamata confesses that she has a lot of trouble distinguishing between "giving up" and "moving on." Metaphorically, she finds herself thinking *I want to get better at this game, don't go and change the rules on me!*

So Minamata reminds herself that as long as she gets "a little bit better at illustration every week," she will be that much better than she was the week before. And ultimately, that's *the* goal, isn't it—just to get better and better at making art? "I can't make a client take a chance on me," says Minamata. "I can't control how much of a budget they have. I have no say if I get into the illustration contests. But I *can* determine what I choose to do every day."

"Professionally," Minamata admits candidly, " I have an inferiority complex. I don't feel that I fit in anywhere, really. Does anyone feel like they fit in?" she says. "I deal with this *by being there anyway*, regardless of my feelings to the contrary. I put on my big girl pants and get to work.

"I will despair and cry about my career, life, and setbacks about eight times a year for an average of half an hour each occurrence," Minamata says. "It doesn't affect productivity too badly and it's cathartic so I have no problem with this. I blow my nose and move on. Next!"

## YOU MUST

"Getting burned out is really easy," says Lea Kralj Jager. "After working on other peoples' projects (and given the time limitations imposed by a steady job), it seems impossible to have your own thing going on. But you must—be it your own comic or animation that you work on a couple of hours a week. No matter how little time you have for it, it will keep you grounded and make you remember why you love what you do and why you're still here and giving your best."

## DAMAGE CONTROL

When you *really* blow it, how do you face that fact? How do you deal with it; what is your recovery process? Dan Yaccarino notes he becomes very conscious of what just happened; he examines his motivation, looking hard at both failures and successes. "I sit down and take a good, long look," he says.

"When mistakes happen, my first reaction is flat-out anger," admits Jarrard. "I'm a perfectionist, but once I settle down a bit, I can honestly analyze the situation. I'll ask myself a lot of questions: 'Exactly what was my glitch? *How* did I blow it—where did I go wrong? What was really expected of me? You come to a happy middle ground when you share expectations."

This means that Jarrard talks over concerns before any drawing begins. He works to avoid conflicts on the job by working everything out in a clear, comprehensive, written agreement. He believes that good communication skills—especially right from the very start of the job—are vital. "If it is truly my fault, or I was completely off track," he states, "I'll start over and suck up the time. If we're in a gray area, I will listen first, then share my point of view. I will talk through my process and concept to explain why I did certain things."

### AN ORGANIZED SELF

Such positive, preventative practice (and creative chicken soup) entails some serious organization. Part of that discipline, and a big block of bouncing back peacefully, involves, as PJ Loughran points out, "Learning *when* to go forward and knowing when to pull back or in another direction." And a sizable chunk of this self-knowledge is a sense of humility.

Be aware of your strengths and your shortcomings, for as Loughran says, "This is the opposite of entitlement; no matter how talented you are, regardless of how easy it all came to you. And while you may be good (or *great*) at something, arrogance is a dangerous thing.

"We all make mistakes," Loughran says, "especially in a creative discipline. You're never going to knock it out of the park every time. Everybody does both good and bad work, but the way to bounce back is to be consistent over the long haul."

Your mom was pitch perfect: even though you crave a challenge, you must live in the present. And your dad was exactly right: failure or disappointment is a learning experience. So when you make a mistake, you pick yourself back up. As long as the quality of your work is consistently good, one healthy mistake shouldn't be the end of your career.

## EMBRACE FAILURE. LEARN FROM IT

*Could've, should've, didn't, wouldn't. Can't, and don't, and maybe not.* Are these big buzzwords in your daily vocabulary? "There are too many whiners out there,"

Loughran says, with a laugh. "Get motivated! Look for opportunities; pursue them—*make* something happen. Create opportunities for yourself or seek them out. There's no lack of talent in the world. If anything, there's a lack of discipline and ambition."

Branch out and go out on that limb, too. That old cliché may be shopworn, but it's still a truism. Mistakes are always an occupational reality, but so are lofty goals and great success. If things go well or head south, you're responsible. Such empowerment can provide a huge sense of your daily worth. This is not an Olympian trait, it's within all of us. It's that balance and control that makes the difference.

Some folks do feel there is a certain safety in failure. There's no pressure if you're convinced that you'll just boot the game, regardless. Hey, why take the risk—you *know* the outcome. So you don't take the shot or you dog it, certain of the results. And sure enough, the self-fulfilling prophecy comes true.

Jarrard tells you to wholeheartedly learn from your mistakes. "Hopefully, by accepting a mistake, I can avoid making the same mistake again," he points out. "If I can now avoid that same mistake, I have progressed. If I have progressed, it means I am learning. And if I am learning then I am enjoying life.

"If my life was 'easy,' or if I didn't struggle professionally, I am shortchanging the future. By heeding my faults *and* recognizing my progress, I have something to look forward to—I look forward to being a better person and a better artist."

To which Ulana Zahajkewycz says, "The long, hard road of making your own mistakes to get to your true, final destination is always open to everyone at all times." Julia Minamata adds that we get way more information out of mistakes than successes anyway—and what you learn from failure is completely dependent on what you're willing to take from the experience. "The most important thing we learn from our successes is that success is possible," she says.

## FAIL TO FAIL

Once, in an interview, I was asked to cite my biggest professional failure (and how I overcame it). But for me, this wasn't a specific event. From my point of view, it was the challenge to resist the tricks ego can play with your self-perception.

For better or worse, the quest for recognition, approval, and rewards (not to mention big bucks) are a part of an illustrator's—actually, any artist's—reality. The competition is fierce in most creative fields, the level of ability out there is simultaneously intimidating and inspiring.

Accolades and achievements are certainly desirable, undeniably cool, insanely great, and guaranteed to clear your complexion while improving your SAT scores at the same time (maybe just *half* a joke). But that's not what being an artist is *really* about, right? Surely that's not actually why we scribble about all day, is it?

Well to me, at least, it *shouldn't* be—you draw because you love it. You create because of the little rush (and big tickle) you get when you realize, "Hey, I made this. *Me*. No one else can do it quite this way."

There will be inevitable moments when you need to remind yourself of that. And getting to that actual heart of the matter is what's really desirable, cool, and insanely great. However I'm still working on my complexion and improving my SAT scores.

## FLIGHT OR FIGHT

Life, professionally and personally, can get more than a bit daunting. Call it a dry spell, but you may hit stretches where not much is happening . . . business spirals down; work drops off or simply evaporates. Been there; done that, thank you very much.

You could sit around to piss and moan, or you could do something about this mess. Granted, it may be hard to keep the faith, but that is why it's called *faith*. If you actively believe in your personal power to make the changes and upgrades on all fronts, personal and professional, you have a clear shot at turning it around.

How? I can sum it up in three words: *resolve, diversification,* and *action*. If you haven't diversified early, it's really never too late. Really? Really. I doubt seriously that you're a hopeless, one-trick pony. Hell, even I can walk and chew gum at the same time.

Diversification is simply figuring out what else you're good at. And what else ya got means simply looking at what else you like to do. We bandy about that term "creative" so . . . well . . . creatively. Here's your chance to dip into that creative *well*, what Vivienne Flesher labels as that whole spirit of being an entrepreneur, and come up with other job descriptions for your multitasking self.

I am also a firm believer that work begets work; that it is easier to find work when you have work. For me, I can pull my thumbs out of a number of pies: illustration, cartooning, design, and fine arts; teaching (public and private; full- or part-time); writing assignments; speaking gigs and lectures (large and small, including school and library visitations); consulting.

I'll risk sounding like a late night TV infomercial to say that a good attitude and positive mindset, strong work ethic, plus active marketing and promotion make the difference. It has for me. And I'm not going to say "at least," as it is hardly a minimal effort. I believe it can for you, too.

So when the creative well dried up for me, could I have worked midnight shift at the local mattress warehouse? Sure. And while that is honorable work, I had different ambitions. And so did Ray-Mel Cornelius, who will tell you the story of his former student bemoaning a hard time deciding whether to enter

the communication arts or go into business with his uncle, who had an air-conditioning/heating repair business.

"I told him that there was nothing wrong with air conditioning and heating repair," remembers Cornelius, "and that if he felt he could make that choice, then AC/heating may well be for him.

"I would have made an awful heating and air conditioning tech, and probably a terrible *just about everything else*," Cornelius states unequivocally. "There's nothing else I could or would want to do with my time than make images."

## UNSTUCK

"I foolishly used to think that being good at drawing was the most important part about being a successful illustrator," says Melissa Doran. "But as time went on I realized there's so much more involved: you need to believe in yourself, be able to get work done, put yourself out there ... and never give up! Those last bits all come from getting in the right mindset and mustering up enough self-love and self-belief to overcome the doubts and fears."

Doran's hypothesis states that working full time as an illustrator means you logically acknowledge the need to work and that you'll draw all the time, even when you don't feel like it . "Even before you get ideas," she says. "You've made the first move and have set working hours every week and you stick to them. Keep turning up every day, be productive and you'll be fine, right? In theory, that all works great, except for the times when you can't get anything done and that little panic begins to set in."

### PLAY

According to Doran, "stuck" just means you've lost touch with yourself and your talents; you need to get plugged back in again and get things moving. She tells us to envision a heavy, dense energy you need to dissolve with something light and fun.

But how to get there when you are feeling lost? Doran has discovered that incorporating play into your everyday experience can help you find your way. "Feeling playful is the opposite of feeling stuck," she says. "When you get into the habit of having fun everything starts opening up and ideas start to flow again.

"Finding a way to play helps get you moving," Doran says. "Once you are moving it's way easier to keep moving and start tackling the more important things."

### FAITH

Doran states that it's easy to get stuck and lose faith from time to time. Not getting results as quickly as you'd like? Dying a little inside? Dealing with some niggling feelings of low self-worth? Worrying about finances? Even considering what Doran cites as the big no-no: "Maybe I need to just give up and get a *real* job?"

"Yes, it's *the* big no-no!" Doran reemphasizes. "When you get in this frame of mind you won't be getting much work done. You are effectively shutting down your creativity and digging a hole for yourself to hide in.

"The serious, worldly side of your brain is taking over and being really bossy, boring, and frankly a bit of a killjoy," Doran says. "Your creative subconscious has infinitely better ideas than your conscious mind, and is also much funnier and *way* cuter. So 'louden her up' and tune in to the good stuff. You've been there with her already, the days when everything just flows and time is meaningless. You get your best ideas and it's a happy place."

# BIG TIME

Here are a few tricks Doran has picked up along the way that have helped her from quitting before she hits the big time. "And I'm going to hit the big time any day now!" she says.

1. "To get things moving, I usually start by drawing something, anything," says Doran, "just as an exercise, not judging if it's good or not. Just draw it—over and over again. Something you are good at drawing, like eyeballs, or cats, trees, or your favorite letters. Pick something easy that you like drawing. Now see if you feel a little better."

2. Another constructive dodge Doran uses is to make a list. "All the things you need to do, including the small stuff," she says. "Emailing, tweets, all of it. Start with the easiest and quickest, then mark them off your list. This is all about getting moving and convincing yourself that it's possible to get things done without too much pain.

   "Once the easy ones are ticked off, prioritize the remainder and figure out how much time you are going to spend on each item today. Baby steps get you places! I'm willing to fall for this ploy again and again."

3. Next, Doran asks herself a few questions: What does she want? What small step can she do today to move toward that goal? *Then she does it.* "Or, she says, "first ring a friend and tell them the plan. Make them promise to check in later or hold you accountable in some way so you have to own up if you don't get it done. By the way, know which friend to ask; make sure it's someone who won't let you get away with anything!"

4. If you have tried all of the above and are still stuck, then Doran suggests that, maybe, you just need a nap. Have you simply exhausted yourself and are in a period of burnout? Sleep and rest are woefully underrated and, as Doran says, "It's allowed. But when you get up, try again. Ask yourself: what haven't I tried yet, or, who can I ask to help me? When you move beyond feeling stuck and get through it, you often get rewarded with some of your best work."

## UNWELCOME GUESTS

"How do you kick out fear and doubt when they come to visit?" Melissa Doran asks. "For one thing, don't let them get their own way," she says. "Outwit them by focusing on your successes."

Doran's priceless advice is both sage and simple: when you feel vulnerable, address this before it starts to fester and spiral. Don't ignore your doubts, thinking they'll just disappear. If you do, they just sneak up and whack you when it's least expected. Acknowledge them and hear them out before thanking them and asking them to kindly leave.

1. "Write down a list of all the things you are worried about," Doran instructs. "Call it Part A. For example: 'I can't draw. I've no work. I can't do it.' Then draw a line and ask yourself: *is this true?*

2. "Okay, Part B: write down the arguments against this. That is, the opposite: 'I can draw, I've got work (or) I'm getting jobs.' And the quintessential, all-purpose 'I can do it.'

3. "Next, imagine that you are speaking from your heart and not your head when you make the positive statements. Your heart is 5,000 times more powerful than your brain, electromagnetically speaking. So use it, and see how your feelings change. Are you feeling more confident?

4. "Now, go back and cross out Part A so you can't see it. Better yet, rip it out and burn it. Sometimes this exercise brings up hidden doubts I didn't even know I had, but once you bring them out in the sunlight they lose any power they might have. It's just a little housework to keep your beautiful idea generator fresh and shiny."

Doran suggests that the more you tackle these problems and overcome them, the easier they are to deal with and the less likely they will make an impact on your day. "I get stuck all the time," she says, "I just try to notice it quicker and move out of it so that I don't stay stuck for too long. A bad morning can spiral into an unproductive week pretty easily unless you change the direction of your thinking. Remember that you are the boss of your thoughts and what you think about becomes your experience, so think about your life as a wonderful, world-famous illustrator!"

## A DISTRACTION EVERY MINUTE

What? Ahh yes, where were we—how do you deal with distraction? Kelly White tells us that distractions are bound to happen, stealing your attention away from vital tasks. It's everything from the phone ringing at inopportune hours (or non-stop), to your children playing around the house while your dog barks incessantly. The weather, too—the thunder storm and lightning strike that took your

computer out; a dreary day's irresistible nap seductively beckoning you away from your desk. "There are many things that can happen," says White, smiling, "and they will. The best thing to do is to plan ahead a bit.

"For instance: you know you have a deadline coming up in two days, but you rationalize, 'Hey, I only have thirty minutes of work left to do. No sweat . . . I can run through it quickly the day before I send it off.' You are making a big mistake and will learn that the real world will quickly get in your way. Anything can happen 'the next day': a loved one in the hospital, unexpected revisions on another project. Even if you only have 'a little to do,' don't procrastinate; just do it."

As White points out, nothing is worse than missing a deadline due to poor planning, especially if it's due to that proverbial "only 30 minutes of work." She recommends a three-pronged attack: Plan A: Think ahead. To the best of your ability, recognize potential distractions and be ready. Take care of the situation; sit back down and try again. If that doesn't work, there's Plan B: Take a second to opportunistically step away and deal with those distractions; put out the fire (figuratively), regroup, and hit it hard again.

This, however, as White points out, will never be a foolproof operation. There will always be days that no matter what you do, your strategies just won't work. So, if this is the case, here is White's extremely important Plan C: If—after you've gotten to the place where you've sent that nagging email, made the long-overdue phone call, or skinned the lunkhead cat (just a joke, no animals were harmed during the making of this chapter)—you're still distracted, just roll with it.

A note here: emergencies are just that. If you were pulled away in the middle of a conversation, make sure you take time to follow up in a timely fashion; explain what just happened. "You'll find that people will not only understand and be appreciative that you were honest," says White, "but will also sympathize."

"I deal with distractions by hiding in my office," Jarrard adds with a laugh. "I have a home office and I absolutely *love* being able to spend time with my wife and kids. But if I need to get a project done, I will turn on some tunes and shut my office door. If the door is closed, my family knows not to bother me.

"But if my wife wants the family to go camping and a client calls with a rush job that can't wait, she knows that the clients are paying the bills, and we'll go camping tomorrow night. So I try to deal with my distractions by prioritizing my client's needs with my family needs."

## SORRY, I GOT PULLED AWAY FOR A SECOND

"I find that distractions actually work for me at the beginning of a project," says Vicki Vandeventer. Vandeventer states that, at least at the get-go, she doesn't really have expectations about what she's going to do. She's figuring out what

exactly the project is about, doing some research, and, in her words, "Just playing around with it a little.

"Then I'll go off and do some weeding in the yard, or take the dogs for a walk," she says. "Maybe I'll flip through a magazine—and very often that's when the ideas start coming."

Vandeventer has learned to note stuff down as she thinks of them (so as not to forget things), but she doesn't flesh these notes out yet; she's just gathering ideas. "Then the next day, I'll have some directions to explore and I can start the evaluation process, filling concepts out a little, and deciding what directions to pursue. *Then* it's time to buckle down and get very productive."

## BUCK UP!

I say this earlier in the book—it's always easier to say it out loud than to put it into actual practice—but it bears repeating: *try* not to get easily discouraged. Learn from your rejections. Every rejection will be a distinct challenge, you will have plenty of opportunities to develop some bark, also known as a thick skin.

As Shaun Tan says back in Chapter 4, most problems and rejections result from creative cross-purposes rather than actual disagreements. He advises you to stay open to discussion, revision, and compromise while still maintaining your own artistic integrity.

Tan comments that staying true to your school while playing nicely with others are not mutually exclusive actions, as many people often believe. He also asserts that clients may be right about things as often as artists are, and that it's important to appreciate outside viewpoints, beliefs, and standards.

At the risk of sounding like your Psych 101 textbook, dealing with rejection filters down to the solid advice your mom and dad laid out for you back in grade school. You know this sandbox game plan from your years on the playground. I can hear your mom's voice right now: "Stay objective." Actually, Ma probably said, "Try not to take it personally. Don't be so hard on yourself. Don't let 'em get to you. Everybody gets rejected." Pa would say, "Shake it off, pick yourself up; dust yourself off; try again. Rethink it. Be patient. Let's not be hasty. Be flexible. Roll with it or do something else."

And, oh yes, didn't they begin or end with "Think positive"? It *can* work. At these trying times, honesty and self-respect are lovely, productive sisters you should get to know. Try to acknowledge your strengths. Pay heed to your victories and understand your goals. Refrain from playing the blame game as your emotional escape route.

Take care of yourself and your relationships and tend diligently to life goals (both personal and professional). And finally, consider this: is it really all about you? Truth be told, you're neither the center of the known universe, nor the

mega-misery magnet you may imagine. No joke. Self-importance is not character building. Wallowing does not become you.

## LAYERS

It's obvious that Linda Ketelhut absolutely loves her job. But making art is more than just a profession for her, it's a major source of bliss in her life. When the going gets rough, she already has a premium tool to help get her through hard times.

Ketelhut wanted to be an illustrator simply due to an overwhelming need to create. For, as she says gleefully, "Illustration is my voice; my art is an extension of myself—it's a wonderful privilege and extraordinarily fulfilling. I want to contribute. An illustrator brings a layer of 'color' to the world and brings joy to people's lives; we can educate, help tell stories."

Working on the business side of production in the film business, Ketelhut found herself increasingly fascinated with animation. Feeling creatively unfulfilled, she decided to take an animation class and started making art for friends and family. "Just as a pastime," she tells us. "I did that for a year or two before I started to seriously envision art as a career path. Once I did, I set my sights on this goal."

## SHIFTING

Such a shift—of personal vision and professional focus—would throw even the most resilient of us out there. And Ketelhut is no exception here. "I welcome change for the most part," she says. "Sometimes it's seamless and a long time coming, other times it forces me to move forward in ways I may be resisting. But that's a good thing too. I enjoy navigating new waters, it allows me to learn new things about myself and sometimes reinforces my strength to adapt.

### HEAD FIRST

"An opportunity to 'change' means a chance to grow; to challenge myself, break a bad habit, or form a new good habit," Ketelhut says. "Taking a risk can be scary. I may not welcome it with open arms, it may break my heart; but I'm a firm believer that the only way out is *through*—you dive in and face it.

"You handle these changes by staying positive," she says. "There may be a meltdown or fear mixed in there, but ultimately it's an opportunity and that's exciting. It usually brings with it positivity, even if it's not immediate. Even if it seems impossible."

## BOUNCE

It must be said that, if you are open to change of any size, you are courting all the myriad possibilities: everything from heady success to spectacular disaster.

"Oftentimes, failure is in my head," says Ketelhut. "I think I've let someone down. Maybe myself. I didn't meet the challenge or work to the best of my ability. We drive ourselves hard and have very high expectations of ourselves."

Ketelhut cautions you not to dwell in that headspace of failure. "If we're giving it our all, that's not failing," she says. "We may be disappointed and may shed a few tears but we must keep pressing forward, learn what we can from the situation and try to set ourselves up not to 'fail' the next time. Once I can escape the negativity or stress, the act of creating can be a soft landing.

"Reflect on what you did wrong or would change, but also concentrate on what you did right. Frame the situation fairly and not only from a negative point of view. You know, sometimes you can even make the most of all that negative energy and see if it has any place in your work."

That is how Ketelhut bounces back. She honors her feelings of failure and disappointment but doesn't attach to them. "These are honest feelings," she says, "but I jump back in because I know how good *that* will feel. It will eventually wash away what's getting me down."

Working to stay positive is a critical objective for any and all artists. "If you love what you do it makes you *want* to bounce back," Ketelhut says. "Persevere by being gentle with yourself. Yes, sometimes we wipe out and that will happen, but don't let it hold you back or break your spirit. Failing is an opportunity to reset our focus, to learn, to reflect on why—or to ascertain if we truly did fail. Because in a way there is no failing, there is only learning."

## RESIST IT

"If you haven't read *The War of Art*, by Steven Pressfield, you should," Tara Reed says. "It's a quick, powerful read with short chapters, each designed to remind us in different ways that, as Pressfield states in the book, 'Resistance cannot be seen, touched, heard or smelled. But it can be felt . . . it is as an energy field . . . a repelling force . . . negative . . . [It prevents] us from doing our work.'

"Resistance is fear and ego and it comes from within," says Reed. "You will feel resistance—in the form of self-doubt, anxiety, stress, panic and more. You must have a plan to deal with it."

For Reed, this personal test happens every year; just about a month before the big SURTEX show—a severe and almost crippling self-doubt rears its ugly, pointy little head. It's a mindset that doesn't make sense logically, but it plays with her emotions and hits her where it hurts most.

Says Reed: "Here's what rolls through my head: 'What if the new work I've done isn't good enough to cut it anymore?' Or 'What if my art is no longer a fit? Have you really been working hard enough to deserve continued success?' I literally begin to doubt everything I know to be true," Reed says.

To combat this monologue of fear and self-doubt, Reed picks up the phone, and calls her sister, who listens patiently and brings her back to reality.

She highly recommends a similar 9-1-1 call for you as well. "Know who to call," she says. "Contact the person who can make you see that what you're feeling is as patently false as you declaring, 'The world is flat!'

"This trusted confidant won't play into and magnify your fear, but will, instead, get you back on the straight and narrow."

### DEFENSE

This support system is a first line of defense that Reed highly recommends. To back this up, the illustrator taps into other tools to keep fear and loathing at bay. She heartily endorses deep breathing, meditation, affirmations, regular exercise and a healthy diet. "An imbalance in the body promotes imbalance in your thoughts as well," says Reed.

She also advises a simple change in location and atmosphere. "Go for a walk, do errands, move into a different room," she says. "Take a break. Walk away for bit. All this can help to shift you in times of stress."

# A GOOD FIT

How's your health—your overall mental, physical, and emotional well-being? For me, it comes down to the three stooges, uh, *stages*: relaxation, exercise (plus diet), and play. All three (often combined) are crucial—especially for board jockeys. You're only a stooge if you don't promote your general fitness.

The following is all old news, but absolutely true. Your program of diet, exercise, and relaxation may be far different than mine. But what I know is that the balance of work to play rounds off the edges of stress and hyperactivity and supplies me the nutrients and endurance—mental, physical, emotional—to sustain my juggling act.

I'd bet you know all this, and probably admit it when your other half's not around.

Fact 1: You *must* exercise—you have to fit it in. We all need to embrace some sort of physical activity. So: butt off the chair, get away from that desk and *move*—move more than just your wrists. You are more than just a wrist, right?

Fact 2: Man does not live by board alone. You are obliged to pursue outside interests; we should actively seek diversion. In reality, you are not actually indentured to Adobe Illustrator. You can take a break.

Fact 3: Likewise, you must figure out how to chill (down *or* out). It's not the stress that rocks and rolls our lives—it's how we deal with that tension.

Fact 4: Sleep and food are vastly underrated. Your mother knew what she was talking about. It goes without saying that adequate rest and good eating (both choices and habits) are paramount to your personal and creative health. This *should* be a no-brainer, but many young guns and old hands still try to defy time, nature, and gravity.

Fact 5: For some, the work itself is ideal therapy. Creatively, there is nothing more satisfying than getting into the "zone." The "zone" is quite addicting. Your mind focuses intensely, and only on what you are doing for that very moment. Such military-grade concentration means that everything else—including time itself—just falls away, often for hours on end. Incredibly, it's simultaneously pure stimulation and complete relaxation.

Fact 6: Now, don't forget to brush your teeth. And hey—flush next time, will ya?

## STAY WITH THE PROGRAM

I am far, far from perfect in the life maintenance department. Don't get me wrong, the agenda makes only good sense, and I strive to practice what I preach. Generally, the machine hums pretty smoothly. But I blow it. Frequently. And so will you. However, I *have* doped out the secret to keeping the program going for the long haul: Kindness, forgiveness, and gratitude.

I'm not talking about rationalization. I try hard not to beat myself up when I fail, at least, not *too* much; brute force guilt in small doses is sometimes an effective motivator. When I stumble or hit a pothole, I strive to acknowledge and own my mistakes. I give myself the leeway to wallow in the muck for a brief spell. I then remind myself to count my many blessings and be kind to the most important cog in the wheel: me. Then I work to clean up and move on.

Moving on also means thinking ahead and/or envisioning the fabled bigger, better, brighter tomorrow. But I also believe that to manifest this future, you should take action *today*—you must live in the here and now.

# ON THE BOARD
## (PROFESSIONAL VIEWPOINTS IN 50 WORDS OR LESS)

When the thing you do for fun is also your job, you find it hard to switch off.

—Rob Hodgson

Risk and insecurity are what keep me feeling edgy and force me to be as good as I can be. If I'm too confident or relaxed, my work may suffer. Actually, some angst really is good for the artist. And bouncing back? Where else is there to go but back?

—Katherine Streeter

Everyone who pursues illustration as a career loves what they do. We just express it differently. And like real love, there are bad days or even weeks or months where it can feel like you don't love it anymore, and that you'd rather be doing something else.

—Charlene Chua

Have you heard the business mindset equation E + R = O? This means Event + Response = Outcome. We only control the RESPONSE.

—Tara Reed

Learning from mistakes . . . Can I ever relate! "A lesson is repeated until it is learned." If I didn't find anything to take away from the experience, then clearly I haven't evolved. I can expect to continue facing the same problem again down the road. Keeps me on my toes.

—Kristine Putt

Test your limits to see how far you can take things (personally, artistically). Enjoy the challenge.

—PJ Loughran

"An understanding, knowledgeable lawyer met me at the White Plains Courthouse and got an immediate temporary order of protection."

"And that was only the beginning."

Kids change everything. Sleep patterns, work schedules. You can't just roll out of bed or wait to get inspired. No time to daydream. There's a short, open window . . . start painting, now.

—Mark Todd

The more I push through it and work with it—the excitement mixed with pressure and challenge are what I consider "good" stress. I can comfortably go into almost any situation and feel relaxed (I did say almost).

—Allan Wood

It's a myth one can do everything; one needs to prioritize, and those priorities need to shift with changes in one's life.

—Vivienne Flesher

© Michael Cho 2016

You have to figure out what's important in life. Is art important, or is it something else? You'll fight about it in your head—not worrying about such things will allow you to go a lot farther.

—Ward Schumaker

I don't believe there are any "mistakes"; mistakes are labels of personal judgment. If you're fearful of making mistakes, this gets in the way of learning through problem-solving, which gets in the way of the pure joy of creativity. There's no single way to view (or do) things.

—David Julian

Phone calls; car pools; meetings; shopping; household tasks; the children—all of which no one can afford to ignore. Inspired by an old Calvin + Hobbes cartoon that I kept on my refrigerator, I used to think, "I don't even have time to die either; too many people depend on me."

—Ilene Winn-Lederer

Temporarily disengage from the struggle. Buy some nice, loose-leaf tea to remind yourself that no matter how bad you feel, the world is full of wonderful little things yet to savor. Twenty-five grams of loose-leaf tea offers a cheap, fulfilling experience—and there's no added sugar.

—Julia Minamata

We sensitive artistic types take it personally when someone doesn't like our work. You will have to get over that, or you are done.

—Nadine Gilden

You are invariably off balance, but you have the aim.

—Paul Melia

I'm a worker; I hunker down and keep on doing artwork, however I can.

—Randy Wollenmann

Tell your cat everything, but keep it all off Twitter.

—Brie Spangler

© Giovanni Da Re 2015

# Chapter 22

# The Next Chapter

---

*My advice is to work hard and be yourself. Everyone else is taken.*

—Thereza Rowe

## IT DON'T COME EASY

Rick Antolic had a phenomenal drawing professor at Carnegie Mellon University. His name was Herb Olds. Antolic tells us that Olds would remind his class, when giving a challenging homework assignment, that "If being an artist were easy, there would be a lot more artists in this world."

"There are aspects to working in this field that are difficult," Antolic says, and which aspects are difficult depends on the individual artist. Few artists, if any, have an easy ride at this.

"But what separates the 'good' artists from the 'bad' ones (or the ones who quit) is the willingness and discipline to do what's difficult," says Antolic. "It's all too easy for me to spot a lazy way to do something. Luckily, I'm good at noticing when my thoughts go there. Then I remind myself, *If being an artist were easy, there would be more artists in this world.* You can't be a good artist and be lazy. You have to choose one or the other."

## KNOW YOURSELF

The small print first. It starts with *you.* As Charlene Chua says, "Change is a personal decision. Change is adopting a different angle or point of view, and steering in that direction."

We can weigh in on (and weigh ourselves down with) life's challenges, but I'd rather make all this tsuris an opportunity for self-examination. I will take the hits for coming off as the happy Mr. Optimist, but, hey, I get all those dirty little jobs.

"My work is spare, strong, intelligent, empathetic, and beautiful," says Julia Breckenreid, who quickly follows with, "Well, that's the goal anyhow!"

It took a few years to nurture her portfolio before Breckenreid could say that with confidence. "You've got to produce a great deal of ugly illustration to come out with work that comes close to something you're proud of.

"However, I am never satisfied with my work," she says, "which is healthy, I think. I never stop thinking of how to break down my own constraints."

To cap that off, Shaun Tan reminds you that "At the end of the day, you are the ultimate judge of your own work, so learn to be critical in an affirmative rather than negative way.

"You also never find out if you've really failed until you actually finish a piece of work," says Tan, "so your goal should always be, first and foremost, to just *finish* things."

## RECOGNIZE THE FACT THAT . . .

Recognizing what you do, can (or can't) do, doesn't always mean that you *can*— or will—do it. It may not be economically viable or you may not have the time

(nor the energy) to go in a particular direction. You may not be cut out to be a *full-time* anything from the get-go; better to ease into your path—wherever you're going—slowly and deliberately.

Maybe think of yourself as a brand. You could advertise yourself that way, redesign your website to tout this. Collect testimonials. Create a portfolio that reflects that thinking and appropriately identifies and positions your aspirations. In essence you become the brand.

Gung ho or go know—neither scenario plays out as a general rule of thumb for those starting out. Rather, both are just out there to demonstrate that thought and preparation can take you down or up any number of time streams.

"I'm not sure what success really is," Rob Hodgson says, "or why it's such a good thing to strive for. I think being able to do what I do and learn things along the way is the most amazing thing. Maybe that is success?

"And if it is, then failure is part of the learning and something that should be seen as a positive," Hodgson says. "Whenever I think I've failed, I tend to run in the exact opposite direction of what I just did before. It's different for everyone. My idea of failure might be your idea of success!"

## . . . AND UNDERSTAND THIS

I observed earlier that the illustration field has changed dramatically with the advent of personal computers and the explosion of the web. Social media has radically altered the face and figure of networking, marketing, and promotion.

And while it's a challenging slog for most everybody of any age—as backed up by my correspondents for this book, and readily determined while exploring this hot topic online—I can speak from experience that it's no easy trick getting work if you're older. Sorry, somebody should talk about this. We are all, hopefully, going to keep getting older. Your sense of denial here will just keep getting older with you if you're not careful.

Most assuredly, an "older" illustrator must stay on top of all the latest technology (as "younger" illustrators certainly do) or the prospects of gainful employment in the "current" marketplace will be dismal.

We can fret about the poor economy and lament over job burnout, but, *boo hoo*, let me direct you to Isabelle Dervaux who asks a simple question: "What would I do if I didn't do this job?" she ponders. "Frankly, I don't know what else."

## ALTERNATIVE REALITIES

When one is described as "alternative," what does that mean? Alternative to what? Aren't artists in general an alternative to "regular" folks? Is there a perception/reality conundrum involved with this label?

The next question I would ask is, when you're part of the "establishment," what exactly are you establishing? Is it actually a roots kind of thing? You know, it seems as if the most alternative lifestyles and/or practices have magazines (or websites, these days) dedicated to that culture. These devotees sum up a certain "establishment," as I see it.

More questions: Does "establishment" really translate to a "pecking order"? Or does it equate to the status quo? Perhaps, a simple frame of mind? Aren't artists in general a common fraternity or sorority—and wouldn't this be the establishment? And how sharp is the "cutting edge"? Well, how'd it get so sharp? And while we're at it, who's this "avant-garde" we're always hearing about? Hey, is the avant-garde keen on this cutting edge? Even with all alternatives within the avant-garde, isn't there a subtle establishment here as well?

"No matter what anybody says about my work, I can only be what I am," Paul Melia wisely says. "I can't force it. Oh I'd love to think of myself as avant-garde, but I'm not—I just do what I love to do. "I'm *progressive*. I am with the times or ahead. But I wouldn't consider myself cutting edge—that's not me. And those are *just words*, they don't bother me. I do what's inside *of me*. If someone accepts it or pays me for it, or has a positive reaction, I'm lucky."

Thus, a last question: Any alternatives to all these labels?

## SQUARE PEG/ROUND HOLE

Is it important to fit in? By classical definition or perception, aren't artists *expected* to be "different"? But, as PJ Loughran says, "Titles are just so silly. It's a way for people to categorize, to simplify, to make sense of somebody (or their work). I try to avoid that stuff as much as I can."

Indeed, as Rick Sealock says, "It used to be the standard to be original and *different* in creating your unique illustrations. Now it's called 'quirky' because it may not be as commercially viable and tolerated as before."

Such folks were always a draw for Sealock. Never boring, always original thinkers; these creative *individuals* challenged and pushed cultural boundaries, and thus educated the public. Maybe political correctness and corporate philosophies of our society, in our culture, created and imposed adverse labels in an attempt to curb originality.

On the flip side of this is that school of thought that rails against any or all conformity: the idea that, if you "fit in," you'll actually lose the (creative) edge. Personal or professional compromise may be real or imagined, but according to Sealock, artistic *integrity* must be maintained.

As Sealock cautions, if integrity is not maintained, and thanks to an ever-increasingly educated populace, we steadily run the risk of dumbing down the industry.

## SUBSTANCE

Mike Cho specifically (and emphatically) pointed out that, in his experience, concept trumps style every day of the week. "That is," he says, "a good idea beats a flashy execution. I'm sure this is self-evident, but it does bear repeating. Trends come and go, and styles change and get dated, but a mind that comes up with great visual metaphors, insightful analysis or a witty new spin on concepts always looks fresh and is in demand."

## KEEP YOUR AVANT-GARDE UP

Reiterating what I expressed a bit earlier: even within the avant-garde lies a dreaded "establishment." After all, the most alternative lifestyles and/or practices have magazines (or blogs and websites, these days) dedicated to that culture.

"You can go wild and crazy on the page because it is the acceptable thing at the moment," Greg Nemec points out. "But [that avant-garde hook is only] whatever's hip *at the moment*: 'Hey, look at me, I'm edgy.' That seems pretty establishment to me."

"You might have to deal with this, play the game, certainly pay attention to it," says Melia. But here Melia offers a counter by affirming these candid sentiments: "I do what I want to do. I do it as honestly as I can do it. I don't let the tags influence me too terribly; I just don't think about it that much. You can't worry about the labels, you simply must do what you do. You let the chips fall where they may."

### WHERE IS THE MIDDLE OF THE ROAD?

When one is described as "in the mainstream" or "middle of the road," what do we mean? Are these two different things? What *is* the mainstream, and is this positive or negative? Is the "middle of the road" actually a perceived ditch off the "cutting edge"? Can you get anywhere in the middle of the road?

Sure, you can. I'll shill for the AAA, the Artmobile Association of America, and ask: isn't the middle of the road the straight road to somewhere? It is the safer path, as opposed to driving on the edges, which is a much bumpier ride. Rocky Road is an acquired taste, and yes, you're supposed to pass on the left. But who decides if this is a "good" or "bad" thing?

It's *your* say; anything anyone else tells you is a judgment call. Neil Young, when discussing his record *Harvest*, said he found himself heading squarely down the middle of the road with this album. He saw that he was being successful at it—and that's putting it mildly—but that it wasn't where he really wanted to be traveling. Yet, he returns to this genre time and again. What's the road map here, then?

"I feel like I'm more of the middle of the road," Ali Douglass muses. "The 'average guy' appreciates my work, but a 'hip chick' may look at a piece and possibly laugh—it's too 'happy and cute.' But I'm excited about it. So what if it's not 'hip' enough?"

That's correct; you heard her right. No tattoos and piercings; no women in compromising positions, nothing sexual. It's not depressing or dark. People see Douglass's work and enjoy it *because* it is fun and upbeat. "And I like that," Douglass states. "That's a great thing. I think it is fine to bring out that particular emotion. This maybe puts me in the 'normal' category; more the middle of the road rather than the avant-garde. But it's all good."

Yes, sometimes Douglass feels pressured to do art that is "cool," more for "her generation," gallery-type work, edgier stuff. But as a wise mentor once reminded her, she realizes that she doesn't *need* to. It is what is: amusing and entertaining; fun, happy, and downright silly is more than okay.

## VICTORY

Competition. Is this a "good" or "bad" thing? Is this all about motivation and drive? How do *you* handle the competition? Who—or what—is *your* competition? Is it actually a grudge match between fact and fiction—*real* competition and *imagined* competition?

"We're all competitors," Sealock says, "sometimes with others and always with ourselves. We compete with every illustration we have created and the ones we want to create.

"We compete with our skill level/technical ability. We compete with our preexisting concepts, our notions and our expected approaches. We compete against labels and definitions, fears and security. We compete."

### INTEGRITY

"Is this the devil's advocate part of the book?" Sealock asks. Could be, because maybe you don't really think about it all that much. And without a doubt, there is no one who does the job quite like you, right? But, if you disregard the competition (or choose not to compete), what does that mean for you—as an illustrator, as a businessperson?

"It's more the business of creating than selling for me," Sealock considers. "The creativity portion is separate from the price tag. I create because I love and need to. It's a bonus that someone wants and will pay for my work."

Again, to each their own. If you judge the creative level of your illustration by its dollar value, that's your call; so be it. But that's certainly not Sealock's mindset. He maintains that selling doesn't mean you give up artistic control. On the contrary, not only can you keep artistic control but you can work to build on it, maintain the integrity of your art, and further its creative merit and development.

And selling it does *not* mean you are selling out and losing your artistic integrity, either. "Giving it away is losing your integrity!" Sealock emphasizes. "Besides, you *can* sell out or have no artistic integrity and still be very successful. It's whatever you think is correct for you.

"Personally, money comes and goes," Sealock comments, "but your integrity has to remain intact, defended to the end. It's difficult to do at times as we're only human; but you must try, and that is the key.

"Yes, giving it away for free *would* be a compromise," Sealock sums up. "If you feel your work is worth *nothing*, then give it away for that. But if you feel it is worth *something*, then get something for it."

# WORK VS. LABOR

Have you heard of Nikola Tesla? If not, definitely research this scientist showman; I'd be underplaying the man's impact on current technology even to say that Tesla made quite the statement.

But even if you are not of the mad scientist or obsessed inventor ilk, it may be more critical to try to make your own individual statement.

I'm of the opinion that the most powerful statement one can make is through one's *work*—the electricity and quality of the product as well as the sweat equity invested. But wait, are we really talking about your *creative labor*?

Writing on the excellent 99U website, Jocelyn K. Glei quotes Lewis Hyde (from his classic book, *The Gift: Creativity and the Artist in the Modern World*) to make a neat and clear distinction between "work" and "creative labor."

"*Work* is what we do by the hour," Hyde clarified. "It begins and, if possible, we do it for money. Welding car bodies . . . washing dishes, computing taxes . . . these are [examples of] *work*. *Labor*, on the other hand, sets its own pace. We may get paid for it, but it's harder to quantify . . . writing a poem, raising a child . . . resolving a neurosis, invention in all forms—these are *labors*.

"Work is an *intended activity* that is accomplished through the will," Hyde continued. "Labor has its own schedule . . . there is no technology, no time-saving device that can alter the rhythms of creative labor. When the worth of labor is expressed [as an] exchange value . . . creativity is automatically devalued every time there is an advance in the technology of work."

By the way, 99U (as an organization) works to help creative professionals dropkick idea generation into idea execution. It takes its name from Thomas Alva Edison's famous quote. Edison, Tesla's arch rival said, "Genius is 1 percent inspiration, 99 percent perspiration." Hello again, Tom; a creative labor lightbulb moment, indeed!

# ARE YOU BUSY?

Melanie Reim has had the good fortune to study with some of the drawing greats in illustration history. "Though they all had their individual styles, idiosyncrasies, and teaching philosophies," Reim says, "there were several threads that mutually transcended their lessons and assignments."

Like threads creating a rug that really ties the room together, Reim points to this constant: "*Drawing rules*," she states, "and believe me—I drank that Kool-Aid and live by it every day."

It's easy to see why that is true (not only for Reim, but for most illustrators still breathing). "Aside from the sheer pleasure that it gives me, drawing—and drawing the figure—is the best teacher that any illustrator can have," says Reim. "And one lesson you need to learn is about the importance of doing your own work, always having a project on your desk.

"Sure, there are passages of time when you might be too busy to concentrate on your own outside project (a great problem to have), but it is hopefully there," Reim says, "something interesting to you; a body of work that keeps you researching, exploring, experimenting.

"It's exactly because you are interested in a topic that—coupled with this amazing gift you have to speak about it *visually*—you can bring to life an image, an animation, or a sculpture. Having this project is like owning a wonderful place you can go to in-between everything else that you are doing. It is almost a guilty pleasure! Except that the benefits are so grand that there is really nothing to feel guilty about."

For Reim, those projects on the side of her desk represent some of the most exciting aspects of her multifaceted career. She is an illustrator, art director, designer, and educator, and her mind is always active. She's forever seeing possibilities and connections—the threads stitching her commissioned assignments into her teaching into simply seeing and playing.

"Often, projects present opportunities for new promotions," she says. "Ideas may linger for years, unfinished . . . but, oh, what branches out from what I call that 'family tree' of ideation! The process of starting one project or interest often leads to something else—this is what grows the family tree. What emerges from the original is what is so interesting and rewarding.

"And that is frequently how the opportunity to expand commissioned work happens. Before you know it, another series is born, and can be of great importance in opening your markets and upsizing your opportunities."

## OF COURSE

Now, about that little statement, "Are You Busy?"

Occasionally, out and about, Reim bumps into a colleague who invariably asks, "How are you? Are you busy?" Reim admits to hedging sometimes: "Oh,

I just finished a job," or "I'm actually between jobs." And, often, she then hears: "You always seem as if you are drawing—what are you working on?"

For Reim, when it finally hit her, it was like lightning struck. *Of course*, she was busy, she was hard at work on ___ (and she'd fill in that blank with any one of a number of creative endeavors she was addressing).

"I would go on to speak about the personal projects that I keep there, on the corner of my desk," she says. "I would hear myself talking, animated; excited, too, that someone else was interested."

"Ahh, so, you *are* busy," she'd hear next. "Another seminal moment in realizing the value of doing my own, personal work," says Reim. "I am busy. I *am* interesting. I can pitch a new idea to a client. I am always working on something because I love what I do and can share these stories through images."

## PIECE OF CAKE

In grad school, Greg Pizzoli took a class in children's book illustration from Robert Byrd who, as Pizzoli says, "Finally gave me insights into what an illustration actually was all about."

So, okay, what is that? "Big question," Pizzoli says with a pause. "First, it's for the client or an audience, at least. It's not for your diary or a sketchbook. Presumably you're getting paid for it, or maybe it's for a nonprofit that aligns with your values (and if you're not getting paid, you're getting something else out of it).

"An illustration can take any form that you want," says Pizzoli, "screen prints, puppets; cakes, even! You need a singular focus, and sometimes that 'mad scientist, off in a lab somewhere' mindset is a definite plus."

Do I hear the good doctor Tesla knocking again?

### THE BOA, PLEASE

Is doing personal work different than doing commercial assignments? "My physical process is not so different," Pizzoli says. "I'm making the art in much the same way. You know when it's summertime, or it's closer to Christmas, publishing tends to shut down those times of the year. You can't get anybody to email you back. At points like these, I try to build into my schedule one day a week where I make work that I don't show to anybody.

"It's a completely personal thing," Pizzoli explains. "I don't put it on Instagram; it's not for a book that will be published. A lot of times I'll do it on the computer and I won't save it. Maybe I'll take a screen shot of it, but it's still not so easy to replicate. It just makes it seem like there's less pressure if I know I'm not starting in on something I have to finish."

Pizzoli points out that the great thing about children's books is that they allow for an incredible amount of authorship. Few illustration jobs allow you to call the shots in this way: Pizzoli comes up with an idea. He fixes the size, the

trim, the print format. He chooses the paper. He writes the text. He lays out the design.

"So the books that I write, especially, are a collaboration in the sense that I'm working with an editor and an art director," Pizzoli says. "But there has never been an instance where they've asked me to do something that hasn't made the book better.

"When I'm doing something for other authors, it's a little less precious to me. I'm still doing my best, still trying to put my own spin on it. I'll fight for what's really important to me, but if you seriously want a boa constrictor instead of a king cobra—for whatever the [unequivocally] good reason you cite—okay, that's cool."

## ON ASSIGNMENT

Grant Snider says you must stay focused; plug away, yet maintain a critical balance. The cartoonist speaks wisely, and from experience. At the time of this writing (in 2015), he'd recently graduated from dental school and went into practice as an orthodontist (yes, you read all that correctly; please stay with us). He bought a home, moved to a new state, celebrated the birth of his second child, illustrated his first book, and made *a lot* of comics (incidentalcomics.tumblr.com).

Snider is an industrious promoter, but tells you his illustration work comes in sporadically. "I let these other projects arrive as they do," he says. "I'm not actively seeking outside illustration—I've made a conscious decision to really focus on my personal publishing projects and the web comic."

But he does welcome outside assignments—soberly. "In a way," he says, "it's a lot of pressure; that's someone's vision, somebody else's blood, sweat, and tears you're entrusted with. At the same time, this can also be very liberating—you're not the one writing the words, you're not generating a script; you can simply react to somebody else's ideas, and just be more free in *your* process."

## SNIDER

When asked to define his field, Grant Snider tells you that he's actually trying to figure that out. "I consider myself primarily a cartoonist," he says, "but I do a little illustration work—webcomics specifically, but also some editorial mixed in. The lines are a bit blurred for me."

Snider started cartooning for his college newspaper. Editorial illustration came later. "I feel I have a lot to learn about being an illustrator," he says humbly, "but as a cartoonist, I'm much more confident and competent."

Snider was still in school when he first actively pursued a cartooning *career*. We're talking 2007, and he was emailing local newspapers (and national newspapers every once in a while) trying to get published in print.

"Generally, that's one thing that has changed for cartoonists," he says, "you know, getting published. For me, certainly. Now I'm placing and showing my work online, and that is the main outlet for my cartoons and illustrations."

## CARTOONS WITH SOME BITE

Now here's where Snider's backstory takes a fascinating, wee twist. Cartooning is not his full-time gig. And he never went to art school. At the time of our 2014 interview, he had just graduated (after ten and a half years of postsecondary education) and was kicking off his career as, brace yourself, an *orthodontist*.

"This work arrangement let me develop my art skills without a lot of pressure," Snider says. "I was able to build my cartooning career around my school (and now, my other work) schedules.

"The nature of the two are really different, but the balance is very good for me—strange, but good!" he says with a laugh. "As an orthodontist I'm working with people all day on my feet. Doing cartoons I am sitting alone, drawing for hours on end.

"I was aways drawing," Snider says. "Cartooning was a constant interest, and really just for fun." But at some point, Snider became fairly ambitious about getting his work published. His efforts here resulted in a strip for the *Kansas City Star* that lasted about five years. And toward the end of that tenure for the *Star*, Snider emailed and submitted samples to, and eventually had a strip published in, the *New York Times Book Review*. Simultaneously, another *Times* art director found him through his online stuff and commissioned work. This is all while he's going to dental school, remember.

"Thus began a focus on the illustration facet of my career," Snider says. "And it was probably my first serious submission to the *Times*. With most papers I might be knocking on the door (via email) maybe four to five tries before something clicks."

# I SEE YOU

"The prospect of sending your work out to be judged can be a bit of a high-wire act," says Steven Hughes. Hughes firmly believes that there's value in simply having your work seen—by judges, art directors, big name illustrators, designers, *whomever*.

"We don't exist in a vacuum," he says, "and your illustrations need an audience to fulfill part of their purpose: communication. It will take some time to build recognition for the visuals you're creating. The more somebody encounters a piece you've done, the more likely they will be to remember it."

Hughes says that critiques at school are often softened with advice that can help you take your work to a better place, but illustration competitions give only that thumbs up or a thumbs down. The "high" of getting a piece accepted is certainly hard to beat, but you must also be prepared for the sting of rejection.

"Unfortunately," says Hughes, "with the prevalence of social networking, the glad-handing that happens as the acceptance letters go out during announcement day (or week, for some shows) makes that rejection feel unending.

"Give yourself some time to be disappointed, but recognize that this is a good point to take stock of your work and put your energy into 'leveling up' in one aspect or another.

"Get off of the Internet and practice figure drawing, go plein-aire painting, do a master copy," Hughes says, "anything to improve your skills in some way. Take a negative review and create a positive result. The cumulative effort will move you forward to a point where you are on the other side—accepting awards."

## DA RE

Giovanni Da Re feels that he always drew passionately. "Even as a child," he says with a smile. "I spent most of my school time sketching on my textbooks during lessons! I was fascinated by the language, the vision, of illustration. Eventually, I decided to turn my childhood passion into a job."

And what is that job? Did he become an "illustrator". . . a "freelancer" . . . an "independent" artist? "As far as I can tell," Da Re says, "These labels are quite unimportant for my clients. For me, too. I see an illustrator as a craftsman who translates the client's message into imagery. He gives the work his touch of talent and applies his skills." But saying that, Da Re does tend to somewhat differentiate the "artist" from the "illustrator." He says that the artist is "free to mostly follow his will and inner voice whereas the illustrator must start by addressing a client's *need*.

"There are pluses and minuses here," says Da Re. "Most of the time you'll enjoy the freedom of your choices: you can choose your style, as well as genre and field of expertise—editorial or conceptual, children's or young adult books, et cetera. You manage clients as well as schedule and calendar.

"At the same time, that calendar can be chaotic; your schedule is all too fluid. The flow of assignments and deadlines (or sometimes lack of assignments) often means that *selling* (while definitely a good thing) becomes your main activity."

Da Re is calling our attention to a rather fascinating conundrum: a truly beneficial goal that can potentially "become a cage for your time and talent. The challenge of

looking for work and catering to clients may become too restrictive or binding," he says. "You yearn to draw for your own pleasure or unpaid assignments that may offer more freedom or creative energy."

To deal with this distinctive problem (that, after all, unavoidably comes with the territory), Da Re offers some wise advice. Says Da Re:

1. "Regard every commission as an opportunity to grow. Which means you . . .

2. "Take as many assignments as you comfortably can. Consider your time, certainly. But your skill set factors in here, too. So . . .

3. "While most of the assignments rattling around your email box are of the same sort, establish at the very start that your know-how truly meets project requirements. I'm sure you understand that . . .

4. "Illustration is communication. Are you an effective communicator? How do you measure this? Through your interaction with art directors, of course! Keep in mind that . . .

5. "A respect for deadlines and a genuine desire to reasonably make a client happy ultimately result in timely rewards. But that also means you must . . .

6. "Educate your client. Be completely clear about your needs as well as your process. Do this and chances are good that you'll . . .

7. "Remember how lucky you are to have this job."

## GREAT TALENT/BIG HEART

Chris Haughton has, among other things, written, designed, and illustrated children's books. He's created toys connected to these projects, commercial animation, murals for hotels, and packaging design for chocolates. He is justifiably proud of the work he has done for the fair trade company People Tree, an amazing group of big-hearted folks who support schools and orphanages around the world. "They work with eighty producer groups in fifteen different developing countries," Haughton says. "They produce ranges of clothing and gifts with women's shelters and disabled groups. I have been helping out with the designs of some of those products: bags, T-shirts, stationery, and repeated patterns for clothing and dresses." One of the ideas Haughton is most excited about here is making rugs from digital designs.

Fees? The profits here all go to building schools and training workers. Staying busy? That's an understatement. "The best thing to do is to work, even in your spare time," says Haughton. The key to "success"? "Find a way of working that you like and enjoy," Haughton tells you. "Don't force style. If your content is unique you definitely will land better and more interesting work. Produce a body of your own work—work you feel comfortable with."

And, as Haughton points out, probably the most important thing to do is to get your stuff out there. "If you're shy about 'showing off,' you won't get half as much work as you should be getting."

When I look at Haughton's work, it's damn hard for me to separate his super "design" sense from his great "illustration." So, for this book, I won't transpose the tags. Here's what he said next; I know you can make the connections.

"I think design has a potential for greater things," Haughton says. "It can make our world and communication clearer and more beautiful. It can help communicate things that are unable to be communicated by language. Sadly, perhaps because of its power in communication, it really has been totally hijacked by advertising and corporate communication. The word 'design' has somewhat become synonymous with branding; I want to counter that."

Haughton thinks ethical considerations are crucial to good design, and tries to design "from every angle," always figuring out how the thing can be done better. And this is a challenge that, for Haughton, all comes back to ethical considerations. "I became a bit disillusioned in my own design when I was doing advertising and branding for large companies," he tells us, "so I wanted to do something that was more rewarding. I think design has a great potential for positive change and I would love to be involved in that aspect of it—that's the exciting part!"

## THE NEIGHBORHOOD

Chris Spollen makes this statement: "Your passion is what will define you." This is just *so* true. This zeal for art, the gusto for your design (and hopefully, the lust for life) should be a no-brainer. But why go it alone? Passion can be absolutely infectious. And if social skills are your challenge, *then meet the challenge*. "Create a *community* around you," PJ Loughran advises. "Get out—socialize."

It's safe to say that networking is how *most* people get most, if not *all*, of their work. As Shaun Tan says earlier in the book, it's what you know *and* who you know (emphasizing the *what* over the *who*).

But that "who you know"—folks branching off and reaching out—is critical. It is referrals and repeat customers, promos that follow art directors jumping from job to job. I've said this repeatedly, but it's solid advice: network at *every* opportunity.

The Internet and email were science fiction when I started out, so you had to do the legwork. Sure, modern marketing/promo gambits, new portfolio strategies plus all the shiny digital toys are indeed game changers. However, smashing interpersonal communications (writing, phone calls, one-on-one contact, attending conferences and art shows, joining art organizations) are still part of the playbook.

Along those lines, I understand that wearing a club jacket (metaphorically) is not for everyone, but art organizations like the Graphic Artists Guild, for instance, all have a common charge: the preservation and advance of the profession for the good of the membership. The fellowship is invaluable.

Of course, the global forums of the Internet and the social media conglomerate, all of these mean you can network electronically 24/7, without even getting out of your pajamas. No jacket required.

So, make the rounds, stop by, stay in touch. Spend some time, be there; give back. "We're all together in this thing," says Dan Yaccarino, "and we all have to support each other."

### IF YOU SUCCEED, I SUCCEED

There are a lot of illustrators out there. It seems that somebody couldn't keep a secret and it went viral: this is one of those coveted "good jobs." Whoa . . . at times, it feels like it's "Everybody in the pool!" So, is diving into that pool like swimming with sharks and piranhas?

Yo, dawg, it doesn't *have* to be dog eat dog. Spollen is one who feels exactly the same. "I *love* keeping in touch with fellow artists," he says. "And if work comes my way and I feel it's more up someone else's alley than mine, I will pass it on. I'm always looking out for my friends and I believe they do the same for me."

Know also that it's more than okay to seek feedback from sources within and outside the creative neighborhood. In addition to advice and critique from other illustrators (and designers, too), input from family and friends, even fans, when appropriate, can be invaluable.

"I can't 'see' my work that well," Melia candidly says here. "But my wife can. When I work on a job, I'm too close to it to see it *objectively*. She hates to criticize me, though. She feels she's hurting me. But she's actually doing me a favor by telling me what's wrong with something so I can correct it. That's a helpful process."

### LONERS

Isolation can crowd your style. I say that with a bit of tongue in a lot of cheek. You *love* the peace and comfort of house and home. You feel truly *alive* in your studio. But the fortress of solitude has a front and back door for a reason. Sometimes, you just gotta get out. It may be trite to say, but the play is to be a highly functional "people person." Ilene Winn-Lederer feels that being a loner is rarely a choice one makes consciously. "Usually the individual's personal, physical, and financial circumstances contribute to this status, more so than the choice of profession," she comments.

"As much as we might wish to be on an island left alone to do the work we love," Winn-Lederer continues, "such a dream is ironic." She knows that without

balance, the work can become monotonous, even mediocre. She understands that in an industry where staying fresh remains the ingredient for success, the personal and professional cost of leading a one-dimensional life is an expense few can afford.

Jenny Kostecki-Shaw also realized early that if you just hole up in the studio you could lose your real-world skills. "You must make the effort to go to town, socialize," she says. "*Be a part of something else.* Don't isolate yourself."

"It *is* a balancing act between solitude and community," Kostecki-Shaw sums up. "Whatever you do away from the drawing board may be small scale, but it can be a big thing for the quality of your life. For me, it is about letting go of judgments and expectations and being open to things different and all that has to teach me."

## GET BACK

Julia Breckenreid works outside of her house with other illustrators, animators, art directors, and a publisher in a storefront studio in Kensington Market (Toronto, Canada). "Everyone is talented, focused, and driven," she says. "We inspire each other every day! I will never work at home again—too isolating."

Breckenreid also creates her own *opportunities,* in the form of shows and other events at her studio that get her peers involved together (www.nookcollective. com). "I have a very large circle of peers I consider my friends here," she says, "and I love to show my support."

An illustration instructor at Sheridan College, Breckenreid teaches conceptual process and visual language to first-year students. "My students inspire me constantly," she says. "I can say honestly that I have become a stronger illustrator because of my teaching experiences. *Give and get back*—it seems to work really well for me."

## SECURE

For Greg Betza, this is a business that is always changing, where you never know what the next assignment will be. It's a world of demanding professional survival skills—learning how to find and keep clients, creating new opportunities for yourself—establishing and maintaining your career becomes the very essence of "security."

But for Betza, that's what keeps the experience fresh and *vital.* "I actually do think a freelance career is more secure," says Betza. "Someone with a typical 9–5 job could walk in to work today, be fired, and find themselves at the back of the endless unemployment line without the skills to survive on their own. Freelancers can never be fired."

In a book that has discussed the ups and downs of wearing many hats, this is a good place to hear Betza's take on the idea of "doing it all." "I think you can," he

says, "but it's a personal choice, of course. I define 'doing it all' as being a part of every aspect of the business that you choose. Whether it be editorial, advertising, fashion, gaming, and so forth. Do you have the versatility to apply your art and thinking to all of these different disciplines?

"I'm interested in exploring many different avenues," says Betza, "and as I base my illustration more in drawing than style, I have been able to navigate between editorial, advertising, concept art, storyboards, fashion, institutional, and more.

"Back in the day," he says, "it seemed as though there were more illustrators 'doing it all.' An illustrator's work would appear in many different markets—for instance, book jackets, movie posters, adverts, and editorial features. "Take someone like Bob Peak or Milton Glaser, two of the most successful illustrators of all time. They both changed and evolved with each new assignment and worked in nearly every possible area of the visual arts. I don't know if it was easier, or if it was just something encouraged.

"In my experience," says Betza, "I had only one teacher expose me to anything besides the editorial market. In fact, the huge world of opportunities available to all illustrators was rarely, if ever, discussed in school. This lack of exposure limits the vision of many young illustrators. They are not told where their work could potentially fit and very often they never realize that their work may be extremely relevant in an area besides the editorial world."

## COMMUNICATING

"To be a relevant illustrator, you must be an effective communicator," Betza says. "If you are not communicating, you are not illustrating."

Betza knows that an honest self-assessment of your work will tell you if you're communicating clearly and effectively. "Ask yourself," he says, "if this illustration is giving a greater insight to the article, enhancing the campaign, the concept, whatever.

"Becoming an effective communicator starts, for me, at the museum. Where else can you see so many historically and culturally diverse approaches to communication? Try to understand how and why the art in a museum is communicating and you will be on your way."

Betza's museum litmus test is all about solving problems visually. Of course, an illustrator takes on the extra challenge of solving problems visually *on a deadline*. But the museum experience also swings open a wonderful window into a vast world of individual artistic perspective.

"A client will have a very specific idea of what they want and they'll expect you to execute the illustration," Betza says. "But as a rule I always offer my point-of-view on potential solutions. You must always do the job, but your clients will appreciate it if you bring your unique method of problem-solving to the table."

## AND THERE IT IS

"I'm not always sure where I fit in or how," says Linda Ketelhut. "Just being an artist makes me part of a creative *co-operative* and offers work that resonates with me, introduces me to interesting people who inspire me—dedicated people who are trying to make a contribution that will move or touch someone else in a positive way.

"And there's the connection," says Ketelhut, "to dedicate yourself to your work. To create; build a community; to promote yourself and start your practice, however that is. To be passionate. To commit. Leap! To stay true to yourself, and not be a copy. You take yourself seriously and others will take you seriously too—no matter where you are in your career.

## LET'S CONNECT

It is fitting in this final chapter to talk about *connections*. Erin Brady Worsham says it well. Worsham feels that, as artists, we can't know where we're going until we've seen where we've been. To that, let's add that you don't know who you are until you recognize and interact with your community.

Let's *not* lament or grouse about the state of the *business*. There's plenty of opportunity to do that, but certainly, if we pay attention to the aforementioned connections, there's the manpower, time, and commitment to do something about it, too. "An optimist suggests that for every door that closes, one opens," Tom Graham says.

To keep opening doors, you'll need to consider where you've been, where you are, and where you're going (and *growing*). To do that you must keep those connections vital.

And you may want to leave some kind of legacy, to make your mark, to have made a difference. Rick Sealock suggests that it might be more reasonable to ask what *not* to be remembered for. "Don't be boring, don't be safe, don't be a sellout, don't be a suck on society, and don't proliferate 'bad' aesthetics," he admonishes.

Here, Paul Dallas picks up the thread. "Yes," he states. "Be mindful of what you don't want to do, perhaps more than you want to do. Allow yourself to gravitate to, rather than aim specifically at, something. You will crash-land otherwise."

As Federico Jordan says, "Communication is the essence. Communication—that's really the ability to look through another's eyes." Or, as Sealock once told me: it's all in the 'I's'. . . you strive to be innovative, interesting, and introspective."

Reiterating earlier sentiments, this communication is now truly global. More than ever, you can broaden your focus into a panoramic world view. And as Ward Schumaker sums it up for us, "The world is really just one big conversation; [go help] pass ideas around."

# STAY THE COURSE, OF COURSE

I want you to go out there, do fine illustration, good works, and be happy (in no prescribed order). No bejeweled words of wisdom or profound, sage advice. Just a simple professional and personal wish for you and yours.

Renowned educator (and master jeweler) J. Fred Woell had this take on the idea of job satisfaction: "It's kind of a long pull," he discussed in a 2001 interview with Donna Gold for the Smithsonian's Archives of American Art. "Be persistent . . . stick to it. Look ahead. There's a Zen comment—I don't know what they call these things in their philosophy—'Go slow, reach fast.' You just keep working at it, and then suddenly it happens. You keep trying to be keep consistent with what you believe . . . and you get there."

# ON THE BOARD

## (PROFESSIONAL VIEWPOINTS IN 50 WORDS OR LESS)

You can work to live, or you can live to work. I prefer the former.

—Darren Booth

Ideas are not really ideas until they are translated into labor.

—Shaun Tan

It's a marathon, not a short sprint. Be open to new ideas and change—that's not only good for your creativity, but is needed in a constantly changing marketplace.

—Ellen Weinstein

I was fortunate to take a class taught by Milton Glaser who told us, "Always give your best effort, no matter who it is for." I've never forgotten that.

—Jason Petefish

What's that saying, "Keep Calm and Carry On"? That defines a professional to me. Put your best foot forward; solve the visual problem you're asked to solve; contribute your own visual language to the project. And complete it on time, of course.

—Veronica Lawlor

© Will Terry 2016

I know the work is not drying up tomorrow. I have a reputation and it precedes me. Why do I have that reputation? Because I draw good pictures and I'm not a jerk.

—Brian Biggs

I have a really big neighborhood. Whenever someone I know moves away to a new town I always figure the neighborhood just got bigger. This is a great source of creative energy for me.

—Lori Osiecki

"Failure" is the wrong focus. The focus should be on "attempt." Attempts have one of two outcomes: success or failure; neither of which you receive without the real aim—attempts.

—George Coghill

Educate yourself by being a sponge. Don't allow fear to keep you from experimenting in the unknown. Risk is okay— be curious and open, it always leads you somewhere good. Work your ass off and create work you can be proud of.

—Julia Breckenreid

© Margaret Hurst 2016

I stopped worrying about getting pigeon-holed a long time ago. I do freelance illustration to make a living. I leave my personal visions for my paintings.

—Kellyanne Hanrahan

It's too easy to say "Learn with each set-back." Call that sonuvagun every name in the book if it helps get you to the next stage. I'm no stranger to welling up with tears when I missed out on a great job. Be professional—you just keep at it.

—Brie Spangler

© Michael Fleishman 2016

# INDEX

Note: Illustrations are indicated by page numbers in *italics*.

401K plan, 159

## A

Abbott, Bill, 385, 387, 389, 390, 392–393, 396, 398
Abel, Jessica, 344
Abrams, Kathie, 243
Accessibility, 18
Accountant, 101–102, 112
Accounting methods, 154–157
Adams, Kathryn, 212–220, 221
Advertising, traditional, 193. *See also* Marketing
Advertising agency, 402, 404
Age, 31
Agliardi, Allegra, 27–28, 197
Allen, Brian, 17, 154, 412
Allsbrook, Wesley, 250
Alternative, 473–474
Animation, 55–56, 69, 347, 348–351
Antolic, Rick, 48, 90, 179, 181, 193–194, 272, 472
Apple (computers), 133–135, 138
Apprenticeships, 44
Apps, 304–305
Aptitude, 31
Arday, Don, 97, 98, 200, 208–210, 221, 298–299, 327
Arkle, Peter, 66, 67, 85, 181, 206–207, 212–220, 235–236, 242, 327, 355, 445
Art directors. *See also Clients*
    at magazines, 359
    point of view of, 178–179
    students and, 42
Art school. See Education
Art therapy, 7
Attire, 236–237, 268–269
Attitude, 31
Audience, in marketing, 246–247
Avant-garde, 475

## B

Backups, data, 139

Baer, Rebecca, 375–376
Bakal, Scott, 23, 26, 39, 43, 74, 170, 222, 227, 260, 288, 289–290, 291, 296, 297
Ballinger, Bryan, 114, 270–272, 285, 288, 290, 292, 335
Banker, 112
Banks, 106–107
Bayraktaroglu, Corrine, 221, 276–277, 278
Being yourself, 8
Beiriger, Joan, 378–380, 400
Bendis, Keith, 91, 281–282
Benun, Ilise, 13, 175, 176
Betza, Greg, 23, 442–443, 486–487
Biggs, Brian, 3, 15, 29, 44, 45–46, 49, 71, 146, 198, 261, 264, 275, 286, 288, 292, 302, 328, 432, 444, 491
Blog, 313–314, 317–322
Blumen, John, 225, 301
Bookkeeping, 154–157
Books, 365–370
Booth, Darren, 144, 300, 490
Bootstrapping, 267–268
Bostic, Alex, 437–438
Branding, 87–88, 383–384
Brant, Shelley, 374, 376–377
Braught, Mark, 263
Breaking even, 105
Breckenreid, Julia, 70, 81–82, 212–220, 472, 486, 491
Broadwell, Bethany, 450–452
Brucker, Roger, 131, 148, 186, 189, 194, 221, 259, 284
Budd, Deborah, 404–405, 406, 409, 411, 417
Bullock, Ken, 24, 40–41, 56–57, 91, 134, 135, 171, 237, 311–312, 425, 430–431
Burning out, 21, 350–351, 449–450
Buschur, Julie, 124
Business. *See also* Freelance; Management; Marketing
    accountant for, 101–102
    costs, 103–104

education in, 46, 53
financing and, 93
importance of, 88, 176
juggling in, 146
as reality, 146
sense, 77, 81, 83–85, 88, 182
software, 136–137
taxes, 101–102
Business plan, 93–100, 152–153
Buyouts, 410–411
Byrd, Robert, 479

**C**

Cable television news, 362
Capabilities, in promotion, 188–190
Capitalization, 107
Cards, greeting, 384–398
Carlson, Fred, 70, 418, 419
Cash flow, 107. *See also* Income
Challenge, 32
Change, 464–465, 472
Checkbooks, 156
Children's books, 55–56
Cho, Michael, 149–150, 248–249, 341–342,
     352, 355–356, 469, 475
Chua, Charlene, 13–14, 24, 25, 37–38, 48,
     51, 70, 90, 248, 285, 289, 290, 291,
     297, 353, 430, 468, 472
Chutzpah, 22
Clarke, Sir Arthur C., 299
Clients. *See also* Art directors
  in business plan, 100
  confidence with, 52
  customer service with, 177, 194–195
  difficult, 179–180
  etiquette with, 195
  finding, 176, 183–184
  getting new, 57
  history with, 151
  matching with, 176
  needs of, 182
  new, 181
  potential, 87
  pricing and, 209
  satisfaction of, 196
  small businesses as, 415–423
  spec work and, 193–194
  updating, 150

Clothes, 236–237, 268–269
Cloud storage, 136–137
Coghill, George, 24, 50, 147, 150, 180, 198,
     212–220, 221, 288–289, 294, 296,
     400, 422, 491
Cold calls, 190–191, 241
Collaboration, 181
Collateral, 107
College. See Education
Colombo, Alex, 374, 375
Color retouching, 299
Comic book. See Sequential art
Commitment, 9–11
Communication, 28–29, 126–127, 150
Community, 154–155
Community college, 30, 35, 38–39. *See also*
     Education
Community newsletter, 362
Competition, 78–79, 82, 88, 95, 154, 177, 476
Competition awards, 272–273
Competitions, in marketing, 193
Computers, 130–142
Concentration, 122–123
Conceptualization, with studios, 404
Confidence, 52, 61, 62
Consultants, 138, 421
Contests, 272–274
Copyright, 165, 275–282, 280–281
Copyright Collaborative, 278
Cornelius, Ray-Mel, 6, 458–459
Costs
  business, 103–104
  education, 29–30
  equipment, 131, 139, 140–141
  managing, 151
Courier service, 147
Cover letters, 249
Creative Commons, 279
Creative directories, 192
Credit, 107
Credit cards, 110, 151
Crowdfunding, 269, 270–272, 334
Cuppleditch, Helz, 374, 376
Customer service, 177, 194–195

**D**

Daily Dot, 90
Daily to-do list, 148–149

Dallas, Paul, 488
Dalziel, Trina, 286, 380–382, 399
Danchuk, Emily, 277–278
Da Re, Giovanni, 371, 470, 482–483
Data backups, 139
Data storage, 136–137
Day job, 80, 81, 180
Decisiveness, 78
Deduction, home-office, 122, 123–124
Defined benefit plans, 159
DeMuth, Roger, 425
Dervaux, Isabelle, 243, 307, 439, 473
Design, 33–34, 39, 52–53, 69, 74–75
Design studio, 75, 402
    conceptualization and, 404
    portfolios and, 408–409
    virtual, 404–405
    work-for-hire and, 410–411
Desktop computers, 140
Digital drawing, 288–300, 301, 302
Digital Millennium Copyright Act
    (DMCA), 280–281
DingDing Studio, 171
Directories, 192, 368
Disability insurance, 159, 160
Disbursement journal, 156
Discipline, 77
Distractions, 461–463
Diversification, 458
Diversity, of illustrators, 51–52
Donation, of work, 64–66, 193
Donovan, Bil, 177, 197, 204–205, 212–220
Doran, Melissa, 72, 459–461
Doubt, 461
Douglass, Ali, 452–453, 476
Dreamweaver (website software), 324
Dress code, 236–237, 268–269
Drop-off, of portfolio, 239
Dry spells, 458–459
Dullaghan, Penelope, 243, 305–307, 328, 424
Dumitrescu, Avram, 23, 71, 197, 228, 286,
    294, 295, 328, 355
D. Vinci, Gerald, 37, 48, 90, 207, 208, 211,
    222, 325
Dykes, John, 266–267

**E**

Ebooks, 365

eCards, 386
Education. *See also* Teaching
    abroad, 27–28, 33–34
    apprenticeships, 44
    basics in, 26
    in business, 46, 53
    commercial art school vs. university,
        35–36, 38
    community college, 30, 35, 38–39
    costs, 29–30
    employment and, 31
    experiences in, 27–28, 46–47
    importance of, 34, 40, 41, 45–46
    internships, 43–44
    maximizing, 32–33
    ongoing, 26–27
    online, 34–35
    on-the-job, 43–45
    open mindedness in, 31–32
    options, 38–39
    quantity vs. quality in, 36
    self, 37
    as success factor, 31
Edwards, June, 31–32, 41, 42, 352, 434,
    439–441, 444
Ego, 62
Eliot Lilly Art LLC, 302
Email, 147
Employer Identification Number (EIN),
    108–109
Energy, 31, 79
Entrepreneurship, 84–85, 254. *See also*
    Business; Freelance
    bootstrapping and, 267–268
    contests and, 272–273
    crowdfunding and, 269–272
    defined, 262
    importance of, 263
    intellectual property and, 275–282
    marketing and, 269
    seven-point plan for, 268–269
    story of, 264–266
    versatility and, 263
Equipment, 128, 130–142
Establishment, 474
Etiquette, with clients, 195
Eubank, Mary Grace, 64, 80
Executive Summary, in business plan, 94
Exercise, 466–467

Expense monitoring, 154–157
Expenses, 103–104, 151
Experience, 31, 57, 82–83
Experimentation, 7

**F**
Facebook, 255
Failure, 10, 453–454, 456–458, 465
Farrington, Susan, 143
Fax, 127–128
Feedback, 33–34
Fencl, Brian, 5–6, 63, 115
Fernandez, Rigie, 5, 259, 307, 308, 327, 400
Financial management, 151, 153, 154
Financing
    business, 93, 100, 106–111
    crowdfunding, 269
    equipment, 132
Fine art, 75
Flat rate, 421
Fleishman, Michael, 23, 24, 70, 213–220, 221, 289, 290, 296, 492
Flesher, Vivienne, 469
Focus, 15, 122–123
Freda, Anthony, 212–220, 448–449
Freelance. *See also* Business
    commandments for, 19–20
    day job and, 80, 180
    independent vs., 13–14
    with newspapers, 364
    pricing and, 211
    with publishers, 369
    sales and, 80–81
    for small businesses, 415–416
    as student, 40, 45
    working and, 56–57
Frieden, Sarajo, 23, 76
Full-service agencies, 402
Fun factor, 202

**G**
Garrett, Tom, 26, 34, 35, 223, 242, 245, 246, 289, 333
GAS (gear acquisition syndrome), 141–142
Gaskins, Nick, 198
Gatekeepers, 336
Gear acquisition syndrome (GAS), 141–142

Gilden, Nadine, 91, 122–123, 134, 183, 197, 372, 421–422, 470
Gladwell, Malcolm, 51
Glasbergen, Randy, 70, 303, 373, 424
Glaser, Milton, 487
Glasgow School of Art, 27–28
Glei, Jocelyn K., 477
Graham, Tom, 363, 408, 424, 453
Grants, 109
Graphic design, 52–53, 69, 74–75, 358
Graphic novel, 344–345. *See also* Sequential art
Greeting cards, 384–398
Guerrilla marketing, 60–61

**H**
Haggerty, Tim, 399
Handbook of Pricing and Ethical Guidelines (PEGS), 208, 212, 214
Hannon, Mark, 29
Hanrahan, KellyAnne, 221, 226, 260, 492
Haughton, Chris, 171, 262, 299, 483–484
Health, 466–467
Health insurance, 159–160, 161
Help, 166
Hemstad, Rebecca, 308, 309, 327
Hiring help, 166
History, with clients, 151
Hodgson, Rob, 369–370, 444, 468, 473
Holzer, Margie, 432–433
Home, working from, 17, 121–124
Home office, 122, 123–124
Hortin, Anthony, 23
Hosting, website, 315–317
Hu, Dingding, 260, 286, 353
Hughes, Steven, 184–185, 227, 232–233, 410, 481–482
Hull, Scott, 185–186, 352
Humility, 62
Hurst, Margaret, 33–34, 291, 292, 371, 491
Hustle, 19, 79

**I**
IED Milano, 28
Illustration studio, 75
Illustrator(s)
    defined, 4, 51
    diversity of, 51–52

Income, 76, 102–103, 105–106, 151
Income monitoring, 154–157
Independent, freelancer vs., 13–14
Individuality, 20
Instagram, 255, 306
Insurance, 159–161
Insurance agent, 112
Integrity, 474
Intellectual property, 165, 275–282
Interest rates, 163–164
Internships, 43–44, 421
Inventiveness, 32
Inventory, in business plan, 99
Investment, 162
iPad, 225
IRAs (Individual Retirement Accounts), 158–159
Isolation, 79, 485–486

**J**

Jabbour, Ellie, 125, 143, 183, 194
Jackson, Adela Grace, 170
Jager, Lea Kralj, 334, 337–339, 343, 353, 455
James, David, 204
Jarrard, Scott, 453, 456, 457, 462
Jaynes, Bill, 429, 435–436
Job jacket, 147–148
Johnson, Dan, 170, 401, 409
Jordan, Federico, 488
Julian, David, 469

**K**

Katt, T. Simon, 92, 372
Keith, Toby, 73
Ketelhut, Linda, 91, 167–169, 248, 260, 464–465, 488
Kimball, Derek, 130
King, Stephen Michael, 12–13
Kisielewska, Larissa, 93–94, 94–95, 104, 105, 106, 110, 111, 112, 114, 128, 130, 131, 132, 135
Klauba, Doug, 45
Kostecki-Shaw, Jenny, 43, 434, 486

**L**

Laptop computers, 140
Lauso, Judith, 420–421

Lawlor, Veronica, 144, 242, 346, 441–442, 444, 490
Lawyer, 112, 113
Leads, 66
Lease
    equipment, 132
    for office, 125–126
Ledger, 156
Leland, Caryn, 392
Leong, Lampo, 436
Libbey, Rhonda, 54–55
Licenses, 103, 129, 375–380, 384–385, 390, 392
Life, drawing from, 32
Life insurance, 159, 160
Lilly, Eliott, 302, 348–350
Line of credit, 110
Lists, daily, 148–149
Liu, Ken, 280–281
Loans, 106–111, 162–164
Local, national vs., 58–59, 184
Location, 30
    market and, 58
    of studio, 121
Loughran, PJ, 456–457, 468, 474
Luck, 30
Lynch, Fred, 27, 48, 221

**M**

Mac (computer), 133–135, 138
Madden, Matt, 344
Magazines, 355–361, 368
Mahan, Benton, 45, 81, 91, 184
Maihack, Mike, 339
Mail list, 191–192
Management. *See also* Business
    financial, 151, 153, 154
    organization and, 147–148
    priorities and, 147
    to-do lists in, 148–149
Manifesto, 190
Marketing, 18. *See also* Business; Sales
    audience and, 246–247
    for books, 366–367
    branding and, 87–88, 383–384
    brevity in, 248–249
    in business plan, 95, 100, 153
    capabilities in, 188–190
    cold calls in, 190–191

collateral, 402
competitions in, 193
cover letters in, 249
entrepreneurship and, 269
guerrilla, 60–61
local, 59–60, 403
for magazines, 358–359
to magazines, 359–360
mail lists in, 191–192
networking and, 249, 250
for newspapers, 364
online, 187
passive vs. active, 256–257
phone book in, 192
postcards and, 247–248
pricing and, 205
pro bono work in, 193
purchased promotion in, 100
research in, 54–55
self-promotion in, 33–34, 186–187, 187–188
to small businesses, 417–419
social media and, 53–54, 245, 247, 248, 250, 252–253, 255
spec work and, 193–194
success and, 86–87
talent directories in, 192
technology and, 245–246
traditional advertising in, 193
website, 246
Markets
chasing, 263
local vs. national, 58–59
print, 358–359
researching, 54–55
Marks, 431–432
Mayer, Bill, 371
McCranie, Stephen, 289, 335–337, 352
McElligott, Matt, 52, 78–79, 419, 424, 438
McGinnis, Marti, 391, 424
Media, 31–32, 441. *See also* Digital drawing
Mega (illustrator), 60–62, 313–321, 314, 327
Melamed, Victor, 20–21, 275, 346
Melia, Paul, 170, 203, 445, 470, 474, 475, 485
Mellon, Nancy, 278
Memory (computer), 139
Meyer, Ken, Jr., 30, 453

Millidge, Gary Spencer, 342–344, 353, 446
Minamata, Julia, 49, 60, 71, 114, 146–147, 177, 244, 259, 288, 327, 455, 469
Mission statement, in business plan, 98
Mistakes, 453–454, 456–458
Miyauchi, Alison, 119
Money, 76, 83, 105–106. *See also* Income; Pricing
Money management, 151
Money Purchase Pension Plans (MPPs), 159
Monitoring, expense and income, 154–157
Monlux, Mark, 240
Motivation, 45, 69, 76, 83

**N**
National, local vs., 58–59, 184
Negative feedback, 338–339
Nemec, Greg, 439, 475
Networking, 57, 63–64, 183–184, 219, 249, 250, 267
Newspapers, 334, 361–364
Nichols, MaryAnn, 238–239
Nicholson, Tom, 101, 114, 259, 285
Nonprofits, 421

**O**
Objectives, in business plan, 98
O'Brien, Tim, 250
Office, virtual, 125
Office rental, 125–126
Office space, 125–126
Office supplies, 128
Olds, Herb, 472
Online learning, 34–35. *See also* Education
Online magazines, 357
Operating systems, computer, 133–135
Organization, 147–148, 149–150
Organizations, publishing, 368
Orvidas, Ken, 114, 197, 256–258, 260, 285, 287, 353, 407, 425
Osiecki, Lori, 42–43, 304–305, 399, 491

**P**
Payne, Chris, 251
Payroll journal, 156
PC (computer), 133–135
Peak, Bob, 487

PEGS (Handbook of Pricing and Ethical
    Guidelines), 208, 212, 214
Peji, Bennett, 90, 412
Pension plans, 159
Perks, Grant, 110
Perseverance, 31, 61–62, 110–111
Petefish, James, 6–7, 198, 490
Phone book, 192
Phone calls, 126–127, 190–191
Piscopo, Maria, 186, 191–192, 228, 238
Pizzoli, Greg, 222, 253, 264–266, 413,
    479–480
Plan, business, 93–97
Portfolio
    assembly of, 229–231
    building, 56–57
    on CD, 231
    delivery, 240–241
    design studios and, 408–409
    drop-off, 239
    identification in, 230–231
    importance of, 224
    iPad, 225
    labeling, 234–235
    layout, 230
    in marketing, 187–190
    neatness in, 230
    physical, 224, 226, 228, 233, 257
    pro bono work and, 65
    review, 236–239
    style and, 227–228
    tailoring, 233
    targeting, 234
    website as, 226, 231, 249, 311–313
    what to include, 228–229
Positivity, 463
Postcards, 247–248
Practice, 32
Prebys, Crispin, 408
Pressfield, Steven, 465
Pressures, 8–9
Pricing, 99, 168, 196
    in art director's point of view, 178
    audience and, 202
    breaks, 422–423
    challenge in, 201–202
    client and, 209
    conditions and, 209
    deadlines and, 201

docket in, 200
elements of, 200–203
factors, 156, 200–203
flat rate, 421
freelancing and, 211
fun factor and, 202
Handbook of Pricing and Ethical
    Guidelines (PEGS) and, 208, 212,
    214
menu-type, 220
money and, 203
monthly profit and, 102–103
nature and, 202
networking and, 219
overhead and, 210
patience and, 204–205
promotion and, 205
rate hikes and, 205–207
revisions and, 201
roundtable on, 212–220
scope and, 209, 217
standards and, 207–210
stature and, 202
time and, 201
turnaround and, 208–209
value and, 202–203
yearly salary and, 105–106
Print
    books, 365–370
    death of, 55, 355
    greeting cards, 384–398
    magazines, 355–361
    newspapers, 361–364
Printers, 405, 420
Problem-solving, 28–29, 42
Pro bono work, 64–66, 193, 421
Product, in business plan, 95
Professional organizations, 160, 183–184,
    361
Projections, income, 102–103, 104
Promotion. See Marketing; Self-promotion
Public relations firms, 402–403
Publishing house, 366
Purchased promotion, 100
Purpose, 11
Putt, Kristine, 21–22, 87, 88, 91, 165, 183,
    222, 275–276, 367, 468
Puzzle, 28–29
Pyle, Howard, 300

## Q

Quon, Mike, 145, 258, 371, 447–448

## R

RAM (computer memory), 139
Rate hikes, 205–207. *See also* Pricing
Recasens, Cristina Martin, 5–6, 227–228, 294
Records, financial, 154–157
Redniss, Lauren, 18
Red Nose Studios, 71
Reed, Brad, 127, 132, 133, 137, 139, 309
Reed, Tara, 382–384, 465–466, 468
References, 66
Referrals, 66
Reim, Melanie, 413, 478–479
Rejection, 52, 78, 463
Relationships, 111–112
Renting office, 125–126
Representatives, 56, 80, 265
Research, market, 54–55, 87
Retirement savings, 158–159
Reverse image search, 276, 279–280
Risk, 9
Rockwell, Lizzy, 445, 453
Rodrigues, Antonio, 46–47, 285, 468
Roth IRAs, 158
Routine, 123, 147
Rowe, Thereza, 54, 471
"Rule of 78s," 164
Rustiness, 449–450

## S

Salerno, Steve, 425
Sales, 18, 80–81, 95, 176–177
Salisbury, Mike, 262, 286, 372
Satisfaction, of clients, 196
Savings, 154, 158–159, 162
Schmelzer, John, 24
School. See Education
Schumaker, Ward, 469, 488
SCORE (Service Corps of Retired Executives), 111
Sealock, Rick, 474, 476–477, 488
Search Engine Optimization (SEO), 314–315
Selby, Bob, 75
Self-assessment, 16, 167

Self-discipline, 77
Self-employment, 14–15
Self-promotion, 33–34, 186–187, 187–188
Self-publishing, 339
Self-realization, 433
Self-taught, 37
Selling point, 21
Sequential art
    animation, 347
    breaking into, 333–334, 341–342
    downsides of, 341
    gatekeepers and, 336
    graphic novels, 344–345
    Internet and, 332–333
    origin of, 332
    trolling and, 338–339
Shapiro, Ellen, 177–178, 212, 425
Shared work space, 120–121
Sharp, Jamie, 422–423
Shaw, Stan, 212–220, 359, 371, 438, 444, 445
Shimizu, Yuko, 80, 146, 240, 354
Shin, Dadu, 5, 7, 8–9, 36, 212–220
Sickels, Chris, 55–56, 204, 249–250, 250–253, 259, 282–284
Side projects, 22
Sketches, 179
Skills, 83–84
Skye, 63
Small Business Administration (SBA), 109–110
Small Business Development Centers (SBDCs), 111
Small businesses, as clients, 415–423
Smith, Charlene, 49
Smith, Elwood, 221, 242, 262–263
Smith, Tammy, 377–378
Snider, Grant, 89, 198, 253–254, 255, 480–481
Social media, 53–54, 182–183, 245, 247, 248, 250, 252–253, 255, 256, 306, 307
Society for News Design, 364
Software, 131, 136–137, 156, 381
Sommer, Mikkel, 15–16, 22, 48, 70, 243, 259, 289, 326, 339–340
Space, for work, 120–126
Spangler, Brie, 454, 470, 492
Spec work, 193–194

Spollen, Chris, 6, 198, 413, 484, 485
Stamina, 31, 79
Standing out, 20–21
Starnes, Roger, 208, 222, 317, 318
Steinberg, Anna, 114, 154–155, 170, 285
Storage, data, 136–137
Strategy, in business plan, 94–95
Streeter, Katherine, 9–10, 10–11, 468
Stress, 79
Studio, 120–121, 348–351, 402. *See also*
    Design studio
Style, 20–21, 26, 227–228, 435, 475
Success, 85–87
Supplies, 128
Suzuki, Keiko, 375

**T**

Taback, Simms, 237, 374
Takedown notice, 280–281
Talent, 31, 45, 179
Talent directories, 192
Tan, Shaun, 71, 88–89, 229–230, 263, 450,
    463, 484, 490
Task management, 149–150
Taxes
    accountants for, 101–102
    equipment leases and, 142
    home office deduction and, 122,
        123–124
    saving for, 154, 157–158
Teach, Gary, 110–111
Teaching. *See also* Education
    assignments, 435, 440–441
    benefits of, 437–438, 438–439
    different media and, 441
    flexibility in, 434–435
    getting started in, 434
    growth in, 442
    impact of, 432–433
    importance of, 432
    joy of, 430
    as learning opportunity, 438
    lesson planning, 439–440
    marks and, 431–432
    as noble, 430
    preparation in, 431
    students and, 433, 435–436
    style, 435
Teams, 166

Technology, 53, 130–142, 245–246. *See also*
    Digital drawing
Telephone, 126–127, 190–191
Television news, 362
Terry, Will, 67–69, 212–220, 247, 248, 490
Tesla, Nikola, 477
Tharp, Rick, 115, 144
Thelen, Mary, 412
Therapy, 7
Time management, 149–150, 167
Tipping Point, The (Gladwell), 51
Todd, Mark, 340–341, 469
Trade magazines, 368
Trade shows, 382–383
Trolling, 338–339
Tumblr, 255

**U**

Updating clients, 150
Usage rights, 165, 218–219

**V**

Value-added resaler (VAR), 138, 140
Vandeventer, Vicki, 143, 366, 370, 414,
    453–454, 462–463
Vendors, credit with, 111
Versatility, 263
Video games, 348–351
Viral content, 336
Virtual agencies, 404–405
Virtual office, 125
Visibility, website and, 307–308
Viviano, Sam, 371, 424
Volunteering, 64–66, 193
Vulnerability, 461

**W**

Wasco, Al, 229, 230, 231, 233, 237, 238–
    239, 240, 243, 288, 292–293, 313,
    314–315, 321–323
Way of Art, The (Pressfield), 465
Web comics, 334. *See also* Sequential art
Weber, Sam, 250
Website
    advantages of, 310
    on all devices, 308
    apps and, 304–305
    blog, 313–314, 317–322

building, 309, 324
coding and, 309
content, 314–315
disadvantages of, 310–311
domains, 317–318
hosting, 315–317
image optimization for, 321–322
importance of, 256, 304
marketing and, 306–307
naming, 312–313, 318
organization of, 320–321
overkill with, 246
platforms, 318
plug-ins, 319–320
as portfolio, 226, 231, 249, 311–313
promotion of, 322–323
quality control, 321
Search Engine Optimization and,
    314–315
tags, 320
theme, 319
updating, 305
URL for, 312, 317
visibility and, 307–308
Weinstein, Ellen, 48, 372, 434–435, 490
White, Kelly, 35, 49, 52, 53–54, 177,
    182–183, 200, 201–203, 209, 210,
    461–462
Wilson, Phil, 5, 19, 26–27, 52, 90, 91

Windows (computer software), 133–135
Winn-Lederer, Ilene, 115, 297, 391, 415,
    469, 485–486
Woell, J. Fred, 489
Wollenmann, Randy, 470
Wood, Allan, 4, 12, 171, 292, 398, 415–416,
    420, 425, 469
Woodward, Lea, 96–97
Wooley, Michael, 406
WordPress, 318
Workbook.com, 187
Work-for-hire, 410–411
Working from home, 17, 121–124
Work space, 120–126
Worsham, Erin Brady, 49, 452, 488
WYSIWYG website construction, 309

**Y**
Yaccarino, Dan, 114
Yang, James, 256
Yeh, C. J., 70, 231–232, 238–239, 309, 312,
    323–324, 410
Young, Neil, 475
Youngblood, Kim, 90, 114

**Z**
Zahajkewycz, Ulana, 43, 44, 445, 457
Zimmerman, Robert, 135, 403, 405

 **Books from Allworth Press**

---

**Business and Legal Forms for Illustrators, Fourth Edition**
*By Tad Crawford* (8 ½ x 11, 168 pages, paperback, $24.99)

**The Business of Being an Artist, Fifth Edition**
*By Daniel Grant* (6 x 9, 344 pages, paperback, $19.99)

**Create Your Art Career**
*By Rhonda Schaler* (6 x 9, 208 pages, paperback, $19.95)

**How to Grow as an Illustrator**
*By Michael Fleishman* (6 x 9, 288 pages, paperback, $19.95)

**Inside the Business of Illustration**
*By Steven Heller and Marshall Arisman* (6 x 9, 256 pages, paperback, $19.95)

**Legal Guide for the Visual Artist, Fifth Edition**
*By Tad Crawford* (8 ½ x 11, 304 pages, paperback, $29.95)

**Licensing Art and Design**
*By Caryn R. Leland* (6 x 9, 128 pages, paperback, $19.95)

**Marketing Illustration**
*By Steven Heller and Marshall Arisman* (6 x 9, 240 pages, paperback, $24.95)

**The Profitable Artist**
*By Artspire* (6 x 9, 240 pages, paperback, $24.95)

**Starting Your Career as an Artist, Second Edition**
*By Stacey Miller and Angie Wojak* (6 x 9, 304 pages, paperback, $19.99)

**Teaching Illustration**
*By Steven Heller and Marshall Arisman* (6 x 9, 304 pages, paperback, $19.95)

**Where Does Art Come From?: How to Find Inspiration and Ideas**
*By William Kluba* (5 ½ x 8 ½, 192 pages, paperback, $16.95)

**To see our complete catalog or to order online, please visit** *www.allworth.com.*